C000125173

THE COSMATESQUE MOSAICS OF
WESTMINSTER ABBEY

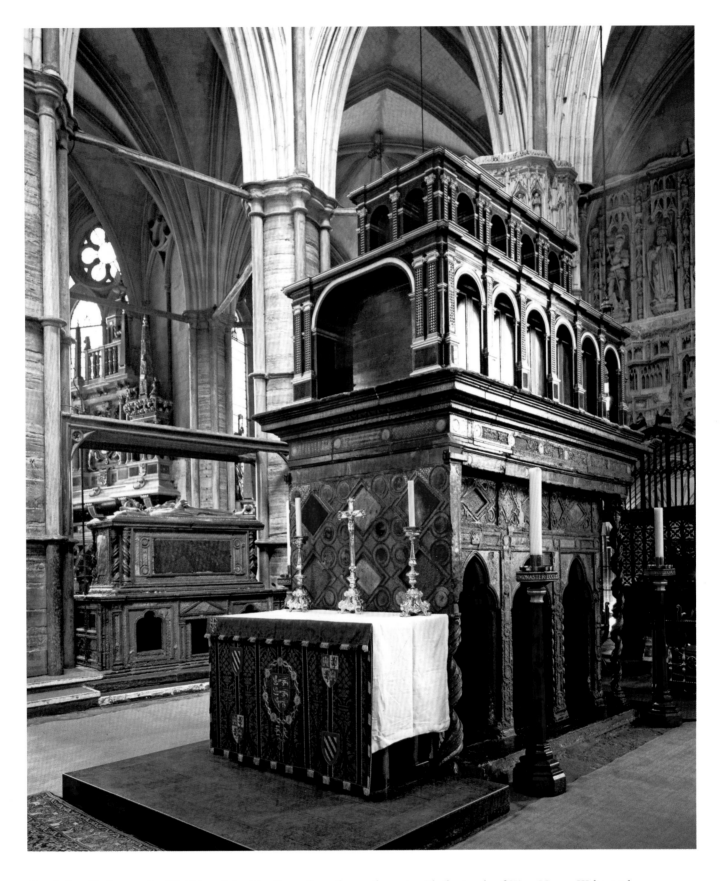

Frontispiece: Shrine-tomb of St Edward the Confessor, from the south-west, with the tomb of King Henry III beyond.
© *Dean and Chapter of Westminster*

THE COSMATESQUE MOSAICS OF WESTMINSTER ABBEY

The Pavements and Royal Tombs:
History, Archaeology, Architecture and Conservation

VOLUME 2

THE ROYAL TOMBS

by

Warwick Rodwell and David S Neal

with contributions by

Paul Drury, Ian Freestone, Kevin Hayward, Lisa Monnas, Matthew Payne,
Ruth Siddall, Vanessa Simeoni and Erica Carrick Utsi

computerized illustrations by

Thomas Clark

Foreword by

The Dean of Westminster

OXBOW | books
Oxford & Philadelphia

Published in the United Kingdom in 2019 by
OXBOW BOOKS
The Old Music Hall, 106–108 Cowley Road, Oxford, OX4 1JE

and in the United States by
OXBOW BOOKS
1950 Lawrence Road, Havertown, PA 19083

Copyright © Warwick Rodwell and David S Neal 2019

Hardcover Edition: ISBN 978-1-78925-234-7
Digital Edition: ISBN 978-1-78925-235-4 (epub)

A CIP record for this book is available from the British Library

Library of Congress Control Number: 2019939193

All rights reserved. No part of this book may be reproduced or transmitted in any form or by any means,
electronic or mechanical including photocopying, recording or by any information storage and retrieval system,
without permission from the publisher in writing.

Printed in Turkey by MegaPrint
Typeset in Great Britain by Frabjous Books

For a complete list of Oxbow titles, please contact:

UNITED KINGDOM
Oxbow Books
Telephone (01865) 241249
Email: oxbow@oxbowbooks.com
www.oxbowbooks.com

UNITED STATES OF AMERICA
Oxbow Books
Telephone (610) 853-9131, Fax (610) 853-9146
Email: queries@casemateacademic.com
www.casemateacademic.com/oxbow

Oxbow Books is part of the Casemate Group

Front cover: Head of King Henry III, from the effigy on his tomb (*Dean and Chapter of Westminster*)
Tomb of King Henry III: north elevation (*Painting by David S Neal*)
Lombardic font taken from the sanctuary pavement inscriptions

Back cover: Shrine-tomb of St Edward the Confessor, from the south-west, with the tomb of King Henry III beyond
(*Dean and Chapter of Westminster*)

Endpapers: Design taken from the gilt latten table upon which Henry III's tomb effigy rests (*David S Neal*)

Note regarding plans: Unless otherwise stated in the caption, or indicated by a compass-point, all plans and vertical
photographic views have north towards the top of the page.

Dedicated to
Her Majesty The Queen,
by gracious permission,
to commemorate the 750th anniversary
of the rebuilding of Westminster Abbey
and the re-dedication of the Shrine
of St Edward the Confessor
by King Henry III on
13th October, 1269

CONTENTS

★ ★ ★

VOLUME 2

The Royal Tombs

9 St Edward's Chapel and the Context of the Shrine

INTRODUCTION

The archaeology of St Edward's chapel is complex and has never been unravelled. In his reconstruction of the Abbey church, Henry III designated the presbytery to occupy four-and-a-half structural bays of varying length, terminating on the east with a polygonal apse. The space was divided at the mid-point by a change of floor level. The first two bays formed the sanctuary, at the eastern side of which four steps rose up to the shrine chapel of St Edward, where the space was dominated by the centrally placed Confessor's shrine-tomb, with its Cosmatesque pedestal supporting the 'golden feretory' that contained the body of the saint himself. Adjacent to the west end of the pedestal was the associated shrine altar and its cosmatesque retable. In the shallow apse at the east end of the chapel, and axially aligned on the shrine, lay another altar dedicated to the Holy Trinity; this was the focus for the Abbey's collection of relics. Henry V's tomb later occupied the site of the altar (plan, Fig. 288, no. 11).

Begun in 1245, the eastern arm of the new church was structurally complete by the mid-1250s, although fitting-out and decorating occupied another decade. Dedication of the eastern parts took place in 1269, and at the same time the body of St Edward was translated with great solemnity to its new shrine. From the outset, Henry III designated St Edward's chapel as the future royal mausoleum, siting his own sumptuous tomb in the middle arcade bay on the north side.

Over the course of the later 13th and 14th centuries the remaining bays around the periphery of the chapel filled up with the tombs of other royalty, some of whom were displaced relatively quickly, to make room for monuments to kings

and their queens: Edward I, Edward III and Richard II. The last monarch to be buried in the chapel was Henry V, whose tomb not only supplanted the altar to the Holy Trinity, but also involved the construction of a monumental chantry chapel overhead. The new upper floor was created by bridging across the axial eastern bay of the ambulatory; the chapel, which accommodated the displaced altar and the collection of relics, is accessed by a pair of stair-turrets that intrude very visibly into St Edward's chapel, the whole edifice having the appearance of a Tudor gatehouse (Figs 12 and 220).

The chantry chapel was constructed in 1437–41 by John Thirsk, the Abbey's master mason, who was also responsible, in 1440–41, for erecting the monumental stone screen that now definitively separates the chapel from the sanctuary (Fig. 289).[1] These two major intrusions totally changed the topography of the area: no longer could one obtain a clear view of the shrine from the quire or sanctuary to the west; or glimpse it from the Lady Chapel to the east. Yet another intrusion into St Edward's chapel was planned in *c.* 1459, but did not materialize: Henry VI designated a site for his tomb there, but its construction was not pursued and he was eventually buried in St George's Chapel, Windsor. Various other interments of adults and children were made in the floor of the chapel, three of them necessitating the destruction of areas of Cosmati pavement (pp. 212–13).

The Dissolution of the Abbey in 1540 resulted in the total dismantling of St Edward's shrine-tomb because it was a monument to papacy, but since Edward was an English king as well as a saint his body was treated with respect, removed from the feretory and deposited in an unspecified

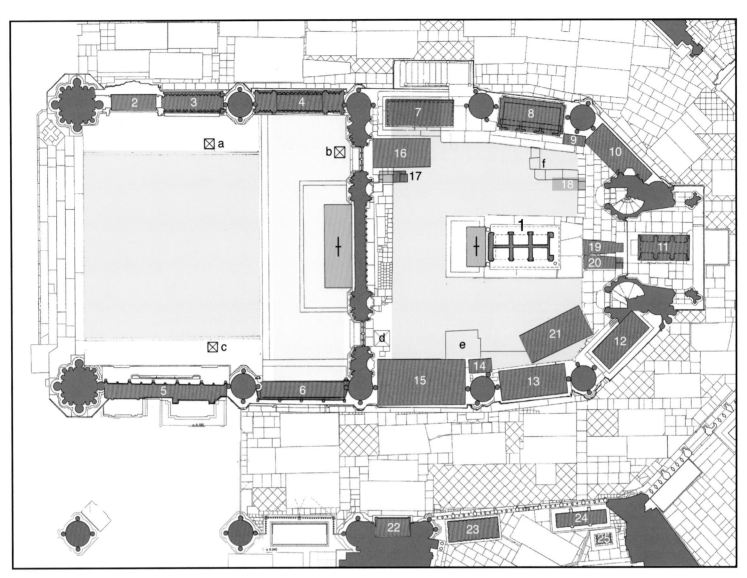

288 St Edward's chapel. Topographical plan of the pavement and monuments, as existing (detail from Fig. 6).
Key to monuments: 1. Shrine-tomb of Edward the Confessor (1269); 2. Aveline, Countess of Lancaster (d. 1274); 3. Aymer de Valence, Earl of Pembroke (d. 1324); 4. Edmund, Earl of Lancaster (d. 1296); 5. Anne of Cleves (d. 1557); 6. Sedilia (*c.* 1307); 7. Edward I (d. 1307); 8. Henry III (d. 1272); 9. Princess Elizabeth (d. 1495); 10. Eleanor of Castile (d. 1290); 11. Henry V (d. 1422), tomb and chantry chapel above; 12. Philippa of Hainault (d. 1369); 13. Edward III (d. 1377); 14. Princess Margaret (d. 1472); 15. Richard II (d. 1400) and Anne of Bohemia (d. 1394); 16. Bishop John de Waltham (d. 1395); 17. Unidentified grave; 18. Bishop Richard Courtenay (d. 1415); 19. Unidentified grave-cover; 20. Grave-cover of de Valence family; 21. Thomas of Woodstock, Duke of Gloucester (d. 1397); 22. Children: probably John of Windsor (d. 1271) and Henry (d. 1274); 23. William de Valence, Earl of Pembroke (d. 1296); 24. John of Eltham, Earl of Cornwall (d. 1336); 25. Children: William of Windsor (d. 1348) and Blanche 'of the Tower' (d. 1342); (d) Access point to the 1910 tunnel under the floor; (e) Original site of the Coronation Chair; (f) Floor slabs delineating the site for the tomb of Henry VI. *After The Downland Partnership,* © *Dean and Chapter of Westminster*

location.[2] The other royal tombs were not desecrated either. During the short-lived Catholic revival under Mary I, something quite remarkable occurred: the shrine was resurrected and the Confessor's coffin reinstated in it. In 1557, on the instruction of Abbot Feckenham, most of the components of the shrine pedestal were brought back into the Abbey and reassembled (albeit not correctly). St Edward's coffin was installed within the pedestal and the Tudor timber canopy rein-

stated on top. The badly damaged Cosmati decoration on the pedestal was restored in a most ingenious fashion: all the empty matrices were filled with plaster, which was then exquisitely painted with *faux* mosaic, a unique event in the history of English medieval shrines. Also unique is the fact that the shrine still survives, complete with its original saintly relic, the entire body of the Confessor.

Stripped of its altar, but not its retable, the

shrine pedestal survived the second Dissolution in 1559 in the form we see it today. Over the course of 750 years, numerous events have physically impinged on the chapel and its monuments, giving rise to its complex archaeology. In order to elucidate the constructional history of the Cosmati monuments, and the vicissitudes they have endured, it is first necessary to formulate a clear understanding of all the potentially relevant archaeological evidence and logistical processes that took place from 1240 to 1269. These are vital to fill the *lacunae* where the historical record is deficient. Such a holistic approach has not hitherto been attempted.

CHRONOLOGY OF ST EDWARD'S ENSHRINEMENT

Edward the Confessor died at Westminster on 6 January 1066. The peregrinations of his corpse over the ensuing five hundred years have never been fully worked out or explained in relation to the evolving topography of Westminster Abbey. Differing views have been expressed on the date of the present shrine base and on the surrounding Cosmati pavement. Equally indecisive hitherto has been the history of Henry III's burial and the construction date of his tomb (p. 440). Consequently the literature on the history and topography of St Edward's chapel and its Cosmati monuments is notable for its opacity and frequent repetition of supposed events and dates that have little or even no foundation in solid fact. Archaeological evidence and constructional logistics can contribute to resolving at least some of the ambiguities and, crucially, to understanding how the Cosmati monuments were constructed, but these resources have not hitherto been called upon.

Edward was interred at a spot, preselected by himself, in front of the high altar of the great Romanesque church that was still being erected at the time of his death. The eastern arm and part of the nave had been completed, and the sanctuary terminated in an apse, the foundations of which lie beneath the floor of the present St Edward's chapel (Fig. 3). The high altar would have been located within the apse (towards its eastern side), which would place the burial site close to its chord (Fig. 531). In relation to present-day topography, the shrine altar is over or very close

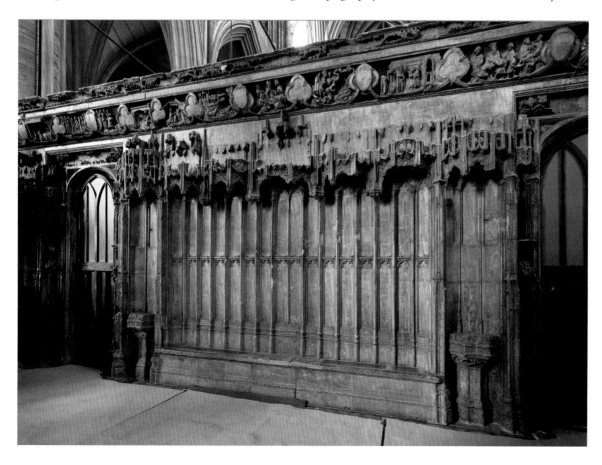

289 St Edward's chapel. High altar reredos and screen, constructed 1440–41 by John Thirsk. Viewed from the east. © *Dean and Chapter of Westminster*

305

to the site of the original high altar, and the saint's grave should lie immediately east of the late medieval stone sanctuary screen (Fig. 289). Edward's queen, Edith, was interred next to him in 1075; her grave was reputedly on the north side, but there is no precise description of its location.

In 1101, Abbot Gilbert Crispin ordered the Confessor's tomb to be opened, in order to examine the condition of the body. Bishop Gundulf of Rochester, who was present for the opening, tugged the Confessor's beard in an attempt to remove some hair, but failed to do so.[3] Edward's body was pronounced 'incorrupt', and in consequence the next abbot, Gervase of Blois, petitioned the pope in 1138 to canonize the king, but without result.[4] Abbot Lawrence, who followed him, had greater success after he told two papal legates that miracles had occurred at the Confessor's tomb, and he also showed them a well preserved piece of his shroud as evidence that the king's body was incorrupt. The legates wrote to the pope, and in 1161 Alexander III duly sanctioned canonization.[5] Richard of Cirencester recorded the monks' impatience at the length of time it was taking to obtain canonization, while Edward's corpse languished in the floor of the Abbey, 'concealed in a tabernacle of mortality. How much longer is our precious treasure to lie hidden buried in the earth?'[6] We have no description of the grave, although it is clear that Edward was not literally buried in the earth, but in a chamber which was to have special significance during the reigns of Henry III and Edward I (pp. 555–7). The tomb most likely took the form of a stone-built chamber in the floor, capped with a large slab or surmounted by a low chest.

Within two years of canonization a shrine had been constructed, and the saint's body was translated into it on 13 October 1163, in the presence of Henry II.[7] There is no mention of providing the saint with a new coffin or clothes, but threads were removed from the original textiles and embroidered into choir copes.[8] It has generally been assumed that the shrine was a low stone structure, erected in what was then the traditional position against the east side of the high altar, although it is equally possible that it was pedestalled and stood independently of the altar.[9] However, there would have been little or no space between the altar and the inner face of the apse wall, and certainly not enough to

accommodate a shrine with dignified access and circulation. From this, we may safely deduce that the apse was not solid-walled, but was either arcaded or at least had a central opening. Either way, there had to be an aperture through the apse wall, and an enclosed space beyond. It has been argued that an ambulatory encircled the apse (Fig. 531; p. 553), and that would have been very convenient for channelling pilgrims past the shrine, while maintaining the privacy of the sanctuary.

Unfortunately, no description of the Romanesque tomb or shrine has been preserved, although they are schematically represented in two well-known manuscript illustrations in *La Estoire de Seint Aedward le Rei*: one supposedly depicts the 'first opening' of the tomb, which is portrayed as a Gothic-decorated sarcophagus with a coped lid, raised on a chest (Fig. 290A).[10] The second portrays the sick flocking to the shrine, also depicted as a Gothic structure (Fig. 290B).[11] This image shows the highly ornate, gabled *feretrum* resting transversely on a stone base with circular apertures (*foramina*) in the side. The Romanesque chest-tombs – later shrines – of Osmund at Sarum (Salisbury) and Thomas Becket at Canterbury were of similar design. Why the *feretrum* was shown end-on is unclear. Another depiction of St Edward's enshrined corpse appears in an illuminated letter in the Litlyngton Missal, 1383–84 (Fig. 291). The saint lies in the golden feretory, resting on a grey stone pedestal, the south side of which is pierced by seven deep but narrow niches. The face of the pedestal is peppered with small squirls, presumably representing the cosmatesque decoration.

Whatever the precise topographical layout, one thing is clear: the sanctity of the original burial site was deemed important. As Binski observed, 'In so creating a shrine, a vacant tomb, a cenotaph was left behind.'[12] That cenotaph would have been in the midst of a building site in 1240s and 1250s, and Henry III must have taken especial steps not only to ensure its preservation intact, but also to facilitate access to it when the presbytery of his new church was complete. Although there is no evidence to indicate that the grave attracted its own cult, it nevertheless remained both vacant and accessible for more than two centuries, as is confirmed by the fact that Henry's own coffin was placed in the Confessor's tomb in 1272, where it remained until 1290 (pp. 439–40), and shortly afterwards Eleanor of Castile's coffin temporarily

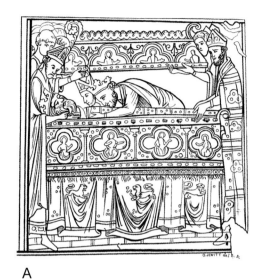
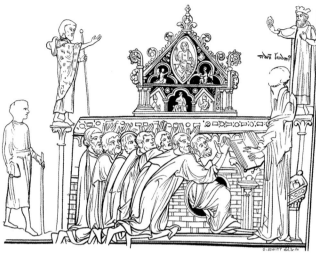

A B

290 Tomb and shrine of St Edward: illuminations from the *Life of St Edward.* A. Probably represents the opening of the tomb to inspect the 'incorrupt' corpse; B. Pilgrims at the Romanesque shrine, with its *foramina*-type circular apertures in the long sides. The *feretrum* has been turned through ninety degrees to display its gable end. Drawn by Orlando Jewitt from Cambridge University Library: MS Ee.3.59, fols 30 and 36. *Scott 1863, pls 27 and 28*

rested there. There can be no serious doubt that the tomb – at least in its mid-13th-century form – was not a hole in the floor, covered by a slab, but a designed structure with a proper entrance; it must have been a dignified and worthy resting place (albeit temporary) for a king and a queen. The point of entry to the tomb had to be beyond the western edge of the shrine pavement, since the Cosmati work in this area has never been disturbed. For discussion of access to the Confessor's tomb, see p. 555.

Henry III's close personal association with Westminster Abbey began in 1220, when he laid the foundation stone for the new Lady Chapel, the construction of which continued for the next twenty-five years. However, well before the chapel's completion in *c.* 1245–46, Henry had turned his mind to further works at the Abbey, to honour Edward the Confessor.[13] He must have set in train the designing of an entirely new church in *c.* 1240. It was to be of monumental proportions and sumptuousness, and the work was entrusted to the French-trained architect, Henry of Reyns (Reims).

Henry's role-model was Edward the Confessor, whom he regarded as England's national saint. St Edward was therefore focal in all that followed, not only at Westminster, but also at Windsor. In January 1240 Henry began the construction of a splendid set of royal apartments at Windsor Castle, the focus of which was a large chapel dedicated to St Edward. The architect there too was Henry of Reyns. Windsor and Westminster ran in tandem.[14]

Even before demolition of the eastern part of the Romanesque church commenced, Henry commissioned the construction of a new shrine for the Confessor. The first reference to making the *feretrum* is in 1241, when the king appointed Edward of Westminster 'keeper of the works of the shrine', and paid him £10 'for a certain wooden shrine for the work of St Edward'.[15] Matthew Paris tells us, in the same year, that:

> … *dominus rex Henricus III unum feretrum ex auro purissimo et gemmis preciosis fecit ab electis aurifabris apud Londiniam, ut in ipso reliquiae beati Aedwardi reponerentur, ex sumptibus propriis artificiose fabricari. In qua fabrica licet materia fuisset preciossima, tamen secundum illud poeticum, 'Materiam superabat opus'.*

291 Shrine-tomb of St Edward. Illuminated letter from the Litlyngton Missal, showing the body of the Confessor lying in the 'golden feretory', elevated on the Purbeck marble pedestal, 1383–84. © *Dean and Chapter of Westminster*

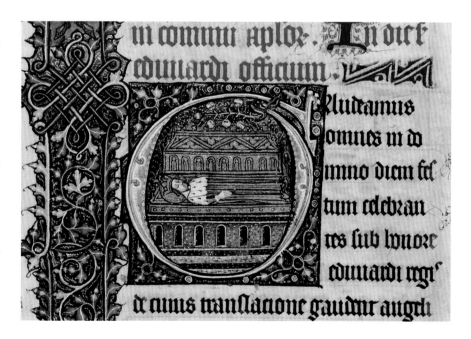

... the lord King Henry III caused to be skilfully made, at his own expense, a feretory from purest gold and precious gems by select goldsmiths at London, so that in it the reliquies of the Blessed Edward should be set. In which construction although the materials used had been the most precious ones, yet, according to the poet, 'the workmanship surpassed the material'.[16]

Paris also records that Henry swore an oath that he would spend more than 100,000 marks on the feretory.[17] In a summary, written by the same author in 1250, of the chief events over the previous fifty years, he stated:

Raedificatur ecclesia Westmonasterii, et feretrum aureum a rege Henrico tertio ad opus Sancti Aedwardi pretiosissimo opere fabricator.

The church of Westminster was rebuilt, and the golden feretory was made by King Henry III for the use of St Edward with most precious work.[18]

Given these two explicit references and the fact that Paris died in 1259, it cannot be doubted that the new feretory was in existence in the 1250s, albeit as yet incomplete. Construction of the new feretory seems to have been well in hand by 1253, when Henry made his will in which he bequeathed 500 marks of silver to finish the work.[19]

The term 'wooden shrine' obviously referred to the oak carcase that the goldsmiths would then clad with precious metals and jewels.[20] This was the receptacle – often subsequently referred to as the 'golden feretory' – intended to house the elm coffin containing the corporeal remains of Edward the Confessor. Payments for marble work in 1241 and 1242 related to the shrine base, the material of which would have been Purbeck marble.[21] There followed many further allusions to the new shrine and its feretory.

Nothing is known about the pre-existing feretrum and the shrine base of 1163 that it surmounted, but clearly Henry intended to supersede both, as he swept away everything Romanesque, and replaced it with fashionable Gothic. However, before demolition of the eastern part of the old church could begin in October 1245, the Romanesque shrine had to be dismantled and re-erected elsewhere in the abbey church, and the saint's body reinstated in it. At the same time, Queen Edith's body had to be exhumed and moved to safety,[22] and there would have been exhumations of other significant personages too (p. 554). Some writers have suggested that the

Confessor's remains were removed to the palace of Westminster during the interim period, but there is no evidence to support such a view, and it is inherently unlikely that the convent was bereft of its precious saint and his shrine for twenty-four years, until the final translation and dedication took place in 1269.

The old shrine was certainly relocated and remained temporarily in use because, in 1251, Henry ordered four silver-gilt candlesticks to be made and attached to it in such a way that they could later be transferred to the new shrine.[23] This reinforces earlier references indicating that work was already in hand on a new shrine base.

Multiple references from 1241 onwards leave no room for doubt that Henry had not only put in hand the construction of a new feretrum, but also the Purbeck marble pedestal to support it. His determination to promote the cult of St Edward was manifest, and never waned.[24] Moreover, it is clear that by 1251 the new shrine was sufficiently complete for plans to be formulated for the translation of Edward. A series of bulls issued by Innocent IV in 1251 granted releases from penance, referring to the imminent translation of the Confessor's body. Also, Henry proposed to knight his son on the day of the forthcoming translation.[25]

However, for reasons not specified, but presumably related to the domestic turmoil that gripped England, Henry could not effect the translation. Ultimately, twenty-eight years were to elapse from commencing the rebuilding of the Abbey before Henry finally oversaw the translation of the relics of St Edward into the completed shrine in 1269, and the simultaneous dedication of the eastern arm of the new church. The scale of the project was monumental and it is not surprising that it took so long to reach the point where the shrine could finally be installed, especially in view of the grave financial and domestic issues with which the king had simultaneously to contend.

Previous writers have paid little attention to historical references to the shrine in the 1240s, 1250s and earlier 1260s, usually dismissing them as having no relevance to the extant monument on account of its being cosmatesque. Extraordinarily, the assumption that such decoration did not arrive in Westminster before the later 1260s has never been questioned. Documented references to St Edward's shrine from c. 1240 to 1540 are

catalogued in appendix 1. Any pedestal constructed in the 1240s or 1250s would undoubtedly have been rooted in the prevailing English Gothic style, albeit displaying French influence, and that would certainly not have included Cosmati work. Hence, in 1863 Burges summed up the situation as he saw it: 'The marble was evidently for the new basement, which, if ever it was executed, was thrown aside for the mosaic one which *Petrus civis Romanus* finished in 1269.'[26] No record exists as to when the crucial decision was made, or by whom, to engage Cosmati mosaicists at Westminster, but the assumption has prevailed that responsibility for this signal change of direction was made by Abbot Ware in *c.* 1267–68. It has further been assumed that the sanctuary pavement, which bears the date 1268, was the first mosaic project to be tackled. Thus the entire 'history' of the Abbey's cosmatesque assemblage is founded on a double assumption, neither part of which is supported by documentary evidence, and is robustly contradicted by archaeology. In a later chapter the evidence *in toto* will be thoroughly re-appraised (pp. 596–600).

EVOLVING TOPOGRAPHY OF ST EDWARD'S CHAPEL

Elevating the shrine

When Henry III rebuilt Westminster Abbey, he lost no opportunity to heighten the sense of wonderment and drama. In the eastern arm he contributed to this by introducing steps and progressively raising the floor levels, until the Confessor's shrine-tomb stood as the most elevated feature inside the church. Archaeological evidence for the floor in the Romanesque building has been revealed in the nave, where the paving was only just below the same level of today.[27] Evidently, Henry took this as his datum, which was logical, given that the western parts of the Confessor's church had to be in simultaneous use with the new eastern arm. The nave floor level continued eastwards as far as the entrance to the quire, which was elevated by three steps, and the pavement of the crossing was at a similar level. The aisle floors flanking the quire remained at the lower level, as did the north and south transept floors. Hence, access to the crossing from the transepts also required the ascent of three steps.

East of the crossing, a further one, or probably two steps were required to reach the pavement in the sanctuary.[28] On the east side of that pavement four more steps had to be negotiated to rise to floor level in the shrine chapel, a total assent of 1.51m.[29] Most likely the high altar was independently elevated yet further above the general level of the sanctuary. Finally, the shrine pedestal itself was raised on a podium of four steps (totalling *c.* 45cm) above surrounding pavement level.[30] In total, elevation from ambulatory floor level to the bases of the niches in the shrine was about 2.05m (6¾ft).

Unlike Canterbury Cathedral, the elevated east end did not incorporate a traditional crypt under the shrine chapel, although ground-penetrating radar has revealed a small infilled chamber beneath the pavement to the west of the altar (p. 255). In the 1960s a theory was advanced that a substantial vaulted crypt underlay the sanctuary, perhaps extending under St Edward's chapel too, but that was quickly dispelled in 1976 by making a series of drillings into the floor (Fig. 224).[31]

Since the paving of the ambulatory encircling the presbytery remained at nave floor level, retaining walls had to be constructed between the pier bases within each arcade bay, to hold in place the considerable volume of imported soil and rubble required to raise ground level before the various pavements could be laid in the quire, sanctuary and shrine chapel. The outer faces of these walls were visible in the aisles and around the ambulatory, but for the most part they have become obscured or mutilated over the centuries by the insertion of major funerary monuments (Figs 3 and 6). Fortunately, the original arrangement is preserved in the three northern bays of the ambulatory, below the tombs of Edward I, Henry III and Eleanor of Castile, respectively. Rising from ambulatory floor level, and integral with the construction of the arcade piers, is a low limestone step, carrying a simple wall-bench.[32] Above the bench is the Reigate ashlar retaining wall, which is butt-jointed against the bases and shafts of the arcade piers; it is topped by a running moulding in Purbeck marble, equating with floor level in the chapel.[33] In each bay, the face of the ashlar work is relieved by a single, recessed rectangular panel with a cavetto-moulded frame (Figs 31 and 462).[34]

An impression of how the platform and chapel floor level related to the arcade piers can be gained

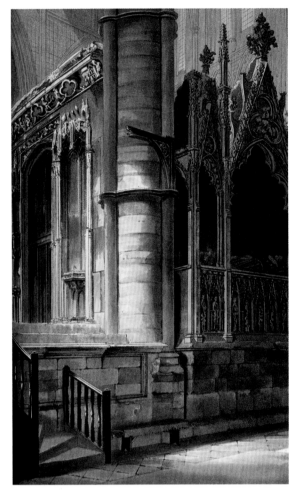

292 North ambulatory. Mackenzie's view of 1811, showing the platform carrying the elevated floors of the sanctuary and shrine chapel. The masonry of the platform clasps the bases of the arcade piers. On the left is seen the first bay of the chapel, with its panelled plinth intact, but the artist has omitted the tomb of Edward I (except for its two steps), thereby providing a clearer view of the sanctuary screen of 1440–41. On the right is the tomb of Edmund Crouchback, Earl of Lancaster (d. 1296), which flanks the high altar. The panelled plinth in this bay has been destroyed, but the low wall-bench remains. Also showing is the 13th-century floor of the ambulatory, paved with diagonally-set squares of Purbeck marble. *Ackermann 1812, pl. 50*

293 North transept, east door. This opened into St Margaret's churchyard, and is most likely the entrance used by pilgrims in the later 13th century. For its location on plan, see 'A' on Figure 6. © *Dean and Chapter of Westminster*

from Ackermann's view of the first bay, from which he conveniently omitted Edward I's tomb (Fig. 292).[35] No clear evidence has been noted to show how the arcade bays around the chapel were screened, as they must have been, prior to their effective blocking by royal tombs. Only the second bay on the north, wherein Henry III's tomb lay, would have been so blocked *ab initio*. The other bays were presumably screened on the medial axis of the apsidal arcade, but whether with masonry walls, timber panelling or iron grilles we cannot tell. Although the arcade piers exhibit evidence for sundry metal fixings, and a few potential pockets for housing timbers, no consistent pattern of attachment is discernible.[36]

Pilgrim access

The question of how 'public' access to the shrine was arranged has never been addressed. Arrangements differed from one great church to another, and were more restrictive in monasteries than in colleges of secular canons. In some instances the

approach was through the west doors, via the nave, an awe-inspiring journey that would properly prepare the pilgrim for the climax of his or her visit to the shrine. It has been argued that such an arrangement obtained at Canterbury in the 11th century, but is unlikely to have been perpetuated.[37] At several cathedrals, including Ely and Winchester, there is a tradition that pilgrims entered by a specially designated doorway on the north side, and that has also been suggested for Westminster, where a door mid-way along the north nave aisle has in modern times been erroneously dubbed the 'pilgrims' door'.[38] It could never have served that function.

Entry via the north transept seems most likely, since this would have facilitated the shortest route from the 'secular' world, to the shrine. The parish church of St Margaret, and its cemetery, lay immediately outside the transept. The ceremonial doors (the king's entrance) in the centre of the north wall of the transept would not have admitted the lay public, and a lesser door, opening into the northern end of its western aisle, was probably not considered suitable either.[39] The alternative was an unobtrusive doorway in the northernmost bay of the transept's eastern aisle, which would have been ideal for admitting pilgrims ('A' on Fig. 6). This east-facing entrance, for which no other practical function can readily be suggested, was embellished with stiff-leaf decoration on the

294 North transept, east door. Detail of the arch, showing the remains of the deeply undercut stiff-leaf foliage on the middle order. Note that the keystone and three adjoining voussoirs were never carved; nor were the label-stops to the hood-moulding and one of the nook-shaft capitals on the left. © *Dean and Chapter of Westminster*

middle order of the arch and on the capitals of the nook-shafts.[40] The carving of one of the capitals and the 'filigree' detail on the arch was never finished (Figs 293 and 294).[41] The doorway permitted easy access from St Margaret's church-yard to the north ambulatory, without impinging on the remainder of the abbey church, or allowing laity to penetrate the heart of the monastic community.

Once inside the transept, pilgrims had to be directed to the shrine, via the north ambulatory. In most great churches, the shrine was at ground-floor level, but Westminster was one of the minority in which the shrine chapel was elevated on a platform, necessitating access by a flight of steps. The present entry to the chapel for the laity is via a timber stair alongside the westernmost bay, an arrangement that has been unchanged since at least the late 16th century (Fig. 32). Almost certainly, this was also the point of entry for pilgrims to the shrine chapel in the later 13th century. It has already been noted how the north end of the western block or 'carpet' of the Cosmati pavement ran into the arcade bay, albeit to an unknown extent, but was overlain by Edward I's tomb (p. 212; Fig. 240). It is therefore suggested that a flight of steps in the north ambulatory initially provided access to the chapel via that bay. There are indications that the southern end of the same section of pavement similarly ran into the opposing arcade bay (where the tomb of Richard II now stands), prompting the suggestion

that there was a second access point to the shrine via steps in the south ambulatory (p. 557; Fig. 288). Chichester Cathedral had an elevated shrine platform, which documentary evidence indicates was accessed by two flights of stairs.[42]

It had long been common for shrine chapels to have two entrances, so that pilgrims could file in through one, and out through the other. That made eminent sense, particularly on festivals and other occasions when a substantial number of pilgrims could be expected.[43] Of course, it meant that pilgrims would need to have access around the eastern curve of the ambulatory in order to reach the south side, but as long as the radiating chapels were screened off and locked, no invasion of them by the laity would occur.[44]

The situation changed when Edward I died in 1307 and his massive but plain chest tomb was installed under the westernmost arcade bay on the north side of the shrine chapel. That totally blocked access to the chapel from the aisle, and since the second and third bays were already occupied by the tombs of Henry III and Queen Eleanor, respectively, henceforth there would have been no alternative but to enter the chapel from the south. The southern entrance could have remained operable until 1394, when Richard II constructed a tomb for himself and his queen, completely obstructing the westernmost bay on that side of the chapel (Fig. 288, no. 15).[45] The other southern arcade bays were already blocked by the tombs of Edward III and Queen Philippa,

311

respectively. There was one more arcade bay that we have not mentioned so far – on the east – but that was occupied by the altar of the Holy Trinity, and the abbey's relics were assembled here. Public access from that direction would have been out of the question.

The upshot of this tomb proliferation was that by 1394, at the latest, the chapel of St Edward was now rendered inaccessible by any means other than through the sanctuary. Clearly, something had to give way. While the sanctuary was jealously guarded by the monks as their preserve, we are forced to consider the virtual inevitability that a defined pilgrim route was established along the northern – and perhaps the southern – margins of the sanctuary. There were analogies for this in the later Middle Ages, including at Canterbury Cathedral. As Nilson observed, 'In a few instances the barriers around shrines suggest that some were approached by way of the presbytery, passing right by the high altar. A view of Canterbury's choir painted in 1657 shows clear abrasions in the pavement at the position of the two doors of the missing reredos, flanking the original position of the high altar'.[46] Wilson has demonstrated that after the renovations of 1472 the shrine at York was almost certainly only reachable by passing the high altar,[47] and a similar situation seemingly obtained at Durham and St Andrews.[48]

The presbytery at Westminster was reorganized in 1437–41, when the sanctuary and shrine chapel were physically and visually separated by the erection of a massive stone reredos screen (Fig. 289) and at the same time Henry V's towering chantry chapel was erected to the east of the shrine. Thus, the topography of St Edward's chapel underwent fundamental change. The screen is pierced with a pair of doorways flanking the high altar, which are ideally situated for circumambulation of the shrine and sanctuary (frontispiece). In practical terms, this would have meant that once pilgrims had arrived in the north transept, they would no longer be directed eastwards along the ambulatory, but would have passed through a gated screen, into the crossing, and then along the northern border of the sanctuary pavement, to the first doorway in the reredos. After praying at the shrine and making offerings, they would either have to retrace their steps to the north transept, or exit the chapel by the more southerly door in the reredos, passing between the high altar and the sedilia, and then along the south border of

the sanctuary pavement, to the crossing. The floor of the sanctuary included, from the outset, defined walkways bordering the Cosmati pavement to north and south.

The latter option was logistically less satisfactory, since it took pilgrims into the monks' quire: they had either to traverse the quire, in order to reach the north transept, or leave the crossing and enter the south transept, then pass into the south ambulatory, and follow this around the presbytery, in order to return to the north transept. In the absence of specific evidence we can do no more than speculate on the subject of the pilgrim route in the later Middle Ages.

At some point in the 16th century – most likely the later 1550s – the route via the sanctuary was discontinued, and access was reinstated to the shrine chapel from the north ambulatory. Edward I's tomb was slightly shorter in length than the others, and thus did not totally fill the space between the arcade piers. The tomb was protected on all sides by an iron-railed enclosure, now lost, but it is recorded in antiquarian illustrations (Fig. 13). By removing the eastern side of the enclosure railing, a narrow but just sufficient gap was created to serve as an access point to the chapel, and a late Tudor or Elizabethan oak staircase was constructed in the ambulatory (Figs 11C, 13 and 32). Despite the very restricted nature of the gap, it still remains in use, although the staircase has been renewed.

Proliferation of royal tombs and its consequences

The three major tombs filling the arcade on the south all date from the second half of the 14th century, but they were not the first monuments to occupy these bays: they displaced an earlier phase of royal burial (Fig. 288, nos 12, 13 and 15). Most scholars since the mid-19th century have accepted that at least three, possibly four, lesser royal tombs were removed to make way for two monarchs and their queens. The first is William de Valence, Earl of Pembroke and half-brother of Henry III, who died in 1296 (Figs 288, no. 23, 500 and 501). His stunningly rich tomb, now a shadow of its former self, is in St Edmund's chapel, but was almost certainly once in an arcade bay of the shrine chapel (p. 593). Two of his children – Margaret (d. 1276) and John (d. 1277) – had already been interred in the floor of the Confessor's chapel nearby (p. 211).

The second major monument to be displaced, to St Edmund's chapel, was John of Eltham's, Earl of Cornwall and second son of Edward II. He died in 1336 and was buried in an elegant canopied tomb, the construction of which has been attributed to the royal master mason, William Ramsay III. The interment took place in St Edmund's chapel. Seven years later, his mother, Queen Isabella, arranged for him to be moved into St Edward's chapel, where his tomb was placed 'between two marble columns'. This could have been in either the central or the eastern bay of the south arcade. However, the relocation was short-lived because Isabella asked for her son to be returned to his original burial place (Fig. 288, no. 24).[49] Hence, Eltham's tomb cannot have been the one displaced in 1394 (p. 212). Sally Badham has argued a case for the so-called de Bohun tomb-chest being the one which was moved in that year by Richard II; it is now in St John the Baptist's chapel (off the north ambulatory: Fig. 6, no. 26).[50] The suggestion that this tomb was once in St Edward's chapel has been much discussed by scholars, as has the identity of its original occupant(s).

Another closely related royal tomb, now situated in St Edmund's chapel, is that to two of Edward III's young children, Blanche (d. 1342) and William (d. 1348). This small tomb-chest, which stands next to John of Eltham's, is possibly another candidate for having once been in the Confessor's chapel (Fig. 288, no. 25).

MONUMENTS IN THE CHAPEL: POST-MEDIEVAL INTERVENTIONS AND ANTIQUARIAN INVESTIGATIONS

c. 1459 Depositions in 1498 relating to the burial of Henry VI refer to an event that took place in St Edward's chapel, when the king was determining where his tomb should be sited.[51] He decided that it would be in the north-east corner of the chapel, close to Eleanor of Castile's monument and in front of one of the stair-turrets to his father's (Henry V's) chantry (Fig. 288, f). At the time, a relic cupboard occupied this space, in front of the arcade pier between Henry III's and Eleanor's tombs; the small tomb-chest of Princess Elizabeth (d. 1495) had not yet arrived. In the event, the proposal was abandoned and the king was buried at Windsor, but had his monument

been erected here it would have obstructed views of Henry III's and Eleanor's tombs, as well as creating an obstacle to free-passage around the chapel.

1536–37 The shrine was stripped of the golden feretory and all precious materials by order of the Vicar-General.[52]

1540–41 The Benedictine abbey was dissolved by Henry VIII in 1540, and the shrine totally dismantled soon after. When the Dissolution Inventory was made in that year, the shrine pedestal was still standing and the feretory canopy in place. They were described as 'A fayre godly Shrine of Seynt Edward in marble in the myddes of the chappell with a case to the same.'[53] The other remaining contents of the chapel were listed too, and the inventory ended with 'ij lytell tombes, one of them of Elizabeth daughter to Henry vii, and the other of Margarett daughter to Edward iiij.' The latter tomb was designed to fit on the steps on the north side of the shrine, and was presumably still *in situ* at the time (Fig. 288, nos 9 and 14).[54]

The Purbeck marble components of the dismantled pedestal were stacked out of doors, where they suffered from weathering, but the timber coffin containing the body of the Confessor remained in the Abbey, unmolested. No record survives to confirm the location where it was kept or possibly interred.[55] At the same time as the shrine was dismantled, the abutting tomb of the infant daughter of Edward IV (d. 1472), had to be removed; it was relocated against an arcade pier on the south side of the chapel (Fig. 288, no. 14).

1554 Bill of expenses, etc: Sept. 1554: 'Item for making cleane of Saynte Edwardes Chappell & for washyng of the kyngs x[d].'[56]

A second bill, similarly dated, is for 'expenses at the coming of the King and Queen [Mary I and Philip of Spain[57]]: payment to the goldsmythe for cleansynge and makynge cleane of the Kyngs and toombes in Saynt Edwards Chappell xx[s].'[58] Significantly, there was no mention of the shrine, which had yet to be resurrected.

1555 On St Edward's Day the shrine and altar were 'sett up' again, but no details of the nature

and extent of the reconstruction are preserved.[59] This was evidently a token gesture, or improvisation.

1557–58 Abbot John de Feckenham caused the 13th-century shrine to be 'nuw set up' and the coffin of the Confessor installed within it.[60] Feckenham was responsible for applying a coat of plaster to much of the pedestal and over-painting it with *faux* mosaic. He did the same to the tomb of Henry III.

1685 An incident occurred in connection with preparations for the coronation of King James II. After the ceremony, during the removal of the temporary scaffolding, a pole, or heavy plank, fell on top of the shrine, damaging both the timber canopy and the masonry structure. It also punctured the lid of the Confessor's elm coffin, affording a view of the interior. The damage was evidently not made good for some time and was left unattended, thereby providing an opportunity for the curious to visit and for unscrupulous antiquaries to rifle the tomb. In the latter category, the principal culprit was Charles Taylour, one of the lay-vicars ('choir men') of the Abbey who, seven weeks after the coronation clambered on to the shrine with the aid of a ladder and removed the saint's gold crucifix and chain via a hole in the coffin lid.[61] Other souvenirs taken included fragments of burial shroud and silk from the coffin (p. 420; Figs 415 and 416).[62]

After this sacrilegious incident, James II ordered the Confessor's coffin to be made secure against further interference. A new outer coffin of oak boards was constructed and reinforced with iron straps; also two iron bars were placed across the tomb from north to south, immediately above the Confessor's coffin, preventing it from being lifted out of the chamber.

1697 A mason's bill exists for installing ironwork at the shrine: for a mason for ½ day about letting in some iron work at Edward the Confessor's tomb and running with lead – 5s. 3d. [63] It was clearly only a small job and no further details are preserved. This entry may, for example, have related to the installation of cramps to secure loose masonry, and there is one such secondary cramp in the cornice at the south-east corner, although that has the appearance of being later (Fig. 402).

1713 John Talman made annotated sketches of the shrine and retable, and included a thumbnail plan showing the coffin. This implies that either the canopy was removed at the time, or Talman was able to gain access to the top, and look down through the interior (Fig. 301B).

1741 Feckenham's plaster and painted inscription were removed from the frieze at the east end of the shrine, presumably in order to access the primary inscription (Fig. 379). As seen today, this bears all the hallmarks of an antiquarian intervention; it was noted by George Vertue in 1741, who described the visible portion of the primary inscription:

> The old mosaic inscription, almost defaced, was thus written ... and the calcined glass, yellow like gold cut and set in. No more than what is marked with these turned commas ... was remaining in April 1741, and in June following they were erased, picked out and taken away.[64]

1808 The indent covering Thomas Woodstock's tomb was lifted and the contents inspected.[65]

1827 A 'beautiful piece of carved work which formed part of the Shrine ... studded with precious stones' was found buried in earth near the Shrine.[66] This description does not match any of the loose fragments in the Abbey Collection, and is presumed lost (or is still in the ground). There are very few areas in the chapel where an excavation into soil could have taken place, but the west end is the most likely, where there is a patchwork of medieval and later paving (Figs 225 and 262).

1850 Shortly after G. G. Scott's appointment in 1849 as Surveyor of the Fabric, he began to investigate the archaeology of St Edward's shrine. He removed the post-medieval brick blocking from the west end of the shrine base, revealing the scars where an altar had once been. The brickwork was doubtless part of the structure of Feckenham's shrine altar. Tudor bricks had similarly been used to back up the moulded stone cornice that he added to the pedestal (p. 411). The appearance of the west end of the shrine, immediately prior to Scott's intervention, is recorded on Figure 29. He also took up the 16th-century pamments on the site of the shrine altar and excavated into the floor around the two Cosmati columns standing at the

western angles of the shrine. The investigation revealed that the columns were deeply embedded in the ground and clearly did not belong in their current positions, having been introduced in 1557 to support the altar retable.[67] Below floor level, much of their mosaic inlay was well preserved.[68]

Sometime in the 1850s Scott's sharp-eyed assistant, James Irvine, noticed that where the east end of one of the supposed de Valence tomb slabs passed under the step at the gates to Henry V's monument, coloured inlay could be glimpsed in the indent. A portion of the step was duly cut out – and later refixed on hinges – to reveal the fillet inscription and cosmatesque inlay that had survived intact as a result of being sealed since *c.* 1437 (Fig. 504). Irvine also noticed that the foot of the brass cross inset into the adjacent tomb slab on the south was still *in situ*, again concealed from view by the step.

1856 Poole recorded finding on the floor in the north triforium gallery 'the remains of what appeared to be one of the twisted pillars' from a corner of the shrine. He pieced them together and found there were almost enough fragments to rebuild 'one perfect pillar', which was then installed at the south-east angle of the shrine, from whence it had come.[69]

In 1856, a fragment of moulded Purbeck marble was found in a blocked-up window of the monastic dormitory above the east cloister range.[70] It was immediately recognized as being part of the entablature of the shrine pedestal, having come from its south-west corner (Fig. 371). Scott had it reinstated, but it did not remain there for long and in 1902 the block was removed. It is now in the Abbey Collection.[71] There would have been a second similar block at the north-west corner, but that has not survived. Both were omitted from the 1550s reconstruction.

1866 Poole made an interesting discovery and wrote:

> By cutting away some of the pointing under the base of Edward I's tomb, we exposed a slip of a brass inscription of very early date which Brayley saw and wrote of in his time. ... it shows that under the tomb of that king there had previously been one or more interments, his own tomb being the enclosure for the coffin.[72]

Poole may have conflated the discovery that he made – a brass inscription *under* Edward's tomb

– with Brayley's account of the matrix for a lost inscription on the edge of the chapel floor, just north-west of the tomb, which is still visible (Fig. 518; see further, p. 522).[73] They cannot have been describing the exact same area, but possibly the two fragments of inscription were related, and potentially contiguous.

1868–70 While Scott was restoring the sanctuary, he also carried out some relatively minor works in St Edward's chapel, including reinstating the original iron gates to Henry V's tomb (removed 1822).

Some years earlier he had examined the shrine and observed:

> The retabulum [i.e. retable] occupies ... its proper position, excepting that it has been lifted by three inches above its original level, a fact proved by its intercepting the space required for the completion both of the ancient and the more modern inscriptions, for neither of which there is now sufficient room.[74]

In 1869 he extricated one of the columns at the west end of the shrine and inverted it in order to display the better preserved mosaic inlay on the lower end. He also observed:

Henry Poole's bill survives for work on the shrine,[75] and in January 1869 he charged for:

> ... shoring & shifting cornice at west end. Taking out and reducing firestone frieze. Removing the large retabulum slab & lowering it. Removing the two spiral pillars. Working and fixing two stone pilasters to carry retabulum. ... Making copper cramps and ties to reattach retabulum, inserting the same in marble and stonework. Searching under the lower surfaces of steps, pavement and other parts.

The 'firestone frieze' must refer to a band of Reigate stone, immediately below the cornice, that had been substituted in the 1557 reconstruction for the lost inscription course on the west end. However, when Scott lowered the retable, he had to re-insert a plain band of stone to fill the void where the primary inscription would have been. At the same time, he refixed the south-west corner-block of Purbeck marble that was found in 1868 (see above) and had once borne part of the inscription. The inserted band, comprising three pieces of roughly dressed Reigate stone, is uncharacteristic of Scott's work and has the appearance of a temporary measure

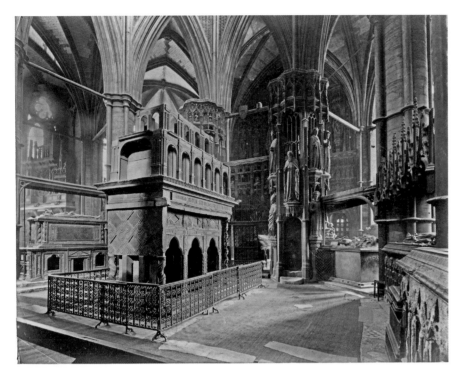

295 St Edward's shrine from the south-west, before 1902. This shows Scott's 1868 alterations to the west end, the protective railing introduced to keep tourists at a distance, and the unsightly array of strips of carpet protecting the Cosmati pavement. © *Dean and Chapter of Westminster*

296 St Edward's shrine, protected by 1,200 sandbags during the First World War. On the far left sandbagging around Henry III's tomb can just be glimpsed. © *Dean and Chapter of Westminster*

(Figs 295 and 330). Since the corner-block was removed again in 1902, the present frieze must, at least in part, be the work of Micklethwaite.

Work continued into February 1869:

> Fitting and refixing the retabulum in its more ancient position and connecting with it the fragment of Purbeck marble architrave lately discovered in the wall of the Westmʳ School. Cutting away rag rubble footings & making foundations for the two pillars – refixing and securing them. Indurating &c. ...

> Repairing & making the stone secure disturbed at the surface of west end of Tomb – attaching the loose plaster work. Indurating the pillars & other parts – and securing the loose & dangerous glass mosaic. Making good the floor. ...

Scott infilled some of the damaged areas of the pavement with cement, but did not attempt to restore the mosaic work, as he did in the sanctuary (Fig. 222). He also initiated the policy of placing protective coverings of linoleum over large parts of the pavement, leaving 'windows' for viewing of the best preserved areas. The practice may have started somewhat earlier, since Burges reported in 1863 that the pavement was 'in bad condition' and 'the Dean and Chapter have very properly caused it to be covered with boards, leaving, however, a small portion, which is nearly perfect, uncovered.'[76]

1902 A new altar and footpace (dais) of black marble were erected against the west end of the shrine pedestal just prior to the coronation of Edward VII (Fig. 326). The step exactly covered the rectangle of red tile pamments that had presumably been inserted here when the medieval altar was removed in the mid-16th century.[77] A pall, draped over a tent-shaped frame, was hung above the shrine canopy, supported by a single chain (bifurcating at the lower end) from the vault above.[78]

1913 Lethaby and Hope removed a section of the step to Henry V's chantry, and some paving to the east of it. They thereby revealed the edge of the dais that carried the original altar of the Holy Trinity, and also exposed the eastern extremity of the more southerly of the tomb-covers lying between the altar and St Edward's shrine. It was established that the slab bore the name 'Valence'.[79] In 2018 the end of the slab was re-exposed and archaeologically recorded (Figs 509 and 510).

1915–18 During the First World War the timber canopy was removed and the shrine protected with sandbags, in case of German air raids. Initially (1915), a timber carcase was constructed around the pedestal, and some sandbags piled against the north and south sides.[80] More were later added, until the entire structure was enveloped by 1,200 sandbags (Fig. 296). When the timber canopy was removed the lid of the Confessor's secondary coffin of 1685 was exposed to view, and H. F.

Westlake, a Minor Canon of the Abbey, compiled some notes, made dimensioned sketches and took a single photograph of the top of the pedestal (Fig. 385). Henry III's tomb was also sandbagged.[81]

1923 Lethaby reported that 'cleaning of ancient colour decoration' was in progress and that 'the effect upon the Confessor's shrine and the tomb of Henry III' was notable. The Purbeck marble was re-polished in 1926.[82]

1925 Lethaby reported that the timber canopy over the shrine was repaired and cleaned, 'revealing some very interesting painted marbling and glass mosaic in the arches and tiny pilasters'. Detached pieces were refixed.[83]

1939–45 The Tudor canopy was once again removed from the pedestal during the Second World War, but it was not sandbagged or protected with timber carcassing.[84]

1954 The interior of St Edward's chapel was cleaned.[85]

1955 Measured drawings were made of the shrine canopy and an analysis obtained of the glass used in its mosaic decoration. A small compartment in the step in front of one of the niches (no. 2) was investigated (Fig. 303). It was thought that this might contain a relic, but nothing was found (p. 329).[86]

1958 J. G. O'Neilly, assistant to S. E. Dykes Bower (Surveyor of the Fabric), made 'a prolonged and minute examination' of the shrine, from which he was able to demonstrate that the reconstruction in 1557 did not faithfully follow the original design: some elements were lost and others incorrectly positioned. In 1966 he published an important paper, setting out the evidence in great detail, and illustrating it with both drawings and timber models that he made for the purpose.[87] Also in 1966 he wrote a short supplementary paper, arguing that the Cosmati child's tomb in the south ambulatory was originally the shrine altar (for discussion, see p. 518).[88]

1958–60 The Tudor canopy surmounting the shrine pedestal was removed and sent away for restoration.[89] The pall that had hung over the canopy since 1902 was dispensed with.[90]

1975 The Conservation Department of the Victoria and Albert Museum repaired damage to the shrine mosaic.[91]

1982 The south-east spiral column of the shrine had been broken, and was repaired by the sculptor, Arthur Ayres.[92]

2018 The canopy was removed for a short period, to enable a thorough archaeological examination and record to be made of the upper part of the shrine pedestal, the coffin and the structure of the canopy itself (Figs 399–401).[93]

IMPACT OF PILGRIMS AND TOURISTS ON THE CHAPEL AND ITS MONUMENTS

Although the sanctuary pavement and its adjacent monuments have suffered from wear and tear through daily use and carelessness associated with great ceremonial occasions, the condition of the shrine chapel is incomparably worse. Not only has it suffered substantially greater pressure from pilgrims and visitors to the shrine and royal tombs, over many centuries, but evidence of deliberate damage and vandalism is everywhere apparent.

The cult of St Edward reached its zenith in the 14th century, when donations at his shrine peaked. The influence of many popular cults was widely disseminated through the medium of pilgrim badges, which were mass-produced, most commonly of lead-alloy and were sold to visitors at the shrine. These badges not only provided pilgrims with a relevant memento of their visit, but also served the very practical function of reducing the level of theft from shrines. The production and sale of St Edward mementoes seems not to have been practised at Westminster on a scale commensurate with the presumed importance of the cult. Indeed, very few definite Edward pilgrim souvenirs have been found in London, where one would have expected many to turn up. It is difficult to find a satisfactory explanation for the paucity of St Edward badges. Had pilgrim souvenirs been more readily available for purchase at Westminster Abbey, it is likely that the shrine and monuments would have suffered less robbing of their mosaic inlays by visitors anxious to leave with something in their hands (see further p. 319). The recorded designs of

St Edward pilgrim badge all date from the 14th to 16th centuries, and include:

(i) Roman letter 'E' with attached fleur-de-lys ornamentation (copper-alloy, silver-gilt).[94] 15th or early 16th century.

(ii) Crowned figure on horseback, inscribed on the base-plate *Edwarde* (lead-alloy).[95]

(iii) Pierced lunate disc with a beaded rim, containing the figures of St Edward and the Pilgrim; between them is a riband bearing the name *S Edwardus* (lead-alloy).[96] Late 14th century.

(iv) Circular disc with a beaded rim and a three-pointed crown at the centre (copper-alloy, silver-gilt).[97]

(v) Pierced circular disc with a beaded border, containing a crowned head (lead-alloy)[98]

(vi) Pierced crown (lead-alloy).[99]

There appear to be no accounts surviving from the Middle Ages describing pilgrimages, access to the shrine and the pressures to which it and St Edward's chapel were subjected. However, monuments were certainly being robbed of valuable accoutrements: thus some cast metal fittings were looted from Henry V's tomb by 1467, and the remainder were stolen in January 1546.[100] When we come to the 17th century and later, records of personal observations are numerous, and they tell a sorry story. There is no reason to suppose that it was any different in earlier centuries. Henry Keepe, when he was recording tomb inscriptions for his monograph in the early 1680s, commented on

> ... a daily concourse of Gentlemen, and Ladies; as well Forainers, as Natives, led by their curiosity, came to behold this so famous Mausoleum, or place of Sepulchre and Repository of our Kings, Princes, and chief Nobility, with the Encomiums and Praises that were continually bestowed thereon ...[101]

With the rise in antiquarian tourism in the later 18th century, the pavements were subjected to yet more destructive activity, the relentless tramping of feet. The effect was graphically described in 1802 by J. P. Malcolm:

> An admirer of the arts must view it with the deepest regret, since it has been the custom to show the choir for money, it is trodden, worn, and dirtied, daily by hundreds who are unconscious of its value, and I know barely look at it. Is it not a national treasure? When it is quite destroyed, can we show such another?[102]

Writing about the shrine in 1819, Brayley reported:

> ... the tesserae, though fixed in a very strong cement, have been mostly picked out; not so much, perhaps, from mere wantonness, or purposed mischief, as from the superstitious veneration of devotees.[103]

Another commentator on the shrine, writing in 1840, bemoaned:

> Neglect, spoliation, and mutilation have done their work here: the rich mosaics and inlay work of the lower portion have suffered greatly, many of the tesserae having been picked out, either through sheer mischievous wantonness, or the equally mischievous affectation of religious piety and antiquarian admiration, seeking to appropriate to themselves a precious relique or curiosity without much scruple as to the mode of effecting it.

> Neither piety nor antiquarianism, however, have thought it worth while to make atonement for the injuries they may have occasioned; that excessive warmth of admiration which induced people to pocket what they ought not even to touch, cools down prodigiously when it comes to the question if they shall put their hands into their pockets, for the purport – not of slily slipping any thing in, but pulling out their contributions towards the good work of repairing what has been defaced.[104]

From the Reformation to the mid-19th century, public access to the shrine chapel was unrestricted, and indeed was encouraged by the Dean and Chapter, which allowed semi-professional 'Tomb-showers' to operate, charging a few pence to each visitor for their services. However, they were in no sense guardians of the Abbey's heritage, and some, at least, turned a blind eye to abuses in return for a little extra financial inducement. From early in Queen Victoria's reign, access was restricted and supervised more closely, with the result that the incidences of graffiti and minor vandalism plummeted. Visiting became more respectful, as many Victorian illustrations show (Fig. 297).[105] Nevertheless, in the 1850s widespread concern over the poor condition of the royal tombs is revealed through correspondence and manuscripts held by the British Architectural Library.[106] The adverse effects of visitors on the chapel are principally manifest in three ways. First, damage to the Cosmati pavement: although

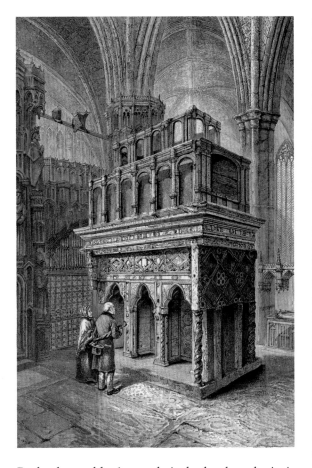

their provenance is exceptionally interesting. They were part of a small collection of relics that may have been in the possession of James II.[107] The shrine pedestal has been almost picked clean, leaving just a few scattered tesserae in the entablature and in the niches, where they were most difficult to reach. When part of the primary glass inscription on the frieze was uncovered, probably by an antiquary in 1741, the exposed tesserae remained for only a few months before being picked out and stolen (p. 418).

Henry III's tomb has been almost entirely stripped of its tesserae on the south face and those parts of the east and west ends that could comfortably be accessed from the shrine chapel. This contrasts with the north face which is only accessible from the ambulatory, and that has a much lower floor level. Consequently, only the lower one-third of the tomb has been stripped of tesserae, and the mosaic above this, which cannot be reached from the ambulatory floor, remains almost entirely intact (Fig. 463). The porphyry panels have mostly been stolen, but the two largest have survived. Thieves attempted, unsuccessfully, to prise the panel off the south face of the upper chest, although they fractured it (Fig. 447; p. 449). Even the gabled canopy and other elements of the great gilt latten effigy surmounting Henry III's tomb have been pilfered (Figs 434 and 435). As already noted, metal fittings on the other royal tombs have similarly suffered depredation.

Thirdly, for centuries visitors have been unable to resist leaving their autographs and other defacing marks on the Abbey's fabric and furnishings. St Edward's chapel and its monuments are awash with graffiti on all the soft stone elements. Since the shrine and the tomb of Henry III are virtually devoid of soft stone, they escaped further disfigurement with graffiti. However, when the shrine was reconstructed in 1557, a large part of its surface had already been robbed of mosaic and the empty matrices were filled with plaster, and painted. This provided a suitable ground for the execution of graffiti.

When did the bulk of the visitor damage occur, and can it be dated? Considering the extremely poor condition of the pavement, it is clear that this could only have been caused by the tramp of countless thousands of pairs of feet, over the course of centuries. Since the floor has been almost continuously protected from foot traffic since c. 1850, we are not looking at damage resulting from

297 A typical Victorian image showing respectful visitors to the shrine, c. 1870. Since the mosaic pavement was permanently covered at this period, artists exercised licence in portraying the chapel floor. Some depicted plain rectangular paving slabs, others created a notional pavement; in this instance we see a combination of both. The image shows the pilasters that Scott built on the end of the shrine to support the retable; they were demolished in 1902. *Bonney 1875, 257*

Purbeck marble is a relatively hard rock, it is polishable, and the incessant tramp of feet over the surface gradually polishes the stone away. Porphyry, on the other hand, is an even harder rock and is virtually unaffected by foot traffic; this has led to differential wear-patterns on the floor. The Purbeck marble slabs forming the matrix for the mosaic have suffered dramatically from foot-traffic, and over the majority of the pavement the surface has been reduced by at least 5mm, with the consequence that the porphyry inlays are left upstanding and vulnerable to dislodgement. Worse still, in some areas the matrix has been eroded by up to 10mm, and the mosaic has long ago been irretrievably lost.

Secondly, visitors to the shrine saw nothing wrong with helping themselves to souvenirs, which they did in prodigious numbers. Tens of thousands of glass and porphyry tesserae were prised out of the Confessor's shrine and Henry III's tomb, until there was virtually nothing left within reach of the human hand. Almost all these pilfered souvenirs have disappeared without trace, but some occasionally surface; for example, in 1905 two gilded glass tesserae from the shrine were exhibited at the Society of Antiquaries, and

the pressures of Victorian or modern tourism. It seems inescapable that the passage of pilgrims through the chapel in the Middle Ages began to wear away the pavement.

When we review damage to the shrine by souvenir pilfering, the Dissolution of 1540 provides a convenient bench-mark. All damage that can be shown to antedate Feckenham's reconstruction must be put down to either physical manhandling at the Dissolution, or the previous actions of medieval pilgrims. Damage assignable to after 1557 may be blamed on post-Reformation tourism. Examination of the two spiral columns supporting the retable at the west end of the shrine reveals that about half of the mosaic inlay is intact on the northern shaft, and very little on the southern: the loss of the remainder must have occurred before the mid-16th century, since the currently exposed areas were buried in the floor of the chapel in the 1550s and remained inaccessible until the shafts were inverted in 1868.

Stripping the timber shrine canopy of its decorative detail may be closely datable. The canopy was normally far out of reach of souvenir hunters, but in the period 1540–56, when the shrine pedestal was absent and hence the canopy was placed somewhere at or close to ground level, it was easily accessible. In effect, it temporarily provided a substitute source of material for souvenir hunters. Thus, all but one of the twenty-six Corinthian capitals were stolen from the arcading on the upper chest, and the pilasters of both the upper and lower chests were almost picked clean of their mosaic inlay, in aggregate a loss of some 10,000 glass tesserae (p. 430). Similarly, the glass roundels were all prised out of the spandrels of the upper chest.

Investigation of the surface of the shrine pedestal has revealed that Feckenham's plastering and painting of *faux* mosaic was not limited to a few small patches, but was extensive. A great deal of the 13th-century mosaic had already been lost before the Dissolution, and where only small patches survived it appears that Feckenham lightly skimmed over these with plaster in order to obtain a unified surface for painting. Where he left primary mosaic exposed, robbing continued. This gave rise to a second phase of plastering: the lacunae were filled with harsh white gypsum plaster, crudely applied and not overpainted.

Both the Tudor plaster repairs and the later patching attracted numerous graffiti. A detailed survey of these awaits the undertaking, but the earliest date so far noticed on Feckenham's painted plaster is 1624.[108] Numerous dated graffiti occur on the later unpainted plaster, particularly on the south face and the earliest seems to read 1620, which provides a *terminus ante quem* for the gypsum patching. Other dates on that material include 1659,[109] 166–, 1678 and 1696. Hence, this secondary phase of repair is datable to the early or mid-17th century. Although the majority of the graffiti take the form of idle scratching, initials and some dates, there are occasional markings of a more profound nature, including several written in cursive script in a small, neat hand: one on the south side reads *Ora pro die*.[110]

Very few crosses are detectable amongst the graffiti, which is surprising for a monument that was the focus of pilgrimage. Tanner, when writing about the kneeling step on the south side of the shrine, referred to 'one of the recesses in which I had long noticed a number of small scratched crosses which presumably had been made by pilgrims'.[111] These are all on the west reveal of bay 3, where they appear to have been linked together with deliberation (Fig. 408). Since the assemblage has been scratched into Feckenham's painted plaster, it must post-date 1557. Finally, a few graffiti occur on the top of Feckenham's moulded cornice – where they are not visible from floor level – include two fishes (Fig. 405C).

It is worth noting that the 13th-century mosaic-bedding mortar was hard and the tesserae were firmly adhered. Consequently, the outlines of thousands of individual tesserae – and the designs they created – are readily discernible as negative impressions. Had the mortar been of a soft or friable nature, tesserae could have become detached without human assistance, but that certainly was not the case, as proved by the intact survival of the upper parts on the north side of Henry III's tomb (Figs 465, 467, 469 and 470). This points to the likelihood that the mortar incorporated gypsum (p. 563). A recent study of visitor-inflicted damage on the Coronation Chair, which permanently stood in the shrine chapel until the late 20th century, revealed that the royal mausoleum was regarded as a European tourist destination in the late 16th century, but the adverse effects only became distressingly apparent as the numbers of visitors increased during the 17th century.[112]

10 The Shrine-Tomb of St Edward the Confessor, I: Description and Primary Fabric

INTRODUCTION

Very few English medieval shrine-bases survive, and they are all fragmentary.[1] St Edward the Confessor's shrine is the most complete although, as seen today, the monument is a highly complex structure of several periods, which has suffered much abuse over the centuries and the majority of its cosmatesque decoration lost, leaving empty matrices (frontispiece vol. 2; Figs 9, 12 and 220). Most of the Purbeck marble pedestal derives from the shrine of 1269, but the structure was entirely dismantled and ejected from the Abbey in 1540–41. When re-erected seventeen years later, some of the structural components had been lost or irreparably damaged, and in consequence they were either replaced with new or reclaimed materials, or omitted altogether. Furthermore, many of the original blocks were not reassembled in their correct positions, giving rise to plainly visible anomalies. The west end is entirely a confection of 1557, embodying the retable of the destroyed shrine altar and a pair of Cosmati columns that once supported the canopy over Henry III's tomb (p. 447).

The confection was partially disassembled and reconstructed again in the 1860s, contributing further architectural and historical confusion. The present shrine altar was added in 1902 (Fig. 298). The pedestal is surmounted by a two-tiered timber canopy (*cooperculum*), painted and inlaid with glass mosaic. It is pre-Reformation and originally covered the precious 'golden feretory' that was seized and destroyed by the Vicar-General in 1536. The canopy itself, although of no monetary value, had also suffered considerable damage over time, and was subjected to a drastic restoration in 1958–60 (Figs 383 and 384).

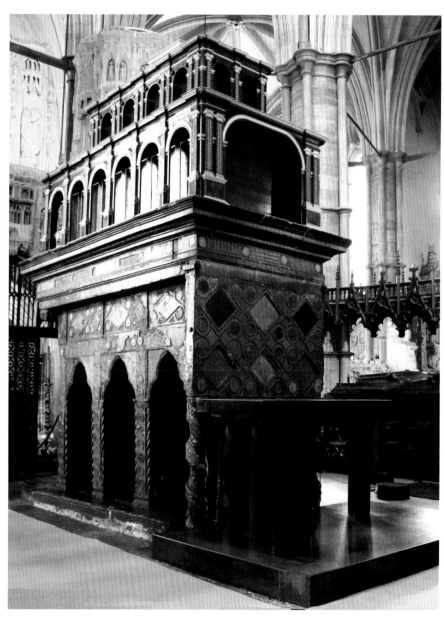

298 St Edward's shrine and altar. View from the north-west. © *Dean and Chapter of Westminster*

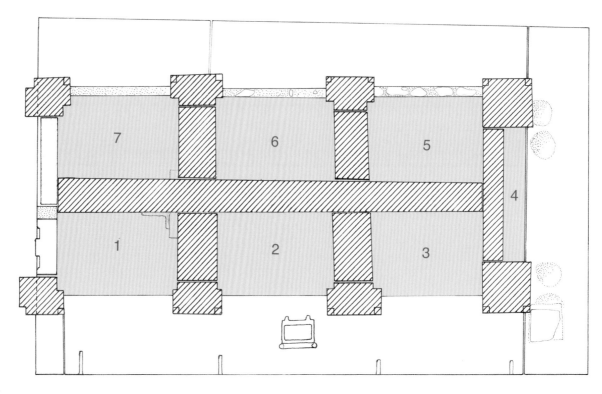

299 St Edward's shrine. Plan
of the pedestal at plinth level.
Authors

The shrine pedestal (Fig. 29) originally stood
on a tiered podium consisting of four steps, the
riser of the first step being immediately adjacent
to the decoration of the floor mosaic on the north
and south, rather than having a plain-paved gap
of 45cm, as there is today (Fig. 288, 1). The previous
overall north–south dimension of the podium was,
therefore, 2.70m, and the east–west dimension
3.80m. Adjoining on the west was a second podium,
probably of two steps, for the shrine altar, measuring
2.50m north–south by 1.95m east–west, which was
abutted on three sides by the Cosmati pavement;
the east–west dimension was reduced to 1.58m
during the Tudor reconstruction. T-shaped in plan,
the overall footprint of the combined shrine and
altar podia was 5.75m long by 2.50m wide.
Following the dismantling of the tomb and its
re-assembly in 1557, the footprint of the pedestal
contracted to 1.83m by 3.20m, and comprised only
a single-stepped plinth. The repositioned shrine is
38cm farther west than it was originally.

Eliminating three steps reduced the elevation
of the shrine pedestal, above the surrounding floor
level, from *c.* 50cm to 17cm.[2] Blocks from the
former steps were reused haphazardly, with the
result that one at the east end, exhibiting two
pairs of circular indentations (supposedly eroded

by the knees of pilgrims), is now situated too close
to the corner colonnettes; it is more likely to have
been located midway along the south side, with
each pair of indentations fronting one of the
niches.[3] Moreover, the blocks must originally have
been from a lower step, and hence slightly further
away from the façade.

Structurally, there are two stages to the shrine
pedestal, the lower of which is much taller than
the upper and incorporates seven trefoil-arched
niches: three each on the north and south sides,
and a much shallower one at the east end (plan,
Fig. 299). The upper stage is a rectangular chamber,
wherein lies the Confessor's coffin. The west end
of the pedestal was plain on its lower stage, since
it was abutted by the altar and its retable; the
decorated primary masonry of the upper stage
(bearing the dated inscription) is lost.

GENERAL DESCRIPTION OF THE SHRINE-TOMB

The condition of the shrine-tomb is fragile and
most of the original mosaic is either lost or
overlain by post-medieval decorative restorations
in painted plaster, the latter being part of Abbot

Feckenham's intervention in 1557. He employed a skilled painter to recreate *faux* mosaic decoration where the tesserae were missing, often imitating the original patterns. Over time, these expedient repairs have laminated, or become defaced, resulting in yet further patches of plain plaster being crudely applied to fill *lacunae*, but not painted. All the plasterwork was subsequently scored by the graffiti of pilgrims and visitors. Feckenham also caused a new inscription, on painted plaster, to be added around the entablature, entirely obliterating the remains of the 13th-century mosaic inscription underneath.

Deciding how best to describe and discuss all these disparate elements presented the authors with a quandary. Since the shrine is of two main periods – *c.* 1241–69 and 1557 – at first it was deemed appropriate to present the survey in two distinct phases, but it quickly became apparent that Feckenham's structural and decorative restorations held important clues for elucidating what went before. The two periods of work are therefore described in tandem, but discussion of the Tudor work will be reserved for the next chapter. Although Feckenham's restorations are not always a true reflection of the underlying designs, where his painted decoration and the original mosaic can be compared, they are often found to be closely matched in style and colour. The minute examination of every part of the tomb has highlighted many previously unrecorded anomalies, both in its primary architecture and its Tudor reconstruction with *faux* mosaic.

The methodology of the survey was similar to that adopted for the floor mosaics. The monument was digitally scanned and computer-generated elevations were produced at a scale of 1:5, to provide an accurate base for recording fine detail. Misrepresented elements of the architecture and the outlines of the decorative schemes were checked and corrected first. Only rarely did the plots adequately show the original mosaic, painted plaster decoration, or the impressions of lost tesserae in the bedding mortar. Hence, the surviving remains in each panel were drawn directly onto the outline plots, thereby saving considerable time. Every part of the monument was also recorded photographically; a selection of the images is reproduced here, and many more are held in the archive.

Antiquarian illustrations are of little assistance in recording and interpreting the damaged decoration. One of the most notable images is George Vertue's engraving of the south elevation, possibly derived from John Talman's survey of 1713. However, there are two versions of the image, both based on the same plate, but with anomalies and distinct differences between these and Talman's measured sketches (Figs 26 and 300). Details and their implications will be addressed in the discussion, but Talman's original work, as with his drawings of the sanctuary mosaic, provides an indisputable record of the shrine-tomb as it was 300 years ago (Fig. 301).

The pedestal rests on a single slab of Purbeck marble, measuring *c.* 2.60m by 1.01m, which forms the floor to all the niches; it is abutted on three sides by the steps. The lower stage of the pedestal incorporates a single massive stone slab comprising the spine wall, 2.33m long by 1.40m tall and 18cm thick (tapering to 15cm at the east end), into which the decoration of the backs of the six lateral niches has been chased. The slab is supported at its ends by a pair of cross-walls of the same height, and 77cm wide. Three bays of niches are formed on either side of the spine by pairs of stub-walls abutting it to north and south; each bay has its own pointed barrel vault (Figs 299 and 338). The outer edges of the transverse divisions are squared to form a rectilinear framework around the niches, with their salient angles rebated to create housings for slender, roped nook-shafts with gilded lines in the creases (Fig. 306). Some of the *en délit* shafts survive, but they are not all identical: the number and direction of the twists vary. The diminutive capitals and bases for these shafts are integrally carved on the rebated slabs. The capitals are tiny versions of those seen on Henry III's tomb (Figs 358 and 438). The tops of the transverse slabs support not only the curved stones forming the vaults to the individual niches, but also a pair of massive facing slabs that run the full length of the pedestal. Each slab has three cut-out trefoil arches, forming the heads of the niches on the north and south sides, respectively (Fig. 338). Rubble and mortar was infilled over the crowns of the vaults, making the lower stage of the pedestal flat-topped. The east end has a similar trefoil-headed arch fronting a much shallower recess; the west end is of plain ashlar.

Moving on to the upper stage, we find this comprises a full-length rectangular chamber, 36cm high, with the north, south and east sides formed from individual blocks of marble. They are

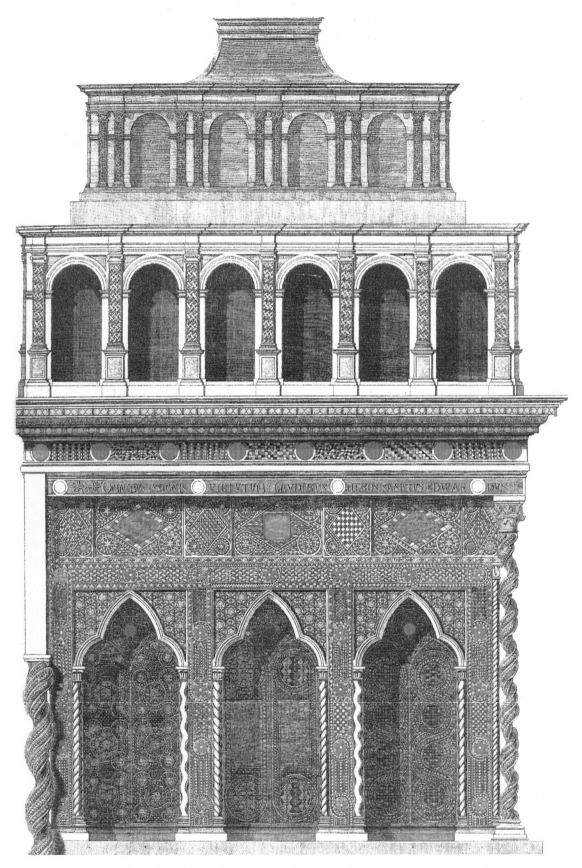

300 St Edward's shrine. The second (coloured) version of George Vertue's engraving of 1724, based on Talman's drawing of 1713, showing the south elevation of the shrine, as reconstructed and decorated by Abbot Feckenham, 1557 (cf. Fig. 26). *Society of Antiquaries of London*

A

B

301 St Edward's shrine. John Talman's annotated sketches of the pedestal and canopy, 1713. A. South elevation of the pedestal; B. Details of the Tudor timber canopy, together with a plan (upper left) and section (far right) of the coffin chamber. © *Dean and Chapter of Westminster*

302 St Edward's shrine. Talman's sketch of the altar retable, supported on two Cosmati columns at the west end, 1713. NB the 'ghost' images seen here are Fig. 301A, which is drawn on the reverse. © *Dean and Chapter of Westminster*

externally divided into rectangular panels of varying widths: seven on each long side and three on the east end. There would also have been a panel at the west end, but that was lost at the Dissolution and the resultant gap concealed by raising the retable of the reconstructed shrine altar to a higher level than hitherto.

The panelled zone is topped by a row of flat stones into which was set a tessellated inscription running around all four sides of the shrine. The upper edge of this course is moulded and, originally, the two western corners were 'eared', i.e. they had wing-like projections to north and south (Figs 371 and 372). Under each of these modest projections was a twisted colonnette, the base of which probably rested on the second step of the podium. However, the entire west side of the inscription course, including the wings and their supporting colonnettes, was omitted in the

1557 reconstruction, and the tessellated inscription on the other three sides was plastered over and repainted with a different text. The oversailing eastern angles of the inscription course were supported and enhanced with slender *en délit* colonnettes, and one – reconstructed from fragments in 1856 – survives at the south-east corner. It has a moulded base, now resting on the top step, which has a shallow square sinking relict from an earlier use (Fig. 353). Originally, this is likely to have been the second step. Additionally, the arrises of the eastern angles of the pedestal were embellished with full-height, slender roped shafts, set into rebates, complementing the shafts flanking the individual niches (Figs 313 and 314).[4]

Above the inscription is another course of flat slabs, comprising three on each long side, a single block at the west end and several conjoined pieces at the east end. It is clearly a confection of medieval and Tudor work and now forms a frieze, supporting a moulded Reigate stone cornice that was added by Feckenham. This reconstruction gave the pedestal a classical entablature comprising three elements: architrave (the old inscription course), frieze and cornice. O'Neilly argued that, prior to 1540, the masonry of what is now the frieze was the uppermost element of the pedestal, and was set back from the inscription course by *c.* 15cm on all sides; it was moved forward (and the length of each side necessarily extended) by Feckenham to bring it flush with the principal faces of the monument. This deduction is fully supported by the physical evidence. It was further argued by O'Neilly that the original purpose of the set-back frieze was to form a plinth upon which to rest the feretory.[5]

Before proceeding to describe the structural elements of the shrine pedestal, it is well to mention a major anomaly in its design, for which no satisfactory explanation has hitherto been forthcoming. It is readily apparent that a fusion of architectural styles occurred during its manufacture: Gothic and Roman. First, the general form of the pedestal is undeniably Gothic, being a two-tiered monument, the lower stage embodying a series of trefoil-headed niches which served as kneeling-places. Secondly, the backs of the niches are decorated with blind, two-light traceried 'windows' which exactly replicate the surrounding architectural detail in the Abbey. And thirdly, the use of Purbeck marble for the pedestal reinforces its affinity with other English Gothic shrines.

That, however, is the sum of the Gothic contribution. The mouldings, surface decoration, colonnettes and all other detail are uncompromisingly Roman in design and execution, as is the employment of exotic marble inlays and a prodigious quantity of glass mosaic. Some writers have seen the amalgam of styles as the result of indecision on the part of Henry III, and one dismissed the shrine as 'a gimcrack compromise of Roman and Gothic'.[6] What none of the previous commentators seems to have taken on board is the fact that the construction of the pedestal was in hand in the 1240s and 1250s, as passing mentions in records attest, and that was prior to Henry's decision to embrace Roman design and cosmatesque decoration.[7] As we shall demonstrate, St Edward's shrine began to be fashioned as an English Gothic monument, but was cleverly adapted during construction in order to clothe it with Roman decoration (p. 564).

The six kneeling-places, labelled niches 1–3 and 5–7, are situated on the south and north sides of the tomb, respectively (Figs 299, 304 and 319). In plan they are rectangular, measuring *c.* 66cm wide by 55cm deep (measurements taken from the exterior face of the dividing piers) by 1.40m high up to the undersides of their vaults. Quasi-niche 4 at the east end of the shrine is 74cm wide and also 1.40m high and, superficially, has the same architectural form as the others but it is not deeply recessed and has no vault. It was purely decorative and did not serve as a kneeling-place (Fig. 312).

The internal surfaces of the niches were decorated with mosaic, including the vaults. Their rear walls all carry the same basic design: an early Gothic blind 'window' of two uncusped, pointed lights with sexfoiled tracery above (Figs 304 and 319). The niches embody two levels of relief, creating a three-dimensional effect; the higher level is represented by the outer mouldings, traceried heads and mullions of the lights. These are raised about 6mm above the surfaces of the matrices into which the tesserae are set, with the central mullion dividing each of the decorative schemes into two parts. The lower level of relief is recessed into the backs of the pairs of lights, and it carries the cosmatesque decoration.

The mosaic schemes vary in each bay. Although the geometrical format of each pattern was calculated to fit exactly the width of a pair of lights, the designs were not readily compatible with containment under pointed arches: con-

sequently, most fail to meet the Gothic heads in an aesthetically pleasing manner. In bays 1, 4, 5, 6 and 7 the designs within the main lights are conspicuously truncated at the upper end.

There are seven different designs in all, but the scheme filling bay 4 on the east is incomplete, having been truncated at the springing level of the window arch (Fig. 312). Above this, the traceried head has been replaced by two large slabs of polished Purbeck marble with a vertical joint between them that is asymmetric to the designs below. It may reasonably be assumed that there was sexfoil tracery here and that the mosaic decoration once completely filled the back wall of niche 4, but the stone head was lost when the monument was dismantled in 1540.

A subtle but possibly significant difference between the designs on the back walls of the niches is that the decoration of each 'window' on the south side is strictly compartmentalized, the design being constrained by the limits of the individual light. However, on the north the designs spread across the full width of each niche, and are only subtly divided into two parts by narrow vertical fillets (diminutive substitutions for the more robust mullions between the lights on the south elevation). These and other differences will be discussed more fully later (pp. 564–5). The reveals of niches 1, 2, 6 and 7 are decorated in similar fashion, their walls being divided into two rectangular panels, 36cm by 28cm, one above the other (Figs 340, 342, 350 and 352).[8] Niches 3 and 7, on the other hand, have four rectangular panels, 36cm by 15cm, on one reveal, and two on the other (Figs 344 and 347). The panels were seemingly all delineated by tessellated bands 4cm wide.

The east wall of niche 7 has been restored with Reigate stone and overpainted. There are also differences in the decoration of the vaults on the north and south sides of the tomb. All the niches have tessellated strips along the undersides of the arch-head slabs, but on the north the soffits of the vaults each carry three longitudinal fillets of mosaic, whereas on the south they are divided into two wide swathes with repetitive patterns, and the latter are more crudely worked.

Virtually every surface of the tomb was decorated with chased patterns inset with tesserae or slabs of exotic marble. The black and blue tesserae are glass, as are the gold tesserae which are flashed on red glass. Many of the blue tesserae have oxidized and now appear pale blue-grey.

Marble was used for the white tesserae but, unlike the pavement around it, no white lias is evident.

The following section records the decorative schemes and patterns in detail, starting with the south elevation and working anticlockwise. The tessellated patterns in the niches are omitted from the main elevation drawings for clarity; they are shown and described separately. Restorations in painted plaster by Feckenham are recorded within each section because their patterns were often influenced by remnants of the designs of the earlier mosaic. The Tudor canopy for the feretory, heavily restored in 1958–60, also has glass mosaic decoration and is described in the next chapter (pp. 394–403).

Each decorative panel on the pedestal is numbered, elevation-by-elevation. Quantifications of the tesserae within each panel are given in appendix 2.

Key to panel numbering

South elevation (Fig. 305)

1 Frieze (a–h roundels; i–o panels)
2 (a) Inscription course (a–d roundels; e–h panels)
 (b) Guilloche on underside of inscription course
3–9 Upper panelled zone
10–14 Framing of niches 1–3
10 Lintel (a–g roundels; h–m panels)
11 West flank
12 Pier between niches 1 and 2 (a–d roundels; e–h panels)
13 Pier between niches 2 and 3 (a–d roundels; e–h panels)
14 East flank (a–d roundels; e–h panels)
15–20 Spandrels of niches 1–3
15 Niche 1, west side
16 Niche 1, east side
17 Niche 2, west side
18 Niche 2, east side
19 Niche 3, west side
20 Niche 3, east side

East elevation (Fig. 313)

21 Frieze (a–e roundels; f–i panels)
22 (a) Inscription course (a–b roundels)
 (b) Guilloche on underside of inscription course
23–25 Upper panelled zone
26–28 Framing of niche 4
26 Lintel (a–d roundels; e panel)
27 South flank (a–e roundels; f–i panels)
28 North flank (a–m roundels)
29 Spandrel on south side of niche 4
30 Spandrel on north side of niche 4

North elevation (Fig. 320)

31 Frieze (a–h roundels; i–o panels)
32 (a) Inscription course (a–d roundels)

 (b) Guilloche on underside of inscription course
33–39 Upper panelled zone
40–44 Framing of niches 5–7
40 Lintel (a–q roundels)
41 East flank of niche 5 (a–m roundels)
42 Pier between niches 5 and 6 (a–l roundels)
43 Pier between niches 6 and 7 (a–l roundels)
44 West flank of niche 7 (a–m roundels)
45–50 Spandrels of niches 5–7
45 Niche 5, east side
46 Niche 5, west side
47 Niche 6, east side
48 Niche 6, west side
49 Niche 7, east side
50 Niche 7, west side

West elevation (Fig. 327)

51 Frieze (a–d roundels, e–g panels)
52 Inscription course (substitute block)
53 Face of retable (a–f panels; a–z roundels)
54 North edge of retable
55 South edge of retable
56 Reverse side of retable, on the north
57 Reverse side of retable, on the south

Interiors of niches

Niche 1 (south side)
58 Back, west light
59 Back, east light
60 Sexfoil
61 West reveal
62 East reveal
63 Vault

Niche 2 (south side)
64 Back, west light
65 Back, east light
66 Sexfoil
67 West reveal
68 East reveal
69 Vault

Niche 3 (south side)
70 Back, west light
71 Back, east light
72 Sexfoil
73 West reveal
74 East reveal
75 Vault

Niche 4 (east end)
76 South light
77 North light
78 Rebuilt panels above 76 and 77

Niche 5 (north side)
79 Back, east light
80 Back, west light

81 Sexfoil
82 East reveal
83 West reveal
84 Vault

Niche 6 (north side)
85 Back, east light
86 Back, west light
87 Sexfoil
88 East reveal
89 West reveal
90 Vault

Niche 7 (north side)
91 Back, east light
92 Back, west light
93 Sexfoil
94 East reveal
95 West reveal
96 Vault

Columns and colonnettes

98 South-east corner
99 North-east corner
101 North-west corner
102 South-west corner

DETAILED DESCRIPTIONS OF THE COMPONENTS

The plinth, or low platform, upon which the pedestal stands, and the secondary cornice that crowns the monument, are common to all sides and will be described first.

Plinth

The shrine base stands on the floor of the chapel, raised only on a plain rectangular platform, which effectively forms a plinth. It is composed of one large slab of Purbeck marble 2.7m long by 1.05m wide, edged by blocks of marble derived from the shrine's original set of steps (Fig. 299). Despite its size, the slab is not large enough for the shrine pedestal to stand securely on it, and all the piers overhang its perimeter. Moreover, a shallow, rectangular recess, traversed by the spine wall, occurs in the slab at the north-east corner of niche 1, and also appears in the south-east corner of niche 7. In this position, the slab played no meaningful role in either the primary shrine or the reconstruction. Whether or not it was part of the original plinth remains uncertain. Sundry wear marks and redundant pockets for iron cramps on

303 St Edward's shrine. Small rectangular chamber, formerly with a hinged iron lid, cut into the step in front of bay 2. The lead plugs that secured the hinges and the keep-plate are labelled 1–4. The remains of a hinge are still present in no. 1. This chamber held the heart burial of Henry of Almain, 1271. *Authors*

the surviving steps confirm that they are not in their original juxta-positions.

On the south side, in bay 2, a small rectangular chamber has been cut into the marble step, and it once had a hinged iron cover. The latter has gone but the remains of one hinge set in lead survive, as does the flat iron plate that acted as the keep for a lock-bolt (Figs 299 and 303). The lid evidently secured a tiny chamber that was intended to contain something precious, but not necessarily a relic. Almost certainly, this is the burial place of the heart of Henry of Almain, the king's nephew. The *Flores Historiarum* tells us that in March 1271 'his heart was buried honourably in a gilt cup, next to the feretory of St Edward'.[9] Two cups were purchased by Henry III in that year, one being described as 'for the feretory', and the purpose of the other was not stated.[10] The chamber, which is now plugged with a block of limestone, was opened in 1955, when it was reported that there was nothing inside.[11] The chamber was presumably raided and the gilt cup taken at the Dissolution.

Cornice

Running around the top of the pedestal is a classical entablature, created in 1557 by adding a moulded and painted cornice, and adapting the uppermost course of the 13th-century Cosmati work to form a frieze. Beneath that is the primary inscription course, complete with a small moulding that allows it to be read as the 'architrave' of a classical entablature. The cornice is composed of a mixture of reused Reigate and Caen stone blocks, all painted in imitation of cosmatesque decoration (for descriptions, see Figs 330 and 335). The four elevations of the pedestal will now be described individually. It should be noted that some

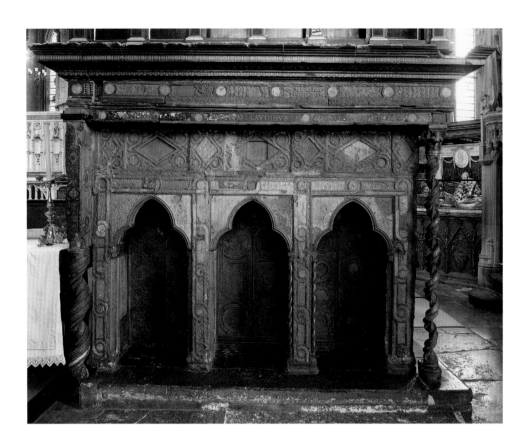

304 (*Right*) St Edward's shrine. South elevation, 2017. *Christopher Wilson*

305 (*Below*) St Edward's shrine. South elevation with the key to panel numbering. Shaded areas represent surviving painted plaster repairs of 1557. *Authors*

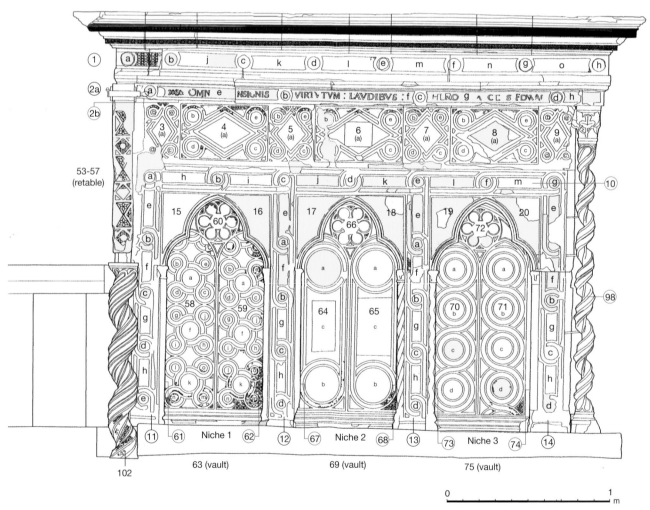

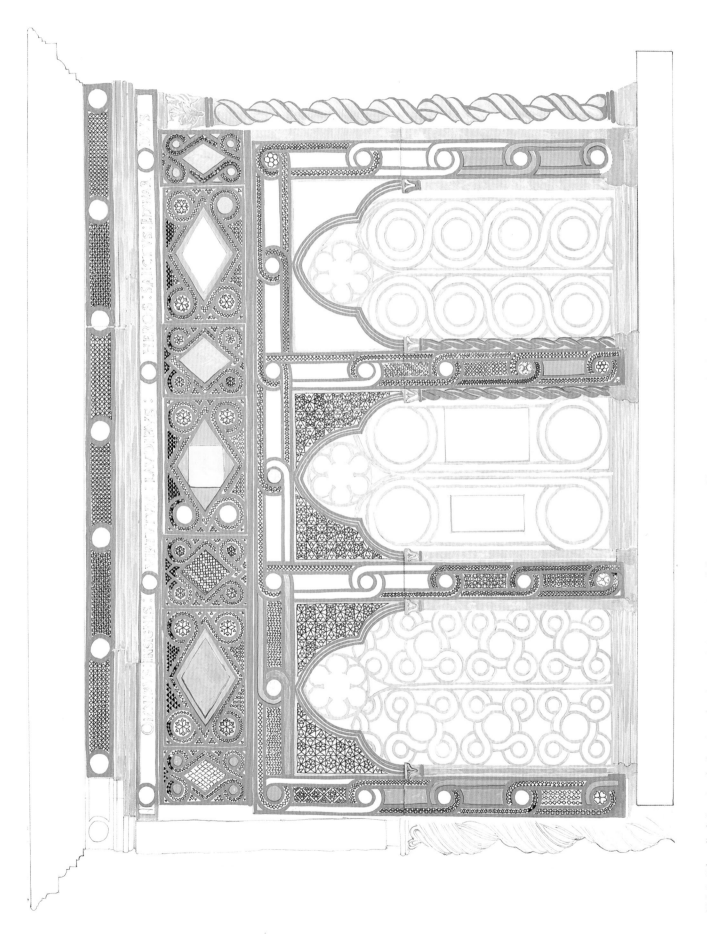

306 St Edward's shrine. South elevation, showing surviving mosaic and the impressions of lost tesserae. Areas left white are filled with post-medieval plaster, sometimes with painted *faux* mosaic surviving. Decoration within the niches is shown separately on Figures 340, 342 and 344. *Painting by David S Neal*

of the descriptions of the mosaic patterns – where the tesserae have been lost, but mortar impressions still survive – provide only an indication of their basic geometric structure; many of the squares and triangles, for example, could have been further subdivided by smaller, differently coloured, tesserae.

South elevation (Figs 304–306)

Frieze

1 Eight roundels (a–h) alternate with six rectangular panels (i–o). The roundels are 7.5cm in diameter (internally) and the rectangles about 32cm long by 8cm wide, with concave ends. An anomaly occurs at the west end, where the space between roundels (a) and (b) is reduced to 15cm (Figs 305 and 307B). This is the result of roundel (a) and rectangle (i) being added by Feckenham: (b) was originally the first roundel on this side; west of (b) a separate block of Reigate stone (and an equivalent block on the north side, Fig. 307A) can be extracted to reveal a roundel fronting the west return of the frieze, thereby confirming that originally the frieze was not flush with the inscription course, but set back from it (Figs 307B and 308).

The roundels are shown by Vertue as alternately red and blue (Fig. 300). No decoration survives in the matrices, just the cream-coloured bedding mortar for lost discs that were only 2mm thick; these were undoubtedly of glass. They were restored by Feckenham, as indicated by the bedding mortar which is the same in the primary roundels as in those newly created on the west elevation in 1557 (below, p. 350). Some of the roundels still contained glass discs when Talman drew the shrine: in (a) he recorded *az.* (i.e. blue); in (b) a symbol;[12] (c) *ae.* (uncertain);[13] and in (d) *az.*

Of the decoration in the rectangles (i–o) only (i) at the west end survives. This decoration too is the work of Feckenham and comprises a grid of tangent squares painted in vertical rows, alternating black and gold, with the interspaces divided vertically into pairs of triangles, white against the black and red against the gold, thereby forming banding (Fig. 307); the pattern is copied from original designs in some of the other

rectangles. Although no tesserae or Feckenham's painted plaster survive in the remaining rectangular panels, their impressions indicate similar patterns, turned diagonally. Talman did not record the patterns, but Vertue's engraving shows them correctly.

Inscription course

2 This is 3.0m long. A row of roundels (a–d) 6cm in diameter alternates with rectangular panels (e–h) 75cm by 6cm (panel (h) is 21.5cm long). At the west end are two roundels, one overlapping the other. The western example is a primary matrix which was filled with plaster and overpainted by Feckenham with a second roundel (a). The plaster has laminated to reveal the western rim of the first roundel and, to the west of that, blue glass tesserae, once forming the background to the earlier inscription, are now exposed (Fig. 410A). Talman recorded the filling of roundel (b) as *oro.*, which was presumably gilded red glass. Nowhere on the south side is the original tessellated inscription evident, but a few isolated tesserae of the blue background are showing proud of the painted plaster. Today the plaster appears almost black, as indicated by Talman in his annotation, 'gold capitals on *nero*'. Blue was intended in imitation of the original tesserae, but the 16th-century pigments have darkened. The secondary inscription is in Roman letters, painted gold (Fig. 409). It reads:

IFA ✷ OMNIBVS : INSIGNIS : VIRTVTVM : LAVDIBVS : HEROS : SANCTVS : EDWARDVS ✷

The initial letters of OMNIBVS and EDWARDVS are larger than the others, presumably for emphasis. Preceding and following the text are foliated motifs (represented here by asterisks). The full inscription is discussed on p. 417.

Chased into the underside of the overhang of the inscription course is a row of guilloche (Fig. 309) with S-shaped loops, creating twenty-one-and-a-half roundels, 6.5cm in diameter, filled with cream-coloured mortar, which retains the impressions of circular discs in panel 2(b). In a few instances the depth of the original impressions in the mortar can be measured as 4mm, which is too shallow to have contained porphyry inserts. The roundels must therefore have been of glass *ab initio*. Following the loss of the glass discs they were filled by Feckenham with plaster and overpainted. As with the background colour of the Tudor inscription, they are

307 (*Left*) St Edward's shrine. Details of the Tudor alteration to the west end of the frieze, showing the two original western corner blocks with their matrices for glass roundels, exposed by removing the painted infill blocks that now form part of the westward extension. A. North side, showing the completely empty matrix for a glass roundel; B. South side, showing the matrix still containing the mortar bed into which the glass disc was pressed. *Authors*

308 (*Right*) St Edward's shrine, frieze, south side. Tudor painted *faux* mosaic on the two blocks extending the frieze westwards. The small block in the middle can be extracted to reveal the western return of the medieval frieze (cf. Fig. 307B). *Authors*

A

B

A

B

309 St Edward's shrine, south elevation. A. Decoration on the underside of the inscrition course; the same is also present on the east and north sides of the shrine; B. Painting of a sample of the decoration. *Painting by David S Neal*

now black but were originally blue, imitating blue glass; possibly a few specimens survived into the post-Dissolution era, which would explain why some matrices are totally void; presumably these discs were lost after 1557.

The indentations for the tesserae forming the loops of the guilloche are well preserved and a considerable number of tesserae survive; all had patterns of alternating gold and blue poised squares with red interspaces, superimposed with small outward-pointing white triangles. At the west end the first 'roundel' is semicircular and adjacent to it is a loop of guilloche with its outline scored but not chased into the marble. The workmanship is good but the tesserae are larger than those used elsewhere on the tomb, except on the undersides of the niches. Presumably, being out of sight, the mosaicists thought finer tesserae were unnecessary.

Upper panelled zone

3–9 Below the inscription is a horizontal course of seven panels, carved on a single block 2.70m long by 37cm high; the panels are alternately arranged vertically and recumbently (Fig. 306). Nos 3, 5, 7 and 9 are narrower and located above piers 11–14 separating the three niches; 3 and 9 at the corners are 22cm wide, compared with those over piers 12 and 13, which are 30cm wide. Their schemes of decoration are similar and alternate with vertical and recumbent lozenge-shaped panels bordered with a single fillet, looped at the mid-points to create roundels filling triangular interspaces. When the monument was reassembled the slab was incorrectly positioned, resulting in the lozenges losing their axiality in relation to the piers and arch-heads below; the same irregularity occurs on the north side of the tomb, a consequence of the north and south slabs having been interchanged.

Tesserae survive only at the top of the course. The large triangular interspaces created between the lozenge-shaped panels and their borders are all filled with patterns of black and white chequered triangles; however, it is clear from the surviving impressions along the bottoms and sides of the panels that the same patterns once existed in the equivalent zones. Enough tesserae filling the single fillets bordering the lozenges

333

survive to establish their patterns: they are of two types (those on diagonally opposite sides being the same) and comprise a row of inward-facing triangles, alternating gold and black, with red interspaces superimposed with small white triangles, also inward-pointing, and a row of poised gold squares, set point-to-point, with black triangles in the interspaces. The contents of the roundels do not survive. These are of three sizes (the largest occupying the recumbent panels) but the impressions indicate that two types had six-lozenge stars with outward-pointing triangles in the interspaces. The exceptions are the small roundels in panels 3 and 9 shown by Vertue (Fig. 300) as being blue, presumably glass. The larger roundels were restored in plaster, but the surviving two have both lost their colours. However, an example on the east side of the tomb (panel 24j) has been overpainted, with the lozenges of the star alternating red and gold, with red interspaces between the lozenges and the rim of the roundel. They are superimposed with small outward-pointing white triangles.

The lozenges in panels 4, 6 and 8 once contained sheets of marble surrounded by tessellation, all now lost. The central slab (6a) has a sunken square (which the equivalent panel on the north elevation lacks) once filled with a sheet of marble, shown by Vertue as red and described by Talman as *por.*; this was undoubtedly purple porphyry. No bedding mortar survives in the triangular interspaces at the sides of panel 6 shown by Vertue filled with horizontal rows of recumbent lozenges forming blue chequers, with the interspaces divided longitudinally red and white. This is not a pattern identified elsewhere on the monument so it is possibly spurious and, furthermore, no indication is given of its survival by Talman who, in his hybrid Italian/English annotation, marked it with the words *senz orlo* (without a border). The equivalent-sized panel to the west (4a) is filled with plain plaster but recorded by Talman as containing a sheet of green porphyry, for which he used the abbreviation *serp.*[14] Vertue similarly shows this in the corresponding panel to the east (8a).

Talman's drawing makes no specific record of the material of panel 8. Today it is filled with plaster) and has a diagonal ridge across its surface, pecked on the lower half. Possibly a broken stone was reset by Feckenham, the diagonal ridge being where the mortar penetrated the crack between two fragments. Similar panels (34a and 36a) on the north side of the tomb show evidence of having been reset, potentially with glass plates and, since the bedding compound is similar, panel 8 may have been decorated likewise (Figs 322 and 323).

Panels 3, 5, 7 and 9 contain schemes of vertical lozenges. The impressions of tesserae surviving in panels 3 and 5 indicate the pattern was diagonal rows of square tesserae, set point-to-point. Differences in the depth of the tesserae are evidence that the rows alternated in colour with the tesserae in every third row divided into triangles. The bedding mortar in panels 7 and 9 is lost but their decoration was probably the same. Talman's representation of the design in panel 3 is a pattern of chequers, but it was rendered by Vertue as arbitrarily arranged coloured squares. If Vertue's engraving is based on Talman's drawing it would seem that most of the patterns had already been lost by the early 18th century.

Framing of niches 1–3 (Fig. 305)

The trefoil-headed niches around the lower part of the shrine are framed by bands of decoration. There are four vertical piers (bands 11–14), linked by a horizontal lintel (10).

Lintel

Panel 10, the horizontal course over the arch-heads, runs the length of the tomb and is in the form of a chain composed of seven roundels (a–g) and six rectangular links or panels (h–m), 27cm long, and delineated by fillets. The roundels, 6.5cm in diameter, are intertwined with similar ornament to that on the faces of piers 11–14, and centred on the arched heads of the three niches. The stone into which the patterns are chased is a single block incorporating the trefoiled heads of the arches, down to their springing points, and the upper portions of piers 11–14. By the time Feckenham reconstructed the tomb the panels had lost their tesserae and all that survives of the original work are some impressions in the bedding mortar. At the western end, panels (h) and (i) have patterns of chevrons and it is almost certain that the other panels were decorated similarly, but these have been plastered over and the Tudor painted decoration lost. Talman records panel (j) as having chevrons, but this is a restoration (Fig. 306). Nevertheless, despite the painted design being on a bolder scale, reducing the pairs of chevrons along each link from about 14 to 10, the pattern is the same as the work of 1269. Contrary to the colours of the chevrons on the east elevation, which are gold and red, they were painted gold and blue (*az.*), and the same colour was adopted by Vertue.

On the west side of panel (j), over niche 2, the chevrons have been reduced for the insertion of a plaque, 6cm square, set into cream coloured plaster. It is only about 2mm deep but its edges are sharply defined by the plaque having been pressed hard into the wet matrix. It is assumed to have been glass or metal but, unlike the plates in panels 34a and 36a on the north side, which have left impressions of ornament, no such decoration is evident (Figs 322 and 323). Following the plaque's removal, possibly for a souvenir, the backing plaster became a fresh space for further graffiti (Fig. 310A, B). No evidence exists for any other inserted plaques on the panels in this course, nor on the corresponding position on the north elevation.

A

B

C

310 St Edward's shrine, south elevation. A. Detail of the Tudor painted band and adjacent impression left by a square insert in the frame in bay 2 (panel 10(j)); the insert was only 2mm thick and may have been a plaque of metal or glass; after the loss of the insert, the plaster bed was defaced with graffiti; B. Reconstruction of the painted panel; C. Imprint of a lost glass roundel in the chain guilloche in bay 3; a long cross and initials 'PH' were subsequently incised in the plaster-filled matrix. *Authors*

No tesserae survive in the roundels, which are mostly empty matrices, or filled with plaster, but the latter has lost its painted ornament. However, indentations associated with the original decoration survive in two of the roundels (b and g): in (b) there is the impression of a four-petalled flower with the outer rims of the petals bifurcated; it has a small circular corolla (centre). In (g) the impression indicates a flower-form composed of five tangent hexagons developing a small central pentagonal interspace. Two more of this type (d and e) are found on the pier between bays 2 and 3 (panel 13); (e) is plastered over, but paint shows the petals alternating red and gold. None with hexagonal petals is recorded by Talman or Vertue, who show the equivalent roundels on the south elevation as having four bifurcated petals, all coloured similarly but with each flower alternating blue and red. Feckenham's restoration is more likely to be a closer representation of the original colours.

Although the chevron decoration within each link seems to have been the same, the fillets surrounding them contain a variety of ornament, surviving as impressions of real tesserae and depictions of Feckenham's *faux* tesserae. Working from west to east, (h) has a string of tangent poised squares, painted alternately gold and blue. The tesserae and impressions in the fillet surrounding the next link (i) are all lost; Talman does not record them and they are shown by Vertue as being basically the same as the previous example. The decoration within link (j) survives in part as impressions of a single row of tangent poised squares; some of the surviving painted restoration indicates the squares to be gold, possibly with blue triangular interspaces; this is probably how the original band appeared. The tesserae are shown by Vertue as diagonally arranged chequers in two rows, but for this there is no evidence. Around the upper part of the next link (k), impressions survive of a chequered band with alternating squares divided diagonally and forming pairs of triangles. On the lower section of the link, however, the surviving impressions demonstrate that the original pattern was a row of tangent poised squares with diminutive triangles in the interspaces. Both are shown by Vertue as having red and gold chequers. Around panel (l) the impressions indicate a row of tangent poised squares interlocked with another row, each square being divided vertically to create two triangles. There is no evidence for colour; Vertue records alternating red and blue squares, each superimposed by a gold poised square but this arrangement is unlikely. The final link surrounding panel (m) has two patterns. The top strand has a row of poised squares with diminutive outward-pointing triangles in the interspaces, and the bottom one a chequered arrangement with alternate squares divided diagonally into two triangles. Vertue shows both patterns with gold poised squares.

Piers 11–14

Panels decorate the external faces of the four piers framing the niches. They stand on the plinth of the tomb and support the arch-head slabs and piers just described; the tops of the stones are at the same level as the small integral capitals from which the arches spring. Hence there is a horizontal joint at this level (f). The decoration is the same and integral with the schemes on the arch-head (10); each has four roundels (a–d) separated by four rectangles (e–h) – shorter than those in the horizontal course – and reducing in length from top to bottom. The same graduated reduction in panel sizes occurs on all four piers.

11 Two (e and h) of the four rectangular panels decorating the west pier have impressions of tesserae indicating their original designs and two (f and g) are voids. The upper panel (e) has a diagonal lattice, once composed of fillets of stone, forming three squares. Where the diagonal arms of the lattice cross, small square tesserae are introduced and, likewise, where the

lattice meets the border, small triangles occur. The three square interspaces formed by the lattice contain a quincunx (colours not known) with intermediate square spaces divided diagonally to create four triangles. The design is the same as that decorating the trefoiled arch-heads (45 and 46) above bay 5 and the same as one of the patterns on the column at the north-west corner of the tomb. The impressions in (h) comprise three vertical rows of tangent poised squares; the interspaces on either side of the central row are divided vertically into pairs of triangles. Details of (e) and (h) are recorded correctly by Talman and Vertue, although the latter tended to exaggerate the number of rows within the panels, resulting in their appearing to contain more tesserae than they do in reality.

The fillets around (e–h) forming the links vary in their designs and differ on opposite sides despite, essentially, being part of the same unit. Those around (e) are filled with plain plaster. On the west side of (f) is a double fillet of chequers, with alternate squares divided diagonally into pairs of triangles; on the east side are two rows of tangent poised squares with the row along the inside edge divided into pairs of triangles. The fillet on the east side of (g) is lost but on the west it has a row of tangent poised squares with diminutive triangles in the interspaces. On the west side of (h) the fillet comprises a chequered composition with alternate squares divided diagonally into four triangles. The east has the same decoration as the east side of (f). The impressions of only roundel (d) survive; it has a flower with four rounded petals, each with clefts. This example was shaded blue by Vertue, who restored the same motif in the other roundels and alternated their colours, blue and red. However, it is likely that these were already lost; Talman does not show them.

12 Panels (e) and (f) were plastered in 1557 and there is no evidence for their original decoration or for the later *faux* mosaic, which has eroded away. Impressions of tesserae survive in (g) and (h); (g) has a grid of squares with alternate squares divided diagonally into four triangles and (h) has the same design, but rotated by forty-five degrees. The decoration of the link on the east side of (e) survives in part and has the same pattern as that on the east sides of 11(f) and 11(h): a fillet of poised squares alongside a fillet of triangles. The decoration in the link along the east side of (f) is sealed by faded Tudor plaster, but on the west is a fillet of poised squares forming triangular interspaces filled with diminutive triangles. The link forming the east side of (g) has an arrangement of poised squares and that on the west a row of spaced squares with the interspaces divided diagonally into four triangles, and along its west side a row of tangent triangles. The decoration within the links on both sides of panel (h) is the same – poised squares and small triangles – as on the east side of (g). Of the five roundels, four are filled with plaster, but only in that below (e) has the paint survived,

showing traces of a flower similar in form to the impressions of a tessellated flower in the roundel below (h).

13 Of the four compartments in this panel only (e) and (f) have evidence for their original decoration. In (f) are the impressions of chequers set diagonally and in (g) a grid of squares with their interspaces containing poised squares. Impressions of tesserae survive in all links: on the west side of (f) are chequers with alternate squares divided diagonally into pairs of triangles and on the east side, diagonally arranged chequers (forming a fillet of small triangles along one side). On the west side of (f) the fillet is the same as directly above and on the east is a band of tangent poised squares with diminutive triangles in the triangular interspaces. Alongside (g) is a row of squares, with alternate squares quartered diagonally to create four triangles; they are flanked by rows of small triangles. The link on the west of (h) has a diagonally arranged fillet of chequers with one row of squares divided vertically into pairs of triangles; on the east side is a diagonally arranged grid of chequers and below this, decorating a truncated link, a pattern of squares each divided diagonally into pairs of triangles forming a dog-tooth effect. All but the lowest roundel is filled with plaster, that between (g) and (h) having traces of a red-petalled flower. However, the surviving impressions of tesserae in the roundel below (h) indicate that this example had a floret with six hexagonal petals and a hexagonal corolla. Talman did not detail the form of the roundels; Vertue showed them, incorrectly, as all having rounded, cleft petals.

14 Apart from (f), which has traces of diagonal chequers, the impressions of tesserae in the other compartments are lost. The roundels are filled with plaster, but *faux* mosaic decoration cannot be distinguished. The only surviving decoration in the links occurs on the sides of (e): the west has a fillet of tangent poised squares with diminutive triangles in the interspaces on the outer side and, on the east, a pattern of diagonally arranged squares with the inner row divided horizontally into pairs of triangles. Talman did not detail this pier and it is likely that Vertue's representation is fanciful.

Spandrels 15–20

The arch-head spandrels over niches 1–3 were originally tessellated but are now mostly covered with Tudor plaster, painted in imitation of mosaic. Where areas of plaster have fallen away, surviving impressions of tesserae indicate that Feckenham's restorations are probably a true reflection of the original designs and that all the panels were similar. In the case of spandrels 19 and 20 this cannot be verified, and they have therefore been left plain on the survey (Fig. 306). Spandrels 15 and 18 occupy the west side of bay 1 and the east side of bay

A

B

311 St Edward's shrine.
A. Detail of south elevation,
bay 2, spandrel 18, showing
Tudor *faux* mosaic with a
secondary graffito, 'E B 1779';
B. Reconstruction of the
Tudor painted spandrel.
Authors

2, respectively, and are sufficiently well preserved to determine their designs and colours, and hence to provide reliable evidence for the lost Cosmati decoration.

The design of spandrel 15 is based on a regular grid of tangent hexagons, set angle-to-angle (forming diagonal rows) and creating triangular interspaces. The hexagons are blue and the triangles white but they are both superimposed by other patterns. In the case of the triangles they all contain a further single red triangle. The patterns in the hexagons are of two types, gold six-lozenge stars with their tips meeting the angles of the hexagons, and large gold triangles with their angles tangent to alternate angles of the hexagons, thereby creating a series of large, shallow, blue triangles. The overall effect can be seen in a variety of ways, one of which is to imagine the six-lozenge stars as the centres of flowers with triangular petals.

Spandrel 18 is a little different in its pattern (Fig. 311). It too has a basic grid of tangent blue hexagons, superimposed with gold six-lozenge stars and gold triangles overlain with red triangles. However, either by design or accident, one row of blue hexagons is not staggered and tangent angle-to-angle, but placed directly beside the hexagons in the row below, making

it necessary to adapt the pattern, resulting in the creation of two pairs of gold triangles set point-to-point. Had the change of pattern not occurred, the upper part of this space would have been occupied by a six-lozenge star. The anomaly was probably a mistake but it demonstrates the ability of Feckenham's painter to make changes which would hardly have been noticed. The spandrel bears a prominent graffito, 'EB 1779'; another date scratched into a secondary patch of unpainted plaster in a loop on the adjacent pier to the east reads 'ES 1696'.

For descriptions of the niches in the south elevation, see pp. 356–62.

East elevation (Figs 312–314)

The decoration on the east side of the monument follows the architectural style of the south and north elevations. However, the piers flanking niche 4 have no colonnettes and small capitals). Instead, the sides of the niche have two parallel

bands of mosaic. The wider outer band is decorated with chequers, alternate squares divided into triangles, thereby forming short diagonal fillets. On the narrower, inner band alternate squares are quartered diagonally. The outer band extends around the soffit of the oversailing spandrels, whereas the inner band runs behind the spandrels to the apex of the vault.

Frieze

21 The decoration of the frieze is basically the same as that on the south elevation; five roundels (a–e) separate four rectangular compartments (f–i) with inconsistent lengths; (f) is 26cm long, (g) 37cm, (h) 23cm and (i) 25cm (Fig. 313). This is the result of

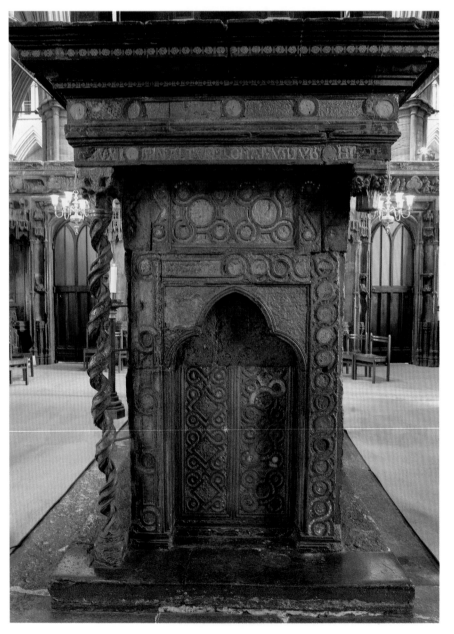

312 St Edward's shrine. East elevation, 2017. *Christopher Wilson*

incorrectly reassembling the components in 1557, and making the frieze longer, in order to bring it flush with the inscription course below. As with the corresponding course on the west side of the monument, originally there would only have been three rectangular panels of equal length, and four roundels. Indentations for tesserae survive in (f), the other panels being filled with painted plaster. Feckenham's rendering of (f) is a grid of tangent squares shaded diagonally, with rows alternating gold and red; intermediate rows have their squares divided diagonally into pairs of triangles, shaded black and white. Sufficient impressions, and a few tesserae, survive in (g) to determine that this panel also had a pattern of squares, possibly arranged in horizontal rows, with alternate rows subdivided into red and white triangles. The evidence for the decoration in panel (h) is slight, possibly a diagonal grid; panel (i) is totally lost. The five roundels originally contained thin discs, perhaps of blue glass, but only impressions remain in the bedding mortar. The fact that these were not filled and overpainted by Feckenham suggests that the original discs survived into the Tudor period.

Inscription course

22 Two roundels (a and b) that once contained thin discs – probably of glass – interrupt the course. As with the inscription on the south side, this was formerly covered with painted plaster, and three letters (**DIE**) still survive at the northern end (Figs 315 and 409), but the remainder of the plaster was picked off in 1741, to expose the underlying matrix of the 13th-century tessellated inscription. The original letters are larger than Feckenham's painted ones. As already noted, the Tudor letters were in gold, and the background blue. The primary and secondary texts read:

Primary
DVXIT : **IN** : **ACTVM** : **ROMANVS CIVIS** : HOMO

Secondary
CONFESSOR : REX VENERANDVS : QUINTO : **DIE**

Emboldened letters are preserved. This is the only area where access is obtainable to the primary matrices; no glass survives in the lettering, but there are two blue tesserae associated with the background. As elsewhere, beneath the inscription course is a band (22b) of guilloche developing nine roundels (cf. Fig. 309).

Upper panelled zone

23–25 These three panels occupy the slab directly beneath the inscription course (Fig. 314). The principal element, panel 24, measures 68cm by 39cm, and is centred directly above niche 4. It is decorated with a pair of tangent quincunxes, the large roundels developing four smaller ones. A concave hexagonal interspace is formed between the quincunxes and axe-shaped interspaces at the sides. Panels 23 and 25 also occur on

the same slab, at the south and north ends, respectively. Their basic schemes of decoration are large, vertical, lozenge-shaped panels, bordered with a single fillet looped at the mid-points to create roundels filling triangular interspaces (cf. south elevation, panels 3 and 9). However, both lozenges are divided vertically with one half of the decoration chased into the same stone as panel 24, and the designs of their other halves painted onto the previously plain ends of panels 9 and 33 of the south and north elevations of the monument (Fig. 316). The explanation for this is that when Feckenham restored the shrine the long slabs on both the north and south sides were positioned too far east (as evidenced by the lozenge decoration on these slabs no longer being set directly above the piers and niches), thereby eliminating a rebate (such as those on the south-east and north-east corners of the main piers) designed to contain a slender, roped colonnette. Originally these spaces would have been filled with small chased blocks, lost at the Dissolution.[15]

The decoration of panel 23 is therefore now both chased and painted. None of the original tesserae survive, but indentations in the lower loop indicate a fillet of tangent alternate gold and wine-red triangles with smaller white triangles in the interspaces. The loop had a fillet of poised squares. Apart from a few impressions of tesserae around the margin of the central lozenge, none of the original work survives, but the painted *faux* mosaic (Fig. 316) is likely to be an accurate representation: a chequered grid of squares shaded, predominantly, in gold to create a border of poised squares defining arrangements of squares divided into triangles, alternately gold and white, and red and white (Figure 317 is an attempt to show how the panel may have appeared). The upper fillet is painted in tangent gold squares with black interspaces, and the lower fillet in tangent triangles alternating black and gold, with red triangular interspaces superimposed with diminutive white triangles. A small roundel in red imitates either porphyry or glass.

24 Indentations of tesserae are present throughout the panel and, in the upper register, are a few surviving tesserae. The roundels of the two tangent quincunxes contain the same patterns. The large ones have designs based on six-lozenge stars, comprising a central star with further lozenges set between the tips of the stars, and divided longitudinally to create pairs of shallow triangles, the outer examples defining a hexagon. This effectively forms a corolla surrounded by further lozenge-shaped impressions with their outer tips tangent to the rim of the medallion.

Eight smaller roundels in the loops had six-lozenge stars with diminutive triangles in the interspaces. A restored example in the north corner, has alternating blue and gold lozenges with red interspaces super-imposed by white triangles (Fig. 317). As elsewhere on the monument, the schemes in the sinuous fillets

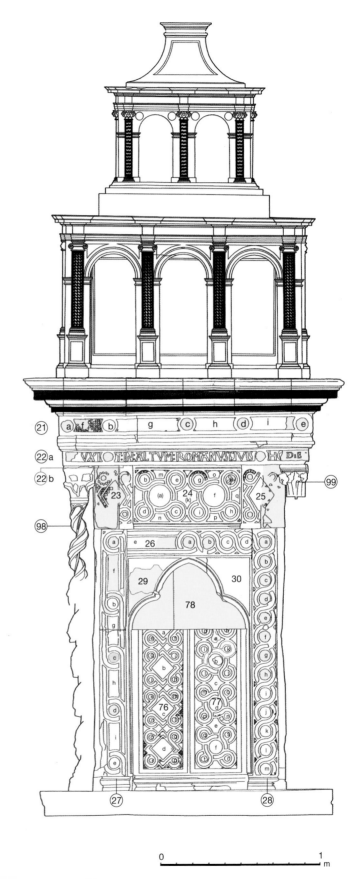

313 St Edward's shrine. East elevation with key to panel numbering. Shaded areas represent surviving painted plaster repairs of 1557. *Authors*

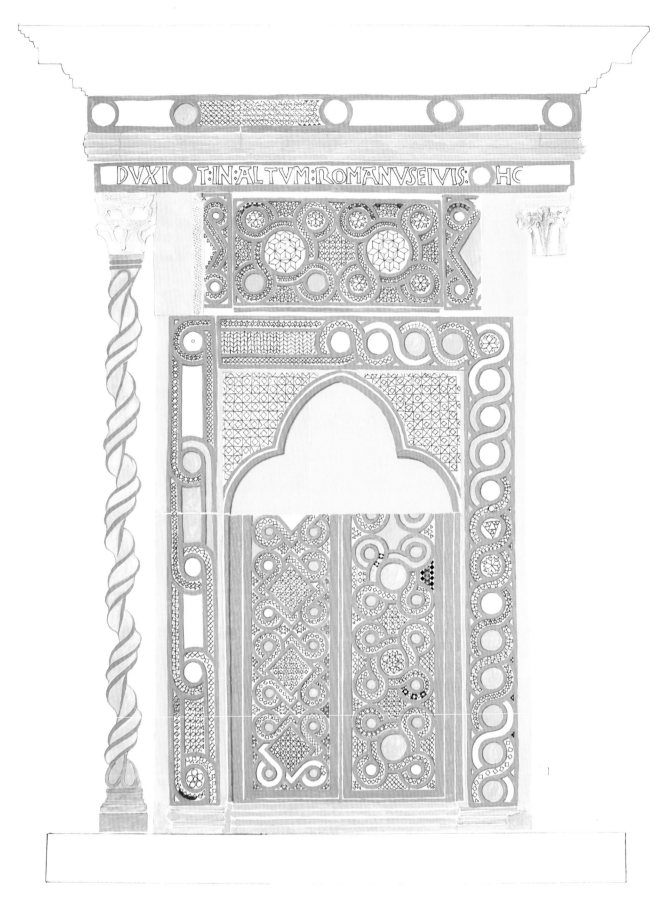

314 St Edward's shrine. East elevation, showing surviving mosaic and the impressions of lost tesserae. *Painting by David S Neal*

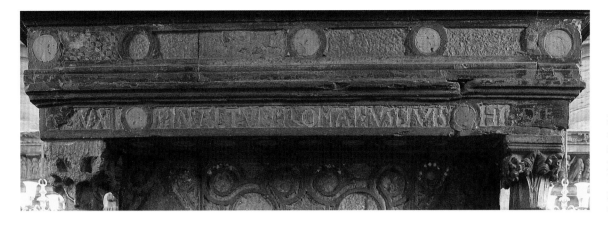

315 St Edward's shrine, east elevation. Detail of the marble matrix that held the primary glass inscription. Note traces of the secondary painted inscription survive at either end. *Christopher Wilson*

defining the quincunxes are paired diagonally; (b) and (c) have rows of alternating blue and gold triangles, alongside a very narrow row of alternating red and white triangles. The fillets around (d) and (e) have tangent squares; those around (d) also have their interspaces filled with tiny triangles. In the adjacent quincunx, the diagonally opposite fillets (g) and (h), and (i) and (j), are the same and match those already described. The remaining, intermediate, panels (k–q) all have various combinations of chequered patterns; at the centre of (k) the poised interspaces are divided vertically into pairs of triangles, thereby forming a series

of bands. In the other examples, the interspaces of a regular grid of squares are all divided diagonally into four triangles. In (o) a few blue and red tesserae survive.

25 The decoration in panel 25 is the same as 23, including the sinuous bands. All traces of mosaic impressions within the original lozenge are lost, but the painted restoration of the northern half of the panel, although faint, indicates a pattern based on triangles (Fig. 316). In the surviving medieval loop encircling the upper roundel on the south is a fillet of gold poised squares with blue triangular interspaces.

316 St Edward's shrine, east end. Tudor *faux* mosaic decoration painted directly on to Purbeck marble. A. Panel 23; B. Panel 25. *Authors*

A B

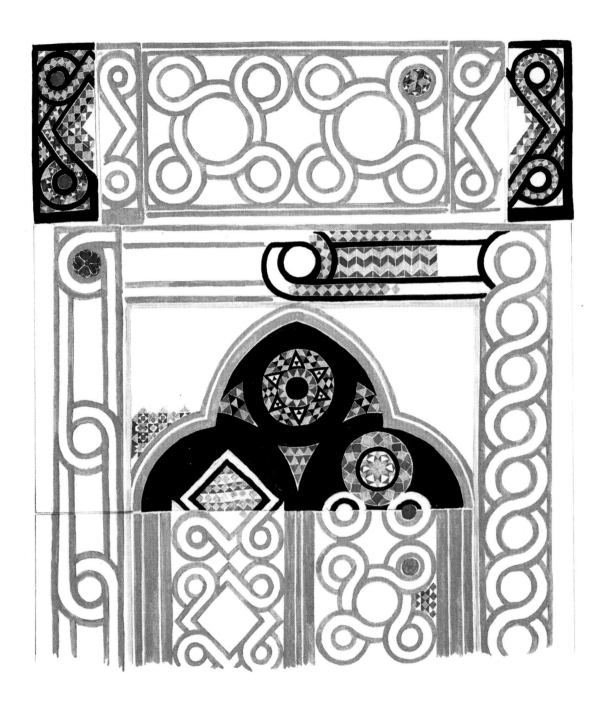

317 St Edward's shrine. Upper part of the east elevation, showing areas restored with *faux* mosaic in 1557. The painted chevrons are at a larger scale than the original mosaic (cf. Fig. 314). *Painting by David S Neal*

27 The decoration on the south-east pier is similar to panel 14 on the south elevation; it too has a scheme comprising four roundels (a–e), separated by rectangular strips created by four chain-links (f–i). As with the equivalent panels on the south, these also reduce in size from top to bottom. The pier is formed from two blocks, joined across (g); no similar division is apparent on pier 28 to the north, which is a single block. Only the lower rectangular compartment has indentations of tesserae surviving: three rows of poised squares. Probably the interspaces were divided vertically into pairs of triangles. Of the five roundels, decoration survives in only three. The uppermost roundel (a) and another, (d), have red four-petalled painted flowers, but in the bottom roundel are tessellated impressions of a flower comprising a cluster of six tangent hexagons, the central example being a corolla and the others, petals. Where tessera matrices survive on the south elevation, they are of this form, and hence it is suspected that Feckenham's restorations on panel 27 are not true to the originals.

Impressions of tesserae survive in most of the fillets forming the chain patterns; on either side of (f) is a single row of tangent poised squares in one fillet, and two rows in the other. On the south side of (g) is a row of spaced poised squares with diminutive triangles in the interspaces (the fillet opposite is lost). On one side of (h) is a double fillet of squares forming chequers, and on the other, tangent poised squares. The same patterns occupy the links around (i), but on the southern

example the squares have been divided vertically to create pairs of triangles which would originally have alternated in colour.

28 As with the northern half of the horizontal course (26), the north-east pier is decorated with a band of continuous loops of guilloche; the same ornament decorating the equivalent elements throughout the north side of the shrine. Apart from a few tesserae surviving in tiny triangles along both sides of the pier they are lost and impressions alone survive. There are 13 roundels (a-m) in the length of the pier but the decoration in only three is known. In (a) are the impressions of a six-lozenge star with small triangles in the interspaces, and the same decoration is indicated in (g). In (f) is a large triangle with its points tangent to the rim of the roundel and filled by a pattern of reducing triangles. On the north elevation of the shrine these two patterns alternate, and the same sequence is likely on panel 28. Whether the roundels on the south elevation also alternated is unknown.

Spandrels

29–30 Like the other examples, they have overall fields of decoration. However, the niche has no

appreciable depth and is therefore decorative rather than functional. The indentations of lost tesserae in both panels are the same and indicate a pattern forming an overall right-angled grid of squares, with a chequered composition of poised squares and squares divided diagonally into four small triangles. Despite no tesserae surviving, Feckenham's restoration of the south panel is accurate and shows a pattern forming a diagonal grid of squares (Fig. 318), alternate squares shaded gold, superimposed by reducing squares, red, white and black, and squares with red and white chequers superimposed with small black squares in the angles, and forming a quincunx. The decoration in the recess does not rise up to the height of the trefoil arch; here it is filled with two slabs of plain Purbeck marble with overpainting (Fig. 317). This anomaly will be described along with the decoration on the north and south niches (p. 363).

North elevation (Figs 319–321)

Frieze

31 Like the frieze course on the south elevation, the north side also has a series of eight roundels (a-h) separated by seven rectangular panels (i-o) with concave ends. Their relative proportions are also the same as on

318 St Edward's shrine, east end. Detail of Tudor *faux* mosaic in spandrel 29. *Painting by David S Neal*

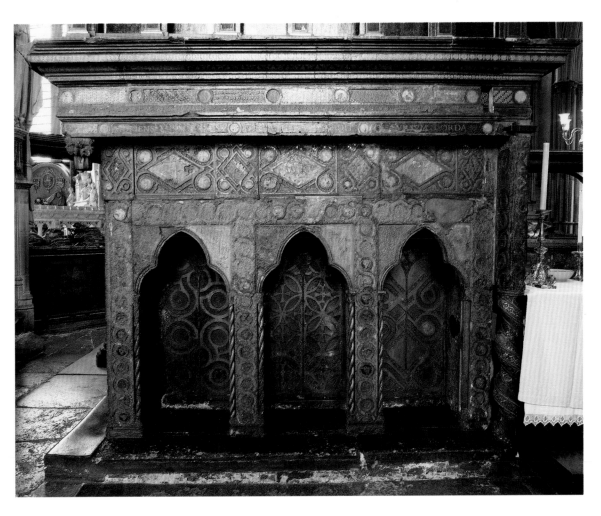

319 St Edward's shrine. North elevation, 2017. *Christopher Wilson*

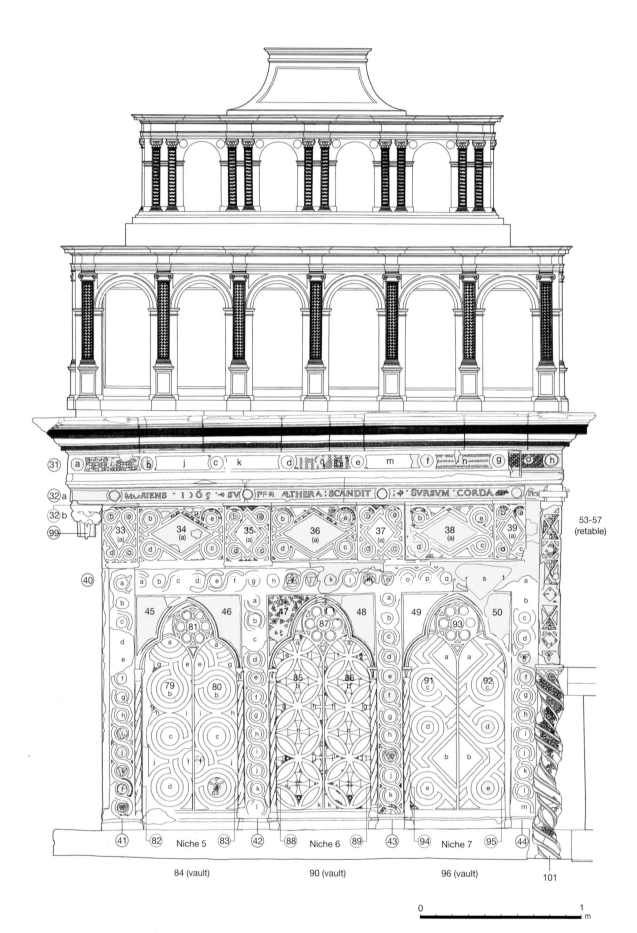

320 St Edward's shrine. North elevation with key to panel numbering. Shaded areas represent surviving painted plaster of 1557. *Authors*

344

the south, including the very short rectangle at the west end (o) (Fig. 320). The roundels are now either voids or filled with Tudor plaster. Again, they retain mortar impressions of thin discs of glass, or possibly metal. Panel (i) at the east end has been painted with a series of vertical alternating red and white bands, superimposed with tangent poised squares, gold on the red, and black (or blue) on the white. In places, the original underlying medieval tesserae are proud of the surface confirming the reliability of the pattern. Panel (j) has indentations of diagonal rows of tesserae almost certainly the same basic pattern as (i), and probably once having the same arrangement of colours. Panel (k) has the same basic pattern with the bands arranged vertically; most is Feckenham's work but a few original tesserae survive on the west side. Panel (l) also has vertically arranged patterns, but (m) is virtually empty, having only a few diagonally arranged impressions in the angles. Panel (n) has a horizontal arrangement of the same patterns; and (o) ornaments the Tudor Reigate-stone western extension to the course and has a right-angled arrangement of the same scheme and colours.

32(a) The inscription course has the same layout as that on the south; four roundels separated by three rectangular panels, 75cm long by 6cm wide (Fig. 409). Nothing of the primary inscription, or its background tessellation, is visible, but the matrices probably survive behind the Tudor plaster. Feckenham's painted replacement, which is gold on blue, reads:

: IANI : MORIENS : 1065 : ⋆ SVPER : AETHERA : SCANDIT : ⋆ ; SVRSVM : CORDA ⋆ IFA

As on the south side, the abbot's initials, *IFA*, are ligatured, but in a different format (Fig. 410, A and E). The inscription is divided by roundels and also by three foliated motifs (represented here by asterisks), one of which is a star-like flower lying between two pairs of stops (colon and semi-colon) separating SCANDIT and SVRSVM.

32(b) Like the south elevation, chased into the soffit of the oversailing inscription course is a band of guilloche with S-shaped loops creating twenty roundels 6.5cm in diameter, some filled with cream-coloured mortar retaining impressions of circular discs, presumably originally glass. Others are infilled with Feckenham's painted plaster, perhaps once blue. However, roundels that are now devoid of ornament might still have held their original fillings at the time of the Tudor reconstruction; otherwise they too would have been infilled with painted plaster.

Upper panelled zone

33–39 This has the same arrangement as on the south side: seven alternating vertical and recumbent panels with the vertical examples situated over the four piers and the recumbent ones above the arch-heads (Fig. 321). However, as on the south elevation, these too are not now correctly centred over the piers or the arch-heads, but are displaced eastwards. Each panel is chased with a large lozenge bordered with a single fillet, looped at the mid-point to create roundels occupying triangular interspaces. In all cases the large lozenges are filled with Tudor plaster and there is no evidence that they ever held mosaic; they were probably filled by discs of porphyry with tessellated borders. Notably, unlike the equivalent panel on the south elevation (6), the central lozenge (36) does not contain a deep, square matrix to hold a thick slab of marble.

The post-medieval plaster fillings here are neither painted nor flush with the borders of the panels, but recessed by *c.* 3mm. Neither is the plaster smooth; examination shows that a thin fillet had oozed out (and been smoothed off) around the edges of the panels, where thin sheets of unknown material had been applied with pressure. The plaster, therefore, served as an adhesive. In panels 34 and 36 the plaster also bears faint imprints of decoration, possibly imitating mosaic; this was on the reverse of the applied lozenges, suggesting that they may have been sheets of painted glass (Figs 322 and 323). The centre of panel 34 displays a striated surface; there is no evidence that similar plates occupied equivalent zones on the south side. Tesserae survive at the upper edges of all seven panels, and there are also mortar impressions of lost tesserae; together, these provide reliable evidence for the original decoration. As on the south and east elevations, the patterns are duplicated on diagonally opposed panels.

The impressions in the lozenge-shaped compartment, panel 33, indicate rows of diagonally arranged tangent poised squares with their interspaces divided into triangles (Fig. 321). The chased loops and fillet at the top left and bottom right have strings of tangent poised squares; the others, rows of triangles with diminutive triangles in the interspaces. The imprint of border decoration on the glass sheet in panel 34 has a row of poised squares tangent to another row of squares divided into triangles (Fig. 322C). Impressions of tesserae around the lozenge and loops include, on the top and bottom, tangent poised squares and, in the others, rows of triangles with diminutive triangles in the interspaces, the same decoration as panel 33. The roundels are filled with plaster but have lost their painted decoration. Triangular interspaces between the lozenge and the sides of the panel have horizontal tessellated rows of alternating red and white bands; tangent poised gold squares on the red, and black poised squares on the white. The decoration in the equivalent-shaped compartments of panel 35 is the same but with the impressions orientated in the opposite direction; the decoration in the surrounding fillets and loops is also the same. The roundels are filled with plain plaster.

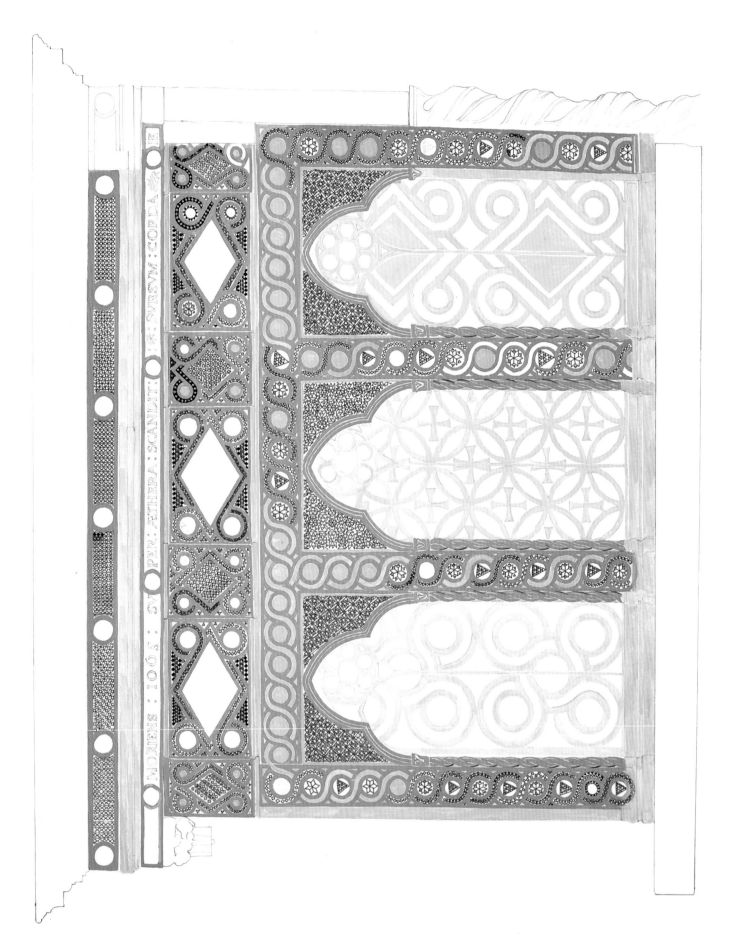

321 St Edward's shrine. North elevation, showing surviving mosaic and the impressions of lost tesserae. *Painting by David S Neal*

In panel 36 are faint impressions of a glass sheet superimposed on an underlying matrix of plaster (Fig. 322); the pattern is an all-over arrangement of squares set diagonally; they were probably once chequered, perhaps reflecting the lost medieval decoration. Tesserae surviving in the fillets and loops indicate the same designs as those in the other compartments; tesserae in the interspaces between the lozenge and the borders of the panel comprise alternate, horizontal red and white bands with tangent poised gold squares on the red examples, and poised black squares on the white. Recreated by Feckenham, the decoration within the roundels survives as six-lozenge stars, alternate lozenges of gold and an indeterminate colour.

The next panel westwards (37) has the same overall decoration as the other examples above the piers and has a lozenge-shaped compartment with impressions of a grid of tangent poised squares, with the interspaces divided across the angles to create four triangles. The surrounding fillet is the same as the other examples; the four roundels are filled with plain plaster. Panel 38, a recumbent lozenge, has the same decoration as (36), but the original contents of its main panel are lost and have been replaced by unpainted plaster. Applied crudely, the surface is flush with the Purbeck marble surround. As with some other panels on the shrine, and the tomb of Henry III, it post-dates Feckenham's restorations, and was never painted. It was probably applied with the intention of preventing further loss of tesserae. Roundels (c) and (e) at the west of panel 38 are different from the others on the upper side slabs in that they probably had small circles of marble surrounded by alternating blue and white tesserae, some of which survive. The circular voids were subsequently filled with plaster and painted with six-lozenge stars. Panel 39 has the same decoration as 37, but its west side has been cut back by *c.* 15mm and the space between it and the altar retable filled with cement and plastered over; a small area of this work survives.

Framing of niches 5–7

Lintel

40 As with the south face, the slab containing the trefoil arch-heads runs the full width of the north elevation and divides the upper panelled zone from niches 5–7 below. The lintel is decorated with a continuous strand of guilloche. It is heavily eroded but originally had 21 roundels with the strands running from top right to bottom left, the opposite direction to the guilloche on the east elevation. At the west end the guilloche is lost where a triangular slab of Purbeck marble has been inserted to effect a repair when the shrine was reassembled; it was once covered in plaster. Evidence for the designs in five roundels, all restored, survives above the central niche (6). There are two designs which alternate and comprise six-lozenge stars with their lozenges alternately gold and possibly blue,

and with red interspaces, imitating purple porphyry, containing diminutive white triangles. The other roundels (only one survives in its entirety) had large red triangles with their points tangent to the rim of the roundel creating three shallow, 'semicircular', black interspaces. Within the triangles are arrangements of reducing triangles, three gold with small white triangles in the red interspaces. There is no reason to assume that the decoration in the restoration is different from the original because the patterns match indentations on the piers elsewhere, including those on the northern part of the east elevation. The only decoration to survive in the S-shaped bands encircling the roundels is located above the central niche; they all have impressions and include, working from east to west; above (j), a fillet of tangent poised squares with the interspaces divided into two triangles; above (k), another fillet of poised

A

B

C

322 St Edward's shrine, north side. Panel 34. A. Matrix of the lozenge-shaped panel containing plaster and showing the impression of a glass sheet with a vertical fracture; B. Line drawing of the same; C. Detail of the left-hand point, showing traces of bands of chequerwork (poised squares and triangles) bordering the edges. Probably associated with the repairs of 1557. *Authors*

347

A

B

323 St Edward's shrine, north side. Panel 36.
A. Matrix of the lozenge-shaped panel containing plaster and showing the impression of a glass sheet; B. Line drawing of faint latticing preserved in the plaster. Probably associated with the repairs of 1557. *Authors*

side slabs. Most the patterns have been replicated in painted plaster but their condition is poor; tesserae *in situ* are rare, although examples survive at the lower levels in diminutive triangles between the guilloche and the edges of the piers. Curiously, many of the painted roundels have three irregular circular holes bored into them, and only rarely do the loops show evidence for overpainting. Exceptions are the loops on either side of 42(d), above 43(e) and below 44(d). Despite this, the writers are of the opinion that all the loops were restored by Feckenham, but cannot explain the absence of plaster.

41 Impressions of tesserae survive in the loops between (a) and (b) and comprise rows of tangent poised squares. However, they are lost further down as far as roundel (f); from thereon the sequence is: tangent poised squares, a row of squares set as chequers with the interspaces divided diagonally into triangles, tangent poised squares, a row of tangent poised squares alongside a fillet of tangent triangles, squares set as chequers, another row of tangent poised squares alongside a fillet of tangent triangles (alternate red and white tesserae survive), and a row of squares set as chequers with alternate squares divided diagonally into triangles.

42 Impressions of tesserae in the loops around the upper roundels are lost but survive from roundel (d) downwards. Their sequence is: a row of squares set as chequers with the interspaces divided diagonally into triangles, and a row of tangent poised squares with the triangular interspaces divided radially into two triangles. Evidence for decoration in the loop between roundels (f) and (g) is lost but the next loop down has tangent poised squares with diminutive triangles in the interspaces, followed by a row of chequers. Evidence for decoration in the next two loops is also lost; the last two loops include a row of tangent poised squares with the triangular interspaces divided radially into two triangles and a row of chequers.

43 The impressions of tesserae surviving in the guilloche loops include: a row of tangent poised squares, two interlocking fillets of tangent poised squares, a lost example, another row of tangent poised squares, chequers, a row of tangent poised squares, three examples which are lost, a row of chequers, another lost row but possibly once with poised squares, a row of tangent poised squares with the triangular interspaces divided radially into two triangles and, finally, a small segment of a loop with chequers with alternate squares divided diagonally, creating pairs of triangles (some tesserae in the last two loops survive).

44 The loops of guilloche encircling roundels (a)-(m) include; two rows of interlocking fillets of tangent poised squares with the squares in one row divided radially into pairs of triangles, traces of a chequered

squares; above (l), a pattern of squares divided diagonally into triangles; above (m), a double fillet of tangent poised squares and triangles; and, above (n), a row of tangent poised squares with the triangular interspaces containing diminutive triangles. The decoration of the remaining bands is lost except for the final example which is described together with those ornamenting the westernmost pier (44).

Piers 41–44
All four piers have a continuous band of guilloche developing large roundels. They are not level with one another; on piers 43 and 44, for example, the pattern is 'stretched' and the bottom roundels truncated. Despite the upper roundels being eroded (evidently because they were unprotected from weather, following their dismantling at the Dissolution), sufficient impressions of tesserae survive in the bedding mortar to establish their original patterns: six-lozenge stars with their lozenges shaded gold, and possibly red with small triangles in the interspaces, alternating with roundels containing large triangles occupied by patterns of reducing triangles (Fig. 348C). However, (l) on pier 41 is an exception in having evidence for a disc of marble surrounded by alternating black and white tesserae; it duplicates a roundel on panel 38 (c), one of the upper

composition, two loops with lost decoration, another of tangent poised squares with triangular interspaces divided radially into pairs of triangles, a row of chequers, a row of tangent poised squares, another row of chequers, and a row of tangent poised squares. The impressions of tesserae in the remaining four loops are lost.

Spandrels

45–50 The arch-heads have the same form as those on the south side of the shrine, and some are infilled with painted plaster imitating mosaic. In panel 45 virtually the entire area has painted decoration and no indentations of tesserae are visible (Fig. 324). The decoration is probably to the original design and is matched by a pattern surviving on the spiral column at the north-west corner of the shrine (101). Panel 46 is covered by plain plaster with numerous graffiti; it post-dates Feckenham's work and is associated with repairs to other structures in the chapel. Assuming pairing, any indentations of tesserae masked by the plaster are likely to be similar to those in panel 45. The decoration on the eastern spandrel (47), over niche 6, includes glass tesserae flush with the surface of the plaster, indicating Tudor overpainting of surviving mosaic (Fig. 325). Although the opposite zone (48) is lost, and has been filled with plain plaster, now covered with graffiti, it is likely to have had the same decoration; a fragment of painted mosaic survives at the top of the panel but it is too small to confirm the design. In panel 49 all indentations of tesserae are lost, but in panel 50 the original decoration can be seen through a break in the later plaster, indicating that the indentations form the same pattern as that on panels 45 and 46 (on this evidence, therefore, the decoration on the arch-head slab on either side of niches 5 and 7 is shown the same on Figure 321). The scheme is based on a diagonal grid of narrow blue fillets forming square compartments, all with identical patterns: an arrangement of nine squares with gold examples in each corner and a blue square in the centre. The interspaces are divided diagonally into four triangles, opposing examples being shaded red and white. Where the blue fillets intersect, small squares of gold are introduced.

Feckenham's decoration of spandrel 47, and probably 48, (Fig. 325) is complex geometrically and can be visualized in various ways, but is perhaps simplest described as having a grid of tangent blue hexagons set angle-to-angle, forming white triangular interspaces superimposed with red triangles. The blue hexagons are arranged in clusters of seven, the central example having a six-lozenge star, a corolla and, in the six hexagons around it, large gold triangles superimposed with red triangles.

324 St Edward's shrine, north side, bay 5. Tudor painted *faux* mosaic in the eastern spandrel (panel 45). The poor condition of the adjacent guilloche framing is due to frost damage that occurred when the dismantled panels were stored in a stone yard, *c.* 1540–56. *Authors*

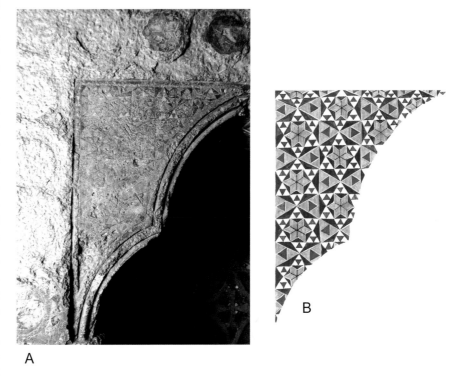

325 St Edward's shrine, north side, bay 6. Tudor painted *faux* mosaic in the eastern spandrel (panel 47). Frost damage is again apparent on the adjacent Purbeck marble frame. *Authors*

West elevation (incorporating the altar retable) (Figs 326 and 327)

As seen today, the west end of the shrine comprises work of three periods: 1269, 1557 and 1868. All that survives from the original shrine are the two piers forming the north-west and south-west corners; all the infilling between them dates from the 16th century, although little of it is readily visible. The lower half is largely obscured by the stone altar erected on columnar legs in 1902, but access underneath is possible. The upper half of the pedestal – rough rubble masonry of brick and stone – is totally hidden by the repositioned Cosmati retable, but its east face is exposed inside the tomb-chamber where the Confessor's coffin now lies (p. 412; Figs 401 and 404).

Feckenham reconfigured the west end of the monument, and physically integrated the retable

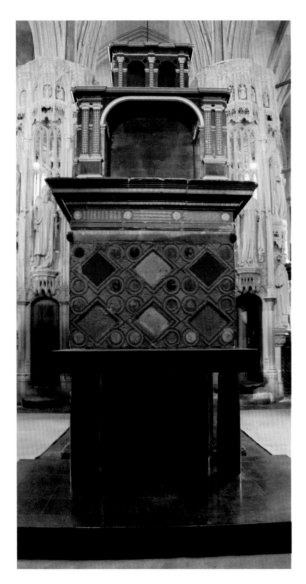

326 St Edward's shrine. West elevation, 2018. The Irish black marble altar and dais were added in 1902. © *Dean and Chapter of Westminster*

panel from the cosmatesque shrine altar and, as already noted, the frieze course, originally set back from the façades, was extended in both directions and relocated flush with the inscription course below (p. 332). This resulted in an irregular distribution of the roundels along the east side of the shrine and the need to extend the frieze westwards, thereby obscuring the original roundels on that face, and creating a completely new section on a block of Reigate stone. This additional masonry also accounts for the irregular distribution of roundels on the north and south sides of the pedestal, close to the corners, the result of two small blocks being added to the frieze, to extend it westwards. These blocks are loosely fitted and can be extracted to reveal the now-hidden primary roundels on the west returns of the frieze (Figs 307 and 329, E).

In the 13th century the mosaic inscription course extended across the west face of the monument and continued around the sides of a pair of small wings that projected 21cm to the north and south of the corners, thereby creating a T-shaped plan to the top of the shrine (Figs 371 and 378); the projecting wings were supported by spirally-fluted colonnettes, similar to those at the eastern corners. In the Tudor reconstruction all of this was dispensed with, and the level of the retable was raised to conceal the missing inscription band.

The next course down – the upper panelled zone – may have been occupied by a mosaic-decorated slab similar to that on the east elevation (panel 24), or there could have been a special feature here, above the retable; O'Neilly posited an arrangement of three small niches for statuettes.[16] Whatever occupied this course, it too was omitted from the Tudor reconstruction, and the retable was raised by 50cm from its presumed original location, so that its top was directly below the frieze course, as confirmed by Talman (Fig. 302).

It has been presumed that a pair of plain Purbeck marble pilasters, integral with the piers forming the western corners of the shrine, originally provided support for the retable (Fig. 327). They are rectangular in cross-section, have a small moulding at the base and currently stand to a height of 60cm above the level of the plinth slab, but they were originally taller. The scars resulting from chiselling the upper parts of the pilasters off the faces of the corner piers are plainly visible, but the present position of the retable prevents us from seeing how high the pilasters reached originally

(Figs 367 and 368). Moreover, their primary function (if any) is uncertain, especially since they may once have extended to the full height of the lower register of the pedestal. They could never have been intended as supports for the retable because they do not project sufficiently far to carry the load: two-thirds of the slab's thickness would overhang, causing it to topple westwards.[17] Nevertheless, the tops of the truncated pilasters are at the correct level for seating the retable, on the assumption that its upper edge aligned with the interface between the lower and upper stages of the shrine pedestal. Such an arrangement would only be stable if the back edge of the *mensa* was inserted under the retable, thereby providing two-thirds of the support necessary to prevent it from toppling forwards. If this arrangement did exist, then it would imply that the pilasters were truncated to their present level in the 1260s, but no certainty can obtain.

When the shrine was reconstructed and the retable placed 50cm above its original level, the pilasters served no purpose.[18] We know that the slab was then supported by the two salvaged Cosmati columns (101, 102), with plastered brickwork between them (Figs 28 and 29). Scott later lowered the retable, sunk the columns deeper into the floor of the chapel, and replaced the Tudor brickwork with a pair of pilasters of his own, leaving the medieval ones untouched (Figs 297 and 329, A–B). Finally, when the present altar was erected in 1902, the retable was supported by both it and the Cosmati columns, and Scott's pilasters were demolished.

51 The frieze has four roundels (a–d) separated by three rectangular panels (e–g), 37cm long and cut from three blocks of Reigate stone. This section dates entirely from 1557 and is decorated in the same style as the 13th-century frieze on the other elevations, but with imitation mosaic painted on plaster. The north end of the northern block, incorporating roundel (a) and rectangle (e), and the south end of the southern block, incorporating roundel (d) and panel (g), can be seen on the south and north elevations where they are numbered 1 and 31, respectively. The roundels are devoid of ornament but the painted decoration in the rectangular panels includes: in (e), vertical rows of tangent poised squares, alternating with rows of squares divided vertically by pairs of triangles; in (f), a similar pattern, but with the rows of poised squares and squares divided into pairs of triangles arranged horizontally; and (g) has the same scheme, but with the rows arranged diagonally (Fig. 330).

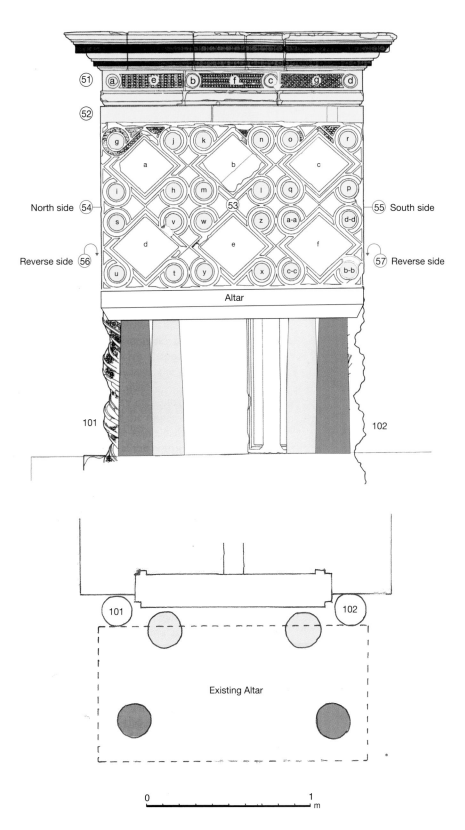

327 St Edward's shrine. West elevation and plan, as existing, with key to panel numbering. The Cosmati retable and marble altar of 1902 are also shown. The latter is supported on four heavy columnar legs (shaded). *Authors*

328 (*Right*) St Edward's shrine. Retable panel. © *Dean and Chapter of Westminster*

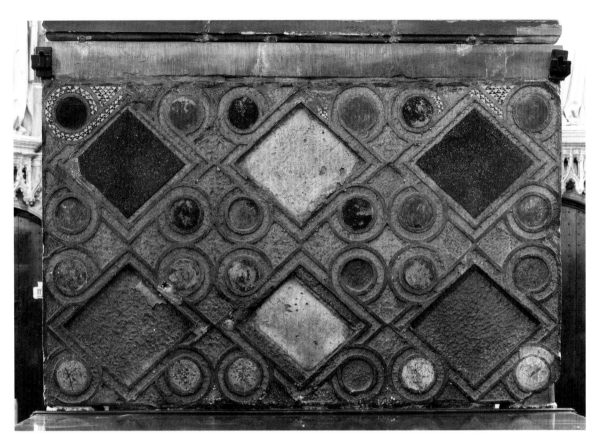

329 (*Below*) St Edward's shrine. View from the south-west before 1902, showing the works carried out by Scott in 1868. *Key*: A, B, Pilasters erected to support the repositioned retable; C. Course of Reigate stone inserted to fill the space where the inscription band would have been; D. Eared block (reinstated) forming the south-east corner of the inscription band; E. Pocket in the frieze with a small block of painted stone removed, to reveal what had been the original west end of the course; F. Spirally-fluted colonnette at the south-east corner, reconstructed from fragments. © *Dean and Chapter of Westminster*

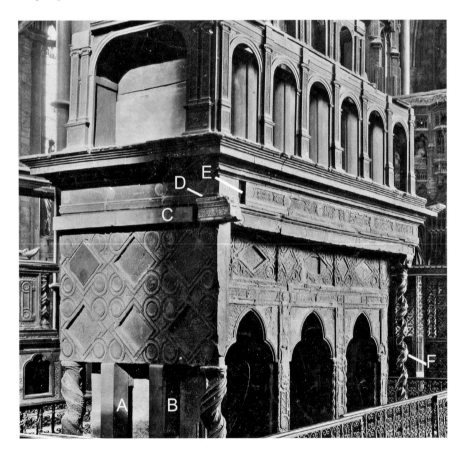

52 Nothing remains of the primary inscription course on the west side of the shrine, its components having been omitted from the Tudor reconstruction. Today, the site of the inscription is occupied by three plain blocks of grey Reigate stone with rough, vertically-tooled surfaces; these were only inserted in 1868, when Scott lowered the retable to what he believed was its original level.[19] He did this in order to re-incorporate the moulded fragment of inscription course that was fortuitously discovered at Westminster School in 1868 (p. 381); this eared block (14.5cm deep) originally projected from the south-west corner of the pedestal and carried parts of the primary mosaic inscription, set into matrices on three faces (Figs 329 and 371). For the missing inscription, see p. 385.

Shrine altar retable

53 This comprises a single block of Purbeck marble, 1.63m wide by 1.01m high by 13.5cm thick (Figs 326, 327 and 331). It now occupies the space between the lost inscription course and the top of the present altar, and rests on a pair of tessellated columns (101, 102) at the corners of the tomb. It has long been recognized that these columns did not belong to the 13th-century shrine (p. 371), only becoming part of it in the mid-16th century. Each vertical edge of the retable projects beyond the face of the shrine, 15cm on the north and

21cm on the south, indicating, perhaps, that an error occurred in resetting the over-sailing elements of the architecture.

The decoration is closely related to that of the upper-zone panels (Figs 306 and 321), the arrangement consisting of six poised squares of equal size, set in two rows of three (a-c and d-f). The squares are, however, slightly distorted (forming lozenges) so that their outer angles meet the margins of the block, and they are surrounded by tessellated bands looped midway along their sides to create roundels. In the central area of the slab the design generated two clusters of four roundels. In triangular interspaces at the sides of the panel the roundels are arranged as tangent pairs, and in the corner compartments are single roundels.

All the poised squares once contained sheets of marble but only two survive, both purple porphyry (Fig. 327a, c). Talman shows the upper central square (b) with a panel of green porphyry in 1713 (Fig. 302), which has since been lost leaving the plaster bed to which it was adhered.[20] The square beneath (e) is chased to receive a block of marble, but along two opposing sides the rebate is shallower and, on one, indentations of tesserae survive indicating that a pair of tessellated strips flanked the rectangular slab (Fig. 331).[21] Talman records that the panel contained purple porphyry, and the two remaining lozenges (d and f) held slabs of green porphyry, all since lost. Thus, the original complement of slabs comprised three purple and three green lozenges, arranged as diagonal opposites (reconstructed on Fig. 335).

None of the contents of the original roundels survives, but they too once held 4mm-thick discs that were presumably of glass, replaced by Feckenham in

painted plaster (Figs 332 and 333): diagonally opposite roundels are coloured red and black (but originally the latter were probably dark blue).[22] The crisply preserved outlines of the bedding mortar for the original discs are consistent with their having held glass, but not stone (Fig. 334). There are interesting differences in the Tudor fillings of the roundels: the row along the base of the slab contains cream plaster that has never been painted, indicating that a low timber *predella* stood on the *mensa* and covered these six roundels. Presumably the altar was installed before the painting of the shrine was finished. The filling of the roundels in the next row above is also inconsistent: two are void and others are painted red and black.

330 St Edward's shrine, west end. Detail of the painted Tudor frieze and cornice, with the undecorated course of Reigate stone below (1868), substituting for the original inscription band. The matrices for the roundels in the frieze retain the impressions left by thin discs of glass. *Authors*

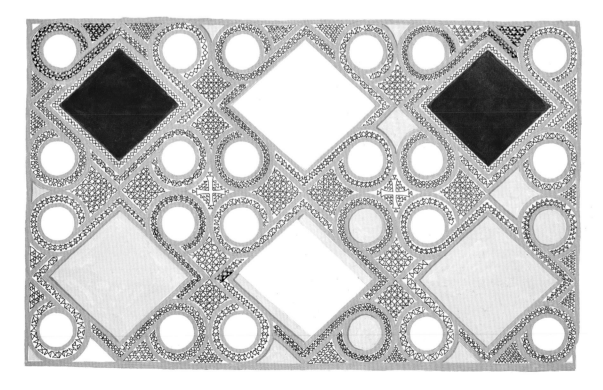

331 St Edward's shrine. Retable panel, showing surviving sheets of purple porphyry, medieval mosaic and impressions of lost tesserae. *Painting by David S Neal*

353

332 St Edward's shrine, retable. A. Surviving mosaic inlay and a purple porphyry panel (a) at the upper left-hand corner; also painted *faux* mosaic on the right; B. Impressions of lost tesserae, ghosting the outline of a *cross pattée* in glass, set in a concave-sided square at the intersection of four roundels (right of centre of the panel; cf. Fig. 331). *Authors*

A

B

Only in the top corners are tesserae preserved (and two small areas elsewhere). However, mortar indentations survive and it is possible to establish the basic designs with confidence. The tesserae in the top corners (Fig. 332A) had arrangements of gold and black chequered triangles, the black examples superimposed by diminutive white triangles; the design originally filled every interspace. One of them has been restored by Feckenham. With two exceptions, all of the interspaces had the same patterns: vertical and horizontal rows of tangent poised squares with the square interspaces divided diagonally into four triangles. Their colours are not known. The exceptions are located in concave-sided square interspaces at the centres of the clusters of four roundels: each contained a *cross pattée*, almost certainly once composed of gold-foiled tesserae,

and with the interspaces filled with arrangements of reducing triangles (Figs 331 and 332B).

The patterns in the bands are more random, and the convention whereby the patterns on one side of a panel were usually matched on the diagonally opposite side does not apply. There are twenty-four looped bands divided into five designs (Fig. 331) which include:

(a) Chequered triangles with smaller triangles in the interspaces (six examples).
(b) A row of tangent poised squares, divided across the angles to form four triangles, and with triangular interspaces (one example).
(c) A row of tangent poised squares with small triangles in the triangular interspaces (seven examples).
(d) Chequered squares with poised squares in the interspaces (five examples).
(e) A row of tangent poised squares, divided vertically into pairs of triangles and developing triangular interspaces (five examples).

Tessellated examples of only (a) and (c) survive, and demonstrate how the patterns become yet more complex when four colours are introduced (Fig. 331). Unfortunately, this complexity can rarely be established from surviving impressions alone.

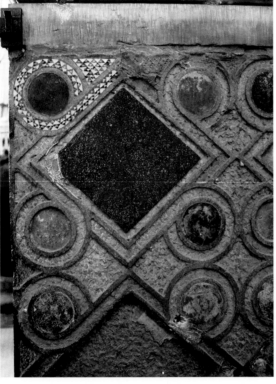

333 (*Left*) St Edward's shrine, retable. Detail of the left-hand end, showing the variety of fillings remaining in the Purbeck marble matrix. © *Dean and Chapter of Westminster*

334 (*Right*) St Edward's shrine, altar retable. Detail of one of the roundels, showing the thin ring of mortar into which an original glass disc was embedded. After its removal, the matrix was infilled with Tudor plaster and painted red. The roundel was later inscribed with the graffito, *B. Clifton 1790.* © *Dean and Chapter of Westminster*

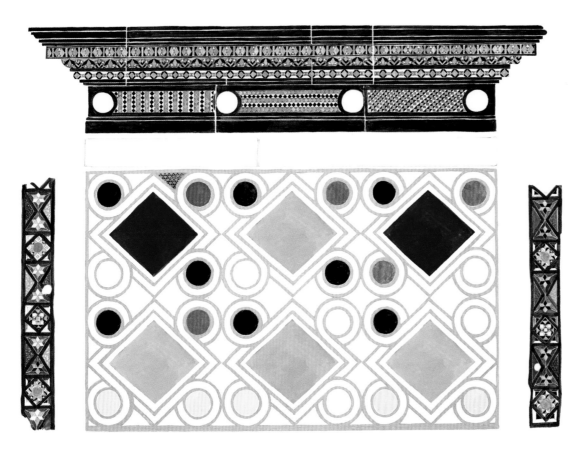

335 (*Left*) St Edward's shrine. West elevation of the upper part, showing Tudor work: viz. cornice and frieze, the painted plaster roundels in the medieval retable, and the bands of painted decoration on the north and south edges of the retable. *Painting by David S Neal*

336 (*Below*) St Edward's shrine, retable. Strips of primary guilloche decoration chased into the reverse (east) face of the retable, where the slab projects beyond the south-west and north-west corners of the pedestal. Most of the original mosaic infill has been lost, and was replaced by painted plaster decoration in 1557. A. South side (panel 57), chain guilloche of the same design as that framing niches 1 to 3; B. North side (panel 56), guilloche of the same design as that framing niches 5 to 7. *Paintings by David S Neal*

A B

54–55 The north and south edges of the retable were originally plain polished marble, and we initially assumed that was because they were largely obscured from view by the north-west and south-west colonnettes (101, 102) being set close to them. However, that is not the case since the colonnettes stood at a slight remove, allowing the plain edges of the retable to be fully visible. Nowhere else on the shrine pedestal are plain strips of marble of this extent exposed to view: every surface that could be inlaid with mosaic was so treated, which raises the possibility that something was originally attached to the north and south edges of the slab. The point is underscored by the fact that it was felt necessary to paint *faux* mosaic on these edges when the Tudor reconstruction took place.

Feckenham's painted decoration is virtually the same on both edges and comprises rows of alternating rectangles and squares (Fig. 335). The rectangles are divided by inward-pointing triangles creating x-shapes; shallow triangles at the margins are filled with imitation marble, presumably purple porphyry. The other triangles are red and contain six-lozenge stars, alternately shaded gold and black. The square examples have poised squares with two types of pattern; two have central blue circles superimposed on eight-lozenge stars, developing small squares in the corners divided diagonally black and white and superimposed by a small gold square. The others have a quincunx with the interspaces divided diagonally to create red and gold triangles set point-to-point. The triangular interspaces between the

quincunx and the corners of the square are black, superimposed by gold triangles.

56–57 On the east side of the retable, where the edges of the stone project beyond the face of the shrine, are vertical bands of guilloche with loops and roundels in the same style and proportions as those decorating the framing of the niches (40) and on the undersides of the inscription course (58 and 59) (Fig. 336). This demonstrates conclusively that the retable was always positioned against the west end of the pedestal. The surface of the band on the north side is better preserved (56): Feckenham's restored roundels alternate, as on the north elevation, with eight-lozenge stars with blue and gold lozenges, and large white triangles containing red hexagons superimposed with gold six-lozenge stars. Shallow interspaces between the triangle and edges of the roundel are black. An exception is a roundel filled with a six-lozenge star on a circular field of white, surrounded by alternating red and blue triangles. Working downwards, the loops comprise: fillets of tangent poised squares, alternately blue and gold, with red interspaces containing tiny white triangles; a row of tangent poised gold squares on blue and, along one side, a row of alternating white and red triangles; and two rows of blue and gold squares with interspaces divided diagonally, half red and half white. An adjacent row is similar, but shunted to create diagonal bands. Feckenham's decoration in panel 57 on the south includes a rectangular compartment with diagonally arranged rows of tangent

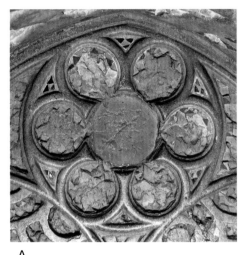

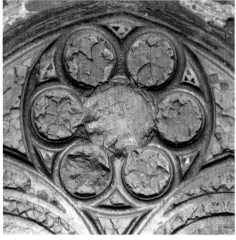

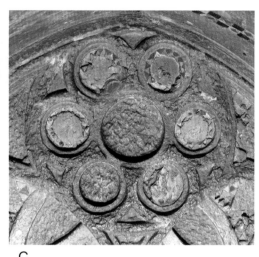

A B C

337 St Edward's shrine. Sexfoils in the tracery on the backs of the niches. A. Niche 1; B. Niche 2; C. Niche 6. *Authors*

poised squares, alternating white and gold, and with the square interspaces divided diagonally into red and black triangles. Two roundels have red and blue flower-forms with gold corollae. The chain links are the same as those on the south side of the tomb.

Although the north and south edges of the retable slab were never inlaid with mosaic, they appear to have had several circular pockets (*c.* 18mm diam.) drilled or chiselled into them. One pocket remains open, at mid-height, on each edge of the slab. The southern is void, but the northern retains part of a lead plug and the stump of an iron fitting. These could be the fixing-points for a pair of brackets to carry lights or statuettes flanking the retable. Alternatively, the pockets could have had a more mundane purpose of holding iron stays to steady the tall, slender shafts of the colonnettes at the western corners of the shrine pedestal. That is not, however, a convincing explanation since the stays would have been too close to the tops of the shafts: they should be nearer the mid-point. Moreover, there is an additional complication: traces of further pockets that have been infilled – seemingly two per edge – are detectable, although largely obscured by Tudor painted decoration. If there were three fittings on each side, a matching pair of moveable attachments, flanking the retable, is implied. One possibility would be pintles for hinged timber panels. If that were so, the marble retable would have been the central component of a triptych.

Niches

The numbering of the decorative schemes within the trefoil-headed niches follows on from that in the façades. The schemes are described first, then the patterns employed. Few tesserae survive, but most of the decoration can be established from the impressions and Feckenham's painted restorations. The basic outline is repeated in each niche and comprises a blind 'window' of two pointed uncusped lights, with a sexfoil above. On the south, the sexfoils are cusped and all received the same decorative treatment: six-lozenge stars with triangles in the interspaces. In niche 1 the lozenges themselves are divided into triangles, the outer example red (Figs 337A and 340). No corollae (centres) survive, but the remaining impressions confirm that all three contained discs, probably of marble, and in the case of niche 3, at least, an encompassing ring of triangles. The mortar beds seem not to be primary and the discs, although roughly circular, were facetted and irregular in outline.[23] The date of this work is uncertain, but potentially Tudor.

On the north face of the shrine, the sexfoils are slightly different in form. Although they have cusps (mostly now lost through decay of the Purbeck marble), the matrices containing the mosaic appear more like a cluster of separate circles. Here, the corolla was filled with a ring of six hexagons, set point-to-point, with a six-lozenge star at the centre and lozenges in the outer interspaces. Each of the outer circles once contained a small roundel of marble, ringed by triangles of mosaic (Fig. 337C).

Niche 4, on the east end of the shrine, although similar in outward appearance to the others, is very shallow and is no more than a blind arch. It has lost both its original trefoil head and the traceried sexfoil. With the exception of no. 4, the

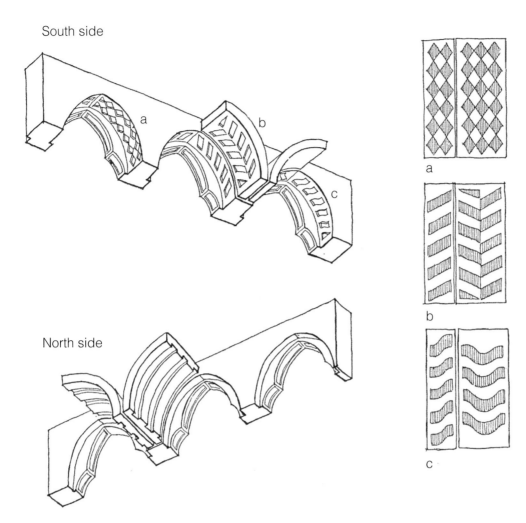

South side

North side

338 St Edward's shrine. Back views of the long head-slabs to the niches on the north and south sides of the pedestal, with three trefoil-headed arches cut into each. Pairs of curved slabs form the vaulted heads to the niches. *After O'Neilly and Tanner 1966, fig. 3*

niches all have soffits in the form of pointed barrel vaults, each being constructed from a pair of curved blocks (Fig. 338).[24] The designs are different in every niche, and the chasing of the matrices for mosaic work in the vaults was crudely executed, compared to that elsewhere. All the niches display evidence for plaster patching during the Tudor reconstruction of the shrine, especially along the joins and in the recreation of lost mosaic bands.

Niche 1 (south) (Figs 339 and 340)

58–63 Both lights are filled with a vertical arrangement of three tangent quincunxes, each with four loops of guilloche springing from a large central roundel, 11cm across. Interspaces between them are concave-sided hexagons and those at the sides, axe-and thorn-shaped. Many had their tessellation covered with plaster and were overpainted in imitation mosaic, but since lost. The quincunxes in the west light are slightly taller than those in the east light, resulting in

their misalignment. The central roundels are lost except for the impressions of a pattern best described as comprising a ring of six small hexagons, with the central interspace filled with a six-lozenge star. The hexagons are overlain with triangles with their tips tangent to alternate angles of the hexagons, thereby creating a complex flower. Smaller roundels in the loops of guilloche were once set with circles of blue glass, a fragment of which survives; they were surrounded by alternating triangles.

There are thirty loops (some truncated by the scheme) with six pattern types which do not repeat on diagonally opposite sides. The two most common (eight examples) are: (a) a row of tangent poised squares with small triangles in all interspaces; and (b) a row of smaller poised squares set along one side of the loop with a single row of small triangles alongside. There are seven examples of a chequered composition (c) arranged diagonally, and another chequered composition (d) with alternate squares divided diagonally (five examples). A single example with a similar pattern (e) has its square interspaces divided diagonally into four triangles. Another single example (f) has a row of regular alternating squares and poised squares alongside a row

357

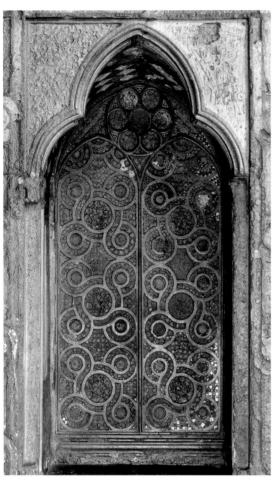

339 (*Left*) St Edward's shrine, south elevation, bay 1. View into the niche. © *Dean and Chapter of Westminster*

340 (*Below*) St Edward's shrine, south elevation, bay 1. Surviving mosaic and impressions of tesserae in the back, sides and vault of the niche. *Paintings by David S Neal*

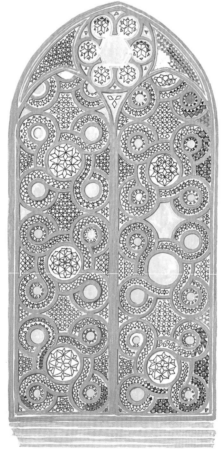

of inward-pointing triangles tangent to the regular squares. The concave-sided hexagons and truncated elements (axe-shapes) of the same panels formed between the quincunxes, and at the margins of the lights, have rows of tangent poised squares with the square interspaces divided into pairs of triangles, creating banded patterns; the same decoration fills the spandrels on either side of the sexfoil. The thorn-shapes at the margins are filled with gold and blue chequered triangles. Original tesserae survive at the eastern edge of the panel.

61–62 The rectangular side panels in niche 1, flanked by piers 11 and 12, retain impressions of the original mosaic; both had chequers with the interspaces divided diagonally into four triangles. However, the main panel of the west flank is not original work; it was rebuilt by Feckenham with a block of Reigate stone that had no previous connection with the shrine. The slab, which is pecked on its east face (to adhere plaster) and retains moulded detail on the west, is rectangular, with a recessed and moulded panel divided longitudinally by the nib for an abutting pilaster (Fig. 368). The block is in clean, crisp condition, and its features were doubtless concealed by plaster, until they were exposed by Scott; it is visible beneath the present altar. The stone probably derives from the dado section of a panelled and pilastered screen.

Within the niche, the west face was once plastered, overpainted black or dark grey to simulate Purbeck marble, and bordered with a band of ornament, now too decayed to distinguish but possibly reflecting the pattern on the adjacent pier. The east flank is largely original work and is divided into two rectangles delineated by narrow bands in which the indentations of lost tesserae have been plastered over and painted with *faux* mosaic. However, at the bottom of the panel a small area of tesserae survives, with a diagonal arrangement of chequers, one row black, the other white, and with a central row of poised squares divided horizontally into triangles, shaded black and gold. The interspaces at the margins of the band have red and gold triangles.

63 The two zones of decoration on the west side of the vault include, at the front, a band of S-motifs, alternately chased and solid, and, at the back, a pattern of bold lozenges, also alternately chased and solid. On the east side, the front too has S-shapes but at the back, on a separate block, is a pattern of staggered chevrons (not lozenges). This inconsistency indicates that the blocks were incorrectly reassembled in 1557, and that the block with the chevrons was originally located in niche 3; here both blocks at the rear of the soffit have been replaced with Reigate stone overpainted with S-motifs. The impressions of tesserae are coarser than elsewhere and all have a chequered arrangement of squares with the interspaces divided diagonally to create

banding; this is demonstrated by tesserae surviving in the north-east corner.

Niche 2 (south) (Figs 341 and 342)

64–69 Both lights have large roundels at the top and the bottom, connected with links creating large rectangular interspaces; these carry rectangular rebates into which marble slabs were once set. Oddly, the western matrix (31cm by 15cm) is markedly smaller than the eastern (35cm by 21cm), implying that they were cut to receive designated slabs that were already to hand. Tesserae survive in the east spandrel and at the bottom of the niche. There is no evidence for decoration in the roundels at the top right and bottom left of the panel, and the bedding mortar is lost. The other two roundels retain impressions of tesserae, indicating a pattern of hexagons with their angles tangent to one another, creating small triangular interspaces. Within the hexagons are six-lozenge stars. No tesserae or overpainting survive, and it must be assumed that the elements of the pattern were complex. The bands bordering the roundels and rectangular panels retain impressions (and a few tesserae). The band around the top left roundel has a row of tangent poised squares with another row of squares alongside and developing small triangles at the outer margins. The same pattern encircles the adjacent roundel to the east where surviving tesserae indicate that one row of poised squares is blue, the other row gold, and the small triangles, red and white. Around the lower left roundel is a band of blue tangent poised squares with red interspaces, superimposed with gold triangles and, encircling the adjacent roundel on the right, a band based on chequers shaded diagonally blue and gold with alternate squares divided red and white. A larger area of this pattern survives in the upper right spandrel and it is likely that the other interspaces on the rear wall of this niche were similarly decorated. The mosaic is lost from the sexfoil and corolla (66), leaving only impressions (Fig. 337B).

67–68 The decoration on the side walls of niche 2 is the same as on the east side of niche 1, including that flanking the dividing piers (12 and 13). The west panel, a solid slab of Purbeck marble, is divided into two rectangles surrounded and separated by a band mostly overpainted with *faux* mosaic. Some plaster has fallen off, exposing the impressions of tesserae, confirming that Feckenham's restoration is an accurate reflection of the original work. The decoration in the bands comprises two rows of tangent poised squares, one black and the other gold with the square interspaces divided into red and white triangles. The east side of the niche is very badly damaged. About 15cm of its northern edge has been filled in with cement and overpainted. The top of the stone has also been replaced with a rectangular slab of Reigate stone, overpainted.

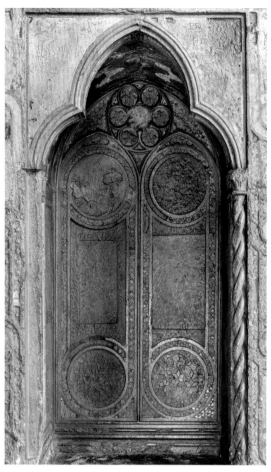

341 (*Left*) St Edward's shrine, south elevation, bay 2. View into the niche. © *Dean and Chapter of Westminster*

342 (*Below*) St Edward's shrine, south elevation, bay 2. Surviving mosaic and impressions of tesserae in the back, sides and vault of the niche. *Paintings by David S Neal*

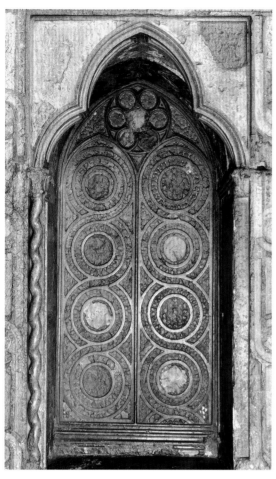

343 (*Left*) St Edward's shrine, south elevation, bay 3. View into the niche. © *Dean and Chapter of Westminster*

344 (*Below*) St Edward's shrine, south elevation, bay 3. Surviving mosaic and impressions of tesserae in the back, sides and vault of the niche. *Paintings by David S Neal*

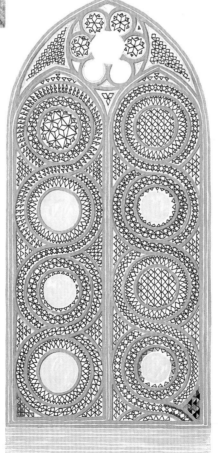

361

Here none of the decoration in the bands can be identified, except in the rectangular panel ornamenting pier (13) which is different from that opposite; it has an arrangement of three rows of tangent poised squares with the square interspaces divided into four triangles.

69 The vault has two zones of decoration. The front comprises a band of diagonal rectangles, alternately chased and solid, which change orientation on either side of the apex. At the rear is a coarse arrangement of alternating chased and solid S-shapes. Their tessellated patterns are the same as those in the soffit of niche 1.

Niche 3 (south) (Figs 343 and 344)

70–75 Both lights have four loops of guilloche arranged vertically and encircling prominent roundels that were once either tessellated or filled with marble; on all sides are triangular interspaces. The sexfoil (72) is the same as the previous examples. There are errors in setting out the design: the upper pair of circles is level, but those at the bottom of the lights are not and, consequently, part of another loop of guilloche has been inserted to fill the void. Tesserae survive only at the bottom of the eastern light.

Working downwards from the west side, the top roundel survives as impressions of tesserae, patterned as examples in niche 1: a ring of six small hexagons with the central interspace filled with a six-lozenge star. The hexagons are overlain with triangles with their tips tangent to alternate angles of the hexagons, thereby creating a complex flower; it is the only example, but in niche 1 all of the large roundels were similarly filled. The next three roundels are lost although the third one down has an outer ring of triangles, indicating that

it potentially encircled a disc of marble. The roundel was later infilled with plaster. All four roundels in the east light retain evidence for decoration; in the uppermost is a diagonal grid of tangent poised squares forming vertical rows, and with alternate rows divided vertically into triangles. The second and fourth roundels also have an outer ring of triangular tesserae (some surviving), similar to the example on the western light just described. These too may have contained discs of marble. The third roundel was probably the same as the first.

Although the decoration within both sets of roundels is inconsistent, the patterns that surround them are matched alternately, both vertically and diagonally. There are two types: (a), a pattern based on chequered squares, with the square interspaces divided diagonally into triangles; and (b), a row of tangent lozenges with diminutive triangles in the outer interspaces. The decoration in the strands forming the outer loops of the guilloche can be divided into four types: (a) top left, are two fillets of triangles, tangent; it is the only example identified on the shrine. The example below, (b), has a row of poised squares with triangles in the outer interspaces and the next, (c), a pattern of alternating squares with the square interspaces divided diagonally. The same patterns are repeated in the strands of guilloche on the eastern light; an example, bottom right, not appearing on the west light, is an arrangement of tangent poised squares with a row of triangles along one side only, but set so that the corners of the adjoining squares are tangent to the triangles at their mid-points. In the triangular interspaces between the guilloche and the sides of the panels are chequered black and gold triangular tesserae, some of which survive at the bottom of the panel.

73–75 The flanks in niche 3 are differently decorated. The west side (73) is divided into two panels, both 28cm wide by 40cm high, delineated by a band *c.* 5cm wide. However, the top of the slab has been restored in Reigate stone, which can also be seen in the east face of niche 2. Nowhere in the matrices can indentations be found of the original mosaic to substantiate Feckenham's painted plaster restoration, which comprises alternating, tangent, poised red squares and lozenges superimposed by gold squares and pairs of black squares, respectively. It is similar to decoration in band 36 on the east elevation of Henry III's tomb (Fig. 454). The upper panel carries a distinct group of graffiti (p. 417; Fig. 408). On the east wall (74), the panel is divided by bands into four framed rectangles of polished Purbeck marble, each 36cm by 15cm. Tesserae in the bands form a grid of squares; alternate squares at the margins are blue, and alternate squares in a central row, gold. The interspaces are divided diagonally into red and white triangles. On this side the reveal has no nib with its own recessed narrow panel, and the same applies to panel 5 (cf. plan, Fig. 299).

345 St Edward's shrine, south elevation, bay 3. A. Painted *faux* mosaic chevrons on the vault; B. Strip of Tudor painted mosaic on the east reveal. *Authors*

As elsewhere, the vault (75) is divided into two zones. The forward section, forming part of the same block as the arched-head slab, has a scheme of lozenges, chased and solid; the former retain impressions of tesserae with a grid-like pattern, but probably once had alternate squares divided into triangles similar to the patterns on the vault of niche 2. However, the pair of stones once roofing the rear of the vault has been replaced by blocks of Reigate stone overpainted with S-shapes in imitation of the chased pattern in niche 1, and 'infilled' with bands of black and gold poised squares with the interspaces painted with red and white triangles (Fig. 345).

Niche 4 (east) (Figs 312–314)

76–78 Unlike the other niches, this is very shallow and is recessed by only 15cm. Incongruously, the decoration does not entirely fill the back of the niche, but stops at springing level of the arch. Here, two plain slabs of polished Purbeck marble have superseded the original mosaic-decorated ones, presumably because they were lost or broken when the shrine was reconstructed. The junction between the two stones is not axial to the shrine, but offset towards the south. The slabs were overpainted to complete the 'window' design, substituting a simple circle for a sexfoil in the tracery, as described below (Fig. 317). The interface between the primary and the Tudor work is at the same level as the joint noted between two blocks of the south pier (p. 342). Unlike the other six niche backs, the two lights here are different from one another. Panel 76 comprises a vertical arrangement of three tangent quincunxes with poised square centres and circular loops of guilloche springing from midway along their sides. Pairs of 'lozenge-shaped' interspaces develop between them, and triangular interspaces along the edges. Above the upper quincunx is half of another unit.

Panel 77 is similar in also having three quincunxes, but each has a central circle developing four loops with small circles at their centres. The interspaces between the quincunxes are concave-sided squares and, at the margins, there are axe-shapes and triangles. Part of a fourth quincunx appears at the top of the panel. The unit size here is larger than that found in the adjacent light, resulting in the quincunxes being out of register.

All three poised squares in panel 76 have impressions of rows of tangent poised squares with the intermediate squares divided horizontally into four triangles. The smaller panels between the quincunxes and the margins of the panel contain patterns of reducing triangles. In panel 77 two of the roundels are lost, but a surviving example has evidence for a six-lozenge star. Indentations of tesserae in the concave-sided squares comprise rows of poised and tangent squares with the intermediate tesserae divided into pairs of triangles; the other equivalent compartments are similarly filled. At the top

right of the panel, surviving tesserae demonstrate that the rows of poised squares alternate black and gold, with the square interspaces divided into red and white triangles.

In the two panels are twenty-eight loops, all surrounding small roundels. Of these only a single example on the left side of panel 77 retains impressions of tesserae, possibly indicating that they had clusters of six small hexagons. The other loops are either void or filled with plaster and painted in imitation of marble. Impressions of tesserae survive in twenty-four loops and demonstrate two patterns matching each another in the loops diagonally opposite. These are: (a), a single fillet of tangent poised squares developing triangular interspaces; and (b), a fillet of regularly spaced squares tangent to smaller poised squares with sets of four small triangles in the interspaces. An exception is a fillet similar to (a), but with tiny triangles in the triangular interspaces.

As indicated above, the tops of both panels have been lost, and it must be assumed that the two-light 'window' design was originally complete. When the monument was restored the lost decorative scheme was replaced in paint (Fig. 317). The head of the left-hand light is very faint, but shows a poised square containing a pattern replicating mosaic; and the right-hand light carries a medallion of the same size as the surviving roundels below, but without interconnecting loops. It has a complex gold, six-lozenge flower copying the medieval roundel further down. Around it is a band of alternating poised gold and red squares with blue triangular interspaces; its width is almost double that of the original work. The tops of the painted lights appear not to have been pointed but were rounded, and no attempt was made to replicate a sexfoil. Instead, a flower was created: working outwards, it has a central black corolla surrounded by a band of twelve red and gold triangles, followed by a ring of six triangles, outlined black and infilled white, containing a black triangle. Between each triangle is a small black rectangle superimposed with gold lozenges and, in the red interspaces in between, more gold lozenges. The roundel is set within a large circle of black paint, and where it meets the arched heads of the lights below are three concave triangles (simulating tracery lights) containing patterns of red, black and gold triangles. This area of Feckenham's restoration owes its survival to the fact that it is painted directly on Purbeck marble, and not on plaster over the mortar bedding for tesserae, which is prone to lamination.

78 Around the inside rim of the niche. Carved into the sides of colonnettes 27 and 28 are two parallel bands of ornament. The outer (a) rises to follow the curvature of spandrels 29 and 30, meeting at the soffit. The inner band (b) is, however, set behind (a) and decorates the sides of the niche and follows the profile of the vault, so that from the point of view where the spandrels spring, (b) diverges from (a) and runs behind the façade.

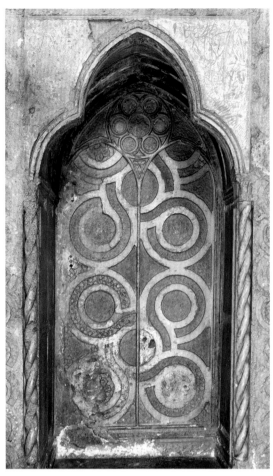

346 (*Left*) St Edward's shrine, north elevation, bay 5. View into the niche. © *Dean and Chapter of Westminster*

347 (*Below*) St Edward's shrine, north elevation, bay 5. Surviving mosaic and impressions of tesserae in the back, sides and vault of the niche. *Paintings by David S Neal*

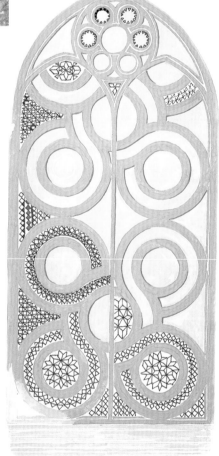

Band (a) is devoid of tesserae, but their impressions indicate a chequered composition (four tesserae wide) with alternating squares divided diagonally to form diagonal strips. Band (b) is narrower (three tesserae wide) and also has chequers, but with alternating squares divided diagonally into four triangles, shaded to form hourglass patterns. Here a few tesserae survive, sufficient to suggest that the squares were red and the hourglass patterns black and white.

Niche 5 (north) (Figs 346 and 347)

79–84 This has an all-over scheme with two large tangent quincunxes, one above the other. It occupies the full width of the niche with the central vertical fillet between the lights dividing the pattern into two parts (79–80). The quincunxes have a central roundel surrounded by four loops of guilloche; the roundels and the loops of guilloche are the same size. The upper quincunx has been awkwardly truncated by the pointed heads of the lights and the sexfoil (81). A concave-sided square interspace (also divided by the central fillet) develops between the quincunxes, and at the edges of the pattern are concave-sided triangles.

Few impressions of tesserae survive except at the top, where a truncated roundel has a six-lozenge star within an interspace between a ring of six tangent hexagons. Despite other roundels being lost, one at the lower right-hand corner, infilled with plaster and painted, displays the same pattern (Fig. 348A). Here the central six-lozenge star is black and the surrounding hexagons gold, superimposed with red triangles with small white triangles at their centres. Interspaces around them have black lozenges and white interstices. Part of another roundel survives diagonally opposite. The pattern within the concave square interspace between the quincunxes is lost, but truncated elements of similar shape along the east margin of the panel have three pattern types; hence the lost panel was probably the same as one of them. An upper example has a grid of tangent poised squares with their interspaces containing smaller squares and red triangles. The next one down has vertical rows of poised and tangent tesserae, alternating black, and possibly gold, with the interspaces divided vertically into red and white triangles. Only the impressions of the third example survive; it has a chequered pattern of squares with the interspaces divided diagonally into four triangles.

Most of the patterns within the loops of guilloche are also lost but three examples survive either as impressions or, in the case of one at bottom left, as painted plaster. This has two fillets with a row of black tangent poised squares on gold. Along one side is a row of red and white triangles. This same pattern survives as impressions at bottom right, although another strand on the left is more complex; it has the same pattern but all its triangular interspaces are further subdivided.

The side panels of the niche differ from one another.

On the east (82) the stone has been divided into four rectangular compartments, 35cm high by 15cm wide, with tessellated bands. As with panel 3, there is no nib on this side. On the west (83), however, are two panels, an arrangement mirroring that on the reveals of niche 3, and indicating that the slabs were incorrectly positioned during reconstruction. Here, tesserae in the bottom right corner are arranged with alternating blue and gold chequers, with the white interspaces divided diagonally into four triangles, alternately white and red (Fig. 348B). Impressions of tesserae with the same pattern survive in all the bands on this side. At the bottom of the west reveal are impressions of tangent poised squares alongside a fillet of triangles. Interspaces between them are divided horizontally into pairs of triangles. Elsewhere on the panel the impressions of tessellation have been plastered and painted over with chequers, with alternate squares divided diagonally into four triangles creating a pattern of poised squares.

Decorating the vault (84) are three parallel, chased bands separated by 8cm-wide intervals of plain Purbeck marble. Impressions of tesserae survive with two rows of tangent triangles, infilled with plaster and shaded blue, gold and white.

D

A

B

C

348 St Edward's shrine, north elevation, bay 5. A–C. Tudor painted roundels in the back of the niche; D. Band of mosaic bordering the panel in the east reveal. *Authors*

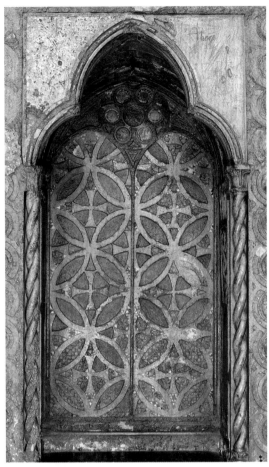

349 (*Left*) St Edward's shrine, north elevation, bay 6. View into the niche. © *Dean and Chapter of Westminster*

350 (*Below*) St Edward's shrine, north elevation, bay 6. Surviving mosaic and impressions of tesserae in the back, sides and vault of the niche. *Paintings by David S Neal*

Niche 6 *(north)* (Figs 349 and 350)

85–90 Intersecting circles constitute the overall design on the back of this niche, divided vertically by the thin line that separates the two lights. The circles are 31cm in diameter and where they intersect, elliptical compartments are formed; many of these are void, but sufficient indentations and tesserae survive to establish most of the patterns. In concave-sided squares between the circles are *crosses pattées*, in relief in the Purbeck marble, with mosaic in the interspaces. In the lower examples, the patterns between the arms of the crosses are six-lozenge stars and, at the ends of the crosses, reducing triangles. At the edges of the panels the crosses are truncated, their interspaces having the same tessellated decoration as the others.

Where the central mullion divides the pattern, the circles are separated slightly and the vertical arms of the crosses made thicker than the horizontal arms. In the ellipses created by the interlaced circles are impressions of chequers with alternate squares divided into pairs of triangles, creating banded patterns. The four small spandrels at the bottom are different from one another; in the western light (89) both spandrels contain a hexagon with a six-lozenge star, whereas in the eastern one (88) the pattern comprises rows of tangent poised squares, alternate squares being divided into triangles creating banding.

Both rectangular panels on the sides of the niche (94–95) are bordered with tessellated bands and were originally divided equally into two parts. However, on the west side the upper section of the panel has been repaired with three blocks of Reigate stone, painted grey, and the joint between them overpainted with a brown band.[25] The original chased decoration survives in part at the bottom and has a row of red tangent poised squares, tangent to a row of red triangles. Square interspaces are divided horizontally into pairs of triangles. Elsewhere, these bands have been restored in plaster; for example, on the north flank the decoration was replaced by a pattern of alternating squares and lozenges, the latter superimposed with two poised squares. It is similar to repairs on the west side of niche 3 (Fig. 344).

The vault (90) has three parallel tessellated bands, the same as in niches 5 and 6, but the patterns are different on either side of the apex, probably indicating that the stones were incorrectly paired in the restoration. On the east side, the design comprises a row of tangent poised squares (lost), with a row of red and white triangles alongside. On the west, there are black chequers with alternating gold and white interspaces, each containing a small red poised square. The fillet closest to the arch-head, and chased into the same block of stone, has alternate chequers divided diagonally into triangles.

Niche 7 *(north)* (Figs 351 and 352)

91–96 This is decorated with two large quincunxes, formed from poised squares with loops of guilloche springing from their sides. The central squares are areas of polished Purbeck marble, in relief, surrounded by tessellated fillets. Interspaces between the quincunxes are thorn-shaped. As elsewhere on the north elevation, the slender mullion between the lights divides the quincunxes into two parts and directs the eye upwards to the sexfoil (Fig. 337C). Only a few tesserae survive, except in a spandrel at the bottom left corner. The impressions of tesserae in the fillets surrounding the two central squares comprise a row of tangent poised squares with triangular interspaces containing tiny triangles; a single preserved example indicates these were white on red. The bands forming the quincunx are about twice as wide and have two types of patterns appearing on diagonally opposite sides. One has a chequered arrangement with the interspaces divided diagonally into four triangles; the other is a double row of tangent poised squares, with the central poised square interspaces divided horizontally into pairs of triangles. The triangular and thorn-shaped interspaces around the sides of the panels have the same patterns as the spandrels flanking the sexfoil.

The east flank of the niche (94) originally had two rectangular panels, but the upper one was rebuilt with three blocks of Reigate stone, painted grey to simulate Purbeck marble. Only at the bottom do tesserae survive: a pattern of chequers with two staggered fillets with every fourth tessera divided diagonally into red and white triangles. The intermediate tesserae are white, gold and black. Elsewhere, original work is lost and the chased bands infilled with painted plaster to the same pattern, some of which can be seen at the top of the panel. The west wall has suffered similar indignities and was rebuilt with different materials and rendered in plaster to simulate Purbeck marble (Fig. 352). It has *faux* mosaic along its outer edge, reproducing the style of decoration in the other niches. At the centre of the panel a circular hollow shows as a surface feature in the rendering.

The decoration in the vault (96) is better preserved and, as with the other examples on the north side, has three chased parallel bands separated by wider strips of plain Purbeck marble. The decoration in the bands differs on the two sides, again suggesting that the vault blocks vaults have been incorrectly paired. On the east side, the original decoration alongside the arch-head, and forming part of the same block, is chequered with alternate squares divided diagonally. On the other examples, however, the bands are narrower and with alternate squares in the chequers set with small poised red tesserae. The decoration on the west vault is consistent and comprises red bands superimposed with a row of tangent poised gold squares and, alongside, a fillet of red and white triangles.

351 (*Left*) St Edward's shrine, north elevation, bay 7. View into the niche.
© *Dean and Chapter of Westminster*

352 (*Below*) St Edward's shrine, north elevation, bay 7. Surviving mosaic and impressions of tesserae in the back, sides and vault of the niche.
Paintings by David S Neal

Columns and colonnettes

The shrine pedestal originally had four detached, spirally-fluted and moulded colonnettes at its corners, all carved in Purbeck marble and inlaid with glass mosaic. These shafts stood well clear of the corners, so that their decoration was fully visible 'in the round'.

Two spiral Cosmati colonnettes at the east end of the pedestal

Only two of the shafts were reinstated in the 1557 reconstruction, at the eastern corners, and the capitals used were extraneous (98 and 99). Both colonnettes were subsequently broken and dispersed, one in the 18th century and the other in the early 19th; this was a period when the chapel and its furnishings were suffering much abuse from tourists. The south-east shaft was subsequently reconstructed (Figs 304 and 312). It has four flutes.

The colonnette (98) was shown by Talman in 1713 (Fig. 301A), and other antiquarian views confirm that it was still in place in 1816 (Fig. 27), but must have collapsed by 1819, when Brayley wrote that there had been spiral columns at the east end, 'only the capital of one of which now remains'.[26] A carefully detailed engraving of 1845 confirms that there was then no colonnette or capital at the south-east corner (Fig. 29). The colonnette consists of a heavily battered, roll-moulded base with a profile that matches the bases on Henry III's tomb: it is Roman, not Gothic, and is therefore part of the cosmatesque assemblage. The base was illustrated and erroneously

described by Talman as being of 'Sussex marble'. Since it has two flat faces at right-angles, and is clearly from a nook-shaft, it does not belong at the east end of the shrine (Fig. 353). It could have been one of the western bases, if it rested in a right-angled junction between the steps of the shrine and altar podium; alternatively, it may derive from another, lost cosmatesque monument. The thick lead flange between the shaft and base appears to be medieval, suggesting that the two elements have remained connected since the 13th century.[27]

The Purbeck marble capital is out of context, being early 14th century and decorated with naturalistic foliage retaining its original gilding (Fig. 354A, B).[28] Again, Talman illustrated it. Shaft, base and capital were all reinstalled by Scott in 1856, having been re-discovered amongst stone fragments in the triforium (p. 315). At its upper end the shaft has a ring moulding with a rectangular profile, which is incorrect; this is actually the lower end of a shaft, the upper moulding of which should have a rounded profile. The lower end of the reconstructed shaft has the correct rectangular-section ring. No mosaic inlay survives. A fragment of the true upper end of a colonnette shaft is in the Abbey Collection (p. 382; Figs 355 and 356), but was not available to Scott when he ordered the reconstruction.[29] Thus, three of the eight shaft-ends for the shrine's colonnettes have been recovered, two lower and one upper end.

The north-east colonnette (99) was depicted by Sandford in 1677 and Crull in 1711, but had gone by 1778, when Carter's drawing showed only the unsupported capital hanging from the underside

A

B

353 St Edward's shrine, south-east corner. A. Lower end of the spiral colonnette (98) and its damaged base; B. Detail of the flat north face of the base, showing the lead joint (arrowed) with the shaft. Also visible is a shallow sinking in the top step, in which the base now rests awkwardly. *Authors*

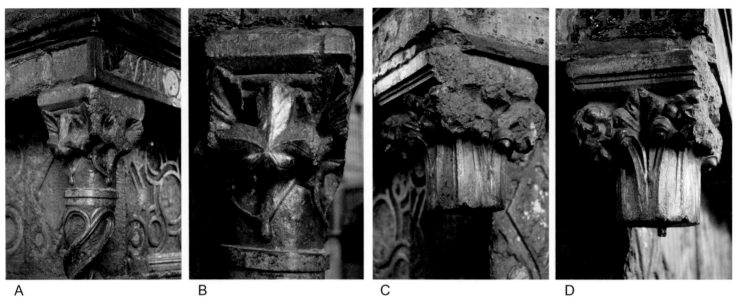

A B C D

354 St Edward's shrine, corner colonnettes. A, B. Capital with naturalistic foliage at the south-east corner (98), and beneath it a reconstructed shaft (using a lower-end moulding, inverted); C, D. Stiff-leaf capital at the north-east corner (99). © *Dean and Chapter of Westminster*

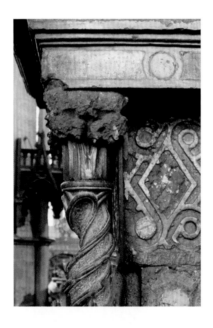

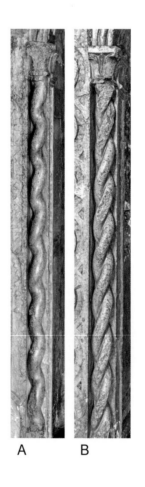

A B

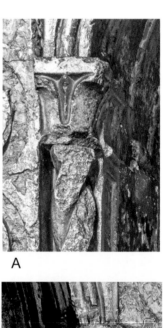

A

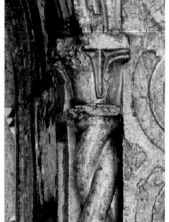

B

Left to right:

355 St Edward's shrine. Fragment of the upper end of a spirally-fluted colonnette from one of the corners of the shrine pedestal. Found near the south gate of the Abbey precinct in 1904. © *Dean and Chapter of Westminster*

356 St Edward's shrine. Fragment of the spirally fluted colonnette (shown in Fig. 355), seen here being temporarily positioned under the capital at the north-east corner. This fragment had been lost and was not incorporated in the 1557 reconstruction. © *Dean and Chapter of Westminster*

357 St Edward's shrine. Examples of rope-moulded nook-shafts flanking the niches. A. Bay 3; B. Bay 7. © *Dean and Chapter of Westminster*

358 St Edward's shrine. Examples of capitals to the nook-shafts flanking the niches. A. Bay 7; B. Bay 6. © *Dean and Chapter of Westminster*

of the inscription course, to which it is pinned (Figs 11B, 11C, 12 and 387); it is still the same today (Figs 354C, D and 356). Once a fine example of a 13th-century, gilded stiff-leaf capital, dating from the period of Henry III, it has been seriously mutilated and does not belong to the shrine.[30] Like its 14th-century companion to the south, the capital was introduced in 1557 as a substitute for a lost original. An oak dowel projecting from the base of the capital presumably engaged with the shaft installed in the Tudor period.

In addition to the mosaic-inlaid *en délit* colonnettes just described, there was a series of slender, rope-moulded, Purbeck marble nook-shafts set into rebates on the flanks of the six lateral niches, and another two nook-shafts placed at the eastern angles of the pedestal (Fig. 357). Including their capitals and bases, the niche-shafts are 90cm high, and those at the salient angles 1.55m. They were undecorated, except for thin gold lines in the creases (cf. Fig. 513). Although the shafts were separate and individually fashioned, their diminutive capitals with spatulate leaves and roll-moulded bases were integrally carved with the masonry of the pedestal (Fig. 358).[31] Several of the shafts associated with the niches survive, but not those at the salient angles of the pedestal, where there are now only empty rebates.[32]

Two spiral Cosmati column-shafts at the west end of the pedestal

Feckenham's reconstruction of the west end of the shrine did not include reinstatement of the eared architrave and slender shafts corresponding to those at the eastern angles; instead, he used a pair of stouter Cosmati columns as supports for the retable (Figs 297 and 298). Although there has never been any doubt that they did not belong to the shrine pedestal, their origin has not hitherto been established. However, it can now be demonstrated that they almost certainly belonged to the quartet of columns supporting the canopy over Henry III's tomb (Fig. 437). Nevertheless, the columns have been part of the shrine-altar confection since 1557, and it is therefore appropriate to describe them here (for discussion of their relationship to Henry III's tomb, see chapter 12).

For 150 years, the two spirally-fluted column-shafts supporting the retable of St Edward's altar have been the subject of archaeological investiga-

tion, discussion and speculation, the consensus of opinion being that they were not originally part of the shrine, and only structurally associated with it since the mid-16th century. They are of larger diameter than the colonnettes supporting the entablature at the east end of the shrine, and could never have served a similar function at the west end.[33] The shafts are not a precisely matched pair, even though they are both spirally fluted and ribbed, and have similar diameters (17cm). Their design follows the usual pattern for cosmatesque shafts: at the upper and lower ends each moulded rib loops across the adjacent flute, to connect with the next rib, as seen also in the shafts of the surviving colonnettes on Henry III's tomb and at the south-east corner of the shrine pedestal. The flutes were filled with glass mosaic, a good deal of which survives *in situ*, particularly on the north-west example (Figs 359 and 361).

The visible end of each shaft terminates with a neck-ring, but the capitals are not present. The ring on the north-west shaft (101) is half-round, but the profile of its counterpart on the south-west (102) is vertical-sided, with bevelled arrises. These subtle differences are exactly replicated on numerous Italian columns, for example, the paschal candelabra at Anagni and Terracina cathedrals: in those instances the upper end of the shaft has a rounded neck-ring, and the lower is squared.[34] Hence, we may conclude that shaft 101 is the correct way up, whereas 102 is inverted. The spiral mouldings and the glass mosaic decoration filling the flutes in the Italian examples are also remarkably similar to those at Westminster. The designs and colour palettes of our north-west column so closely parallel the cloister columns at San Paolo fuori le Mura, Rome, that one might reasonably argue they were created by the same team of mosaicists.[35] The fact that the two Westminster shafts are not precisely identical in detail is of no material significance, and is probably a consequence of two carvers working on the same project. It is common for 'sets' of Cosmati columns to exhibit variations in the numbers and styles of the flutes, the direction of spiralling and the designs of the mosaic inlays.[36] This is well demonstrated by the colonnettes around the tomb of Henry III, where the number of flutes in each varies between eleven and fourteen (pp. 471–5).

In their present locations, the shafts appear incongruous, having no capitals or bases, and with

their lower ends disappearing into the chapel floor. Consequently, their exact heights cannot be measured, but 1.2m of shaft is currently visible. In 1850, Scott dug into the floor where the altar dais now stands, to locate the lower ends of the shafts, and reported that he found them 'to agree in height' with those supporting the entablature at the east end of the shrine.[37] It should imply that the shafts measure *c.* 1.75m in length, exclusive of capitals and bases.[38] However, that rather vague observation does not accord with other evidence.

In 1868 Poole reported that:

> There remained no vestige of mosaic in the flutes of the twisted columns, but below the floor-line much of the mosaic was found intact. The pillars were therefore turned upside down, so that the bare parts were buried, and the ancient mosaic revealed. This long episode of discovery and restoration will no doubt be read by many archaeologists with satisfaction.[39]

If the very emphatic statement that there was 'no vestige of mosaic' is accepted at face-value, it must imply that all of the *c.* 1.2m of decoration currently visible was previously buried. On that basis, the calculated height of each shaft ought to be *c.* 2.4m.[40] The pattern of mosaic survival is different on both shafts, from which some conclusions may be drawn. The most intact mosaic is at the upper end of shaft 101, below which its survival progressively declines, petering out at floor level. Since the profile of the neck-ring on this shaft confirms that it is the correct way up, in its primary location this must have been too high for pilfering hands to reach. In the case of shaft 102 the majority of it has been stripped bare, and the survival of mosaic is essentially confined to the lowest 30cm (but rises higher on what must have been a less accessible side), where it disappears into the floor (Fig. 359).[41] Moreover, the neck-ring confirms that this shaft is inverted, and the stripping of what was originally its lower end must have occurred pre-Dissolution. It is a reasonable assumption that Feckenham displayed the best surviving mosaic, and concealed that which had suffered most from pilfering. The second phase of stripping can be dated between 1558 and 1868 (tourist abuse of the chapel had been curbed by the 1840s, and it is unlikely that many tesserae have been lost subsequently).

Most commentators have suggested that the columns were either from candelabra, or were supports for freestanding statuettes, possibly of St Edward and St John the Evangelist. Paschal candlesticks in Italian churches were commonly cosmatesque, and had shafts akin to the Westminster examples but, since we have two columns and a church can only have one such candle, that option can be eliminated. If the columns had stood on the pavement (as candelabra or pedestals) they would have been more consistently robbed of tesserae, but their differential survival is wholly consistent with elevation on a tomb-chest, thus putting about half of the mosaic out of reach. We postulate that the columns were part of a set of four that supported a canopy (*ciborium*) over the tomb of Henry III (p. 447). The single surviving spiked iron stanchion rising from the top of the lower chest to the present timber canopy measures 2.2m long. Since the upper ends of the 13th-century security ferramenta must have been attached to the previous canopy, they indicate the minimum height of the latter above the tomb.[42]

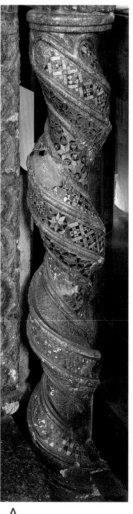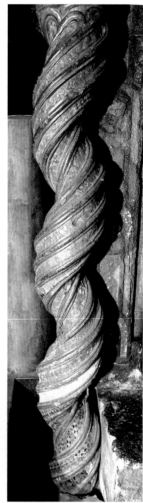

A B

359 (*Right*) St Edward's shrine, columns supporting the retable. A. Column 101, from the north; B. Column 102, from the south. © *Dean and Chapter of Westminster*

Description of the column-shafts (Fig. 359)

Column 101, at the north-west corner has four flutes (a–d), 4.0–4.5cm wide, and the spiral rises clockwise, whereas the south-west column (102) has six flutes (a–f), 2.0–2.5cm wide, and rises anticlockwise. The decoration on 101 is more elaborate than on 102, with patterns matching those preserved on the north face of Henry III's tomb, while the simpler designs on column 102 more closely resemble the style of the decoration on the colonnettes at the angles of both the upper and lower tomb-chests. It is also apparent that the fineness of the decoration is superior to that on the Confessor's shrine. Moreover, both columns incorporate small numbers of silver-coated glass tesserae, their only known occurrence at Westminster (Figs 362 and 363).

As with the decoration of the colonnettes on Henry III's tomb, the designs have been recorded in detail and an estimate prepared of the numbers of tesserae once ornamenting them (appendix 2). On the basis of Scott's recollection, the full vertical height of the decoration on the shafts is conservatively estimated as *c.* 1.7m; but when the spiral flutes are measured the overall length of decoration in each can be established as not less than 1.90m. This length has been applied as the basis for quantifying the minimum numbers of tesserae in each flute. The tesserae are glass and of five colours: dark blue (appearing almost black under some lighting conditions), red, white, silver and gold (the last being of red glass flashed with gold, often now laminating). However, if Poole's seemingly explicit statement is heeded, the number of tesserae would be considerably greater than estimated, by a factor of at least 30 percent (appendix 2).

Column 101 (Figs 359–363)

(a) A pattern of large tangent blue hexagons. Gold six-lozenge stars are superimposed on the large hexagons (creating small blue hexagonal interspaces) and red triangles, overlaid with a white triangle, superimposed on the small hexagons. This is the uppermost flute of the column (where a large gold star survives) and its decoration is well preserved four flutes down; there is no evidence that the pattern counterchanged along the length of the band.

(b) A chequered pattern (three squares wide), alternating red and blue, with gold central squares. White square interspaces between the squares are divided diagonally into triangles forming red and blue hourglass patterns creating, along the spine of the band, a row of tangent poised squares. The first block of squares along the flute differs from the remainder in having silvered tesserae forming the blue hourglass patterns, instead of white triangles (Fig. 362). Further down the length of the flute the pattern changes to four tesserae wide (with no evidence for silvered tesserae), so it is assumed that a star-like division, such as those in bands (c) and (d), may exist on the hidden side of the column.

(c) A design based on a lattice of squares set diagonally to the band and formed from gold fillets. Where the fillets overlap, single small red tesserae are introduced. Within alternate squares are gold quincunxes with red centres, on a blue ground of triangular interspaces and in the other examples, chequers of nine small squares alternately red and gold, or blue and gold, with alternate squares divided into confronting red, or blue (on white), triangles. The gold lattice is interrupted along its length by square panels superimposed with gold eight-lozenge stars on red (or blue) octagons. The first star is different in that the triangles completing the octagon around it are of silvered glass, as are the interspaces of border triangles with hourglass shapes (Fig. 363). Although the quincunx patterns along the band are constant, the triangular interspaces bordering the band vary and include patterns of reducing triangles without gilded tesserae.

(d) A pattern based on a grid of tangent hexagons, defined in gold fillets, containing gold six-lozenge stars on a blue ground. Triangular intersections between the fillets are white. About 30cm along the length of the band the colours change: the fillets defining the hexagons become blue with their gold stars set on red. It is possible this section of the band will be the same length as the first because at least four blue hexagons are visible.

Column 102 (Figs 359, 360, 364 and 365)

Much less mosaic survives on this column, and there is no evidence that any of the patterns alternated in style or colour. A few silvered glass tesserae are present.

(a) A band of alternating red vertical rectangles and pairs of upright tangent gold lozenges (which can also be seen as hexagons). Triangular interspaces between the lozenges are red with white diminutive triangles superimposed, and the triangular interspaces between the lozenges and the rectangles, blue.

(b) A scheme based on alternating tangent pairs of red and blue squares. However, the red squares are divided into pairs of triangles, the outer half red and the inner half gold. Square interspaces forming a spine are divided vertically, and alternately shaded gold and red, and triangular interspaces at the margins of the band, gold.

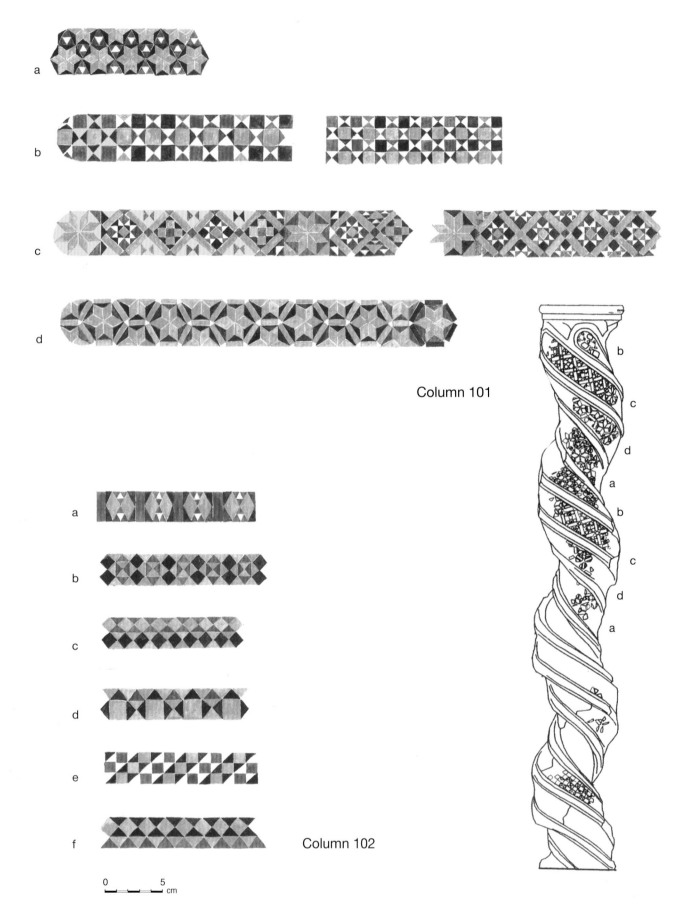

Column 101

Column 102

360 St Edward's shrine. Schemes of mosaic decoration in the flutes of columns 101 and 102. *Paintings by David S Neal*

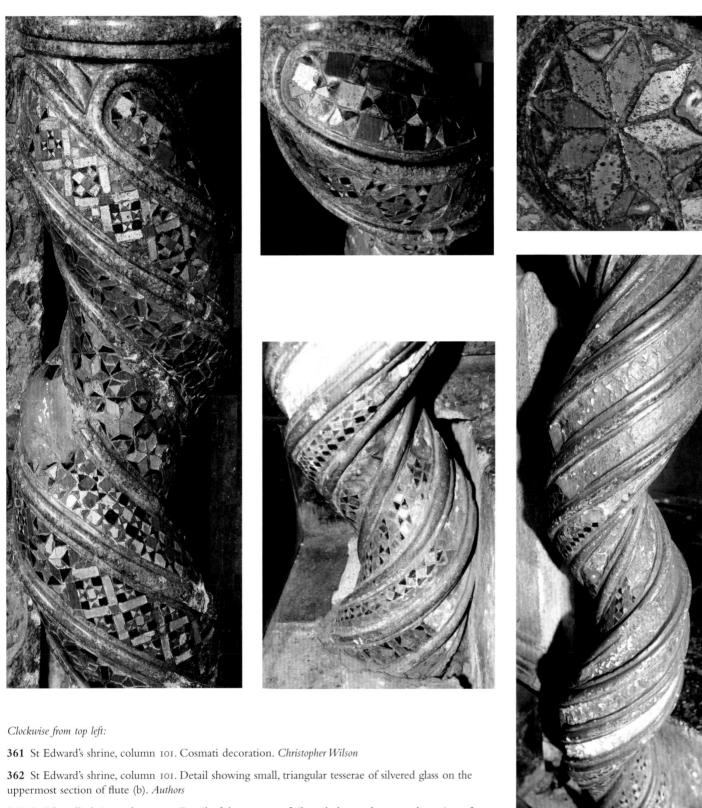

Clockwise from top left:

361 St Edward's shrine, column 101. Cosmati decoration. *Christopher Wilson*

362 St Edward's shrine, column 101. Detail showing small, triangular tesserae of silvered glass on the uppermost section of flute (b). *Authors*

363 St Edward's shrine, column 101. Detail of the tesserae of silvered glass set between the points of the star at the beginning of flute (c). *Marie Louise Sauerberg*

364 St Edward's shrine, column 102. Surviving remnants of Cosmati decoration. *Authors*

365 St Edward's shrine. Detail of mosaic decoration on the south-west column (102), immediately above present pavement level. *Authors*

(c) A band divided along its length into two strips, one half red and the other half gold. The red strip is superimposed with a row of tangent poised gold squares and the other strip, blue squares.

(d) A row of large tangent blue poised squares superimposed by gold squares, thereby forming blue hourglass shapes. On one side of the band gold triangular interspaces contain red triangles.

(e) A band of alternating diagonal rows of tangent red and gold squares (forming chequers). White square interspaces are divided diagonally, one half blue, forming an overall pattern of alternating diagonal bands.

(f) A row of poised gold squares tangent to one another, and to a row of red triangles along the lower edge of the band. Square interspaces so formed are divided longitudinally into triangles, one half blue, and the other gold.

For the posited original context of the columns, see p. 446.

RECONSTRUCTING THE ORIGINAL FORM OF THE SHRINE-TOMB

Evidence that the shrine pedestal was hastily and inexpertly re-erected in 1557 is overwhelming, and O'Neilly's meticulous study in 1958 revealed just how much of the 13th-century fabric was either incorrectly assembled or omitted altogether. He made a demountable scale model in timber, to demonstrate how the original components of the shrine were assembled (Fig. 376).[43] Our own conclusions are entirely in agreement with O'Neilly's. Consequently, it is unnecessary to reiterate every detail of the argument here, and a summary of the principal morphological changes inflicted on the shrine base will suffice, augmented as necessary with recent observations. O'Neilly also drew an artist's impression of the complete shrine structure as it may have existed on the eve of the Dissolution (Fig. 540).

Location, steps and plinth

First, we need to consider whether the rebuilt shrine, and its altar, occupy precisely their original positions in St Edward's chapel. Lethaby thought not, surmising that the shrine had been twice moved, the first being in *c.* 1437–40 when Henry V's chantry was constructed.[44] The presence of

areas of plain, irregularly-sized Purbeck marble paving to the north, east and south of the pedestal confirm that the present footprint of the shrine is not the same as it was in the 13th century. Marble paving that was intended to be seen was composed of regular squares, as surviving examples around the Abbey – including some in the shrine chapel – attest.[45] A greater width of the rough paving is exposed on the east side of the pedestal than on the north and south. Moreover, on the latter two sides there are small and unexplained offsets at the junction between the plain paving and the mosaic floor (Figs 227 and 230). These offsets not only indicate that the platforms for the shrine and the altar did not have the same north–south dimensions, but also pinpoint where the interface between the two lay: it was 35–40cm east of its present position. This was the location adopted for the reconstruction in 1557, and there is no basis for positing any earlier relocation of the pedestal. In any case, the shrine could not be shifted bodily and the logistics of totally dismantling and reassembling it, less than half a metre away, would render such an operation nonsensical, as well as causing damage to the mosaic. Any interference with the shrine would have had repercussions for the altar too; Lethaby did not adequately ponder the physical consequences of what he was proposing.

O'Neilly convincingly demonstrated that the shrine's plinth was originally elevated on four shallow steps of equal extent on the north, east and south. That being so, it is immediately apparent that for all the plain paving to be covered, the complete shrine-altar ensemble must have stood slightly further east than it does today (Fig. 366). Once that has been acknowledged, other details fall logically into place: the eastern limit of the steps would align with the extremity of the Cosmati paving to the south of the shrine (but not to the north, where other factors obtain), and the heads of the two so-called 'de Valence' floor slabs would neatly abut the eastern steps (Fig. 288, nos 19, 20). Finally, O'Neilly drew attention to the fact that the centre of the repositioned shrine would lie directly beneath the point from which the vaulting ribs of the presbytery apse radiate. Collectively, these details provide compelling evidence for determining the precise location of the shrine in the 13th century.

The centre of the current plinth, or platform, is formed of a single large slab of marble, edged

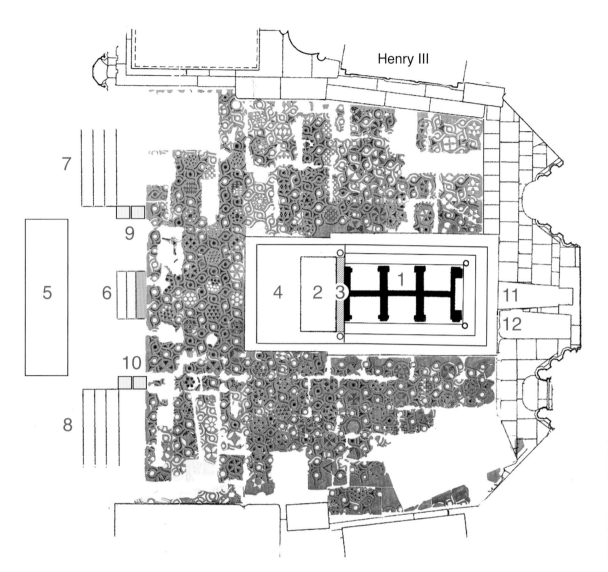

366 St Edward's chapel and shrine. Reconstructed ground plan, showing the relationship between Confessor's shrine, the tomb of Henry III and the Cosmati pavement. Also shown are the two undated grave-covers east of the shrine. *Authors*

by long blocks (former steps) on the north, east and south, and upon this the pedestal has been reconstructed (Fig. 299). Empty pockets attest that these steps were formerly locked together with iron cramps set in lead, and their arrises and upper faces exhibit various patterns of wear that could not have occurred in their present positions. Often mentioned by past writers are the paired hollows that were plausibly eroded by centuries of pilgrims kneeling in front of the north and south niches. O'Neilly demonstrated how the long block containing the hollows could be rearranged so that the wear-marks related meaningfully to the niches on the south side. He also astutely observed that the stepped plinth of Princess Margaret of York's small tomb corresponded to the profile of

the shrine steps.[46] This infant's tomb, which now lies on the southern perimeter of the chapel, between those of Edward III and Richard II, is recorded as having originally abutted the north side of the Confessor's shrine (Fig. 288, no. 14).

Lower stage of the pedestal and niches

The spine wall, together with the north, south and east side panels forming the heads of the niches of the lower stage are correctly juxta-positioned, but several areas of patching and replacement were necessitated where elements were missing. In particular, the once-decorated upper part of the back of the eastern niche (bay 4)

377

A B

367 (*Above*) St Edward's shrine. Lower part of the west end, as seen under the 1902 altar. A. View north-east, showing the two truncated pilasters (arrowed), surviving mosaic decoration on the west side of column 102, and one of the columnar supports for the present altar; B. The northern pilaster, from the north-west. © *Dean and Chapter of Westminster*

368 (*Below*) St Edward's shrine. Lower part of the west end, as seen under the 1902 altar, showing the reused moulded panel of Reigate stone, adjacent to the truncated Purbeck marble pilaster on the south-west corner pier. © *Dean and Chapter of Westminster*

has been superseded by two plain slabs of Purbeck marble. The flanking panels between the niches are not all correctly located: one on the south is inverted and one on the north has been partly replaced in Reigate stone. The western face of the pedestal was undecorated, since it would have been entirely obscured by the shrine altar and its retable. Closing this end now is a mixture of materials, mainly Tudor (p. 411; Figs 367 and 368). Consequently, evidence for the original arrangement here is lacking.

The curved blocks forming the pointed vaults within the niches on the north and south sides have not all been correctly paired either, as revealed by non-matching mosaic decoration: e.g. a block now in niche 1 clearly belonged with its identical companions in niche 3, where two missing parts of the decoration on the vault have

been reproduced in paint. On the south, only niche 2 has its original vault intact.

Upper panelled zone and chest

The panels in this zone on the north and south do not align correctly with the framing of the niches below, a consequence of the large slabs having been interchanged (Fig. 369). The east-end slab is correctly placed, but the west one is missing. The exposed eastern ends of the north and south side slabs are plain and were not meant to be visible. Moreover, these slabs are too far apart, placed too far to the east, and have lost some of their moulded edges. Consequently, they overhang and compromise structural details and decoration below. O'Neilly resolved the conflict by deducing that the side slabs not only needed to be interchanged, but also had to be inverted: the eastern blank ends (painted with *faux* mosaic in the 16th century) were meant to be towards the west, where they must have been concealed by the lost end-panel. Satisfactorily completing the eastern corners, and restoring the errant spacing of the components, required a pair of mosaic-decorated blocks that are now also lost (Fig. 370).[47]

The chest was topped by the inscription course, which was correctly assembled on the north, east and south sides, but is now missing from the west. The discovery of the eared fragment of Purbeck marble originating from the south-west corner of this course provided the vital clue to its primary arrangement (Fig. 371). All four corners of the pedestal were once punctuated by spiral colonnettes inlaid with glass mosaic, but the projecting wings at the western corners were omitted from the reconstruction, along with the colonnettes that would have supported them (capitals, shafts and bases, all lost). The eastern corners were not eared, and antiquarian illustrations confirm that slender colonnettes with capitals, bases and spiral shafts were installed here, albeit using a concoction of fragments. With the passage of time, both fell apart, but the southern one was reconstructed by Scott (p. 369).

The uppermost surviving element of the 13th-century pedestal – the frieze – is mostly present, but has been extended and repositioned as described on p. 411. If there ever was a medieval cornice, it was lost at the Dissolution, and in the Tudor reconstruction a wholly new one of classical profile was fitted. O'Neilly argued that, prior to

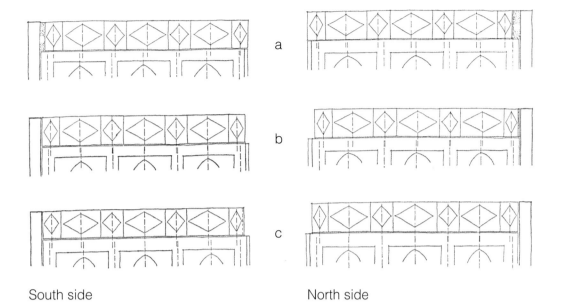

South side North side

369 St Edward's shrine. Diagrams illustrating the relationship between the geometry of the north and south slabs in the upper panelled zone and that of the six trefoil-headed niches below. A. The existing arrangement, as reconstructed in 1557; B. The effect of shunting the upper slabs slightly to the west; C. The benefit to geometrical symmetry obtained by transposing and inverting the upper slabs on the north and south sides. *After O'Neilly and Tanner 1966, figs 4 and 5*

the Dissolution, the course that now functions as the frieze was a small plinth upon which the feretory rested; at the same time it would have served as an upstand to guide the canopy when it was lowered on to the pedestal (Fig. 372).[48] Apart from the west, the remaining elevations of the pedestal can be reconstructed with confidence, and that on the north, as it would have appeared in the 13th century, is given on Figure 373.

The absence of any evidence for physical attachment indicates that the shrine altar was not integrally constructed with the pedestal, and the marble altarpiece – technically a retable rather than a reredos – would have stood on the back edge of the *mensa*.[49] The panel was re-installed by Feckenham, but at a higher level than originally, and was now supported by brickwork and a pair of large column-shafts that once belonged to the canopy over the tomb of Henry III (p. 446). There can be no doubt that the extant cosmatesque panel is the primary retable – and not, for example, the front of an altar – since it carried two vertical strips of mosaic decoration on its reverse (east) face that

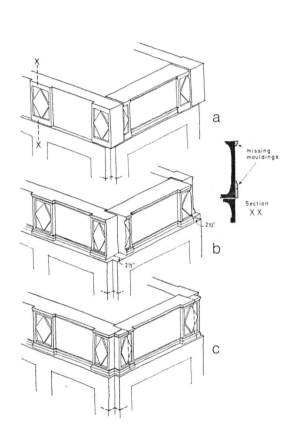

370 St Edward's shrine. Diagrams illustrating the relationship between the north and south side slabs of the upper panelled zone and that at the east end. A. The existing arrangement, as reconstructed in 1557; B. The effect obtained by interchanging the north and south slabs and reinstating missing mouldings; C. The same, with the addition of a pair of small blocks to complete the missing decoration on the east end. *After O'Neilly and Tanner 1966, fig. 6*

371 St Edward's shrine. Moulded block of Purbeck marble from the south-west corner of the inscription course, 14.5cm deep. This was omitted from the 1557 reconstruction, reinstated in 1868, and removed in 1902. A. West face; B. South face; C. East face. © *Dean and Chapter of Westminster*

A

B

C

372 St Edward's shrine. Isometric reconstruction of the shrine pedestal, viewed from the south-west. This shows how eared blocks originally formed part of the inscription course at the west end; and suggests how the frieze course above was inset, so that it could serve as a plinth to support the feretory. *After O'Neilly and Tanner 1966, figs 8 and 10*

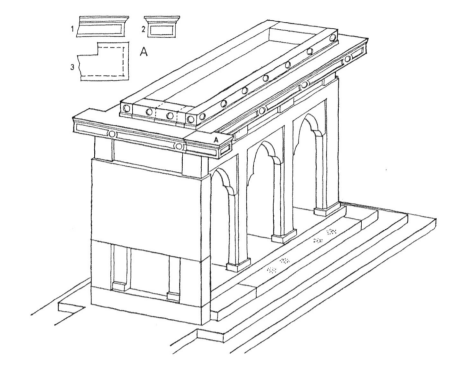

373 St Edward's shrine. Reconstruction of the north elevation of the shrine in the later 13th century. Lowest step not shown. *Authors*

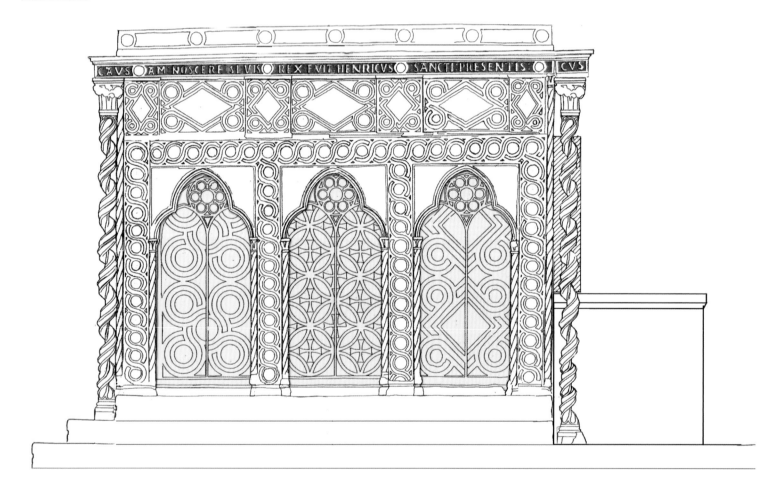

precisely match the two different framing designs on the north and south sides of the pedestal.

During the investigation in 2018, it was discovered that the long slabs of Purbeck marble forming the upper panelled zone on the north and south sides not only bear external mosaic decoration, but also define the chamber. Internally, the southern panel has a continuous, neatly cut rebate along its upper edge, and the northern panel has a continuous bevel in the same location (Figs 401 and 407).[50] No practical use for these features can be suggested, and they are presumably residual from an earlier element of the design that was not carried through (cf. Fig. 374, a, b).

The only aspect of O'Neilly's interpretation of the 1557 reconstruction with which we cannot agree is his insistence that the Cosmati child's tomb, now in the south ambulatory, originated as the shrine altar.[51] The evidence that this was purely a tomb, and had no connection with the shrine, is overwhelming (see chapter 13). Leaving aside the altar, O'Neilly's reconstructed elevations and sections through the shrine-tomb in the early 16th century are still valid, although accurate details relating to the interior of the chamber in the upper register can now be added (Fig. 374).

Detached architectural fragments from the shrine

The Abbey Collection contains two decorated pieces of Purbeck marble that were certainly once part of the 13th-century shrine.[52]

1. Fragment of entablature (Fig. 371)

This moulded block of Purbeck marble was spotted in 1868 amongst rubble infilling a medieval window in the dorter range over the east cloister. It was noticed by Hubert Poole, the Abbey's master mason, who recognized its distinctive profile as being part of the entablature of the shrine.[53] Deducing that it was originally fitted as a projecting 'ear' at the south-west corner, he reported the discovery to Scott, who devised a means of reinstating the block where it belonged. This set in train a succession of investigations and interventions in the shrine (pp. 314–16).

The block has its outer edges channelled to hold part of the glass mosaic inscription that ran around the entire perimeter of the frieze; the matrices are now empty. When the shrine pedestal

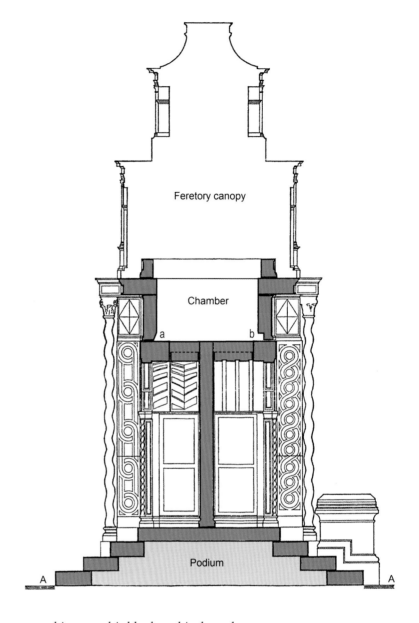

was re-erected in 1557 this block and its long-lost companion at the north-west corner were not reinstated; nor were the colonnettes that supported them. The design of the west end of the shrine was thus simplified, and in order to re-affix the corner block where it originally belonged Scott had to revise part of that simplification.[54]

Without a colonnette to provide visual, if not structural, support, the eared frieze had an uneasy appearance (Fig. 329, D), and did not remain in place for long:[55] 'The queer-looking projection failed to commend itself to one of his successors in the office of Surveyor'.[56] That was J. T. Micklethwaite, who removed the block in 1902, when he installed the present shrine altar and laid a pall over the wooden canopy, immediately prior to Edward VII's coronation.[57]

374 St Edward's shrine. Reconstructed section through the pre-Reformation pedestal and canopy, looking west. A–A indicates the edges of the Cosmati pavement in relation to the podium. The slabs with a bevel (a) and a rebate (b) are shown here in their original orientations. The tomb of Princess Margaret of York (1472) is shown mounted on the steps on the north side. *Adapted from O'Neilly and Tanner 1966, fig. 16*

THE COSMATESQUE MOSAICS OF WESTMINSTER ABBEY

2. Fragment of a colonnette (Fig. 355)

The upper end of a spirally fluted colonnette of Purbeck marble was discovered in 1904 during contractors' excavations on the site of the millstream bridge on the southern boundary of the Abbey precinct.[58] As we have noted above, the fragment was part of the shrine, and formerly located at one of the four corners (p. 369).[59] Except for the profile of the neck-ring, it is identical to the colonnette that Scott reconstructed from fragments and is now positioned at the south-east corner. None of the mosaic inlay survives, but there are residual traces of the bedding mortar.

The location of the discovery, being at some remove from the Abbey church, is not without interest. The bridge referred to lay immediately outside the south gate of the precinct, and carried the road across the millstream. In the 16th century there was a stone yard hereabouts, and just inside the gate lay the 'King's Tomb-house'. This was the workshop where Henry VIII's sepulchral monument for St George's Chapel, Windsor, was being fabricated in the 1540s and 1550s (but was never completed).[60]

It is likely that when the Confessor's shrine was dismantled, the components were taken to one of the Abbey's stone yards, where they were stored in the open for several years and suffered weathering and frost damage. Finding the fragment of colonnette near the millstream bridge points to the likely location where the components of the dismembered shrine were stored prior to their re-erection in 1557.

METHOD OF CONSTRUCTION AND ASSEMBLY

There were four basic stages to the construction of the shrine-tomb:

1. All the components of the Purbeck marble pedestal would have been fabricated in a specialist workshop, located somewhere within the palace complex at Westminster. Construction would have included polishing the marble and installing the mosaic decoration in the prepared matrices.

2. Preparations for the erection of the shrine were made in the chapel. These involved first, constructing a solid foundation to carry the considerable weight of the pedestal, then laying a rectangle of plain marble paving to the dimensions of the intended footprint of the shrine. Upon that template was constructed the four-stepped podium that would form the base for the pedestal. The central area of the uppermost step probably comprised a single massive slab of marble upon which the components of the shrine would be erected without fear of unwanted movement. The same slab also formed the floor of the six lateral niches. The steps around it were secured in position with iron cramps set in lead.

3. The finished components of the shrine were transported from the workshop to the chapel, where they were assembled on the podium and similarly secured with iron cramps and tying-bars.

4. Finally, the mosaicists made good the interfaces where the inlays crossed junctions between adjacent blocks.

Fabrication of the pedestal took place in a straightforward series of stages, similar to those adopted for most chest-tombs. First, the large slabs comprising the lower register of the monument would have been cut and approximately shaped by banker masons. Then slabs for the four sides of the chest forming the upper register, and the blocks for the moulded inscription course, would be prepared; probably also those for the four corner colonnettes and the various nook-shafts. When marble for all the structural components had been assembled and initially sized, mouldings would be worked on those that required them.[61] That was a considerable task, particularly in respect of the spirally twisted column-shafts with their multiple flutes and raised mouldings. The monument is then likely to have been temporarily assembled in the workshop, to ensure that the parts fitted together properly, and running mouldings continued smoothly from block to block.

The next stage involved drawing the intended designs for the mosaic and marble inlays, and marking their outlines on the surfaces of the blocks. The components were then handed over to a team of banker masons, to cut the matrices to the required depths, a task that must have been overseen by the master mosaicist. The depths varied according to the thickness of the materials that would be used for inlays: the matrices were shallowest where translucent glass mosaic was intended (5–6mm); some of the smaller roundels that were evidently once filled with glass were 9mm deep, which would be consistent with fixing

thicker, opaque glass; the panels designated to receive sheet-marble inserts were mostly 20–22mm deep, but the central square on the south side of the chamber (panel 6) was the deepest of all, at 28mm. One porphyry lozenge on the retable (53e) was even thicker, requiring a matrix depth of 35mm. In those instances where it was intended that a panel or roundel of marble would be framed or encircled with a narrow border of mosaic, the profile of the matrix was stepped to accommodate the different thicknesses of the inserts.

When all the matrices had been chased out, the components could be polished. Also at this stage, at least some of the housings may have been cut for the wrought iron cramps and tie-bars that would – when finally secured with molten lead – lock the whole structure together. Up to this point, there was probably little that English stonemasons and carvers could not do under supervision. The materials and skills required were readily available for chasing out the matrices, although the design of the ornament (which included classical capitals) and the profiles of the mouldings were far removed from 13th-century English Gothic. The greatest application of skill was, however, required for cutting and polishing the fine mouldings of the four spirally ribbed and fluted colonnettes that embellished the corners of the shrine. These mouldings and other carved details were all so perfectly executed, and precisely in the Italian manner, that they must surely have been worked by imported craftsmen, who would have needed to familiarize themselves with Purbeck marble.

The monument was now ready for the mosaicists to begin their work. Installing the tessellated decoration was a highly specialist task that only the Italian marble workers could do. The patterns were so complex, involving constant alternation and counterchanging, that the marblers must have worked from pre-prepared designs, brought with them from Italy. The marble and glass tesserae would also have been pre-cut there and packed in bags for transport, according to material, shape, colour and size. The mosaicists in Westminster then had only to choose a pattern for each decorative element, pick out the appropriate materials from the bags and install the tesserae in the matrices on beds of lime mortar. All this was executed on the bench, with the panels lying flat, just as the mosaicists' predecessors had done centuries earlier in the Antique world. A funerary

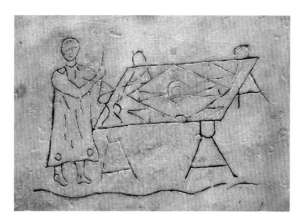

375 Roman funerary slab showing a *marmorarius* at work on a panel of mosaic or *opus sectile* decoration. The marble matrix rests horizontally on a pair of trestles. *National Museum of Rome*

slab, dating from the second half of the 4th century shows a *marmorarius* at work in Rome on a mosaic or *opus sectile* panel, supported on trestles (Fig. 375).[62] In those panels that required them, the large squares, lozenges or medallions of porphyry were inserted into their deep matrices first; then the thin glass tesserae used for the surrounding borders were laid in the shallower matrices abutting them. The evidence for the sequence of fabrication has largely been lost from the shrine, but the archaeological detail is well preserved on Henry III's tomb (Figs 454 and 458C) and the shrine retable.[63]

Where a decorative element was totally contained within the parameters of a single Purbeck block, the mosaic inlay could be entirely finished on the bench. However, where the decoration had to cross a joint between two blocks, it could not be completed to the same extent. Instead, the tesserae were set into one block, almost up to the joint, and stopped there. The adjacent block was then accurately positioned in relation to the first, and the mosaic inlay restarted just beyond the joint, leaving an unfilled gap in the pattern equivalent to the width of one or two rows of tesserae. These gaps would be filled later.

When the structural work on the chapel and the stepped podium for the shrine were complete, the components of the shrine and its altar could be moved into the Abbey, ready for reassembly (Fig. 376). This would not have been a particularly lengthy task. The components had to be assembled in a strictly logical order, since the shrine was dry-built with tightly fitting, mortar-free joints between the blocks. Wrought iron dog-cramps were inserted in the joints, and molten lead run around them, to ensure that the whole structure was securely locked together: it was essential to prevent any future movement that would rupture

A

B

C

D

376 St Edward's shrine. Wooden model made by J. G. O'Neilly in 1966; viewed from the south-west. The model is demountable and can be progressively assembled to illustrate the stages of construction. A. Stepped podium for the altar and shrine, with the lower stage of the latter partially constructed (spine wall, transverse partitions and vaults to niches); B. The lintel embodying the three trefoil arches has been added, together with the panels forming the sides of the hollow upper stage (NB the retable should not be shown here, or in the next image, since it did not form part of the west end of the shrine); C. Addition of the eared inscription course, plinth course for seating the feretory and the four corner colonnettes; D. Placement of the altar and retable against the west end of the pedestal, and mounted feretory (notional form). *After O'Neilly and Tanner 1966*

the mosaic decoration where it bridged joints.

The lower register, with its seven niches, was a structural entity and had to be assembled first. The slender, twisted nook-shafts flanking the niches may have been inserted at this stage, but that was not essential since they could be added later.[64] Erecting the lower stage, which essentially comprised only seven large slabs of marble, was an operation that would have taken less than a week. Next, the chambered upper register of the

pedestal was assembled, a task that could easily have been accomplished in a few days. After that, the moulded inscription course remained to be fixed and the freestanding colonnettes at the four corners attached at the same time. They provided essential support for the oversailing cornice, particularly at the west end, where the corners were eared. Each colonnette consisted of a base, twisted shaft and capital, all of which had to be locked together – and tied to the oversailing

course – with iron pins and lead. This operation would take about another week, assuming that the pockets for the pins and runnels for pouring the lead had previously been cut in the workshop.

That left only the uppermost masonry course to be laid (the plinth for seating the feretory), a task that could not have taken more than a day. The chamber in the upper stage may have been capped with slabs, or boarded over at the same time. We cannot be certain how the void was covered, but it cannot be doubted that something was required to provide basal support for the feretory when it was eventually installed; the small plinth course alone was inadequate. In all, assembling and securing the prefabricated components of the pedestal on the pre-prepared podium would not have taken more than a few weeks, two months at the outside. Once the structure was complete, the mosaicists could return and infill the gaps where junctions between blocks occurred with the appropriate tesserae, correctly spaced; this ensured that the continuity of the mosaic design appeared unbroken, but inevitably when the gaps were filled there would be slight discrepancies and misfits, not noticeable on casual inspection but discernible with a critical eye, as seen on Henry III's tomb (Fig. 458C). Making the final adjustments to the mosaic inlays would have been no more than two days' work for one or two artisans.

Upon completion of the shrine pedestal, the altar would have been installed at its west end. It similarly comprised prefabricated panels, each prepared and decorated in the workshop; and the retable – the only component that still survives – was a single panel also. Again, assembling the prefabricated parts on site could have been accomplished within a week.

THE PRIMARY INSCRIPTION: AN ASSSESSMENT

An inscription, executed in glass mosaic, ran all round the frieze of the monument and incorporated the shrine's date of construction. When the pedestal was re-erected by Abbot Feckenham in 1557 the damaged remains of the inscription were totally occluded by the application of a coat of plaster, on to which an entirely new text was painted. Moreover, the west-end panel, containing the beginning of the inscription, including the

date, was not reinstated and is lost. The sole evidence for the original wording – and hence for the documented construction date of the shrine – is a transcription in Richard Sporley's *Historia Ecclesiae Westmonasteriensis*, compiled in 1450 (Fig. 377).[65] Sporley was a Westminster monk who copied and augmented a history of the Abbey, *De Fundatione Ecclesie Westmonasteriensis*, produced in 1433 by his brother monk, John Flete.[66] The inscription as Sporley recorded it reads (with our expansions underscored):

Anno milleno d<u>omini</u> c<u>um</u> septuageno
Et bis Centeno c<u>um</u> completo quasi deno
hoc opus est factum q<u>uod</u> Petrus duxit in act<u>um</u>
Romanus civis homo causam noscere si vis
Rex fuit henricus\[ij]/ san<u>c</u>ti presentis Amicus

In translation, this would read:

In the thousandth year of Our Lord, with seventy
And two hundred, with ten virtually complete,
This work was made which Peter, a Roman citizen, took the lead in making
If you wish to know the instigator
It was King Henry [III], beloved of this present saint

Thus the name of the principal craftsman was Petrus, a Roman citizen, and the construction date of the shrine seemingly 1279. Sporley's date has excited antiquaries for three centuries because it is so plainly in conflict with the known date of translation of the Confessor's body into the shrine in 1269. In his own history, Richard Widmore, the Abbey's librarian, 1732–64, simply amended the text of the inscription to overcome these difficulties: *septuageno* silently became *sexageno,* and the problem was spirited away.[67] Numerous other scholars have also unhesitatingly made the assumption that *septuageno* is a straightforward scribal error for *sexageno*.[68] On the other hand, Binski has inveighed against amending the text in this way: 'the burden of proof is strictly upon those who

377 St Edward's shrine. The primary inscription on the pedestal, as recorded in five lines by Richard Sporley, 1450. © *British Library: Cotton MS Claudius A V III, fol. 59v*

wish to dispose of Sporley's evidence'.[69] But how reliable is Sporley?

Over the past four centuries Sporley's transcription has been re-published innumerable times, in a variety of forms, both with and without punctuation and textual contractions. When we examine the manuscript, it is immediately apparent that this is not Sporley's primary record, but is an immaculate copy, probably at several removes from the original transcript that one presumes he made on the spot. It is written in five lines, representing the structure of the leonine hexameter, and bears no relation to its physical disposition around the four sides of the monument. Finally, Sporley

employs various contractions, but no punctuation.

Moreover, there were several opportunities for error in what Sporley himself saw and recorded. Was the inscription damaged by the time that he saw it? Was it partially obscured by gifts attached to the shrine? Did he copy it down incorrectly? Did an error creep in whilst transcribing his field notes (in whatever form he took them) into the draft document, or between the draft version and the final manuscript? A damaged inscription by 1450 is not unlikely. When Sporley saw it, the shrine pedestal was almost two centuries old, and we know that a hundred years later the majority of the tessellation had been lost, causing Feckenham

378 St Edward's shrine. Plan of the inscription course and possible reconstruction of the layout of the eight separate sections of text. Sporley's known errors and punctuation omissions have been corrected, and *sexageno* has been substituted for his *septuageno* in section (a). *David S Neal*

to infill the empty matrices with plaster and overpaint them with *faux* mosaic.

Turning now to the shrine, two facts have to be taken into consideration when attempting to elucidate the disposition and appearance of the lettering around the perimeter of the pedestal. First, although the monument has four principal sides, we have shown that it once had a pair of small rectangular projections ('ears') to the entablature at the western corners, around which the lettering also ran. Hence, the inscription was broken into eight sections by changes of angle (Fig. 378). Moreover, the frieze is interrupted at regular intervals by roundels, inserting another ten breaks into the text. Hence, in total, it was fragmented into eighteen separate compartments.

The second piece of evidence of which we must take special cognizance is the exposure of the matrices for the letters on the east end of the shrine, where the Tudor plaster covering was stripped off in 1741 (Fig. 315). The glass inlay was pilfered within months of its being exposed, but the outlines of the letters are plainly visible in the mortar matrix. Moreover, there are punctuation marks between words (with one exception). The exposed text matrix reads:

DVXIT : IN : ACTVM : ROMANVS CIVIS : HO[MO]

This section of the inscription fills the frieze at the east end, and the first archaeological record following its exposure was made by Gough in 1781 (Fig. 379). What clearly emerges from this section is that Sporley's transcription is unreliable: not only did he fail to record any of the punctuation marks, but he also introduced into *actum* a contraction that is not present. Similarly, it is improbable that *completo* (line 2) was contracted to *copleto* in the original.[70] That being so, it is likely that other contractions (especially *cum* and *factum*) were of his own making. He contracted *domini*, seemingly to *dm*, but it could be read as *dni*, the usual formula found on English medieval funerary inscriptions. We may also question whether *sancti* was actually contracted to *sci*. Notwithstanding these certain and potential discrepancies, Binski

maintains that 'Sporley was a generally reliable witness, and the veracity of his transcription is demonstrated by the surviving fragment of this inscription on the base's east face', and he insists that Sporley's record 'should lead us without hesitation to accept at face value the inscription's date ...1279/1280, marking the completion of the work.'[71] To do so would be reckless.

Although not favoured by most historians, there is another possible scenario that could explain why early some commentators saw no conflict between Sporley's *septuageno* and the recorded translation date of 1269.[72] Binski and Carpenter both mention this, but do not embrace it as a plausible explanation. It is worth quoting Carpenter, who refers to

> ... the possibility of reaching 1269 by another route, namely by assuming that the *cum completo quasi deno*, 'with ten nearly complete', was meant to qualify the 'one thousand, with seventy and two hundred', indicating that the last ten of the 1270 years was nearly concluded, hence making the date 1269. But this reading requires the *cum* to be employed in an apparently unique fashion, one different from that found both in the first line of the inscription (*Anno milleno cum septuageno*) and in many other dating verses of this type, in all of which its effect is additive.[73]

Knowing that the inscription began and ended at the north-west corner of the shrine, and having the full text on the east end securely recorded, enables us to reconstruct the layout of the north and south sides (Fig. 378). The west end is the only area where real uncertainty obtains. The available space could have accommodated either *septuageno* or *sexageno* without difficulty. In tomb inscriptions, contractions are commonly employed for the words *anno*, *domini* and *milleno*, and Sporley gave the first two in full and the last as *dm* but we cannot be confident of that particular rendering. Some writers have placed great emphasis on the fact that the name of the craftsman – *Petrus* – occurs at the mid-point of the inscription, but that cannot be precisely established either, given the uncertainty regarding the total number of

VXIT ◯ IN ĀCTVM ROMĀNVS CIVIS ◯ HO

379 St Edward's shrine. Gough's transcript of the exposed portion of the inscription, made in 1781. *Gough 1786*

characters. Moreover, since the inscription was broken into eighteen discrete sections, any significance attached to the positioning of the name would not have been apparent to observers. Visually, it would have been more impressive if *Petrus* had been retained physically intact, and centred on the east end of the pedestal, but that would have been incompatible with the poetic structure.

Since no scale-drawing of the complete inscription band, including the eared corners on the west, has previously been made, informed discussion of the layout of the text has been impossible. By tracing the letter-forms and spacing exposed to view on the east side of the shrine, the typographic arrangement of the now-hidden text on the north and south can be established with confidence. Breaks in the text were inevitable where the inscription band incorporated roundels, and where it changed angle at the corners of the pedestal. There were four equally-spaced roundels on the north and south faces, but only two on the east, and probably the same on the lost west face.

Some words were demonstrably fragmented by roundels: one each on the east and north sides, and two on the south; no evidence survives on the west. Thus, on the east the 'i' and the 't' of *duxit* are separated by a roundel. The north side began with *causam*, but that was interrupted by a roundel between 's' and 'a'. The last word in the inscription on the south side, *Petrus*, must have been severed by a roundel between 'e' and 't', there being insufficient space adjacent to the south-east angle of the pedestal to fit in all six characters. Breaking the name in this way certainly diminishes its *gravitas*.

Matthew Payne has studied both Sporley's original manuscript and the context of its production, and identified a plausible scribal error that could have led to the incorrect appearance of *septuageno* in the initial line. Moreover, this may have been not merely a careless substitution for *sexageno*, but an altogether misplaced section of wording that actually belonged in another context, unrelated to St Edward's shrine.[74] In sum, he suggested that the initial line of the inscription could have read: *Anno millesimo domini cum sexagesimo*, which not only restores the 1269 date, but also retains the internal rhyme. If it were written in full, there would have been difficulty in fitting all the characters on the west end of the

shrine but, as noted above, dates are frequently contracted. There would be no problem with length if this line read: *An° millesimo dni cum sexagesimo*. Objections to this rendering have, however, been raised on the grounds that, although it preserves the internal rhyme, it is not metrically accurate, and that cannot be gainsaid.[75]

Nevertheless, metrical accuracy may not be definitively invoked to reject that, or any other proposed reading, since the scansion in Sporley's transcription is technically imperfect too, and is not what it superficially appears. This has been discussed elsewhere.[76] The problem is further compounded by the fact that instances of the metrically imperfect use of *septuageno* in other contexts can be cited. Ironically, we are forced to admit the version of the text that incorporates better scansion is the one which has been silently adopted by many historians since the 18th century, namely the substitution of *sexageno* for *septuageno*.[77] We have now turned full-circle and, metrically, the purest option is the one that returns us to the date of 1269.

Short of discovering another medieval transcript of the shrine inscription that has no association with Sporley, we can never know precisely what the wording was on the west end. The possibilities for incorrect recording of the primary evidence, and the interpretative options are too numerous for any sound conclusions to be drawn. In such circumstances dogmatism is inappropriate and relentless speculation pointless. Other strands of evidence contributing to the dating of the shrine need to take precedence. The necessity of seeking alternative approaches to the problem is made, *a fortiori*, by the fact that 13 October 1269 is incontestably the date of Edward the Confessor's translation. It would be unscholarly to manipulate the history of this nationally important event on the basis of one unconfirmed word in a medieval manuscript of dubious reliability. The matter should now be firmly laid to rest.

When the inscription is set out in detail, and inserted into the eighteen matrices on the elevations of the shrine, it fits to perfection (Fig. 378). Moreover, no contractions are required, not even to *domini* or *sancti*, and maintaining the integrity of individual words was clearly not a substantive issue since fragmentation occurred throughout. As we have seen, even the name *Petrus* was interrupted by a roundel between the second and third letters. The suggested layout of the inscription is thus:

West
ANNO : (()) MILLENO : DOMINI : CVM : SEXAGENO : (()) ET : BIS : |

South
CENT | ENO | (()) : CVM : COMPLETO : QV (()) ASI : DENO : HOC : OPVS : (()) EST : FACTVM : QVOD : PE (()) TRVS |

East
DVXI (()) **T : IN : ACTVM : ROMANVS CIVIS : ** (()) **HOMO** |

North
CAVS (()) AM : NOSCERE : SI : VIS (()) : REX : FVIT : HENRICVS (()) : SANCTI : PRESENTIS : (()) | AMI | CVS |

Note: changes of angle around the frieze are indicated with a bar (|), and the positions of decorative roundels interrupting the text are represented by pairs of double brackets ((())).

Additionally, most authors have shown a cross (+) as the initial character of the inscription, although there is no evidence to support that.[78] Sporley did not include an opening cross, but he inserted a mark in the left-hand margin of his manuscript, to indicate that he was introducing a quote; this has been mistaken for a Greek cross (Fig. 377). The true number of characters in the inscription is a subject upon which several writers have placed considerable interpretive weight, declaring that *Petrus* falls precisely at the centre.[79] However, Sporley's cavalier use of contractions, his omission of punctuation and his disregard for physical breaks in the text preclude the use of his manuscript as reliable evidence in this matter. Despite that, the perfection with which the deduced reading fits the physical constraints of the monument, suggests that we *may* have elucidated the original letter-count as 168. If so, the breakdown is thus: west, 33; south, 53; east, 28; north 54. The centre-point of the inscription does indeed fall within *Petrus*, although not between the *t* and the *r* – as would be required for perfect symmetry – but one letter to the right (i.e. between *r* and *u*). We have noted that the name itself is broken by a roundel, although that is one letter to the left of centre. Unfortunately, this is another line of enquiry that cannot be pursued to a definitive conclusion.

Finally, it is worth mentioning that there has been confusion in the literature concerning the colour of the glass in the frieze. In 1741 Vertue correctly described the lettering as 'yellow like

DVXI(O)T:IN:ACTVM:ROMANVS:CIVIS:(O)HC

gold cut and set in' (p. 314), whereas Burges wrote of 'letters of blue glass'.[80] Lethaby, immediately after quoting Vertue, inexplicably declaimed, 'The inscription, therefore, was formed of bars of blue glass set in gold mosaic,' and he offered a reconstruction of part of the text on the east end (Fig. 380).[81] Subsequently, Lethaby corrected his error and reversed the colour combination: 'on the south side there are some traces of the actual inscriptions in gold glass on blue.'[82] Perkins, *inter alia*, followed Lethaby's erroneous version: 'a minute examination of such fragments as survive indicates that the letters were made of glass of a deep blue colour inlaid in a ground of gold mosaic.'[83]

The only visible glass today is a single vertical row of blue tesserae at the extreme west end of the frieze on the south side, and other tiny areas of survival on the south and east elevations. These are all part of the background colour, not the lettering (Fig. 410, A). Blue glass, both in sheet form and as tessellation, was similarly employed as the background for finely painted gilt decoration on other 13th- and 14th-century monuments, including the Westminster Retable[84] and the Coronation Chair.[85] The Tudor canopy over the feretory of St Edward was likewise decorated with blue and gold glass tesserae (p. 395).

CONCLUDING OBSERVATIONS

The shrine-tomb of St Edward is archaeologically the most complex of all the royal funerary monuments in Westminster Abbey, on account of the fact that it was completely dismantled in 1540 and clumsily reassembled seventeen years later. In the intervening period some of the structural and decorative elements were lost, others badly damaged; moreover, the reconstruction was *ad hoc*, and seemingly not guided by any pictorial record of the original form of the monument.

When Henry III ordered the demolition of the eastern parts of the Confessor's church in 1245, the Romanesque shrine, dating from 1163, and the saint's coffin were moved to a new location

380 St Edward's shrine, east end. Lethaby's reconstruction of the glass mosaic inscription, based on the extant matrices. He erroneously depicted the letters as dark blue, and the background gold, whereas the reverse obtained. *Lethaby 1906, fig. 111*

where they would be safe from the building works for the next two decades. A temporary sanctuary was doubtless created in the eastern part of the Romanesque nave, and the shrine installed there. Henry's new sanctuary and shrine were destined to be not only the most sacred component of the rebuilt abbey church, but also the most lavishly appointed and visually spectacular. Small wonder, therefore, that Henry began to commission sumptuous furnishings for it, even at the design stage of his new church, several years before construction commenced on site. In 1241 he appointed Edward of Westminster as 'keeper of the works of the shrine', and the fabrication of a new *feretrum* was immediately put in hand. This provides eloquent testimony to Henry's core objective: to honour St Edward.

In 1251 the king ordered four silver-gilt candlesticks to be made for the new shrine, but instructed that they were to be temporarily attached to the old one; the translation of St Edward was imminent and had been reported to the pope. But it was delayed. The following year an enigmatic instruction was given, seemingly to construct a temporary chapel in honour of the Confessor; it may have been intended to showcase the new *feretrum*, which Matthew Paris had evidently seen in 1250, when he described it as the 'golden feretory'. The shrine pedestal was incomplete when Henry made his will in 1253, the king bequeathing 500 marks of silver to finish the task. Completion must now have been firmly in sight because in 1254 dedication of the new work was being planned for the following year. But in what style was the pedestal being constructed? Other English Gothic shrines were under construction in the mid-13th century, and one would naturally presume that Edward's was Gothic too, and intended to harmonize with the architecture of the new church. By this time the walls of the new presbytery and transepts stood to full height, and were roofed.

However, the shrine that was installed in Henry's church in 1268–69 is of hybrid design: the basic form of the structure is recognizably English Gothic, whereas the decorative details and surface embellishments are overwhelmingly Roman. Since every surface of the pedestal was inlaid with cosmatesque mosaic decoration, it is self-evident that work cannot have begun on its fabrication until the momentous decision had been made to bring to England a team of Italian Cosmati artists, and the specialist materials that they employed in their mosaics. The date at which this occurred is not recorded, but it has traditionally been associated with the abbacy of Richard de Ware, whose election took place in 1258. Although Ware is firmly associated with the sanctuary pavement, there is nothing to connect him with the shrine. Moreover, the inscription thereon unambiguously states that Henry III was responsible for commissioning it.

Since a *feretrum* – no matter how lavish – was of little use if there was no base to support it – and the saint's body – it cannot seriously be doubted that the pedestal was under construction in the 1250s. Superficially, the corollary of this would appear to be that whatever work was done prior to Ware's abbacy had to be discarded and a fresh start made under the superintendence of Italian marblers. However, the extant physical evidence tells a somewhat different story, one which seems largely to have been overlooked by previous commentators. The architectural form of the Westminster pedestal bears no resemblance to Italian tombs and shrines of the mid-13th century: instead it displays characteristics of an English Gothic monument of the 1240s or 1250s. There is no basis for claiming that an Italian artist had a hand in initially designing the Confessor's shrine-tomb, a clear contradistinction to the situation obtaining in respect of Henry III's tomb, the form of which is uncompromisingly Italian (for discussion, see pp. 581).

The evidence points to the present shrine pedestal having been designed and its fabrication commenced before the decision was taken to embrace Cosmati work at Westminster. The principal stages involved in constructing and decorating the pedestal have already been outlined in some detail (p. 382), and it may be envisaged that, prior to the arrival of the Cosmati fashion, all the Purbeck marble blocks had been acquired, cut to their respective sizes and surface-dressed. Furthermore, roughing-out of the decorative scheme had begun on the lower stage of the pedestal, and that included outlining the trefoiled heads of the seven niches. Once the arch-heads had been cut into the long slabs forming the side panels of the lower stage, the Gothic appearance of the niches was fixed (Fig. 338). There was no turning back: too much marble had already been cut away for the trefoil-arched openings to be re-worked as classical semicircular heads.

Delineating and chasing out the decorative components on the large slab that constitutes the spine wall of the pedestal would have been the next task to tackle: all other structural elements either abut it or are supported by it. The slab is decorated on both faces with three blind, two-light, 'windows' with sexfoil tracery in the heads. These features fill the backs of the niches and are miniature reproductions of the two-light, uncusped windows in the apsidal chapels and transepts of the abbey church, dating from the late 1240s and early 1250s (Figs 381 and 382).[86] It is suggested that roughing-out of the blind windows in the niches began in *c.* 1250, and any design change involving switching from a Gothic to a wholly Italianate scheme at that stage would have been difficult and costly and, more importantly, set the project back. Contemporary references show that the king was driving the work forward, with the intention of carrying out the translation in the mid-1250s, but there was a change of plan, and the decision was made to embrace cosmatesque decoration. Consequently, the proposed translation and dedication had to be postponed and a compromise design for the shrine was adopted, retaining the basic Gothic form and the major work that had already been done on it, while heavily overlaying the structure with cosmatesque mosaic.

Only one face of the spine-wall slab could be chased to receive mosaic inlay at a time, and it is evident that work began on the south side, where the spirit of Gothic is more apparent than on the north. The sexfoils have expanded cusps similar to those in the presbytery windows, but on the north the cusps have largely vanished as a result of disaggregation of the marble. Although the two-light window design is basically the same on both faces, the matrices of the sexfoils are more Roman on the north: each comprises seven separate circular compartments (a ring of six, enclosing another at the centre). The seven-circle cluster is not a decorative feature found elsewhere in the Abbey's architecture, but is a ubiquitous motif employed by the Cosmati mosaicists. Thus, it occurs as one of the medallion types in the shrine pavement (Fig. 232, row 16a). Italian mosaicists were accustomed to filling circular compartments, but not Gothic foiled tracery. It therefore seems highly likely that the decision to adopt cosmatesque decoration occurred either between chasing the matrices on the south face

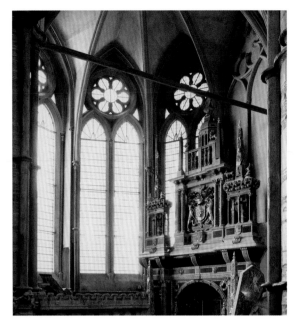

381 St John the Baptist's chapel. Glazed and blind two-light windows of the late 1240s, with circular foils. These are identical to the blind windows reproduced in the micro-architecture of St Edward's shrine. *Christopher Wilson*

of the spine-wall slab, and turning it over to work on the north side, or shortly after chasing had begun on the latter. That provided the mosaicists with the opportunity to adapt sexfoils into seven-circle clusters.

There are also other tell-tale differences between the faces; for example, the central mullion between the two lights is visually robust on the south but is reduced to an almost insignificant line on the north. On the south, each light was individually chased with a cosmatesque design, which was then filled with mosaic, but on the north a single design spanned each pair of lights, the diminished 'mullion' appearing as no more than a false joint in the stone (e.g. compare Figs 339 and 346). Fitting any of the cosmatesque designs into a lancet-headed space was a challenge, and the level of success in achieving compatibility varied from bay to bay. Some of the designs thrust into the lights collide very awkwardly with the lancet heads (cf. especially Figs 339, 348 and 351); it is only in bays 3 and 6 that the geometry of the inserted design sits reasonably harmoniously with that of the architecture (Figs 343 and 349).

The Italian mosaicists had to retain and work around that which had already been shaped and chased by English marblers. However, the complete absence of Gothic mouldings and decorative motifs (apart from the blind windows) on the shrine confirms that no part of the work had progressed beyond the roughing-out stage. In conclusion, the foregoing analysis readily explains how the Confessor's shrine emerged as an amal-

382 Westminster Abbey, north transept, exterior of the west elevation. Two-light window of *c.* 1250–52, with slightly pointed foils. *After The Downland Partnership, © Dean and Chapter of Westminster*

gam of English Gothic and Italian classical design, an enigma that has often received mention but never been satisfactorily explained.

One further anomaly calls for comment, and that concerns the difference between the design on the bands of guilloche framing the niches on the north and south sides. Niches 1 to 3 on the south are framed by chain guilloche, four links in height by two in width (Fig. 306), whereas niches 5 to 7 on the north are framed by continuous running guilloche (Fig. 321). The difference in style was immaterial, until a decision had to be made regarding the treatment of the east end: which type of guilloche should be employed to frame niche 4? Either would have worked perfectly well, but the carver devised an ingenious compromise, giving the southern flank and half of the lintel of bay 4 a chain guilloche, and the northern half a running guilloche (Fig. 314). Changing the style of the shrine pedestal from Gothic to Roman had no bearing on this purely decorative matter, and another explanation is required. Superficially, it seems unlikely that such obvious asymmetry was intentional, and perhaps resulted from human error. Both types of guilloche are common on Roman monuments, and if two carvers were employed, beginning simultaneously on components for the north and south sides, a simple misunderstanding of instructions could have given rise to the dichotomy. Once carving had commenced, there was no way of rectifying such a mistake, short of discarding the work already done: that would have involved replacing large blocks of Purbeck marble. On the other hand, it is well to remember that asymmetry is not uncommon in cosmatesque work: it is strongly apparent in both the sanctuary pavement (p. 584) and the child's tomb (p. 499).

A subject of uncertainty in the literature concerns the location of the Confessor's body within the shrine, in the 13th century. It was usual for the saint's relic to be contained within the *feretrum* itself, placed on the flat top of the shrine, and not in a chamber within the upper part of the pedestal, the function of which principally being to elevate and support the *feretrum*. Westminster did not follow the norm, in that the pedestal incorporated a chamber of adequate proportions to receive an adult-sized coffin (p. 381; Fig. 374). Essentially it could have served as a stone sarcophagus.[87] Notwithstanding, most writers have accepted without question that the body was contained within the golden feretory, on top of the pedestal.[88]

There has been a general assumption that, following the shrine's reconstruction in 1557, the containment of the saint's coffin within the upper part of the pedestal was an expedient consequent upon the feretory having been sequestered. Some commentators have asserted that the pedestal was adapted to house the coffin, but that is demonstrably not the case. This study has confirmed that the shrine pedestal was, *ab initio*, a two-tiered structure, the lower stage containing a series of niches (kneeling-places), while the upper stage comprised a sarcophagus-sized rectangular chamber. The internal masonry was well finished and the chamber had a stone base on top of the vaults over the niches. The coffin has rested on this base since 1557. But at what level did it sit in 1269?

A decorated marble plinth, set around the perimeter of the chamber, on top of the inscription course, formed the seating for the *feretrum*, and at the same time served as a kerb to locate the *cooperculum* accurately when it was lowered. No evidence survives in the rebuilt pedestal to indicate whether there was a timber lid, or marble slab, over the chamber. If such was the case, it presumably rested within the perimeter of the plinth course, and could have provided a suitable platform upon which to place the Confessor's coffin. However, two issues arise. First, the coffin would effectively seal a large, empty chamber to which there was no access.[89] Secondly, if the coffin stood on, and projected above, the top of the masonry pedestal, it would have prevented the feretory from resting there, unless the latter had no base, and if that were the case, it would have been a canopy, rather a reliquary. Moreover, we know that there was a separate timber canopy over the feretory from 1270 onwards (p. 597). The 'empty' chamber remains a conundrum.

11 The Shrine-Tomb of St Edward the Confessor, II: Tudor Reconstruction and Later History

Over the course of time, the shrine attracted gifts of various kinds, some of which were substantial in physical terms, such as the three marble columns, ordered by Edward I in 1290–91. They stood independently around the shrine and presumably supported statuary or lights.[1] At his coronation in 1308, Edward II gave two gold figures, representing St Edward and the pilgrim.[2] One accoutrement that the shrine would have possessed from an early date was an outer timber case, to protect and enclose the feretory: it was known as a *cooperculum*. This would have been suspended on long chains or ropes, anchored to the stone vault high above the presbytery. Feretory covers had to be raised and lowered, either by operating a windlass in the roof space above the vault, or by a configuration of pulleys and counterbalance weights.

The medieval canopy has not survived, nor has any description of it, but its existence is attested by accounts for expenditure, where it is variously described as *capsella*, *capselle* and *capse*.[3] The first reference relates to the final stage of its construction, probably in 1270, and was for 'gold leaf, enamels, various colours and other things necessary for painting the casket (*capse*) in which the body of the blessed Edward is laid'.[4] Later accounts confirm that the canopy was suspended from ropes that descended from the vault above, although there is also a reference in 1363 to Brother John Redyng being paid 6s. for some newly made iron chains, 'hanging before the feretory'.[5] These are easily explained. It is likely that the feretory cover was suspended by two short chains attached to an iron bar, between one and two metres in length, and that in turn would have pulleys attached at both ends, through which the ropes descending from

the vault were passed. A suspension arrangement of this kind was essential to ensure that neither the draught within the church nor the natural tendency for long ropes to twist caused the canopy to rotate as it was lowered over the feretory.

Renewal of the rope is implied in 1377/8, when a 'large rope' was bought for the feretory.[6] A series of explicit references to the shrine canopy (*capselle*) begins in 1422/3, when a payment was made for mending it, followed in 1423–25 by another payment (in two instalments) for two new ropes made of twine, for raising the canopy of the feretory of St Edward.[7] In 1425/6 two additional ropes were purchased for the shrine, and a blacksmith from London was paid to make a 'barell' for raising the *capsella*.[8] This potentially indicates that an unsatisfactory arrangement, perhaps involving counterbalance weights, was superseded by a winding-drum in the roof-space above the presbytery vault.[9] The drum was operated by a cranked handle, or a capstan, and the ropes passed through holes in the vaulting.[10] The new machinery must have operated successfully, since the next entry does not occur until 1448/9, when rope was again purchased.[11] Installing the winding mechanism and ropes in 1425/6 may signal the appearance of a new and heavier timber canopy for the shrine. Grease appears regularly in the late 14th- and early 15th-century accounts for the bell wheels and pulleys.

The 'wheels' (i.e. pulleys) of the feretory were repaired in 1488/9, 1493/4, 1495/6 and 1497/8,[12] Accounts were paid in 1498/9 for 'eight wainscot' bought 'for the wheel of the feretory and other wheels in the church' (8s. 8d.), for sawing the said wainscot (2s. 8d.) and for six nails bought for the same (12d.); these items must relate to making

timber pulleys.[13] The pulleys were mended and greased in 1505/6, when hides were also purchased for the feretory, together with nails for fixing the same. This entry effectively reveals that the roof was boarded and covered with skin, which needed renewal. A covering of hide was commonly applied to timber trunks, and the pattern of nailing was often ornamental. The feretory canopy would have resembled a gabled trunk with no bottom.

Unspecified repairs to the shrine pedestal (referred to as 'the sepulchre') were undertaken in 1493/4 and 1495/6,[14] and there were also many yearly accounts for 'nails for the sepulchre and the canopy, 3*d*.' It is unclear why there should have been an annual requirement for the same quantity of nails.[15] A payment in 1495/6 was made to Richard Russell, carpenter, for 'repairing the sepulchre and the coffin under the feretory of St Edward'.[16] This is both interesting and enigmatic for its description of the coffin as being 'under' rather than inside the feretory. If this statement is accepted at face-value, it indicates that the Confessor's coffin lay in the sarcophagus-like chamber within the pedestal, and not inside the *feretrum* (p. 392). Either way, one wonders why the coffin was in need of repair. 'The bells and wheels' of the feretory were again mended in 1513/14 and the ropes replaced in 1516/17.[17] Thereafter references to the canopy cease.

THE FERETORY CANOPY (*capsella* or *coperculum*)

A detailed investigation of the upper register of the shrine pedestal has demonstrated that it was hollow from the outset and incorporated a rectangular chamber with ample capacity to contain a full-size adult coffin (Fig. 374). Although Edward the Confessor's coffin has occupied that chamber since the re-erection of the shrine in 1557, it has always been assumed that prior to the Dissolution it was contained within the sumptuously decorated *feretrum* that Henry III commissioned in 1241.[18] This was a large ark-like timber box with gabled ends, plated with sheets of gold and having jewels and other precious materials attached to it.[19] No reliable illustrations of the *feretrum* have survived, but stylized versions exist in the *Estoire* and Litlyngton Missal (Figs 290B and 291). Whether the chamber in the pedestal was merely a void, or housed some of the shrine's treasure, cannot be determined, although that seems highly improbable since access

to it could only be obtained by removing the feretory itself.[20]

The *coperculum* was a hollow timber canopy that served as a protective case for the *feretrum* and its attached treasures. It would have been of architectural form, highly decorated, and having a gabled roof covered with hide: effectively, it was a 'mortuary house'. O'Neilly argued that the *feretrum* rested on a mosaic-decorated, rectangular stone plinth surmounting the inscription course, but set back from its outer edge on all elevations (see also p. 378).[21] He convincingly demonstrated that the masonry course to which we refer as the 'frieze' in the present Tudor entablature was created from the stones of that plinth, augmented with some new blocks to facilitate the necessary enlargement. Overall, the plinth would have measured 2.80m by 1.24m, set back 19cm from each face of the pedestal. The surrounding ledge thus created – being the top of the inscription course – would have provided the seating for the lowered canopy, and its dimensions fit perfectly with the top of the pedestal, as reconstructed by O'Neilly. Thus when the canopy was lowered it would have embraced both the *feretrum* and the cosmatesque plinth upon which it rested, concealing them from view.

However, the heavy oak canopy that currently graces the top of the shrine pedestal – itself often incorrectly referred to as the 'feretory'[22] – cannot date from the 1420s. It is not medieval, but a purely classical structure assignable to the 16th century, and decorated with glass mosaic (frontispiece, vol. 2; Fig. 383). The canopy has traditionally been described as Marian, and assumed to have been constructed in the late 1550s. But there is a fatal flaw in this supposition: the express purpose of a *coperculum* is to encase a *feretrum*, but the feretory had been seized and destroyed in 1540 and the coffin containing Edward the Confessor's body was now inside the shrine pedestal. There was nothing on top of it for a canopy to cover. One could appreciate the desire to place a small gabled chest on the pedestal, as a symbolic reminder of the former feretory, but the structure we have today is neither small nor symbolic. It is a mighty two-storied and roofed oak construction, standing 2.25m (7½ft) high, and is equal in height to the shrine pedestal. Both stages of the canopy were built with their internal spaces wholly unobstructed by transverse timbers or bracing, expressly so that it could be lowered over the

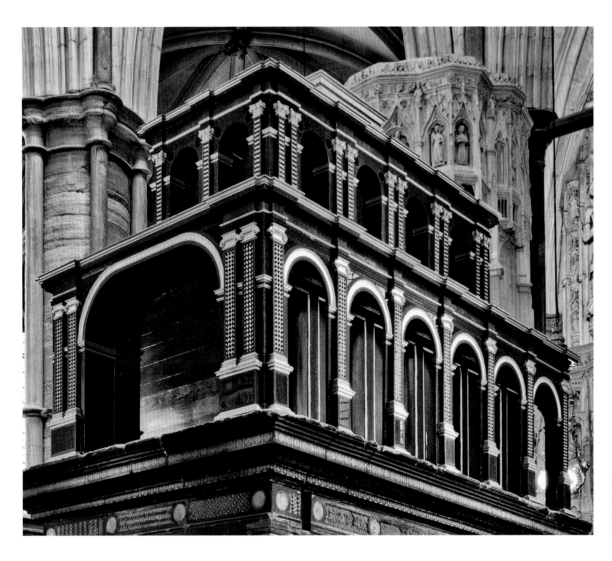

383 St Edward's shrine canopy. View from the south-west, 2013. © *Dean and Chapter of Westminster*

feretory. As O'Neilly observed, if its intended function was merely to adorn the 1557 reconstruction of the shrine pedestal it would have been much easier to manufacture the canopy with internal bracing and ties.[23]

The canopy was expensively constructed and intricately decorated with Italian glass mosaic, and the date and purpose of this seemingly redundant furnishing need to be carefully explored. What we have today are two superimposed, basilica-like oak chests, surmounted by a 'caddy' top. The internally hollow chests are classically detailed on the exterior with rows of semicircular arches carried on modest imposts, and separated by flat pilasters, the latter sheathed with glass mosaic (Figs 391, 392 and 394). The canopy was over-restored in 1958–60, and now has the appearance of being a wholly modern creation. Prior to restoration, it featured in numerous antiquarian illustrations and photographs as a somewhat dilapidated, two-tiered

structure, lacking its roof (Figs 29 and 297). Trustworthy illustrations, such as Carter's watercolour of 1778, show the upper stage roofless, and having all the arched recesses open-backed, with light passing through them (Fig. 12). Prior to restoration, therefore, it had the appearance of a lantern structure. Ackermann's view of 1812 (drawn by Pugin) similarly confirms the condition, although detail is not rendered with such precision (Fig. 384). A vertical photograph taken in 1916 shows the interior of the lower chest, but without the wainscoted lining (Fig. 385).[24] Another photograph, taken in 1937 from Henry V's chantry chapel, not only reveals both chests in their unrestored condition, but also the degree to which structural components were missing, and the extent of the improvisation that was required in order to support the upper chest above the lower (Fig. 386).

The earliest archaeological record of the canopy

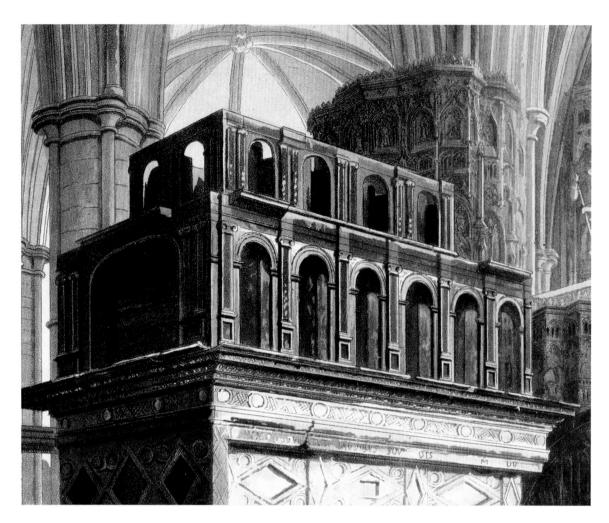

384 St Edward's shrine canopy. South-west view, drawn by Augustus Pugin. *Ackermann 1812*

385 St Edward's shrine. Vertical photograph taken in 1916, looking down through the lower chamber of the canopy, on to the top of the shrine pedestal, where the Confessor's iron-bound outer coffin of 1685 can be seen. This view also confirms that the wainscoted lining of the chamber was not present, and nor was the internal void obstructed by timberwork. West is at the top. *Perkins 1940, pl. opp. 105*

is provided by dimensioned sketches of its component parts, made in 1713 by Talman (Fig. 301).[25] He used these sketches to inform a reconstruction drawing of the shrine, which was engraved by Vertue in 1724 (Fig. 300). That reconstruction shows the canopy roofed with a caddy top, evidence for which was noted by Talman. We cannot now determine the form of the original roof, which one might expect to have been gabled; if that were the case, there are likely to have been low-pitched classical pediments at both ends.[26] A flat roof is a plausible but unattractive alternative. Certainly, it would not have been caddy-shaped, that being a fashionable termination for cabinets, clocks and other furniture in the late 17th and early 18th centuries. It might be expected that the caddy top recorded by Talman dates from 1685–86, following the accident that damaged the canopy and coffin (p. 419). However, Sandford's drawing of 1677 also shows a caddy top (Fig. 387), pointing to the likelihood that it dated from the 1660s, and was a replacement for the original roof that was perhaps destroyed during

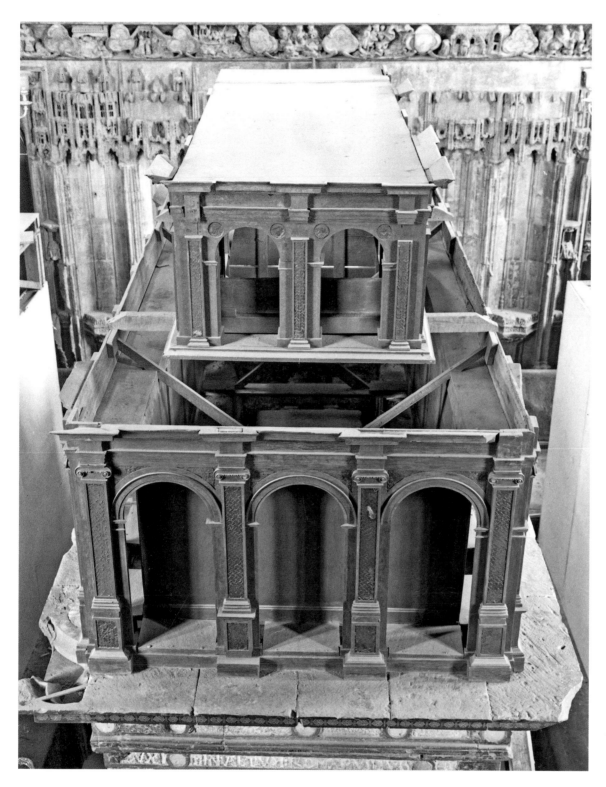

386 St Edward's shrine canopy. View looking west from Henry V's chantry chapel in 1937, showing the upper chamber supported in an *ad hoc* manner by beams and braces. Its arches were still open-backed, and a flat roof had been fitted. In the lower chamber the floor under the three arches was not continuous, as it is now, and each bay had been a self-contained unit, before the wainscoted back was fitted. This view also confirms the extent to which the mosaic and glass-inlaid panels had been stripped out of both chambers. © *Dean and Chapter of Westminster*

the Commonwealth. The canopy was obviously semi-derelict by 1723, when Dart wrote: 'This Frame was covered at [the] top, as appears in a Draught by Mr Sandford; but the upper Frame is much disjointed and sunk in.'[27]

Pulleys must have been fixed at either end of the roof, and ropes passed through these to facilitate raising and lowering the canopy. The great weight of the structure could not be lifted by its roof alone, and there were most likely iron straps running down the inside walls, with secure attachments to the upper and, especially, the lower chests.[28]

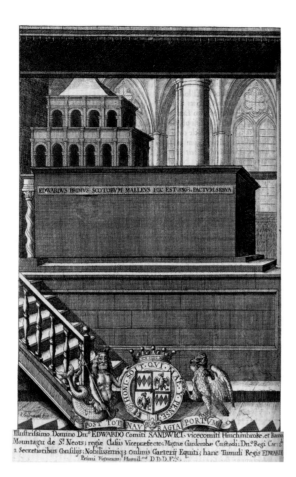

387 St Edward's shrine canopy. The earliest illustration, showing the caddy-shaped roof that was probably destroyed in 1685. View from the north by R. Gaywood. *Sandford 1677, 136*

Description

Elevation drawings of the canopy were prepared in 2012 by The Downland Partnership, using laser scanning (Figs 313, 320, 388 and 389). In 2018, a scaffold platform was erected around the shrine at cornice level and the canopy lifted off, thereby enabling the first detailed archaeological examination of both its structure and the top of the shrine pedestal (Fig. 390).[29]

Lower chest

The carcase measures 3.15m by 1.63m, by 1.00m high, and comprises a rectangular box made of oak wainscoting, divided into six panels on the north and south sides and three on the east end (Fig. 313 and 386). The west end is treated differently, being a series of horizontally placed boards (Figs 389 and 393). There is no bottom to the chest and it had no cross-members or bracing internally until these were added in 1959. The timber is close-grained, knot-free and of Baltic origin; the backs of the panels are neatly finished, but evidence of sawing and adzing is discernible.

The joinery is of high quality: the rails and muntins are 8.5cm wide, and the joints double-pegged; the principal panels measure 39cm wide by 59.5cm high, and the individual boards are 28–29cm wide, butt-jointed, with strips of scrim glued on for reinforcement. No setting-out lines, assembly marks or graffiti are visible. Very little sapwood is present on the panels and framing, but the timber used for the frieze around the top of the chest is of poor quality (doubtless English) and has extensive sapwood on the rear face.[30]

Wrapping around the carcase, on all sides except the west, is a continuous 'ambulatory' 14cm wide, comprising six bays of semicircular arcading on the north and south, and three on the east end (Fig. 386). The arcading is cut from thin oak boards (with the grain horizontal), to which face-mouldings and diminutive imposts have been applied. At the west end is a separately defined broad recess spanned by a single flat-topped arch of unconventional form. In essence, it is a semi-circular arch that has been split into two quadrants, which have then been parted and reconnected with a horizontal member. It could be described as a laterally-expanded semicircular arch. The niche so formed gives the impression of being designed to receive a figural composition. The carcase is largely open-topped, having just a broad ledge around the perimeter, upon which the upper chest rests. That ledge is entirely modern.

Between the bays are Ionic pilasters with moulded capitals and bases, raised on panelled plinths with clear glass inserts (Figs 391 and 392). At the west end the broad arch is flanked by coupled pairs of pilasters, bringing the total of these to twenty-two (Fig. 393). The capitals are all in fine condition, and may be original.[31] The faces of the pilasters are inlaid with rectangular panels filled with dark blue and gold glass tesserae, forming a guilloche pattern. All now replaced, the glass was described as 'probably of Venetian origin'.[32] Although the tesserae had been picked out by souvenir hunters, they were embedded in putty, and the remaining impressions confirmed that the pattern was uniform throughout the chest. The spandrels above the arches are fitted with pieces of clear glass, painted on the rear to imitate green porphyry.[33] All this detail is confirmed by Talman's sketches, the annotation of which indicates that the capitals and bases of the pilasters were gilded (*or*), the glass tesserae being gold and blue (*az.*); the spandrels over the arches had

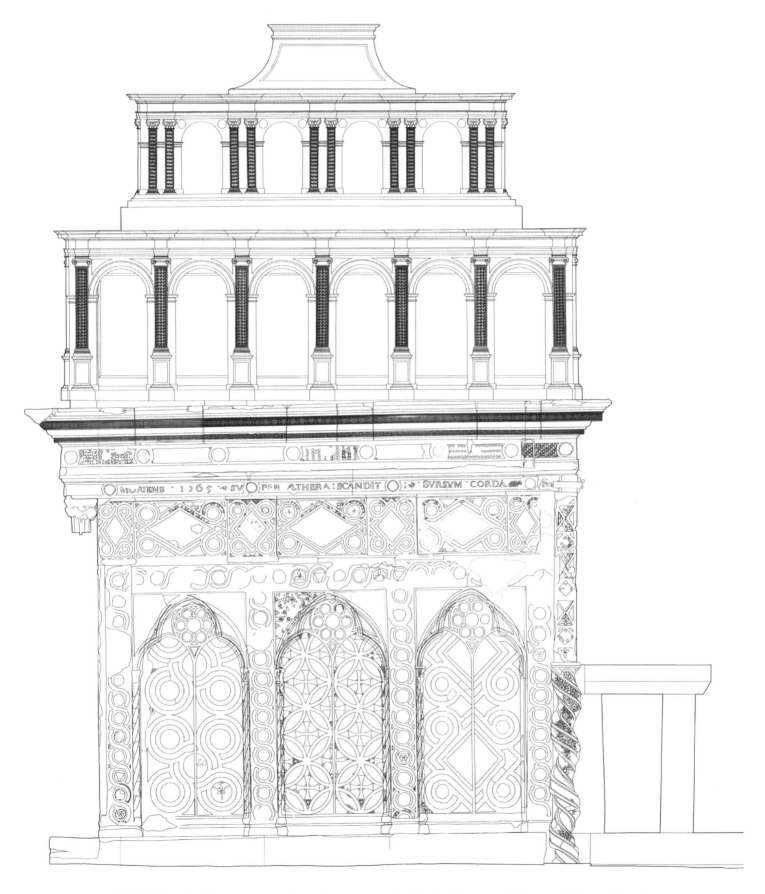

388 St Edward's shrine and canopy. North elevation, 2012. *The Downland Partnership,* © *Dean and Chapter of Westminster*

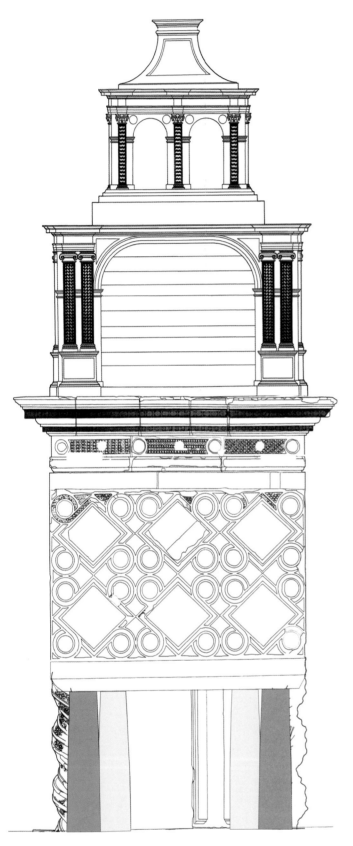

389 St Edward's shrine and canopy. West elevation, 2012, showing also the altar of 1902. *The Downland Partnership, © Dean and Chapter of Westminster*

0 ————————————— 1
m

painted glass inserts, as did the panelled plinths of the pilasters. The painted decoration of the timber casing imitated purple and green porphyry (*por.* and *serp.*, respectively).

The 1958–60 restoration not only involved making many additions, to replace known or presumed losses of mouldings and decoration, but also some significant changes were introduced. Thus, the floor of the 'ambulatory' around the chest is now formed by a continuous board on each side of the structure, but previously it comprised a series of short boards, individually sited in each arched opening, indicating that these had once been separate entities, as is the case with the upper chest (see below and Fig. 386). Ackermann's view also appears to confirm the compartmentation (Fig. 384). The 'floor' boards were nailed to the plinth. However, there is no indication in the continuous wainscoting now forming the back of the 'ambulatory' that divisions ever existed between the bays.[34] The pilasters supported an entablature, comprising a stepped architrave, plain frieze and moulded cornice. Most of the cornice was already missing when Pugin drew the canopy in 1812.

Upper chest

This is also of rectangular box-like construction, but somewhat smaller, measuring 2.41m by 1.08m by 0.8m high. It was originally hollow, with no bottom, and the solid plank top is entirely modern. Four semicircular arches front deep recesses on each main side, with a further two at either end. Again, the arches have moulded imposts. On the north and south sides the bays are separated by pairs of pilasters, and blue glass roundels punctuate the spandrels. Single pilasters define the bays on the east and west ends. In all, there are twenty-six pilasters with Corinthian capitals and moulded bases, but the latter are not raised on panelled plinths (as they are on the lower chest). The flat faces of the pilasters are again inlaid with rectangular panels of blue and gold glass tesserae, arranged in a chevron pattern; alternately, the chevrons point up, and down (Fig. 394).

Unlike the lower chest, there is no wainscot or jointed framing in this structure: iron nails were used to secure the components. The corners of the chest are formed by pairs of vertical boards, nailed together at right-angles; the sides, through which the arches are pierced, each consist of two

390 St Edward's shrine, with the canopy dismantled and moved off the pedestal, on to a scaffold platform, 2018. The top of the pedestal with the chamber containing the encased coffin are seen in the foreground; the lower chest of the canopy stands on the scaffolding beyond. View north. © *Dean and Chapter of Westminster*

391 St Edward's shrine canopy, Lower chamber. Detail of the arcading and mosaic-inlaid pilasters on the south side. © *Dean and Chapter of Westminster*

392 St Edward's shrine canopy, lower chamber. Detail of the south-east corner. © *Dean and Chapter of Westminster*

oak planks with their grain horizontal. The planks are joined together along their length by tongue-and-grooving, and their ends housed in continuous grooves in the edges of the corner planks. On each side a single plank at plinth level, projects shelf-like into the chest, providing a common 'floor' for the recesses, which are all self-contained, having reveals and a semicircular ceiling vaults: there is no lateral interconnection between them. Their backs consist of individual oak boards (all renewed). The pilasters supported a similar entablature to that on the lower chest, and there is a cavetto-moulded basal timber upon which they stand.

The finish to the internal (i.e. unseen) carpentry of this chest is rougher than that of its counterpart. Moreover, traces of setting-out lines are discernible, but there are no carpenters' marks or graffiti.[35] However, parts of four incomplete timber merchants' marks are visible, confirming that the oak originated from the Baltic region (Fig. 395). Again Talman's sketches of 1713 are invaluable for confirming the nature of some missing details, such as the Corinthian capitals and the glass roundels, and for indicating the decorative finishes, which comprised purple and green *faux* porphyry and gold leaf.[36] The upper stage now simply rests upon the lower, without any form of registration. Nothing survives to indicate how the two components were originally united, or what happened to the interconnecting framing that must once have existed (Fig. 386).

393 St Edward's shrine canopy, lower chamber. West end, showing the deep recess under a laterally-expanded semicircular arch. © *Dean and Chapter of Westminster*

394 St Edward's shrine canopy, upper chamber. Detail of the paired pilasters, glass roundels and mosaic inlay. *Authors*

Roof and decoration

The canopy has a diminutive roof with concave slopes and a flat top. It is caddy-shaped, dates entirely from the 1950s, and was based on Vertue's engraving of 1724; that in turn was copied from Talman's sketch of 1713 (Figs 300 and 301). The caddy-shape is also confirmed by Sandford's engraving of 1677 (Fig. 387). The present version was made as a separate unit, heavy and solid, and it rests on the boarded top of the upper chest; it is likely that the 17th-century 'caddy' was hollow.

Externally, the canopy was decorated all-over to resemble purple and green porphyry; the capitals and some mouldings were gilded. The spandrels and plinth panels on the lower chest were inlaid with sheets of clear glass and there were blue glass roundels in the spandrels of the upper chest. The pilasters were all inlaid with dark blue and gold glass tesserae: 3,960 in the lower chest and 3,330 in the upper. The total of 7,290 falls somewhat short of the 10,000 tesserae stated in the press report (p. 430). Internally, the joinery of the carcases was neatly finished, but not given any surface treatment.

Discussion and dating

The joinery of the shrine canopy is of high quality, and since the carcase is panelled with close-grained, knot-free oak boards – undoubtedly of Baltic origin – it might be possible to determine a date-bracket for construction by dendrochronology, if access to end-grain could be obtained and the heartwood-sapwood boundary established on at least one board. However, in the absence of a full complement of sapwood rings, close dating by this means is not feasible.[37] An additional matter to take into account is the fact that the lower chest is of two phases. The finely finished wainscot panelling forming the inner carcase is strikingly different from the rougher, nailed carcassing surrounding it, the latter being in harmony with the construction of the upper chest. There can be no serious doubt that the wainscoting represents a secondary lining – perhaps of the late 17th century – and that initially the lower arches fronted individual recesses, harmonizing with the upper ones.

We have already noted that it has been traditional to assign the canopy to Feckenham's reconstruction of the shrine in the late 1550s,[38]

and to refer to it as 'Marian'.[39] Thus, when discussing the 1557 reconstruction of the pedestal, Micklethwaite asserted, 'At the same time the base was crowned by the wooden structure … which though not to be compared with the golden shrine, the place of which it takes, was in itself a handsome and rather costly piece of work, and it is noteworthy as an early example of Italian Renaissance design in England.'[40]

Hitherto, the only writer to question the assumed dating was O'Neilly, who asked pertinently: was there sufficient time for Feckenham to have it made?[41] He thought not, since Feckenham's abbacy was of such short duration, and we concur with him. A hasty reconstruction of the shrine pedestal was apparently achieved in one month (March–April 1557), and it would have taken several more months to execute the superficial restoration of its decoration in plaster and paint, which were Feckenham's signature materials.[42] He applied a great deal of *faux* mosaic to the shrine pedestal and to Henry III's tomb by this means (p. 415; Figs 317 and 335). None of his restoration involved true mosaic work. The canopy, on the other hand, displays a wholly different order of craftsmanship: the skills required to construct the oak carcase, carve a mass of intricate classical detail and create glass mosaics was prodigious. This would have consumed a considerable amount of time, substantial funding and required specialist craftsmen (probably Italian) for about two years. Moreover, it is likely that the glass for the mosaic

395 St Edward's shrine. Fragmentary remains of four Baltic timber merchants' marks on boards inside the upper chamber of the canopy. *Authors*

inlays had to be acquired from Italy. There are no points of comparison between Feckenham's reparations and the design and decoration of this canopy.

The corollary must be that the canopy was a pre-Reformation replacement for the medieval original, and O'Neilly briefly discussed its design elements in the context of similar works for which construction dates are known. But he did not cite evidence preserved in the Abbey's own records. We know the canopy was in existence in 1540 because it was mentioned in the Dissolution inventory: 'A fayre godly Shrine … with a case to the same'.[43] This points to its origin in the earlier part of the 16th century, and one close English parallel exists in the timber quire screen at King's College Chapel, Cambridge, made *c*. 1530–35. The authorship of the screen is unknown, but was most likely Italian.[44] The lower chest of the Westminster shrine canopy and the lower storey of the chapel screen share identical design traits: the laterally-expanded semicircular arch is the distinctive feature that unmistakably connects the two (Figs 393 and 396).[45]

The canopy is a highly accomplished artefact of elegant classical design, and of a style that would not be expected in England before the third decade of the 16th century. However, exceptional circumstances obtained at Westminster: the abbacy of John Islip (1500–32) was marked by extensive new works in the Abbey, involving a high level of artistic expertize, and the presence of foreign artisans. Islip is the strongest contender for the person who might have commissioned a costly new canopy for St Edward's feretory. No record of its acquisition has survived, but there are a few references in the accounts to the pre-Reformation shrine canopy during the earlier years of his abbacy. We have already noted repairs carried out in 1505/6 and 1513/14 (p. 394), but it is the reference to the purchase of rope in 1516/17 that provides a crucial dating clue:

> 1516/17: paid for ropes (*cordul*') of 'fynetwyn' bought this year for the feretory of St Edward 57*s*. 4*d*.[46]

This entry confirms that a new set of ropes was purchased in 1516, and potentially that could indicate the arrival of a new canopy. The cost of the ropes was prodigious (57*s*.), implying that a large quantity of 'fine twine' was purchased, and that accords with what would have been needed to operate the hoisting mechanism.[47] Thirty

metres of rope were required for a single length, from the pavement to the presbytery vault, but shrine canopies had to be raised by two ropes: each descended from the vault, passed through a pulley attached to the canopy, and back up to the vault again. We know that since 1426 the canopy had been operated by a winch located in the roof-space above the vault, and that would have required 120m of rope (p. 393).

The question of the canopy's date of manufacture requires critical consideration. Although of a seriously different order of magnitude and elaboration, the design link between King's College Chapel screen and the Westminster *cooperculum* is undeniable. The expanded semicircular arch is not a characteristic feature in the vocabulary of English Tudor architecture, and it must have been imported with the craftsmen who created these particular furnishings. The arch-form occurs only twice in the abundant woodwork in King's College Chapel: principally it is seen in the great opening at the centre of the screen (Fig. 396A), but an unadorned version is also found in the back of the first return-stall on the north (Fig. 396B). The date-bracket for constructing and installing the screen must fall in the period *c*. 1530–35, although the design was most likely generated a few years earlier. What seems to have passed unnoticed hitherto is that the same arch-form is also depicted, *inter alia*, in the glazing of the chapel (Fig. 396C). Contracts for the glazing span the years 1526–32, and there are close links between the glass in King's College Chapel and that in Henry VII's Lady Chapel at Westminster.[48]

While the screen and the glazing at Cambridge provide a general indication of the likely date-bracket for the Westminster canopy, they do not prescribe it closely. However, we can be certain that it has a *terminus ante quem* of 1540, and that can reasonably be pushed back to 1532, the date of Islip's death. With the Dissolution looming in the mid-1530s, it is highly unlikely that Islip's short-term successor, Abbot William Benson, would have commissioned the canopy. We have already noted that the surviving sacrists' accounts at Westminster contain a succession of references to maintenance from the 1420s onwards, but there is nothing from the 1520s or 1530s (p. 393); nor are there any payments for a new canopy. The final mention of matters relatable to the feretory canopy is in 1516/17, when new ropes were purchased for raising and lowering it.

A

B

C

396 King's College Chapel, Cambridge. A. Central opening in the west face of the oak quire screen, *c.* 1535, showing the laterally expanded semicircular arch, flanked by pilasters and with roundels in the spandrels; B. Detail from the east face of the quire screen, showing the back of the first return-stall on the north; C. Window in the north wall of the nave, with an expanded semicircular arch displayed across two lights. *A, B. Christopher Wilson; C. Authors*

The Renaissance canopy was monumental in scale, of robust construction, and undoubtedly heavier than its medieval predecessor. Hence, it is unlikely that old ropes would have been trusted to support this prestigious and expensive adornment. Since no further entries appear in the Abbey's accounts relating to the canopy, the problems besetting it in the past must have been solved. Thus circumstantial evidence points strongly to 1516 being the date of its installation.

It might be objected that 1516 is too early for classical Renaissance woodwork of this kind to appear in England, but that cannot be summarily rejected because Italian artisans already had workshops in London, even within the precinct of Westminster Abbey.[49] Moreover, they had already been engaged on the furnishing and decoration of Henry VII's magnificent new Lady Chapel for several years: Pietro Torrigiano signed his first contract with the Abbey 1511.[50] Although it seems not to have been discussed hitherto, another source of evidence provides a strong and cogent context for the construction of the canopy at precisely that time. The clue to it is embodied in Henry VII's will of 1509. He charged his executors with commissioning a statue of himself, made of timber and plated with gold; he was to be portrayed wearing armour, kneeling on a silver-gilt 'table', and holding his crown in his hands. The figure was to stand three feet (95cm) high, fixed centrally on the crest of the feretory, and boldly inscribed 'REX HENRICUS SEPTIMUS'.[51]

Executing the numerous instructions in Henry's will would doubtless have taken several years, and the golden figure for the shrine may not have been made until *c.* 1511–13. Once this had been mounted on the crest of the feretory, the height of the latter was immediately increased by about a metre, and the medieval canopy would not have been lofty enough to fit over the statue.[52] There would have been no option but to construct a new canopy with an uninterrupted internal void at least 2.0m in height. And that is exactly what we have in the present canopy. Its design and construction can therefore be assigned to the period *c.* 1514–16, which coincides with the purchase of ropes for hanging the canopy in the latter year. 1516 was a date of signal importance at Westminster Abbey, marking the completion and consecration of Henry VII's sumptuous new Lady Chapel, and it was appropriate – even

essential – that the king's bequest to the shrine should be in place for that event.

What we do not know is whether the king's executors paid for the new canopy, because it was necessitated as a consequence of his bequest, or whether Islip himself shouldered the burden. The sacrist's accounts record payment only for the ropes to hang it. Much work was carried out during Islip's abbacy, and in the 1520s he created a two-storied chantry chapel for himself in the north ambulatory, overlooking St Edward's shrine (Fig. 6, no. 4). The upper chapel commanded the most impressive view of the feretory from anywhere in the Abbey, and consequently it would occasion no surprise if Islip had personally commissioned the new canopy (Fig. 397).

We have next to consider how it managed to survive the Dissolution. Once relieved of any statuary or other images that may have been placed in its niches, the canopy had no outward religious connotations: it resembled an item of Tudor furniture, and consequently there was no imperative to destroy or further deface it. It is possible that religious images (the Apostles?) were painted on the twelve panels in the backs of the recesses of the upper chest. Since the entire complement of back panels has long been missing, this cannot be the result of casual loss, and their removal must represent a deliberate act. By knocking out the panels from the upper tier of arches a lantern-effect was created, although perhaps not deliberately (cf. Fig. 384).

In order to remove the feretory and dismantle the shrine pedestal, the canopy had to be winched up, and O'Neilly suggested that it may simply have been left hanging from its ropes. But it seems inherently unlikely that this bulky object would have been allowed to dangle in mid-air for eighteen years. Sooner or later it would have been lowered to the floor in the centre of St Edward's chapel, where its resemblance to a two-tiered tomb-chest would have been strikingly obvious, especially since it was only three metres away from Henry III's similar chest. The very survival of the canopy must imply that a new use was quickly found for it; otherwise this immensely heavy and unwieldy object would have been broken up on site and carted out of the chapel in pieces.[53] That did not happen, and consequently there must be a strong presumption that it never even left the chapel. Royal tombs in Westminster Abbey were not desecrated at the Dissolution,

and the coffin containing the body of Edward the Confessor was preserved intact. Indeed, no attempt was made to open the iron-bound elm coffin, or to rob the saint of the gold cross and chain that he was wearing. They were not looted until 1685 (p. 420).

No record exists regarding the coffin's place of deposition in 1540, and speculations by early antiquaries have not yielded any compelling suggestion. Since history is silent on the subject, coupled with the fact that there was no necessity for the monks to conceal the king's body, the most obvious and reverent solution would have been to leave it in the royal mausoleum-chapel. Once the shrine pedestal and altar had been dismantled, and the stepped podium removed, the coffin could simply have been placed on the pavement and the oak canopy lowered over it, thereby instantly creating a seemly tomb without popish overtones. Acceptance of this hypothesis goes a long way towards resolving the seemingly contradictory evidence surrounding the rein-statement of the shrine in the 1550s, a subject to which we must now turn.

SHRINE OF ST EDWARD: HISTORICAL CONTEXT OF ITS TUDOR RECONSTRUCTION

On the instruction of Henry VIII, the monastery of St Peter, Westminster, was dissolved on 16 January 1540. The diocese of Westminster was created and on 17 December 1541 the former abbey became its cathedral church, administered by a dean and canons. Dismantling the shrine would have taken place sometime between those two dates. The diocese was abolished on 1 April 1550, after barely ten years' existence. Westminster was re-combined with the ancient diocese of London, but the former abbey continued to be run by a dean and chapter, nominally serving as a second cathedral in tandem with St Paul's. This ineffectual arrangement, albeit confirmed by a special Act of Parliament in 1552, continued until 26 September 1556, when the dean and chapter surrendered their church to Queen Mary.[54] A bull issued by Pope Paul IV on 21 June 1555 had retrospectively confirmed the status of Westminster as a secular cathedral.[55]

Mary I ascended the throne in August 1553 and set about restoring Catholicism to England, and

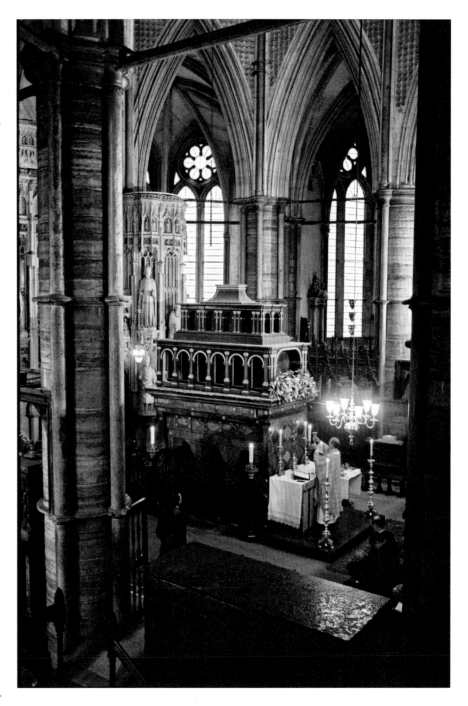

Benedictine rule to Westminster. Before her coronation on 1 October, she replaced the Protestant dean, Richard Cox, with a Catholic supporter, Hugh Weston, and by April 1554 Mary had removed the remaining Protestant members of chapter. The way was now clear for Benedictine observance to return to Westminster. A page of accounts for payments, signed by Weston, contains three non-consecutive references to St Edward's chapel by name; it also mentions the King and the Queen, and hence post-dates the marriage of Philip and Mary, so 1554 x 1556.[56]

397 St Edward's chapel. Eucharist being celebrated at the shrine altar, as seen from Islip's upper chapel in the north ambulatory, 2005. © *Dean and Chapter of Westminster*

- Item for a burthen of Russhes to saynt Edwards chappell 2d.
- Item when the aulter was set upp in Saynt Edwardes chappell against the kynges Ma^tie cumynge for ij burthen of Russhes 4d.
- Item for Saynt Edwardes chappell the same tyme [the coming of King and Queen] for ij burden of Russhes 12d.

Other entries suggest that the royal visit took place on St Andrew's Day, 30 November 1554, when a very large service was held.[57] The next reference occurs in the *Chronicle of the Grey Friars of London*, on St Edward's Day, 5 January 1555:

> … thene was sett up the scrynne [shrine] at Westmynster, and the aulter [altar] with dyvers juelles that the qwene [Mary] sent thether.[58]

These two sources not only confirm that the Catholic liturgy was once again being practised with full vigour in the former abbey, but also that the shrine had recently been 'sett up' and its altar reinstated at the instigation of Dean Weston. This all took place in the latter months of 1554/5.

The mass was doubtless a celebration of the token reinstatement of St Edward's shrine, on his feast day, the first to arise since the eviction of the Protestant chapter. Moreover, for the shrine and its altar to have liturgical veracity, the Confessor's coffin must have been reunited with them. Of course, we do not know precisely what was implied by setting up the shrine and altar, but it was certainly not their full physical reconstruction: that came several years later. If Edward's coffin had been placed upon, or interred in, the floor of the chapel on the site of the shrine, and the canopy lowered over it as a chest-tomb – and that would have been the most logical course of action in 1540–41 – then a token shrine could quickly have been established. An altar would have been constructed from salvaged masonry, and candlesticks placed at the corners of the tomb.

On 26 September 1556 Dean Weston and his chapter resigned, thus ending Westminster's term as a secular cathedral. The queen immediately appointed John Howman of Feckenham as abbot, and the dean and chapter handed over control of the Abbey to him on 10 November; his installation took place eleven days later. John de Feckenham, as he chose to be known, was hitherto Dean of St Paul's, a position to which he had been appointed on 10 March 1554. Under the new abbot, Westminster was once again populated by a Catholic Benedictine community, the members of which had already been approved by the queen. This revival was, however, short-lived since the abbot and monks were ejected for the final time by Elizabeth I on 12 July 1559.

By happenstance, a reference to reinstating the Confessor's shrine appeared in a speech defending the Right of Sanctuary, made before the House of Commons by Feckenham on 12 February 1558. He stated:

> We have here the most precious relics in this realm … the body of that most glorious holy King, St Edward, remaineth there among us, which body the favour of Almighty God so preserved during the time of our late schism, that although the heretics had power upon that wherein the body was enclosed, yet on that sacred body they had no power; but I have found it and since my coming I have restored it to its ancient sepulture.[59]

This speech corroborates Henry Machyn's account of the reinstatement of the shrine. The latter witnessed this momentous event, recording it in two diary entries, the first being on 20 March 1557:

> The xx day of Marche was taken up at Westmynster again w^t a hondered [hundred] lyghts King Edward ye Confessor in ye sam[e] plasse wher ys [his] shrine was and yt shalle be sett up agayne as fast as my lord abbott [Feckenham] can have yt don for yt was a godly shyte [sight] to have seen yt how reverently he was cared [carried] from plasse yt he was taken up wher he was led [laid] when yt the abbay was spowlyd [despoiled] and robyd and so he was cared [carried] and goodly syngyng and senssyng as has bene sene and masse song.[60]

The entry records the ceremony preceding the reinstatement of the marble shrine pedestal, when Edward's coffin was taken up from the place where it had been laid in 1540 and carried in procession with much ceremony to an unspecified location. Significantly, there is no mention of exhuming the coffin from the ground or removing it from a vault, but simply to taking it up from the place where it was *laid*.[61] If the coffin had been laid on the pavement on the site of the former shrine, as we have argued, it inevitably had to be temporarily removed from the chapel to a place of safety while rebuilding of the pedestal was in progress. The same would apply if the Confessor's coffin had

been buried in the floor of the chapel. Machyn does not recount where the coffin was taken during the ceremony, but it cannot have been far from the chapel. Most plausibly, the saint was placed in the sanctuary, in front of the high altar, for the duration of the work on the shrine. Returning the saint to his original tomb-chamber was no longer an option, since access to it had been blocked since 1440 (p. 303).

Machyn's second diary entry came a month later, on 19 April 1557, when he

> … went to Westminster to hear mass and to the lord abbots to dinner the duke of Muscovea, and after dener came into the monastery and went up to se sant Edward shrine nuw set up and there saw all the plasse …

Reconstruction of the shrine and its altar can thus be confirmed within the date-bracket of March–April 1557. Many commentators have observed that the shrine shows physical signs of being hurriedly reconstructed, and Machyn's diary entries confirm that reinstatement was indeed rapid. Reassembly of the basic marble structure could have been achieved in that time, but cutting the new cornice moulding, infilling the matrices that had lost their original mosaic with plaster, and exquisitely painting them with *faux* mosaic, would have taken months, perhaps even carrying the work into 1558. The tasks involved were painstaking and required specialist craftsmen. We have already demonstrated that the monumental canopy – usually attributed in error to Feckenham – was not a product of this era (p. 404).

Abbot Feckenham has invariably been credited with restoring the Confessor's shrine pedestal, and this is confirmed, not only by the House of Commons speech, but also by the painted inscription running around the frieze which bears his initials: *IFA* (*Iohannes Feckenham, Abbas*; see p. 419; Fig. 411). The sequence of events is not difficult to reconstruct. The unsatisfactory state of affairs found by the abbot when he arrived in Westminster would have been wholly unworthy of one of England's premier saints: his coffin probably lay on the pavement under a makeshift tomb, with a token altar alongside it. Consequently, the abbot set about restoring some semblance of dignity and *gravitas*, replacing the temporary arrangements introduced by the preceding dean and chapter with a permanent structure.

ABBOT FECKENHAM'S RECONSTRUCTION OF THE SHRINE PEDESTAL AND ALTAR, 1557

The reconstruction was *ad hoc* and not super-intended by anyone with profound knowledge of the original shrine. Elements of the Purbeck marble pedestal were missing, or too badly damaged to reuse, and much of the 13th-century mosaic work lost, leaving empty matrices. With some ingenuity, Feckenham's mason partly re-designed the shrine, to make use of the available materials, and added a wholly new cornice of classical design. This was cut by someone who was familiar with the vocabulary of classical architecture. The mason rearranged the west end, omitting the upper register of decorative panels, the inscription course and the projections at the north and south angles, together with the two spiral columns that supported them. The shrine altar retable had survived, was reinstated and supported by a pair of stout twisted cosmatesque columns that were not originally part of the monument. Cohesion of the decorative surfaces was achieved by infilling the empty matrices with plaster and painting them with *faux* mosaic, adding a new honorific inscription to Edward the Confessor around the frieze, in place of the largely lost mosaic one. Finally, he reinstated Henry VII's (or Islip's) monumental timber and glass-inlaid feretory canopy that still crowns the shrine-tomb.

Very little documentation exists concerning physical aspects of the shrine subsequent to its reconstruction in 1557. By the time antiquaries began to illustrate it, the altar had gone for a second time, the canopy had been badly damaged and the pedestal largely depleted of its mosaic decoration, both real and *faux*. The shrine of St Edward was robbed of its 'golden feretory' and other valuable materials on the order of the Vicar-General in 1536, four years prior to the Dissolution of the abbey, but the fate of the Purbeck marble pedestal and the coffin containing the corporeal remains of Edward the Confessor appears to have escaped record. Historians have tended to gloss over this important issue, simply asserting that the coffin was interred, either on the site of the shrine, or at another unspecified location within the Abbey. Early opinions varied as to whether the shrine was completely dismantled, or only partially

so.[62] That the pedestal was indeed totally dismantled in 1540, or perhaps 1541, and the component parts stored somewhere in the precinct, is not in doubt, but no record of this operation has come down to us.

Although it does not appear to have attracted comment hitherto, it can be deduced that the components were stored out of doors and consequently suffered from weathering. Purbeck marble, especially the more granular variety, is easily damaged if it becomes water-soaked, and subjected to frost. Some elements, particularly on the north side of the shrine, display typical water/frost damage, but others do not (Figs 324 and 325). Interestingly, several slabs show only partial damage, with a definable interface between the area that has suffered erosion and that which has not. This leads to the conclusion that the slabs were stacked in a heap and that those on top (and others partly protruding from the stack) were not protected from rain and frost. The slab embodying the three trefoil arches on the north side was especially badly damaged: the remnants of the guilloche moulding on the lintel were entirely plastered over and the decoration reinstated in paint. Most of the plaster has subsequently been lost, but a thick patch of it survives over bay 6.

The pedestal and sarcophagus chamber

Although in the 13th century the pedestal was raised on four steps, Feckenham recovered enough blocks only to construct a single-stepped platform. The patterns of wear on the stones, together with redundant pockets for former iron cramps (and other housings), confirm that the blocks were not reassembled in their original configuration. The reconstructed step was laid directly upon the Purbeck marble paving that had previously supported the shrine. But with fewer steps, the footprint was smaller, and hence areas of undecorated paving that were formerly concealed from view now became visible as plain strips along the north, south and east sides of the shrine (Fig. 230).

The pedestal was re-erected, maintaining the rectangular chamber immediately above the vaulted niches, which served as a stone sarcophagus to hold the Confessor's wooden coffin (Figs 374, 398–401). According to a 17th-century account, the latter was made of elm boards, bound with iron (p. 420). The dimensions of the chamber were 2.28m long by 83cm wide and 95cm deep, and the void was spanned, at slightly above mid-height, by two wrought iron ties (20mm square): one halfway along the chamber, to prevent the north and south sides from spreading apart, and the other at the foot-end to strengthen the inherently rather weak eastern corners. The coffin had to be *in situ* before the tie-bar could be inserted midway along the chamber. The blocks forming the two uppermost courses of the 13th-century work were then laid, trapping both bars.

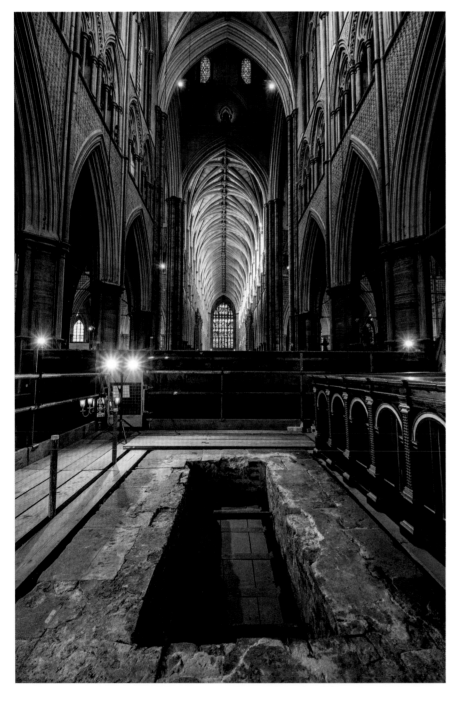

398 St Edward's shrine. The top of the pedestal with the Tudor timber canopy removed, revealing the Confessor's outer coffin of 1685. View west. © *Dean and Chapter of Westminster*

0 1 m ——— Registration line for tomb cover DSN

The small Cosmati-decorated plinth, upon which O'Neilly argued the 'golden feretory' previously rested, was redundant and not replaced. Instead, Feckenham incorporated the blocks from the original feretory plinth into a frieze, and above that added an entirely new moulded cornice. The result was a fully classical entablature, comprising architrave, frieze and cornice. Internally, he raised the sides of the chamber, using a combination of Tudor brick and masonry. The latter was cut entirely from reused blocks, mostly of Reigate stone but also incorporating a few of Caen stone. Several blocks display dressed arrises, chamfers and tooling relating to their previous uses, but two also retain moulded detail. The block forming the south-east angle of the cornice is part of a 14th-century blind panel with curvilinear tracery, probably derived from a screen: a complete *mouchette* and elements of foiled work are preserved (Figs 399 and 402). The large slab at the west end, adjacent to the south corner, is also derived from a panel of blind tracery.[63]

The former feretory plinth course – now reused as a frieze – was decorated with rectangular panels of mosaic, separated by roundels, each containing a single circular disc (1, 21, 31, 51; p. 332). Only the mortar beds for two of these discs survive at the west end (where they were obscured by the Tudor work: Fig. 307), and reveal that the inserts were smooth-faced, flat and 3–4mm in thickness. They were presumably glass. Although the discs had already been lost, Feckenham's reconstruction perpetuated the scheme: he added fresh mortar beds and pressed into them smooth-faced circular discs that were uniformly 2mm thick. Presumed also to have been glass, they too have gone. Vertue's engraving shows alternating red and blue roundels (Fig. 300).

O'Neilly drew attention to the correspondence between the dimensions of the shrine-top (minus the Tudor cornice) and the pre-Reformation timber canopy, arguing that originally the top of the pedestal was stepped and had no cornice.[64] We have already noted that O'Neilly painstakingly elucidated the mistakes and alterations inherent in the reconstruction and made timber models to

399 St Edward's shrine. Plan of the top, showing the structural components of the Tudor cornice, including iron cramps. The line scored in the top of the masonry (shown here in red) marks the position for seating the timber canopy. The lid of the 1685 coffin and its ironwork are also visible. *Drawing by David S Neal*

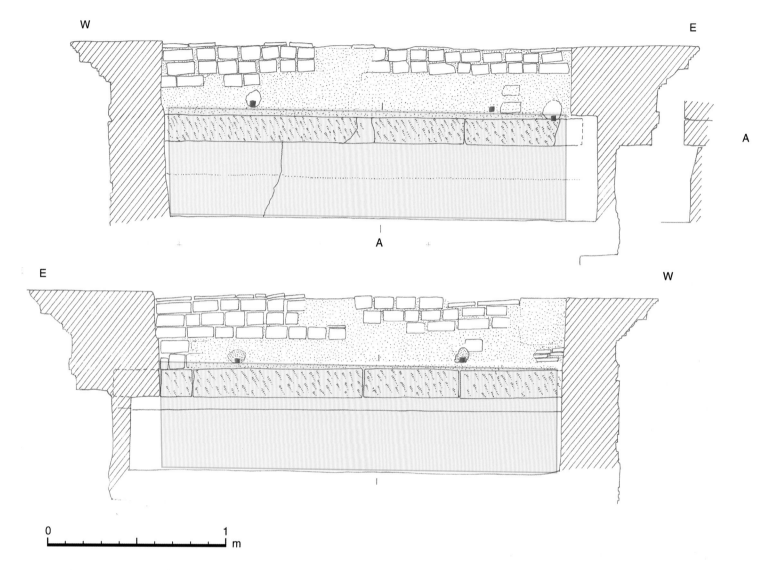

400 St Edward's shrine. Sectional elevations of the north and south sides of the coffin chamber, showing its Tudor heightening in brick and rendered rubble. The outline of the coffin is indicated in brown tone. The line of flat blocks that is almost level with the top of the coffin is primary and equates with the inscription course. *Drawing by David S Neal*

demonstrate not only how the components of the pedestal were originally arranged, but also their subsequent reconfiguration (p. 379; Fig. 376).

Iron dog-cramps, unskilfully set in lead, were used to tie some of the cornice blocks together, including those at the corners of the pedestal (Figs 399 and 403). The inner wall-face of the chamber containing the coffin was continued upwards, to the same level as the new external cornice, using red brick and a levelling course of thick peg-tiles, set in lime mortar.[65] The workmanship is crude (Figs 404 and 413). There is no evidence for the burial chamber having been capped, unless it was by a loose board: instead, the timber canopy was simply placed over the void. A rectangular outline scored on the top of the cornice blocks aided the correct registration of the canopy (Figs 399, 403 and 405).

Also on the upper surface of the cornice are two groups of graffiti (Figs 403 and 405). The first, at the north-west corner, comprises a series of curvilinear lines. These were not merely scratched with a sharp point, but were made with deliberation, using an engraving tool (or similar) which was rocked as the lines were deeply scored; that imparted a regular texture into the incisions. Two of the marks are S-shaped, but two others are more complex, having the appearance of the Arabic numeral '3'; and adjacent to one of these is a lightly incised sub-rectangular graffito, traversed by straight lines. The second group of graffiti comprises a pair of fish on the south side, adjacent to the west corner. These were lightly scored with a sharp point (Fig. 405). All the graffiti are outside the positioning-line for the canopy, implying that they were incised with the latter in place. It is also strikingly apparent how much the exposed upper faces of the Reigate stone blocks have eroded since 1557: where the stone has been protected beneath the timber canopy, tooling

marks and finely finished surfaces are well preserved, but outside the registration-line they have been heavily degraded (Fig. 406).

In the reconstruction of 1557, the chambered upper stage was retained, and the coffin installed therein. The coffin is only about 33cm deep, whereas the chamber – including the Tudor cornice – has a depth of 95cm. Consequently, there is a sizeable void above the coffin (see further, p. 421 below; Fig. 404). There was thus no practical need for Feckenham to have heightened the chamber, and we can only presume that he did so (adding the cornice) for aesthetic reasons. There remains the unresolved matter of why the south side of the chamber internally has a horizontal channel running from end to end, and the north side a corresponding continuous bevel (Figs 401 and 407). Both run along the top edges of the side slabs, where they serve no function. They would have been at or just above the lid-level of the pre-1685 coffin, which prompts the suggestion that these features could have been housings for a large timber plank covering the chamber. However, logistically that will not work because it would have been impossible to insert the cover once the entablature had been constructed.[66] They cannot be related to the Tudor reconstruction of the pedestal, and it has already been suggested that the rebate and bevel are redundant medieval features, which would have been on the lower edges of the side slabs before they were transposed and inverted in 1557 (p. 381; reconstructed on Fig. 374).

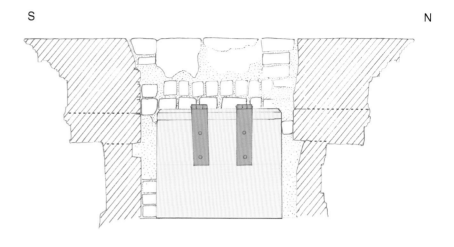

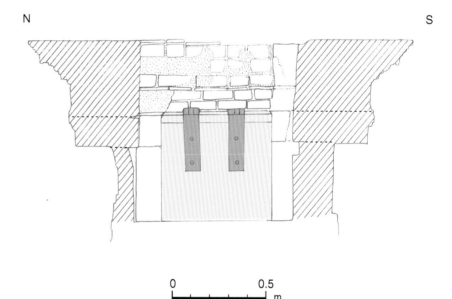

401 St Edward's shrine. Sectional elevations of the west and east ends of the coffin chamber, showing its Tudor heightening in brick. Each end of the coffin is drawn in its respective position, but the image has been reversed in order to show the iron straps. *Drawing by David S Neal*

402 St Edward's shrine. Top of the Tudor cornice at the south-east corner. The reused block of Reigate stone was previously part of a screen or wall-panel decorated with blind curvilinear tracery. The decoration was doubtless once infilled with mortar, but the slender edge of the moulding has broken away and the mortar removed (probably by a curious antiquary). © *Dean and Chapter of Westminster*

403 St Edward's shrine. Top of the Tudor cornice at the north-west corner. This shows the iron cramps securing the blocks of Reigate stone, the registration-line for seating the timber canopy and various graffiti. © *Dean and Chapter of Westminster*

413

404 Shrine pedestal. General view of the chamber and top of the outer coffin of 1685, looking west. © *Dean and Chapter of Westminster*

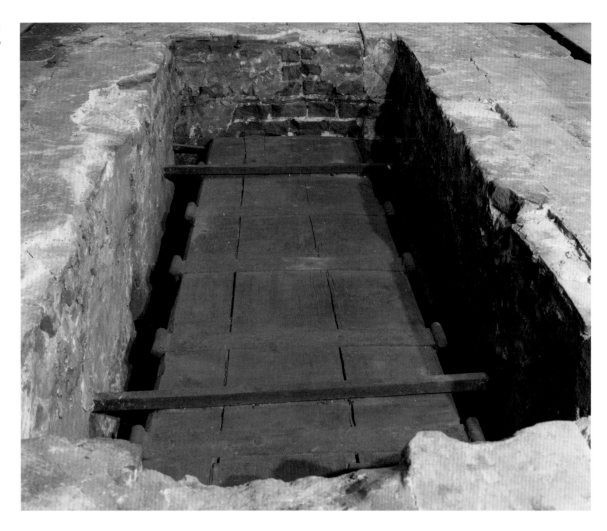

405 St Edward's shrine. Graffiti on the upper surface of the Tudor stone cornice at the west end. A. Group of motifs, including the numeral '3' on the west side; B. Two curvilinear marks (serpents?) on the north side; C. Two fish on the south side. © *Dean and Chapter of Westminster*

Although the shrine pedestal and altar were hurriedly and incorrectly reassembled, this was not an overnight task. At least one major panel of Purbeck marble had been lost from the east end (p. 363), and was replaced with two much thinner slabs, as can be seen in the longitudinal sections (Fig. 400). The west end is largely missing, and other smaller parts were either misplaced or

lost altogether (p. 350). The losses included the capitals and bases for the two eastern colonnettes: replacement capitals previously unconnected with the shrine were substituted (Figs 312 and 354); the restored spiral shafts were made up from original fragments, and included a moulded base. The two western colonnettes are entirely missing.

The overall size of the rebuilt pedestal was

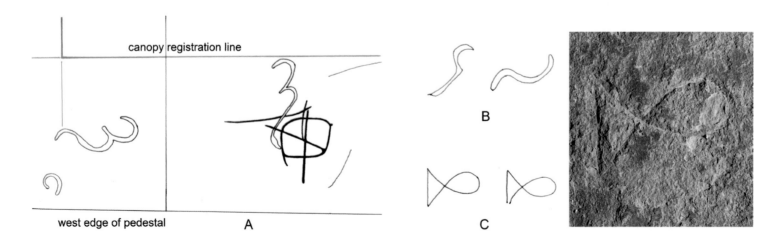

414

almost the same as it was in the 13th century, but the redesigned entablature required the frieze (formerly the feretory plinth) to be lengthened by 28cm at the west end (p. 351). Instead of being inset from the outer edge of the upper panelled zone, the components were now used to make a frieze flush with the perimeter. A new section of Reigate stone frieze was prepared for the west end, with returns of 20cm at both corners (Figs 330 and 335). However, there was still a shortfall of *c.* 7.5cm in the overall length of the north and south sides, and so two small blocks were made to fill the gaps (Figs 307 and 308). When Scott repositioned the retable in 1868, he had temporarily to remove Feckenham's western section of frieze, and in so doing would have discovered that it (and the two small inserts) concealed the original 13th-century western returns on the north and south sections of frieze. In order to render this archaeological discovery accessible, when he reassembled the west-end frieze, Scott did not bed the two infill blocks in mortar. Consequently, they can easily be withdrawn, facilitating inspection of the hidden medieval detail (Fig. 329, E).[67] Creating access points to facilitate inspection of archae-

ologically interesting features was one of Scott's trademarks.[68] Westlake noticed that the masonry plugs were removable, but was at a loss to explain their purpose.[69] He assumed that they must have had a specific function, and offered various conjectures, such as their being pockets into which timbers could be inserted, or channels through which the saint's coffin could be glimpsed, neither of which was a practical proposition.

Decoration and defacement

It is readily apparent that the majority of the 13th-century mosaic decoration and marble inlay had been robbed from the shrine components before Feckenham ordered their re-erection. It is equally clear that he was not in a position to reinstate the structure, using the appropriate natural stone for repairs. No attempt was made to recreate mosaic in gilded or coloured glass, but some glass was employed for roundels. The Confessor's shrine was a major national symbol of the Catholic faith, the work was urgent and funds scarce; consequently, filling the empty matrices with fine-grade lime plaster and over-painting them with *faux* mosaic was an expeditious alternative. The quality of the artwork was high and was clearly executed by a skilled painter. Moreover, it can be demonstrated that, where traces of the original mosaic design survived, the painter often took these as his cue: patterns were not created at random, except where there was no surviving evidence for guidance. Some of the larger panels – and small roundels too – had been filled with slabs of purple or green porphyry, with or without mosaic borders. Again, respect was shown for the different forms of treatment, and this is even more evident on Henry III's tomb (p. 475). Thus, on the shrine, some tessellated roundels in the niches were restored in paint, as in bays 3 and 5 (Figs 317, 346 and 348). On the other hand, it would appear that all the roundels on the retable were originally filled with glass discs, but Feckenham reinstated them with painted plaster (Fig. 335). Full descriptions of the Tudor *faux* mosaic are given in chapter 10, along with the medieval work, panel-by-panel.

Although Feckenham did not introduce any new marble, he replaced numerous discs with a smooth-faced material that was only *c.* 2mm in thickness: this could have been either glass or metal, but none survives today. He also set a single,

406 (*Left top*) St Edward's shrine. Top of the Tudor cornice at the south-west corner, showing the degree of stone erosion that has occurred since 1557. Where the masonry was protected by the canopy, the original surface and tooling are perfectly preserved but, outside the canopy-registration line, atmospheric dampness and pollution have significantly eroded the surface. *Authors*

407 (*Left bottom*) St Edward's shrine. Horizontal channel (arrowed) of uncertain purpose, extending along the full length of the south side of the coffin chamber. © *Dean and Chapter of Westminster*

small square plaque into plaster in bay 2; this lay at the end of a rectangular panel, at the centre of the south elevation, and was the only square decorative insert on the restored pedestal.[70] Hence, there was presumably something special about it: perhaps it was of sheet metal and bore a monogram or diminutive inscription. Sometime after the plaque had been prised out, the matrix was inscribed with a group of undated initials (Fig. 310A, B). The lozenge in the south face of the upper stage, above niche 3, displays evidence of an attempt to repair what must have been the original marble insert. Its matrix is empty today, but retains two types of plaster. The bed is intact, as is some of the plaster that surrounded and gripped the 12mm-thick lozenge (presumably porphyry). One-third of the bed is smooth and bears the impression of the lost panel; the remaining two-thirds also preserve the original bed, but here the surface has been finely pecked all over. The purpose of this was to facilitate adhering something to it. Also, along part of the western edge of the matrix is a fillet of white secondary plaster coinciding exactly with the extent of the pecking on that side. It would appear that the primary stone insert was fractured – perhaps in an attempt to remove it – and the detached piece was reinserted, adhering it to the existing (pecked) bed and filling the joint between the slab and the matrix with new plaster.

There is tantalizing evidence on the north side of the pedestal, indicative of the incorporation of single sheets of glass in the three large lozenge-shaped panels (Fig. 305, nos 34–38) of the upper stage. The lozenge in panel 34 was pressed firmly into a bed of wet plaster, where continuous contact was made around the margins, but not to the same degree in the centre. Impressions of a faint border forming a regular chequer pattern are present, consistent with thin lines having been painted on the reverse of the glass (Fig. 322). A vertical disjuncture in the plaster, close to the centre of the lozenge, runs from its lower edge to meet another disjuncture in the form of slightly curved line, cutting off the upper obtuse angle; the cut-off portion is itself subdivided by a break in the plaster, towards the west end. This exactly what one would see if the lozenge were a sheet of painted glass that had fractured into four pieces while being pressed into the plaster.[71]

The question arises: what was the date of these glass lozenges? They were undoubtedly Tudor

insertions, but might they have been primary material, salvaged and reset? The impressions left in the plaster by the tiny ridges of paint prove that the decoration was applied to the reverse, and would only have been outwardly visible if the glass was clear. All the tesserae painted on plaster in the Tudor *faux* mosaic were delineated with thin white lines, but that could not have obtained in respect of the glass lozenges. Being bedded on plaster, the background behind the glass would have been white, and any similarly painted lines would have been invisible. Consequently, a contrasting colour would have been necessary to 'read' the design. An alternative scenario needs to be mentioned, even if it is less likely. The lozenges could have been of medieval coloured glass, originally decorated on the outer face, but were salvaged and reversed during the Tudor reconstruction. One has only to look at the sheets of cobalt blue glass, with linear decoration executed in mordant gilding, on the Westminster Retable to appreciate the possibilities (Fig. 514).

Impressions in the plaster bed in panel 36 are fainter and less well preserved, but appear to define a simple chequer pattern, again painted in relief on glass. The edges of the lozenge are sharply defined by the plaster bed, revealing how it was carelessly set off-centre within the marble matrix (Fig. 323). The third panel (38) has been filled with rough secondary plaster, obscuring any remaining evidence of an earlier inserted lozenge. Presumably there was one, otherwise the matrix would have been infilled with Tudor plaster and painted with *faux* mosaic.

The temptation to inscribe plaster – and hence to deface the painted Tudor decoration – could not be resisted by visitors to the shrine, who left behind scores of graffiti. Most are crudely incised, often rather faint, and many intercut (cf. Fig. 310B). On the other hand, there are some carefully executed cursive inscriptions, diminutive in scale: e.g. *Ora pro die*, on the 17th-century white plaster on the lintel over bay 2. Very few graffiti incorporate religious symbols: e.g. a roundel on the south elevation was scratched with a long Latin cross flanked by the initials *PH* (Fig. 310C). More emphatic are two fish incised on the top of the cornice, where they cannot be seen from floor level (Figs 405C and 406). Legible dates are not numerous, but the earliest noted is 1620 (p. 320). One of the roundels on the retable retains clear evidence for the mortar bedding that

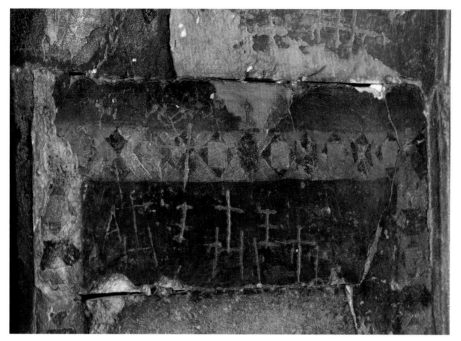

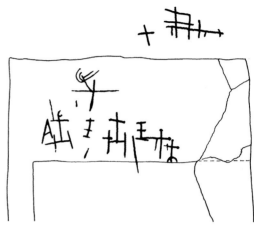

held the original medieval disc, which was probably opaque glass;[72] that was lost and its matrix infilled with Tudor plaster, painted red. Then, in 1790, B. Clifton inscribed his name and the date (Fig. 334).

On the west flank of niche 3 is a series of graffiti, scratched into the painted Tudor plaster. Some of the incisions take the form of Latin crosses, but others look more like tally marks (Fig. 408). Tanner reported the ensemble as crosses inscribed by pilgrims,[73] but it is curious that the marks are found only in one small area of the shrine and are so similar in appearance as to suggest that they were the work of a single hand, although probably inscribed on different occasions. While the uppermost of incisions could be tally-marks, the lower group has the appearance of a meaningful series. Reading from the left, are: the letter 'A'; a Latin cross standing on the horizontal bar of an H-frame; a barred letter 'I'; another cross standing on an H-frame; another barred letter 'I'; a cross; and a smaller cross with a semicircular foot. Obviously, the group has a *terminus post quem* of 1557, and a date in the late 16th- or early 17th-century seems most likely.

Very few graffiti appear to belong to the 19th century, and some of those were executed in pencil. Thus, there is one dated 1866 on the plaster infill of the lozenge-shaped panel above niche 7. Making a complete record of the innumerable graffiti on the shrine pedestal is a task that awaits the undertaking.

The secondary inscription

Abbot Feckenham not only attempted to restore two royal monuments and as many of the liturgical furnishings as were capable of being resurrected, but also attached historically descriptive labels to many items. Whether this was primarily to remind the brethren of the antiquity of their surroundings, or was for the benefit of pilgrims and visitors, we cannot determine. Doubtless it served both functions. His inscriptions were in Latin and, where possible, were painted directly onto the monument in question. If that was not feasible, the text was applied to a panel, placed alongside the subject to which it referred.

Thus, in St Edward's chapel a painted inscription on plaster ran around three sides of the shrine pedestal. The tombs of Henry III and Edward I were given boldly painted texts that were intended to be read from the ambulatory. The former reminded the beholder that Henry was the builder of the abbey (p. 476; Fig. 475), and the latter alluded to the Scottish wars and included the soubriquet 'Hammer of the Scots' that Edward had acquired. Labels were probably appended to all the major monuments, and there was even one painted on the arch moulding above the child's Cosmatesque tomb in the south ambulatory (p. 483; Fig. 481).[74]

Where it was not convenient to add an inscription to an item, it was written on a separate *tabula* (plaque). The Coronation Chair, kept in the shrine chapel, bore a *tabula* that alluded to Edward

408 St Edward's shrine. Post-medieval graffiti in the form of crosses, and possible tally-marks, scratched into the painted Tudor plaster in niche 3. © *Dean and Chapter of Westminster*

I and his acquisition of the Stone of Scone.[75] Edward III's shield and Sword of State were displayed next to his tomb, and were likewise labelled. In the mid-16th century the Abbey must have assumed the air of an art gallery or museum. Feckenham was not, however, the originator of Westminster's *tabulae*: a silver one, set up at the altar of St Edward, was repaired in 1377/8;[76] and there was a painted wooden example in 1394/5.[77] All the non-attached *tabulae* were lost long ago, and most of the *in situ* painted inscriptions have succumbed too. Camden was the first historian to record the inscriptions *en masse*, but other visiting antiquaries in the later 16th and 17th centuries also transcribed those that interested them.[78]

Feckenham's painted inscription around the shrine was restricted to the north, south and east sides; the west end was unavailable since the frieze there was covered by the repositioned retable (Fig.

409). The text bore no relation to its 13th-century predecessor (p. 385), mentioning only the Confessor, and not Henry III. Most of the text remains on the north and south sides, but the plaster bearing the inscription was stripped from the east end of the shrine in 1741 (p. 314), thereby destroying a section of the text. Fortunately, the full reading has been preserved by antiquaries who transcribed it, and is given below.[79] The surviving part of the text is emboldened, and the positions of the three foliate motifs are marked with asterisks (★) (Fig. 410). The letters are 40mm high – smaller than those of the primary inscription – and stops between words vary in style; most are lozenge-shaped colons, but one is a semi-colon. These differences are shown on the illustration and the transcription below. Most of the roundels interrupting the original inscription were retained.

The lost section of inscription on the east face is taken from Widmore's transcript.[80]

409 St Edward's shrine. Abbot Feckenham's painted inscription on plaster, 1557: (a–c) south face; (d) east face; (e–g) north face. Most of the inscription can still be discerned, except where the plaster has been hacked off the east end of the pedestal; there, the text has been reconstructed from historical evidence. *Painting by David S Neal*

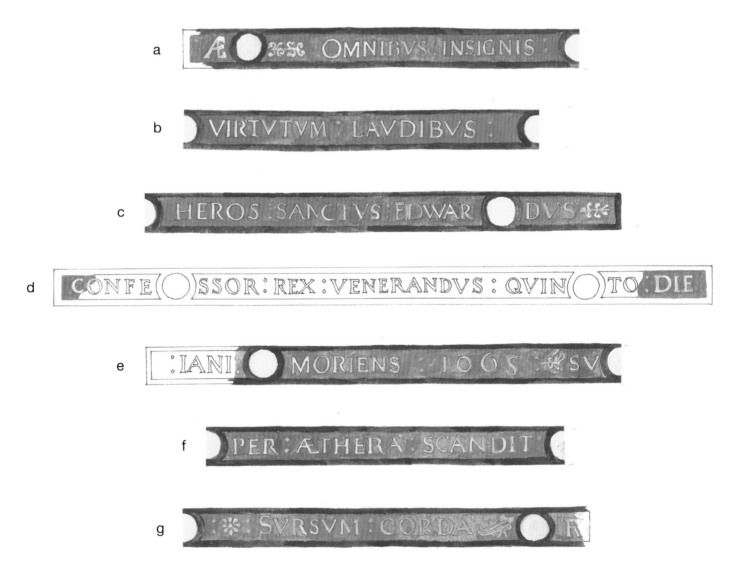

A B

C D E

410 St Edward's shrine. Details of Feckenham's painted inscription. A. The opening *IFA* monogram, partly overlying the infilled matrix of a primary roundel (*a*), to the left three blue glass tesserae surviving from the primary inscription course, and to the right the impression made by a 16th-century glass roundel (*b*); B, C, D. Flourishes acting as space-fillers; E. The closing *IFA* monogram. *Authors*

South

IFA ★ OMNIBVS : INSIGNIS : VIRTVTVM : LAVDIBVS : HEROS : SANCTVS : EDWARDVS

East

CONFESSOR : REX : VENERANDVS : QVINTO : DIE

North

IANI : MORIENS 1065 : SVPER : ÆTHERA : SCANDIT : ★ ; SVRSVM ; CORDA ★ : IFA

IFA ★ Edward, hero and saint, pre-eminent in all the praises of his virtues, Confessor, King, venerable [to be revered?], dying on the 5th day of January in 1065, he ascends above the heavens ★ Lift up your hearts ★ IFA

The lettering is painted in gold on a background of dark blue, consciously imitating the primary inscription composed of gold-foiled glass set against a background of cobalt blue glass. Three discrete foliate flourishes served as space-fillers. This inscription provides proof that it was Feckenham, and not some later antiquary, who was responsible for the post-Dissolution labelling of monuments in the Abbey. He initialled it twice: **IFA** (*Iohannes Feckenham, Abbas*) (Fig. 411). At the beginning are the ligatured letters **FA**, overlaid on a thinly sketched flower, the stem of which

substituted for the letter **I**. The monogram at the end of the inscription comprises the letter **I**, followed by a ligatured **FA**. These monograms, or 'sigles' as he called them, were first drawn by Gough in 1781.[81] Failing to comprehend their significance, he wrote:

> At the head and end of this second inscription are these sigles, which to better mystagogues than myself may unravel the whole. The first is most unfaithfully given, the other totally omitted, in Vertue's and Dart's plates.

ACCIDENT AND INTERVENTION, 1685

Whenever a coronation occurs, extensive works are undertaken in Westminster Abbey to provide additional seating, and these invariably involve the construction of temporary galleries. Many complaints have been recorded over the centuries concerning damage inflicted on the fabric and fittings, and one such instance was reported in 1685 in relation to works associated with the coronation of James II on 23 April, when a scaffold pole or plank fell from a high level on to the

411 St Edward's shrine pedestal. Two monograms composed of Abbot Feckenham's initials, *IFA* (*Iohannes Feckenham, Abbas*), at the beginning and end of the painted inscription (cf. Figs 409 and 410). Drawn by Richard Gough, 1781. *Gough 1786, 3*

419

shrine, breaking a hole in the lid of the Confessor's coffin. This gave rise to a fresh intervention in the shrine. The incident is best known for the fact that it facilitated the theft of the Anglo-Saxon gold cross and chain from the Confessor's corpse.[82] Ancient textiles in the coffin were also pilfered.

The accident is recorded by Prebendary Simon Patrick (later Bishop of Ely) in his diary:

> When the workmen were making scaffolds in the Church of Westminster for the Coronation of K. James, they chanced to bore a hole in the tomb of Edward the Confessor: so that they could see the shroud wherein his body was wrapped; it was of mixed coloured silk, very fresh. By this they got a great deal of money from people who hearing of it came to see it; and made the hole wider and wider, till they could put their hand into the tomb. Which one of the vergers hearing of, went and forbade them to suffer this, or threatened to have them turned out of their work by Sir Christopher Wren. This made them forbear to admit people to come into the chapel. But one Taylor, being a singing man in the church, prevailed with them one day to let him in with some friends of his to see the tomb; and he thrust his hand so far as to pull out the shroud, and together with it a crucifix hanging on a gold chain, weighing about ten guineas. This he brought to the chanter of the church, who went immediately to search if he could find anything more, but could not, only several bones, and particularly a thigh bone, which was very large. Then he carried the crucifix to the Dean, the Bishop of Rochester, who went with Taylor to the King, representing to him how honest he was in not concealing his treasure. His Majesty was highly pleased with it, and pulled a crucifix out of his pocket, and showed it to them, telling them it was his late brother's. He immediately ordered Taylor fifty pounds which was paid him out of the privy purse. And he spake to Sir Christopher Wren to make up the coffin strongly again, which was only of elm, hooped with iron, very coarse and cloutery.[83]

The king ordered the coffin to be encased within another, made of two-inch thick oak planks and bound with iron, so that future unauthorized access would be impossible; Sir Christopher Wren was charged with the task. To achieve this, Edward's damaged coffin had to be lifted out of the chamber, and that involved first removing the iron tie-bar that crossed over it at the mid-point;

the empty pockets remain in the side walls. The new outer coffin, which is tapered in plan, was presumably made no larger than was necessary for it to encompass the medieval one, and still be capable of fitting within the chamber (Figs 390 and 404).

St Edward's coffins

We have but the briefest description of the saint's medieval coffin, which Patrick recorded as 'only of elm, hooped with iron, very coarse and cloutery'.[84] It is most unlikely to be post-Dissolution, and there are three potential dates for this coffin: (i) it could belong to the Confessor's primary burial in 1066; (ii) his first enshrinement in 1163; or (iii) his second enshrinement by Henry III in 1269. The description is so alien to the spirit of Henry's lavish veneration of the Confessor that the last date can be ruled out. Moreover, Henry would certainly have regarded the coffin as an important secondary relic, and therefore respected it. Iron bindings were commonly attached to Anglo-Saxon timber coffins, but are found on some of medieval date too. They usually took the form of angle-brackets and straps that held the base, sides and ends together; the lid was generally attached by nailing.[85] Edward's corpse was inspected on several occasions, implying that the lid was readily detachable (see above p. 306). Since the corpses of saints were frequently re-dressed and re-coffined when they were first enshrined, the date of 1163 might be considered as the most likely (see further below, p. 423). On the other hand, it could be argued that the simplicity of the coffin was more in keeping with the original interment. Without physical examination, it is impossible to determine the true date of the coffin. However, the 11th-century textile in which the corpse was wrapped was undoubtedly associated with the primary burial, and thus provides a significant pointer to the likely date of the coffin itself.

The wrapping of the body was described as 'a mixed coloured silk, very fresh',[86] and pieces of this material were taken from the coffin by souvenir hunters in 1685. Despite the king's instruction, protecting the Confessor's coffin from pilfering and desecration was not afforded high priority, since it was still accessible seven weeks after the coronation. Fragments of patterned silk survive in two public collections,[87] and there is

also a tiny square of another silk, described as coming from the Confessor's burial shroud (p. 423; Figs 414–416).[88] Additionally, in 1398, Richard II gave to his uncle, the Duke de Berry, a 'small piece of cloth-of-gold, wherein are contained fifty-four gold buttons'. This was presumably a pouch, and the cloth was described as having come from the primary burial of Edward the Confessor.[89]

The medieval coffin was tapered in plan and still survives, encased inside what we shall call the secondary coffin, made in 1685. The latter's overall dimensions are 2.23m long by 67cm wide at the west end and 59cm at the east end; the depth is 57.5cm, and the thickness of the oak planks varies between 5.0cm and 7.0cm (Fig. 399). The dimensions of the inner coffin can be approximately deduced since they must be at least 12–15cm less in both length and width than the outer coffin. The depth can, however, be shown to be *c.* 12.5cm less than that of the void inside the 1686 encasement.[90] Hence, the overall dimensions of the medieval coffin could be up to 2.08m long by 55cm wide (west end), and 33cm deep. Early medieval timber coffins exceeding 2.0m in length are rare, the average for adult males being *c.* 1.80–1.90m. Nevertheless, the longest of a group of coffins excavated at Barton-upon-Humber (Lincolnshire), and dating from the late 11th and early 12th centuries, was 2.04m.[91]

The only previous investigation of the upper part of the shrine pedestal and its contents was hurriedly carried out by Westlake in 1916, when dimensioned sketches were made and a single photograph taken (Fig. 385).[92] A close examination of the secondary coffin was conducted in 2018, without disturbing it. The coffin carries no elaboration beyond a small chamfer on the arris of the lid.[93] Each side is made from a single plank, and both the lid and the base from two planks. The timbers of the lid are butt-jointed, their edges counter-rebated and five stout iron spikes driven in edgewise to secure them (Fig. 399).[94] The side planks rest upon the base-board and the ends are fitted between the sides, to which they are attached with five iron spikes at each corner.[95] Heavy hinge-like straps were employed to secure the lid, five running transversely and two at each end. All were fashioned from wrought iron bars 8cm wide by 4–5mm thick, trenched into the planks. The transverse bars have knuckle joints at each end, attached to 30cm long straps, riveted to the sides

412 St Edward's outer coffin, 1685. Detail of the east end of the lid and its iron strapwork. © *Dean and Chapter of Westminster*

of the coffin. The east and west end straps are necessarily short, each comprising only two components of equal length (30cm) connected by a knuckle joint: basically, these are conventional strap-hinges (Figs 401 and 412). The account for the outer coffin is extant:

> Paid to Matthew Bankes for a large coffin by him made to enclose the body of Edward the Confessor and setting it up in the place in the year 1685 – £6 2s. 8d. And to William Backe, Locksmith, for large hinges and rivets and 2 crossebars for the said coffin £2 17s. 7d.[96]

The logistics of constructing the secondary coffin and transferring the saint's body to it are of interest. Although the straps have the outward appearance of being hinges, it would have been impossible for any of them ever to have functioned as such, since they are all rigidly attached to the lid, sides and ends of the coffin with iron rivets, locking the structure together in all directions. Moreover, there are indications that the rivets pass through yet more iron plates (or washers) inside the coffin. Explicitly, the lid was not hinged or meant to be openable. The design and method of assembly was ingenious, and almost certainly conceived by Sir Christopher Wren, who was Surveyor-General of the royal works at the time and would have been directly instructed by James II.[97]

The method of fixing the ferramenta, and thereby permanently securing the coffin, was as

follows. All nine straps were fabricated in hinged form, complete with the necessary holes for attaching them to the planks, but the pins that passed through the knuckles and held the components together did not have their ends riveted-over at this stage: hence, the 'hinges' could be disassembled again by withdrawing the pins. First, the straps were all riveted to the coffin lid. Then the lid was placed on the empty coffin, with the hinged strap-ends hanging loosely down its sides. Using the straps as templates, holes were drilled through the side and end boards in preparation for riveting. The lid was lifted off and the hinges disassembled by knocking the pins out of the knuckles, after which the nine separate plates were individually riveted to the sides and ends of the coffin. The new outer receptacle was now ready to receive the Confessor's damaged medieval coffin. Once inside, the lid was replaced on the outer coffin, with all the knuckled strap-ends engaging correctly with their counterparts on the sides and ends. Finally, the pins were reinserted in the knuckles, and their ends riveted over, so that they could not be withdrawn again.

The secondary coffin was a large and exceedingly heavy object, the potential weight of which (including its contents) can be estimated as approximately 400kg (8cwt).[98] Scaffolding had to be erected around the shrine pedestal, to provide a working platform at cornice level. The empty receptacle would have been hoisted on to the platform, ready for the Confessor's damaged medieval coffin to be lifted out of the chamber and into its new container; the lid was then attached to the latter, the hinge-pins inserted and their ends riveted-over, as described above. Manoeuvring the new coffin and its contents, and lowering it into the chamber would have been tricky, requiring at least four ropes and eight men. The length of the secondary coffin had been measured to fit snugly

inside the chamber, but no allowance had been made for the fact that the knuckles of the hinged plates would project at either end, thereby increasing the coffin's overall length by 4cm. Consequently, the coffin would have become jammed when it was being lowered, and had to be taken out again while adjustments were made. An axe, or similar tool, was used to hack back the face of the brickwork at both ends of the chamber (Fig. 413).

Unlike Henry III's coffin, this one does not have any iron rings or other means of attaching lifting tackle. Inevitably, the ropes had to pass under the coffin, to create a series of four slings, with two men on each. Since the coffin rests directly on the stone floor of the chamber, and not on bearers, it would have been impossible to release and withdraw the trapped ropes, unless temporary provision for this was made. Hence, there must have been some timber wedges or chocks under the two ends of the coffin, which were eased out after the ropes were removed. Once the coffin had been installed, pockets were cut in the north and south sides of the chamber and two iron bars, 25mm square in section, were mortared into them (i.e. the two 'crossbars' made by William Backe. These lay immediately above the coffin lid, and were intended as a further deterrent to interference with the burial (Figs 404 and 413).

FRAGMENTS OF SILK FROM THE TOMB OF EDWARD THE CONFESSOR

Lisa Monnas

King Edward the Confessor was buried on 6 January 1066 in front of the high altar of his Abbey church. After that, through pious devotion, curiosity, or accidental damage, the contents of his tomb were disturbed on four occasions. The tomb was first opened in 1102, in the presence of Gilbert Crispin, abbot of Westminster (1085–1117/18) and Gundulf, bishop of Rochester (1077–1108), an event described by Osbert de Clare in 1138. When the lid was lifted, a sweet smell apparently emanated from the tomb, in which the corpse was found wrapped in a precious shroud, and that the body and its textile adornments were uncorrupted.[99] In 1161–63, Aelred of Rievaulx related in his *Vita S. Eduardi Confessoris*, that at this first opening the burial shroud was retained and replaced with

413 St Edward's shrine. East end of the chamber, showing the face of the Tudor brickwork hacked back to facilitate the insertion of the enlarged coffin in 1685. One of the transverse iron bars set into the walls of the chamber, above the coffin, is also seen here. © *Dean and Chapter of Westminster*

another 'of equal value'.[100] Edward was canonized in 1161, and two years later, in 1163, the tomb was opened again and his body and burial robes were once more found to be quite uncorrupted. At that point, the saint's robes were removed, and the Abbot of Westminster, Laurence of Durham (1158–1173), reputedly had three copes made from them, for use in the Abbey.[101] In the 20th century, this action was denounced as 'vandalistic', but the appropriation would have seemed justified at the time because textiles that had been in close contact with the body of a saint acquired the status of holy relics.[102] To wear the copes made from the actual silk that had encased the miraculously preserved body might have been viewed as imparting a desirable spiritual benefit to the wearers. The saint's body was freshly dressed, enclosed in an oak chest, and transferred on 13 October 1163 to a new tomb in a ceremony held in the presence of Henry II, presided over by Thomas Becket, Archbishop of Canterbury. On 13 October 1269, the saint's body was transferred to the splendid new shrine built by Henry III.[103]

In April 1685, the tomb of the Confessor was accidentally damaged by workmen erecting a scaffold for the coronation of King James II, when a pole dropped onto it, creating a hole. Charles Taylor (or Taylour), a lay-vicar, published an account of this in 1688, in which he described reaching into the hole, and finding in the coffin a gold crucifix 'richly adorned and enamelled', with a long gold chain. He added, 'There was also … white-Linnen and Gold-colour'd flowr'd silk that look't indifferent fresh, but the least stress put thereto shew'd it was well nigh perish't. There were all his bones, and much dust likewise, all which I left as found, taking only thence along with me the crucifix and gold chain'.[104] The cross and chain were subsequently shown to James II, who took the crucifix for himself.[105] The king commanded a new, strong wooden coffin to be made, enclosing the old, broken one.[106] Almost two decades later, in 1706, Simon Patrick, Bishop of Ely (b. 1626; d. 1707), also recalled the accidental damage to the tomb in his diary, with additional details, describing his view of the saint's shroud, 'which was a mixed coloured silk very fresh'.[107] A minute fragment of silk purportedly from the tomb was pinned to the manuscript of Bishop Patrick's diary (Fig. 414).[108]

Taylor did not admit to taking any silk himself, but the tomb remained open for several weeks and he was not the only person with access to it. In 1714, the Leeds antiquary, Ralph Thoresby, noted in his diary that a fellow-antiquary, Mr Wotton of Bloomsbury, had given him 'a small shred of the silk shroud of King Edward the Confessor cut off when the coffin was accidentally broken … at the Coronation of King James the Second.'[109] Nothing more was heard of textiles from the Confessor's tomb until 1943, when Mrs Alison Inge sent three small silk fragments, found among some books at her home in Dorset, to the Science Museum in London for an opinion (Fig. 415).[110] The fragments were accompanied by scraps of paper carrying the following inscriptions, written in a 17th-century hand:

(i) part of ye cote w[hi]ch was next to ye searcloath on ye boddy of King Edward ye Confesser taken from it in Aprill 1686★ when ye tombe was found open & ye little peese was a small part of a ribin tied above his head
 there was then found a gold cros hanging to a gold chaine, soposed to have bin a bout his neck, ye cros was very neatly maid on on[e] side a crusifax on ye other a p[i]ct[ure] of ye then pope, & was to open but nothing then in it, ye gold waied a bout 30 peeces, ye King had it & now hath it

(ii) the searcloath yt was next ye Body of King Edward ye Confeser found open in Aprill 1686★, & then taken out

(iii) a peese of ye Shroud, or that w[hi]ch was as a sheet, on ye out side of ye boddy of King Edward ye Confesser, taken ofe Aprill 1686★

★an error for 1685

414 St Edward's coffin. Fragment of silk resting on a page in the diary of Bishop Simon Patrick. With it is also the brass pin that formerly attached the silk to the page. *Cambridge University Library, Add. MS 36*

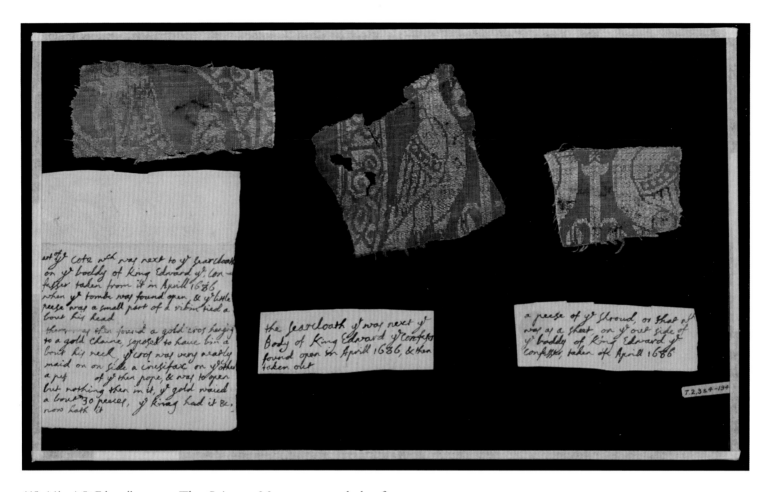

415 (*Above*) St Edward's coffin. Three fragments of silk, with handwritten labels. The date on the labels is incorrect, and should read April 1685. *Victoria and Albert Museum, London: T.2, 3 and 4-1944*

416 (*Right*) St Edward's coffin. Fragment of silk, with handwritten label, in the collection of Westminster Cathedral, London. *Courtesy of Westminster Cathedral*

The Science Museum passed the fragments to the Victoria and Albert Museum, where, on the authority of Albert Kendrick, they were pronounced to be authentic fragments from the Confessor's tomb. Mrs Inge initially wanted to sell them, but the Museum's director, Eric Maclagan, persuaded her that, although of historical interest, they might not fetch much at auction (which was probably true at the time), and suggested that the museum would welcome them as a gift. Mrs Inge acquiesced. She subsequently wrote to the Museum in March 1945, at the instigation of the Dean of Westminster, asking for one of the fragments to be returned to the Abbey, but this proved impossible.[111] Following their acquisition, the Victoria and Albert Museum framed the silk fragments with their labels between two sheets of glass, bound in black tape. In 1944, while the Museum was considering Mrs Inge's fragments, another small piece of silk came to light among relics owned by Westminster Cathedral.[112] It, too, was accompanied by a piece of paper inscribed in a 17th-century hand (but a different hand from the previous examples): 'This came out of St Edward's

s[h]rine a great Relick'.[113] The Museum offered to frame the Cathedral's silk in the same manner as the first fragments (Fig. 416).

Dating, weave and design

The fragments in the Victoria and Albert Museum and Westminster Cathedral now appear to be monochrome, in a dull shade of tan, but this is not their original colour. They are woven in a proto-lampas weave, with a tabby ground and weft-faced twill pattern (Figs 417 and 418). The ground weft is bound in tabby by alternating paired and single warp ends; the pattern weft is bound only by the single warp ends in a weft-faced twill.[114] This weave corresponds to that of the stockings of Pope Clement II (r. 1046–1047), from his tomb in Bamberg Cathedral, Germany (Fig. 419).[115] The Confessor's fragments and the papal stockings form part of a group of comparable surviving textiles, with early to mid-11th-century dates attached to them.[116]

Together, the four fragments show part of two birds, and of a griffin. The whole design, incorporating the three Victoria and Albert Museum fragments, was reconstructed by Frances Pritchard in 1992, with reference to Clement II's stockings (Fig. 420).[117] The design is composed of roundels, formed by bands of geometric ornament, which enclose alternating pairs of panthers and of griffins.[118] Between the roundels, there are pairs of addorsed doves with folded wings, alternating, in horizontal rows, with confronted doves with raised wings. The Cathedral's fragment, which shows an incomplete bird, was identified by Kendrick as part of a bird with a 'Sassanian scarf' fluttering behind its neck.[119] Re-examination of the four fragments has confirmed that they present the identical weave, and that they all come from the same textile.[120] Instead of representing a bird wearing a scarf, the Cathedral's fragment shows part of a bird with a raised wing, and the 'scarf' is actually part of the wing (Figs 421 and 422). The fragment contains (from left to right) some geometric pattern framing a roundel, the lower part of a bird's raised wing and part of its chest, with, on the right, a fraction of the opposite bird's chest. The bird on this fragment corresponds almost exactly to the left-hand confronted birds of the reconstruction drawing, except for a detail on its neck, which is absent from the drawing, but which does appear on the matching bird on the silk stockings of Clement II. This precise correspondence means that, despite the first opening and subsequent translations – and the reported removal of the saint's original shroud

417 St Edward's coffin. Fragment of silk (Fig. 416); detail of the weave. The scale is 4mm. *Courtesy of Westminster Cathedral*

418 St Edward's coffin. Fragment of silk (Fig. 415); detail of the weave. *Courtesy of Victoria and Albert Museum, London: T.2-1944*

and burial robes – the four related silk fragments are most likely to date from the Confessor's original burial in 1066.[121]

The tiny fragment in Bishop Patrick's diary is quite different (Fig. 423). As mentioned earlier, Bishop Patrick observed that when the Confessor's shroud was first seen, it was 'mixed colored' and 'fresh' in appearance. This fragment does present strongly contrasting colours, with black silk warp threads and yellowish-tan silk weft threads. It is woven in a compound twill weave, and is an early silk, possibly dating from the eleventh century, but it does not come from the same textile as the other fragments. Unfortunately, it is too small to permit a reconstruction of the original design.

425

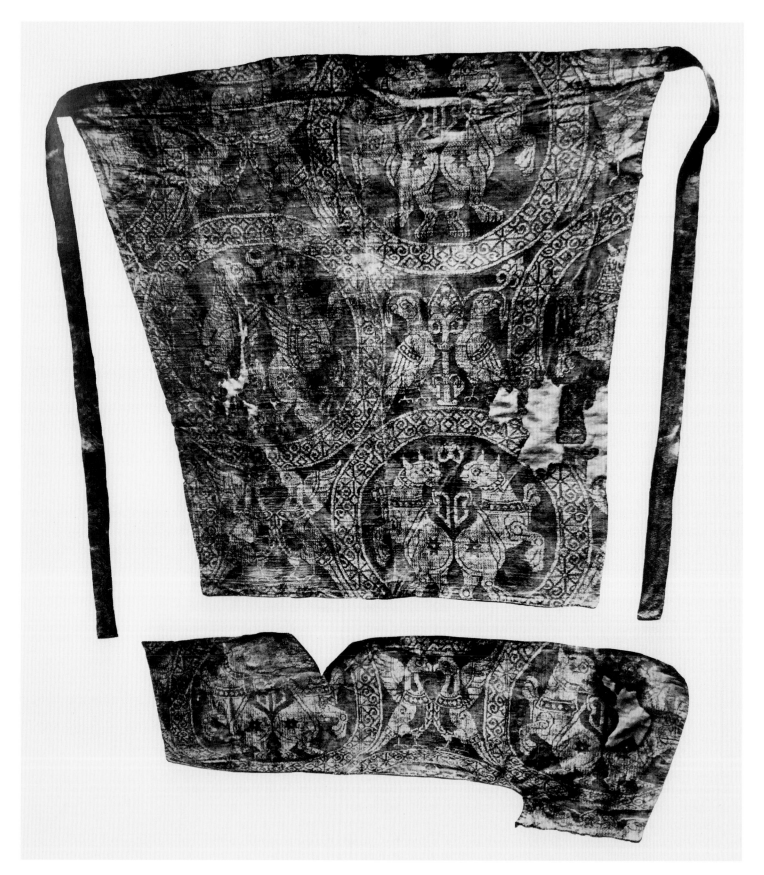

419 Bamberg Cathedral, Germany. Stockings from the tomb of Pope Clement II (r. 1046–1047). *Müller-Christensen 1960, pl. 2*

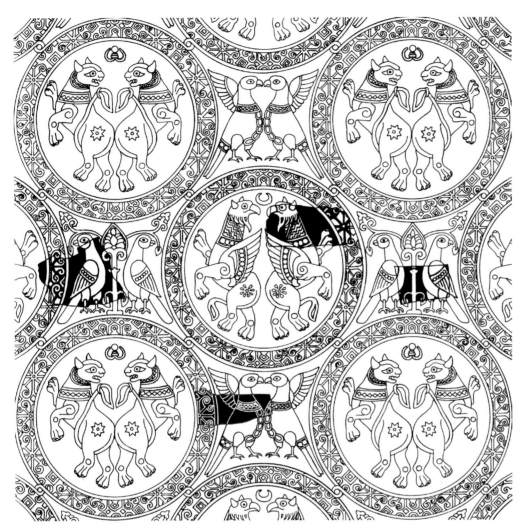

420 Silk from St Edward's coffin. Reconstruction of the design, integrating the four surviving fragments of silk. *Drawn by Christina Unwin*

421 (*Below left*) St Edward's coffin. Fragment of silk. *Courtesy of Westminster Cathedral*

422 (*Below right*) Bird traced from a photograph of the stockings of Pope Clement II from his tomb in Bamberg Cathedral (Fig. 419). It corresponds to the bird on the silk fragment from Edward the Confessor's tomb (Fig. 421). *Drawn by Lisa Monnas*

427

423 St Edward's coffin. Fragment of silk preserved in Bishop Patrick's diary. *Cambridge University Library, Add. MS 36*

Attribution

The fragments in the Victoria and Albert Museum are registered as 'Byzantine, 11th century'.[122] In 1982, Krijnic Ciggar suggested that the Confessor's fragments might have come from silk received as a diplomatic gift from the Byzantine emperor on the occasion of the Confessor's coronation.[123] The Victoria and Albert Museum's fragments were displayed in the *Byzantium* exhibition held at the British Museum in 1994.[124] In her entry for the exhibition catalogue, Hero Granger-Taylor discounted Ciggar's suggestion, pointing out that the fragments belonged to a wider group of silks that are not of outstandingly high quality, with design features that reflect a possible Islamic origin. She concluded that the Confessor's fragments were not necessarily woven in Constantinople and could equally have been woven in Persia, ascribing them to the 'Eastern Mediterranean or Western Asia', an attribution that is accepted here.[125]

DILAPIDATION OF THE SHRINE CANOPY AND ITS RESTORATION, 1958–60

By the beginning of the 19th century the Tudor shrine canopy had fallen into a severely dilapidated condition, the cause of which is not immediately apparent since it was far out of the reach of tourists and souvenir hunters (Fig. 384). Since the Confessor's coffin was damaged by the scaffolding accident in 1685 (p. 419), it is inevitable that the timber which pierced the saint's coffin must have broken through the roof of the canopy as it fell,

unless the latter had already been removed from the shrine pedestal. There is no obvious reason why, at the time of a coronation, the canopy should have been brought down, set aside and later replaced, since it would have been an unwelcome encumbrance on the floor of the chapel. Nevertheless, the caddy-top is shown intact shortly before and after the coronation (Figs 11B and 387), and is also recorded on Talman's sketch and Vertue's engraving (Figs 300 and 301B). Hence, it would appear not to have been damaged. One potential explanation is that James II ordered the canopy to be repaired, following the 1685 incident, as he did the coffin. The two roughly contemporary accounts of the related events are not in agreement over some details.

The looter, who returned to the scene more than once, reported that he used a ladder to gain access to the top of the shrine, which is 2.75m above pavement level (p. 420). The two tiers of the canopy rise a further 1.8m, and a ladder nearly 5m long would have been required to reach the top of the canopy. From there, a vertical drop of 2.2m had to be negotiated to descend to the level of the coffin lid, either by climbing down the interior of the canopy, or using an additional short ladder. The logistics involved militate against such a course of action, especially since the looter was accompanied by other persons on one of his visits to the shrine; moreover, the scaffolders had been taking money from visitors who came to view the coffin (p. 420). Hence, we conclude that the canopy was taken off the pedestal prior to the coronation (and hence probably did not suffer damage), allowing easy access, via a short ladder, to the top of the pedestal and the exposed coffin. They remained accessible for a period of at least seven weeks.

The foregoing does nothing to explain the depleted condition of the canopy itself, which is clearly portrayed in Carter's watercolour of 1778 (Fig. 12). The roof had entirely disappeared and the backs of all the upper-tier niches had been removed, creating a lantern-effect. It is also apparent that the niches in the lower tier had been modified: they were no longer compartmented, and the framed panelling that currently exists behind the niches had been installed.[126] The canopy was also heavily robbed of its decorative components: twenty-five gilded Corinthian capitals on the upper tier had been removed, and thousands of glass tesserae prised out of the pilasters, along with

roundels and other glass inserts. All of these must have been taken as souvenirs but, once again, how did the miscreants gain access? And when?

The majority of the robbing must have taken place when the canopy was at floor level, and there are only two occasions when we can be certain that occurred. The first was between 1540 and 1556, when there was no shrine and, if we are correct in deducing that the canopy stood on the pavement, over the coffin of St Edward, pilgrims and visitors would have treated it as a substitute source of souvenirs. The second time the canopy was at floor level was in 1685, when the Confessor's coffin was removed from the pedestal, for encasement in a new iron-bound oak chest, on the orders of James II. Although this episode was likely to have been of relatively short duration (but possibly several months), further depletion of the decorative elements doubtless occurred. The fact that all save one of the capitals had been removed from the upper tier, but *only* one from the lower, may point to the actions of a single 18th-century thief, systematically attempting to strip the canopy of its highly decorative and saleable carvings.

Early 20th-century photographs reveal just how much of the basic structure was also missing:

cornices, plinths and the entire ledge surmounting the lower tier that provided a platform to support the upper tier (Fig. 386). We are unable to offer an explanation for the loss of so much timberwork. The secondary panelling inside the lower chamber had also become detached from the carcase and could be removed, as evidently occurred for the 1916 photograph (Fig. 385). Damaged though it was, the canopy was still evocative of the shrine's antiquity and traumatic history: it sat harmoniously with the equally damaged pedestal. But all that changed in 1958, when Dykes Bower instigated its 'restoration'. Total overpainting of the canopy in 1960 concealed the extent of this intervention, and the only way to ascertain – even approximately – how much of the Tudor structure survived was to examine the interiors of the two chests. Hence, the investigation carried out in 2018 was designed not only to record the top of the shrine pedestal, but also the interior of the canopy (Fig. 424).

The 1958–60 restoration was carried out by a firm of joiners in Sussex,[127] and the principal account of the work appears to be a newspaper article.[128] We have noted that a significant amount of the structural skeleton was already missing, including the top of the lower chest and the supporting framing upon which the upper one

424 St Edward's chapel, view north from the triforium gallery, 2018. The upper and lower chests of the shrine canopy have been removed (and rest on the scaffold platform), revealing the top of the shrine pedestal and the chamber within. © *Dean and Chapter of Westminster*

425 St Edward's shrine canopy, lower chest. Detail of one of the restored pilasters, with its new Ionic capital and glass tesserae set in dark brown mastic. *Authors*

426 St Edward's shrine canopy. Detail of the lower chest, showing the decorative scheme applied to it in 1960: *faux* porphyry (purple and green) and gilding. Clear glass inserts were fitted to the spandrels (S) and to the plinth panels (P). © *Dean and Chapter of Westminster*

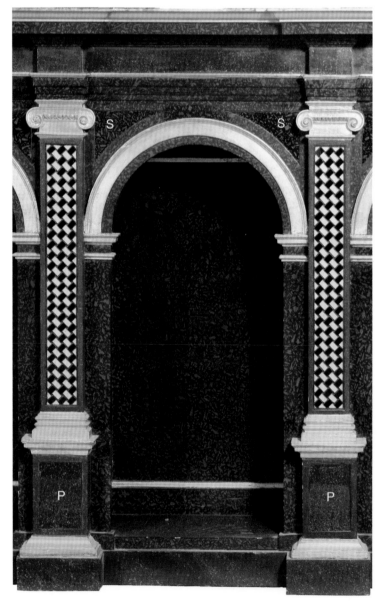

rested. Similarly, no framing remained on the upper chest to carry the roof, and that too had been wholly lost since 1713; also the backs had been removed from all the arched recesses, and replaced with sections of wainscot panelling on the lower stage, but left open on the upper. The majority of the cornicing on both chests was missing, as was the plinth of the upper chest.[129] Many small parts of the applied architectural detail were also wanting, especially the capitals of the upper-tier pilasters, and arch and impost mouldings. Nearly all of the glass mosaic had been lost, together with the roundels on the upper chest and the spandrels and plinth panels on the lower (Fig. 386).

The newspaper article emphasizes the meticulous care that was taken to ascertain the nature of every original detail, and to replicate it, referring *inter alia* to carving twenty-five replacement Corinthian capitals for the upper chest and cutting 10,000 pieces of 'limpid blue' glass for the mosaic inlay in the pilasters.[130] Regrettably, it has not been possible to identify any original glass tesserae.[131] It was stated, somewhat ambiguously, that 'each piece of glass was gilded from behind to give a richness to the colour'; half of the tesserae are of course gilded on the outer face, and presumably the remainder have their gilding on the back. The latter did not have a beneficial effect – and certainly did not impart 'richness' to the colour – since the glass appears uniformly black, rather than blue (Fig. 425). The original dark blue tesserae and roundels were embedded in lead-white putty, which would have lightened the colour effect (albeit only slightly); they are now set in dark brown mastic, which has deadened the appearance of the mosaic.[132] Late 13th-century glass inlays in the Coronation Chair were similarly embedded in white putty.[133]

Clear glass was inserted into recessed areas in the spandrels and panelled plinths on the lower chest (Fig. 426), but in both instances, the glass is barely noticeable, even at close ranged contributes nothing to the overall aesthetic. This is because the flat surface around the arches, as well as behind the triangular glass inserts in the spandrels, is decorated with *faux* green porphyry. Similarly, the plinths of the pilasters, as well as their glass-covered panels, are painted as *faux* purple porphyry. Consequently, there is negligible visual differentiation, and the modern reconstruction must surely be in error. Had the spandrel inserts been

decorated to represent purple porphyry, they would have provided an aesthetically pleasing contrast with the expanses of green paint around them.[134] Likewise, differentiation was required in the plinths of the pilasters.[135]

For glass inserts to be effective, they needed to be differently coloured from their immediate surroundings (as the blue roundels are on the upper chest; Fig. 394); similarly, if the panels were originally filled with clear glass, whatever lay behind them must have been visually distinct. The technique is seen to good effect on the West-minster Retable, where painted imitation enamel was plated with clear glass.[136] In the case of the canopy we suspect that the plinth panels and arch spandrels were painted to imitate purple porphyry, over which clear glass was fitted. The reflective quality of the glass would have provided the illusion that the panels were filled with sheets of polished porphyry. Differential colouring on Ackermann's view (1812) supports this suggestion (Fig. 384).

Re-marbling the entire structure took place, in purple and green, in imitation of porphyry, and a considerable quantity of gold leaf was also applied. No trace of the historic decoration of the canopy now survives. Consequently, the external appearance of the timberwork is pristine

and aesthetically at odds with the worn and damaged condition of the pedestal below. A high proportion of the applied detail of the pilasters, their capitals and bases has been renewed. When the canopy was removed and inspected internally in 2018, it was readily apparent how much of the structural framework was modern too, including the plinths and cornices, the tops of both chests, and the roof. Also, a great deal of additional framing and cross-bracing has been introduced into what were originally unencumbered voids. As a consequence, the weight of the canopy has now been greatly increased (Fig. 427).

Several sets of drawings, showing alternative approaches to the restoration and re-colouring of the canopy, were produced in 1957 by O'Neilly, for Dykes Bower.[137] One includes a complicated, sarcophagus-like roof for which there is no supporting evidence. It also provides a key to the proposed use of gilding and coloured glass: the roundels on the upper chest and the plinth panels on the lower are blue, and the spandrels red (Fig. 428). No colour is indicated for the overall *faux* marbling of the woodwork. A second set of drawings shows the caddy roof that was adopted; it also depicts the glass inlays, gilding and the *faux* marble colouring of the timberwork, almost as executed (Fig. 429).[138]

427 St Edward's shrine canopy. View into the restored upper chest (turned on its side), showing the extensive new framing, bracing and backs to the arched recesses. Only the dark coloured timber is Tudor. For the Baltic timber merchants' graffiti on these boards, see Figure 395. *Authors*

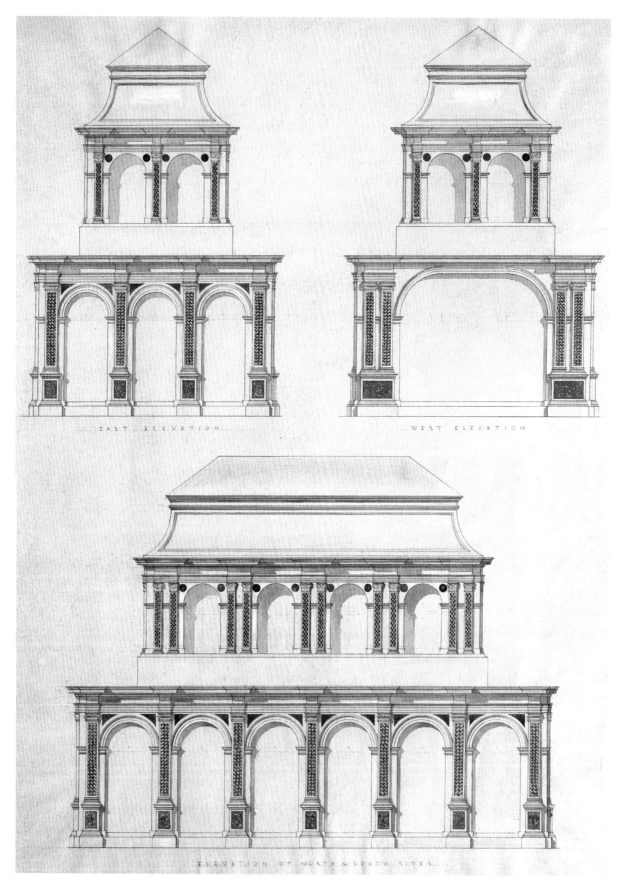

EAST ELEVATION

WEST ELEVATION

ELEVATION OF NORTH & SOUTH SIDES

428 St Edward's shrine canopy. One of the restoration proposals by Dykes Bower, 1957, showing an elaborate roof structure and key to the coloured glass inlays. © *Dean and Chapter of Westminster*

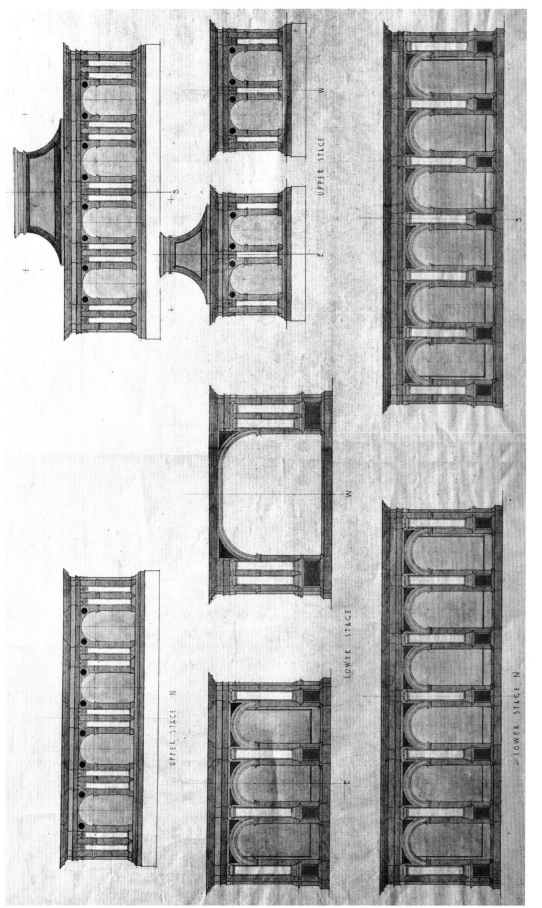

429 St Edward's shrine canopy. A second restoration proposal by Dykes Bower, 1957, showing a caddy roof and key to the coloured glass inlays. This was the version adopted, with minor changes to the colouring of the woodwork. © *Dean and Chapter of Westminster*

12 Tomb of King Henry III

INTRODUCTION AND ANTIQUARIAN DESCRIPTIONS

The tomb of Henry III is located on the north side of St Edward's chapel, under the second arcade bay, where it directly faces the saint's shrine. It is a composite monument, comprising two rectangular chests, resting one upon the other; the upper chest, containing the royal interment, is surmounted by a recumbent gilt copper-alloy effigy (frontispiece, vol. 2; Figs 430–435). The tomb is freestanding and all its faces were encrusted with Cosmati mosaic decoration, although much of this has been lost. Despite having suffered at the hands of pilgrims and tourists, who picked off tesserae, especially on the south side where few now survive, the monument still retains a stunning array of mosaic of greater complexity and higher quality than the other cosmatesque works at Westminster.

Early antiquaries described the tomb, but not in any great detail and with little concern for factual accuracy. In 1683, Keepe considered it to be

> … a composure of curious work, framed of diverse coloured Marbles and glittering Stones, chequered and gilt with Gold … supported at each Corner by twisted or Serpentine Columns of the same speckled Marble, all brought from beyond the Seas by his Son Edward.[1]

The incorporation of precious stones imported by Edward I is again repeated by Crull, who described the tomb as

> … made in the form of an Altar, with Three Ascents [stages]; on the first whereof is a plain Pedestal of grey Marble, wherein are several Aumbries and Lockiers [lockers], made use of in former Times to lay up the Vestments and rich

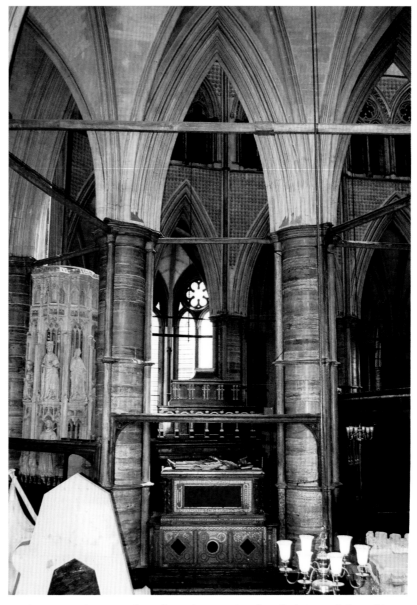

430 The setting of Henry III's tomb in relation to St Edward's shrine and the architecture of the presbytery apse. View south from St John the Baptist's chapel. © Dean and Chapter of Westminster

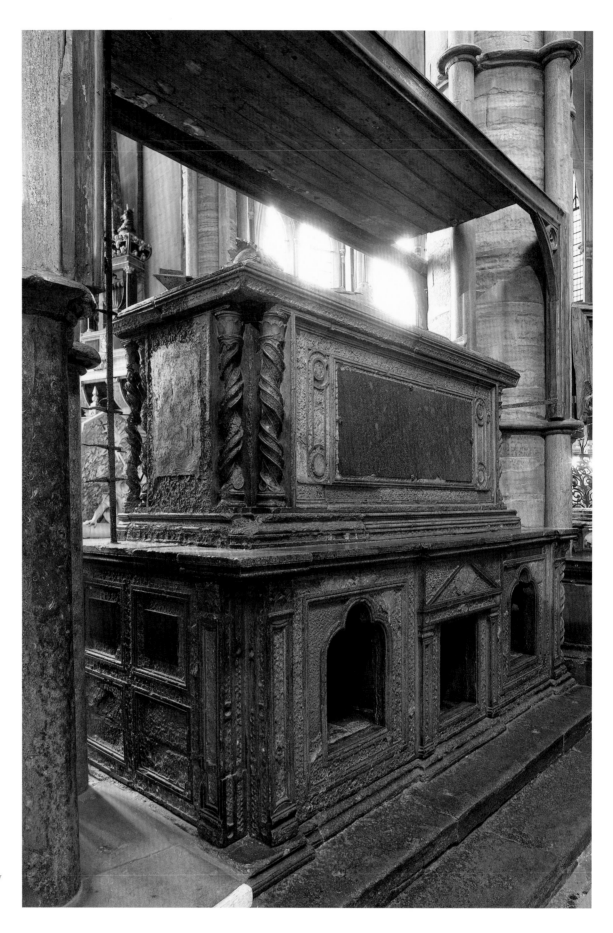

431 Tomb of Henry III. View
from the south-west.
Christopher Wilson

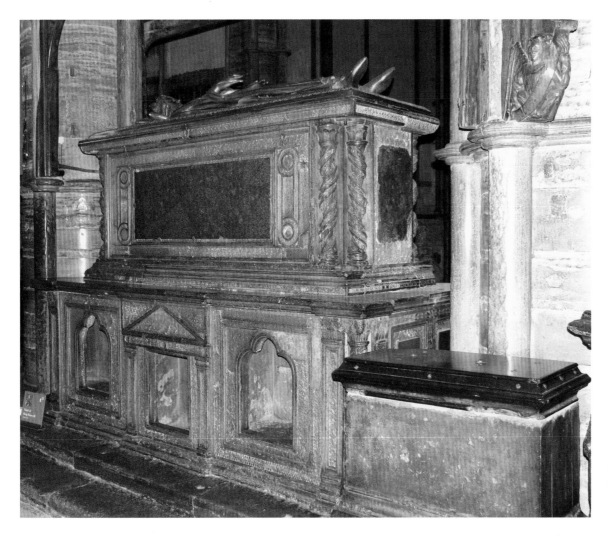

432 Tomb of Henry III. View from the south-east, showing also the small chest-tomb of Princess Elizabeth (d. 1495). *Authors*

Copes, belonging to the Altar of St. Edward. But the other [stage] is the most artificial Composure and Frame of the finest coloured Marbles of divers Colours, and other Stones, imitating those on the Feretory of St. Edward, chequer'd and gilt with Gold, supported by Four twisted Columns (one at each Corner) of speckled Marble, which are said to have been brought from beyond the Seas by his Son Edward. On this Tomb you see the Statue of this King, of solid Brass, curiously design'd, and gilt with Gold …[2]

Keepe's and Crull's descriptions, like many others, are derivative and inaccurate. Some of the inaccuracies are curious: for example, the 'Columns of speckled Marble … brought from beyond the Seas', are simply Purbeck marble from Dorset, the same material as was used in the rest of the structure. Nevertheless, part of the interest of Crull's description lies in the fact that antiquaries were beginning to reflect on architectural comparanda. Thus, attention was drawn to the altar-

like form of the tomb and the three niches in the lower chest were likened to aumbries and lockers. One description mentioned the 'lockers' as having once been fitted with doors, on account of the 'evidence preserved in the masonry' for attaching hinges. There is, however, no such evidence, and there certainly never were doors on the niches, as Burges recognized: 'These are generally said to be aumbries for vestments used at the shrine; it is far more probable, however, that they contained rich reliquaries, for had they been aumbries there would have been doors, but there are none, and no possibility of putting any.'[3]

Dart waxed lyrical about the tomb:

It is admirably curious in the workmanship, and inimitably rich in the materials; the side and end panels of the table [i.e. upper chest] being of the most polished porphyry of a clear red; and the work round them Mosaic of gold and scarlet: it is upon an ascent of steps, and under it are three aumbries or lockers …[4]

437

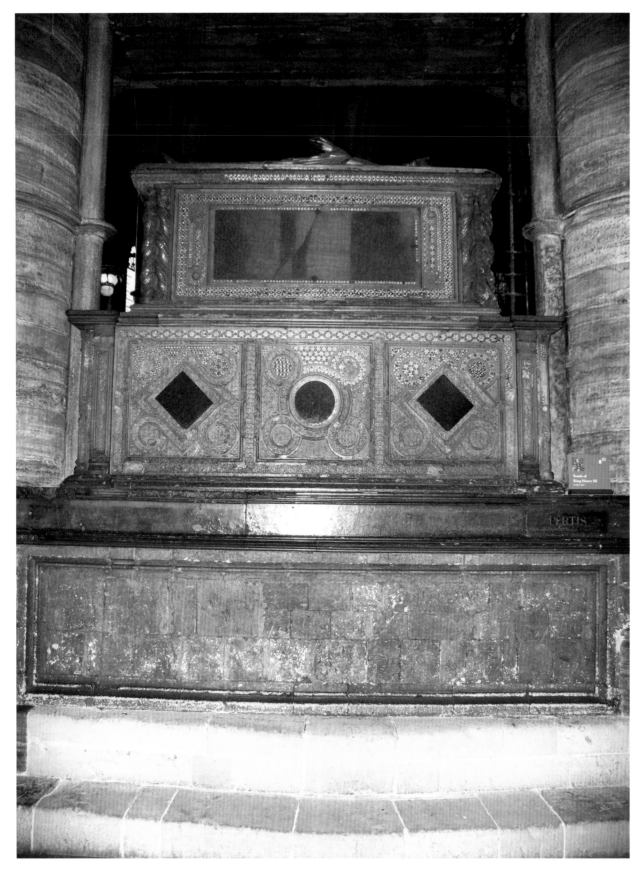

433 Tomb of Henry III. North elevation, showing also the panelled face of the platform upon which the tomb stands, and the two-tiered wall-bench below. *Authors*

Descriptions by 19th-century antiquaries repeated earlier accounts, but also lamented the tomb's dilapidated condition. Thus, Ackermann wrote in 1812:

> This royal and once splendid tomb, but now sacrilegiously deprived of the larger portion of its sumptuous decorations … Little is left on the tomb within the chapel but a tablet of porphyry; and the part next the north aisle, within reach of the spoiler's hand, has shared the same fate: but much of the upper division is in a perfect state. Two lozenges of verd antique [i.e. green porphyry], and a square of [purple] porphyry, remain on this side.[5]

Antiquarian illustrations of the tomb are not numerous and they do not reveal much lost detail of archaeological significance. This applies particularly to the earliest depictions, such as Crull's (Fig. 11A). Views eastwards along the north ambulatory – showing the tomb obliquely – were principally favoured by artists such as Carter, Ackermann and Scandrett (Fig. 32). The earliest detailed, square-on image of the north face is by Carter (Fig. 31). The south face received less attention, doubtless on account of the more depleted condition of its mosaic decoration, but there are views by Basire and Neale (Fig. 30). A painting of *c.* 1920 provides the most detailed depiction of the tomb, accurately delineating the surviving mosaic decoration on the north face (Fig. 33).[6]

Summary of historical evidence relating to the burial and tomb of Henry III

Remarkably little historical evidence has been preserved relating to the burial and tomb. No accounts survive for the construction of the monument, which remains historically undated. Nor are there any contemporary descriptions of it. Nevertheless, the following events are not in doubt.

(i) **1245** When Henry III began the rebuilding of Westminster Abbey, he determined that it would be his place of burial, rather than the Temple Church, London, which he had previously favoured.

(ii) **1272** Henry died and was interred in the empty tomb (now a cenotaph) that, down to 1163, had held the body of Edward the

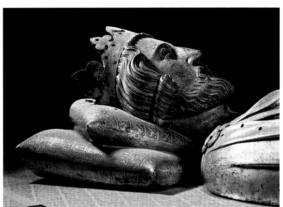

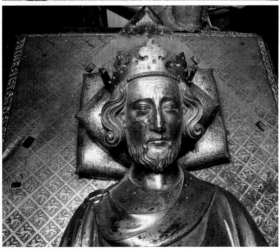

Confessor. The reason for this action is not recorded, but there is no historical evidence to support the frequently-made assertion that Henry's own tomb was unfinished, or that its construction not even started in 1272.

(iii) **1276** The bishops of Verdun (Lorraine, France) and Bath-and-Wells (Somerset)

434 (*Above*) Tomb of Henry III. High-level view, looking north, of the top of the crudely made oak canopy, with the king's effigy below. *Authors*

435 (*Left*) Tomb of Henry III. Images of the king from the recumbent gilt metal effigy, 1291. © *Dean and Chapter of Westminster*

issued indulgences for their parishioners who visited Henry's tomb; other diocesans also ratified these indulgences.[7]

(iv) **1280** Edward I acquired 'precious stones of jasper' from France to embellish his father's tomb. No details are recorded.

(v) **1287** The bishops of Ely (Cambridgeshire), St Andrews (Scotland) and Emly (Ireland) granted indulgences to pilgrims who prayed at the tomb of Henry III.[8]

(vi) **1290** Edward I caused his father's body to be removed from the Confessor's tomb and placed in the cosmatesque monument constructed as Henry's permanent burial place, under the arcade on the north side of St Edward's chapel. In the same year Henry of Lewes was paid for unspecified *ferramenta* for the tomb.[9]

(vii) **1291–92** The extant recumbent effigy in gilt copper-alloy, with a border inscription, was cast by William Torel and placed on top of the Cosmati tomb-chest (Figs 434 and 435). At the same time Walter of Durham, the king's painter, was commissioned to paint the tomb canopy; it does not survive.

(viii) **15th–16th century** (undocumented). The primary canopy was superseded by the present plain oak one (Figs 430, 431 and 434).

(ix) **1557** (undocumented). Abbot Feckenham repaired the tomb, using plaster on which he painted *faux* mosaic (as he did with St Edward's shrine-tomb, p. 409); at the same time he added a painted inscription to the plinth on the north side (Fig. 475).

(x) **1871** Dean Stanley removed the effigy, opened the upper chest and made an archaeological record of the coffin, but did not open it.

Nothing can plausibly be deduced regarding the date of construction of the tomb from these few brief mentions, except that it was presumably in existence in 1276, when the granting of indulgences for visiting it began. For further enlightenment, we must turn to archaeological evidence and logistical considerations. The tomb is part of a closely integrated assemblage of cosmatesque and other structures in the sanctuary and shrine chapel, and it is only through the holistic study of these that a plausible dating framework can be evinced. This is discussed in depth in chapter 15 (p. 525).

ARCHITECTURAL FORM OF THE TOMB

Henry III's tomb consists of five distinct components: (i) two-stepped podium; (ii) lower chest; (iii) upper chest; (iv) recumbent effigy of gilt copper-alloy; (v) timber canopy. Purbeck marble was used structurally for the first three elements, and for the columns that supported the initial canopy.

Stepped podium

The principal face of the tomb is on the south, where it is elevated on two steps above pavement level in St Edward's chapel (Figs 431 and 432). The steps return around the east and west ends of the monument, but run for only a short distance before they meet the piers of the ambulatory arcade (Figs 436 and 437). The broad lower step is featureless and well worn; the upper step is narrower and has square pockets cut into the upper face to house the stanchions of a long-lost metal screen. Several of the paving slabs of the chapel floor are overlapped by the lower step to an unknown extent. However, the neat abutment of the inlaid mosaic decoration to the step indicates that the latter was already in place when the matrices were cut. Although a constructional sequence is indicated here, essentially, the two components were contemporaneous (Figs 227 and 230).

There are no steps on the north face of the tomb, their place being taken by a low plinth comprising a slim rectangular panel with a moulded border (Fig. 462, no. 59). Floor level in the adjacent ambulatory is 1.45m below this plinth on account of the entire shrine chapel being raised on a platform (p. 309). The perimeter of the latter is retained by a high, panelled plinth of Reigate ashlar which is integral with the bay structure of the ambulatory arcade and envelops the basal mouldings of the piers. It is topped by a moulded string-course of Purbeck marble (Figs 31 and 462). The face is relieved by a large rectangular panel with a moulded frame. The panel field is not of superior masonry and was doubtless skimmed with lime plaster, which probably bore polychrome decoration, but is now bare. The comparable panel in the adjacent bay, below Eleanor of Castile's tomb, formerly carried a painting, now virtually

Upper Tomb Chest

0 1
 m

Lower Tomb Chest

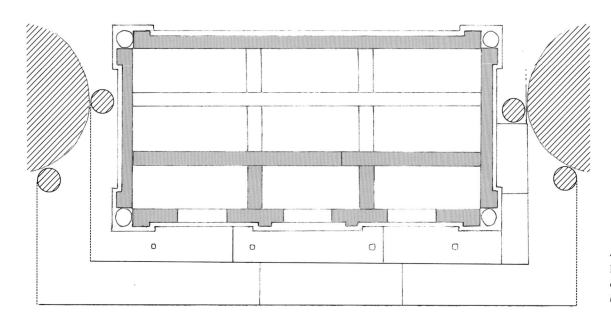

436 Tomb of Henry III. Plans of the upper and lower chests at plinth level. *Drawn by David S Neal*

obliterated: it depicted Otho de Grandisson kneeling before the Virgin and Child.[10]

There were originally seven individual sections of plinth around the ambulatory – one per arcade bay – but only three survive intact, all on the north side of the chapel, the others having been superseded by later work. The tombs of Henry III, Edward I and Eleanor of Castile are centred within their respective arcade bays, directly above these plinths (cf. Fig. 13). The visual effect of their elevation is striking, especially so in the case of Henry's tomb, where the plinth gives the illusion

that the monument comprises not two, but three, panelled chests stacked one upon another (Fig. 433).

Lower chest

In plan, the chest measures 2.90m by 1.48m, and its two principal elevations present markedly different aspects. Essentially, the chest consists of two long panels (north and south), two end panels and two longitudinal walls running through the enclosed void (Figs 436 and 437). Concealed

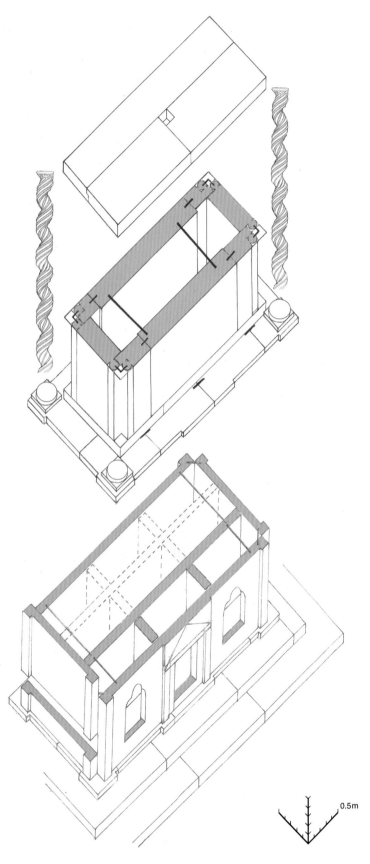

437 Tomb of Henry III. Partly exploded axonometric views of the upper and lower chests, showing the Purbeck marble components. For structural analyses of the individual elevations, see Figures 445, 453, 462 and 471. *Drawn by David S Neal*

wrought iron dog-cramps, set in lead, tie the side slabs together. The chest has boldly projecting 'eared' corners, each of which incorporates two flat, panelled pilasters, set at right-angles to one another, and a freestanding spirally-fluted colonnette in the nook between them. Only one of the original four *en délit* colonnettes survives, at the south-east corner (no. 28; Fig. 438), and that has been stripped of its mosaic decoration. The colonnette (capital, shaft and base) is carved from a single block of marble.

A continuous moulded plinth runs around the base of the chest, and seven slabs of Purbeck marble with moulded edges and eared corners form the composite top. They are all tied together with leaded iron cramps. A line of four pockets along the southern side provided fixing points for an iron grille, and two further pockets – one at each end, on the axis of the ambulatory arcade – housed stanchions bearing horizontal spikes.[11] The western stanchion survives (Figs 431, 443B and 450), but the eastern one has been lost since it was illustrated by Crull (Fig. 11A).

The upper chest is centred on the top slab of the lower one, but it is significantly smaller in plan, with the result that there is a broad flat ledge (25cm wide) around all sides of the monument. This ledge, and especially the eared corners, appears slightly incongruous and out of scale in relation to the proportions of the rest of the tomb, inviting the suggestion that something is missing. Italian tomb-chests often had broad ledges like this, and they invariably supported columns for a canopy. With this in mind, the surface of the ledge was minutely examined for any evidence that might shed light on the matter.

The ledge, especially on the southern side, has become heavily worn over the centuries, and nothing can be gleaned there. The surface of the marble at the north-west corner, however, shows relatively little wear and the scored outline of a 20cm square is discernible, centred on the eared projection. Faint traces of a similar outline can be detected under optimum lighting conditions in the corresponding position at the north-east corner too. These are the registration marks for the bases of columns. It is therefore reasonable to conclude that there were originally four columns seated on this ledge, to support a *ciborium*-type canopy. With bases measuring 20cm across, the diameters of the column-shafts would have been *c.* 15–17cm. Two spirally-fluted and mosaic-inlaid

shafts that would fit perfectly here survive, having been incorporated in the 1557 rebuild of St Edward's shrine (p. 409; Figs 359–365).

Returning to the carcase of the lower chest, the pilasters and single surviving *en délit* colonnette all have moulded bases and finely carved capitals. Each pilaster capital carries three broad, upright spatulate leaves with mid-ribs and out-curled tips. Each leaf stands within an ogival-headed arcade, the central arch terminating with a foliate sprig, and the outer half-arches with simple volutes (Fig. 438). The extant colonnette has a slightly more ornate capital: its narrower spatulate leaves have mid-ribs and each stands within an ogival-headed arcade, but in this instance the arches are double-bordered and rise from symbolic capitals. Again, the central arch supports a foliate sprig. There are simple volutes at the corners of the capital, pendant from the abacus.

The south façade is formed from a single slab of marble, divided into three equally proportioned panels, 79cm wide by 87cm high (Fig. 439). The central panel breaks forward and has the appearance of a classical colonnaded temple with a pediment over the portal, 35cm by 44cm (Fig. 440). The portal opens into a small rectangular chamber 72cm by 31cm in plan, the back of which is formed by one of the internal compartment walls, and chased into this is a Greek cross. Floor level in the chamber is recessed by 9cm below the sill of the aperture. Both flanking panels have openings with trefoil-shaped heads and, proportionally, they are identical to the piscina arch in St Faith's chapel (Fig. 441). Floor level in these chambers equates with the sills of the openings. Again, the matrices for Greek crosses filled with mosaic have been chased into the back wall of each compartment (Fig. 442). All three crosses were carved into the same slab: the central cross is correctly positioned, but those in the lateral chambers are off-centre as a result of a setting-out error when the slab was on the mason's bench (Fig. 441A).[12] The ends of the cross-arms are mostly concave, but in the central example they are squared.

Since all three chambers are only 31cm deep, there must be a further, inaccessible, space of *c.* 90cm inside the chest. Given the huge weight that the lower structure had to support, almost certainly there is a second longitudinal wall within the void, and probably two more cross-walls, dividing the interior into nine compartments, six of which are totally inaccessible (Fig. 437).[13]

In contrast, the three panels on the north side of the chest have no openings, but are decorated with mosaic quincunxes, all chased into a single slab of marble (Figs 467–470). The east and west ends of the chest are each formed from two joined slabs of marble and decorated with four rectangular panels (Figs 458 and 474). The two upper panels measure 30cm by 35cm and are now inlaid with slabs of purple porphyry.

A

B

438 Tomb of Henry III, lower chest, south-east corner. A. South face, showing pilaster 27 and detached colonnette 28; B. Detail from the east face, showing the capitals of colonnette 28 and pilaster 35. *Authors*

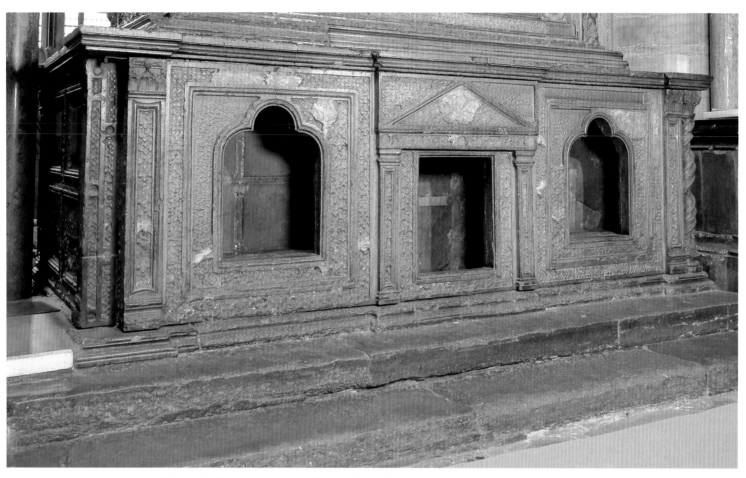

439 Tomb of Henry III, steps and lower chest. Oblique view of the south elevation. *Authors*

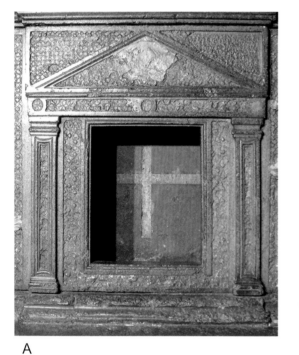

A

B

440 Tomb of Henry III, lower chest, south elevation. A. Pedimented central niche (panels 16–19, 23); B. Santa Maria Maggiore, Rome: altar front decorated in the form a pedimented portal. *A. Authors; B. Hutton 1950, pl. 24B*

441 (*Left*) Tomb of Henry III, lower chest, south elevation. A. Trefoil-headed eastern niche (panels 24–26); B. Piscina in St Faith's chapel, *c.* 1250. *A. Authors; B. Christopher Wilson*

442 (*Right*) Tomb of Henry III, lower chest, south elevation. Matrix for inlaying a Greek cross in mosaic in the back of the central niche (panel 23). The ends of the arms are concave. *Authors*

Upper chest

The chest, which carries the gilt copper-alloy effigy of Henry III, measures 2.40m by 98cm overall. It is hollow internally and the chamber measures 1.85m long by 50cm wide; the depth is 76cm. This chamber contains the king's oak coffin. The north and south sides are each carved from three slabs of marble, cramped together; the east and west ends are formed from single slabs (Fig. 437). The chest has a separate moulded plinth, joints in which show that it is of composite construction, and probably comprises four pieces of marble laid flat. The end-slabs of the plinth have return mouldings to north and south, where they connect with further sections of moulding on the two long sides, probably leaving an unseen rectangular space at the centre of the tomb, filled with rough stone and mortar, forming a floor upon which the coffin rests.

Each of the four corners of the chest was embellished with a triple set of spirally-fluted colonnettes: two are engaged and the third is freestanding. The engaged colonnettes are carved on the corners of the main facing slabs, and the third, *en délit*, is more slender and located in the re-entrant angle between the engaged pair, directly beneath the corner of the top slab. Only one of the *en délit* set (no. 60) survives, at the north-west corner (Fig. 443). The spirals run in opposite directions and the bands of mosaic ornament in the flutes vary in width. Each colonnette does not represent a single spirally-fluted shaft, but three shafts twisted together in the form of a rope, swollen at intervals along its length. The colonnettes have simple moulded bases and carved capitals with abaci; they are less elaborate than those on the lower chest, being decorated only with rib-less spatulate leaves having out-curled tips (Figs 444 and 450).

Wrought iron cramps held the components together. When the tomb was opened in 1871 the original cramps at the top corners were replaced with new cast bronze ones of a different pattern (Fig. 444). The tops of the north and south sides of the chamber are also linked by a pair of iron tie-bars (Figs 437 and 477). Inset into the north and south elevations are remarkably large sheets of purple porphyry, still retained in place by their ornate iron clips. On the east and west sides are smaller upright panels, 42cm by 72cm, once also containing slabs of marble but now represented in painted plaster contemporaneous with Feckenham's restoration of 1557.

Unusually for an important tomb-chest, the top slab comprises three separate pieces of Purbeck marble with moulded and mosaic-inlaid edges, linked together with four dog-cramps; unlike the lower chest, the corners are not eared. The abutting edges of the slabs are counter-rebated, to achieve tightly fitting joints, and the top is pierced by a 15cm-square socket at the centre (Figs 437 and 476).

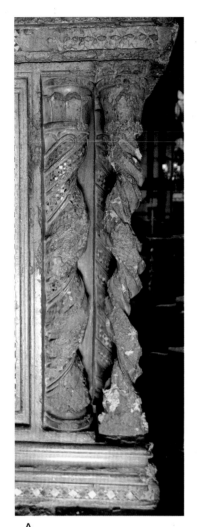

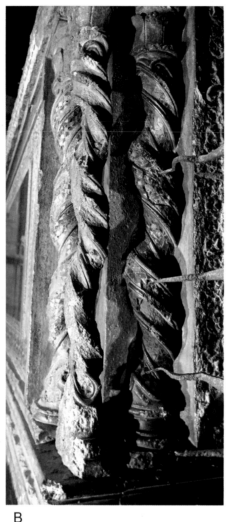

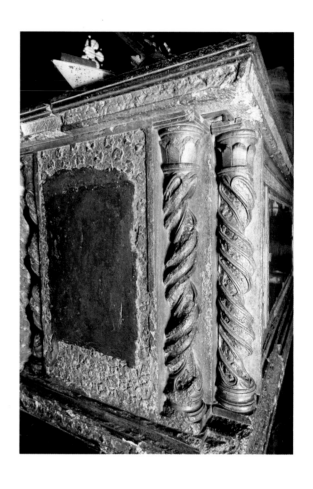

A

B

443 (*Left*) Tomb of Henry III, upper chest. Set of triple colonnettes at the north-west corner (47, 48 and 63). A. From the north; B. From the west. Note also on the right the wavy iron spikes, part of the protective ferramenta for the chapel. *Authors*

444 (*Right*) Tomb of Henry III, upper chest. Rectangle of painted plaster on the west end, replacing a lost porphyry panel (60). Also, engaged colonnettes 5 and 6 at the south-west corner; a third, detached colonnette is missing. *Authors*

Effigy

The composite nature of the top slab indicates that, from the outset, it was intended to be concealed beneath an effigy. The design and material of the effigy proposed by Henry III are unknown: it could have been stone or, more likely, metal, and it may have lain directly on the slab, or been raised on a low plinth bearing an inscription. There is nothing to indicate that such an effigy was ever made, or to warrant further speculation. However, an important piece of evidence survives, to which attention has not hitherto been drawn, demonstrating the former presence of an upstanding sculpture mounted at the centre of the tomb-slab: it is the mortice cut to receive the basal tenon of a piece of sculpture or statuary that topped the tomb-chest, prior to the installation of the recumbent metal effigy in 1291. The significance of this will be discussed in chapter 15 (p. 583).

The extant effigy of cast gilt copper-alloy was made by William Torel and carries an inscription in French around the perimeter of its base-plate (Figs 30, 434 and 435). The effigy has been described and discussed elsewhere, and does not require recitation here.[14]

Canopy and accoutrements

The present oak-boarded canopy is a very modest and cheaply constructed furnishing of late medieval or Tudor date, which retains traces of dull red paint (Figs 430, 431 and 434). It is no earlier than the 15th century, and may well be early 16th century.[15] The principal function of such a canopy was to reduce the amount of atmospheric dust falling on the effigy, since this is seriously harmful to gilt metalwork.

There is, however, no doubt that Henry's tomb was surmounted by a canopy of honour in the

446

late 13th century. In the same year that the present effigy was cast (1291), the king's painter, Walter of Durham, was commissioned to decorate the canopy. Since there is no reference to constructing it, it follows that the canopy must have already existed. It has been demonstrated that the two Cosmati columns now supporting the retable at the west end of the Confessor's shrine-tomb had no connection with that monument prior to 1557, and several pieces of evidence point to their primary function as the supports for a *ciborium*-type of canopy over the tomb of Henry III (p. 371; Figs 359 and 437). The subject will be considered as part of the wider discussion of the tomb in chapter 15. Although the columns for the *ciborium* were of Purbeck marble, and the interconnecting lintels would have been likewise, the remainder of the superstructure was most likely of timber, and may have been open-topped or flat-roofed. However, there must have been a ceiling within the canopy by 1291 for Walter of Durham to paint.

There were evidently other features closely associated with the tomb, but not attached to it. Leaded into the south-east quadrant of the arcade pier to the west of the tomb are three large iron pintles, from which sepulchral accoutrements doubtless hung. The lower of a pair of pintles, 44cm apart, occurs at the level of the effigy table; and 1.72m above that is another, single pintle, but not on the same vertical axis (Fig. 548). These fixings may have been for the suspension of the king's sword and shield.

Summary list of the mosaic-decorated components of the tomb

As with Edward the Confessor's shrine-tomb, apart from the mouldings and other intentionally exposed elements of the Purbeck marble structure, virtually all surfaces were originally covered with mosaic set into chased matrices. However, far more mosaic decoration has survived *in situ* on Henry III's tomb, partly on account of its upper levels being beyond the reach of souvenir hunters, particularly on the north side, and partly because the monument was not dismantled and reassembled during the Reformation. Figures 446, 454, 463 and 473 show areas of tessellation, both surviving and lost, and painted plaster patches associated with Feckenham's restoration in 1557. Also evidenced is a second phase of unpainted patching using off-white plaster, again similar to that found on the Confessor's tomb and there attributed to the early or mid-17th century (p. 320).

Conforming to the order of description of Edward the Confessor's shrine-tomb, the south elevation is described first, followed by the east, north and west sides, respectively. Each panel of decoration has a unique number, although pairs of features are sometimes combined and described alphabetically. Where the same colonnette appears on two adjacent elevations it is identified with the number first assigned to it. For quantification of the tesserae, see appendix 2.

South Elevation (Figs 445 and 446)

Upper Chest

1 Central panel.
2–3 Chain guilloche, flanking east and west sides of panel 1.
4 Border around panels 1–3.
5–6 Engaged spiral colonnettes, south-west corner.
7–8 Engaged spiral colonnettes, south-east corner.
9 Band on edge of top slab.
10 Narrow fillet on face of plinth.

Lower Chest

11 Side of pilaster 72 on west face (originally concealed by a lost colonnette).
12 West corner pilaster.
13 West niche, outer border.
14 West niche, inner border.
15 West niche, Greek cross.
16 Central niche, west pilaster.
17 Central niche, east pilaster.
18 Bands flanking central niche.
19 Frieze above central niche.
20 Pediment above central niche.
21–22 Triangular panels above pediment.
23 Central niche, Greek cross.
24 East niche, outer border.
25 East niche, inner border.
26 East niche, Greek cross.
27 East corner pilaster.
28 Freestanding spiral colonnette, south-east corner.

East Elevation (Figs 453 and 454)

Upper Chest

7–8 Engaged spiral colonnettes, south-east corner (described under south elevation).
29 Central panel.
30 Border around 29.
31 Band on edge of top slab.
32–33 Engaged spiral colonnettes, north-east corner.
34 Narrow fillet on face of plinth.

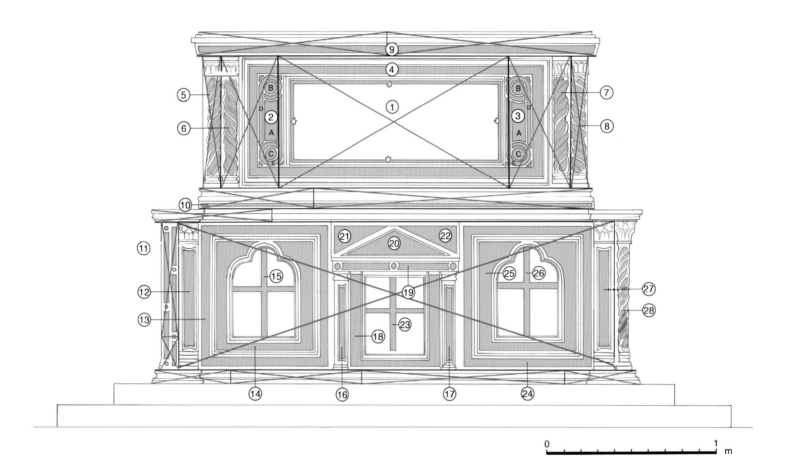

445 Tomb of Henry III, south elevation. Diagram defining the individual Purbeck marble blocks in the construction; also the key to panel numbering. *Authors'*

Lower Chest

28 Freestanding spiral colonnette, south-east corner (described under south elevation).
35 South corner pilaster.
36 Borders around panels 37–40.
37–40 Rectangular panels.
41 North corner pilaster.
42 Side of pilaster 51 on north face (originally concealed by a lost colonnette).

North Elevation (Figs 462 and 463)

Upper Chest

43 Central panel.
44–45 Chain guilloche flanking east and west sides of panel 43.
46 Border around panels 43–45.
32–33 Engaged spiral colonnettes, north-east corner (described under east elevation).
47 Engaged spiral colonnette, north-west corner.
48 Freestanding narrow spiral colonnette, north-west corner.
49 Band on edge of top slab.
50 Narrow fillet on face of plinth.

Lower Chest

51 Side of pilaster 42 on east face (originally concealed by a lost colonnette).

52 East corner pilaster.
53 East panel (A-V).
54 Central panel (A-Q).
55 West panel (A-V).
56 Borders around panels 53–55 (A–D).
57 West corner pilaster.
58 Side of pilaster 64 on west face (originally concealed by a lost colonnette).
59 Painted inscription on basal step of tomb.

West Elevation (Figs 471 and 472)

Upper Chest

5–6 Engaged spiral colonnettes, south-west corner (described under south elevation).
48 Freestanding spiral colonnette, north-west corner (described under north elevation).
60 Central panel.
61 Border around panel 60.
62 Band on edge of top slab.
63 Engaged spiral colonnette integral with west elevation.
64 Narrow fillet on face of plinth.

Lower Chest

65 Side of pilaster 58 on north face (originally concealed by a lost colonnette).

66 North corner pilaster.
67 Borders around panels 68–71.
68–71 Rectangular panels.
72 South corner pilaster.
73 Side of pilaster 12 on south face (originally concealed by a lost colonnette).

DETAILED DESCRIPTION OF THE MOSAIC DECORATION

Colonnettes at the corners of the upper and lower chests are numbered and listed here, but their detailed descriptions are presented collectively at the end, to enable comparisons to be made (pp. 471–5; Figs 451, 452, 455 and 466).

South elevation: upper chest (Figs 445 and 446)

1 The central panel is filled with a single large sheet of purple porphyry, 1.22m by 43cm, supported at the axes by four leaf-shaped iron clips (Figs 447 and 448).[16] Two scars on the lower edge of the slab and one on the upper, reveal attempts made to prise it off the monument. Although the slab was fractured, the clips did not budge. The slab is surrounded by a narrow fillet with only the impressions of tesserae surviving. Around the top and sides of the panel, the mosaic pattern comprises a row of lozenges, but at the bottom it appears to be a row of tangent poised squares; the same design occurs on the north face (panel 43), which has diminutive triangles in the triangular interspaces at the margins.

446 Tomb of Henry III. South elevation. *Painting by David S Neal*

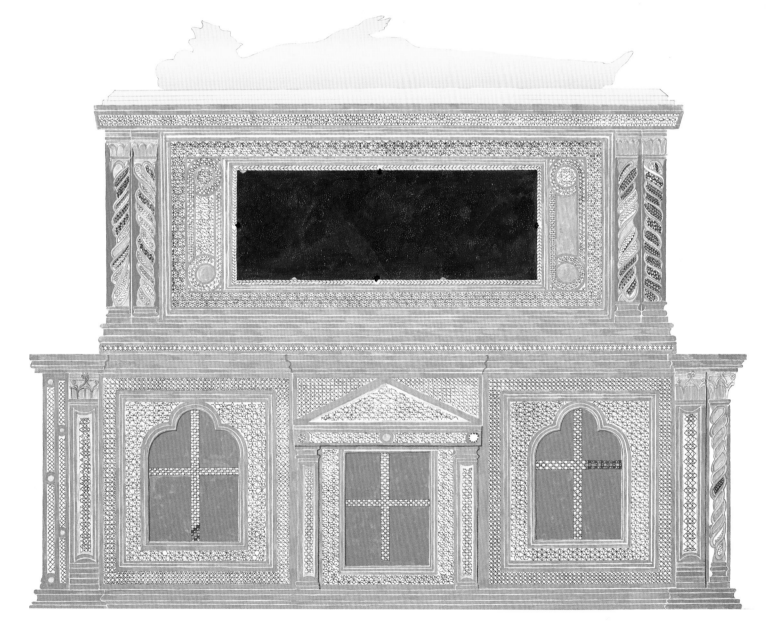

449

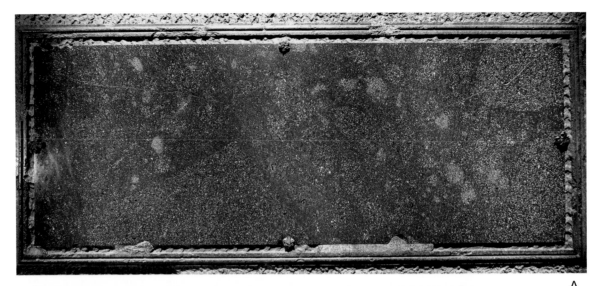

A

B

447 Tomb of Henry III, upper chest, south elevation. A. Sheet of purple porphyry (panel 1), showing the foliate iron clips and damage incurred to the edges of the slab where three attempts were made to prise it out; B. Detail of the lower left-hand border, showing also the impressions of lost tesserae that originally formed a narrow band around the panel. Note: the prominent right-angled triangle with a different textural appearance in the left-hand half of the panel is in the geological structure of the rock. *Authors*

448 Tomb of Henry III. One of the stamped iron clips used to secure the porphyry panel in Figure 447. *Authors*

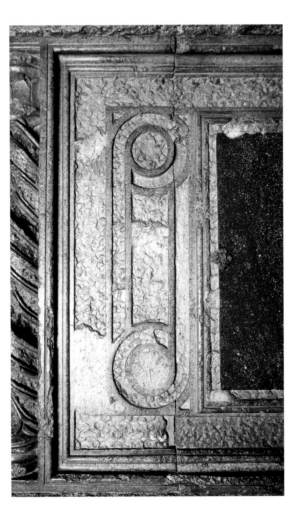

449 Tomb of Henry III, upper chest. Western part of the south elevation (panels 1, 2, 4 and column 6). *Authors*

2–3 On the west and east flanks of panel 1 are rectangles, each decorated with a single link of chain guilloche with roundels B and C, top and bottom; only the impressions of tesserae survive (Fig. 449). On the western example, the lower roundel (C) is filled with plaster attributed to Feckenham's restoration, but has lost its pattern, which is believed to have been a copy of the roundel above (B), probably containing a six-lozenge star with small triangles set in all the interspaces. Fillets (D and E) forming the pair of chain links comprise a row of chequers, with alternate squares divided diagonally to create diagonal bands. The other link (E) had a double row of tangent poised triangles (arranged as chequers) with diminutive triangles in alternate triangular interspaces. The rectangular panel created by the links is mainly void of impressions but at the top there are patterns of tesserae with an arrangement based on alternate rows of tangent eight-lozenge stars and hexagons, sub-divided by small squares and triangles. Evidence for similar patterns survives in panel 3(A–E) on the east face, but this is also mainly void.

4 Apart from impressions, none of the tessellated border surrounding 1–3 survives. However, the impressions are sufficiently clear to establish the scheme as being based on a grid of tangent hexagons, all filled with six-lozenge stars. Small hexagonal interspaces so formed contain triangles. Patches of plaster, probably 17th century, indicate

attempts to halt further losses of tesserae. The basic design is identical to the pattern surrounding the east niche (25) on the lower chest, but rotated through forty-five degrees and with the tangent lozenge stars running horizontally.

5–6 These engaged colonnettes were decorated with bands of ornament set into the spiral flutes (Figs 444, 450 and 451). Colonnette 5 is carved on the edge of the slab forming the west face of the chest; it has thirteen flutes, in only nine of which the patterns partially survive. Fourteen flutes ornament colonnette 6, which is carved on the west end of the frontal slab of the chest; only twelve flutes retain evidence for patterns, most of which are reduced to impressions (Fig. 451B). Every fifth flute repeated the sequence of pattern types, but there are inconsistencies.

7 This engaged colonnette, carved on the east end of the frontal slab of the chest, retains sufficient tesserae (or their impressions) to determine the patterns and colours of sixteen flutes (a-p), some of which are duplicated (but not always in the same sequence) and vary in width; they are shown schematically (Fig. 452A).

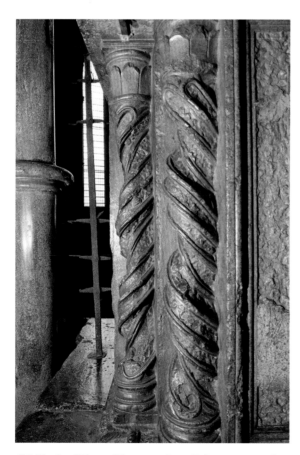

450 Tomb of Henry III, upper chest. Colonnettes 5 and 6; also showing the spiked iron stanchion that obstructed access between the west end of the tomb and the adjacent arcade pier. *Authors*

451 Tomb of Henry III, upper chest. Schematic illustrations of the tessellated patterns on spirally-fluted colonnettes at the south-west corner. A. Colonnette 5; B. Colonnette 6. *Paintings by David S Neal*

A **B**

452 Tomb of Henry III, upper chest. Schematic illustrations of the tessellated patterns on spirally-fluted colonnettes at the south-east corner. A. Colonnette 7; B. Colonnette 8. *Paintings by David S Neal*

8 Engaged colonnette carved on the southern edge of the slab forming the east end of the chest. Its fifteen flutes, well preserved at the back of the colonnette, exhibit the following bands of patterning (Fig. 452B). The colonnette would not originally have been seen from this elevation because it was masked by a freestanding, narrower, colonnette (missing). It can be demonstrated, therefore, that the decoration on the colonnette, despite sometimes having permutations of colours, is confined to four pattern types. For the bases of 7 and 8, see Figure 457.

9 Impressions of tesserae on the southern edge of the top slab are the same as those surviving on the other three elevations: a row of recumbent tangent lozenges with their sides clasped by pairs of triangles forming arrow or delta-shapes (thereby creating rows of upright lozenges). Within the triangular interspaces so formed are outward-pointing triangles.

10 A narrow fillet along the plinth of the chest has impressions indicating a row of tangent poised squares with small triangles in the triangular interspaces. The same pattern occurs on the other three faces.

South elevation: lower chest (Figs 439, 445 and 446)

11 A spiral colonnette at the south-west corner of the tomb has been lost, thereby exposing the flank of pilaster 72 on the west end-slab. A pair of narrow fillets, punctuated by small roundels (a form of chain guilloche) is decorated with tangent poised squares and triangles. This pattern also survives in the corresponding position on the east end of the chest, but is masked by the freestanding colonnette 28. For an identical example, with most of the tessellation surviving, see panel 65 (Fig. 474B).

12 Pilaster, adjacent to south-west corner. The decoration in the rectangular panel is known only from impressions and a few tesserae surviving at the bottom. It comprises a chequered arrangement of poised squares, but the varying depths of the impressions indicate that the squares were coloured so as to create quincunxes, with triangular interspaces at the margins filled with outward-pointing triangles. Interspaces between the tesserae forming the quincunx were quartered diagonally. The decoration on pilaster 27, at the south-east corner is the same. It has crude patches of plaster infilling.

13 The impressions in the frame around the western niche indicate a scheme based on a grid of squares with each square (or rectangle where the pattern has been truncated by the border) containing

poised squares. An alternative way of envisaging the pattern is as rows of tangent poised squares, set as chequers, with the square interspaces divided diagonally into four triangles.

14 Apart from a few tesserae, the pattern immediately surrounding the western niche is only known from impressions. These indicate a scheme based on clusters of hexagons filled with six-lozenge stars, almost certainly the same as in panels 20 and 25. Triangular interspaces contain single triangular tesserae forming petals. Patches of plaster have been crudely applied; the western part of the panel is mainly void.

15 Chased into the otherwise plain back wall of the niche is a Greek cross (Fig. 446).[17] It has a grid of squares that are alternately divided diagonally into pairs of triangles, creating diagonal bands, and alternating gold on black, and red on white.

16–17 Impressions of tesserae on the pilasters flanking the central niche are the same and comprise chequered squares, with alternate squares divided diagonally into four triangles (Fig. 440).

18 The surround to the central pedimented niche has a scheme based on a regular grid of spaced squares, tangent to smaller tilted squares with eight-lozenge stars in the interspaces (Fig. 440). Only indentations survive and the colours of the tesserae are not known. However, the basic pattern occurs on a pair of roundels in panel 54 on the north side; here, the squares contain reducing squares, black, white and red and the stars are gold. The pattern does not occur on St Edward's shrine, but is found on panel 31 of the sanctuary pavement (Fig. 76B).

19 The entablature over the portal carries impressions of a row of tangent hexagons, each containing a six-lozenge star and forming triangular interspaces along the margins of the panel (Fig. 440). At the terminals and centre-point are small roundels: the western example has impressions of a six-lozenge star; the central one is void. The eastern example is filled with plaster but spaced red triangular tesserae around its margin indicate that it too probably had a six-lozenge star.

20 Only impressions of tesserae survive on the triangular pediment. It has a complex design best described as being based on an overall pattern of clusters of six tangent hexagons, arranged angle-to-angle and creating central interspaces filled with six-lozenge stars. Every hexagon contains a triangle pointing away from the central stars, to create the effect of petals. The pattern is the same on panels 14 and 25. In the centre of the pediment is a crudely worked patch of plaster (Fig. 440A). When this was applied the tessellation was presumably still intact in the two ends of the pediment: it is as though a central medallion or other focal feature had been robbed out, and the *lacuna* roughly filled with unpainted plaster.

21–22 Impressions of tesserae in the two triangular panels above the pediment have ten rows of tangent poised squares. The pattern is a common one and where it survives in panel 53 on the north side of the tomb, for example, the poised squares alternate gold on red, and red on white.

23 Chased into the back wall of the niche is a Greek cross, similar to that on panels 15 and 26 (Fig. 440A). Impressions indicate a different mosaic pattern from the western example: a grid of squares, alternate ones being divided diagonally into four triangles. No tesserae survive to establish their colours.

24 The frame for the eastern niche has a similar pattern to 13 bordering the western niche but there is no evidence from the impressions that its outer squares were also quartered (Fig. 441A).

25 The decoration immediately surrounding the eastern niche is the same as on panels 14 and 20: clusters of six tangent hexagons creating a central interspace filled by a six-lozenge star (Fig. 441A). Each hexagon has a triangle pointing away from the six-lozenge stars, creating the effect of petals.

26 The Greek cross decorating the rear wall in the eastern niche has the same decoration as 23 (Fig. 442), with alternating red and gold tesserae set diagonally, the interspaces divided diagonally, shaded blue and white.

27 The eastern pilaster has the same decoration as 12 (Fig. 438A).

28 Slender, freestanding colonnette at the south-east corner of the chest (Fig. 438). Of its twelve flutes only one retains tessellation: two rows of tangent gold squares, one row divided, creating black and gold triangles. Red triangles flank both sides of the band.

East elevation: upper chest (Figs 453 and 454)

Note: the engaged colonnettes at the south-east corner of the upper chest (7 and 8) have already been described. Originally, however, colonnette 7 (and its northern counterpart, 33) would have been partially hidden from view in this elevation by freestanding colonnettes similar to the surviving one (48), at the north-west corner of the tomb.

29 The central panel, originally 30cm by 42cm, is now filled with red painted plaster with flecking in imitation of a sheet of purple porphyry. The quality of the restoration suggests that it is the work of Feckenham. The plaster panel is the same height as the sheets of porphyry on the north and south faces.

30 This band of ornament surrounds panel 29. It is 45cm by 77cm overall with broad zones top and bottom and narrower strips on each side. The decoration is consistent throughout but, apart from a small area of tessellation on the northern edge, survives only as impressions. It includes three diagonal bands of tangent poised squares, alternating blue squares on white and gold squares on red (some of the surfaces of the gold squares have laminated exposing the red glass beneath). It is possible more tesserae survive beneath later plaster. The workmanship is bolder than elsewhere on the monument perhaps because this elevation was hardly visible, some mouldings of the lower chest being only 3cm from the adjacent arcade pier.

31 Edge of the top slab, with the same decoration as 7 on the south elevation.

32 Engaged spiral colonnette carved on the north edge of the end-slab (Figs 455 and 456). Its thirteen flutes (a–l), exhibit the following bands of pattern (p. 456); the decoration in every fourth flute is usually repeated but there appear to be slight inconsistencies in some of the patterns.

33 Engaged colonnette carved on the east end of the slab forming the north face of the chest (Figs 455 and 456). Its decoration (a–m) would have been obscured by the missing colonnette mentioned above. As with colonnette 32, the sequence of some of the patterns is inconsistent, but every fourth flute is stylistically similar.

34 An arrangement of tangent poised squares on the plinth fillet is the same as elsewhere (see 8). However, here the tesserae survive with alternate tangent gold and dark blue poised squares, creating red triangular interspaces superimposed with white triangles.

East elevation: lower chest (Figs 453 and 454)

28 Freestanding spirally-fluted colonnette at the south-east corner of the chest; for description, see south elevation 28.

35 The southern pilaster has a right-angled grid of chequers shaded as diagonal bands, alternately dark blue poised squares on white, and gold squares on red (for the capital, see Fig. 438B). The surfaces of the blue squares have been deliberately abraded, *in situ*, to adhere *cabochons* of stone or glass (Figs 458B and 459).

36 A block of four rectangular panels divided and framed by an elaborate band with a scheme based on a diagonal grid of chequers. Along the centre-line of the band are groups of four converging poised squares, alternating with pairs of white tesserae, divided diagonally into pairs of triangles to create an arrangement of hourglass shapes. The tesserae here are well preserved and demonstrate that the pattern was further elaborated by the use of alternating rectangles of colour 13cm long: red, white and gold; blue-black, white and gold (Fig. 458A, B).

37–40 Four rectangular panels. The upper pair measures 30cm by 35cm and contains slabs of purple porphyry, 20cm by 15cm, inserted into empty matrices in 1873 (Fig. 458A). Their edges are machine-cut and they are mounted on thin sheets of slate.[18] The panels are surrounded by tessellated bands. Panels 39 and 40 below have no porphyry and are tessellated throughout. Most tesserae in panel 37 are lost but impressions indicate a pattern similar to that in panel 35; a small red triangle filling an interspace in the bottom corner would indicate that alternate gold squares had red hour-glass shapes. Panels 39 and 40 are both decorated similarly: a diagonal arrangement of blue and white, and blue and gold chequers, respectively. In 39 the white interspaces are superimposed by gold lozenges with pairs of red triangles, creating hour-glass motifs and forming a series of horizontal bands 'underlying' the grid. The blue glass

453 Tomb of Henry III, east elevation. Diagram defining the individual Purbeck marble blocks in the construction; also the key to panel numbering. *Authors*

454

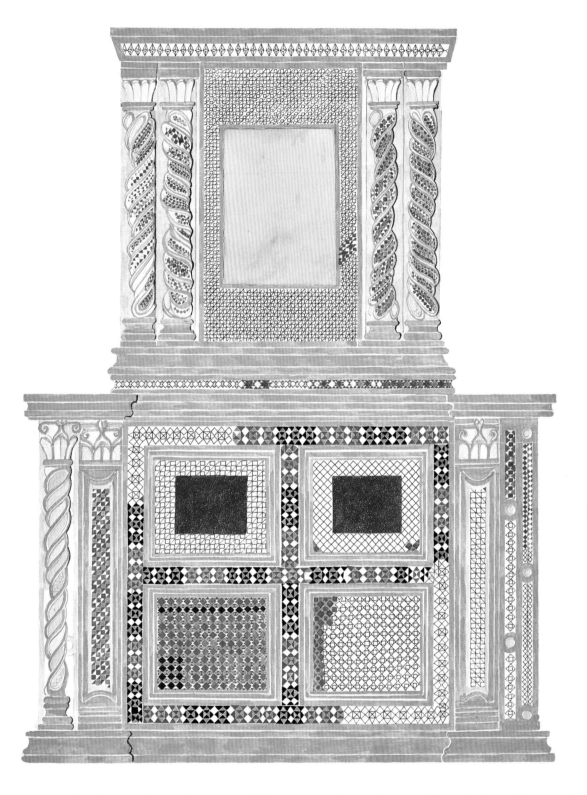

454 Tomb of Henry III. East elevation. *Painting by David S Neal*

tesserae in the second row down are slightly smaller and a brighter shade of colour (Figs 458C and 460). This row covers a horizontal joint between slabs of Purbeck marble forming the structure of the chest, confirming that the blocks were decorated when they were prefabricated, and this row of tesserae was set following assembly. In panel 40 the gold interspaces contain red poised squares. The majority of the poised blue squares exhibit deliberate abrasion to the surface (Fig. 460); this was done *in situ*, to provide keying to adhere *cabochons* of stone or glass (cf. panel 35). All the *cabochons* have been lost.

41 The north pilaster has the same pattern, but is somewhat bolder than the southern (35).

A

B

b

c

d

e

f

g

h

i

j

k

l

m

a

b

c

d

e

f

g

h

i

j

k

l

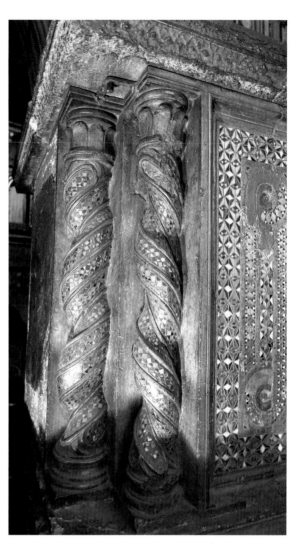

456 (*Right*) Tomb of Henry III, upper chest. Colonnettes 32 and 33 at the north-east corner. *Authors*

455 (*Left*) Tomb of Henry III, upper chest. Schematic illustrations of the tessellated patterns on spirally-fluted colonnettes at the north-east corner. A. Colonnette 32; B. Colonnette 33. *Paintings by David S Neal*

457 Tomb of Henry III, upper chest. Detail of the moulded bases of colonnettes 7 and 8 at the south-east corner. *Authors*

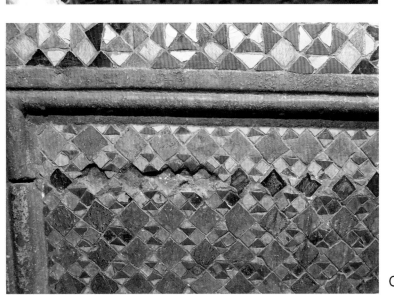

458 Tomb of Henry III, lower chest. Surviving decoration on the east end (preserved by being in a confined space). A. Panels 35–37; B. Detail of panel 35 and band 36; C. Panel 39 and band 36. Note the line of darker glass tesserae close to the top of the panel, bridging the joint between two Purbeck marble slabs that comprise the matrix. *Authors*

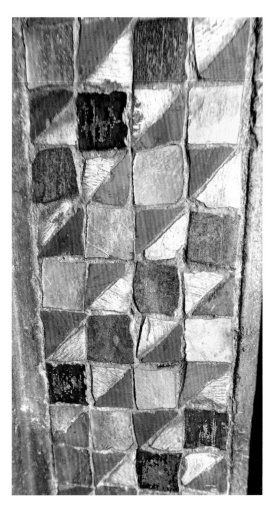

459 Tomb of Henry III, lower chest, east end. Pilaster 35, containing square blue glass tesserae with abraded surfaces. *Authors*

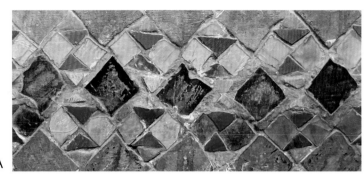

460 (*Right*) Tomb of Henry III, lower chest, east end. Panel 39, containing square blue glass tesserae with abraded surfaces, filling a structural joint (A) (details from Fig. 458C). *Authors*

A

B

461 (*Below*) Tomb of Henry III, lower chest. Surviving bands of decoration (42 and 51) in the rebate at the north-east corner where a shaft formerly stood. Also showing is part of band 36, around panel 38 (cf. Fig. 458). *Authors*

42 The freestanding colonnette at the north-east corner is lost, thereby exposing a pair of narrow strips of mosaic chased into the flank of pilaster 52 on the north face of the tomb. Its Purbeck border is a form of chain guilloche (Fig. 461). The inner strip has a row of tangent poised squares, each containing a smaller red square, and with blue triangles in the interspaces at the sides. The outer fillet has a chequered pattern set diagonally to the band, forming two parallel rows: tangent red tesserae on white, and tangent white squares on blue (cf. band 65 at the north-west corner). Two of the small roundels here retain traces of red-stained mortar.

North elevation: upper chest (Figs 433, 462 and 463)

Note: the engaged colonnettes at the north-east corner of the chest (32 and 33) have already been described. A lost freestanding colonnette (similar to 48) would have obscured 32, as viewed from the north.

32–33 Engaged spiral colonnettes at the north-east corner (described under the east elevation; Figs 455 and 456).

43 As with the south elevation, the main panel comprises a large sheet of purple porphyry, 1.27m by 43cm, secured on its axes by leaf-shaped iron clips (Figs 464 and 465). The slab is fractured on a line running from the clip at the top edge, diagonally down to the bottom; and also across

the lower right corner, from just above the clip. There is no overt evidence of any attempt to prise it off the chest, and it is most likely that in this instance it was rusting of the top clip that applied pressure to the slab, causing it to crack. Surrounding the panel is a fillet of mosaic with tangent gold poised squares and red triangular interspaces at the margins, superimposed with diminutive white triangles. The same design occurs on the equivalent fillet on the south side, where it also has a pattern of chevrons.

44–45 Links of chain guilloche flanking panel 43, are well preserved (Fig. 465). They are narrower than their counterparts on the south elevation (2–3), with three strips of decoration of similar width. In the east example (44), the decoration of the central strip is based on a pattern of large squares tangent to smaller tilted squares, with gold eight-lozenge stars in the interspaces. The large squares are blue with white poised squares superimposed; the smaller tilted squares are red. The pattern occurs on panel 18 on the south elevation and in a spaced variety in panel 2. It is also represented in panel 31 on the sanctuary pavement, but in different colours. There is no symmetry of pattern in the equivalent panel to the west (45A), which has six-lozenge stars. In the link on the east side of 44B is a row of tangent gold lozenges with red triangular interspaces, each superimposed with white triangles. The adjacent link (C) has gold chequered triangles, in two rows, with blue interspaces in the outer row, and red in the inner. Both rows are superimposed with white triangles. The corresponding links on the west (45) are narrower, and the outer one has the same ornament as the outer link in (44), but the inner link has patterns based on blue and white chequers, poised gold squares on the blue and poised red squares on the white. The roundels top and bottom on both panels are lost but possibly once had discs of blue glass.

46 Border around panels 43–45 (Fig. 465). Its scheme is best described as an arrangement of chequered gold and blue recumbent lozenges (each formed from four tesserae), containing a vertical lozenge, those in the gold lozenges being red with pairs of white triangles forming hour-glass shapes superimposed, and those in the blue lozenges with white, single, upright lozenges.

47 Engaged spiral colonnette at the north-west corner (Figs 443 and 466). Enough tesserae and their impressions survive within the flutes to determine the patterns, which tend to duplicate in every fourth flute.

48 Freestanding, narrow, spirally-fluted colonnette at the north-west corner (Figs 443, 465 and 466). Unfortunately, it is poorly preserved and insuf-

ficient tesserae, or their impressions, survive to indicate the patterns, although they were probably variations of those already described. The damage to this colonnette is not consistent with casual pilfering; the other two colonnettes (47, 63) that make up the triplet at this corner are in relatively good condition. Not only has 48 been comprehensively stripped and generally battered, but much of its northern face (including the base) has also been hacked away. This could have been associated with the erection of a large post-medieval monument in the ambulatory, backing against Henry III's tomb; or the shaft may have been removed altogether, mutilated for some other purpose, and later reinstated.

49 Band on the edge of the top slab is the same as 9 (south elevation).

50 The decoration on the plinth fillet is the same as 10 (south elevation).

North elevation: lower chest (Figs 462 and 463)

51 Side of pilaster 42 on the east elevation. Same as 11 on the south elevation. It was originally concealed by a now-lost colonnette.

52 Pilaster adjacent to the north-east corner (Fig. 467). No tesserae survive but their impressions indicate that it had the same design as the equivalent panel (57) to the west, which is better preserved. The pattern is best described as a series of tangent hexagons into which gold six-lozenge stars are set. It is made more complex by shading the hexagonal interspace so formed, blue, and superimposing on these red triangles with small white triangular centres. The overall effect is a series of circles of blue hexagons, creating flower-forms with the central space occupied by one of the gold stars.

53(A–U) The east panel, 62cm internally, contains a large poised square with loops on each side encircling roundels filling the outer corners of the panel and creating a quincunx (Fig. 467A). In the centre is an almost square slab of green porphyry (probably reset or replaced) surrounded by a band (A) of inconsistent tessera impressions. The top left and bottom right examples have patterns of chequered triangles, almost certainly with diminutive triangles in the interspaces. The band to top right has a poised grid of octagons containing six-lozenge stars in an arrangement similar to the pattern in panel 52. The band to bottom left of the porphyry is also similar but no attempt seems to have been made to insert another row of six-lozenge stars, substituting a row of triangles instead. The patterns in diagonally opposite loops are the same. In the top left

459

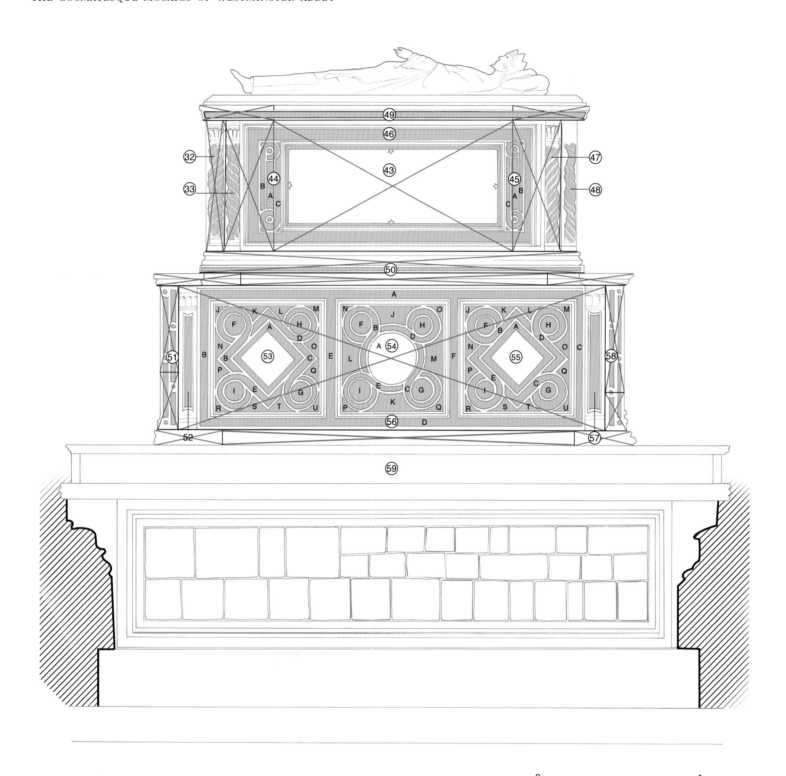

462 Tomb of Henry III, north elevation. Diagram defining the individual Purbeck marble blocks in the construction; also the key to panel numbering. *Authors*

example (B), which survives in part (Fig. 467B), and possibly in the bottom right example (C), is a row of tangent poised squares containing a quincunx of four blue-grey tesserae in the corners and a gold tessera in the centre. White interspaces are quartered diagonally, creating pairs of red triangles set tip-to-tip and with the triangles tangent to the gold square in the quincunxes,

creating the effect of another square. In triangular gold interspaces at the margins are outward-pointing red triangles with white triangular centres. The loops to top right (D) and lower left (E) have patterns of tangent gold lozenges, of four tesserae, overlain with recumbent blue lozenges. Red triangular interspaces on either side are superimposed with gold triangles.

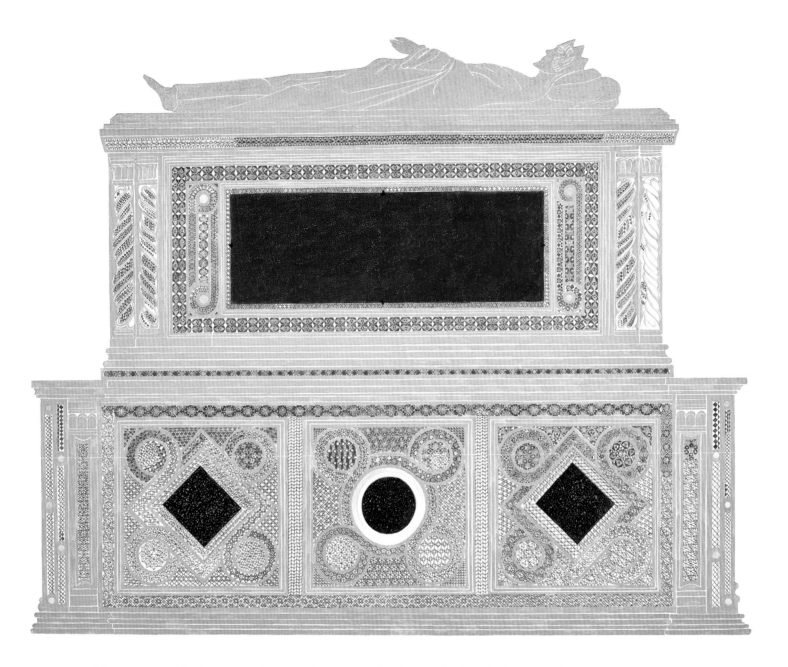

Of the four roundels, the two at the top of the panel are well preserved; that on the left (F) has a diagonally aligned grid of gold lozenges set tip-to-tip with square gold tesserae in the red interspaces and with their angles tangent to the angles of the lozenges. Another way of seeing the design is as a pattern of overlapping octagons: the two sides of each lozenge representing two of the eight angles of the octagon. Impressions of a matching panel survive at bottom right (G). The roundel at top right (H) is complete and has a cluster of seven tangent gold hexagons superimposed with blue six-lozenge stars (Fig. 467B). Red triangular interspaces contain a small gold triangle. The diagonally opposite roundel, bottom left (I), seems to have had the same design but the central eight-lozenge star has been substituted

with reducing triangles. The interspaces between the quincunx and the frame of the panel are filled with rows of poised squares, gold on red and red on white (with diminutive blue triangles on the white interspaces). The pair of triangular interspaces (S–T) at the bottom of the panel were restored with fictive mosaic in plaster (Fig. 468), similar to Feckenham's repairs on St Edward's shrine.

54 The central square panel is almost the same width as the eastern example and is dominated by a large roundel adapted into a quincunx, with loops creating medallions extending into the four corners (Fig. 469). In the centre is a circular slab of green porphyry with sharp edges indicative of a machine-cut replacement; it is slightly smaller

463 Tomb of Henry III. North elevation, with some infilling of gaps to show how the mosaic would have looked when it was newly constructed. For a larger version, see Plan 3 at the end of this volume. *Painting by David S Neal*

461

464 Tomb of Henry III, upper chest, north elevation. Panel of purple porphyry and its borders. *Authors*

than the original, and there is a narrow concentric scar around it filled with mortar. The original roundel was framed by a tessellated band of which only the impressions of a few triangles survive in a runnel shallower than the circle chased for the porphyry. Decoration in diagonally opposite bands is the same, but only the top right example retains tessellation. Its scheme has large alternate inward- and outward-pointing gold and red triangles superimposed by hexagons, each containing a six-lozenge star, white examples on the gold triangles and gold examples on the red. Both types have shallow blue triangles between the points of the stars. Impressions of tesserae in the loops at top left and bottom right (F and G) indicate rows of six-lozenge stars within hexagons, and having triangular interspaces at the margins filled with reducing triangles.

The roundel at top right (H) and that at bottom left (I), which is now a void, has a scheme of large squares tangent to smaller tilted squares, with gold eight-lozenge stars in the interspaces. The large squares are blue and contain a white poised square with a red centre. The small poised squares are red with white centres. The roundels at top left and bottom right (F–G) have tangent rows of alternate gold and black lozenges forming

zigzags. In the red square interspaces, so formed, are white squares. The decoration in concave-sided trapezoidal panels between the roundels and the sides of the overall panel is matched top and bottom, and side to side. A surviving example at the top (J) has a pattern of tangent gold six-lozenge stars creating blue hexagonal interspaces superimposed by red triangles, each with a white tessera in the centre. The decoration within the equivalent trapezia at the sides of the panel (L–M) comprises a diagonally arranged grid of fillets with small squares at the intersections (probably once blue and gold, respectively). Each square of the grid contains a quincunx with the interspaces having pairs of triangles set point-to-point. The four spandrels in the corners of the panel (N–Q) have blue and gold chequered triangles.

55 The overall scheme in the west panel is identical to that in the eastern panel (53); however, the decoration within the bands is mostly different (Fig. 470A). The tessellated borders around the central poised square of green porphyry (reset or replaced) are lost and only impressions survive. Those on the north-east and south-west sides had bands comprising two rows of chequered triangles with smaller triangles in the interspaces.

A

B

The pair of bands north-west and south-east had rows of tangent poised squares, with the poised squares forming interspaces divided into pairs of triangles and creating a banded effect. The loop at top left (B) is preserved and is best described as having a row of tangent gold poised squares, each superimposed by a blue square, overlain by a poised white square enclosing a central blue square. Triangular interspaces at the margins are red and superimposed with gold triangles and diminutive white triangles. The diagonally opposite band, bottom right (C), had the same pattern. The bands forming loops at top right (D) and bottom left (E) of the panel are most complex, and exhibit the finest workmanship anywhere on the tomb; most of the decoration of the top right loop survives (Fig. 470B). Its

patterns are best described as having rows of large gold hexagons, tangent point-to-point, each superimposed by a bewildering sequence of overlays. Working 'inwards' the first of these is a star with its six triangular points shaded red, and triangular white centres. In the centre of the star is a gold hexagon superimposed by a red six-lozenge star.

Two of the upper roundels survive; the eastern example (F) has an arrangement of seven blue hexagons each with a gold six-lozenge star. Small hexagonal interspaces are blue with red triangles and small white triangles superimposed; the diagonally opposite roundel was the same. The roundel at top right (H) has a basic pattern of blue hexagons (Fig. 470B); those at the margins contain gold triangles with a red triangle

465 Tomb of Henry III, upper chest, north elevation. Details of mosaic decoration. A. Eastern end; B. Western end. *Authors*

466 Tomb of Henry III, upper chest. Schematic illustrations of the tessellated patterns on spirally-fluted colonnettes at the north-west corner. A. Engaged colonnette 47; B. Detached colonnette 48; C. Engaged colonnette 63. *Paintings by David S Neal*

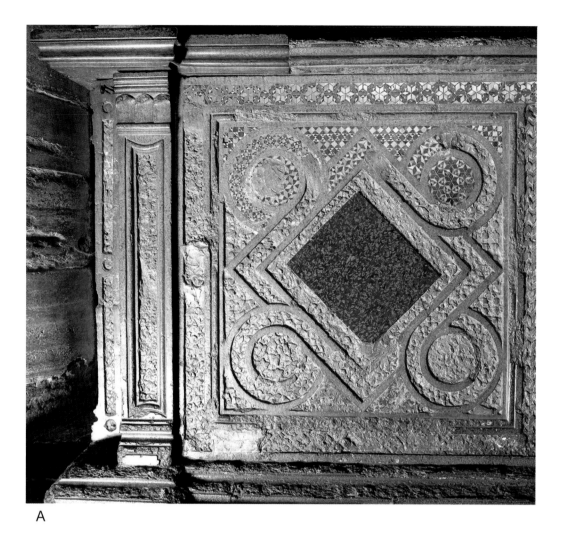

A

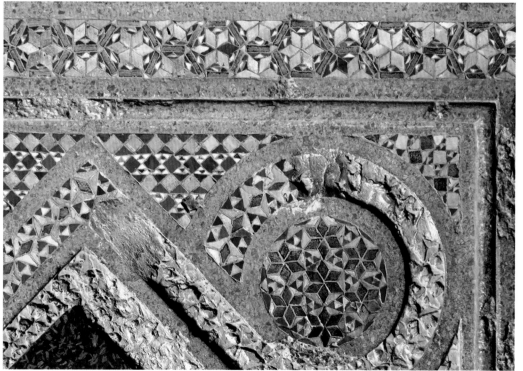

B

467 Tomb of Henry III, lower chest, north elevation. A. Eastern quincunx panel (53) and pilaster (52); B. Detail of mosaic decoration in the upper right corner of panel 53. *Authors*

465

468 Tomb of Henry III, lower chest. Detail from panel 53. Tudor *faux* mosaic painted on plaster in spandrels at the bottom of the panel. *Authors*

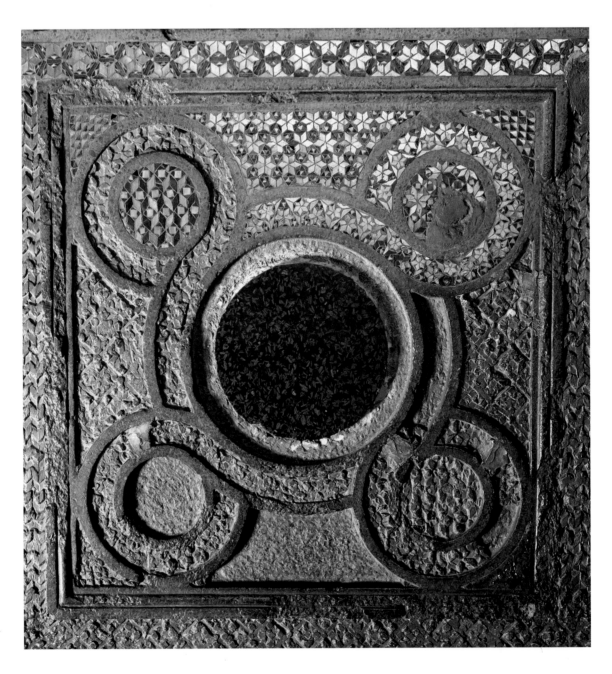

469 Tomb of Henry III, lower chest, north elevation. Central quincunx panel (54). *Authors*

superimposed. A central hexagon, also blue, has a gold six-lozenge star (two of the tesserae, having lost their gold covering, show as red). In white triangular interspaces around the central star are red triangles. Impressions indicate that the same pattern existed in the roundel at bottom left (I). Pairs of spur-shaped compartments at the top (K–L) and bottom (S–T) of the panel have the same decoration, a large gold triangle with a blue hexagon superimposed, and upon this a white triangle with a red triangle superimposed. Hexagons with gold six-lozenge stars occupy the red interspaces at the sides and, in the remaining spaces, small white triangles. The equivalent spaces on the east and west sides (N–O) were decorated with rows of triangles set as chequers, and with the interspaces containing diminutive triangles (all lost).

56 Although the pattern bordering the upper tomb-chest is the same throughout, the frames around and dividing panels 53–55 are of four types (a–d). The decoration in the top border (A) survives (Figs 467, 469 and 470); its basic scheme is a grid of hexagons defined by blue fillets, with tiny white triangles where the fillets change angle. However, because the pattern is set within the confines of a band, the consequence has been the formation of a row of hexagons linked to one another by single fillets, creating trapezoidal interspaces. Each hexagon contains a gold six-lozenge star with red triangular interspaces with diminutive white triangles. Half-units of the same motifs occupy the trapezia. The decoration of the eastern vertical border of the panel (B) is known only from impressions, except for a small part in the top left corner. However, it has the same decoration as the western vertical border (C, Fig. 470). Here, about one-third of the band survives and has the same scheme as the top right roundel in panel 55, although in different colours and on a smaller scale. It has a row of large gold tangent hexagons, each superimposed by a blue hexagon that is in turn superimposed by a gold six-lozenge star. The triangular interspaces are red with a gold triangle and diminutive white triangles on each face. The decoration of the horizontal border at the bottom (D) is known only from impressions, indicating a pattern based on a diagonally arranged grid of squares defined by fillets (probably blue, and reflecting the style of the upper band (A)). Where the fillets of the grid converge, small tesserae are introduced and, within the squares, quincunxes with alternate squares quartered. In triangular interspaces along the margins of the band are 'quincunxes' divided diagonally. The two vertical bands (E–F) separating the three panels are known only from indentations, but a pattern based on chevrons (D)

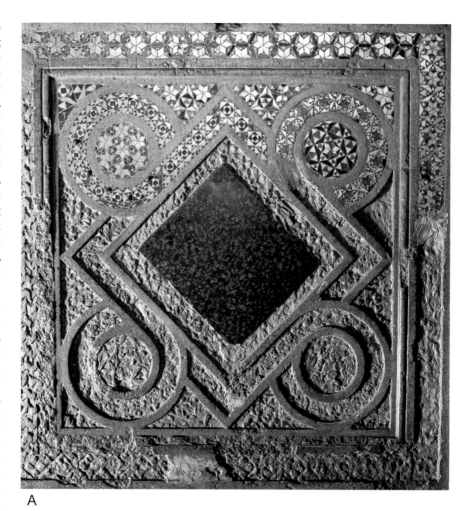

A

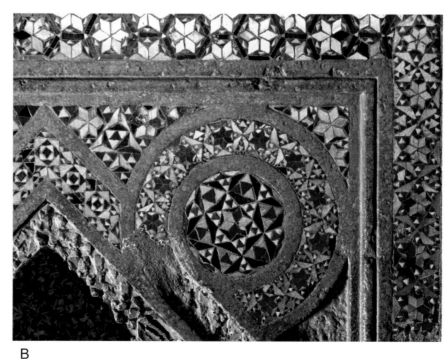

B

470 Tomb of Henry III, lower chest, north elevation. A. Western quincunx panel (55); B. Detail of mosaic decoration on the upper right corner. *Authors*

is evident. Presumably the chevrons alternated in colour similar to the nearby roundel in panel 54.

57 Tesserae surviving on the western pilaster indicate that its decoration was the same as the eastern pilaster (52); patterns of six-lozenge stars, tangent tip-to-tip, creating hexagonal interspaces, infilled blue, with red triangles, each with a white triangular tessera, superimposed. The overall effect is a series of circles of blue hexagons creating flower-forms, with the central space occupied by one of the gold stars.

58 The side of pilaster 58 on the west face of the chest was originally concealed by a freestanding colonnette, now missing, and has the same decoration as the other examples (see 11).

59 There is no mosaic decoration on the riser of the basal step, but a gold painted inscription was added in the 16th century; only the last six letters now survive, reading …] PERTIS, followed by a flourish (Fig. 475). For the full inscription, see p. 476.

471 Tomb of Henry III, west elevation. Diagram defining the individual Purbeck marble blocks in the construction; also the key to panel numbering. *Authors*

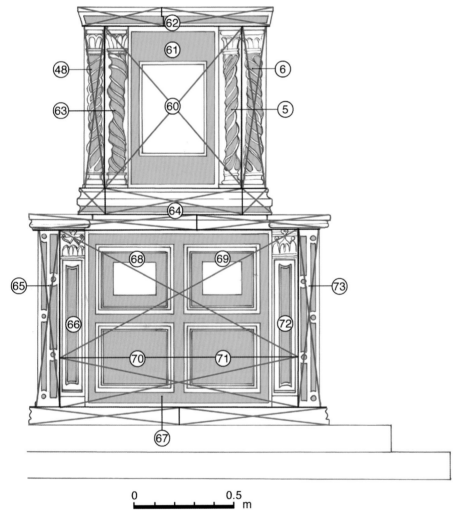

West elevation: upper chest (Figs 444, 471 and 472)

5–6 Engaged spiral colonnettes at the south-west corner (described under the south elevation).

48 Freestanding spirally-fluted colonnette at the north-west corner (described under the north elevation).

60–61 The main panel (60) once comprised a slab of purple porphyry, as on the south and north elevations, but much smaller. It probably measured 33cm by 44cm, but was robbed in antiquity and replicated by Feckenham in red painted plaster set within a narrow border of imitation Purbeck marble (Fig. 473). The original porphyry panel was surrounded by tessellation (61), but by the 1550s this too had been largely destroyed and was restored in *faux* mosaic. In places, the plaster has laminated revealing the impressions of tesserae, confirming that the Tudor restoration is an accurate representation of the original mosaic. Its scheme is complex. The pattern could be seen as based on a right-angled grid of bands created from pairs of tangent lozenges, side by side, separated at their points by small square intersections of the grid; the interspaces so created are filled with four-pointed stars with a poised square in the centre. However, the materials of the lozenges were probably gold and blue glass tesserae of different thicknesses, which have left the deeper impressions of one group of materials than the other, revealing the pattern to comprise a series of octagons. The design was therefore based on tangent octagons, alternately gold and blue, into which white (or red) four-pointed stars have been introduced, each with a gold or red poised square in the centre. The interspaces between the tangent octagons are small red four-pointed stars with a gold square in the centre (these tesserae represent the intersections of the grid). As elsewhere, Feckenham's painted restoration shows blue tesserae as black.

62 Band on edge of top slab. Impressions only; same decoration as 49.

63 Engaged spiral colonnette. Its flutes are sufficiently preserved to establish that the decoration repeats the patterns observed on other examples on the upper chest (Figs 443 and 466).

64 Narrow fillet on the face of the plinth, with impressions indicating a row of tangent poised squares with small triangles in the triangular interspaces. The same pattern as on the other sides.

West elevation: lower chest (Figs 471 and 472)

65 West flank of north-facing pilaster 58. Most of the tesserae survive (Fig. 474B). In one channel is a blue band superimposed by tangent, poised gold squares and a band, white and gold, super-imposed by tangent red squares. An adjacent band is blue, overlain with tangent poised white squares, developing triangular interspaces at the margins, and containing red squares.

66 Pilaster adjacent to north-west corner (Fig. 474B). Impressions of tesserae indicate a pattern of hexagons tangent at their angles. Down the spine of the pilaster, alternate hexagons are substituted by six-lozenge stars. The pattern described would have approximately 210 tesserae. However, the design is similar to that ornamenting the north face of the adjacent pilaster (57), where the hexagons all contain triangles with white centres, thereby increasing the quantity of tesserae for each hexagon from one to seven.

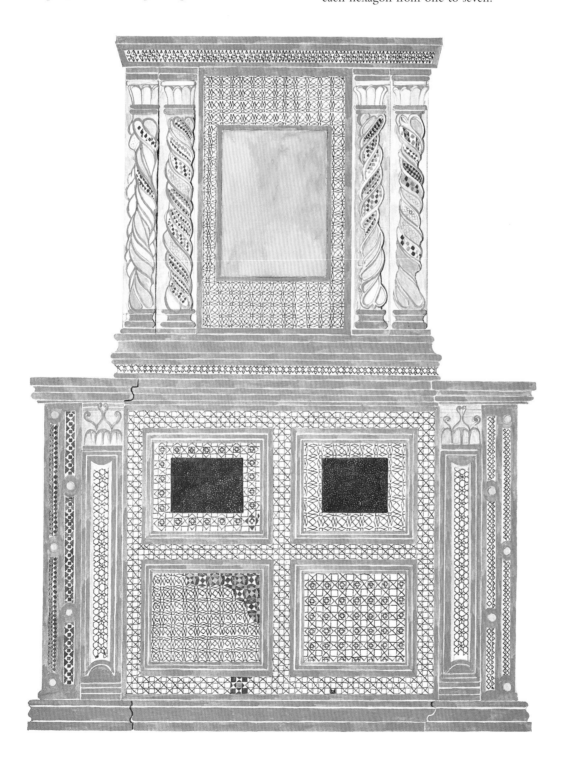

472 Tomb of Henry III. West elevation. *Painting by David S Neal*

473 Tomb of Henry III, upper chest. Restoration drawing of Tudor painted *faux* mosaic on the west end (panel 61). *Painting by David S Neal*

67 Borders around and between panels 68–71. Only a small area of tessellation survives, displaying a chequered pattern of squares, red, blue and gold (and probably white) with white interspaces divided diagonally into red and blue triangles, forming hour-glass shapes and thereby converting the central row of squares into tangent poised squares. On the equivalent panel (36) on the east elevation the decoration, although not the same, is divided into rectangular segments alternating

in colour, and it is possible such an arrangement existed here.

68 Rectangular panel measuring 31cm by 35cm. overall (Fig. 474A). It has a sheet of purple porphyry in the centre which is a replacement of 1873 (see also panels 37–38). Surrounding the porphyry is a band, lacking mosaic impressions, but a small area of surviving tesserae in the lower right-hand corner is sufficient to determine the pattern. It had an arrangement of large poised tangent blue squares, containing a white square superimposed by a red square, with a diminutive white square in the centre. Originally, the colours would probably have counter-changed, with the interspaces shaded gold.

69 Rectangular panel, the same size as 68. This too contains a replaced sheet of purple porphyry. No tesserae survive, but the impressions indicate that it probably had the same decoration as panels 61 and 70.

70 About one-quarter of the tesserae survive in this rectangular panel (Fig. 474A). The scheme is the same as that described under panel 61 on the upper chest.

474 Tomb of Henry III, lower chest. A. Mortar impressions of robbed tesserae in panels 68–71, and pilaster 72, on the west end; the plaques of purple porphyry were installed in 1873; the arrow points to the original iron cleat that secured the top of the detached colonnette (lost) at the south-west corner; B. North-west corner with bands of tessellation (65) surviving behind the lost colonnette, and pilaster 66. *Authors*

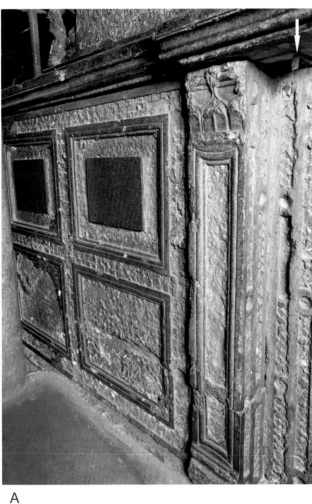

A

B

71 A similar rectangular panel with sufficient impressions of tesserae to indicate that the pattern was originally the same as in panel 68.

72 Pilaster adjacent to the south-west corner (Fig. 474A). Few impressions of tesserae survive, but sufficient to indicate that the pattern was probably the same as that in its counterpart, pilaster 66.

73 West flank of south-facing pilaster 12. Only the impressions of tesserae survive, indicating a pattern the same as that on panel 65. Originally, it would have been hidden from view from the west by a detached colonnette (missing).

Tomb colonnettes

Henry III's tomb was originally graced with sixteen spirally-fluted, mosaic-inlaid colonnettes. Single, freestanding, examples were placed at the four corners of the lower chest, flanked by narrow pilasters with capitals. A cluster of three colonnettes occupied each corner of the upper chest, two of them being carved on the ends of the side walls of the tomb, and the third freestanding in the nook between them. The shafts of these describe three-quarters of a circle (see plan, Fig. 436). One of the *en délit* colonnettes survives on the lower chest at its south-east corner (28), and one on the upper chest at the north-west corner (48).

The condition of the colonnettes is varied, most having been at least partially robbed of their decoration, and six out of the eight detached colonnettes have been lost or stolen. Colonnette 28 probably owes its survival to the close proximity of the tomb of Princess Elizabeth (1495), which acted as a barrier, providing some protection against souvenir hunters; even so, it was stripped of mosaic (Fig. 432). Colonnette 48, being on the north side high above ambulatory floor level, was inaccessible without the aid of a ladder. Curiously, it has not only been stripped of mosaic, but the Purbeck marble itself is also badly damaged, indicating that the colonnette may not be primary to this location.

Examples on the upper tomb-chest, south elevation (5–8), are heavily damaged, but usually enough tesserae, or their impressions, survive at the terminals of the flutes to determine the patterns, which mostly repeat every fourth band. The degree of preservation of the mosaic decorating the flutes of colonnettes 32, 33, 47 and 48 on the north elevation is better. Here, their height above the ambulatory floor has afforded protection from souvenir hunters; again, the decoration

usually repeats every fourth band, although sometimes with different colour sequences of the same basic pattern.

The tesserae are all made of glass and their colours include black (sometimes seen as being very dark blue), red, gold (red glass flashed with gold) and white. The flutes vary in width, and consequently some bands of pattern are wider than others. Also, some are of better quality: for example, 6(g), 7(d) and 7(j), contain micro-mosaic with tesserae as small as two millimetres across.

Descriptions and illustrations of the colonnettes are presented here collectively to enable comparisons to be made. The illustrations are diagrammatic and show the flutes as being complete, but only when evidence for their patterns and colours is known; where no tesserae survive the patterns can sometimes be determined by their impressions in the mortar bed.

Colonnette 5 (Figs 444, 450 and 451A)

Upper chest, south elevation. Twelve flutes (a–m); (c) and (j) are void.

(a) Two fillets of chequers, alternately red and gold, staggered and forming diagonal bands. White interspaces are divided diagonally, creating a sequence of alternating diagonal white and black bands. Same as (e) and (i) but set in a narrower flute.

(b) Two fillets of tangent poised squares; impressions only.

(d) Three fillets. A central spine of tangent poised squares in gold with black triangles in the interspaces. On either side of the fillet are rows of red and gold triangles alternately pointing inwards and outwards, with the bases of the red examples tangent to the tips of the gold squares forming the spine. Same as (h).

(e) As (a), (i) and (m).

(f) Two fillets of poised squares; the squares in one are divided into triangles. Triangular interspaces at the margins are red. Similar to (k).

(g) As (f) but with sufficient colours preserved to determine one fillet of tangent squares to be gold and the other divided into pairs of black and white triangles.

(h) Same as (d).

(i) Same as (a), (e) and (i).

(k) Two rows of pattern; a fillet of tangent poised squares in gold with black triangular interspaces. Along one side is a fillet of alternate red and white triangles.

(l) Impressions only, but probably the same as (h).

(m) Same as (a), (e) and (i).

(n) A fillet of tangent poised squares, impressions only.

Colonnette 6 (Figs 444, 450 and 451B)

Upper chest, south elevation. Fourteen flutes (a–n); (a) is void.

(b) A pattern of poised chequers. A fillet of tangent poised squares in gold has red triangular interspaces. Another fillet alongside has a row of alternate white and gold triangles.

(c) Three fillets of tangent poised squares, one row red, the other gold. The squares in a central fillet have been divided into triangles but their colour is not known. This pattern is basically a repeat of (g), but without the tiny white triangles.

(d) Possibly the same as (c); only a fillet of red tangent poised squares survives.

(e) Similar to (i), but without alternate gold tesserae.

(f) A fillet of tangent poised gold squares with white interspaces. On either side are fillets of tangent red triangles alternating with black and gold triangles.

(g) A chequered arrangement with a row of tangent poised squares in gold alongside and tangent to a row of gold triangles (half-units of the gold squares). Square interspaces are divided into pairs of triangles, red and black, with the black examples superimposed by tiny white triangles.

(h) Impressions only. Probably the same as (d).

(i) Two fillets of chequers, alternately red and gold, staggered to form diagonal bands. White interspaces are divided diagonally, white and black, creating alternating diagonal black and white bands upon which the gold and red tesserae are set. Similar to (e).

(j) Impressions only, but probably the same as (f).

(k) Impressions only. Possibly the same as (g).

(l) Impressions only. Possibly the same as (k).

(m) Impressions only; same as (e).

(n) Impressions only; similar to (k).

Colonnette 7 (Figs 452A and 457)

Upper chest, south elevation. Fourteen flutes (a–n).

(a) A band of chequered triangles in red, gold, black and gold.

(b) Impressions only. Two fillets of tangent poised squares with evidence that a central row of squares is quartered.

(c) A band of chequered triangles alternately gold and red with the red examples superimposed with diminutive white triangles. Same as (g) and (k).

(d) A central fillet of tangent gold poised squares with black triangular interspaces superimposed with small white triangles. Triangles on each side alternate red and white.

(e) Two rows of tangent poised squares, red and gold, with a central fillet of squares divided black and gold. The triangular interspaces at the margins are red and gold.

(f) A row of tangent gold squares with red triangular red interspaces. On one side is a row of alternate black and gold triangles. Same as (n).

(g) Same as (c) and (k).

(h) A central fillet of gold tangent poised squares with black triangular interspaces. Fillets on either side have alternate red and gold triangles.

(i) Similar to (e) but with a marginal strip of white, rather than gold, triangles. Same as (m).

(j) A row of white tangent poised squares with red triangular interspaces. A fillet on one side has a pattern of alternating gold and black triangles with diminutive white triangles superimposed on the black examples.

(k) Same as (c) and (g).

(l) Same as (h), but with a central fillet of poised white squares rather than gold squares.

(m) Same as (i).

(n) Same as (f).

Colonnette 8 (Figs 452B and 457)

Upper chest, south elevation. Twelve flutes (a–l).

(a) A central fillet of gold tangent poised squares with black triangular interspaces. Fillets on either side have alternate red and white triangles. Same as (j).

(b) Two fillets of chequers, alternately red and gold, staggered to form diagonal bands. White interspaces are divided diagonally, white and black, creating alternating diagonal black and white bands upon which the gold and red tesserae are set. On this example the red squares form zigzags. Similar to (f).

(c) A central fillet is composed of alternating black and white squares with poised gold squares on the black and red poised squares on the white examples. Fillets on either side have alternating, tangent, red and gold triangles. Similar to (h) and (k).

(d) Two rows of tangent poised squares, red and gold, with a central fillet of square interspaces, divided

black and gold. The interspaces at the margins are red and gold. Same as (e).

(e) Same as (d).

(f) Similar to (b), but without a zigzag effect. Same as (i).

(g) Similar to (d) and (e), but with a fillet of white tangent poised squares instead of gold.

(h) Similar to (c), but with the main fillet of alternating black and white squares containing gold and red poised squares, respectively, along one margin of the flute, and with half-units of the same design along the other side (forming a continuous pattern).

(i) Same as (f).

(j) Same as (a).

(k) Many tesserae missing, but possibly similar to (c).

(l) Impressions only of a diagonally arranged chequered pattern.

Colonnette 28

Lower chest, south elevation. Twelve flutes (a–l).

Colonnette 28 is heavily abraded, and only (g) has tesserae surviving. Flutes (a–f) and (h–j) are void; (k) and (l) have impressions of diagonally arranged tesserae.

Colonnette 32 (Figs 455A and 456)

Lower chest, north elevation. Thirteen flutes (a–m).

(a) Obscured.

(b) A chequered arrangement of black and white squares containing gold and red poised squares, respectively. Same as (f) and (j).

(c) A central fillet of tangent gold poised squares with black triangular interspaces. Fillets on either side comprise arrangements of alternating, tangent, red and gold triangles but with their points tangent to the bases of the triangles, rather than at the intersections, creating a zigzag. See 7 (l).

(d) Two rows of tangent poised squares, red and gold, with a central fillet of square interspaces divided black and gold. The interspaces at the margins are red and gold. Same as (h) and (l).

(e) Three fillets of chequers, alternately red and gold, staggered to form diagonal bands. White interspaces are divided diagonally white and black, creating alternating diagonal black and white bands upon which the gold and red tesserae are set. Same as (i) and (m).

(f) Same as (b).

(g) A central fillet of tangent poised gold squares with black interspaces. On each side are fillets of alternating red and gold triangles. Although the pattern is very similar to (c), for example, because the points of the triangles are tangent to the intersections of the central triangles, rather than mid-way along the bases, they do not create a zigzag effect.

(h) Same as (d), but one of the outer rows of triangles is white.

(i) Same as (e) and (m).

(j) Similar to (f), but one outer side has a row of white triangles, thereby dramatically changing the general appearance of the band. It is the only example of its type.

(k) A central fillet of gold tangent poised squares with black triangular interspaces. Fillets on either side have alternate red and white triangles. Similar to (g), which has alternate red and gold triangles along the sides.

(l) Same as (h).

(m) Same as (e) and (i).

Colonnette 33 (Figs 455B and 456)

Lower chest, north elevation. Twelve flutes (a–l).

(a) Two rows of tangent poised squares, red and white, with a central fillet of square interspaces, divided black and gold. The interspaces at the margins are red and gold.

(b) Two fillets of tangent poised squares, one red and the other gold, forming a chequered composition. Rows of red and gold triangles at the margins are integral with the overall pattern.

(c) A central fillet of gold tangent poised squares with black triangular interspaces. Fillets on either side have alternate red and white triangles. Same as (g).

(d) Three fillets of chequers, alternately red and gold, staggered to form diagonal bands. Gold interspaces are divided diagonally, gold and black, creating alternating diagonal gold and black bands upon which the gold and red tesserae are set. On other examples of this pattern, such as (k), these colours alternate with square interspaces, divided diagonally white and black. Same as (h).

(e) Same as (a), but with variations of colours. Similar to (l).

(f) Two fillets of tangent poised squares, one gold and the other black and red. Same as (i).

(g) Same as (c).

(h) Same as (d).

(i) Same as (f).

(j) Similar to (c), but with outer rows of alternate red and gold triangles.

(k) Similar to (d): see notes above.

(l) Similar to (e).

Colonnette 47 (Figs 443 and 466A)

Lower chest, north elevation. Thirteen flutes (a–m).

(a) Two rows of tangent poised squares, red and gold, with a central fillet of squares divided black and white. The triangular interspaces at the margins are red and black.

(b) A row of gold tangent poised squares; along one side is a fillet of gold triangles, continuing the overall chequered arrangement of the pattern, but on this band a row of square interspaces is divided into red and black triangles with diminutive white triangles superimposed on the black. Similar to the decoration of flute 7(d) but with a narrower composition.

(c) A central fillet of gold tangent poised squares with black triangular interspaces. Fillets on either side have alternate red and white triangles. The same pattern recurs in other fluted colonnettes, but here the red and white triangles at the margins, point in opposite directions. Same as (g).

(d) Three fillets of chequers, alternately red and gold, staggered to form diagonal bands. White interspaces are divided diagonally, white and black, creating alternating diagonal black and white bands upon which the gold and red tesserae are set. Same as (h).

(e) A fillet of gold tangent poised squares with red triangular interspaces on one side and black interspaces on the other side. A second fillet has an arrangement of alternating red and white triangles.

(f) Similar to (e), but with the second fillet having red and gold triangles. Same as (j).

(g) Same as (c).

(h) Same as (d).

(i) Same as (e), but set in a wider flute, so consequently a second fillet of red poised squares is introduced.

(j) Same as (f).

(k) A central fillet of tangent gold poised squares with black triangular interspaces. Fillets on either side comprise arrangements of alternating, tangent, red and white triangles but with their points tangent to the bases of the triangles, rather than the intersections, creating a zigzag effect.

(l) A pattern of red, gold and black chequers set, consecutively, as diagonal bands. There are no white tesserae in this flute and no attempt made to create the effect of alternating black and white bands apparent on (h), for example.

(m) Similar to (e) and (i), but with different combinations of colours.

Colonnette 48 (Figs 443 and 466B)

Lower chest, north elevation. Eleven flutes (a–k). Flutes (b), (c), (e–g) and (i–k) are void.

(a) Three fillets of chequers, alternately red and gold, staggered to form diagonal bands. White interspaces are divided diagonally, white and black, creating alternating diagonal black and white bands upon which the gold and red tesserae are set.

(d) A row of gold tangent poised squares, with triangular interspaces on each side, one red and the other white. Alongside the white triangles is a fillet of red and gold triangles.

(h) Impressions only of regular chequers.

Colonnette 63 (Figs 443 and 466C)

Lower chest, west elevation. Thirteen flutes (a–m); (k) is void.

(a) Two rows of tangent poised squares, gold and red, with a central fillet of square interspaces, divided black and gold. The interspaces at the margins are red and white. Similar to (j).

(b) Impressions only with one row of tangent poised squares.

(c) Two rows of pattern: a fillet of tangent poised squares in gold with black triangular interspaces. Along one side is a fillet of alternate red and gold triangles.

(d) Three fillets of chequers, alternately red and gold, staggered to form diagonal bands. White interspaces are divided diagonally, white and black, creating alternating diagonal black and white bands upon which the gold and red tesserae are set. Same as (h).

(e) Impressions only of two rows of tangent poised squares.

(f) A row of gold tangent poised squares: on one side is a fillet of red triangles and, on the other side, a row of alternating red and gold triangles. Between the two rows is a fillet of white triangular interspaces each filled with a diminutive red triangle.

(g) A central fillet of tangent gold poised squares with black triangular interspaces. Fillets on either side comprise arrangements of alternating, tangent, red and gold triangles, but with the

points of the gold triangles tangent to the bases of the black triangles, rather than the intersections, creating a zigzag effect.

(h) Same as (d).

(i) Impressions only of two rows of tangent poised squares.

(j) Two rows of tangent poised squares, red and white, with a central fillet of square interspaces, divided black and gold. The interspaces at the margins are red and white.

(l) Two rows of tangent poised squares, divided into red and gold triangles, with a central fillet of white tangent poised squares. Triangular interspaces at the margins are gold.

(m) Similar to (d), but with two fillets rather than three.

The overall number of flutes with evidence for decoration totals 102. They can be divided into six basic types, but some patterns have many permutations. The most common are arrangements of tangent poised squares (fifty-one examples) but where the flutes are wider than others they may have two rows of squares (e.g. 33(l) and 47(a)). Some rows of squares may be divided into triangles, shaded in such a way as to create horizontal bands, exemplified by 8(a) (Fig. 452B). This technique can also be seen in arrangements of chequers (twenty-six examples), where white interspaces between the red and gold tesserae (see 5(e)) are divided into triangles to create a series of diagonal, alternating, black and white bands. Sometimes their angles are reversed. In the case of 8(b) the red squares form a zigzag. Less common types (ten examples) comprise a central band of poised squares flanked by alternating coloured triangles; see, for example, 32(k) (Fig. 455A) and 47(k) (Fig. 466A). However, these are not set consistent with the main row of squares, angle-to-angle, but with their points tangent to the sides of the interspaces, creating horizontal red and black, or gold and black, zigzags as seen, for example, on 7(l). A less common type, with six examples, has bands with black and white chequers, but with poised gold squares set on the black examples and red squares on the white (e.g. 8(h)). A single flute (7(a)) has a pattern of red, gold and black triangles set as chequers.

However, perhaps the most interesting group (eight examples) with all-over arrangements of triangles, or poised squares divided into triangles, contains patterns of very fine tesserae as small as 2mm (micro-mosaic) creating chequered triangles

(see 6(g), 7(d), 7(j) and 47(b)). Most of the examples using this technique occur on colonnette 7 located at the south-east corner of the tomb, rather than on the north side of the tomb where the more exceptional workmanship can be found. Inconsistencies in workmanship can be seen throughout the tomb and vagaries are probably random rather than by intent.

In addition to the colonnettes, there were four larger, similarly decorated columns that stood on the broad ledge forming the top of the lower chest; these supported the primary tomb canopy. Two of the columns survive, having been reused to support the retable in the Tudor reconstruction of St Edward's shrine. For detailed descriptions, see pp. 373–6 and Figures 359–365.

LATER INTERVENTIONS

Restoration, 1557

Unlike the shrine-tomb of St Edward, Henry's sepulchre was not a target for anti-popery reformers. It and the other royal tombs were theoretically unaffected by both the Dissolution of the Abbey and events during the Commonwealth. However, the monuments all suffered from casual physical abuse and vandalism of various kinds over the ensuing centuries. Henry's tomb, like St Edward's, was massively robbed of its mosaic inlay and underwent restoration in the late 1550s at the hands of Abbot Feckenham, although the full extent of the latter's intervention can only be conjectured. The upper chest had lost its purple porphyry panels from the east and west ends, and these were simulated in painted plaster (Figs 432 and 444). The wide mosaic borders around the panels had gone too, and were infilled with painted *faux* mosaic, of which sufficient remains on the west to inform a reconstruction (Fig. 473). Several small areas of plaster decorated with *faux* mosaic survive on the north side, but there must have been much more (Fig. 468). It would have been illogical and aesthetically meaningless to carry out small-scale patching, if the result was visually insignificant in relation to the large areas that were utterly bereft of mosaic decoration, particularly on the south elevation, which faced the shrine. We are minded to conclude that much of the tomb was restored in painted plaster by Feckenham, but that it has subsequently been stripped off.

475 Tomb of Henry III, plinth on the north side. Remaining fragment of Tudor painted inscription. *Authors*

Feckenham was also responsible for a single line of painted inscription on the plinth above the platform wall, facing into the ambulatory. The words have been scrubbed off, leaving only the scar of their outline and the letters **]pertis** belonging to the final word (Fig. 475). The inscription ended with a painted flourish, akin to those on Feckenham's text on the shrine (Figs 409 and 410). Camden published the full inscription:

> *Tertius Henricus est Templi conditor hujus, 1273. Dulce Bellum Inexpertis*[19]

> Henry III is the creator of this church, 1273. War is sweet to those who have never experienced it.[20]

Vertue, writing in 1736, stated that only part of the inscription survived, and that had been all but obliterated by 1823.[21]

There are also a few remnants in the marble matrix of crudely applied, unpainted plaster of the type found on the shrine pedestal, and dating from the 17th century (p. 320). Again, these trivial interventions are pointless *per se*, but were doubtless applied as patches to fill specific *lacunae* in the then-surviving decoration (both primary and *faux* mosaic). Unfortunately, the plaster repairs of the 16th and 17th centuries have largely been lost, and doubtless additional theft of the tesserae continued to take place down to *c.* 1840.

Clearly, the accessible parts of the tomb had been massively robbed before 1557, but by happy chance a *terminus post quem* for the robbing can be established stratigraphically, as a result of the fortuitous placement in 1495 of the small tomb-chest of Princess Elizabeth of York against the south-east corner of Henry's monument (Figs 288, no. 9 and 432). The chest almost touches the corner and obstructs access to much of its east

476 (*Right*) Tomb of Henry III. Sketch plan of the top slab of the chest. *After Stanley 1880*

end, where we find that the mosaic work of panels 35 and 39 is fully intact (Figs 458 and 459), because it could not be reached by leaning over the child's tomb. The panels directly above (37 and parts of 36), on the other hand, have been stripped of mosaic where they are reachable. Had Elizabeth's tomb not been placed here, access to the lower panels on the east end of Henry's monument would have been as easy as it is on the west end: they have been stripped bare (Fig. 474). Thus the evidence is conclusive: wholesale robbing of Henry III's tomb was a phenomenon of the first half of the 16th century.

Archaeological investigation, 1871

Motivated by antiquarian curiosity, Dean Stanley caused Henry III's and Richard II's tombs to be opened in October 1871.[22] In the instance of the former, a good deal of valuable information was recovered, not only about the monument but also relating to the king's coffin. The cast copper-alloy effigy was removed and estimated to weigh about 12cwt (610kg); beneath that was the inscribed base-plate, or 'table', of similar metal, weighing 8–9cwt (*c.* 450kg). Concealed beneath the effigy, the upper face of the table displayed an unfinished engraving of three standing figures.[23] The purpose of this is unclear, if indeed it has any relevance to the tomb: the engraving may be nothing more than a practise-piece by an apprentice metalworker. It was obviously never intended to be seen.

The three separate pieces of Purbeck marble comprising the top slab of the tomb-chest had the appearance of being held together in the conventional manner with iron cramps set in lead, but when the Stanley's workmen dug the lead out of the runnels they were surprised to find that no iron was present.[24] The most likely explanation for this unusual scenario is that when the plumber came to seal the joints, it was discovered that the cramps had been mislaid: pouring the lead, notwithstanding, was a quick

PLAN OF MARBLE BED.

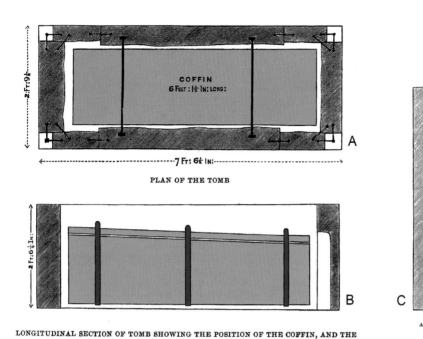

PLAN OF THE TOMB

LONGITUDINAL SECTION OF TOMB SHOWING THE POSITION OF THE COFFIN, AND THE
IRON STRAPS AND LOOPS FOR CHAINS

ARRANGEMENT OF CHAINS TO LET
DOWN THE COFFIN.

477 Tomb of Henry III. A. Plan of the upper tomb-chest with the top slab removed; B. Longitudinal section through the chest, showing also the form of the oak coffin; C. Partial cross-section of the chest and coffin, showing an iron stirrup and lifting-chain. *After Rodwell 2013, fig. 148; adapted from Stanley 1880*

and convenient way to conceal the embarrassing *faux pas*. Whether this occurred in 1290, or when the tomb may have been opened at a later date, cannot be determined. The former seems more likely, since there is no evidence to indicate that the tomb was ever opened prior to 1871.

At the junction of the three slabs is a neatly formed aperture *c.* 15cm square; it lies on the east–west axis at the centre of the tomb (Fig. 437). The plan published in 1880 incorrectly shows the socket to the west of the centre-point (Fig. 476).[25] The top slab is not only composite, but also was never polished, chased or inscribed, and was doubtless intended *ab initio* to support a recumbent effigy, which it has done since 1291. However, it is clear that the slab was previously crowned with something else: the square hole in it is a socket intended to receive a tenon on the base of an object that stood upright on the tomb-chest, most likely a stone sculpture. Whatever it was, it certainly preceded the installation of the recumbent metal effigy, and was therefore dispensed with in *c.* 1291.

The two smaller parts of the top slab were removed in 1871, revealing Henry's oak coffin in good condition. A plan and section through the tomb-chest were drawn to record its construction, but regrettably the joinery of the coffin was not described (Fig. 477). It was, however, noted that the lid was not fixed to the sides of the coffin, but merely rested upon them. Curiously, the coffin

is only very slightly tapered in plan, but somewhat more acutely in elevation.[26] Three iron stirrups with chains and rings were attached to aid lifting.[27] Despite the lid being loose-laid, the interior of the coffin was not inspected, and it is unknown whether there is a lead lining.

The coffin was covered with textile (Fig. 478):

> … all over, top, sides and ends, with cloth of gold, the warp of the gold thread similar to that now used by our arras weavers; the weft being only silk. It is woven in two alternating patterns of great beauty, consisting of striped stars and eight foils. The cloth is in one continuous piece … the four corners not cut away but folded… .The colour of the silken fibre was far gone, but some portions of it retained a crimson hue.[28]

Eight-pointed stars and octofoil rosettes are common in Cosmati work, and the latter occur

DIAPER OF THE CLOTH OF GOLD ON THE COFFIN OF
HENRY III. SCALE ½ LINEAR.

478 Tomb of Henry III. Cosmatesque pattern recorded on the cloth of gold, laid over the coffin. Later 13th century. *After Stanley 1880*

479 Tomb of Henry III. Fragments of floral-patterned silk, depicting a sunburst and a flower, reportedly removed from the tomb in 1871. They date from the 16th century. © *Dean and Chapter of Westminster*

in medallions in the chapel pavement (Fig. 233, no. 25b).[29] There is no record of a sample of the textile having been removed from the tomb.

Finally, in the Abbey Collection are two framed pieces of silk, accompanied by a handwritten label stating them to be, 'Fragments of the Cloth of Gold (samite) which cover the oaken coffin of Henry III. 1871' (Fig. 479). This fabric has been identified as having a weave known as 'satin of eight', which first appears in the 16th century.[30] Earlier descriptions of it as 'cloth of gold' are therefore incorrect.[31] The material is a brownish-coloured figured silk: one fragment shows a design based on sun-rays, and the other a small flower bud with leaves. If these pieces were retrieved from the tomb, it is most curious that no mention of them occurs in Stanley's account of the opening in 1871: possibly they are incorrectly labelled, and came from another tomb.[32]

It is not inconceivable that the upper chest was opened in the 16th century and the 'satin of eight' fabric inserted by Feckenham, but this lacks conviction. There is no plausible reason why he should have opened the tomb, and no evidence that he, or anyone else, ever did so, and removing the heavy metal effigy was no mean task. The 13th-century coffin-cover was still intact in 1871, and the likelihood that anyone opening the tomb would have re-leaded the cramp-housings is slim. Nevertheless, the textile could still be a genuine find from this tomb, as opposed to one of the other tombs that Stanley opened. These small pieces may well have been casually dropped through the open socket in the top slab on one of the occasions when the effigy was removed.[33]

Restoration, 1873

A note by Henry Poole records that in 1873 a gift of porphyry by a 'titled lady' enabled the missing panels on Henry III's tomb to be made good.[34] The replaced panels are on the east and west ends, and on the north side, of the lower tomb-chest. Two machine-cut rectangles of purple porphyry were installed on the east end (Fig. 458), and two more on the west (Fig. 472). Moreover, they are very thin (*c.* 5mm) and are adhered with glue to pieces of grey slate, mortared into the matrices in the Purbeck marble (for slate-backed porphyry on the sanctuary pavement, see p. 193).

The two lozenges of green porphyry on the north side are primary and undisturbed, and are mentioned by some early writers.[35] The central roundel is however missing on all antiquarian illustrations (cf. Figs 31 and 32), and was not reinstated until the late 19th century (Figs 463 and 469). While the replacement roundel is a perfect match for the prominently figured porphyry in the adjacent squares, it is dissimilar in other respects to the panels donated in 1873. It appears to be an old roundel, with a slightly chipped circumference, and is not backed onto slate. In profile, the Purbeck matrix is stepped, having a shallow outer ring that once contained a narrow band of glass tesserae, and the deeper central recess into which the thicker porphyry roundel was set.[36]

Antiquarian illustrations fail to show the matrices where the four end-panels had been lost, but the sight of the voids doubtless offended Stanley, and hence prompted him to secure

replacement panels. This contrasts with the circumstances obtaining on the upper chest, where a large rectangular panel was missing from each end. These had been lost at, or before, the Dissolution and Feckenham filled the empty matrices with plaster and coloured it red in imitation of purple porphyry (Figs 431, 432, 444, 454 and 472).[37] Had the matrices on the lower chest been similarly treated, Stanley would probably not have cut out the plaster and replaced it with porphyry.

There is no record of the colour of the original panels on the ends of the lower chest, and hence it is mere supposition on Stanley's part that they were purple. More likely, they were originally green, harmonizing with the panels on the north side. Arguably, there was a deliberate colour distinction between the upper and lower chests: the former was embellished with the four largest panels of purple porphyry to be seen in the Abbey, and the latter with seven smaller panels of green porphyry.

13 Child's Tomb in the South Ambulatory

The only cosmatesque monument in Westminster Abbey, outside the presbytery, occupies an arched wall-recess in the south ambulatory, directly opposite the tomb of Richard II and Anne of Bohemia. Here, in the south wall, a broad pier of masonry divides the chapels of St Benedict and St Edmund, both of which open off the ambulatory (Fig. 288, no. 22). The north face of the intervening pier, below string-course level, incorporates a shallow recess, framed by a trefoil-headed arch under a pointed hood-moulding. A pair of colonnettes, *en délit*, each with a stiff-leaf capital, circular shaft and moulded base, rises from the wall bench and flanks the recess (Figs 10 and 480). It is subdivided internally, at mid-height, by a moulded segmental arch with leaf decoration at the two springing points, and the ashlar back below the arch is recessed deeper into the wall than the masonry above. All the moulded detail is of Purbeck marble.

The trefoil-headed recess is integral with the late 1240s construction of the eastern arm of the church, and is *en suite* with the surrounding wall-arcading. The recess has long been occupied by a small chest-tomb decorated with cosmatesque ornament that is clearly not in its primary position. It has been accepted by most scholars since the 19th century that the existing tomb was relocated from St Edward's chapel to the ambulatory in the late 14th century, to make way for a royal monument of greater import.[1] Consequently, we have to seek answers to three basic questions: for whom was the monument made, where was it originally sited, and when was it moved?

IDENTITY OF THE TOMB AND ITS OCCUPANTS

For four centuries antiquaries have exercised their minds over this small tomb, not for its art or architecture, but for the identity of the unknown occupant, or occupants. Many have been tempted to associate it with Henry III's first daughter, Katherine, who died in 1257. The king ordered a sumptuous tomb to be constructed for her, including a gilt bronze effigy. That order was subsequently changed to provide for a silver effigy, plated onto a timber core.[2] The description makes it clear that this was not a cosmatesque monument, and its location is not recorded, but the princess's tomb was most likely in the new Lady Chapel built by Henry in the 1220s. There is no evidence to indicate that her tomb was moved to another part of the church, following the great rebuilding that was in progress at the time of her death.[3]

Early antiquaries claimed no knowledge of the tomb's location, and simply noted the documented evidence for its construction.[4] It was only later writers who sought to identify Katherine with the Cosmati tomb in the south ambulatory, notwithstanding the fact that this structure was clearly never designed to carry an effigy or image of any kind; furthermore, cosmatesque decoration had not been introduced into the Abbey at the time of Katherine's death. Nevertheless, writing in 1819, Brayley asserted:

> Between the Chapels of St. Benedict and St. Edmund. And partly built into the south wall, under a segment arch, is an altar Tomb in memory of Catherine, youngest daughter of Henry III, who died in 1257, in the fifth year of her age.[5]

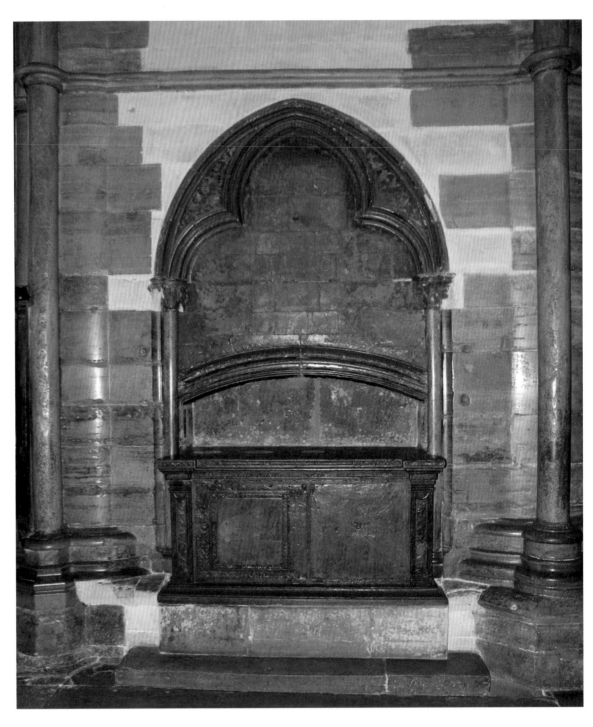

480 Cosmati child's tomb, and its setting under a trefoil-headed wall-arch in the south ambulatory. *Authors*

Others followed his lead, including Burges and Westlake who unhesitatingly referred to this as 'Princess Katherine's tomb'.[6]

Earlier than the creation of this myth was another – promoted even more vigorously – that the Cosmati tomb was constructed for 'the children of Henry III'. But that was further compounded by another equally unfounded assertion that the tomb *also* contained the bodies of the infant children of Edward I. If that were true it could make a total of nine interments. Camden seems

to have been the first to promote this, and to list the supposed burials.[7] He does not mention the tomb itself, but merely refers to the burials being 'in the space between the chapel of St Edmund and St Benedict'. Writing about the south ambulatory in 1720, Strype makes a similar statement:

> In the Area, that is the Passage that leads round the Chapel called, The Chapel of the Kings, between the Chapel of St. Blaze, and that of St. Benedict, there is [a] small raised Tomb, under which lye the Bones of three Children of Henry

the Third, viz. Richard, John, and Katharine; and four Children of King Edward the First, John, Henry, Alphonsus, and Eleonore.[8]

Confusingly, this total of seven follows only a few pages after Strype had placed nine children in St Thomas's chapel (the next chapel east of St Benedict's):

> In St. Thomas's Chapel lye the Bones of the Children of Henry the Third, and of Edward the First, in Number Nine.[9]

Other antiquaries also listed between seven and nine children, the containment of whom would only have been possible if their loose bones were piled into the chest. The corpses of royal children – some of whom had briefly been heirs apparent to the throne – would have been individually coffined and treated with much greater respect. We have only to reflect on the modest scale of the monument to appreciate that it would have been impossible for it to hold multiple coffins, although two might just be accommodated. There is no epigraphic or other historical evidence to identify unequivocally the primary occupant of the Cosmati tomb, but Sally Badham has thoroughly examined the chaotic assertions made in the past, and persuasively ruled out the majority of the alleged contenders.[10] Hence, we need not concern ourselves here with the antiquarian mythology, but consider only what is realistically feasible. The tomb must have been commissioned for one child unless, perchance, two siblings died in quick succession.

The internal dimensions of the Purbeck marble chest can be estimated as 1.25m long, 50cm wide and 60cm deep. It was designed to receive a single timber or lead coffin of a child who was no taller than 3ft 6ins (1.06m), and that would have been the average height of a male aged between four and six years. When the tomb was constructed, the plinth would have been of solid masonry, and served as the floor of the chamber; if so, there probably would have been just sufficient space for a second coffin to be placed on top of the first. On the other hand, if the initial coffin was elevated within the chamber – for example, by being placed on a stone block – there may not have been room to add another.

Since none of Henry III's children died, aged between four and six years, in the late 1260s or 1270s, we can rule out his offspring. However, turning to the children of Edward I, two candidates

481 Cosmati child's tomb. Remaining fragment of the painted inscription on the moulding of the arch.
© *Dean and Chapter of Westminster*

immediately present themselves: John of Windsor, died 1271, aged five years, and Henry, died 1274, aged six years. John must therefore be the strongest candidate for the original occupant of the tomb, a conclusion previously reached by Tanner and supported by Badham.[11] Speed, writing in 1611, was in no doubt that John of Windsor was buried here, and stated, 'There is remaining over him a tomb of marble inlayd with his picture and the name in an arch over it'.[12] Although not mentioned by recent commentators, faint traces of an inscription can still be seen immediately above the tomb arch, but unfortunately it is no longer intelligible (Fig. 481).[13] Speed's evidence is compelling.

The possibility that, three years later, Henry was added to his brother's cosmatesque tomb is not unattractive, and we have seen that the void within the tomb-chest was probably sufficient to place his coffin on top of John's, but no further additions would have been feasible. Handed-down knowledge that there were two interments in this tomb could ultimately have been responsible for the grossly exaggerated claims made by later antiquaries. Either way, the myth of multiple burials – in excess of two – in the ambulatory tomb should be laid firmly to rest.[14]

Edward I's third son, Alfonso, whose death followed his brothers' in 1284, has often been cited as a strong candidate for the primary occupant of the tomb, largely because two accounts of his burial have been preserved in chronicles, both confirming that he was interred in the Confessor's chapel. The *Flores Historiarum* records:

> … cujus corpus in ecclesia Westmonasterii juxta feretrum sancti Edwardi honorifice collocatur.

> … whose body is laid up honourably in the church of Westminster, next to the shrine of St Edward.[15]

The second account has excited more interest amongst antiquaries because it mentions cosmatesque work, stating that Alfonso was buried

> ... inter fratres suos et sorores juxta praedictum feretrum praesepultas inter lapides claudebatur marmoreos et porphiriticos et de thaso.

> ... among his brothers and sisters, who were buried before him, next to the aforesaid shrine; he was buried among stones of marble, of porphyry and of Thasian [marble].[16]

This description cannot be taken to imply that Alfonso was buried in a cosmatesque tomb; merely that he was surrounded by marble monuments. Furthermore, he can be discounted as the occupant of the child's tomb on grounds of size.[17] He was aged eleven and, unless his growth was exceptionally stunted, he would have been too tall to fit into this tomb-chest: the mosaic-decorated coffin lid in the floor of the chapel, east of the shrine pedestal, has been considered as a possible alternative place of sepulture for him (p. 509). Edward had no more sons who could be considered as potential occupants of the child's tomb. Similarly, none of the king's daughters who were born and died in the 1260s and 1270s are primary contenders, since they were either of an incompatible age or their burial places are known to lie elsewhere.

DATE AND PRIMARY LOCATION OF THE TOMB

In the light of the above, the date of construction of the Cosmati tomb can be narrowed down considerably, if not precisely pinpointed. If it was commissioned for John, a date after August 1271 is implied, or if for Henry, it was after October 1274. Bearing in mind that these were the king's first two sons – each briefly heir apparent to the throne – it would not be unreasonable to suggest that one or both were honoured with prestigious tombs or, alternatively, a combined monument. Prince John's body was interred in the shrine chapel, five days after he died:

> *Cuius corpus in Ecclesiae Westmonasterii ex opposite basilica Sancti Edwardi in parte aquilonali datum et sepulture viij die mensis Augusti.*[18]

> His body was brought to burial in the Church of Westminster, opposite the shrine of Saint Edward, on the northern side, on the 8th of August.[19]

No interments disturbed the Cosmati pavement before the 15th century, and the only plausible location for John's burial would have been the north-east corner of the chapel, where the floor was paved with plain slabs, an area deliberately kept accessible for the interment of royal children. It is reasonable to suppose that commissioning a suitable tomb followed shortly afterwards. But who ordered that: was it Henry's father, Prince Edward, or his grandfather, Henry III? It is far more likely to have been commissioned by the king, especially since his own tomb and the child's were clearly the work of the same masons (for discussion, see chapter 15). Henry III could not have witnessed the completion of his grandson's tomb because he died in November 1272. Work was still ongoing in 1273, when 'Master Robert of Beverley, the King's Mason and Keeper of the Works at Westminster, received payments for the stipends of several workmen employed on the tomb of John of Windsor.' One payment was for £6. 16s. 4½d., to cover wages for a period of sixteen weeks.[20]

The masons were obviously working on a monument grander than a floor slab, and in the following year, an account for 40s. 3d. reveals that Robert and marble polishers were again engaged 'around the tomb of the king's son'.[21] The wording may imply work to the setting of the tomb, rather than on the monument itself but, either way, it can only relate to John since the task antedated the decease of his brother Henry on 14 October 1274. Shortly afterwards, William of Corfe was paid 53s. 4d. for work on the tomb of the king's son, Henry.[22] That was followed by another payment to William for a marble polisher and six masons, working around the tomb for one day.[23]

Although no specific record of Prince Henry's place of burial has been preserved, it was undoubtedly in the north-eastern part of the shrine chapel, as implied later in the account of the burial of Alfonso, Edward I's third son in 1284. He was interred: 'among his brothers and sisters, who were buried before him, next to the aforesaid shrine'.[24] The recorded cost of work on Henry's tomb was very modest, which tends to imply that it was not a separate structure, but an adaptation of the monument recently completed for John. Almost certainly the tomb-chest would have comprised four side panels and a top slab, surmounting a deep plinth of solid masonry. If there was insufficient space within the chamber to place Henry's coffin on top of John's, the simplest solution would have been to dismantle the chest, remove the rubble core from within the plinth

and reassemble the chest. That would have quickly and economically created a chamber of sufficient capacity for two children's coffins.

It may reasonably be assumed that the child's tomb did not occupy or obstruct the north-east arcade bay, which was most likely earmarked by Edward for his own monument. A more practicable location would have been abutting the north-east pier, either on its south or west side. Edward may have intended that the children should be close to his eventual burial, but a sudden turn of events in November 1290 changed that when Queen Eleanor, the boys' mother, unexpectedly died. She was buried in the north-east arcade bay, which her monument entirely fills (Fig. 288, no. 10). She therefore lay close to her children, and Edward himself had ultimately to be buried in the westernmost bay in 1307, blocking access to the chapel from the north ambulatory (p. 212).

The east end of St Edward's chapel is defined by a pair of piers, against which the twin stair-turrets of Henry V's chantry were erected in c. 1437 (Fig. 220). The chantry chapel itself was sited directly above the king's tomb (Fig. 288, no. 11). An ideal location for the child's tomb would have been abutting the west face of the northern pier, and this is consistent with the 1271 description. It could remain there, undisturbed, until work began on Henry V's chantry.[25]

This scenario seems not to have been considered hitherto; instead antiquaries have long assumed that the child's tomb was originally sited in the western arcade bay on the south side of St Edward's chapel, where Richard II buried his queen, Anne of Bohemia, in 1395 but, as Badham has demonstrated, there is a fatal flaw in that argument.[26] Certainly, a tomb had to be removed in that year, to make way for the massive royal monument that now occupies the bay (Fig. 288, no. 15): a contract dated 1 April 1395 with Henry Yevele and Stephen Lote, royal masons, provided for its construction, and a subsequent entry in the Issue Roll, dated 15 December, records a payment of £20 for painting the tester over the tomb of Anne, and

> … quam pro removacione unius tumbe prope tumbam euisdem regine ac etiam pro pictura euisdem tumbe …[27]

> … also for the moving of one tomb near the tomb of the same Queen, and also for painting the same tomb …

This cannot refer to the Cosmati child's tomb, no part of which was ever painted and, as we have just argued, it was not moved until four decades later (c. 1437). Furthermore, if the identification with Edward's sons is accepted, it was on the wrong side of the chapel. The tomb in question in 1395 was most likely made of freestone, with mortar joints between the blocks, the painting of which would have taken place after erection. Dismantling and rebuilding such a tomb would inevitably result in the loss of much original paint, with the consequent need for redecoration. There are two prime candidates for the removed royal tomb: William de Valence, who reposes in St Edmund's chapel (Figs 288, no. 23 and 505), and the so-called 'de Bohun' tomb, now in St John's chapel, off the north ambulatory (see p. 313; Fig. 288, no. 26). De Valence's brass-clad oak effigy and tomb-chest are supported on a panelled Reigate stone base that would have been painted, as would probably also have been the 'de Bohun' tomb, which is of plain Purbeck marble.

RELOCATION OF THE TOMB IN THE SOUTH AMBULATORY

Although frequently repeated, the supposition that the Cosmati tomb was moved in 1395, to make way for Richard II and Anne's monument, must now be set aside. If the foregoing argument is accepted, that the child's tomb was originally sited against the north-east pier of the shrine chapel, then the date of its removal can be linked to the construction of Henry V's monumental chantry chapel that radically changed the appearance of the eastern part of St Edward's chapel. Henry died in 1422 and was buried in a chest-tomb on the site of the altar of the Holy Trinity (Fig. 288, no. 11). In his will of 1415, he specified that a high-level chantry chapel was to be constructed above his tomb; and the displaced altar was installed therein. The chapel itself was the work of John Thirsk, 1437–41, and his first task would have been to remove such royal tombs as were in the way of the foundations for its twin stair-turrets. These tombs are likely to have included the various children who were 'buried among stones of marble'.

There is no specific dating evidence in the south ambulatory to assist with confirming when the relocation took place, but architectural style

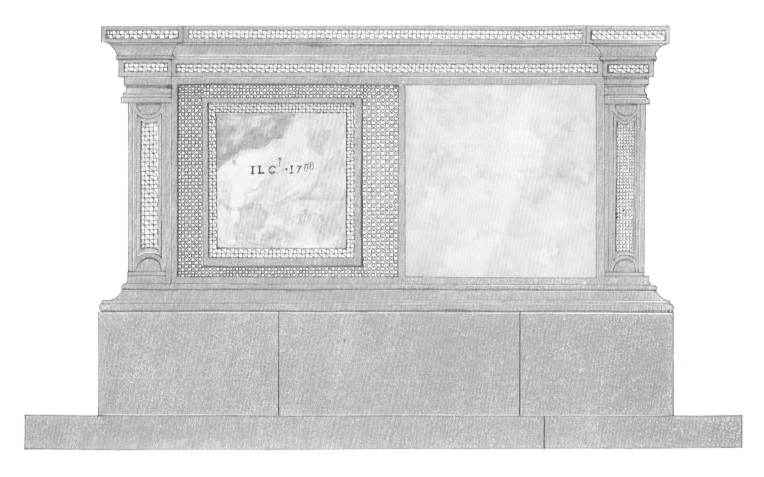

482 Cosmati child's tomb, north elevation. Surviving impressions of lost tessellation and later infilling of the main panels (4 and 6). *Painting by David S Neal*

provides a clue. Moving the Cosmati tomb here entailed making serious modifications both to it and to its new architectural setting. The tomb had to be dismantled into its component parts in order to install it in the recess which, conveniently, happened to be approximately the right width. A sizeable slab of Purbeck marble comprised the front panel and its flanking pilasters (Fig. 482); the back, which does not survive, was presumably the same; the east and west ends each consist of a single panel, as does the top slab (Fig. 483); the moulded plinth was made from strips of marble, probably just one per side. The plinth may have included a further course of masonry below the moulding. Hence, in total, the tomb-chest was originally assembled from five sizeable slabs and four moulded strips of stone (and possibly some plain ashlar). When the monument was relocated, only the top, the two ends, the front and its moulded plinth were retained.

The 13th-century recess in the ambulatory wall was not deep enough to house the tomb-chest properly, and hence its lower half had to be substantially rebuilt: the height of the wall-bench was reduced slightly, by removing the top slab,

and its projection into the ambulatory was increased by facing the bench with three ashlars of Reigate stone, thereby creating the semblance of a deep plinth; beneath that, and projecting yet further, is a modest Purbeck marble step. These modifications provided a suitably elevated base for the reconstructed tomb (Figs 480 and 482).

At the same time, the depth of the lower half of the recess was doubled by removing the ashlar facing of the back wall and hacking out some of the rubble core behind it. The back of the now-deepened recess was probably then re-faced with the old ashlar, and the two end-panels of the chest (minus their moulded plinths) were built into the flanks. Since the south side of the tomb-chest would have been totally concealed from view when it was installed in the recess, the panel was not retained, and the ashlar facing of the wall itself served as the side of the chamber. The front (north side) of the chest was installed, complete with its plinth moulding. The sepulchral remains were then deposited in the chamber and the top slab set in place. Following that, reconstruction of the back and reveals of the recess, above tomb-top level, was completed: here, the ashlar blocks were

483 Cosmati child's tomb. Overall view, looking south, of the top slab and masonry lining of the associated recess, where there were once four painted figures on the ashlars at the back (cf. Fig. 14). *Christopher Wilson*

laid directly on the slab, concealing its outer (southern) edge, the two eared projections at the southern corners, and a small amount of the mosaic inlay (Fig. 484).

Finally, a low segmental arch was constructed to support the superincumbent masonry above the chest (Figs 14, 480 and 483). The inserted arch is well moulded and embellished with a flourish of 'seaweed' foliage at each springing point (which is partly hidden from view by being tucked behind the Purbeck marble shafts flanking the primary recess: Fig. 485). This foliage is consistent with a 15th-century date, and contrasts with the stiff-leaf decoration of the capitals of the original 13th-century recess, which remain *in situ* at a higher level. The jambs of the inserted arch are short and their mouldings stop just above the top slab, confirming their contemporaneity with the installation of the tomb.

It has been noted above that the moulded bases of the 13th-century marble wall-shafts flanking the original recess projected into the opening, thus reducing its effective width. Consequently, in order to insert the Cosmati tomb, the bases of these shafts had to be cut back. Also, since the top slab oversailed the chest below, it would not fit between the wall-shafts, with the result that two semicircular pockets were crudely hacked out of

the east and west ends of the slab, enabling it to embrace the shafts (Fig. 484). Manoeuvring the slab into position would have been tricky: it had to be tilted, raising one end so that it could be slotted around the wall-shafts, and then lowered on to the chest. Since the Cosmati tomb was integral with the reconstruction of the recess that held it, there was no possibility of adding further human remains after the installation: the tomb could not be opened without dismantling the structural masonry around and on top of it.

We have argued that the tomb was made for John of Windsor, and almost immediately modified to receive Henry also. Hence, both boys' coffins would have been re-installed when the Cosmati monument was reconstructed in the ambulatory, and that would explain how the grossly exaggerated claim of multiple child burials came about. Once the true identities of the two occupants had been forgotten, antiquaries picked at random, and variously aggregated, the names of the deceased children of Henry III and Edward I, eventually reaching an impossible total of nine.

It would appear that the mosaic inlay was largely intact when the tomb was repositioned and small, hidden areas are probably still well preserved: one can see glimpses, particularly on part of the east end-panel. Moreover, when

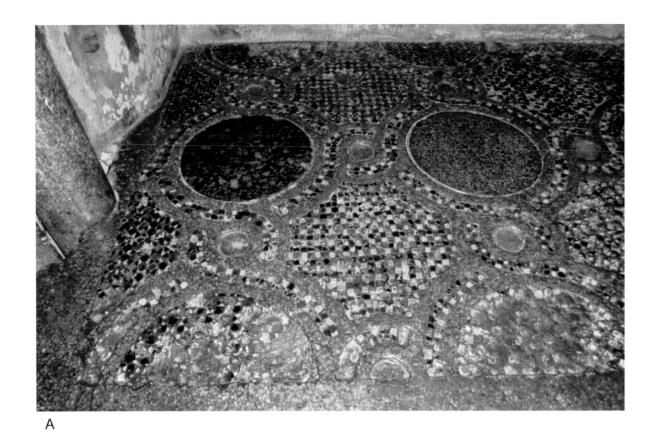

A

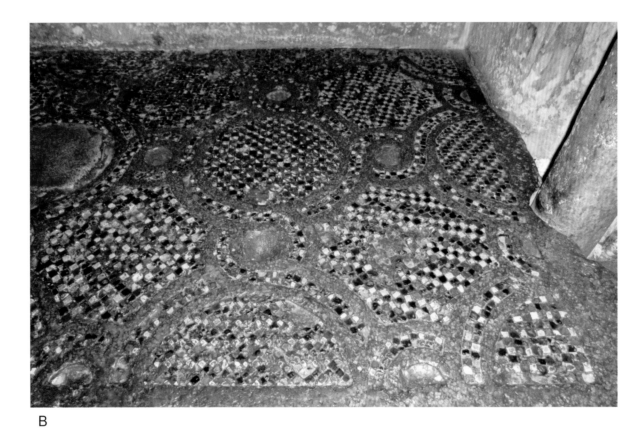

B

484 Cosmati child's tomb. Details of the top slab, showing the present condition of the tessellation. View south. A. Eastern half; B. Western half. *Authors*

masonry was removed from the back of the recess in 1937, to expose and investigate the inaccessible southern edge of the top slab, its mosaic decoration was found to be fully intact (below, p. 503; Fig. 498). This stands in contrast to the front and other readily accessible parts of the tomb-chest, which have been thoroughly robbed of mosaic; some of the matrices have been crudely infilled with plaster, but this is not in the style of Abbot Feckenham's work of the late 1550s (Figs 488 and 489). One portion of the front panel, however, was not plastered, but fitted with a single rectangle of coral limestone of Swedish origin (Figs 482 and 487).

A fair amount of mosaic survives on the top slab, which was less easy to rob on account of the fact that it was protected in the 18th and 19th centuries: the tomb

> … now serves as a writing-desk to the person who attends at the gates of the south aisle; its top is covered with boards, and on them are the paper, pens and ink. This cover serves to hide the rich Mosaic work, which either doth, or probably did adorn it.[28]

Since the monument has not undergone any recent cleaning or conservation treatment, the surviving mosaic decoration on the top is somewhat obscured by the heavy coating of wax and dirt that has accumulated over a long period.[29]

THE TOMB-CHEST

Only five of the primary components of the Purbeck marble tomb survive today: the north side together with its plinth moulding, the east and west ends, and the once strikingly ornate top slab. The north side is supported upon a secondary plinth and step, and it is possible that the latter was recycled from the original monument. The end panels are largely concealed by the flanks of the recess into which the tomb has been set, and the southern edge of the top slab, together with parts of its east and west ends, lie beneath the ashlar masonry that was built upon them. As with St Edward's shrine and Henry III's tomb, the panels were inlaid with mosaic designs and slabs of porphyry, set in matrices chased into the marble. The sides of the chest are held together with iron cramps. The plinth moulding was made from strips of marble, most likely four in all: the surviving

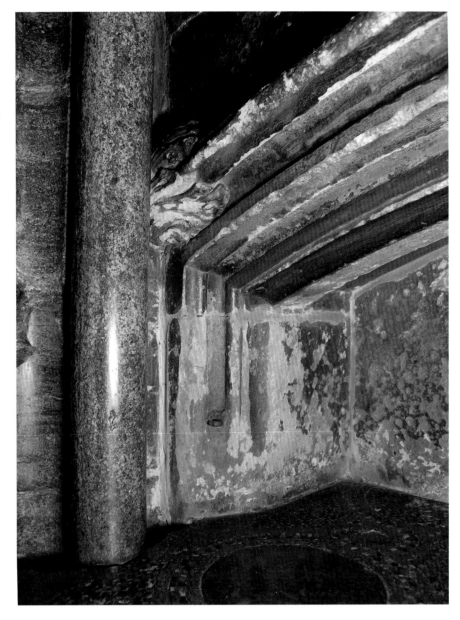

one on the north measures 1.72m long, by 25cm wide. It is improbable that the three blocks of Reigate stone currently supporting the plinth were retrieved from the original base of the tomb: the use of Purbeck marble for the entire plinth would be expected in a luxury monument of this kind.

Eared projections at the outer corners of the top slab oversail paired angle-pilasters on the chest below. The pilasters have simple moulded capitals and bases, and their vertical faces are decorated with narrow, sunk panels with moulded borders; the upper and lower ends of the panels are concavely semi-circular (Fig. 492), as on Henry III's tomb (cf. Figs 461 and 467A). The north face is divided unequally into two main panels, both

485 Cosmati child's tomb. East end of the recess, showing the mouldings of the reveal, including the foliate springer for the segmental arch. The red paint probably dates from the 15th century. Note how the top slab of the tomb has been notched to fit around the 13th-century marble shaft. *Authors*

decorated, resting on a cavetto-moulded plinth. Each end of the chest consists of a single decorated panel.

The top comprises a slab of Purbeck marble, with eared corners and moulded edges, measuring 1.70m long by 89cm wide, and is 14.5cm thick (Fig. 483). It is decorated on the upper face with interlaced mosaic quincunxes, the layout of which is asymmetrical (Fig. 493). Running round all sides, the stepped and moulded edge incorporates two narrow fillets of mosaic decoration (Figs 498 and 499).

DETAILED DESCRIPTION OF THE DECORATION

The three extant elevations of the tomb will be described first; nothing is known about the former south side panel.

North elevation (Figs 482 and 486–488)

The north elevation, including the angle-pilasters, is carved from a single slab, measuring 1.58m by 60cm. It has two main panels, 1 and 3, unequally proportioned and divided by a narrow vertical strip of Purbeck marble. That to the west (panel 6) is 56cm square, internally undivided, and contrasts with the eastern panel (4) which measures

65cm by 56cm overall, and contains within it a 40cm square with its own marble border and fillet. The original central panel has been superseded by a slab of Swedish pink coral limestone from Gotland, dissimilar to anything employed in the floor mosaics or in the furnishings of St Edward's chapel; and the narrow border around it is filled with mortar, in place of tesserae (Fig. 487). However, the presence of the limestone slab indicates that the matrix for the central square must have been more deeply cut than the surrounding border, implying that the original centrepiece was a square of marble, rather than a panel of mosaic.

Around the slab of Gotland limestone in panel 4 is a narrow band, mostly now filled with white plaster that has been given a grey wash, to simulate Purbeck marble. Originally, the band held a mosaic fillet with the same decoration as the upper and lower fillets on the edges of the top slab: chequers with alternating squares divided diagonally into triangles. The width of the band forming panel 5 around it varies. It too has been filled with grey-painted plaster, but where this has fallen away on the east side, impressions of tesserae indicate a chequered pattern of alternating squares divided diagonally into four triangles. No tesserae survive to indicate colour.

Nothing is known of the decoration in the western panel (6), which is now rendered with

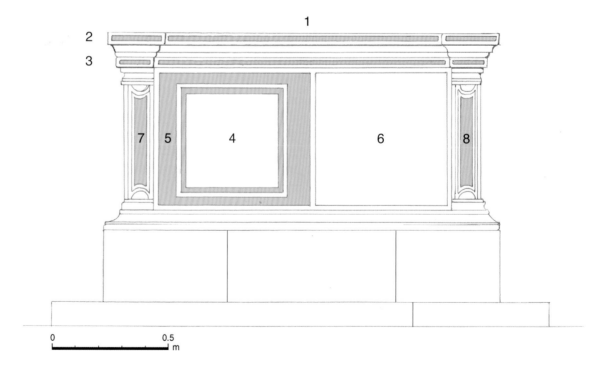

486 Cosmati child's tomb, north elevation. Outline drawing of the Purbeck marble matrix and key to panel numbering. *Authors*

487 Cosmati child's tomb, north elevation. Panel 4, filled with a slab of Gotland limestone. *Authors*

489 Cosmati child's tomb, north elevation. Detail from the western pilaster 8 (Fig. 488), showing crude plaster patching and remnants of micro-mosaic decoration in red and white. *Authors*

488 Cosmati child's tomb, north elevation. Panel 6, filled with plaster, and pilaster 8. *Authors*

490 Cosmati child's tomb, north elevation. A. Reconstructed red and white mosaic pattern on pilaster 8; B. Reconstructed red, white and gold mosaic pattern on border panel 5. *Paintings by David S Neal*

cream plaster of post-medieval date. Similar plaster patching occurs on the north face of the west pilaster (8) (Fig. 488). There is nothing to indicate that the matrix was physically partitioned like its neighbour to the east, but the plaster could conceal a narrow Purbeck marble fillet defining a central square. Alternatively, the fillet may have been hacked off by the plasterer, so that he could skim the entire panel as one. Nor can the nature of the original decorative infill be determined without removing the later plaster, which is entirely intact.

The scale of panel 6 renders it most unlikely that it was filled originally with a single sheet of porphyry, without a wide mosaic border: cf. panels in the east and west ends of Henry III's tomb-chest (Figs 454 and 472). In all probability the two panels on the north face of the child's tomb were generally similar in form. Consequently, it is difficult to assess the likely number of tesserae in panels 4–6. If the central square of panel 1 was occupied by a slab of porphyry, then the number of tesserae in 4 and 5 combined is calculated as about 3,500, and a similar number might be expected for panel 6 if it too incorporated a slab of porphyry, bringing the total therefore to about 7,000.

The decoration of the two north-facing pilasters differs. On the eastern example, mortar impressions show a chequered pattern with alternate squares divided diagonally, forming bands (Fig. 482). There are four tesserae across its width. However, on the western pilaster (8) impressions indicate seven tesserae across the same width, and these were much finer stones, with three red and four white examples remaining *in situ*. The pattern can be reconstructed as red and white chequered triangles (Figs 488, 489 and 490A), and the angle of orientation is the opposite of that ornamenting the eastern pilaster.

East elevation

This remains largely intact, including some of its tessellation (Fig. 491). Although only about one half is visible – and is partly obscured by a 13th-century detached shaft, flanking the wall-recess – it shows a quincunx of circles within a rectangular panel, once containing five small discs – probably all of porphyry – surrounded by inter-laced circles. Only the central disc of purple porphyry visibly survives and is axial to the medial row of medallions on the top slab (Fig. 492A). It is highly likely that the two concealed discs south

of the centre are also extant. The circles were probably inter-looped but this cannot be verified. Concave-sided hexagonal interspaces are formed at the edges of the panel, between the upper and lower circles, and small triangular compartments at the top and bottom, as shown in the reconstruction (Fig. 492B). Lethaby's reconstruction incorrectly shows the roundels symmetrically placed within a square panel, rather than in an upright rectangle (Fig. 492C).[30]

The loops differ in their decoration: the top right example has diagonally arranged poised tesserae, set corner-to-corner, and alternately shaded gold, white and black; the loop below has a right-angled chequered pattern of the same colours. A circular band around the central disc comprises a row of poised squares, tangent at their tips, with the white interspaces on either side set with diminutive black triangles. As with the north (and doubtless formerly the south) elevation, the panel is flanked by pilasters; that on the north-east has only an empty matrix, but the decoration is most likely intact in its concealed south-eastern counterpart.

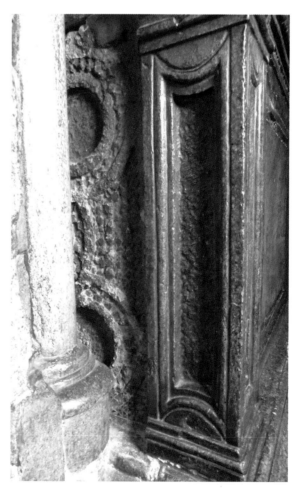

491 (*Right*) Cosmati child's tomb, east elevation. Pilaster at the north-east corner and part of the quincunx. On the left is the lower end of the marble shaft and base flanking the 13th-century wall niche. *Authors*

A B 0 30 cm C

492 Cosmati child's tomb, east elevation. A. Painting of the accessible half of the end panel; B. Reconstruction drawing of the quincunx design; C. Incorrect reconstruction of the design published by Lethaby.
A. Painting by David S Neal; B. Authors; C. Lethaby 1925, fig. 142

West elevation

The west elevation is also partly concealed by the flank of the wall-recess and its associated shaft. It is apparent, however, that the decorative scheme did not replicate that on the east elevation; instead, there was a single panel, measuring 44cm by 53cm, confirmed to have no marble subdivisions. At first glance, the 18mm-deep matrix appears to be entirely empty, having lost not only its inlaid decoration, but also the mortar upon which that was bedded. By shining a beam of light into the very narrow gap between the end of the tomb and the flank of the recess, one can observe the irregular edge (but not the face) of what remains of the mosaic inlay and its mortar bed. The trapped decoration is evidently intact where it has been protected from souvenir hunters.[31] Moreover, this archaeological cross-section through the inlay holds a surprise, since not only are there tesserae present, but also the edges of two thin pieces (c. 8mm) of sheet marble can be discerned. These must represent *opus sectile* decoration.[32] No inlay survives in the west face of the north-west pilaster.

Top slab

An asymmetrically planned grid of spaced medallions, 40cm in diameter, decorates the top (panel 1), and includes various patterns of mosaic, mainly shaded bands, set at right-angles, or diagonally, to the grid (Fig. 493). The medallions are contained, and linked to one another, by chain guilloche

forming small roundels, similar to the decoration on the floor mosaic in the shrine chapel. Around the perimeter, semicircles replace full circles, and in the south-east corner alone is a quadrant. Now devoid of decoration, the roundels once contained discs of unknown material, bedded on pinkish, gritty mortar. They display no impressions of tesserae and are too shallow to have held porphyry or other stone discs. The mortar beds are not only recessed by a few millimetres but, curiously, most are also slightly concave, and they include some of the half-roundels at the edges of the slab. The average depth around the rims of the roundels is 5mm, but the maximum reached by the concavities is 9mm (Figs 494 and 495). Hence the thin discs housed in these matrices were presumably flat on the upper surface and certainly convex on the lower. Nothing comparable has been observed on the other cosmatesque monuments, where the discs filling roundels were all flat-backed. One matrix is now devoid of mortar and measures 10mm deep.

The overall design of the top slab is asymmetrical and, surprisingly, no panel occupies the centre point. Moreover, the east–west axial displacement of the design precisely reflects the asymmetry of the panels on the north face of the tomb. A flat, irregular stone has been set into the matrix of what superficially serves as the focal medallion (8); the insert is clearly secondary because some of the original tesserae survive around the rim (Fig. 494). They formed either a

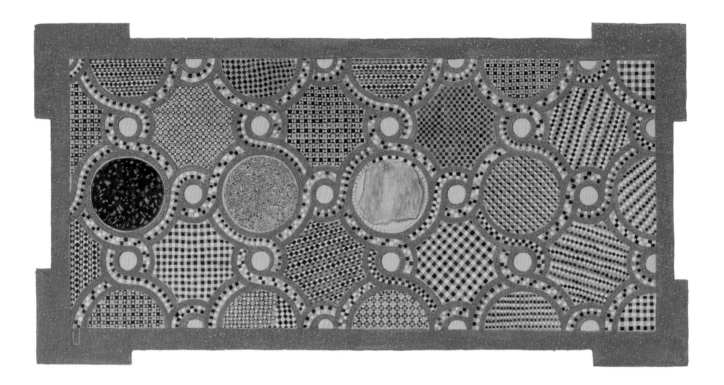

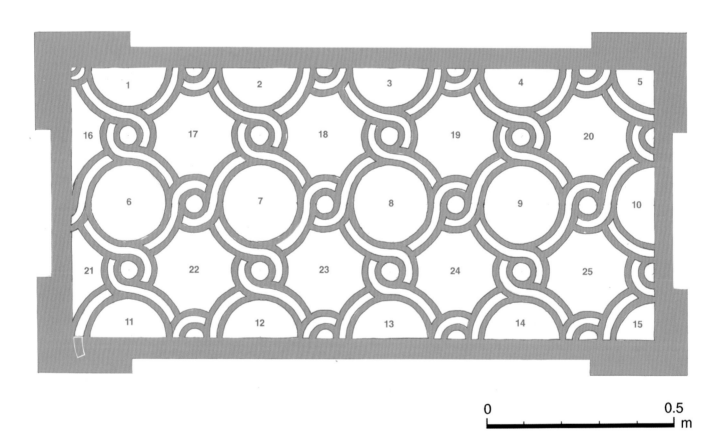

493 Cosmati child's tomb, top slab (panel 1). A. Reconstruction of the mosaic designs based on partial survival of the evidence; B. Plan of the Purbeck marble matrix and key to the panel numbering. N.B. North is at the bottom. *Painting by David S Neal*

single, or possibly a double, fillet around the original stone setting (as on the east end panel). Two circular medallions to the east (6 and 7) are occupied by discs of green porphyry and black-and-white granite, respectively; their physical appearance is compatible with their being late 19th-century inserts by Dean Stanley (Fig. 484A). Apart from medallion 8, all the other circular and semicircular panels are tessellated (Figs 484 and 496).[33] A minor anomaly in the construction can be seen at the north-east corner (panel 11), where the mason overran the guide-lines for a guilloche loop, into the plain margin (Fig. 493B).

The interspaces formed by the pattern of medallions and roundels are irregular concave-sided octagons, eight in all (17–25), with a further two truncated versions (16 and 21) on the eastern edge of the mosaic; descriptions of the decoration within the individual panels follow. The most incongruous feature of the slab is the irregular stone nearest to the centre (Figs 483 and 494). Its surface is fairly smooth and carries faint graffiti, but its edges are irregular, partly because they were crudely chipped to fit into the existing matrix. Lethaby opined that the stone was so irregular and so far from materially precious that it must be a relic, possibly a fragment from the Mount of Olives.[34] In 1952, it was examined by a geologist, who reported that it is composed of fine-grained white saccharoidal marble, 'unquestionably of foreign provenance' and probably from the Mediterranean area.[35] Re-examination by Kevin Hayward confirms the material as marble.

Descriptions start from the top left corner, as if viewing the slab from the north (Fig. 493). Circular and semicircular panels (1–15) are

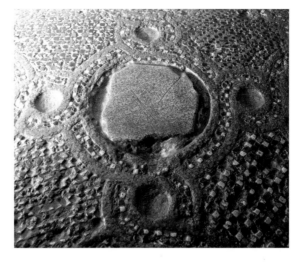

494 Cosmati child's tomb, top slab. Medallion 8, showing the rough piece of marble now filling the matrix where there had once been a porphyry disc bordered by a fillet of tesserae. The four satellite matrices that held small roundels retain their concave mortar beds. *Authors*

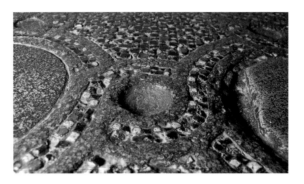

495 Cosmati child's tomb, top slab. Detail of the matrix for a small roundel between medallions 7 and 8, showing the smooth, concave, pink mortar bed. *Authors*

described first, followed by the concave-sided octagons (16–25); detailed representations of them are orientated the same way as the patterns on the mosaic (Fig. 497). Some patterns are duplicated, but rotated. There are ten loops (links), either complete or 'halved' at the margins. Each link has a continuous double fillet of inlay with the same design throughout, despite the fact that the strand is interrupted by being interwoven with others. The decoration of the loops is described following that of the octagons.

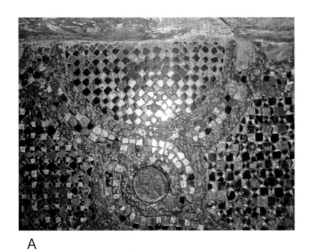

A

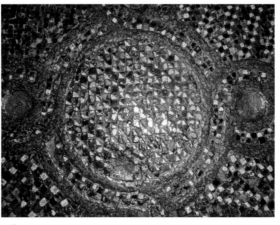

B

496 Cosmati child's tomb, top slab. A. Half-medallion 2, parts of panels 17 and 18 and matrix for a small roundel; B. Medallion 9 and matrices for two small roundels. *Authors*

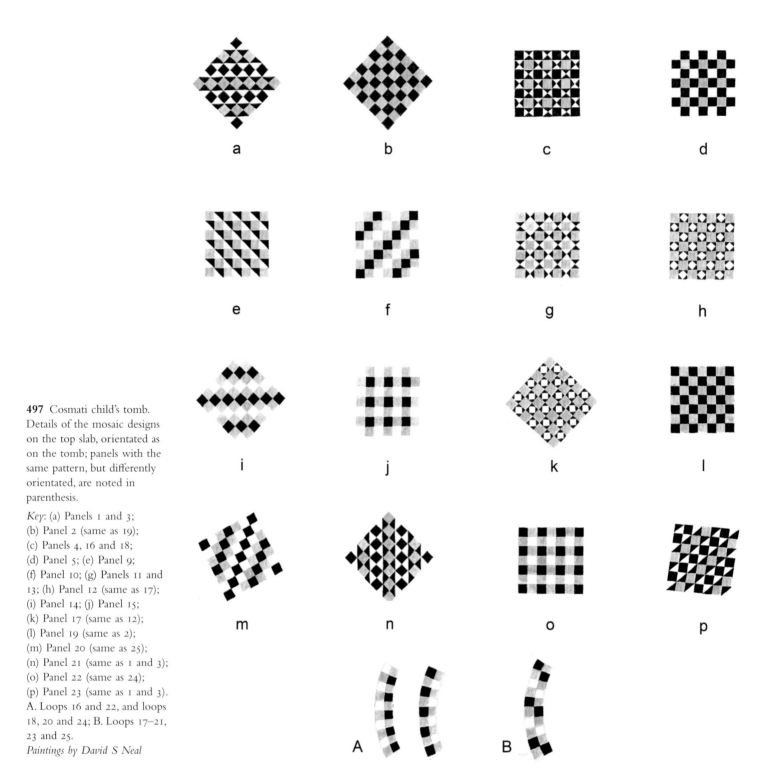

497 Cosmati child's tomb. Details of the mosaic designs on the top slab, orientated as on the tomb; panels with the same pattern, but differently orientated, are noted in parenthesis.

Key: (a) Panels 1 and 3;
(b) Panel 2 (same as 19);
(c) Panels 4, 16 and 18;
(d) Panel 5; (e) Panel 9;
(f) Panel 10; (g) Panels 11 and 13; (h) Panel 12 (same as 17);
(i) Panel 14; (j) Panel 15;
(k) Panel 17 (same as 12);
(l) Panel 19 (same as 2);
(m) Panel 20 (same as 25);
(n) Panel 21 (same as 1 and 3);
(o) Panel 22 (same as 24);
(p) Panel 23 (same as 1 and 3).
A. Loops 16 and 22, and loops 18, 20 and 24; B. Loops 17–21, 23 and 25.
Paintings by David S Neal

1 Semicircle with horizontal bands, alternating black and white, with gold tangent poised tesserae on the black, and black tangent poised squares on the white. Triangular interspaces form hourglass shapes. Same as 3, 21 and 23.

2 Semicircle with an overall arrangement of black and gold chequers set diagonally. Same as 19, which is set at right-angles (Fig. 496A).

3 Same as 1, 21 and 23, the last set diagonally.

4 Semicircle with a regular grid of alternating horizontal and vertical fillets of black and white squares, and gold and white squares. White squares are quartered diagonally to form black hourglass shapes. Same as 11, 16 and 18.

5 Quadrant with an overall regular grid of fillets alternating black and gold, and white and gold. Same as 15, 22 and 24, the last set diagonally.

6 Disc of green porphyry with prominent phenocrysts. Inserted in the late 19th century (Fig. 484A).

7 Disc of black-and-white granite. Inserted in the late 19th century[36] (Fig. 484A).

8 Irregular slab of probably pale grey/white marble (see above)[37] inserted into a circle that was originally bordered with a fillet of tesserae alternating gold, white, black, and white. The marble is certainly secondary, and most likely replaces a lost disc of porphyry (Fig. 494). The surface bears various scratched lines, seemingly not intelligible graffiti.

9 Circular panel filled with a right-angled grid of gold and white chequers. The white tesserae are divided diagonally, one half black (Figs 484B and 496A). The only example of its type.

10 Semicircle filled with diagonal alternating rows of tesserae set point-to-point and alternating black, gold, white and gold (forming diagonally arranged shaded bands) (Fig. 484B). Same as 14 (set horizontally), 20 and 25.

11 Semicircle with a grid of black and white fillets with poised gold squares in the interspaces. The white squares are divided diagonally to create hourglass shapes (Fig. 484A). Same as 4, 16 and 18.

12 Semicircle with a right-angled chequer pattern of black and gold squares with poised white tesserae on the black. The west side of the panel has been restored in antiquity with a diagonal grid of black and white chequers (Fig. 484A). Same as 17.

13 Diagonal pattern of black and white chequers each square superimposed by gold squares forming black and white hourglass shapes. Same as 12, but the colours are reversed.

14 Semicircle with horizontal rows of poised black, gold, white, gold and black tesserae forming shaded bands (Fig. 484B). Same as 10, 20 and 25 (which have diagonal orientations).

15 Quadrant with a regular grid of right-angled black, gold and white chequers (Fig. 484B). Same as 5, 22 and 24 (which is set diagonally).

16 Black, gold and white chequered grid. The white squares are divided diagonally into black and white triangles forming hourglass shapes. Same as 4, 18, and 11.

17 Concave-sided octagon with a diagonal arrangement of gold and black chequers. The black squares are superimposed by white poised squares. The strands in the double fillet of the surrounding chain link are all the same, but staggered and alternating gold, black, gold and white (Fig. 496A). Same as 12.

18 Concave-sided octagon with a regular grid of alternating horizontal and vertical fillets of black and white squares, and gold and white squares. White squares are quartered diagonally to form black hourglass shapes. The double fillet in the surrounding chain link is the same as that surrounding panel 16 (Fig. 496A). Same as 4, 11 and 16.

19 Black and gold chequers. Same as 2, but with the chequers set at right-angles.

20 Concave-sided octagon with diagonal alternating fillets of gold, black, gold, white, black and white tesserae, set point-to-point forming shaded bands. Same as 10, 14 and 25. The arrangement of the colours in the surrounding chain is hard to define, although the two fillets are probably the same, but staggered, and sequenced black, white, gold and white.

21 Horizontal bands alternating black and white, with gold tangent poised tesserae on the black, and black tangent poised squares on the white (Fig. 484A). Same as 1 and 23.

22 Concave-sided octagon with an overall regular grid of fillets alternating black and gold, and white and gold (Fig. 484A). Same as 5, 15 and 24.

23 Concave-sided octagon with diagonal rows of alternating black and white bands, the black bands superimposed with gold tesserae set point-to-point, and the white bands superimposed with black tesserae. Their angle is incongruous to most other patterns on the slab. Same as 1, 3 and 21. Both fillets of the surrounding chain are shaded white, gold, black and gold, but staggered.

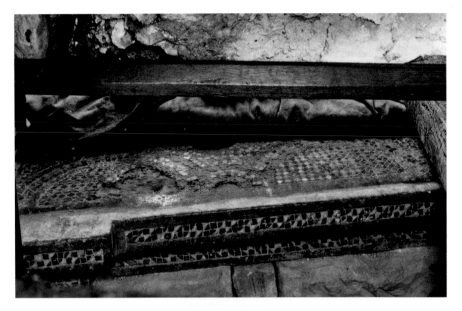

498 (*Above*) Cosmati child's tomb. Photograph taken by Robert Howgrave-Graham in 1937, showing a band of intact mosaic on the southern edge of the top slab. © *Dean and Chapter of Westminster*

499 (*Right*) Cosmati child's tomb, north elevation. Detail of mosaic bands (2 and 3) on the eared north-east corner of the top slab. *Authors*

24 Overall regular grid of fillets alternating black and gold, and white and gold. The same design as panels 5, 15 and 22, but rotated by forty-five degrees; its setting is more accurate. The outer fillet in the surrounding chain is shaded black and gold, and the inner strand white and gold. Where it runs around panel 9 the sequence of the colours is reversed (Fig. 484B).

25 Concave-sided octagon. As with panel 23, the shallow angle of the pattern is at variance with the other designs on the mosaic. Its shaded bands are sequenced: black, gold, white, black, white and gold. The strands in the surrounding double fillet of the chain are staggered and shaded white, gold, black and gold (Fig. 484B). Same as 10, 14 and 20.

The decoration of the loops is of two types, based on arrangements of gold, black and white tesserae (Fig. 497).

A Pairs of fillets, alternately shaded white and gold, and black and gold. Examples include the loops around panels 16, 22 and 24.

B Pairs of fillets, alternately white, gold and black, and with their tesserae set alongside one another, angle-to-angle, creating diagonal bands of the same colours. Examples include loops around panels 17–21, 23 and 25.

The upper and lower fillets on the edges of the top slab are inset with chequers in rows, sequenced black, gold, black and white, with alternate squares divided diagonally into triangles; the decoration survives intact on the south edge, where it was temporarily exposed and photographed in 1937 (Fig. 498), and traces also remain on the east. It can be assumed that the same decoration ran around all sides of the slab, including the eared projections (Fig. 499).

DISCUSSION

Design and execution

Of all the cosmatesque works in Westminster Abbey, this small tomb is the most enigmatic: not only has it had an unusual history, but also the dichotomies posed by the variations in workmanship and the palette of materials employed for its decoration. From a constructional point of view the monument is wholly Roman, with no hint of Gothic, and it has much in common with Henry III's tomb. Both are constructed from large slabs of Purbeck marble, locked together by wrought iron cramps. The tops have mouldings all round the edges, and the corners are eared. The one-piece side-panels have integral clasping pilasters at the corners and, particularly significant is the fact that in both monuments the pilasters have sunk panels with moulded borders that are lunette-ended at the top and bottom (Figs 488 and 491). Narrow, mosaic-filled vertical panels with moulded frames are commonplace in cosmatesque monuments, but lunette-shaped ends are notably rare. Having two examples in the Westminster assemblage must surely point to their being products of the same workshop.

As with Henry III's and the Confessor's monuments, the components of this tomb would have been prepared in a workshop: mouldings were cut, matrices were chased and inlaid with

glass mosaic and porphyry decoration. All this would have been carried out on the bench by masons and mosaicists, so that the components were complete in every detail when they were brought into the Abbey church. Assembling the tomb could have been achieved in two or three days.[38]

From the design point of view, several anomalies command attention, the first being an unexpected lack of geometrical symmetry in both the top slab and the north side panel. The slab carries the matrix for mosaic inlay, the design being interlinked quincunxes. The geometry works perfectly across the width of the slab, with one full medallion on the medial axis, flanked by two halves, but in the longitudinal direction the design comprises a row of four-and-a-half medallions, the incomplete one falling at the west end. Aesthetically, this is distracting and causes the tomb top to lack a true centre-point (Fig. 493B). Given the proportions of the slab, this particular quincunx design could not work to perfection in both directions, but the mason-carver could have achieved a more elegant and fully symmetrical solution by placing a lesser segment of a medallion at each end of the slab, rather than a full half at one end. That would have resulted in the small roundel between medallions 7 and 8 falling at the centre. However, marking the true centre with a small roundel is an unlikely arrangement. Alternatively, the three whole medallions could have been arranged so that no. 8 lay at the centre, leaving space for three-quarters of a medallion at each end. A third option that would have resulted in a fully symmetrical layout would have been to compose the central row as three whole medallions, with halves at the ends (thus complementing those along the north and south sides). The small shortfall at either end could have been taken up by a pair of transverse tessellated bands, a not uncommon feature for filling narrow spaces in cosmatesque work. Sets of three interlinked quincunxes find analogues on rectangular Italian panels such as the c. 1200 altar front at Santa Prassede, Rome, where the geometry was more skilfully managed to achieve symmetry.[39]

Attention is further drawn to the infelicity of the design of the top slab by the disparate treatment of the medallions, but that has been caused by ill-considered Victorian intervention. The easternmost two medallions (6 and 7) were either empty matrices, or their mosaic was very

fragmentary, until the discs of green porphyry and black-and-white granite were inserted in the late 19th century. These aesthetically incongruous additions were made by Dean Stanley, with materials provided by Lord Elgin.[40] It seems clear that originally only medallion 8 had a central marble disc; all the others were fully tessellated.

Panel 8 now houses a roughly broken, irregularly shaped and heavily abraded piece of white marble, while around the circumference of the matrix are the remains of a single border of tesserae. This implies that the stepped matrix originally held a disc of stone encircled by a narrow tessellated fillet, similar to the arrangement seen in the other cosmatesque monuments: e.g. the middle panel on the north side of Henry III's tomb (Fig. 469). Doubtless the disc was purple porphyry, and marked the notional centre of the tomb slab.

Also difficult to explain is the asymmetrical subdivision of the north elevation of the tomb into two rectangular panels (4, 6). Their matrices are separated by a narrow vertical band of Purbeck marble that is not central to the front, with the result that the eastern panel is 9cm wider than the western (Fig. 482). Less certain is whether the decorative treatment of the panels differed: one has an inner border and fillet, while the other currently does not. Both panels may have held large squares of porphyry with tessellated borders, akin to those on the east and west ends of Henry III's tomb, and also the north side of the lower chest (where the squares are poised). The narrow panels in the northern faces of the angle-pilasters (7, 8) were not decoratively matched: one had an estimated 315 relatively coarse tesserae, the other 858 very fine tesserae (for quantifications of tesserae on the tomb, see appendix 2). The mortar impressions in the matrix of the north-east pilaster confirm that the pattern of tessellation was the same as that on eastern pilasters of Henry III's tomb (cf. Fig. 459).

Since the decoration on the north side did not include medallions there would have been no difficulty in arranging the panels symmetrically. Consequently, it could be argued that the mason made an error when marking out the position for the reserved 'central' strip of marble. An element of doubt however presents itself when one recognizes that the degree of asymmetry in the north side corresponds exactly to that in the top slab; this can hardly be coincidental, but it may

not possess any great significance. Unexplained anomalies occur throughout the Cosmati ensemble at Westminster, and elsewhere.

The lack of symmetry extends also to the east and west ends of the tomb, which are markedly different in both design and quality. The east end was decorated with a mosaic quincunx having a central roundel of purple porphyry; the fillings of the other four roundels are unknown, but purple or green porphyry is most likely. By contrast, the undivided matrix at the west end was designed to hold a single rectangular panel of mosaic inlay, but even that is not straightforward because the surviving fragment – which can scarcely be glimpsed – contains not only tesserae but also flat pieces of stone indicative of *opus sectile*. Close inspection suggests the possibility of there once having been a rectangular slab, bordered by a tessellated band, but too little survives to admit confident reconstruction.

When the Abbey's cosmatesque assemblage is viewed as a whole, the poorly coordinated decorative schema of the child's tomb does not stand out as being markedly different from that of the other monuments. More significantly, it shares constructional features and design details with St Edward's shrine and Henry III's tomb, and with the pavement in the shrine chapel. The matrix of that pavement comprises an all-over pattern of interlinked septunxes, as opposed to the interlinked quincunxes of the tomb top. 'Carpet' patterns of this kind are relatively rare in Cosmati work, and it would be surprising if the two examples at Westminster were not created by the same team.

To summarize: on design and technical considerations, there are grounds for arguing that the child's tomb provides a substantive link with the shrine-tombs of Edward and Henry III, and with the pavement in St Edward's chapel: all may reasonably be claimed as products of the same workshop. Moreover, the deployment of materials is consistent with their being constructed from the same consignment, and hence close in date.

Decorative materials and their deployment

The asymmetry in the layout of the decorative elements extends also to the deployment of materials throughout the tomb. The mosaic on the top slab is marred aesthetically by the conflicting angles of some of the patterns, notably in panels 9, 10, 20 and 25. Apart from later insertions of three pieces of stone (6, 7 and 8), all other panels are consistent in the materials and colours of their tesserae: gilt greenish glass, black Tournai marble and white marble. No other colours were employed. The black tesserae, especially, are poorly cut and irregular in shape; this is a consequence of using Tournai marble, which is a very hard rock and difficult to cut into very small pieces with precision. The sizes of the tesserae employed in different panels of similar dimensions are also inconsistent. For example, panel 24 contains a design based on chequers: it has an estimated 315 tesserae, far less than the number in the identical-sized panel 17, where diminutive square tesserae are divided into triangles, set point-to-point to create hourglass shapes, and this employs 858 tesserae.

The top of the tomb was the largest and most important component to decorate, and the consistent colour palette of the tesserae – black, white and gold – is both limited and muted. This contrasts markedly with the remaining cosmatesque work at Westminster, and must reflect a conscious decision, the reason for which we shall never know. It is as though the king wished the tomb top to strike a sombre note. In the other monuments and pavements, gilding was applied mainly to imported red glass, whereas here green glass, of Italian or French manufacture, was substituted.[41] Conversely, blue (or blue-black) glass was also extensively employed in all the monuments except the child's tomb. This must surely indicate that the supply of imported red and blue glass tesserae had been exhausted and it was necessary to obtain substitutes, possibly locally-sourced.

Porphyry and other materials may also to have been in short supply, forcing the mosaicist to devise a scheme that would enable all the matrices to be filled with coloured materials that were to hand, or could be obtained without replenishing the stock from Italian sources. Hence, there was only one medallion – probably of purple porphyry – in the top (panel 8). A small slab of white marble, or offcuts amounting to less than one fifth of a square metre, would have sufficed to make the white tesserae. Tournai marble had long been imported to England for the manufacture of funerary slabs, and hence would have been readily available to make black tesserae, and French green

glass could be used to support gilding. Large quantities of glass were concurrently being imported for the windows of the Abbey.[42]

Finally, the twelve small roundels, and ten half-roundels, amongst the interlacing had to be filled. The equivalent roundels in the shrine pavement held porphyry discs, and the numerous circular matrices around the entablature of the Confessor's shrine were filled with discs of blue and red glass. A different solution was seemingly employed for the child's tomb. We have noted that the mortar beds remaining in the matrices indicate that both the full-circles and semicircles were filled with something relatively thin, convex on its underside and, presumably, flat on the top (p. 493). The smoothly rounded undersides indicate that the roundels were not fabricated from marble or sheet glass. Consequently, other options have been considered. First, that the roundels were made from the discarded centres of crown glass (bulls'-eyes), although if that were the case the upper face would also have been convex, not flat.[43] Such an aberration in Cosmati work seems most unlikely, and there is no precedent. Second, is the possibility of hammered, or spun, concave discs of polished metal (e.g. silver), but again the tomb-top would not have been flat. Moreover, metal dishes would have constantly collected dust, and thus lost their reflective quality.[44] Third, a batch of plano-convex discs could be cast in moulds, using a material such as mastic resin or pitch.[45] Cutting some of the discs in half, to create the required number of semicircles, would be a quick task.

Of all the options, the last is the simplest and most expeditious for producing an identical set of flat-faced discs and half-discs, which could then be bedded on mortar in the matrices in the Purbeck marble slab. We need look no further than the sanctuary pavement for the precedent of using reddish-brown mastic resin both as an adhesive for holding metal letters in their matrices, and as a decorative filling for channels chased in Purbeck marble (discussed in chapter 8). The colourant in the mastic was haematite, which imparted a rich deep red appearance; conceivably, its use in the tomb-top was an attempt to imitate purple porphyry.

The mosaic decoration on the three surviving sides of the tomb varied in composition. The quincunx panel at the east end was clearly the most formal and embodied at least one small porphyry disc; the black, white and gold mosaic inlay harmonized with that in the top slab (Fig. 497). Little can be said about the north elevation, except that the tesserae varied greatly in size and included some that were brightly coloured. Although these panels have mostly been robbed of their decoration, and the impressions of the bedding mortar obscured by later plaster, the mosaic seems to be of better quality, especially in the border (5) on the north side, which it is estimated incorporated some 3,500 stones. One might have expected the sunk panels in the pilasters to be complementary, but that was not so. The north-west pilaster (8), with about 900 tesserae, was of exceptional workmanship, having an estimated 700 more tesserae than its counterpart (7) at the north-east corner.

This just leaves the single panel at the west end of the tomb, which was apparently filled with mosaic that combined tesserae with cut stone (*opus sectile*). Elsewhere, this combination is found only in the eastern border panel of the sanctuary pavement (Figs 57B and 92).

Architectural setting of the repositioned tomb

Before leaving this tomb, its current architectural setting requires further comment. First, it should be noted that the orientation of the chest was almost certainly reversed when it was moved. When the tomb initially stood in the north-east corner of St Edward's chapel, the south side and west end would have been the principal faces, and their decoration is likely to have been superior to that on the two scarcely visibly sides. Consequently, when it was found that only one of the long panels was required in the new location, the finer one would naturally have been retained, and that is now the north face. The present east end is superior to the west end, and doubtless they too have swopped positions.

There were formerly wall paintings on the ashlar backs of the recesses, both above and below the segmental arch, but only faint traces now survive. Antiquarian accounts refer to the painting under the 13th-century trefoiled arch as depicting a church on an heraldic pavement composed of leopards and fleurs-de-lys, but no image of this has been preserved. Some bright red paint of uncertain date, but no earlier than the mid-15th century, is found on the ashlar and on the capitals

of the nook-shafts (Fig. 480).[46] Traces of a few Gothic letters belonging to a painted inscription can be detected on the moulding at the centre of the segmental arch (Fig. 481).

Painted on the back of the lower recess were four kneeling figures, referred to in some publications as 'children'. Illustrations of them are sketchy and it is by no means certain what they represented; in one account two of them are said to be saints. Dart identified the figures as two boys and two girls, and Gough's illustration seems to depict four women (Fig. 14), although he confusingly represented the two on the left as nimbed and those on the right as possibly wearing armour.[47] It is possible that the latter represent the two princes, and the former either saints or angels. In 1815 the remnants were described thus:

> The back of the niche over the table has a red painted ground much decayed, on which are very imperfect traces of four children, whose draperies are a dirty yellow; the mouldings of the arch still show fragments of gilding and spots of red, as do the capitals of the pillar. Above this are the remains of a painting evidently defaced on purpose; what it has been cannot be discovered on the closest inspection; there are, besides, marks where a statue has stood, which Strype gives us reason to suppose was of silver.[48]

E. W. Tristram apparently 'found and cleaned the last remains of the painting' in the mid-20th century.[49] We do not know whether this refers to the upper or the lower painting. Consequently, both the subject matter and the date of these images are uncertain. Badham considered all the paintings to antedate the translocation of the Cosmati tomb, and dismissed them as irrelevant to its history.[50] However that cannot entirely be the case: the central one-third of the higher level painting is framed with vertical lines that continue right down to the moulding of the segmental arch. The lower ends of the lines are painted on the inserted 15th-century masonry; the arch itself is also decorated in red and black, and the inscription painted on the moulding (Figs 481, 483 and 485).

The four kneeling figures in the lower arch were unquestionably associated with the monument since they were painted on the ashlar in the back of the recess which was only constructed in its present form after the tomb had been installed. Moreover, the figures were symmetrically disposed under the segmental arch, immediately above the top of the chest, so that they appeared to be kneeling on the slab. Only the faintest traces of polychromy are discernible here today.[51] Since the paintings were executed *c.* 160 years after the tomb was made, they are of little or no evidential value in respect of the primary burial(s).

Post-medieval interventions

In *c.* 1437, when the tomb-chest was relocated to the ambulatory, the mosaic decoration was evidently intact but, like the other cosmatesque monuments, it has subsequently been heavily robbed. Some of the matrices have been infilled with lime plaster, but there is no sign that Feckenham painted *faux* mosaic on this monument in the late 1550s, as he did on St Edward's shrine and Henry III's tomb (pp. 409 and 440). The western panel on the north side (6) is now rendered with cream plaster carrying graffiti: one reads *ES 1697*, implying that the mosaic had been robbed and the plaster applied no later than the 17th century (Fig. 488). Similar patching is present on the north face of the west pilaster (8) (Fig. 489).

The eastern panel on the north side was repaired in a unique manner: the decoration in the central area has been superseded by a slab of variegated pink marble 40cm square, dissimilar to anything employed in the floor mosaics or in the furnishings of St Edward's chapel. It bears the graffito, *ILC 1788*, the last two digits of which are crudely scratched; the letters have fine horizontal lines of registration (Figs 482 and 487).[52] The slab has been identified as coral limestone from Gotland, Sweden (p. 272). This material is found in post-medieval buildings in Britain, including Hampton Court Palace and St Paul's Cathedral. College Hall (part of the medieval abbot's lodging at Westminster) was entirely floored with squares of Swedish marble at an uncertain date, but probably in the 17th century.[53] This may provide the context for the appearance of a surplus paver in the child's monument.

Around it was a narrow band of mosaic which has been lost and the matrix mostly filled with white plaster, finished with a grey wash. An outer band (5), lacking its mosaic, has also been filled with grey-washed plaster and, while that was still wet, four pronounced indentations were made in it with the tip of a finger. All the plaster patching on this tomb carries graffiti (mostly non-literate).

Archaeological investigations, 1937 and later

The southern edge of the tomb top is hidden beneath the inserted rear wall of the lower recess. In 1937, to determine the dimensions of the slab, and establish whether decoration existed on the concealed side, the western block of ashlar in the back wall was removed and the rear of the tomb exposed. Using a mirror and much ingenuity, a photograph was taken by Robert Howgrave-Graham, establishing beyond doubt that the monument was indeed a tomb, had originally been free-standing, and was decorated with mosaic on all sides. Moreover, the tessellation on the protected edge of the ledger was fully preserved (Fig. 498).[54] Although the suggestion, periodically voiced, that the monument could originally have been the altar fronting the Confessor's shrine was unequivocally dispelled, repetition of the myth has continued.

No first-hand account of this archaeological investigation seems to have been recorded, and subsequent mentions of it refer only to the removal of a single block of ashlar, in order to access the back edge of the slab.[55] The 1937 photograph shows rough masonry beneath the southern edge of the top slab, confirming that the original mosaic-decorated south side-panel of the tomb does not survive.[56] However, this did not satisfy O'Neilly, and shortly after publishing his account of the shrine in 1966,[57] he developed a further theory that the 'altar' (tomb) had been installed in the wall-arch purposely to block the entrance to a hypothetical medieval crypt under the presbytery. Subsequently, O'Neilly wrote, 'The Dean and Chapter authorised me to carry out some slight excavations which were unsuccessful, but later Peter Foster, the then Surveyor of the Fabric, thought there was merit in the theory and produced a plan showing where he thought the crypt might lie, with access from the arch where the present altar/tomb now lies.'[58] The date of this investigation is not recorded, but it must have been in the late 1960s.[59]

Although no account of the 'slight excavations' appears to have been made, a careful re-examination of the tomb in 2017 under powerful lighting was unexpectedly revealing. The two ashlar blocks forming the back of the recess, together with those comprising the moulded east and west reveals, had all been removed, and the pale modern mortar used in their reinstatement is plainly visible (Figs 483 and 485). The sole purpose of such a substantial intervention could only have been to free the tomb slab, so that it could be raised vertically, or at least tilted, in order to look inside the chest. Without removing all the surrounding masonry, it would have been physically impossible to prise up the top slab on account of the fact that the lining of the wall-recess was built directly upon it, when the tomb was installed here.

Examining the bed joint between the top slab and the sides of the tomb-chest provided further confirmation of the nature of the intervention. It is readily apparent that a thin saw blade has been inserted into the joint in modern times, to cut away the mortar bed along the north side of the tomb, and around the accessible parts of the two ends. Timber wedges could then have been driven into the joint and the slab prised up sufficiently to peer into the chamber, or to insert a hand. By coincidence, in 2006, one of the authors (WR) was informed that when O'Neilly investigated the tomb, the top slab was lifted sufficiently for Lawrence Tanner to put his hand inside the chest, where he was able to feel two coffins.[60] Whether they are of timber or lead we do not know, but they undoubtedly contain the remains of Edward I's sons, John and Henry.

14 Related Monuments and Furnishings

The three principal surviving Cosmati monuments have been described in the foregoing chapters: the shrine-tomb of St Edward, the tomb of Henry III and the tomb of John of Windsor ('the child's tomb'). There are no grounds for suggesting that any other substantial cosmatesque funerary monuments were formerly present, and have been lost. However, there is one heavily worn grave-slab with mosaic inlay, set into the paving immediately east of the shrine pedestal, which has long been attributed to the de Valence family, albeit without supporting evidence. It is described below, where its history and context are also discussed.

In addition to the pavements and funerary monuments, there certainly were other furnishings with cosmatesque decoration that did not survive the Reformation intact, and are now represented by fragments. The only one we can identify unequivocally is the retable that was associated with the shrine altar: the rectangular marble panel is extant and owes its survival to the fact that it was physically attached to the west end of Confessor's shrine when that was rebuilt in 1557. The panel has been described along with the shrine pedestal, and is further discussed below (pp. 516–19). The altar of St Edward was lost at the Dissolution, but there can be no serious doubt that it too was cosmatesque, and was *en suite* with the shrine and the retable. The outer angles of the shrine pedestal and the reveals of its six niches all had slender colonnettes in the form of cable-moulded nook-shafts, decorated with gold lines in the creases. Several fragments of identical shafts – but of larger diameter – have been discovered around the Abbey in the past. They were not part of the shrine, but could well have been complementary colonnettes from the corners of

the altar. The fragments are described below (p. 519).

Nothing is known of the 13th-century high altar, except its length, and that is provided by the dimensions of its surviving altarpiece, known as the Westminster Retable. Made of oak and encrusted with decoration in multiple forms and media, this was such a sumptuous furnishing that it demanded an altar of comparable elegance, but whether that was cosmatesque, is now impossible to surmise (p. 520).

There may have been other mosaic-decorated furnishings too, such as the paschal candlestick, low screens where the change of level occurred between the sanctuary and the St Edward's chapel, and wall decoration around the entrance to the chamber built to protect the site of the Confessor's primary tomb. In Italy, Cosmati work is regularly found in all such locations, but it is less likely that the display of mosaic exuberance was so extensive at Westminster.

THE 'DE VALENCE' TOMBS

William de Valence, Earl of Pembroke

Henry III's half-brother, William de Valence (d. 1296), was almost certainly buried in one of the ambulatory arcade bays on the south side of St Edward's chapel. In the 14th century the tomb was removed to make way for the interment of a monarch, and is now located on the south flank of the ambulatory, in St Edmund's chapel (p. 312; Fig. 288, no. 23).

William's tomb comprises a panelled chest of Reigate stone, surmounted by a second chest made of oak. That in turn supports a recumbent

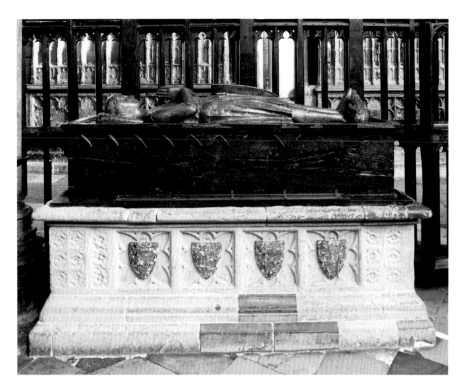

500 Tomb of William de Valence. The south side.
Christopher Wilson

501 Tomb of William de Valence. Details of the upper and lower parts of the brass-clad oak effigy.
Christopher Wilson

effigy, also of oak (Fig. 500). Originally, all the surfaces of the timber components were covered with thin sheets of copper-alloy, fixed with small tacks. The plates were variously chased with decorative detail and gilded; considerable areas were also embellished with Limoges *champlevé*

enamel work (Fig. 501). Although now sadly depleted of much of its plating, this is still an impressive monument, the only surviving example of its kind in England. The enamelling on the pillow and the shield remains in remarkably good condition. The earl's arms appear on the monument in several places, including enamelled shields attached to his surcoat, but evidently much more of the decoration was present when Keepe described it in 1683:

> A Wainscot Chest, covered over with plates of Brass richly enamelled, and thereon the Image of William De Valence, Earl of Pembroke, with a deep Shield on his left Arm, in a Coat of Male with a Surcoat all of the same enamelled brass gilt with gold and beset with the Arms of Valence

> ... round about the inner ledge of this Tomb is most of the Epitaph remaining in the ancient Saxon letters, and the rest of the Chest covered with Brass, wrought in the form of Lozenges, each Lozenge containing either the Arms of England or that of Valence, alternately placed one after the other, enamelled with their colours. Round this Chest have been thirty little Brazen Images some of them still remaining, twelve on each side, and three at each end, divided by certain Arches, that serve as Niches to inclose them: And on an outward ledge, at the foot of each of these Images are placed a Coat of Arms in Brass, enamelled with their colours.[1]

This is the most plausible candidate for the monument that Richard II ordered to be displaced from St Edward's chapel in 1394, to make way for the massive tomb for himself and his recently deceased queen, Anne of Bohemia. If so, the de Valence tomb stood under the arcade in the westernmost bay (i.e. directly across the ambulatory from its present position). It is worth noting that a small rectangle of stone has been roughly cut out of the north-west corner of the lower chest, but this has no relevance to the monument's present location. However, if the chest is turned through 180 degrees, so that the cut-out falls at the south-east corner, that would have abutted the ambulatory pier, where there may have been a projecting shaft or stanchion for a railing.[2] De Valence's monument is much smaller than Richard II's, and would only have obstructed slightly more than half of the arcade bay, leaving ample room for pilgrim access to the chapel via the steps and entrance that we have posited here (p. 311). Finally, there is an account for re-painting the tomb that

had to be relocated in 1394, and that most likely relates to the stone chest, which was originally polychromed. It had to be dismantled in order to move it, and would have required redecoration after reconstruction.

Three of William's offspring were buried in Westminster Abbey. Most notable is Aymer de Valence (d. 1324), whose monumental tomb stands under the north ambulatory arcade in the sanctuary (Fig. 288, no. 3). In 1600 Camden noted that two of William de Valence's children, Margaret and John were buried in St Edward's chapel between the shrine and the tomb of Henry V.[3] The years of their deaths are invariably cited as 1276 (Margaret) and 1277 (John), but there is reason to believe that both occurred in the latter year (see further below, p. 515).[4] Writing in 1683, Keepe referred to the graves as having 'two small stones of grey marble placed over them without any inscription'.[5] In 1723 Dart disputed the claim that these were both de Valence burials, and offered the suggestion that the southern slab was the memorial to Roger of Wendover.[6] Dart appeared to accept the northern slab as belonging to the de Valence family, although it lacked a legible inscription (even in 1683).

In the floor of St Edward's chapel, between the east end of the shrine and the gates to Henry V's tomb enclosure, are two heavily worn, 13th-century Purbeck marble grave-covers that have been the subject of much speculation (Fig. 288, nos 19, 20). They were once inlaid with latten crosses, inscriptions and other embellishments, but nearly all visible detailing – and hence evidence for the identities of the persons buried here – had been lost before the 17th century. Today, very little survives, even of the matrices for the brasses. Moreover, since the 1420s the eastern ends of both slabs have been sealed under the threshold step and paving to Henry V's tomb enclosure (Fig. 288, no. 11). Despite the lack of firm evidence for the identities of the persons commemorated, both of these slabs have become inextricably associated in academic literature with William de Valence's offspring.[7]

The slabs are tapered in plan and laid flush with the surrounding paving. For centuries they have been constantly walked upon, being on the circulatory route around the east end of the shrine, and have lost several millimetres of stone from their surfaces. There is no reason to doubt that they are *in situ*, and ground-penetrating radar has confirmed that they overlie archaeological features, rectangular in plan (p. 254; Fig. 257). The west ends of both slabs were set against the easternmost step of the shrine podium, and their east ends pointed towards the dais carrying the altar of the Holy Trinity. The altar was removed in the 1420s, when Henry V's tomb was positioned here, and either then or in the following decade, when the

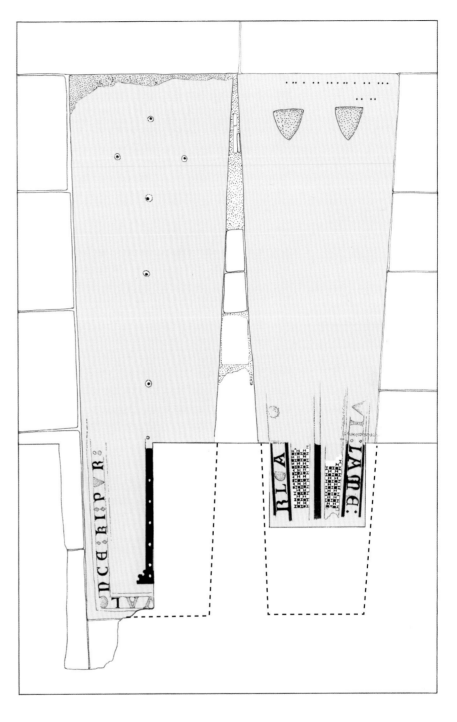

0 10 50 cms

→ N

502 St Edward's chapel. Plan of two Purbeck marble tomb-covers in the pavement immediately east of the shrine. *David S Neal*

chantry chapel was constructed, the eastern ends of both grave-slabs were concealed beneath the step to its enclosure. As a consequence, only 1.4m of the length of the slabs is now visible, which probably accounts for their description by antiquaries as 'small'. Even so, it is obvious from their proportions that they were both adult-sized slabs (Fig. 502).

St Edward's chapel: northern tomb-cover

This burial lies axially east of the shrine (Fig. 288, no. 19). In the 1850s, Scott's archaeologically minded assistant, James Irvine, noticed that the slab extended eastwards, under the step to Henry V's tomb enclosure and, moreover, that parts of the original brass inlays were still trapped there. Accordingly, a section was cut out of the step to expose the long-concealed lower portion of the slab, but its eastern extremity was not found, having been truncated when the substructure of Henry V's tomb was built (Figs 503 and 504).[8] A note on the discovery, together with a partially

reconstructed plan of the slab and a coloured lithograph, was published by Charles Boutell in 1860.[9]

The surviving length of the slab is 1.66m, but the original measurement would have been *c.* 1.75–1.80m. The width at the west end is 60cm, tapering to *c.* 40cm at the original east end. Irvine made a rubbing and E. M. Vincent painted a watercolour of the discovery.[10] This slab formerly displayed the matrices for a full-length central cross, but only a short section of the lower shaft survives. Nothing is known about the arms, their terminals, or the base. The shaft was flanked by tapering panels of Cosmati mosaic inlay, two portions of which survive, where they had been protect by the step to Henry V's chapel. Above the head of the cross, at the west end, lay a pair of shields, for which the matrices are preserved (Fig. 505). The slab bore a marginal inscription in Norman French, composed of individually-set latten letters 40mm in height; the font is Lombardic. A pair of latten fillets ran around the edges of the slab, framing the inscription.

The cross was made from sheet metal, the width

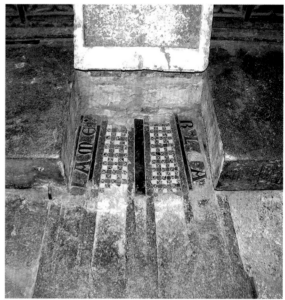

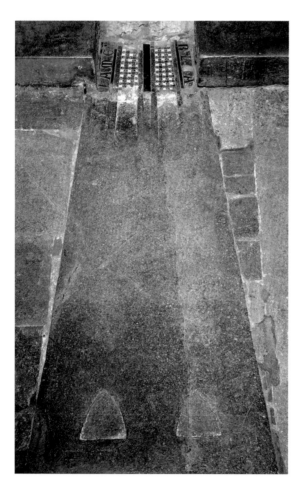

503 (*Left*) St Edward's chapel, northern tomb-cover (probably Aveline de Forz). Full-length view of the slab, looking east. In the foreground are the matrices for the heraldic shields, which would have been depicted in mosaic. © *Dean and Chapter of Westminster*

504 (*Top right*) St Edward's chapel, northern tomb-cover (probably Aveline de Forz). By raising a hinged section of the step at the gates of Henry V's chantry, the preserved east end of this Cosmati-decorated slab can be inspected. *Authors*

505 (*Bottom right*) St Edward's chapel, northern tomb-cover (probably Aveline de Forz). Matrices for a pair of heraldic shields at the west end of the slab. The last vestiges of the channels that formerly held the fillets flanking the marginal inscription are also visible. *Authors*

of the shaft being 27mm, and the thickness 4mm. The shield matrices were more deeply cut into the slab, and hence their forms are fully preserved.[11] Their original depths must have been 7–9mm, implying that the shields were not of sheet brass, but were infilled with mosaic set in mortar. There are no holes in the slab for lead plugs or rivets, and all the latten components were embedded in brown mastic.[12]

The inscription

Beneath the chantry chapel step the border fillets are still *in situ*, as are seven letters and a pair of diamond-shaped stops.[13] Additionally, there are matrices for a letter 'E' on the south, and for two badly damaged letters and another pair of stops on the north (Fig. 502). The first of the damaged matrices can only be for the letter 'V' and the second comprises the vertical stroke and a trace of the top of the letter 'R'.[14] Thus the surviving portions of the inscription read:

North
] V R : L A M E : [

South
] R L E A [

Unquestioning acceptance of the supposed identification of the slab with John de Valence, led early scholars to wring readings of 'William' (John's father) and 'Valence' out of these letters. The first was Boutell, who pronounced the letters on the north edge to read **VIILAME**, and suggested that those on the south were part of the concocted surname **VARLEANCE**.[15] The latter has never been regarded as plausible. Scott accepted the inscription as commemorating John, the 'infant' son of William de Valence.[16] Burges, on the other hand, correctly read the surviving lettering on the north side, not as the name William, but as part of the common funerary inscription formula *pries pur l'ame*, and suggested that the tomb may belong to Alfonso, third son of Edward I, who died in 1284, aged eleven years.[17] The *Flores Historiarum* expressly records his interment in the chapel, 'next to the aforesaid shrine' and amongst his brothers and sisters (p. 484).[18] That can only have been at the east end of the chapel, and if it were the Cosmati tomb it would imply that the southern tomb post-dated

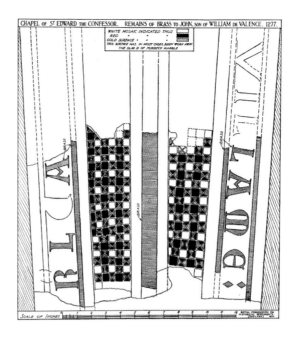

506 St Edward's chapel. Reconstructed plans of the two floor slabs east of the shrine. *Lethaby 1906, 318*

507 St Edward's chapel, northern tomb-cover. Interpretive drawing of the remaining parts of the decoration and inscription, 1924. *RCHME 1924, 27*

1284, and could not therefore be John de Valence's. Neither Scott nor Burges could interpret the lettering on the south side of the slab.

Faint traces of another letter on the north were said to be discernible in the marble matrix in the early 20th century, and Lethaby's drawing of the slab shows a variation on Boutell's reading] **C V I L L A M E :** [(Fig. 506).[19] Failing to recognize that this is a conflation of two words, separated by a pair of stops, he convinced himself that the letters spelled out the beginning of the name Guillame de Valence. This mistaken reading was published in 1924 by the RCHME (Fig. 507), and has been adopted by subsequent scholars. Lethaby, like previous commentators, was unable to interpret the surviving lettering on the south border; indeed, no plausible explanation of this incomplete word has been forthcoming until now (below, p. 514).

The return on the east end of the slab has been destroyed, and hence the inscription irretrievably lost; nothing is visible on the west end, except slight traces of two pecked lines, 6cm apart, representing the channels for the fillets flanking the inscription (Figs 502 and 505).

Description of the mosaic

The chased panels on either side of the cross-shaft are decorated with fine cosmatesque mosaic (Fig. 504). The patterns in both fields appear the same: a lattice of red glass tesserae with white glass

interspaces. However, many of the tesserae are of opaque red glass flashed with gold which has mostly worn away; distinguishing between plain red tesserae and former gold-flashed tesserae, now appearing red, is therefore difficult (Fig. 508A). The restoration drawing recreates the original composition which is best described as a chequerboard pattern of red and white tesserae of equal size (Fig. 508B). The square interspaces so formed are divided diagonally into four triangles, red and gold confronting triangles forming pairs of hourglass shapes. A consequence of this arrangement is the formation of tangent, diagonally arranged, red and white squares each with a poised square, and white squares on red, and red squares on gold. Because the fields of the patterns taper, at the narrow ends the mosaicist has staggered the pattern in one zone and truncated a row of hourglass shapes in the other.

It is uncommon to have gilded glass tesserae on floors where they could be walked upon but, as we have already seen, they occur on the ledger of Abbot Ware, and on some of the other ornamentation of the sanctuary mosaic. Considering that the slab under discussion lay between the shrine and the altar of the Holy Trinity, where the surviving panels of mosaic would have been walked upon, from the 1270s to the 1420s, they are remarkably well preserved. The destruction of the remainder of the mosaic must have occurred subsequently, or else the eastern ends of the two tomb-covers were fortuitously protected from foot-traffic by an item of furniture (for the condition of the second cover, see p. 512).

When seeking contenders for the occupancy of the axial tomb, the dating implied by the Cosmati mosaic itself needs to be born in mind. The high quality red, white and gold chequerwork is clearly related to that on Henry III's tomb and the shrine: the red crown glass and distinctively

508 St Edward's chapel, northern tomb-cover. A. Detail of the mosaic inlay, composed of red, white and gilded (red) glass; the joints were grouted with grey cement in the early 20th century, making them now considerably more prominent than they would originally have been; B. Panels of glass mosaic flanking the cross-shaft. *A. Authors; B. Painting by David S Neal*

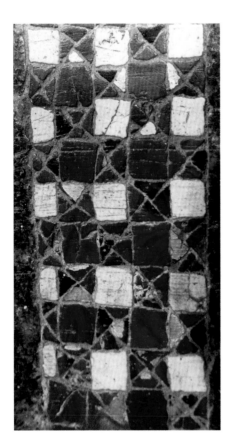

A

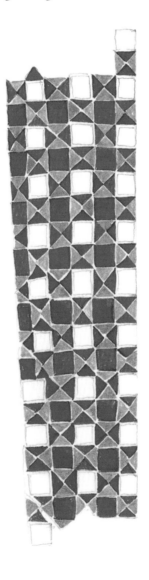

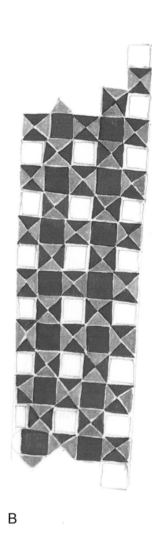

B

striated white cylinder glass are identical on all three monuments, as are the pattern of the mosaic and quality of workmanship. Moreover, the former presence of mosaic shields places this monument in the mainstream of cosmatesque work. Although undeniably a hybrid of English and Roman design, the slab was certainly not an attempt by a local stonemason to emulate a past style of decoration. The tomb-cover and its latten inlays were the work of a London marbler, but the once-spectacular decoration was undoubtedly added by a master mosaicist engaged on the other monuments in the Abbey. A date in the late 1260s or early 1270s is therefore most likely (p. 594).

Finally, the GPR survey revealed that the material immediately below the slab is subtly different from that to either side, but it did not yield a convincing outline for a stone coffin (Figs 254 and 255). Moreover, if there had been one it is likely that the interior would have been at least partially voided, and the presence of air would have shown up clearly on the radar, as it did in the surveys of the sanctuary pavement (p. 151). Lower down, however, the outline of a potential grave-cut was defined by the radar (Fig. 257). We therefore conclude that this burial was probably in a timber coffin, laid directly in the earth. Given the unquestionably high status of this grave's location and the equally exceptional nature of the cover-slab, the absence of a stone coffin is noteworthy.

St Edward's chapel: southern 'de Valence' tomb-cover

This tomb-cover directly abuts the last, on its south side (Fig. 288, no. 20). Again, all traces of matrices that held the border inscription and fillets have been lost through wear, but the shaft and arms of the cross are defined by brass rivets set in lead. Irvine first noted that the slab once held brass inlays and, as with the previous tomb, some of these were visibly trapped under the step of Henry V's chantry. Half-a-century later, Lethaby reported that the shaft and base of a brass cross were still *in situ*, together with several letters and fillets. He prepared a drawing on which he reconstructed the hidden ends of both slabs (Fig. 506), but did not mention any disturbance to the paving, or reveal how he obtained his information.[20] The drawing he published could not have been made without specific knowledge of the east

end of the tomb-cover, particularly in respect of the foot of the latten cross. Hence, prior to 1906, a paving slab in the tomb enclosure must have been taken up, exposing the foot of the cross, but not the inscription.

In 1914 Lethaby and St John Hope obtained permission to investigate the southern grave-cover. Another section was cut out of the marble step and two floor slabs taken up in Henry V's tomb enclosure, exposing the south-east corner of the 13th-century slab, which is 1.96m long, 62cm wide at the west end and 45cm wide at the east end. The surviving part of the shaft of the cross and half of its moulded base were revealed, along with parts of the Norman French inscription on the east end and south side, including eight latten letters and one pair of lozenge-shaped stops.[21] The empty matrices for a further six letters and two pairs of stops were also preserved, either wholly or partially. A rubbing of the newly exposed brass was made.[22]

In 1925 Lethaby wrote:

> About twelve years ago, a portion of the plain paving by Henry V's tomb, which overlies the slabs, having been lifted, the end of the second [i.e. southern] slab was exposed and this retained several letters and imprints giving **VALENCE : KI : PUR : LA** The name Valence began under the foot of the cross and the rest continued up the south side of the slab.[23]

In order to check the evidence and make a more precise record, the portion of step and slabs that had been taken up in 1914 were lifted again in September 2018 (Figs 509 and 510). The reading of the inscription was confirmed, although the letter 'K' was not present: it was found in the Abbey Collection (Fig. 271C).[24]

East
] **V A L E**

South
N C E : K I : P V R : L A [M E

The name Valence turns around the south-east corner of the slab in the following manner: 'VAL' is on the eastern edge; 'E' is placed askew across the corner; and 'NCE' is on the south side. The north-east corner of the slab, where the first part of the deceased's name would occur, was not accessible and may well have been destroyed by the foundation for Henry V's tomb-chest (just as

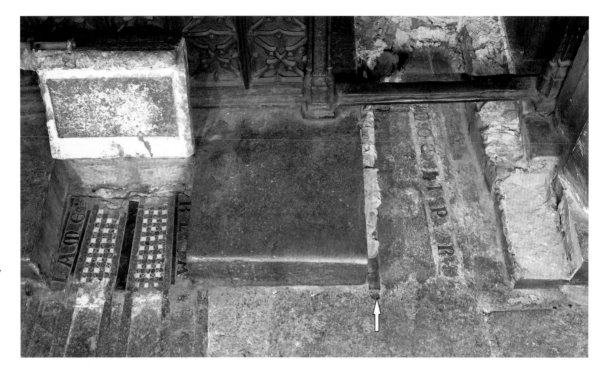

509 St Edward's chapel. Investigation of the two tomb-covers in the pavement, east of the shrine, 2018. The ends of both lie under the step and iron gates to Henry V's chantry chapel. The shaft of the cross of the southern slab is arrowed. *Authors*

510 St Edward's chapel, southern tomb-cover (probably John de Valence). A. Vertical view of the south-east corner of the slab (east to the left), showing also the abutting primary Purbeck marble paving of the chapel; B. View from the south-west, showing the remains of the de Valence inscription along the southern edge of the slab, and the shaft and base of the latten cross. The fillets flanking the inscription are missing, and their matrices mostly filled with lime mortar. *Authors*

the entire eastern termination was of the northern slab). Like those of the first tomb-cover, the letters are 39–40mm in height, but in this instance they are embedded in pitch. The fillets forming the borders to the inscription were similarly secured, but had later been reset in white lime mortar

(presumably in 1914). No shields or mosaic decoration were present on this slab, and it is less acutely tapered than the northern one.

The shaft of the cross is 29mm wide and made from thin latten sheet, the joints being lapped; the metal was held in the matrix with brass rivets set in lead, and not by mastic alone. This raises a technological issue, since riveting is a feature of brasses of the mid-14th century and later, whereas inscriptions composed of individually cast letters (as opposed to incised plates) belong primarily to the previous century. The possibility that the cross was initially set in mastic alone, but became loose and had to be refixed with rivets must be borne in mind.[25] A further anomaly is the moulded profile of the cross-base, for which no close parallel appears to have been recorded. Interestingly, there is very little evidence of wear on the surviving fragment of shaft, not even on the projecting head of the rivet that secures the cross-base. Either this slab was also fortuitously protected from foot-traffic in the chapel, or it was laid (or repaired) not long before Henry V's tomb enclosure was constructed.

Once again, the GPR survey revealed no trace of a coffin directly under the slab, or the presence of a void. A rectangular feature dug into the earth beneath the pavement was detected, but it is wider than would be expected for a single grave, having more the appearance of a double, or two adjacent graves that have coalesced (Fig. 257).

This grave undeniably belongs to a member of the de Valence family. But which one? The lives of William de Valence's offspring are all documented to some extent, with the sole exception of Margaret, which almost certainly implies that she died as a very young child.[26] That being so, she is less likely to have been interred under an adult-sized tomb-cover, and she may be one of the now-anonymous child burials identified by GPR in the eastern end of St Edward's chapel (p. 254). That leaves John as the only known de Valence contender for the southern grave.[27]

There is conflicting evidence regarding John's likely age at death, but he was certainly not an infant, as Dart baldly stated.[28] He was the first-born son of William, who had married Joan de Muntchensey on 13 August 1247. Consequently, when John died in 1277 he was most likely in his late twenties. In 1272, Henry III, at the behest of his grandson John, pardoned Laurence Duket of London for a breach of the peace arising from the death of Master William le Fremund.[29] William de Valence and his son John are next mentioned in a contrabreve, 1273/4.[30] Other contemporary references to John's activities imply that he survived into adulthood and died in Wales. His death is recorded in the *Flores Historiarum*, under 1277:

> *Obit dominus Johannes primogenitus domini Willelmi Valencia comitis de Pembrok, mense Januarii, et sepultus est apud Westmonasterium juxta sororem suam Margaretam ibidem xxiv°die Martii praesepultam.*[31]

> Lord John, first son of Lord William Valence, Earl of Pembroke, died in the month of January, and was buried at Westminster next to his sister Margaret, who was buried there on the 24 March before.

The infancy claims made by earlier antiquaries are uncorroborated and seem to be based on the fact that Edward I contributed to John's burial costs in a rather curious way. The Exchequer Roll for 1277 records that the king paid for 'two little coffers' to contain John's bones, a provision that is equally difficult to explain, whether he was a child or an adult.[32] However, the king was at Rhuddlan in North Wales when he ordered these coffers on 14 October, and John's parents were both at Pembroke on 4 October.[33] Edward also gave money to pray for John's soul, but the exact date of his death is not recorded, although it

probably occurred about the beginning of October whilst he was on campaign in Wales.[34] Weather conditions may have been poor, preventing his body from being transported to London before putrefaction set in. In such circumstances dismembering or 'boiling down' of the corpse was sometimes practised, and thus the two receptacles that Edward I provided could have been for John's disarticulated bones (or one might have contained his visceral parts). When the coffers reached Westminster they would have been interred together, beneath an adult-sized slab. Indeed, the king's account specifically records that the coffers were for John's 'bones', rather than his body:

> ... for two small coffers [*cofr'*] for putting the bones [*ossa*] of John de Valence in for the alms of the King, 6*d*. Item for preparing the same coffers to inter the said bones at London by the hand of William de Faversham, 19*d*.[35]

Since the coffers cost 6*d*., but 'preparing' them for the interment cost 19*d*., we should perhaps regard the latter sum as relating to the treatment of the corpse.

Identifying the occupants of the two tombs: a reappraisal

Matthew Payne

The question of the identity of the occupants of the two graves to the east of the Confessor's shrine, and in front of what would have been the altar to the Holy Trinity (now the tomb and chantry of Henry V), is one that has remained unresolved for a century-and-a-half, ever since Irvine suggested the removal of part of the step to Henry V's tomb enclosure and the subsequent revelation of the few surviving letters from the inscriptions which ran around the grave-covers. Before this, Camden's suggestion that the graves were those of John and Margaret de Valence had largely been followed, and, even since this, no convincing alternative has so far been put forward. The surviving portion of the inscription on the southern grave-cover demonstrates that it was unquestionably that of a de Valence, and, since the Abbey's copy of the *Flores Historiarum* refers to John having been buried *juxta sororem suam Margaretum*, the logical conclusion was that one of the graves was hers, and the other his.[36]

No satisfactory suggestion has so far made sense of the surviving letters of the northern grave,

especially the southern sequence]RLEA[. A recent tentative offering of ORLEANS, which would neatly fit the lettering, has no basis in any known burial at the Abbey in the 13th century. Given such a high profile location it is difficult to believe that the interment of a distinguished French man or woman would not have been noticed by the contemporary chroniclers.

A more plausible alternative, not previously suggested, lies with an individual already known to be buried in the Abbey. In fact this version would make sense not only of the disposition, status and chronology of these two graves, but would also throw light on the production of a later monumental tomb in the Abbey. On this interpretation the surviving letters formed part of the words ALBA MARLEA, or some variant thereof, a not uncommon version of the latinized form of the French 'Aumale' (later anglicized as Albemarle).[37] The title was held in the late 13th century by the de Forz family. William de Forz, Count of Aumale, who was born before 1216, was a major landowner, and a prominent counsellor to Henry III.[38] At his death on 23 May 1260, his body was taken to Thornton Abbey in Lincolnshire for burial, and his heart interred at Meaux Abbey,

Yorkshire. William's powerful wife Isabella, the elder daughter of Baldwin de Revières, survived him until her death in 1293, when she was buried at Breamore Priory, Hampshire.[39] Isabella was an influential figure, who outlived all of her children, each one of whom seems to have died at a young age.[40] Her elevated status is confirmed by the arrangement of the marriage of her surviving daughter Aveline to Prince Edmund, son of Henry III, at Westminster Abbey in April 1269, only a matter of months before the formal rededication of the Abbey.[41] It was the first royal wedding to take place in the new church. Aveline was aged only ten at the time, and was not declared of age until 1273.[42] Nonetheless, she was regularly referred to as the Countess of Aumale.[43]

However, on 10 November 1274, three months after the coronation of her brother-in-law as Edward I in Westminster Abbey, she died in childbirth.[44] Her death caused profound grief among the royal family, as well as a significant alteration in the circumstances around her huge estates, many of which reverted to her mother. Aveline's body was taken for burial in Westminster Abbey, with a funeral service officiated by the Bishop of London, at the request of Queen Eleanor.[45] The precise location of her burial is not specified.

A canopied tomb, with a recumbent effigy, in the north-west bay of the sanctuary of the Abbey, has long been said to belong to Aveline (Fig. 511).[46] But on art historical grounds this monument must post-date her death by about twenty years.[47] The reason for the construction of the tomb so long after her decease has never been satisfactorily explained. The tomb is heavily worn, and the heraldic escutcheons above the weepers, which may well have been painted on applied pieces of parchment, are all lost.[48] In addition, it has apparently been dismantled and repositioned at some point, because the plain ashlar plinth is missing.[49] The figure's headrest was apparently diapered with the arms of Lancaster and de Forz, although no evidence of this now remains.[50] According to Neale and Brayley, writing in the early 19th century, twenty-four separate arms could be distinguished at that point, on various parts of the monument (many repeated), including the de Forz arms on Aveline's garments, as well as those of her maternal grandfather and husband, all suggesting that the identification must be correct.[51] But no inscription survives, or has been

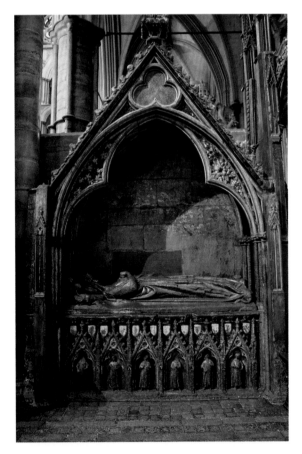

511 Sanctuary, north arcade. Canopied tomb of Aveline de Forz, Countess of Lancaster (d. 1274). The monument dates from *c*. 1295 and is not in its original position.
© *Dean and Chapter of Westminster*

recorded, stating that Aveline's body actually resides within the tomb structure.

Someone of Aveline's status must have had a tomb-marker when she was buried in 1274, two decades before the construction of the effigy in the mid-1290s. She was, after all, the king's sister-in-law, and therefore of exceptional status. As already discussed, in the early 1270s other members of Edward's immediate family were at that point being inserted into the chapel: Edward's children, John in 1271 and Henry in late 1274 (very close in date to Aveline); the heart of Edward's cousin, Henry of Almain, into the shrine in 1270; and half-cousins Margaret and John de Valence in 1276–77; not to mention Edward's own father, Henry III's reported initial position in front of the shrine altar in 1272. The chapel was clearly envisaged as a family mausoleum, rather than as a space reserved solely 'for anointed kings'.[52] Placing of his sister-in-law some way to the west of the Confessor's chapel, beyond the high altar, where her effigial tomb now rests, would have been entirely out of keeping with prevailing practice of the 1270s. Far more appropriate would have been a spot within the Confessor's chapel itself, along with other members of the royal family, and a site at the eastern side of the shrine, in front of the altar of the Holy Trinity, would be perfectly natural.

The construction of the canopied effigial tomb for Aveline two decades later still requires some explanation. Whether she was in fact transferred into her new tomb in the 1290s (in the way Henry III is supposed to have been) it is not possible to tell. The immediate motivation for its construction may have been the death of her husband, Edmund, in 1297, and the construction of a similar monumental canopied tomb for him (Fig. 36B). Or Edmund himself may have chosen to create the effigy to his first wife in response to his brother's installation of the first effigy in the chapel, that of Edward's wife Eleanor, and immediately afterwards, to their father Henry III. This was soon followed by the effigy of William de Valence, Henry's half-brother, in 1296 (Fig. 500). Another motivation for the retrospective recognition of Aveline may have been the death of her mother in 1293, and the resolution of the long-standing matter of her estates. Edward I had for many years been attempting to acquire the vast de Forz estates from Isabella, a process which only came to fruition on her deathbed.[53]

If the identification of the northern grave as the original resting place of Aveline is accepted, the larger dimensions of the grave under the southern tomb-cover make sense. The detail given by the (Westminster) author of the *Flores* that John de Valence was buried 'next to his sister' was evidently quite precise; he, or rather his remains in two coffers, were buried in the same grave as Margaret, which had only recently been dug and which had simply to be widened slightly to accommodate them both. As the king's (half) cousins, they would of course be entitled to such a location, within a chapel being increasingly filled with Edward's family.

Discussion

Both grave-covers abutted the steps on the shrine pedestal, and it is likely that the east end of each cross-slab lay close to the dais of the altar of the Holy Trinity, which stood where Henry V's tomb-chest now is.[54] The dimensions of the slabs fall within the standard range for adult grave-covers of the period. Indeed, the southern slab, with a length of almost two metres, falls at the top end of the range, which might lead us to suppose it was associated with the burial of a tall male, but that is not necessarily the case. Logically and stratigraphically, the axial northern interment took place first, as Lethaby observed. Also, the use of rivets for securing the cross in the southern slab is a later technique than setting in mastic alone, although that could reflect a repair.

Despite confident assertions by innumerable writers that the cosmatesque tomb-cover belongs to John de Valence, and the plainer one on its south side to his sister Margaret, there is no specific evidence to support that, and no cogent case for either identification has ever been argued. From an archaeological point of view, these alleged attributions are insupportable. If they were the burials of Margaret and John (1276–77), the northern slab, which is axial to the shrine, should belong to the female, and the southern one – abutting it, and secondary – to the male. This would give the young child Margaret the mosaic-decorated slab with two shields, and John the plainer one: an unlikely scenario. Most commentators have overcome this inconvenience simply by reversing the burial order, without attempting to justify such an action, equating John's grave with the axially-aligned, mosaic-

decorated slab. But a credible explanation is required for making such a swop. Additionally, the stylistic and technical differences between the monuments – particularly the use of rivets and pitch in the later one – have been ignored, and they would suggest a time-interval between the burials of more than ten months.[55] Moreover, the grave-covers are not sufficiently similar to be regarded as a pair, since they were probably not of equal length and the taper on one slab is more acute than on the other; only the font and size of the lettering provide points of comparison, but those similarities *per se* are unremarkable for London brasses of this period.

Exceptional importance must be accorded to the northern slab on account of the presence of high quality Cosmati mosaic panels in red, white

A

B

512 Santa Maria in Aracoeli, Rome. A. Marble tomb-slab with a combination of incised and cosmatesque mosaic decoration; B. Detail of one of the mosaic-inlaid shields. *Vanessa Simeoni*

and gold, together with two mosaic shields. Almost certainly, nothing else like this had hitherto been seen in England: it may well have been both the first and the last in its class. Cosmati shields are found on high-ranking Italian monuments, as in the tomb of Luca Savelli and a floor slab at Santa Maria in Aracoeli, Rome (Figs 195 and 512). The latter is a particularly apposite parallel for the Westminster tomb-cover.

To summarize: by rejecting the archaeologically impossible, we have narrowed-down the options, and confirmed our suspicion that the northern tomb does not commemorate a member of the de Valence family; nor can it belong to Edward I's son Alfonso. The unusual combination of surviving letters on the southern edge does not fit any of the common formulae for brass funerary inscriptions, which in turn suggests that it most likely belongs to a title, office or place-name. The close similarity of the mosaic to the Cosmati work on Henry III's tomb and the Confessor's shrine indicates the likelihood that it was created by the same team, and at about the same time. The date of decease can therefore be placed with a high degree of confidence in the period 1265–75. Matthew Payne has argued a compelling case for identifying the slab with Aveline de Forz, Countess of Aumale and Countess of Lancaster (d. 1274). This fits perfectly both the enigmatic fragment of inscription on the slab and the chronological order in which burials took place at the east end of the chapel. The presence of two mosaic shields on the tomb is also readily explained: de Forz and Lancaster.

That leaves John de Valence as the only likely contender for the southern burial. Given that the GPR survey revealed the grave to be unusually wide, there is no difficulty in accepting that the infant Margaret was interred here in March 1277, and John beside her in October.

ST EDWARD'S SHRINE ALTAR

No information concerning the size or materials of the altar was recorded by pre-Dissolution historians, and no illustrations of it exist. Nevertheless, we can reasonably assume that the altar would have been *en suite* with the shrine-tomb, especially since it abutted the west end of the latter, and supported the Cosmati retable that fortuitously survived the Reformation (Fig. 328).

The altar would have been raised upon a dais of one or two steps, and the footprint of that dais was delineated in the chapel floor by a rectangle of red clay pamments, measuring 2.5m by 1.6m. The pamments, which are seen in many anti-quarian illustrations antedating the coronation of 1902, were most likely laid in c. 1540, when the shrine, together with its altar and dais, were removed and the floor levelled (Figs 9 and 12).[56] There was evidently no previous marble paving here: the dais rested directly on the sub-floor material and was abutted on three sides by the Cosmati pavement.

The site is now exactly covered by a massive slab of dense black marble forming the dais for a new altar erected at the time of the coronation of King Edward VII (Fig. 326). The present cumbersome altar is made of the same material and was designed by J. T. Micklethwaite. It has attracted much adverse criticism, not least from Jocelyn Perkins, a former Minor Canon:

> A footpace of black Irish marble was constructed at the west end of the Shrine, and on this were erected a pair of stout legs, of the clumsiest description, on which the new mensa was supported. Hideous in itself, the design was utterly out of keeping with its surroundings.[57]

Although not generally recognized as such, a significant component of the Henrician altar has survived, namely the Purbeck marble retable with cosmatesque decoration, described in detail in chapter 10 (pp. 350–6; Fig. 328). It comprises a single rectangular panel, 1.63m by 1.01m by 13.5cm thick, chased on the west face to accom-modate six near-square slabs of porphyry. Each is the centrepiece of a mosaic quincunx. Two squares of red porphyry remain, but in 1819 there were evidently three.[58] The remaining three slabs – all now lost – were apparently of green porphyry, and two small *crosses pattée* formed in glass mosaic were incorporated in the central region of the panel, where they would have flanked the altar cross (Figs 331 and 335). The overall design of the retable, and the marble squares in particular, is on a somewhat bolder scale than the Cosmatesque decoration of the shrine.

Although now secured to the west end of the shrine, the retable was not an integral part of its construction, and originally it would have rested on the altar *mensa*. However, in the Tudor recon-struction two Cosmati columns, unrelated to the shrine, were introduced to support it. Between the columns was a 'wall' of Tudor brickwork, which was the back of the short-lived replacement altar. When that was in turn demolished in c. 1560–61, the rough brickwork left behind was plastered (Fig. 29), and remained so until it was entirely removed by Scott in 1868, and replaced by a pair of pilasters (p. 350; Fig. 329).

The vertical north and south edges of the retable are plain and never sported Cosmatesque decoration, it being assumed that this was unneces-sary because they were partially eclipsed by the spiral colonnettes at the corners of the western corners of the shrine. However, in the light of careful measurement and reconstruction, it is apparent that the colonnettes stood sufficiently far away from the edges of the retable for the plain marble to be fully on view. Furthermore, it has been noted that scars in both edges of the retable indicate former iron fittings (either two or possibly three per side), and it is suggested that there were hinged timber panels on both flanks (p. 356). That being so, the extant marble panel slab was the central portion of a triptych.

The plain back of the retable abutted the undecorated west end of the shrine, but it was wider by 17cm to north and south, allowing two narrow vertical bands of unadorned Purbeck marble to be visible from the east. Even though they were not part of the shrine *per se*, these plain bands would have appeared incongruous alongside it. Consequently, two bands of mosaic matching the ornament on the pedestal were introduced to unify this aspect (Fig. 336).

The altar would have measured between 5½ft and 6ft in width (1.68–1.83m), and was doubtless of Purbeck marble. Given that the retable and the shrine were cosmatesque, it is virtually a foregone conclusion that the altar itself was similarly decorated, although to what extent we cannot tell. Italian Cosmati altars tend not to be heavily encrusted with mosaic, their decoration being restricted to panels on the front and sides, and sometimes colonnettes at the corners. It is just possible that a few additional fragments of St Edward's altar have survived into modern times. There are, for example, in the Abbey Collection several lengths of cable-moulded Purbeck marble shaft for which no place can be found amongst the extant Cosmati monuments (described below, p. 519; Fig. 513). We have noted that the shrine itself had undecorated spiral nook-shafts at its

eastern corners (as well as free-standing, mosaic-encrusted colonnettes) and other cable-moulded nook-shafts flanking each of the six arched recesses. It is therefore entirely plausible that the altar conformed too, and had cable-moulded shafts at its salient angles.

The altar will have been dismantled at the same time as the shrine, in or soon after 1540. A replacement altar was reconstructed under Mary I, but seemingly not in its original form. While the retable certainly survived intact and was reused, it would appear that the *mensa* did not. Queen Elizabeth's coronation plan of the chapel in 1558/59 shows an altar that was far too long for the width of the shrine, implying that another *mensa*, probably salvaged from a side-chapel, was substituted (Fig. 17). The ultimate destruction of the shrine altar would have taken place in 1561, when Elizabeth I ordered all remaining stone altars to be expunged.[59]

Finally, it is necessary briefly to discuss an idea that was first mooted in the 1930s, namely that the Cosmati child's tomb in a recess in the south ambulatory could have been the shrine altar (p. 503; Fig. 480). The top slab measures 1.70m by 89cm and these dimensions seemed to meet the shrine's requirements so perfectly that the case merited further consideration. There was one obvious objection in that it was not normal for a *mensa* to be elaborately decorated with mosaic inlay, and to lack consecration crosses. Robert Howgrave-Graham argued that, if the slab was a *mensa*, its back edge would not have been inlaid with mosaic – like the three visible edges are – because it would not have been seen. He therefore obtained permission in 1937 to remove one of the ashlar blocks from the back of the recess in which the tomb stands, so that the concealed edge of the slab could be inspected for decoration, and it was found to have two bands of mosaic inlay, matching the front and ends of the slab (p. 498; Fig. 498).[60] The back corners are also eared which they would not be if the altar was intended to support a retable.

Thus, Howgrave-Graham demonstrated conclusively that the slab was not a *mensa*, but the top of a freestanding tomb. That should have been the end of the matter, but in the early 1960s John O'Neilly[61] refused to accept that the cosmatesque tomb was not the shrine altar.[62] He was only able to muster two arguments in support of his contention: first, that the length of the tomb was

equal to the width of the shrine, and second, that the two structures had matching mosaics. One is true, but the other is not: the materials, colour palette and artistic composition of the tomb-top mosaic differ from those of the shrine pedestal. In an attempt further to bolster his contention, O'Neilly offered 'another fact that supports the altar theory', namely that the fragment of marble set into one of the medallions on the tomb top is a relic, or conceals one. This attempt to elevate the monument's prestige is weak and it is evident upon close inspection that the stone is merely a crude secondary insertion, filling the matrix where a disc (probably of porphyry) has been lost (p. 495; Fig. 494). Another definitive objection that seems to have escaped notice hitherto is the fact that the child's tomb was installed in an arched recess in the mid-15th century, and not the mid-16th century, when the shrine and its altar were dismantled.

O'Neilly published an important paper on the architectural reconstruction of the shrine but, despite opposition from other scholars, persisted in claiming that the tomb was its altar.[63] Apart from being a monument intended for viewing 'in the round', the top slab is eared at all four corners, a feature of many chest-tombs, but not of altars that were placed against a wall or supported a retable. Moreover, there are no consecration crosses cut into the slab, or formed in the mosaic work, and at 2ft 8ins (82cm) the tomb was too low to serve as an altar. In his reconstruction drawing, O'Neilly attempted to overcome this objection by raising the tomb on a deep step of the same dimensions as its plinth. The result was neither orthodox nor convincing.[64]

Undeterred by the objections raised by his peers, O'Neilly drafted a further manuscript that he submitted to the Dean and Chapter, restating his argument.[65] In it he advanced yet another hypothesis, namely that there was a crypt beneath St Edward's chapel, the entrance to which was via a door in the blind wall-arch where the child's tomb now stands in the ambulatory. He adumbrated that in 1540 the Confessor's shrine was dismantled, its components carefully hidden in the hypothetical crypt, and the entrance then concealed by blocking it with the shrine altar, itself now taking on the guise of a tomb. He was unable to adduce any solid evidence to support this fanciful theory, and also failed to explain how the components of the shrine pedestal were

retrieved from the crypt in 1557, whilst leaving the 'altar' blocking the entrance.

FRAGMENTS OF CABLE-MOULDED COLONNETTE-SHAFTS

The Abbey Collection contains two loose fragments of spirally twisted colonnette-shaft, and a further two fragments of similar shafts are embedded in the floor of niches 5 and 6 in the shrine pedestal. They are set in mortar, having been used to fill gaps in the masonry at the time of the 1557 reconstruction. The fragments are all likely to have been associated with another monument or feature within the chapel of St Edward.

The two extant short lengths of spirally-twisted colonnettes of Purbeck marble were discovered in 1861, when rubble blocking was removed from an internal opening in the north-west tower, facing into the nave of the Abbey (Fig. 513).[66] Poole did not state how many fragments were discovered, but it was clearly more than two, since he wrote 'some of which matched and joined'.[67] The fragments were noticed by Lethaby in the early 20th century amongst the loose stonework stored in the triforium.[68] A description of items in the Abbey Museum in 1934 alluded to 'some Purbeck spiral marble fragments'[69] and an inventory of the same year noted 'Purbeck spiral fragments with gilding (6) discovered in the Triforium and forming parts of two columns'.[70] Hence, at least six lengths, belonging to two shafts, were found in 1861; four have been lost since 1934. The two surviving pieces in the Abbey Collection may be from the same shaft, 8cm in diameter. It is not possible to obtain measurements from the other two fragments, embedded in the floor of the pedestal.

The three-strand spirals rise in an anticlockwise direction and have gilding in the creases between them. They are similar to, but of greater diameter than, the spiral shafts flanking the niches in the shrine, and they are too slim to be from the missing minor shafts at the eastern and western corners (Fig. 357). As Platt noted, they will not fit anywhere on the shrine as presently reconstructed.[71] Nor are they compatible with any of the missing shafting on Henry III's tomb. Consequently, they must derive from a lost monument. The corners of the shrine altar or the high altar are distinct possibilities (p. 520).[72]

513 Two fragments of Purbeck marble, cable-moulded colonnette-shaft, with gold lines in the creases. They may be derived from the corners of the shrine altar. Westminster Abbey Collection. *Authors*

STATUE PEDESTALS AND CANDELABRA

There is no surviving evidence to indicate that any pedestals or candlesticks were cosmatesque. However, we have already noted that paschal candlesticks were commonly encrusted with cosmatesque mosaic, and it would not be surprising if the Abbey had one that was so decorated. Although details are lacking, we know that the paschal candlestick stood close to the place where abbots Kedyngton and Henley were buried on the north side of the sanctuary pavement.[73]

The often-published manuscript depiction of the sick flocking to St Edward's shrine in the hope of being cured shows a pair of free-standing columns with stiff-leaf capitals, supporting statuettes of St Edward and St John the Evangelist dressed as a pilgrim (Fig. 290B).[74] This structure had *foramina* and was clearly not the present shrine. The Cambridge manuscript has been attributed to Matthew Paris, who died in 1259,[75] and must depict the 1163 shrine, although probably not on its original site, but more likely in the temporary

location set up for it by Henry III in 1245, while rebuilding the presbytery was in hand (see p. 562).

Numerous writers have dwelt on the record of expenditure in 1290 of 46s. 8d., for making three marble columns to place around the shrine.[76] Neither the dimensions nor the purpose of the columns was specified, but they are generally assumed to have been candlesticks, and antiquaries have been tempted to equate them with the two *ex situ* fragments of cable-moulded Purbeck marble shaft, described above (Fig. 513). Such an equation is highly improbable, since cable-moulded shafts as slender as these would not be satisfactory, either structurally or aesthetically, for candlesticks with a height of around 1.2m to 1.5m. When an inventory of the contents of St Edward's chapel was taken on 10 November 1520, we find only one potentially relevant entry for two 'longe Candylstekkys in either side of the Awter'.[77]

HIGH ALTAR AND THE WESTMINSTER RETABLE

No information has come to light regarding the design and construction of the medieval high altar of Westminster Abbey, although there is an explicit record concerning its installation in 1259 'in the new work'.[78] The only illustration in which it appears is Islip's funerary roll (1532), but there the altar is fully dressed and nothing can be seen of its structure (Fig. 16). It can be determined from the arrangement of the panelling on the face of the stone screen of 1440 that the length of the altar was *c.* 3.3m and that a separate altarpiece of similar length, and *c.* 95cm high, was housed in a recess in the screen. Remarkably, that altarpiece has survived, and is generally known as the Westminster Retable (Fig. 514).[79] It has been the subject of a major study by art historians, archaeologists and conservators.[80]

Dating from *c.*1260–70, the Retable is one of the most remarkable and technically accomplished works of art to have survived from the later 13th century in Western Europe. It is essentially a large oak panel, carved and moulded to create a three-dimensional display of micro-architecture, which was then decorated and embellished with a variety of media. Flat, translucent glass laid on to a bed of putty formed one of the principal decorative elements. Large amounts of gilding were also present which, together with the shimmer of the

cobalt blue glass, contributed in large measure to its vibrancy. That was further heightened by exquisite polychromy, imitation gems and cameos, and multi-coloured enamels. The last are largely geometric in form and have the appearance of micro-mosaic work.

Although the Retable and the Cosmati mosaics do not share identical design elements, they complement one another aesthetically and have features in common, such as red, blue and green glass bedded on putty or mortar, gilded glass, and brilliantly coloured geometrical patterns in mosaic. Some of the closest comparisons may be drawn between the designs on the false enamels of the Retable and the tomb-covers on the sanctuary pavement.[81] Also the focal feature of the Retable is the figure of Christ holding the globe in his left hand: around the circumference of that globe is concentrically depicted a thick black line, representing night; a ring of red stars, together with representations of the sun and moon; and the blue sky and clouds of day (Fig. 515). The focus of the sanctuary pavement is similarly a globe, encircled by a ring of golden yellow limestone (representing day), a broad band of stars in red, white, blue and turquoise glass, then a narrow ring of porphyry lozenges, and finally a dark grey band of Purbeck marble (representing night; Fig. 63).[82] Appropriately, the marble band carries a latten inscription, telling us that 'Here the spherical globe shows the archetypal macrocosm' (p. 119; Fig. 100).

Considerable use was made of cobalt blue glass, decorated with gold motifs, in the Retable, an aesthetic echoed in the shrine, where we find the gold inscription set against a rich blue glass background. There were also numerous glass roundels – probably red and blue – all over the shrine pedestal and on the shrine altar retable. It may be recalled that the reverse side of the Westminster Retable was decorated to imitate a large expanse of purple porphyry (Figs 516 and 517).[83]

To have attached the Retable to a plain Purbeck marble altar would have been aesthetically incongruous. We should therefore expect the high altar to have been an impressive structure, with architectural mouldings, corner pilasters and colonnettes, and probably divided into three panels on the front. Polychromy would be expected, and could have been achieved with cosmatesque decoration. Not only did the altar have to support the sumptuous Retable, but it was principally seen

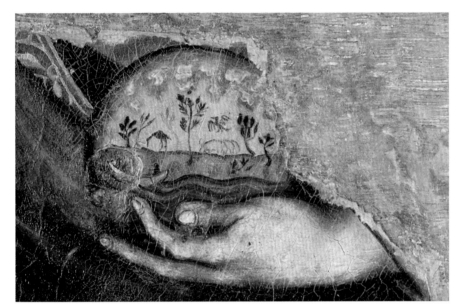

514 (*Above*) The Westminster Retable. © *Dean and Chapter of Westminster*

515 (*Left*) The Westminster Retable. Detail of Christ's cupped hand holding the globe. © *Dean and Chapter of Westminster*

516 (*Below left*) The Westminster Retable. Panelled reverse, painted to imitate purple porphyry, but now darkened in colour. Note: the paler horizontal battens were added in 1898. © *Dean and Chapter of Westminster*

517 (*Below right*) The Westminster Retable. Detail of the painted porphyry decoration on the reverse. © *Dean and Chapter of Westminster*

from the west, where the vibrant carpet-like sanctuary pavement graced the approach.

Since the floor of the chapel was 60cm higher than that of the sanctuary, there was a vertical face which would have been surmounted by a low screen, interrupted by steps towards the north and south, and punctuated by the entrance to the Confessor's original tomb behind the altar itself. This area too was highly visible from the west, and needed harmonious integration with the aesthetics of both the sanctuary and the chapel beyond. The obvious means of achieving such a union was to follow Italian practice. There was thus potential for further Cosmati decoration

hereabouts, in the vertical plane. The tantalizing reference to discovering cosmatesque work, when digging a hole in the floor of the shrine chapel in 1827, has already been mentioned (p. 314). If that excavation was in the gap between the western edge of the shrine pavement and the screen of 1440, it would have exposed the vertical interface between the sanctuary and the chapel.

INSCRIPTION FRAGMENT IN THE FLOOR OF ST EDWARD'S CHAPEL

Although not cosmatesque, a fragment of the indent for an early funerary brass was incorporated in the paving at the north-west corner of the chapel in such a way that it has relevance for the discussion of pilgrim access and the provision of steps up from the ambulatory (p. 310). The Purbeck marble tomb-chest containing the body of Edward I (d. 1307) appears to rest directly on the floor of St Edward's chapel, under the westernmost bay of the north arcade (Fig. 288, no. 7). Here, the north-west corner of the Cosmati floor is visibly overlain by the tomb (p. 222; Fig. 221).[84] We have argued that, prior to the insertion of the royal monuments around the periphery of the chapel, the paving extended into the arcade bays of the apsidal ambulatory, where the outer edge of the platform terminated with a moulded string-course of Purbeck marble, 1.51m above ambulatory floor level (Fig. 292).

At the west end of the first bay, immediately adjacent to the tomb of Edward I, is a length of the Purbeck marble string-course bearing the matrices in its upper face for a brass inscription in Lombardic letters: Brayley first noted the lettering in 1823 and read it as **REGINA**.[85] Burges commented on the inscription in 1863, having read it as]**KETINI**, out of which he implausibly attempted to create the word 'Katherini'.[86] The seven metal letters and a pair of stops are all missing, but their individual matrices remain, together with the narrow fillets flanking the lettering. The inscription does not run parallel to the moulded edge of the block and it is generally agreed that it does not belong here, but is part of a tomb-slab cut up and reused to make the moulding. One might presume that the brass was stripped out and the redundant matrices filled with mortar to disguise their presence, and that an assiduous antiquary in the early 19th century

spotted evidence for the inscription and picked out the mortar. But that may not be so.

Although the string-course is a feature of the 1250s construction, it has been argued that this section must be a later replacement, probably at the time of the installation of Edward I's tomb in 1307.[87] Binski and Blair read the inscription as] **N K E T I N I :** [deducing that it was part of a name such as Anketin. They dated it to *c.* 1300 (Fig. 518). Related to the foregoing is Poole's discovery in 1866 of evidence for a brass inscription on the edge of the pavement, directly beneath Edward I's tomb-chest:

> By cutting away some of the pointing under the base of Edward I's tomb, we exposed a slip of a brass inscription of very early date which Brayley saw and wrote of in his time.... This little relic of brass is again in total obscurity, for some ignorant or ill-directed workman has lately concealed it by covering it in with cement.[88]

Poole did not record under which side of the tomb this discovery was made, but it was doubtless the north, and he was presumably searching for the eastward continuation of the fragment that Brayley saw. He clearly implies that there was still brass in the matrix under the tomb-chest, from which it may be deduced that the metal was not stripped from the Purbeck marble when the slab was recut, but lost in more recent times. Poole's discovery must still be concealed from view by the pointing beneath the northern step of Edward's tomb-chest.

The context for renewing part of the moulded string-course in *c.* 1307 is clear: when Edward I's tomb completely blocked access through the westernmost arcade bay, the steps no longer had a function and would have been removed. If we are correct in deducing that flights of steps were constructed in the north and south ambulatories, to provide pilgrim access to the chapel and shrine, the string-courses in the westernmost bays would have been interrupted by landings. Consequently, a search was made for archaeological evidence relating to the positions of the former stairs and landings. Nothing survives in the south ambulatory, where later medieval activity eclipsed the 13th-century work. On the north, however, the complete string-course survives on the edge of the chapel platform, and its moulding is cut on three slabs of marble, totalling 4.85m in length. The westernmost slab (which carries the inscrip-

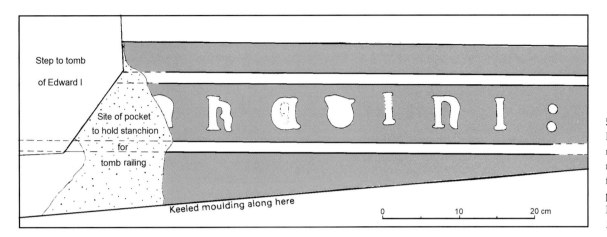

Step to tomb
of Edward I

Site of pocket
to hold stanchion
for
tomb railing

Keeled moulding along here

0 10 20 cm

518 St Edward's chapel. Fragment of a Purbeck marble indent showing matrices for lettering and fillets, reused in the paving projecting from under Edward I's tomb-chest. *After Binski and Blair 1988, fig. 1*

tion on its upper face) measures 1.15m long; the middle slab is 1.27m, and the eastern 2.43m.

Together, the two shorter lengths are equal to the longer slab, which points to the stairs having been sited in the western half of the bay, and the middle slab potentially being the stone inserted when the landing was dispensed with. Naturally, the string-course and any other damage to the masonry would have been made good. The east and west slabs are identical in colour, texture and state of preservation (somewhat battered), whereas the middle slab is markedly different in appearance and condition. Unfortunately, it is in such good

condition that it must be a post-medieval replacement, and consequently is not helpful to the present enquiry. There is no discernible evidence to indicate that the eastern and western slabs are other than primary to Henry III's work, but that cannot be so, because it would require the indent and its brass to be at least half-a-century earlier than their currently accepted dating.[89] Of one fact we can be certain: the inscribed slab was already in place when the iron railing around Edward I's tomb was installed: a pocket for its north-west stanchion was cut through the slab, truncating the inscription (as shown on Fig. 518).

15 The Westminster Mosaic Assemblage: Summary, Assessment and Dating

THE COSMATI EPISODE: EMBRACING THE ACADEMIC CHALLENGE

Henry III's aspirations, architectural legacy and the history of his reign have been discussed with great erudition by Paul Binski, David Carpenter, Christopher Wilson and others, but the archae-ological, technological and logistical aspects of his legacy at Westminster have received little attention. This omission has severely curtailed our understanding of the physical emergence and chronology of the sacred core of Westminster Abbey in the second half of the 13th century. Some of the claims made in the past are demonstrably untenable on practical and logistical grounds, and the long drawn-out dating of the Cosmati interlude proposed by several writers is not convincingly supported by either documentary or archaeological evidence. Conversely, the shorter chronology favoured by others is rational, practicable and perfectly in harmony with the modest amount of relevant historical evidence, without the need to strain it beyond the bounds of credibility. Moreover, archaeology overwhelmingly supports not only a short chronology, but also a different order of construction for the Cosmati pavements and monuments from that usually supposed.

For the most part, previous discussion of the presbytery has focused on individual components, particularly the royal tombs and the Cosmati pavements, and a holistic approach to the study of the *locus sanctus* and its assemblage of furnishings has been lacking.[1] We have attempted to fill the *lacuna* by undertaking detailed studies of the sanctuary and St Edward's chapel, not merely in the context of the later 13th century, but from the Confessor's era to the present day. By adopting a holistic and wide-ranging approach, it is possible to place the spectacular components within a more secure archaeological framework, and thereby evince a clearer understanding of the likely date of their fabrication and primary physical form, than is achievable by studying them individually. The quintessential importance of such an approach may be demonstrated by listing a few examples of the fields of study that have not hitherto been addressed with sufficient scholarly rigour.

A. The layout of Henry III's sanctuary and shrine chapel were conditioned by elements of the presbytery of the Confessor's church: the sites of the high altar, burial chamber of 1066 and shrine of 1163 all seem to have been respected. Provision was undoubtedly made in the Henrician rebuild not only for the preservation of the Confessor's tomb, but also for permanent access to it. However, the logistics and structural consequences of this have never been explored, and the fact that the floor of the saint's grave in the 11th-century church must lie two metres below the shrine pavement has been entirely overlooked. Edward's sepulchre was emphatically not a rectangular chamber of coffin-size, conveniently situated just below 13th-century floor level in the sanctuary, and covered by a slab. When demolition and rebuilding commenced, the only way to preserve the Confessor's tomb-chamber, as a cenotaph, was to construct a small crypt around it with a permanent entrance and steps for access.

B. Elucidating the original appearance of the sanctuary pavement cannot be achieved without closely interrogating both the purposeful altera-

tions and the casual repairs that have taken place over the centuries, especially since the Reformation. Records made by Talman in the early 18th century have proved to be of crucial significance for understanding the Henrician work, and have revealed a slew of unexpected details about the design and original appearance of the pavement.

C. Unjustly, the Cosmati pavement in the shrine chapel has been denigrated or all-but ignored by most scholars. Far from being a second-rate work, late in date, and of little significance, it is now apparent that the pavement was conceived as part of the primary layout of the chapel, and is archaeologically linked to the construction of both the shrine of Edward the Confessor and the tomb of Henry III.

D. Surviving accounts unambiguously confirm that Henry ordered the fabrication of both the marble shrine pedestal and the 'golden feretory' to begin in 1241, but it has been assumed by commentators – even expressly stated – that whatever work was carried out on the pedestal between then and the mid-1260s was discarded, and an entirely new cosmatesque structure commissioned. This view of events is not supported by the physical evidence. Edward's shrine-tomb is an extraordinarily complex monument, first on account of a dramatic change of artistic direction, from Gothic to Roman, that occurred in its early stages of fabrication and, secondly, because it was completely dismantled and rebuilt in the mid-16th century. Reconstructing the shrine's original form is substantially dependent upon understanding what happened to its *disjecta membra* between 1540 and 1560.

E. The date of completion of the shrine is contentious. Although it was dedicated and received the body of Edward the Confessor in 1269 – a major national event – a 15th-century monk-historian reported the date as 1279, based on his reading of an inscription destroyed in 1540. Some scholars have elected to support the monastic version rather than the solidly historical, with the result that the ten-year discrepancy has been debated to exhaustion. Meanwhile, insufficient attention has been paid to other sources of evidence that have a material bearing on the context of the dedication: they offer the opportunity to untie the Gordian knot.

F. Much ink has been spilled over dating the construction of Henry III's tomb, and the presumed reason why the king's coffin was not installed in it until eighteen years after his death in 1272. Intensive study of the tomb, and the recorded circumstances surrounding Henry's interment, has been surprisingly revealing. In our view, to infer that the king made no provision for his own burial is not credible, nor are repeated claims that the tomb was largely or even wholly constructed by his son Edward I. There is no plausible evidence to support the latter, or to indicate that Edward had any interest in Cosmati work. Henry's monument was sumptuous, possibly even rivalling the Confessor's, and was designed not merely to serve as a tomb, but also had some attributes of a shrine. No explanation has so far been offered for these.

G. For four centuries, a great deal of speculation and discussion has focused on the child's cosmatesque tomb, originally in the Confessor's chapel but now in the south ambulatory. Again, archaeological study of the construction and subsequent repositioning of the monument, coupled with a rigorous reconsideration of the historical evidence that has variously been linked to it, enables this tomb to be viewed with greater clarity, distinguishing the one or two plausible options for its origin and dating from the implausible.

The surviving historical records relevant to all of these issues are frustratingly meagre, disjointed and often opaque: they cannot be used on their own to create a meaningful narrative for any single cosmatesque element. Consequently, primacy has been given here to studying the physical evidence, followed by an analysis of the practical and logistical aspects of construction. Once these had been thoroughly interrogated, the disparate fragments of historical evidence could be set alongside them, to investigate whether a credible union between the two can be effected. When this was done, not only was it apparent that virtually every documented reference to the fabric and furnishings of the presbytery could be comfortably integrated with the physical evidence, in a rational chronological order, but also that several accounts which previously seemed so opaque as to be incapable of interpretation – and consequently had been sidelined in antiquarian writing – acquired fresh

meaning. In arriving at the conclusions set out in this chapter, we have embraced every scrap of evidence of which we are aware, be it historical, archaeological or logistical. What we have eschewed is the unquestioning acceptance of certain preconceptions that have confounded the study of Henry III's presbytery for two centuries.

The two principal offenders in this category are, first, the common assumption that Abbot Ware initiated the entire Cosmati episode at Westminster in *c.* 1267–68 – although this has been questioned in the past – and, secondly, that the reason why Henry III was not interred in his own tomb in 1272 was because its construction was incomplete, or even not yet begun. Historically, there is no explicit support for either claim and, archaeologically, both are refutable. And there are more examples. Out of the assumption that the 1241 shrine was abandoned, and replaced *in toto*, sprang another assumption, namely that the pedestal could not have been finished in time for the translation of the Confessor's corporeal relic in 1269: hence the leap to accept the highly problematic 1279 date. Meanwhile, two other historical documents of considerable interest have been glossed over because they appeared too enigmatic to comprehend. One was an order made in 1252 to construct a temporary chapel to St Edward; the other an indulgence (1237x1267) referring to the *capella* 'built under' the chapel of St Edward. Both now find their places in the reconstructible narrative of events of 1240–1270.

We are mindful that some of our conclusions differ fundamentally from those that have long been accepted, and not everybody will agree with them. In his stimulating paper of 2002 on 'The Cosmati and *Romanitas* in England', Binski posed a number of questions concerning the source that might have inspired Henry III to embrace mosaic decoration, the date at which that occurred, and which monument was constructed first. He acknowledged that we were not then in possession of as much factual evidence as we might be, and concluded, 'These questions remain open, and may be resolved only by a detailed archaeological survey of the shrine and its environs and by further consideration of the earlier history of *opus sectile* in England.'[2] Since he wrote, an intensive archaeological survey of the whole presbytery has been carried out, and the archaeology of the mosaics themselves has been interrogated to a degree that has never before been applied to Cosmati work.

The logistics of construction have received in-depth consideration too, an aspect barely touched upon in the past. Consequently, fresh perspectives have opened up and more questions have been posed. Some have been answered definitively, others only tentatively or hypothetically. Scholarly debate will undoubtedly continue.

In the foregoing chapters, we concentrated on presenting the physical evidence for the construction and evolution of the Henrician presbytery and its major monuments, and restricted general discussion. It is to the latter that we turn in this final chapter, addressing each of the issues just raised. In order to structure the discussion and resist the temptation to digress into the many potentially related avenues of enquiry, we have elected to focus on those topics most germane to a holistic appreciation of the nature, fabrication, setting and dating of the cosmatesque monuments.

LUXURY PAVING AND MOSAIC DECORATION: WESTMINSTER IN CONTEXT

Henry III would have been aware of the existence of the ornamentally patterned, monochromatic stone pavements possessed by some, if not most, of England's great Romanesque churches.[3] In a different league, however, was Canterbury Cathedral which William of Malmesbury tells us in the 12th century had a marble pavement in its eastern arm, and it was probably polychromatic. The pavement was destroyed in the great fire of 1174. Marble was again employed for flooring in the post-fire reconstruction of Canterbury in the 1180s, particularly in the Trinity chapel. Purbeck marble paving was laid in some areas but, uniquely, in combination with Belgian pink marble from the Dinant region of the Meuse valley.[4] The crowning glory of the chapel was, however, a polychromatic pavement embodying much purple and green porphyry (Fig. 519). The individual pieces of marble were cut to geometrical shapes and fitted together, a technique derived from the Antique world and known as *opus Alexandrinum* or, descriptively, *opus sectile*. The date of the pavement is not recorded, but it is late Romanesque in style, and most authorities currently attribute it to *c.* 1182–84, with the incised limestone (Caen?) Zodiac roundels added in the period *c.* 1213–20.[5]

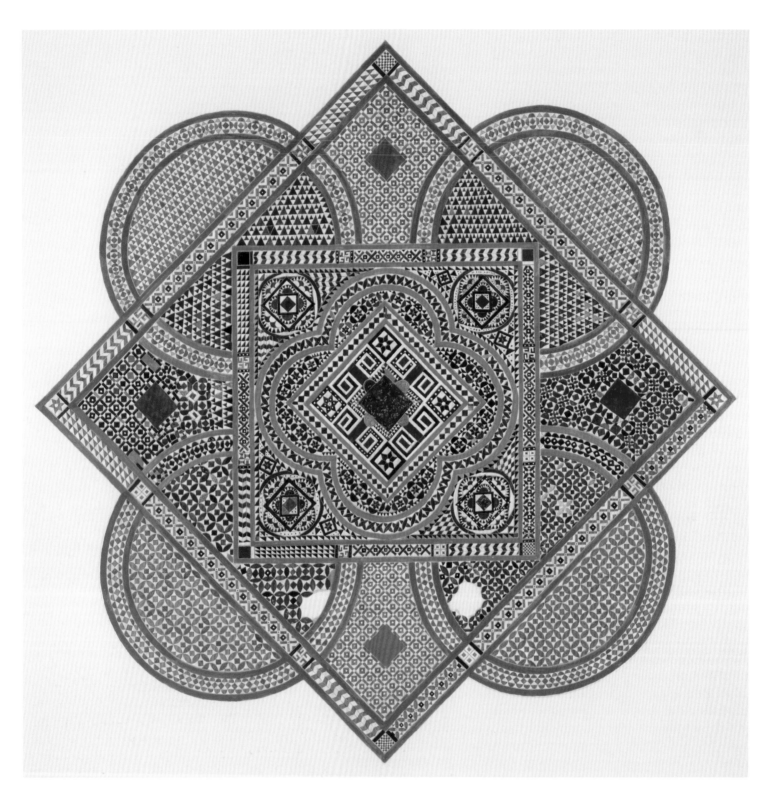

519 Canterbury Cathedral. *Opus sectile* pavement in the Trinity chapel. *Painting by David S Neal*

If the marble pavement is really as early at the 1180s, it possibly heralded the first appearance of porphyry in England, in an architectural context, since the Roman period. The pavement's function was obviously to provide a rich setting for the new shrine of St Thomas Becket, dedicated in 1220, but apart from its uncertain date the major unanswered questions concern how and why it was commissioned, and by whom. But that is not a subject to be explored here.

We can be certain that Henry III was familiar with the Canterbury pavement, since he attended in July 1220 when the translation of St Thomas's body to a new shrine took place, and he sub-

sequently visited the cathedral on numerous occasions. The king was aged only thirteen at the time of his first recorded visit, and nearly half a century was to elapse before the Westminster pavements were laid and St Edward's body was translated into its spectacular new shrine. Unlike the Westminster pavements, that in the Trinity chapel was not true mosaic, but *opus sectile*. As far as we know, polychrome mosaic work was not to be seen anywhere in England or France in the 1250s, although the principal materials – purple and green porphyry – were familiar. Cosmati mosaics, whether as floors, or decorating monuments in the vertical plane, could only be seen in Italy. Hence, there would not appear to have been a local model for Henry to inspect or emulate, unless one has it has subsequently been lost. The case for such a scenario will be explored.

Although the Westminster mosaics are now the only *in situ* examples of cosmatesque work in England, there is good evidence to indicate that they were not alone.[6] Nor was the Trinity chapel pavement at Canterbury the sole example of *opus sectile* work. Excavations in 1914 on the site of the Romanesque cathedral at Old Sarum (Wiltshire) revealed the mortar beds for a decorated floor in the axial chapel (which was presumably the Lady Chapel) to the east of the presbytery. The floor in the western part of the chapel comprised a discrete group of interlacing circles; to the east of it, at the centre of the building, there had apparently been a fixed object which may well have been the tomb of Bishop Osmund, for whom canonization was being sought. Eastward again, lay two broad steps leading up to the altar (Fig. 520).[7] The excavations yielded *ex situ* fragments of green and purple porphyry that must be derived from *opus sectile* work, either on a grand episcopal monument or, more likely, from the interlaced paving of the presbytery.[8] The interlacing comprised a single, large-scale knot and the context points to a late 12th-century date, broadly contemporary with the Canterbury pavement (Fig. 521).[9]

Glastonbury Abbey (Somerset) too seems to have had an *opus sectile* pavement as the setting for the high altar, but unfortunately neither the plan of the area has been archaeologically recovered, nor any of the diagnostic materials.[10] Nevertheless, the pavement was convincingly described by William of Malmesbury, *c.* 1130:

… the floor, tiled with polished stone, the sides of the altar, and the altar itself, above and below … in the pavement on both sides stones carefully placed in triangular and square patterns, and sealed with lead.[11]

The pavements at Canterbury, Old Sarum and Glastonbury were all earlier than Westminster's, and they were not cosmatesque. Nevertheless, they demonstrate that high quality floors containing slabs of shaped and polished marble, set in a matrix of indigenous stone, were present in southern England in the 12th and 13th centuries. It is important to acknowledge the corollary of this: a trade in porphyry was operating between Italy and England, and Italian *marmorani* were laying *opus sectile* pavements here. Moreover, they were in collaboration with English masons who were providing and working the matrix material which, in the instance of Canterbury, was Purbeck marble. Despite their differences in date, style and construction technique, there is one remarkable coincidence shared by the three extant pavements: the overall dimensions of the poised squares of Canterbury and Westminster are identical, and also equate with the north–south measurement of the

520 Old Sarum Cathedral (Wiltshire). Excavation plan of the ornamental paving on the presbytery floor.
After D. H. Montgomerie

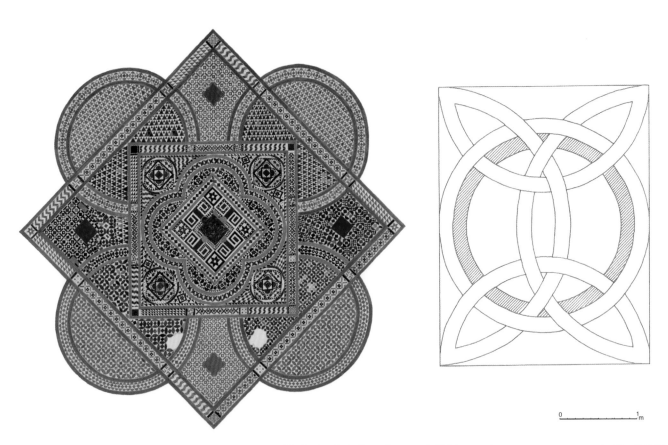

521 Mosaic pavements from Westminster (omitting outer guilloche border), Canterbury and Old Sarum drawn to a common scale. *David S Neal*

pavement at Old Sarum. Since Italian marble workers provided the only physical link between these three distantly-spaced structures, we must assume that they determined the dimensions.

In 1675 the antiquary John Conyers observed the debris of mosaic decoration in the ground at the east end of Old St Paul's Cathedral, London, on the site of the Lady Chapel, immediately to the west of which lay the shrine of St Erkenwald. He observed

>shreddes of pretty green serpentine hard stone or Egiptian marble and the porphery or Redd and white[e] such like a Jasper and other Collourd stones as was used in the mosaick worke of Westminster.[12]

Such an explicit comparison leaves little room for doubt that Conyers saw the remains of cosmatesque mosaic work. Another observer reported that in the quire there was a pavement of 'black marble spotted with green', similar to some at Westminster.[13] The Lady Chapel and shrine area at St Paul's were constructed between 1259 and 1314, indicating that the Cosmati work was probably coeval with that at Westminster Abbey.[14]

Glass tesserae and fragments of purple and green porphyry have been found in excavations at St Augustine's Abbey, Canterbury, attesting lost mosaic work there too. Well over one hundred fragments have been recovered since the excavations in 1900 began to dig out the crypt, and the published report refers to 'bits of porphyry and serpentine mosaic, with some brightly painted stones and gilded pinnacles, apparently belonging to some rich shrine'.[15] This may be debris from both a pavement and the destroyed shrine of St Augustine, and the presence of glass certainly implies Cosmati mosaic. No less significantly, fragments of curved bands of Carrara marble were also recovered, indicative of the framing of a true Italian pavement.[16]

Most recently, attention has been drawn to Wimborne Minster (Dorset), where a manuscript reference, compiled in the first half of the 18th century, records 'a fine pavement of Old mosaic work, now quite broke to pieces by making Mortar thereon for the repairs of the Church and by other abuses'.[17] Moreover, in the 19th century further pieces of 'rich mosaic' were discovered whilst constructing a vault beneath the choir.[18] One fragment of cosmatesque glass mosaic has survived, and bears a label written in an 18th-

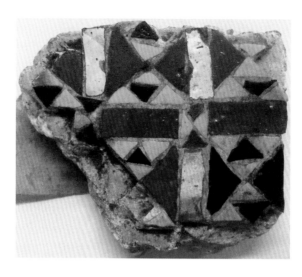

522 Wimborne Minster (Dorset). Fragment of cosmatesque mosaic. *Rees and Lewis 2014*

century hand, stating that 'this specimen of Mosaic' was found in the crypt of Wimborne Minster, 'where King Ethelred was bur[ied]'. The label was signed by one Peter Romilly (1712–84).

There seems no reason to doubt that this was a genuine archaeological discovery, rather than an antiquarian import. Since the fragment is composed entirely of glass tesserae, some of them gilded, it is perhaps more likely to derive from a monument than from a pavement (Fig. 522). The decoration bears close comparison with that on the spiral columns of Edward the Confessor's shrine, but is identical to that on the paschal candelabrum in the church of Santa Maria in Aracoeli, Rome.[19] Since Wimborne Abbey was home to two Anglo-Saxon royal saints, King Ethelred I and Queen Cuthberga, there is a credible context for a cosmatesque shrine in the 13th century.

Collectively, the evidence from Wimborne, St Augustine's Abbey (Canterbury) and St Paul's Cathedral raises the likelihood that although Westminster did not initiate the importation of Italian marble for flooring, it contributed significantly to a fashion for cosmatesque work in high-status tombs and shrines in the third quarter of the 13th century. Manuscript illuminations of English shrines do not reveal much convincing evidence for cosmatesque work, although porphyry is possibly represented on several illustrations of feretories, such as St Fremund's shrine at Dunstable Priory, (Bedfordshire), where a poised square of purple stone appears at the centre of the gable (Fig. 523A).[20] St Edmund's shrine at Bury (Suffolk) had, according to one illustration, a rectangular panel of what was presumably purple porphyry in a gable, but in another image, we see

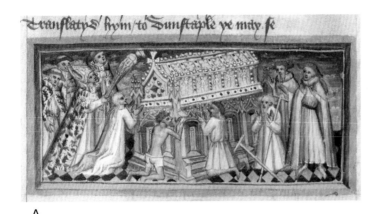

A

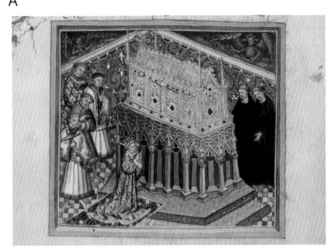

B

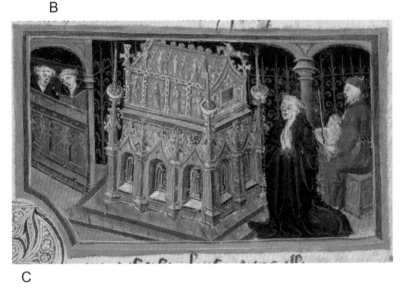

C

523 Shrines of St Edmund and St Fremund. Manuscript illustrations in Lydgate's *Lives of SS Edmund and Fremund*, 1434–39. A. St Fremund's shrine at Dunstable (Bedfordshire); B, C. St Edmund's shrine at Bury (Suffolk). © *British Library: MS Harley 2278, fols 4v, 9r, 97v*

a blue lozenge in the gable and three green panels on the side. The latter take the form of a disc and two lozenges, potentially of green porphyry (Figs 523B, C): the same combination is found on the lower chest of Henry III's tomb.

A feature common to numerous illustrations of feretories is a row of coloured discs along the plinth, or around the top of the pedestal. It has

been demonstrated that the frieze forming part of the Tudor entablature of St Edward's shrine was originally the small plinth upon which the feretory rested. That plinth was decorated with mosaic and a series of spaced roundels which can only have been of glass, and there is some evidence to indicate that they were red and blue (p. 332; Fig. 300). The feretory of St Fremund's shrine rests upon what looks like a white (stone?) plinth, but is evidently the basal moulding of the shrine: it is similarly decorated with roundels, but here they alternate between red, green and blue (Fig. 523A).[21] St Edmund's shrine displays a somewhat similar arrangement of red and green roundels, but in this instance the illumination clearly shows them to be part of the basal moulding of the feretory (Fig. 523B).[22] While we must openly acknowledge that medieval pictorial representations of lost shrines cannot be regarded as very reliable evidence, it is apparent that panels of porphyry and discs of coloured glass were components of their micro-architecture.

Porphyry roundels, alternating purple and green, occur in the entablature of many Italian Cosmati monuments and in outdoor architectural contexts such as the cloister frieze at San Paolo fuori le Mura, Rome.[23] Comparisons with St Edward's shrine at Westminster are instructive, where roundels feature prominently, not only in the entablature, but also the bands of guilloche decoration (Figs 309 and 328). These were all of glass, and the colours seem to have been red and blue. A question that needs to be asked, but unfortunately cannot be answered for lack of evidence, is: were these numerous glass roundels all plain, or were they embellished in some way? We have only to look at the Westminster Retable to appreciate how extensively glass inserts were decorated. Thus, some panels had silver foil placed behind them; others were mounted with false cameos; and blue glass was invariably decorated with mordant gilding: the larger pieces bore foliate scrollwork, and individual tesserae were decorated with small lions (Fig. 514).

The inclusion of porphyry panels in feretories is not surprising since they were also incorporated in the small portable altars that church dignitaries took with them on journeys, or where there was a need to celebrate mass in the open air. These altars were made of stone, metal or timber (sometimes clad with ivory, bone or sheet metal), with a rectangular slab of purple porphyry inserted

into the top, for the *mensa*. Although most of the surviving portable altars are precious works of art, their use was not confined to high-status locations: a fragment of purple porphyry, probably derived from one of these altars, was found in excavations at Rivenhall, a rural church in central Essex, for example.[24]

THE SANCTUARY AND ITS PAVEMENTS

The eastern arm of Henry III's church covers a sizeable area and consists of three distinct but visually integrated zones, all demanding high quality flooring. The sanctuary pavement comprises a large, near-square space (80m²), excluding the floor under the north and south arcades. Hence, a square Cosmati pavement embodying a bold geometrical design fits well here, occupying 62.5m² of the overall floor. It does not fill all the available space, but stops short of the north and south arcades by 1.2m. The mosaic floor is thus flanked and protected from excessive wear by lateral walkways (Fig. 42). Now ornamentally paved with Purbeck marble, and prior to that with black-and-white marble chequers, the medieval treatment of these areas is unknown, having been destroyed in 1706. At the very least, the walkways would have comprised decorative borders of Purbeck marble, if not *opus sectile*.

East of the great pavement, and at the same level, lay a second area of paving that wrapped around, and included, the high altar dais, comprising a total of 40m². Although sizeable, there were physical constraints that essentially divided this area of the floor into three sections. The centre was occupied by the high altar and its dais, in front and to the sides of which would have been luxury paving of some kind. This may have incorporated cosmatesque elements, but *opus sectile* panels, set in Purbeck marble, could equally have provided a dignified and less ornate setting. If Italian precedent was followed, separate panels of decorative paving around the altar might be expected, but whatever the layout of the floor, it was also destroyed in 1706, giving rise to anguished comment by John Dart (p. 16). The third area of high-status paving was in the chapel of St Edward the Confessor that adjoined the sanctuary on the east, and was elevated on a platform reached by four steps.

Abbot Richard de Ware, 1258–83

Ware's involvement in the Westminster Cosmati episode has long been regarded as pivotal, and this is due principally to a short passage in John Flete's history of the Abbey, written in 1443 (p. 13). Ware was elected to the abbacy on 16 December 1258 and, at Anagni on 11 March 1259, he was appointed as a papal chaplain.[25] It is uncertain whether he returned quickly to England, or remained abroad for up to two years, there being several references to transactions involving the abbot in Rome, and 'protection' for him for 'going beyond the seas'.[26] He was certainly back in Westminster in June 1262, when he issued a ratification,[27] but another 'protection' was dated 11 November, for the abbot 'going beyond the seas by order of the king'.[28] In April 1265 Ware was sent by the king to France, and in November 1266 to the court of Rome.[29] In September 1267, he was in the Roman *curia* on business for the king and that of his son, Edward,[30] but Ware seems to have returned to Westminster by December.[31]

Although Flete states that Ware 'brought back' materials and *marmorani* with him, to construct the Cosmati pavement in the sanctuary when he returned from the Roman *curia*, that cannot be taken literally, but he doubtless placed an order and generally set the wheels in motion. Before they began work on site, the mosaicists must have known that they would be constructing the framework out of Purbeck marble, not Carrara, and using English cream limestone for tesserae and subsidiary framing, rather than Thasian or another Mediterranean marble. They also needed dimensions and a design, so that the appropriate quantities of non-English materials could be assembled in Italy and shipped to London. Most likely, mosaicists were already in England, or had at least previously worked here and knew what they would be dealing with. Given that Ware made multiple trips to Italy, and Flete's narrative was compiled 185 years after the abbot's appointment, uncertainty over timing and detail is inevitable. The salient facts are:

i. Sometime between 1259 and 1267, acting on behalf of the king, Ware played a role in facilitating the construction of the sanctuary pavement.
ii. He caused a tomb capped with an expensively decorated Cosmati cover to be incorporated in that pavement for himself.

iii. The work was undertaken in 1268, according to the latten inscription, but was probably not finished until the following year.

iv. The king paid Ware the sum of £50 in 1269, which was partly a reimbursement for materials, and partly for other services.[32] This is the only contemporary document relating explicitly to the construction of the pavement.

v. The now-lost epitaph on Ware's tomb-cover provided additional confirmation that he was involved with arrangements to pave the sanctuary.

However, none of this evidence has any bearing on the chronology of the other cosmatesque works in the Abbey. Expressly, there is no basis for tacitly assuming – as many writers have – that the sanctuary pavement was the first Cosmati project to be commissioned. It certainly was not, and merely happens to be the earlier (by one year) of the two monuments that bear dates (and the reliability of both have been questioned). The king, as already noted, was mindful of the existence of luxury pavements containing purple and green porphyry long before Ware became abbot of Westminster, and Henry himself would have been the initiator of the entire Cosmati episode, not his abbot, who was merely an instrument in the execution of one element of it. The Canterbury pavement probably provided the king with the initial inspiration.

En passant, it is interesting to note that the early 16th-century antiquary, John Leland, stated that the sanctuary pavement was made from the remains of marbles used in the tomb of Henry III.[33] Superficially, this seems to be such a fanciful claim that it has been ignored by later writers, but there is almost certainly an element of truth in it.[34] We have noted that three panels in the pavement stand out as being markedly different from the majority, and the materials in one (Ware's tomb-cover) match those employed in the shrine and Henry III's tomb (p. 104). Moreover, the design of the cover is clearly related to both, and the conclusion that certain panels were indeed fabricated using the residue left over from those monuments should not to be dismissed.

Richard Foster reminds us that Ware did not endear himself to his own brethren: 'The Abbot of Westminster in London, treasurer to the king, died more or less without warning; scarcely mourned by his convent because of his severity.'[35] To some extent this sentiment may be reflected

in his terse and unemotive epitaph (inscription D, p. 122), which hints, perhaps ironically, at his burden of *still* carrying the stones from Rome. It is highly unlikely that Ware himself was responsible for the wording, which would have been generated after his death.

In 1443, Flete reported on Ware's involvement with the pavement, describing it as being of 'wonderful workmanship', and that 'beneath the northern side ... [the workmen] made the most becoming tomb for this abbot, at his instruction' (p. 13; Fig. 93B). It would not have escaped the notice of the brethren that Ware's tomb-cover (panel 56) was the most spectacular cosmatesque component in the pavement. When a comparison is made between the numbers of tesserae in the tomb-cover, and other parts of the pavement, it is readily appreciable that this memorial would have been relatively expensive to construct. It contained some 6,600 tesserae, compared to about 1,900 in the similar-sized tomb-cover on the south side of the pavement (panel 55). Moreover, it contained some micro-mosaic work. Although

A

B

524 (*right*) Sanctuary pavement, Abbot Ware's tomb-cover. A. Central medallion of Belgian *rouge de Rance*, precision-fitted into the Purbeck marble matrix; around it are the remains of bands of tightly packed, small glass tesserae (micro-mosaic) in red, white and gold; B. Western lozenge, containing a square composed of two stones: a rectangle of purple porphyry and one of Egyptian gabbro (*granito verde antico*). *Authors*

now heavily denuded, the slab was once replete with intricate patterns, mainly of glass, and many of the red tesserae were probably gilded, as on the tombs of Edward the Confessor and Henry III (Fig. 524). Ware's conspicuous profligacy in respect of his own tomb could well have angered his contemporaries, and was perhaps one of the reasons why he was 'scarcely mourned by his convent'.

Aspects of the pavement's design and construction

In terms of its overall design and construction techniques, as well as the use of exotic marbles and glass, the sanctuary pavement shares much in common with its Italian counterparts. There are, however, some striking differences which, in Binski's words, confirm that it was 'a joint Anglo-Roman project'.[36] The principal aspects of design and construction may be summarized under the following headings.

Layout and matrix

One is immediately struck by the scale of the floor, which Binski described as 'no more than an exceptionally large copy of the Cosmati pavements being set down in contemporary Rome'.[37] While Italian marble pavements often covered large areas, they were assemblages of squares and rectangles, comprising visually distinct mosaic compartments, often laid contiguously but separated by plain borders. The Westminster floor, on the other hand, was designed as a single unit incorporating a complex variety of elements, including two actual and two *faux* tomb-covers. While provision was sometimes made in Italian pavements for integral burials, these were usually on the central axes of naves and aisles, or in front of altars, as at San Clemente, Rome.[38] Similarly, there is a tomb-sized rectangular panel in the Cosmati floor in Anagni Cathedral crypt, towards the liturgical east end of the west aisle.[39] In these examples the tomb-covers were not overtly elaborate and did not influence the basic design of a pavement, as was the case at Westminster. Here, we have two highly ornate tomb-covers, one each midway along the northern and southern borders. They are so fundamental to the overall design of the pavement that, in order to achieve symmetry, two complementary panels had to be incorporated in the east and west borders too.

Purbeck marble is the foundation matrix of the pavement and the other cosmatesque monuments in the Abbey, rather than the usual white Italian marble. It is not difficult to appreciate why a local alternative was found, obviating the need to ship many tons of white marble to England from Italy. The choice of a dark grey matrix is less easy to explain, when a fine-grained, pale cream English or French limestone could easily have been acquired. Caen stone, for example, was already being imported in bulk at this time for work on the Abbey. The objection that springs most readily to mind is the fact that most of the available limestones, including Caen, are not hard-wearing when subjected to foot-traffic. Not only does Purbeck marble wear better but, since the late 12th century, it had also become the predominant paving material for high status buildings in southern England. By the time the decision was made to lay Cosmati pavements in the Abbey, the majority of the eastern arm was probably already floored with Purbeck marble. Also, the arcade piers and most of the mouldings inside the church were in the same stone, and the introduction of large amounts of light-coloured flooring at this stage would have been visually discordant. Hence, the aesthetic decision to stick with Purbeck marble as the matrix for all the cosmatesque work probably outweighed concerns about the cost of importing pale-coloured stone. Precedent for its use to frame an *opus sectile* pavement had already been established at Canterbury.

A framework of undecorated, straight and curved strips of marble delineates the overall design. Many of the curved segments have one, or two, spurs coming off them, to link seamlessly with adjacent elements of the framing (Fig. 47). Exact parallels for the layout of the sanctuary mosaic are found in Rome at San Crisogono and Santa Francesca Romana, and also at San Francesco, Vetralla, where each pavement comprises a central quincunx, contained within a poised square with large *rotae* developing from each side, and the whole is framed by a great square (Fig. 525).[40] It is an uncommon formula, so much so that Dorothy Glass dismissed the few extant examples as the work of restorers.[41] Westminster proves otherwise. Interestingly, the *faux* cosmatesque floor depicted by Holbein in *The Ambassadors* (1533) shares the same unusual layout (p. 19; Fig. 15). Although little of the floor is visible in the

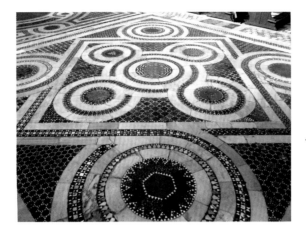

525 San Crisogono, Rome. Cosmati pavement with a similar geometrical layout to that at Westminster.
Vanessa Simeoni

painting, it is clearly based on a quincunx contained within a poised square, developing large *rotae* on its sides, and the whole framed within a great square.[42]

More difficult to parallel in the sanctuary pavement is the appearance of a broad guilloche border enclosing the great square. In the transept at Santa Maria in Aracoeli, Rome, a guilloche border surrounds three sides of a square pavement, and at Santa Maria in Cosmedin a similar border encloses the square space in which the altar stands.[43] Although smaller in scale, and set in the vertical plane, running guilloche interrupted by rectangular panels is found on some furnishings, including one of the pulpits at Santa Maria in Aracoeli.[44] The major decorative components of the sanctuary pavement – but not the assemblage *in toto* – can thus all be paralleled in 13th-century Italy.

Although many Italian Cosmati floors survive, nearly all have undergone substantial restoration, and in some instances that has been repeated several times between the 17th and 20th centuries. It is painfully apparent from Glass's study of the Italian pavements that past repairs were not undertaken sparingly, or with any consideration for conservation: large parts of many floors have been relaid, or totally renewed, and in some cases different designs substituted.[45] Thankfully, that did not happen to the Westminster pavements, with the exception of Scott's 'restoration' of the eastern border in the sanctuary, where he uncharacteristically adopted the Italian *ethos*.[46]

The Cosmati teams had pattern-books, accompanied by tables of dimensions from which they could construct the geometrical framework for a new pavement expeditiously. Linked to the dimensioned patterns would have been sets of accurately scaled stencils which travelled with the masons (Fig. 47). It would have been exceedingly time-consuming and wasteful of effort if the geometry of every new pavement had to be set out from first principles.

White lias limestone and its use for sub-framing

Throughout the pavement, the bands and panels of mosaic are separated by Purbeck marble framing, with three exceptions. These all relate to discrete sub-frames that surround individual panels, and appear to have received little scholarly mention in the past. They are narrower than the Purbeck framing, and the material used is white lias limestone from the Mendip Hills (Somerset). The colour of this rock ranges from white to golden yellow, and the latter hue was chosen for the bands.

The central medallion (1) is encircled by two tessellated bands, the inner one consisting of glass stars (2). Around that is a narrow band of white lias (3), separating the stars from the outer tessellated band (Fig. 63). The golden lias ring may perhaps be interpreted as a nimbus surrounding the Macrocosm (Earth) and its starry firmament (p. 54). The second occurrence of white lias banding is found in the four *rotae* attached to the poised square of the inner framing (17–20). Each *rota* has a large tessellated hexagon for its central panel, encircled by a band of mosaic. The two elements are separated by a band comprising six segments of white lias: the extrados is circular and the intrados hexagonal (Figs 70 and 71). The third appearance of white lias banding occurs around the western threshold panel (53) in the guilloche border (Fig. 91). Here, the lias sub-frame is rectangular and separates the main mosaic panel from a surrounding tessellated band (53A).

White lias of a paler hue occurs extensively in the pavement as tesserae filling interspaces. Identifying the stone-type exercised the minds of geologists for many years, and was not finally resolved until 2010. This must be the stone that, since the late Middle Ages, antiquaries persisted in labelling as Thasos marble. We cannot now discover the reason for the choice of white lias, but it has an extremely fine, smooth, porcellaneous surface texture that gives it a marble-like appearance. It was used for tesserae in Roman-period mosaics in south-west England. White lias is not quarried in large blocks and is not therefore useful

for paving, in the way that blue lias is. More significant in the present context is its employment for small sculptures and micro-architecture in Somerset churches in the 13th century. Thus, the angels in the lowest quatrefoil tier on the west front of Wells Cathedral were carved in white lias, and many fragments of mouldings were recovered during excavations.[47]

Similarly, the collection amassed from archaeological activity at Glastonbury Abbey includes exquisitely detailed small-scale sculptures in white lias.[48] The stone has also been found in medieval contexts in London, but no other occurrence of it at Westminster Abbey has yet been noted.[49] We will never know why Somerset white lias was chosen to substitute for a light-coloured marble of Mediterranean origin, but it demonstrates that the Italian mosaicists were already familiar with this English stone – as well as with Purbeck marble – and were prepared to use them both.

Medallions within the great square

The principal medallions in Cosmati pavements, particularly those forming the 'eyes' of quincunxes and the centres of large *rotae*, most commonly incorporated solid discs of marble, encircled by narrow tessellated bands; complex mosaic patterns are less frequently found in these locations. Consequently, the scale of the decoration on Italian pavements appears bold and uncluttered. Initially, the Westminster quincunx broadly conformed: the large, richly-figured calcite-alabaster disc at its centre, surrounded by a band of multi-coloured glass stars (1–4; Fig. 63), is outstandingly fine, and the centres of the four linked medallions (5–8; Figs 59–62) were occupied by single discs of *giallo antico*, a brecciated limestone (later reworked into polygonal forms). The centres of the four large *rotae* outside the poised square (17–20; Figs 59–62) do not, however, incorporate discs of marble, but are occupied by hexagons filled with complex tessellation. All are different in design, but six-pointed stars and hexagons are prevalent throughout.

The guilloche border and its medallions

Turning to the broad guilloche outer border, we find that the Purbeck marble frame, with its four rectangular panels and twenty medallions, was laid out with near-perfect symmetry. That precision did not, however, extend to the mosaic infilling, where extreme contrasts are apparent in both the design and composition of the individual medallions. Although of similar size, the designs and quality of the four rectangular panels differ dramatically, and their constructional techniques vary too. We have noted that the northern panel (56) contains the most intricate glass mosaic in the entire pavement, and the schemes in the other three panels are not only simpler, but all are different. Close by the northern panel are two medallions inlaid with complex glass decoration (33, 35; Figs 77 and 79) that sets them apart from their companions, some of which carry only very simple designs, and two are the plainest possible: a disc of breccia encircled by a narrow tessellated band (36, 47; Figs 81A and 86B).

In sum, there is no coherent theme or symmetry displayed by the patterns in either the rectangular panels or the medallions, and such a jumble of designs and variation in quality cannot have been originally intended. Moreover, the numbers of tesserae found in identical or complementary panels vary hugely, and the inclusion of glass was, for the most part, both random and aesthetically ineffectual (p. 540). These differences are too fundamental to be attributable to the relative skills of master craftsmen and apprentices. The rectangular panels, which have not been greatly altered since they were laid down in the 13th century, are separately discussed below (p. 541). However, we now appreciate that the majority of the medallions have been heavily compromised by post-medieval repairs and deliberate changes to their designs, but sufficient evidence is nevertheless recoverable to determine the primary appearance of many.

The twenty similarly-sized medallions are divisible into two groups on the basis of structural type: those that were prefabricated in the workshop, and then fitted into the marble frame as complete units, and those that were assembled *in situ* on the floor, using stone discs and individual tesserae. Eight (possibly nine) medallions fall into the former category and eleven or twelve into the latter (Fig. 526). Although the six medallions that currently comprise the eastern border are 19th-century replacements, sufficient evidence is preserved in antiquarian illustrations (mainly Talman's drawings of 1707) to indicate that none of these was pre-fabricated (Fig. 57B).

There are circumstantial grounds for believing

that most of the medallions in the second group originally comprised single discs of breccia (*giallo antico*), each encircled by a narrow tessellated band.[50] The same applied to the four satellite medallions of the quincunx (Figs 65 and 66). Certainly, in at least one border medallion, but probably in three, the disc was set into a marble tray (47, 50, 51) and was thus hybridized with the prefabricated panels (see below).

Prefabrication of mosaic panels

In addition to the medallions, the northern and southern tomb-covers were also prefabricated, being large slabs ('trays'), infilled with mosaic. The essential component of prefabrication was the Purbeck marble tray, the upper face of which was chased with the matrix to receive an inlay of glass and stone tesserae. Each unit was 10–18cm in thickness, circular for the medallions and rectangular for the tomb-covers. Such units could be entirely fabricated in the workshop, and simply slotted into place within the marble framework of the floor. Prefabricated units do not appear to have been a major element of pavement construction in Italy, except in the instance of grave-covers, where the use of monolithic slabs was inevitable. Most of the other inlaid panels seen in Italian floors today originated as parts of monuments and furnishings.

The northern and southern grave-covers (55, 56; Figs 94 and 95) in the sanctuary pavement were chased with complex designs mainly filled with glass tesserae. Eight of the medallions in the guilloche border were similarly manufactured on the bench. One tray simply contains a disc of breccia, and no tesserae, causing the panel (47) to have nearly the same appearance as those that were constructed *in situ*.[51] A second tray was almost certainly the same (51; Fig. 89), but its disc was removed in the 17th century and replaced with a tessellated geometric pattern.[52] Another tray with a circular matrix holds a square of serpentine, abutted by tessellated segments (37; Fig. 81B). Three of the trays were chased with simple designs, replicating at a larger scale examples of medallions in the shrine pavement, but these have all lost their original mosaic inlay (34, 44, 52; Figs 78, 86A and 90). That leaves just two more prefabricated medallions, both of which were chased with highly intricate designs. Panel 33 comprises a mesh of triangles containing six-pointed stars, and has the same geometric base as the southern tomb-cover (panel 55; cf. Figs 77 and 94), and medallion 35 exhibits an even more complex geometry, comprising three separate, interlaced patterns (Figs 79 and 80). There is nothing with which to compare it in the Westminster mosaic assemblage; the origin of this design is unexplained, although it has usually, but incorrectly, been referred to as Arabic.[53] The amount of work involved in setting out the geometrical constructs, chasing the marble, and inlaying the resultant pattern with several hundred glass tesserae was prodigious.

Studying the distribution of the prefabricated panels within the pavement is instructive (Fig. 526). First, there are none in the quincunx or the great square: they are all in the outer border, where they are restricted to three of its sides. We have already noted that the finest display of tessellation was in the tomb-cover that Ware commissioned for himself (56), and adjoining it on the west is the most intricately designed medallion (35). Less elaborate, but nevertheless still a fine piece of work, is the second tomb-cover (55) and another medallion (33) stylistically related to it. All of these demanded a high level of skill to create the trays that hold the tesserae, not only because the designs are complex, but also to chase out the matrices, leaving narrow upstanding fillets of marble delineating the elements of the patterns. Cutting narrow fillets and retaining sharp arrises is slow and painstaking work in Purbeck marble, on account of the granular nature of the stone: if a fillet is subjected to too much shock, or lateral pressure, it easily breaks off or crumbles, and the work is ruined. Chasing the matrices in discs like 33 and 35 could occupy a carver up to two weeks, while installing the tesserae would not take a mosaicist two days. The evidence points to one conclusion: Ware intended the guilloche border to be highly ornate, and the tomb-covers and medallions replete with intricate designs and glass mosaic, all pre-fabricated and set in trays. But that ambition was unfulfilled.

Infilling the marble framing of the pavement would have begun at the centre, and worked outwards. All the tesserae and stone discs within the great square were laid on the spot, and nothing was prefabricated off-site. In every respect, this was standard Cosmati work, but the treatment of the outer border was a different matter altogether. By the time the two tomb-covers and the first

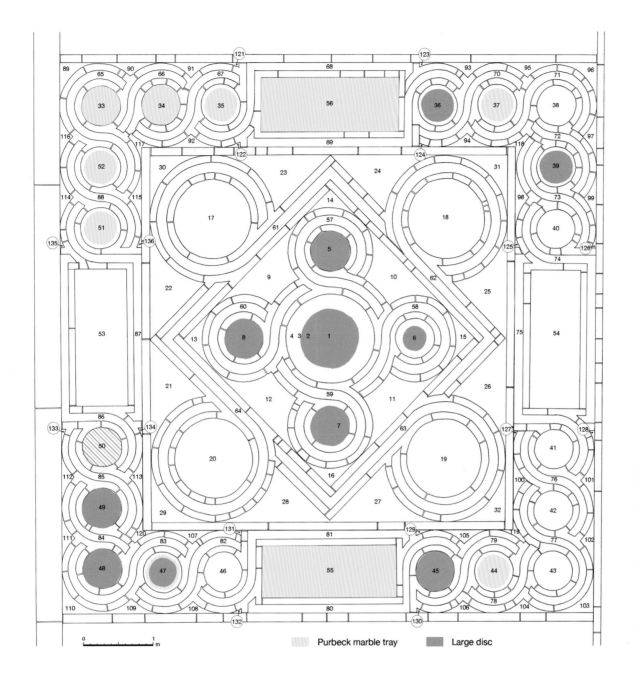

526 Sanctuary pavement. Distribution of two characteristic features of the primary construction: A. (fawn) Medallions and rectangular panels consisting of a Purbeck marble tray, chased and inlaid with mosaic decoration; B. (green) Medallions that once certainly, or probably, comprised a single disc of brecciated limestone, usually encircled by one or two narrow bands of tesserae. The uncoloured medallions held either mosaic or a now-lost disc. *Authors*

Purbeck marble tray Large disc

two medallions had been fabricated in the workshop, it must have been evident that either the cost could not be sustained, or the pavement would not be completed within the time-scale available. The 1269 deadline was looming, and hence a change of direction may have been unavoidable.

However, a further six discs of Purbeck marble must already have been prepared for the production of trays, but instead of chasing intricate designs into them, they were decorated with very simple patterns, as described above, each of which could be cut in less than a day. The positioning

of the eight circular trays is interesting: five were clustered at the north-west corner of the pavement, with the most elaborate example adjacent to Ware's tomb (33–35, 51, 52), and the remaining three were distributed symmetrically, one at each of the other corners of the great square (37, 44, 47). Constructing the final twelve medallions in the guilloche border, using large marble discs and modest quantities of stone tesserae, was achievable in far less time than it would have taken to chase trays and fill them with tiny glass tesserae. The revised approach would have saved several man-months of work.

The use of glass tesserae in the pavement
(Fig. 196)

Ostensibly, the fragility of glass renders it generally unsuitable for use in mosaic floors, but there was originally much of it in the sanctuary pavement, the greatest concentrations being in the pre-fabricated components. Two types of glass occur: opaque and translucent. The former is considerably thicker and more robust than the very fragile translucent material. Moreover, glass occurs in some quantity in the northern arm of the shrine pavement (p. 219) and in the tessellation of the cosmatesque tomb-cover in the floor of the Confessor's chapel (p. 508; Fig. 508). Predictably, after centuries of being walked upon, all the glass elements in the pavements are in poor condition.

The distribution of glass tesserae in the sanctuary is curious. The largest quantities are found in the two tomb-covers (panels 55, 56) and the two prefabricated medallions carrying complex designs (33, 35). Both types of glass are present in these panels, except in medallion 33 which contains only translucent. The rationale for the use of glass in these highly intricate works is readily appreciable. Similarly, the appropriateness of glass is evident at the centre of the pavement, where the band (2) of hexagonal reticulations embodying six-lozenge stars encircles the central medallion. Here, the opaque-glass stars, set against a background of translucent glass, may represent the firmament encapsulating the world (Figs 63 and 212). The visual impact is now greatly diminished because most of the thin translucent glass has perished. The outer concentric band (4) also contains numerous triangular translucent glass tesserae, set amongst a ring of porphyry lozenges (Fig. 211).

Band 86, which forms the west border to the western rectangular panel (53), also contains much translucent glass, which might have been intended to lend sparkle to the threshold at the axial point of entry to the sanctuary from the quire, although the impact would have been modest (Fig. 208). Other occurrences of glass are scattered, seemingly unplanned and defy logical explanation: parts of bands 59, 61, 63, 65, 78 and 81; small spandrels 16, 29, 32, 111 and 113. In addition to those listed, occasional glass tesserae occur in other panels, evidently as accidental inclusions.[54] There may have been some glass in the original eastern border medallions, since Scott recorded finding sherds in the rubble under the early 18th-century altar pavement when he broke it up.[55] Apart from the few locations where glass was deliberately concentrated – notably the central medallion and tomb-covers – its casual inclusion amongst stone tesserae was pointless and would most likely have gone unnoticed.

A further aspect of interest concerning the employment of glass tesserae is their physical appearance in the pavement. The vibrant colouring of opaque glass – red, blue, turquoise and white – is easily read, but the true colours of translucent glass are less apparent: dark blue, for example, invariably appears as black (cf. band 86). Red shows well, but amber and green less so. However, the knottiest problem to solve relates to gilding on glass: it was commonplace on the monuments, but to what extent were tesserae on floors flashed with gold? Little evidence of gilding has survived on the sanctuary pavement, but it certainly was once present,[56] and gilded red glass tesserae are still extant in the cosmatesque tomb-cover incorporated in the floor of St Edward's chapel (p. 509; Fig. 508). There can be little doubt that some of the red glass tesserae, at least in the ornate northern tomb-cover (56), were also gilt. Moreover, Scott was satisfied that they occurred elsewhere, and so he introduced this finish into three of his replacement medallions (38, 39, 40). Additionally, the new pavement that he laid on the altar dais in 1868 is almost entirely covered with gilt tesserae (Fig. 43). They are subjected to little foot-traffic and have survived remarkably well for 150 years.

Although ubiquitous in furnishings and monuments, glass is very scarce in Italian Cosmati floors. Glass-decorated tomb-covers and other panels can be found,[57] but they are not numerous, and it is generally agreed that there is a simple explanation for this. Since most Italian pavements have been thoroughly restored, it is highly likely that glass components, where they had been virtually destroyed over time, were simply eliminated and replaced with marble.

The inclusion of glass tesserae, gilded or not, in pavements and monuments confirms that the surfaces of cosmatesque mosaics were not ground and polished in the same way that mosaics were in the Roman period. The latter acquired their flat, smooth finish as a result of much effort being expended with a rubbing-block, sand and water. Cosmati mosaics relied on the pre-polished surface

of the stone tesserae and the natural shine of the glass. A smooth surface was obtained through the skill of the mosaicists, tamping the tesserae into soft lime mortar, as the experiment in reconstruction in 2010 demonstrated (p. 204). Copious payments to marble polishers are recorded in the accounts, but these were for columns, mouldings and probably plain paving. They would, of course, have polished all the Purbeck marble components of the Cosmati work, before inlaying the tesserae began; they may also have been required to carry out some careful tidying-up afterwards, to remove mortar stains and any other blemishes.

Four rectangular border panels

The middle third of each side of the guilloche border is occupied by a single rectangular panel. This is framed by a 10cm wide band of mosaic that links into the guilloche at both ends; within that framework is a second 10cm band formed by strips of Purbeck marble, enclosing a rectangular panel 1.95m × 72cm.[58] The different treatment accorded to these four panels requires comment.

West panel (53)

Purple and green porphyry chequerwork fills the panel, framed by a narrow (8cm) strip of golden white lias limestone, which in turn is framed by a narrow (8cm) mosaic border (53A), and the whole is enclosed by the Purbeck marble band that unites with the guilloche (Fig. 91). This multiple framing of the main mosaic panel is a feature not found elsewhere on the pavement, but it possibly helped to emphasize the 'threshold' on the axial approach to the sanctuary. We have already noted that the outer mosaic band (86) on the west is embellished with glass tesserae.

East panel (54)

In marked contrast to the west panel, this one has no subdivision within the outer 10cm Purbeck marble frame, and the whole space is filled with a diagonal grid of mosaic composed of rectangular 'tiles' of purple and green porphyry (Fig. 92). Not only does this panel combine mosaic and *opus sectile*, but the scale of the design is larger and bolder than anything else on the pavement. It is less ornate and stands out as being distinctly different.

Although attention is subtly drawn to the axial location of the panel, by its appearance as a 'threshold' at the foot of the steps up to the altar pavement, that is misleading since there were no steps at this point in the Middle Ages: the depiction of Abbot Islip's funeral in 1532 provides compelling evidence for steps to the altar dais being further to the east (Fig. 16). More likely, the site of this out-of-scale panel was initially reserved for another purpose, but a change of plan at a late stage during construction of the pavement resulted in the discordant infilling of the rectangle. A grave is clearly out of the question since the feature is aligned north–south, but another possible explanation is worthy of consideration, namely that it was initially designated as the location for an altar 1.95m (6½ft) long.

In this connection, it is worth recalling that the Westminster Retable, which was designed to stand behind the high altar, is 3.33m long but was originally intended to measure only 2.56m (8ft 5ins): its length was increased by two feet (60cm) during manufacture (Fig. 514).[59] While not suggesting that there was an association between the Retable and the rectangular panel in the pavement, it remains undeniable that we have two anomalies in the design of the sanctuary and its furnishings that can only be explained by changes introduced during the construction process.

The dimensions of the floor panel would be consistent with an altar having a *mensa*, *c.* 2.10m (7ft) long, which was sizeable but still too modest for the high altar of a church on the scale of the Abbey. Also, it is too far west, which would have left a large space between the altar and the shrine of St Edward. Such an arrangement would have been impracticable and can be discounted. While the matutinal altar was traditionally located a short distance to the west of the high altar, there is too little space between them for this to be a convincing identification. Whatever may initially have been contemplated, it was evidently not pursued to completion and the medieval matutinal altar was seemingly located in the crossing, immediately west of the sanctuary pavement.

North panel (56)

Here we find a different structural treatment on account of this panel's function as a cover for Abbot Ware's tomb (Fig. 93B). The 10cm wide frame composed of strips of Purbeck marble is

present, but has a shallow, flat-bottomed channel chased into it (Fig. 175). The latter is 4.5cm wide, positioned centrally within the strip and contained a continuous layer of mastic resin upon which the latten fillet-inscription had been bedded (inscription D). The channel was once continuous around all four sides, but is now only present along two-thirds of the south side and across the west end; the remainder of the marble frame has been replaced and the channel omitted.[60]

Nothing now remains of the fillet, and its loss occurred before the mid-17th century. Whether it was still present in 1600, when Camden noted the text of the inscription is very doubtful, and it is likely that he simply transcribed the wording from Flete's record.[61] The surviving evidence is consistent with the loss of a continuous latten fillet, not individual letters set in a channel of mastic. Dating from 1283, this is one of the earliest known examples of a fillet inscription.

Set within the inscribed frame is a single slab of Purbeck marble measuring 1.94m by 62cm. This is the lid to Ware's monolithic stone coffin which lies directly below and was set in position as the pavement was being laid (Fig. 49). Into this lid was chased the matrix for a complex design, executed with marble and glass mosaic. Since the floor-level tomb was commissioned by Ware in 1268 for his own eventual use, it had to be openable without doing violence to the sanctuary pavement. Scanning with a metal detector revealed four lifting-rings, two on each of the long sides.[62] The rings were concealed in narrow gaps adjacent to the north and south edges of the lid. The *ferramenta* appeared to be similar to those attached to the Stone of Scone, comprising a staple set in a lead plug in the side of the block, a figure-of-eight link, and a plain circular ring (Fig. 270).[63]

When Ware died in 1283 the tomb was opened, the abbot's corpse and his funeral furnishings inserted into the stone coffin, and the lid replaced (Fig. 269). The ironically worded latten inscription around the perimeter of the tomb-cover was most likely added soon afterwards (p. 122). Ground-penetrating radar has revealed the internal shape of the coffin as having a head-recess at the west end, a provision that would be expected in a high-status burial of the 13th century (Fig. 118).[64] Objects within the tomb have also been detected: one may be a crozier, others a chalice and paten (p. 151). The evidence for these is not unequivocal.

Elements of the design and decoration on the tomb-slab are almost identical to those on the upper stage of St Edward's shrine, and were doubtless copied from it. The two lozenges on his slab each have four attached *rotae* and a deeply recessed central square, to hold a single piece of sheet marble; this arrangement is exactly replicated in the central panel on the south side of the shrine (bay 2; Fig. 306).[65] The quincunx with its disc of marble, occupying the middle section of the tomb-cover (Fig. 95B), is replicated on the east end of the shrine entablature, and in some of the niches; it is also found as the central feature on the north face of Henry III's tomb (Fig. 463) and on the east end of the child's tomb (Fig. 492). Adjacent quincunxes on the shrine are separate entities, abutting one another without physical interlinking, whereas on the tomb-cover the roundels of the quincunx and those attached to the lozenges are intertwined with S-shaped bands of mosaic. This is reminiscent of the interlinking of roundels and medallions (some of which are quincunxes) on the shrine pavement (Fig. 243).

Similarly, Henry III's tomb appears to have inspired Ware, whose slab (56) prominently displays three modestly sized panels of marble, one circular and two square (Fig. 95; cf. the north face of Henry III's lower tomb-chest, Fig. 463). The square panel in the eastern lozenge is a post-medieval reconstruction, but the western is unquestionably primary, although at first sight one might not think so. The square is composed of two rectangles of stone: one is purple porphyry of an uncommonly dull variety, the other black-and-white speckled granite, *granito verde antico* (Fig. 524B). Visually discordant though they are, both pieces are embedded in the primary mortar and directly abutted by a few small porphyry tesserae (micromosaic) that are also *in situ*. The explanation seems clear: Ware wished his tomb, like Henry III's, to display panels of purple porphyry, but there were no pieces of sufficient size available to meet his needs. Instead, a disc of Belgian red marble had to be substituted for the medallion, and the western square could only contain a token rectangle of porphyry, augmented with granite. Clearly the stock of sheet porphyry had been exhausted. We cannot know what was in the eastern square, but the fact that the post-medieval repair similarly comprised two rectangles of marble is surely not coincidental: the original filling of this square also was most likely in two parts. Evidence for joining two rectangles of

marble, to create a square, occurs on the retable for the shrine altar (p. 352; Fig. 527). Composite panels are also found on some Italian monuments (but invariably they are much larger than those at Westminster).

Turning to the disc in the central panel, this is primary and of *rouge de Rance*, a red Belgian marble that rarely appears on the pavement (Fig. 524A).[66] In colour, it bears some resemblance to the redder varieties of purple porphyry, but this particular example is also strikingly figured and in that respect is reminiscent, in diminutive form, of the pavement's central medallion (panel 1; Fig. 63). Perhaps the marble disc was deliberately chosen to reflect that; there is nothing else like it in the Cosmati assemblage. Doubtless, Ware's original intention was to set a disc of purple porphyry at the centre of his tomb-cover, but when it was realized that there was nothing large enough to fill the matrix, he had to choose a substitute. We are minded to speculate that he noticed this disc, already occupying one of the medallions in the central quincunx of the pavement, and ordered it to be extracted. That would explain an anomaly to which attention has already been drawn (p. 130). The eastern medallion of the quincunx (panel 6; Fig. 65B) is a distinct oddity in two respects: first, it is smaller than its three counterparts and consequently has a double border of tesserae, to make up the required overall diameter; second, it initially held a stone disc 27cm in diameter, which was later extracted and replaced with the present larger one of *ammonitico rosso*. In order to insert the new disc, the tips of the inward-pointing tesserae in the surrounding border were crudely cut off (pp. 69 and 130). This was a much quicker expedient than reducing the diameter of the disc by 1cm. The replacement has a rough texture, is orange in colour and would have appeared markedly incongruous had it been used as the centrepiece of Ware's tomb-cover, but is less noticeable in its current location.[67]

South panel (55)

Like the north panel, this is a tomb-cover. It is of similar width (62cm), but is slightly shorter at 1.85m. Again, it comprises a single slab of Purbeck marble, overlying a rectangular chamber, integrally constructed with the pavement. The slab has been chased with a latticed design of hexagons and triangles, forming a matrix to receive six-lozenge

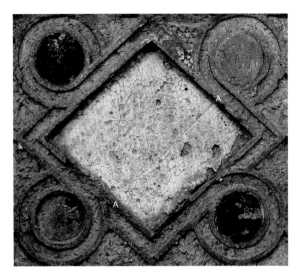

527 Shrine altar retable. Detail of the matrix for the upper central panel, showing a line (A-A) in the mortar bed, indicative of the junction between two rectangular panels of marble. © *Dean and Chapter of Westminster*

stars of both glass and porphyry (Figs 93A and 94). The design is much less intricate than that on Ware's tomb-cover, with far fewer tesserae and no micro-mosaic work, but the quality of the workmanship is high. Separating the slab from the marble strips of the surrounding rectangle is a tessellated band, slightly narrower than the sacrificial strips along two sides of the northern slab. This band runs around all four sides of the tomb-cover and comprises a zigzag of purple and green porphyry, neatly laid and with small squares punctuating the corners.

This is all primary work, and the perimeter band of mosaic in this instance is not 'sacrificial', having never been taken up and relaid as a consequence of inserting a burial. Nor has a matrix for an inscription been cut into the Purbeck frame around the slab. In short, the southern tomb-cover is undisturbed, a detail that seems to have escaped remark hitherto. Nevertheless, GPR has demonstrated the presence of a tomb-like chamber beneath the cover (p. 153; Figs 122 and 124). Metal-detecting yielded no indication that there are lifting-rings attached to the sides of the slab, as there are on the northern tomb.[68] This slab was certainly laid down at the time of construction, and was never intended to be a removable cover: whatever the chamber contains must have been placed there prior to sealing it with the slab.

It has frequently been asserted that Ware's successor, Abbot Walter de Wenlock (d. 1307), is interred here, but that is fallacious, not only because the tomb-cover has never been lifted for the insertion of a corpse, but also because the true location of Wenlock's grave is reliably documented. Historians of the 17th and 18th centuries are

united in reporting that his burial lay to the south of the high altar, in front of the doorway in the 1440 stone screen (p. 14).[69] Significantly, it was also adjacent to the sumptuous sedilia that were commissioned during Wenlock's abbacy and installed in *c.* 1307.[70] He was buried under a slab of Purbeck marble, bearing a brass plate inscribed with a rhyming couplet, the wording of which was recorded by Flete (p. 14).[71]

There is no logical reason why Ware should have created an empty tomb in the pavement, to receive at some future date the body of his as-yet unknown successor, or of any other person unconnected with the pavement. Moreover, there is no suitable location where an inscription plate could have been affixed to this tomb-cover. The posited identification with Wenlock appears to have been conceived in the Victorian era, and become more firmly embraced as time passed.[72] Having an unidentified tomb in the Cosmati pavement was too great a *lacuna* for 19th-century antiquaries to accept, and the temptation to assign a name to the presumed occupant was over-whelming. This erroneous identification must now be firmly set aside.

However, several questions have to be addressed: first, is there an occupant, or has the chamber remained empty for three-quarters of a millennium? The tomb is not empty. If it were, the radar scans would have revealed it as a void (p. 152). It certainly has contents, and although there are small air spaces within the chamber, they are not of the volume that one would expect to see if this was a chamber containing a single corpse. It is also strikingly clear that, unlike Ware's coffin with its shaped head-recess, this feature is internally square at the west end, the corollary being it is unlikely that the chamber was ever intended to house the burial of a single individual of high status. Moreover, it is almost certainly not a monolithic coffin, but a stone-lined chamber, constructed from several separate slabs set on edge. Graves constructed in this manner are widely attested in the 13th century, e.g. at Wells Cathedral, Somerset.[73]

Scanning the area of the tomb with a metal-detector was instructive: it picked up weak signals all round the perimeter of the chamber, at intervals of 15–20cm, indicating the presence of numerous discrete objects. Almost certainly, these are nails, or possibly small brackets. The obvious inter-pretation is that the chamber contains a timber chest with a lid that was either nailed directly to the carcase, or was more elaborately carpentered and held in place with metal angle-brackets. In sum, all the evidence points to the southern floor-slab marking the site of a stone-built chamber containing a timber ossuary chest. This is best identified as the place where exhumed remains of several persons that were considered important to revere were collected together and reinterred.

The construction of Henry III's new church involved a massive amount of excavation, which would have led to the disturbance of scores, if not hundreds, of burials, stretching well back into the Anglo-Saxon period. The principal Norman and pre-Norman cemetery associated with the Abbey would have encircled the eastern arm of Edward the Confessor's church.[74] For the most part, no special attention was given to exhumed bones, which would have been gathered up and either buried in charnel pits or deposited in the foundation trenches of the new building before they were backfilled; both were common practice in the Middle Ages. Archaeological excavation in Poets' Corner Yard in 2015 revealed a large assemblage of human bones dumped in the 1240s in the foundation trench for Henry III's south transept.[75] Different treatment would have been accorded to the intact burials encountered in stone-lined cists or coffins within the sanctuary and quire of the Confessor's church. In the 11th and 12th centuries interments in such prestigious locations would have been few and restricted to persons of the highest status, and their corporeal remains would have been exhumed before demolition began in October 1245. Henry would have ensured that their bones were gathered up and reverently reinterred within the consecrated building.

That is exactly what happened when the Confessor's chapter house was demolished to make way for its Gothic replacement. Up to eight abbots may have been buried in its vestibule before being temporarily translated in the late 1240s to the south cloister walk, in preparation for Henry's great rebuild.[76] Another example of translocation has recently been recognized during a reassessment of a well-known discovery made in 1869. A decorated Roman limestone sarcophagus was unearthed just outside the Abbey church, on North Green, in the angle between the north transept and the nave.[77] The coffin had been reused in the 11th century for the burial of a high-status

male, and the originally plain lid was carved with a splayed-arm cross.[78] The coffin, which may contain Abbot Aelfwig (993–c.1020), was almost certainly removed from the sanctuary of the Confessor's church in 1245.[79]

Other monuments and important burials would have been encountered in the eastern arm of the church, and their remains also demanded seemly reburial. Edward's queen, Edith, was re-interred in the new shrine chapel, close to her husband, but the site of her grave is not known. She may have been simply buried in the ground, adjacent to the shrine pedestal, and the pavement laid over her without any form of marker. But surely Henry III would have accorded greater respect to the Confessor's queen? Local tradition locates Edith on the north side of the chapel, and it would not be unreasonable to suggest that her remains were placed in a chest or other receptacle and ceremoniously interred in the floor under one of the arches. It was unlikely to be the bay directly north of the shrine, since that was reserved for Henry III's own tomb. So it could have been in the canted bay to the north-east, now occupied by Eleanor of Castile's tomb, or in the westernmost bay where Edward I lies.[80] Edith's exhumation occurred in September or early October 1245, and on the ninth of the latter month Henry III ordered that the orphrey which was found over her body was to be used to decorate a new cope.[81] Edith's remains were temporarily held somewhere until the new St Edward's chapel had been built.

The tradition that Sebert, king of the East Saxons (d. c. 616), was buried in the abbey has been persistent for many centuries, and there is a 13th-century tomb-slab in a low-arched recess on the south side of the sanctuary, beneath the sedilia, that has long been claimed as his. No certainty attends this attribution, however, and Sebert's remains could be in the ossuary under the pavement. His queen, Ethelgoda (d. c. 615) is similarly alleged to be buried in the Abbey.

Inscriptions

While Cosmati monuments were often signed in mosaic by their artists, pavements were not. It is, therefore, all the more remarkable that the Purbeck marble framing of the Westminster sanctuary pavement carries no less than four separate inscriptions (designated (A–D), and that they were not executed in mosaic, but in latten

(Figs 99, 100, 103 and 104). They were undoubtedly the work of London marblers, who were accustomed to insetting latten inscriptions on tomb-covers (for further discussion, see p. 119). The narrow metal fillets customarily flanking inscriptions – including our cosmatesque example (Fig. 504) – were not replicated on the pavement.[82]

It is noteworthy that three different techniques were employed to create the inscriptions: A and C were formed by insetting individual letters into matrices in the Purbeck marble frame, and fixing them with mastic; B comprised a continuous channel filled with reddish mastic resin, into which metal letters were separately pressed; D was an incised latten fillet laid in a shallow channel on a thin bed of mastic. Only a trace of inscription B survives, and nothing of D, but many matrices and a few letters of A and C are present. In the case of inscription B, the entire band of reddish mastic resin was intended to be visible and constituted part of the decoration of the quincunx (Fig. 99). At Canterbury, reddish mastic was also used decoratively, to fill the incised designs on the stone medallions added to the Trinity chapel pavement in the early 13th century.[83] We have also argued that the top slab of the child's Cosmati tomb was decorated with small mastic-filled plano-convex roundels (p. 493).

The inscriptions have not suffered any material losses in the last two hundred years: in 1815 the surviving letters and their locations were listed, and remain the same today.[84] An *ex situ* latten letter 'E', held in the Abbey Collection, is said to have come from the inscription. It is 40mm high and in the same Lombardic font as the letters preserved (Figs 105 and 271, A). The reverse of the letter has been scored to act as a key to the mastic, and analysis has confirmed that its composition is latten.

We cannot be certain that all the inscriptions were contemporaneous, especially in view of their different methods of execution. The case has been argued for the dated inscription (C), at least, being a subsequent insertion, following the death of Henry III in 1272.[85] Being based on mathematical subtraction, the formula adopted for representing the year of the pavement's construction implies that the inscription was conceived in 1272, and then four years were deducted to arrive at 1268, the actual date of laying the pavement. Conversely, Norton has pointed out that other instances are known of mathematical subtraction in inscriptions,

to arrive at a required date, and that those could have been motivated by the need to preserve poetic metre.[86] However, it would be an extraordinary coincidence if, in 1268, a calculation was made that not only 'anticipated' the year of Henry III's death, but also subtly recorded the length of his reign (56 years) by incorporating the words 'sixty minus four [years]' (p. 120). It is surely more plausible to regard this as a memorial inscription to the late king, added in 1272.

Inscriptions A and B are integral with the quincunx, cosmological in nature, clearly associated with one another, and undoubtedly primary; C, on the other hand, is a purely historical record which could well have been added *in situ*. However, Howlett considers the fifty-seven words making up the inscriptions (A, B and C) to be an epigraphic entity, dating from 1272 or later, 'for if the inscription was devised in 1268, the author was uncannily prescient'. He goes so far as to question the date of laying the pavement: 'close study of the internal structure of the inscription has implications for the widely accepted date of the sanctuary pavement'.[87]

The fillet inscription on Ware's tomb-cover (D) did not bear a date and was added after his death in 1283. It does not follow a recognized formula for sepulchral inscriptions of that era, and contains no sentiment or exhortation to pray for the abbot's soul: it merely makes a brief statement regarding his involvement with the construction of the pavement (p. 122). For that reason, it is very unlikely that Ware himself had a hand in the wording. He may well have left instructions that his tomb was to bear a suitable epitaph, but the resultant inscription was not concomitant with his expectations.

Since cast latten letters were routinely installed in Purbeck marble tomb-slabs by the London marblers, it is not difficult to appreciate how the idea of adding an inscription to the Cosmati pavement came about.[88] At first sight, it seems curious that a random mixture of fonts was used: Roman and Lombardic, but this is unexceptional for the period.[89] More curious is the embedding of individual letters in a continuous mastic-filled channel. It represents a profligate use of mastic, and in terms of the labour involved, it would have been no more expedient than setting the letters into individual matrices. One can only suppose that there was a particular desire for the inscription to appear as golden letters set against a dark red ribbon (the colour imparted by the inclusion of haematite in the mastic). Norton has drawn attention to the use of coloured mastics in decorative floors in France and the Rhineland from at least the early 12th century, and in particular to their appearance at Saint-Denis in the mid-13th century.[90] As noted above, mastic was also being used in England to fill incised decoration in sepulchral and other sculpture, for example in the Trinity chapel pavement at Canterbury.[91]

The texts of the three main inscriptions have been discussed by numerous writers, and it will suffice to generalize here: A, B and C suggest that the pavement's complex design sets out a symbolic image of the cosmos.[92] The middle verse (B) gives the age at which the world will come to an end, expressed as a formula of multiplied life-spans of various animals, the total giving the prediction of the end of the world as 19,683 years.

The sanctuary pavement inscriptions did not stand alone in Henry III's abbey: they are virtually contemporaneous with those in the ceramic tile pavement in the chapter house.[93] Although survivals *in situ* are rare, inscriptions on tile pavements were not uncommon in 13th-century England.[94] At Westminster the six separate texts, now almost entirely illegible, appear to have been cast in Leonine hexameters. The letters were individually stamped into rectangular blocks of brown clay, and the matrices filled with white clay before the tiles were glazed and fired. The only fully legible text extols the glories of the new chapter house:

Ut rosa flos florum sic est domus ista domorum

As the rose is the flower of flowers, so is this the house of houses

A second, incomplete text speaks of King Henry as the friend (*amicus*) of the Holy Trinity (Fig. 528). It can be no coincidence that the inscription on St Edward's shrine refers, in similar vein, to Henry as *amicus* of the Confessor (p. 385), and just to the east of the shrine lay the altar of the Holy Trinity. All round the presbytery at ground level, and high above in the clerestory, were large windows filled with some of the finest stained glass in England. Although the glazing is no longer intact, the surviving fragments attest not only its superb quality but also confirm that it contained texts in large letters.[95] The wording of the shrine

A

B

528 Westminster Abbey chapter house, decorated tile pavement. A. Inscription I, comparing the chapter house to a rose; B. Inscription II, recording Henry III as 'friend of the Holy Trinity'. © *Dean and Chapter of Westminster*

inscription is consistent with Henry III's personal involvement, but far less likely to have been composed after his death. It is, therefore, more compatible with the 1269 dating than 1279.

The king himself must have had a hand in wording the various inscriptions, as he doubtless did in ordering sixty-two depictions of the royal arms to be incorporated in the chapter house pavement (Fig. 5). Two parallel lines, each containing thirty-one armorial tiles, define the approach from the inner entrance of the chapter house to the abbot's seat, upon which the king sat when he held council in the chamber. Since construction of the chapter house must have begun by *c.* 1247, the king's thirty-first regnal year, placing the same number of pairs of his arms in the pavement may have been a subtle date-code.[96]

Finally, inscription C on the sanctuary pavement incorporates not only the date 1268, but also the name Odoricus, the Roman craftsman responsible for the floor. Although Odoricus did not sign it with his name, he left an unmistakeable emblem or 'trademark' in band 68A of the mosaic border at the north-west corner of Ware's tomb-cover (p. 111; Figs 93B and 98). It stands out as being utterly different in style, not only from the rest of the band, but also from everything else in the pavement. Consisting of a block of nine

squares, the four corner tesserae were cut from a single slab of red marble incorporating a distinctive quartz vein (*rosso antico*); there is no other occurrence of this stone type in the Westminster Cosmati assemblage. Mosaics dating from the Roman period also sometimes exhibit 'trademarks'.

The primary design and materials

As a result of centuries of piecemeal intervention, the overall appearance of the pavement has changed considerably, but by archaeologically peeling back the layers its original detailing can be established with a high degree of confidence. The design of the marble matrix for the quincunx, poised square, *rotae* and great square is entirely conventional, but the addition of the outer guilloche border on all sides, embodying four rectangular panels, is seemingly without parallel. Both running and chain guilloche borders are not uncommon *per se*, for divisions between pavements, and they sometimes include rectangular links, a combination that also finds parallels in Cosmati monuments, such as a panel on one of the pulpits at Santa Maria in Aracoeli, Rome.[97] At Westminster, the four panels are not merely links, but dominant features in their own right. The addition of the outer border may simply have

been a response to the need to enlarge the panel, to suit the proportions of the western bay of the sanctuary. However, as already noted, the dimensions of the poised square exactly match those of the Trinity chapel pavement at Canterbury (Figs 519 and 521), which is perhaps an unlikely coincidence (p. 529).

The majority of medallions in Cosmati pavements contain a single, large circular slab, with or without an encircling band of tessellation and, prior to modification, all five discs of the Westminster quincunx conformed: a central roundel of Italian (Piedmont) calcite-alabaster and four discs of *giallo antico*. The *rotae* attached to the poised square usually consist of several concentric circles of marble banding and mosaic, as at San Crisogono, Rome (Fig. 525), but may also incorporate sizeable discs as centrepieces, as at Santa Nicola, Genazzano and Santa Francesca Romana, Rome.[98] However, this was not the case at the Abbey, where the centres of the *rotae* all comprise mosaic-filled hexagons, clasped by segments of white lias, which are in turn encircled by a narrow mosaic band (Figs 70 and 71). The same composition is found in some Italian pavements (e.g. Santi Giovanni e Paolo, Rome).[99]

Turning now to the outer border, Italian precedent for large guilloche bands suggests that the twenty medallions ought to display a coherent decorative scheme, but that is not the case. Instead, we find a jumble of materials and designs, juxtaposed with no attempt to achieve consistency, or symmetry. We have noted that eight medallions contain Purbeck marble trays, chased to receive decorative inlays of marble, stone mosaic or glass mosaic (Fig. 526). The chased designs range from simple to highly complex (pp. 538–9).[100] The fillings of fourteen medallions seem simply to have been discs of variegated yellow breccia (*giallo antico*), but in two instances they were of deep red marble (*rouge de Rance*) (Fig. 529). The chaotic disposition of designs and materials in the outer border stands in marked contrast to the orderly approach within the great square. In similar vein, the designs of the four rectangular panels are all fundamentally different, progressing from the most elaborate on the north, via the south, and then the west, to the coarsest on the east.

A limited number of stone types was employed, the principal ones being purple and green porphyry, *giallo antico* for most of the medallion discs, and much English white lias limestone. A singularly large and prominently figured disc of calcite-alabaster formed the centrepiece of the pavement, and was clearly specially imported from Italy for the purpose; there is no other recorded occurrence of this stone in the entire Cosmati assemblage. There were three smaller discs of Belgian *rouge de Rance*, one of *ammonitico rosso*, a square of gabbro, a modest amount of grey granite (*granito verde antico*) and sundry other non-native stone types in very small quantities. Opaque and translucent glass occurred in the two tomb-covers where, as in the centre of the pavement, it was employed in a consistent and meaningful manner, but its use elsewhere was sporadic and effectively inconsequential (pp. 195–8; Fig. 196).

The logistics of laying the pavement may now be examined. First, a lime mortar screed was laid and the plan of the entire Purbeck marble frame accurately marked out, and the two tombs set into position. Infilling the compartments within the matrix began at the centre with several mosaicists simultaneously working outwards in each direction, completing one panel at a time. The quincunx, poised square and great square were all decorated according to a coherent plan; attention then turned to the guilloche border. The rectangular panel on the west (53) may have been tackled first: it has a golden lias inner border (like panels 1 and 17–20) and the adjacent band (86) employed a large quantity of translucent blue-black glass tesserae; similar tesserae appear in the panel itself, although an insufficient quantity was available to fulfil the requirements of the design. The dominant element in this panel is a chequer of red and green porphyry squares of larger than the average tessera size. It would appear that there was also an insufficiency of these, since they were eked out with a few substitutes in grey granite.

The prefabricated north and south tomb-covers would have been brought onto site from the workshop and placed in position over the sarcophagi. We have discussed the eastern border panel, which is strikingly different in scale and design, and suggested that the location was initially designated for another purpose; what we have today represents a change of plan (p. 541). That leaves the twenty medallions, the last compartments to be filled, and we have argued that the intention was to prefabricate marble trays, chase and inlay them with intricate designs that incorporated much glass and numerous small tesserae (p. 540). Work on a highly elaborate border

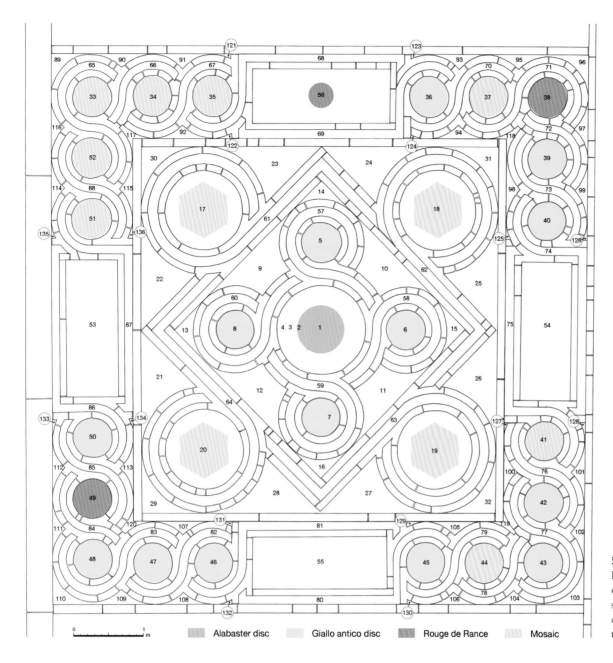

529 Sanctuary pavement. Diagrammatic reconstruction of the primary layout, showing the distribution of different types of filling in the medallions. *Authors*

started at the north-west corner of the pavement, adjacent to Ware's tomb-cover, but was quickly abandoned and the remaining compartments haphazardly filled with discs of *giallo antico* and mosaic. The random incorporation of two discs of *rouge de Rance* may indicate that the stock of *giallo antico* had been exhausted.

It is clear that the original complex design for the pavement could not be followed through, and the quality of materials and skill of the workmanship both tailed-off. Ware's tomb-cover was by far the most accomplished component, and the outer border the least impressive. Leland was surely correct when he remarked that the sanctuary

pavement utilized residual materials from other cosmatesque works in the Abbey (p. 534).

Later history of the pavement

The extent to which the decorative elements on the sanctuary pavement have been altered over the centuries, subsequent to its construction, has hitherto been underestimated: details are set out in chapter 4. As we have noted, there were three principal phases of alteration and repair between the 13th century and the end of the 19th, and dating evidence for them is frustratingly lacking. Seventy percent of the primary work survives

(Fig. 106), and the earliest identifiable repairs were late medieval (Phase 2); they relate primarily to panels and bands within the inner square, around the north-east and south-west *rotae* (Fig. 107). A creditable attempt was made faithfully to restore the patterns and colours of the original work, using substitute stone types, since supplies of porphyry were no longer obtainable.

One area of repair is particularly remarkable, in that special 'composite' tesserae were manufactured for band 64, in an attempt to replicate the intricate detail that had been lost. Small triangles of cream limestone (possibly Caen) were prepared, and an even smaller triangular pocket drilled and chased into the upper face; this was then filled with either red or green paste, to imitate the colours of porphyry (Figs 273 and 274A). Each of these newly fabricated tesserae was a replacement for four originals of tiny proportions: three of white lias, abutting one of porphyry.[101] The technique of inlaying coloured mastics in medieval grave-slabs is known at least from the 14th century,[102] and we have mentioned it in connection with the mastic band into which inscription B was set. However, we have been unable to trace any similar composite tesserae from other ecclesiastical sites in England.

It is not difficult to appreciate how a complete panel might require replacement, following rough usage or an accident during building works, but it is more curious that several metres of three narrow, tessellated bands should have been destroyed, and hundreds of tesserae lost.[103] Interference with the southern tomb-cover (55) is equally perplexing. At the centre of the slab is a six-pointed star fashioned from a single piece of green porphyry, and it is very likely that there were two more stars on the east–west axis. However, these have been removed, together with the smaller glass stars that surrounded them, and parts of the overall lattice grid in the Purbeck marble tray have been chiseled away, thereby creating two sizeable hexagonal voids. Into those voids were set large six-lozenge stars of red Belgian marble and serpentine; the considerable gaps around these inserts were filled with lime mortar rather than tesserae (Fig. 94). No explanation can be offered for this gratuitous mutilation of the tomb-cover, but it may usher in the next phase of intervention in the pavement.

Phase 3 is characterized by the introduction of new geometrical shapes, implemented in two

stages, although they were not directly inter-related or contiguous. In Phase 3.1, the medallions were targeted, and extensive changes made to many of them (Fig. 108); they had initially contained plain discs, mostly, it seems, of *giallo antico*. The four outer medallions of the quincunx (5–8) were all re-worked, their centres now displaying a circle, a hexagon, a heptagon and an octagon, respectively.[104] The four large *rotae*, which already held hexagonal designs in mosaic (but no discs), were untouched. Where practicable, the medallions in the guilloche border were also adapted to display geometrical forms; the pre-fabricated panels chased with individual designs were left alone, including the central disc in the northern tomb-cover, 56. Three discs from Phase 1 were allowed to remain (36, 39, 47) and another, probably primary, disc (40) was reduced in diameter. At least four more were trimmed to create hexagons (42, 43, 45, 50), and two were converted into octagons (38, 49). Evidence of the treatment accorded to disc 46 is lacking. This phase had little, if anything, to do with essential repair: it was the result of a decision – in the late 16th or early 17th century – to introduce polygonal forms where there were previously only circles.

Phase 3.2 is more commensurate with repair and probably followed after an interval of several decades (Fig. 109). No attempt was made to restore the lost patterns or colours: instead, wholly new geometrical designs in polished marbles of various colours were introduced. Compared to the medieval mosaic, the colours are much less vibrant. The quality of the work varies, and clearly more than one hand was involved. In the finest panels, the pieces of marble were cut with great precision and fitted so tightly that there was no room for mortar in the joints (e.g. panels 12 and 27; Figs 68B and 75A). Marble veneers of this quality on a contemporary item of furniture would be described as *pietra dura*. Finally, panel 51 presents a conundrum: its geometrical pattern is based on concentric rings of triangular tesserae, precision-cut. At the centre of the medallion they are tightly jointed, but not in the outer rings, where the gaps are wide and filled with coarse lime mortar (Fig. 89). In most respects, this medallion stands alone, but it is not dissimilar to one that was destroyed in the eastern border (panel 41; Fig. 57B). Most likely, 41 and the centre of 51 were both primary, but the outer rings of the latter were reconstructed in Phase 3.2, and the rim chiselled off the Purbeck

marble tray at the same time. Medallions comprising a central disc of porphyry, enclosed by several concentric rings of triangular tesserae are found in some Italian pavements.

In addition to the foregoing, other localized repairs and alterations took place, including to the small roundels in the northern tomb-cover (56). These interventions are grouped according to style, but cannot be securely placed chronologically: they may have occurred between Phases 2 and 3, but some might have taken place in Phase 3.1. The principal interventions are marked on Figure 108. Phase 3.2 is potentially datable to *c.* 1660 and may reasonably be identified with the recorded repairs carried out at the time of the coronation of Charles II, rectifying damage resulting from abuse of the Abbey during the Commonwealth; the same conclusion was reached by Foster.[105] Phase 3, as a whole, represents a concerted effort to introduce new geometrical forms into the pavement, and is presumably a reflection of the 17th-century burgeoning interest in geometry, mathematics and all matters scientific.

Along with the repairs and alterations came a range of new stone types, including serpentine, Carrara and Belgian marbles (all described in chapter 8). The Belgian stones included black marble from several sources – Tournai and Meuse – which was commonly employed in medieval funerary monuments, and two types of red marble, *rouge royal* and *rouge de Rance*. The former was used extensively in repairs and alterations, and is not present in any primary work. A few pieces of *rouge de Rance* are, however, found in Phase 1 work.

Altar pavement and screen

Between the Cosmati pavement in the sanctuary and that in the shrine chapel is an entire bay of the presbytery which must have been paved, although nothing of antiquity now survives here. The high altar stood on its own dais, but the sanctuary was not transversely divided by two steps as it is today. We have reconstructed the 13th-century topography of this area, eliminating the monumental stone screen that only arrived in 1440, and replacing the 18th- and 19th-century configurations of steps with the arrangement that obtained prior to the Reformation, helpfully revealed in the depiction of Abbot Islip's funeral in 1532 (Figs 16 and 535).

Although unprovable, there is a possibility that the altar was a cosmatesque structure, raised on a single step. The richly decorated Westminster Retable (*c.* 1260–70), an oak panel 3.33m long, was physically attached to the back of the altar by three of the battens that strengthened the panel being elongated to form 'legs' (Fig. 503). The east face of the Retable, including the battens, was decorated to resemble purple porphyry (Fig. 504). Visual communication between the altar and the shrine would not have been obstructed, but low stone or metal screens may have flanked the altar, at the change of floor level between sanctuary and chapel. There must also have been two short flights of steps, approximately where the screen doorways now are, linking the two levels. The differential is 60cm, implying at least four steps, or possibly five (Figs 533 and 535).

We have argued that there must initially have been aesthetic continuity between the sanctuary pavement and that in the bay now occupied by the Victorian altar pavement, but which was previously floored in 1706 with various coloured marbles (Figs 35–37). Plain Purbeck marble slabs here and on the high altar dais would not have sufficed in the 13th century, and we may reasonably surmise that there was a further substantial area of decorative paving, potentially either Cosmati or *opus sectile* work. If it followed Italian precedent, a relatively narrow 'carpet' of mosaic might be expected in front of the altar dais, with separate panels to north and south, respectively. There may also have been something more colourful than merely squares of Purbeck paving on the north and south walkways flanking the sanctuary pavement. Dart certainly implies that was so, when he wrote that the pavement 'was for the most part sav'd; yet they broke it up under where the Altar stands, and where the marble Slabs lie round the edges on the sides' (p. 16). He is evidently referring here to the walkways on the north and osuth.

ST EDWARD THE CONFESSOR'S CHAPEL AND ITS PAVEMENT

The underlying topography of the chapel, 11th to 13th centuries

For Henry III, the rebuilding of Westminster Abbey revolved around his personal devotion to St Edward, and inevitably the existing Romanesque shrine will have remained the focus of the

entire operation. That shrine, constructed in 1161–63, would have been a low, tomb-like structure, possibly divided longitudinally by a spine wall, and with two or three 'port-hole' openings (*foramina*) in each of the long sides. Matthew Paris illustrated the 12th-century shrine base three times, as he saw it in the 1240s.[106] In the first, he showed the uncoffined body of the saint lying on a mattress(?) on top of the pedestal, being inspected and censed. The base had two circular *foramina* visible in the side, with another implied in the west end.[107] The masonry is represented as small ashlars with double-lined joints.[108] In the second drawing, we see an ornate Gothic feretory standing transversely on the same base, with a gathering of pilgrims and the sick.[109] The third illustration shows the Gothic feretory, this time lying longitudinally on the base, which is draped with textile that conceals the three *foramina*, but the ashlar masonry of the pedestal with its double-lined joints can still be glimpsed.[110] The feretory has been opened, the upper (roof) portion being held aloft while Henry III embraces and reveres the body of the Confessor (Fig. 290A).

A depiction of St Thomas's shrine base in stained glass at Canterbury Cathedral is similar to Edward's, except that the openings were either oval or D-shaped. The base of St Osmund's shrine at Salisbury still survives, and that has three D-shaped *foramina* in each side. These were all fairly plain structures, but in the early 13th century greater elaboration became fashionable, although the basic form did not change; we witness this in the surviving fragments of St Swithun's shrine at Winchester.[111] Minor shrines, however, remained plain: e.g. St Hwita's at Whitchurch Canonicorum (Dorset) and St Bertram's at Ilam (Staffordshire). Each has three *foramina*, the former vesica-shaped and the latter quatrefoiled.[112]

Although there is nothing to confirm whether the site of Edward's tomb became a significant cult-focus in its own right, it was a powerful secondary relic, certainly not lost from view, and was therefore presumably revered as a cenotaph. Hence, there were three liturgical foci closely juxtaposed on a west–east axis in the sanctuary of the Confessor's church: tomb, high altar and shrine. At least the first and the third will have left archaeological evidence in the ground, but where, and at what depth? We know that 11th-century floor level in the present sanctuary was *c.* 1.10m below the Cosmati pavement, and that equates to 1.70m below pavement level in St Edward's chapel. This closely corresponds to the foundation offset (indicative of floor level) on the inner curve of the 11th-century apse, which was revealed by excavation in 1910 (Figs 261 and 530). If Edward's coffin was placed in a stone-lined chamber beneath that floor, as would undoubtedly have been the case, then the base of the chamber is likely to have been about 60cm deeper. In other words, the base of Edward's tomb-chamber was *c.* 2.30m below the present Cosmati pavement level.

We cannot be certain whether the grave simply had a cover-slab set at floor level, as was typical for the period, or was surmounted by a tomb-chest. However, a royal grave of this importance is more likely to have been dignified with, at least, a low chest. Either way, the Confessor's coffin must have been sunk into the floor, not encased in a structure above it, a situation implied by the monks' impatience to have Edward canonized, and not to 'lie hidden buried in the earth' (p. 306). Whatever the precise form of the tomb-chamber, it not only survived the Henrician reconstruction, and was incorporated in the new presbytery, but was deemed suitable to be twice reused as a temporary sepulchre in the late 13th century, first for a king and then for a queen (but see further,

530 Edward the Confessor's church. Southern side of the apse foundation, as exposed in 1910. This vertical view shows the masonry offset (A–A) that marked internal floor level, 1.7m below the present Cosmati pavement. East is at the top. *Authors*

pp. 574–6). Consequently, the circumstances point strongly to the Confessor's tomb having been a substantial masonry structure below, and possibly also above, floor level and that it was carefully preserved in the great rebuilding.

So where did the first shrine stand? To answer that, we need to look back at the mid-11th-century topography of the sanctuary. There can hardly be any doubt that the altar lay within the apsidal termination, although how close it was to the east wall is debatable. Nevertheless, the floor area within the apse was not great, and King Edward was buried in front of the high altar, in a tomb that he constructed even before the altar was installed.[113] From this, we may deduce that Edward had determined that the Abbey would be his burial place sometime in the 1040s or early 1050s. By doing so, he unwittingly laid down a marker that, two hundred years later, prompted Henry III to propel Westminster into fulfilling the role of royal mausoleum for the ensuing six centuries.

Floor level in the sanctuary would have been elevated above that in the remainder of the presbytery, if only by one step, and that is likely to have been on the chord of the apse. The altar of St Peter may have been additionally raised on a dais. There was doubtless also a low screen running across the chord, and it is reasonable to deduce that the altar lay against, or towards, the east wall of the apse, leaving sufficient space between it and the screen to accommodate Edward's tomb. In terms of the 13th-century (and present-day) topography, that would place the 11th-century high altar on the site where the shrine altar now stands, and the empty tomb under the western edge of the Cosmati pavement, where GPR has revealed a masonry chamber (p. 254).

The shrine of 1163 could have been placed directly over the now-empty grave, but that would have presented a significant physical and visual obstruction to the altar. Moreover, it would not have been a location to which pilgrims would have been admitted, and we can discount it. The shrine therefore occupied the traditional position behind (i.e. east of) the high altar. The corollary of that tells us something about the plan of the east end of Edward's church: there must have been either an ambulatory around the apse, or an eastward-projecting chapel, or perhaps both. We are strongly of the opinion that there was an ambulatory, and hence the inner apse wall was

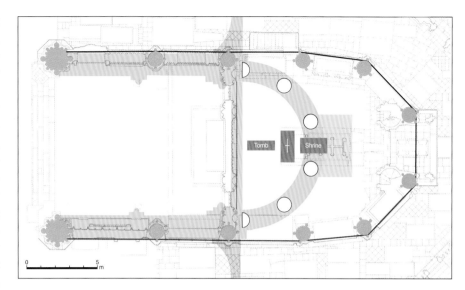

531 Edward the Confessor's church. Reconstructed plan of the topography of the apsidal sanctuary in the 1160s. *Authors*

presumably arcaded, with screens in each bay (Fig. 531).[114] That being so, the axial bay on the east would not have required modification to accommodate the shrine, which would nevertheless have projected somewhat into the ambulatory. That in turn would have provided a convenient access route for pilgrims to visit the shrine without the need to enter the presbytery.[115] The shrine might either have abutted the east face of the high altar or, more likely, stood at a slight remove.[116]

Although we have deduced the layout of the apsidal bay of Edward's sanctuary with some confidence, based on the archaeologically recovered plan of its foundation and the description contained in the *Vita Aedwardi Regis*,[117] additional supporting evidence, particularly for the location of the primary tomb, is required. Since there can be no question of ever disturbing either of the Cosmati pavements in order to excavate beneath them, another method of interrogating the inaccessible archaeology needed to be found, and GPR provided the solution. Surveys of the sanctuary and high altar pavements resolutely failed to reveal any evidence for a significant sub-floor chamber in those areas (pp. 254–5). Hence, the likelihood that either the Confessor's tomb, or its access point, lay within the present sanctuary could be eliminated. East of the high altar stands the 1440 stone screen, and immediately beyond that an unexplained band (80cm wide) of mixed tile and stone paving, also partly of late medieval date, before we reach the western edge of the Cosmati floor, which is distinctly worn (Figs 226 and 230, zone F). Closer inspection of this anomalous band shows that it is in three parts: towards the north and south are the

remains of regular Purbeck marble paving slabs, similar to those flooring the east end of the chapel. The central 3.3m of the band is filled with a jumble of materials, but with regular stone blocks punctuating the interfaces on the north and south (Fig. 534; also marked 'a' and 'b' on Fig. 230). These blocks have the appearance of being the tops of stub-walls, projecting westwards from the Cosmati pavement: we suggest they flanked short flights of steps connecting the levels in the sanctuary and St Edward's chapel (Fig. 533, nos 9 and 10).

The GPR survey of the chapel floor was highly instructive. It revealed that between the western edge of the pavement and the shrine altar there is a now-infilled rectangular chamber, and that its depth is in the region of 1.8m. The eastward extent of this structure could not be determined owing to the presence of the altar itself, and beyond that the shrine pedestal. The existence of a large feature beneath the floor here is additionally confirmed by the fact that the area is capped with a single, massive slab of Purbeck marble, forming part of the matrix of the Cosmati pavement (Fig. 230, no. 16). The unparalleled size of the slab (3.25m × 1.5m) is commensurate with the need to bridge an open-topped rectangular chamber, a feature substantially wider than a single grave. The obvious conclusion is that the Confessor's tomb was preserved by constructing a small crypt-like chamber around it. The floor slab is an integral part of the 1260s pavement, and has certainly never been disturbed since it was laid. Consequently, access to the interior of the chamber must have been obtained from beyond the extremities of the Cosmati pavement, and that could only have been from the west.

Collectively, the evidence is sufficient to claim that the Confessor's tomb lies under the western edge of the chapel pavement, and that in the 13th century access to it could be gained from the west, behind the high altar. There follows a remarkable corollary: the 13th-century shrine altar (and its successor of 1902) must overlie the 11th-century altar of St Peter, or be very close to it. Moreover, the shrine of 1269 must be on approximately the same site as that of 1163.[118] These coincidences cannot be fortuitous. Preserving and physically incorporating the three major liturgical foci of the Confessor's sanctuary in the new shrine chapel is wholly in keeping with the devotion of Henry III. We need next to consider what practical steps had to be taken to ensure the intact preservation of the Confessor's tomb-chamber during the rebuilding of the church, and how permanent access to it was provided.

In sum, Edward's church had a presbytery of two bays, and a modest-sized apsidal sanctuary which was probably ringed by an ambulatory. The high altar and Confessor's tomb lay within the apse, but when the Romanesque shrine was constructed to the east of the altar it projected through the arcade wall, into the ambulatory beyond, or into a specially created chapel. When Henry III rebuilt the eastern arm of the abbey church, he did so with care and deliberation, retaining the primary grave intact and positioning his new shrine over the foundation of its predecessor. Moreover, the shrine altar perpetuated the site of the original high altar. Henry made his two-bay sanctuary c. 1.5m wider in the north–south dimension than the quire of Edward's church, thereby physically encapsulating the foundations of the former.[119]

Demolition and preparations for reconstruction: some logistical considerations

On 31 July 1245, Pope Innocent IV issued a bull stating that he had been informed that the King of England was preparing to transfer to another spot in the Abbey the body of St Edward, and he granted a release from enjoined penance of one year and forty days for all who flocked to Westminster on the day of the translation.[120] Hence the first (interim) translation of Edward occurred sometime between August and early October 1245, and was shortly followed by the exhumation of Queen Edith's remains (p. 308).[121] It may be assumed that the 1133 shrine pedestal was relocated at the same time. Furnishings and other important burials would also have been removed during the course of the summer, and the latter included the recycled Roman stone sarcophagus that was later reinterred on North Green (p. 544).

The next task was to secure the physical remains of the Confessor's tomb, and that was achieved by constructing a rectangular, stone-walled chamber around it: a small crypt, or *hypogeum*. Since floor level in the new chapel was destined to be considerably higher than that in the sanctuary of the 11th-century church, it was necessary to build the walls of the chamber up

to proposed pavement level. Consequently, the internal height of the chamber is at least 1.60m, the width can be established as 2.5m, and the length is uncertain, but possibly *c.* 3.0m; the walls are 75cm thick. These details can be gleaned from a combination of the GPR results and archaeological evidence preserved in the structure of chapel floor. At this stage the chamber was probably capped with heavy balks of timber, later to be replaced with the large Purbeck marble slab that forms an integral part of the Cosmati pavement. The saint's grave was thus protected within a small crypt which would eventually become a significant feature in Henry III's new presbytery.

Demolition of the eastern arm of the 11th-century church took place, and foundations were dug and laid for the new building. The crypt-chamber would have remained covered and the Confessor's tomb protected for five years, at least, while the ambulatory arcades were erected, together with the superstructure above them, including the high vault of the presbytery. Then a panelled retaining-wall 1.5m high was built, in separate sections, between each pair of piers around the eastern bays of the ambulatory. That wall defined and supported the platform upon which St Edward's chapel would be created. Ground level within the retaining-wall had to be raised by dumping *c.* 1.30m of soil and masons' stone waste, to provide a solid base upon which to lay the chapel pavement. At the same time, support for the new shrine and its stepped podium had to be provided. This was a sizeable construction weighing several tons, and it needed founding on a solid base, not on unstable material recently deposited to raise floor level. It was therefore necessary to build a masonry raft or other substructure that could carry the load without settlement.[122] This can be identified on the GPR survey, which has revealed bands of masonry running along the north and south flanks of the shrine pedestal, and seemingly extending beyond it to the east (p. 254; Fig. 256).[123]

By the time this stage of the work was completed, ground level in the chapel had been raised and the crypt chamber surrounded on three sides by rubble and soil: it had become a subterranean feature. The fourth (west) side was part of the retaining-wall that ran across the full width of the presbytery and defined the change of floor level between the sanctuary and St Edward's chapel. By forming an opening at the centre of that low wall, access to the tomb-chamber was readily obtainable from the west (Fig. 533).

Laying out the chapel in the early 1250s

Although Henry III rebuilt the liturgical heart of the Abbey on a larger and architecturally far more ambitious scale, he preserved the *locus* of the 11th-century eastern arm *in toto*, while expanding its footprint in all directions. Moreover, as we have just demonstrated, he chose to preserve, as fully as possible, one critical area: the burial site and focus of commemoration of Edward the Confessor. That decision having been made, other elements of the presbytery had to be repositioned, including the high altar, which was given a new, spacious setting against the east side of a much enlarged sanctuary.

No structural division was intended between the sanctuary and the chapel of St Edward, the principal demarcation being a change in floor level, accompanied by steps and, possibly, a low screen. The chapel was raised on a platform, hence when seen from the monks' quire, the shrine rose majestically behind the altar in the sanctuary; also, the chapel as a whole towered impressively over the ambulatory that encompassed it on three sides. The arrangement was not just an ensemble of cosmatesque decoration, but a display of architectural grandeur, the progressive rise in levels culminating with the Confessor's shrine which itself was raised on a podium of four steps above the level of the chapel floor (Figs 533 and 535).

Once the chamber protecting the Confessor's tomb was capped and the chapel floor laid over it, access could only be obtained by providing a permanent entrance through the retaining-wall on the west, which was necessary so that the faithful could view this important secondary relic. Coincidentally, it also facilitated the chamber's use for temporary entombment in exceptional circumstances (as occurred in 1272 and 1290). The arrangement indicated by the archaeological evidence bears comparison with small Anglo-Saxon crypts and *hypogea*, where access to the burial chamber was normally from the west, via a short passage and often a narrow flight of steps. The 7th-century crypt at Hexham Abbey (Northumberland) is a classic example,[124] but the simpler *hypogeum* at Glastonbury Abbey (Somerset)

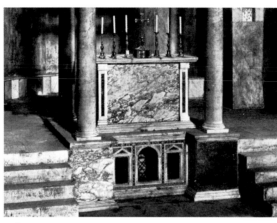

532 *Confessiones* in Italian churches. A. San Giorgio in Velabro, Rome; B. Ferentino Cathedral. *Hutton 1950, pls 20 and 23*

A

B

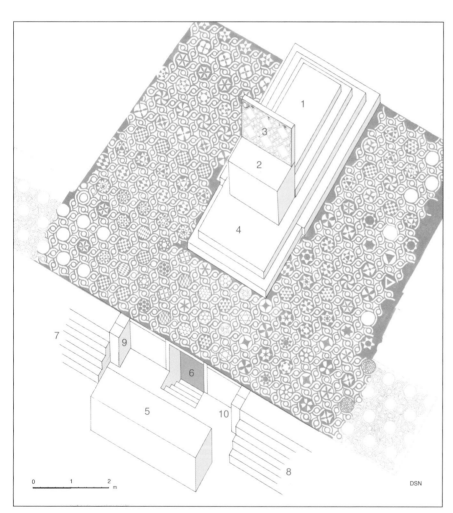

533 St Edward's chapel. Indicative axonometric reconstruction of the chapel platform and principal features. *Key*: 1. Four-stepped podium carrying the shrine (the latter omitted for clarity); 2. Altar of St Edward; 3. Shrine retable; 4. Two-stepped dais for altar; 5. High altar and the Westminster Retable (the latter omitted for clarity); 6. Retaining wall for the chapel platform, pierced by the *fenestella* and entrance to the crypt containing Edward the Confessor's primary tomb; 7, 8. Steps; 9, 10. Stub-walls flanking the steps. *Drawing by David S Neal*

is more commensurate to the scale of the Westminster chamber.[125]

However, Henry III did not take his cue for the Confessor's crypt from Anglo-Saxon England, but from Rome. The provision of a small, underfloor relic chamber (*confessio*) directly beneath an altar platform, and entered from the west via a low doorway, was common in major Italian churches, as, for example, at San Giorgio in Velabro, Rome and Sant'Andrea in Fulmine, Ponzano; and the cathedrals of Anagni and Ferentino (Fig. 532).[126] In all of these, a small, arched opening is sited axially in the transverse retaining-wall at the edge of the sanctuary, and an iron grille or pierced door forms a *fenestella* through which the relic housed within the chamber could be viewed.

In some Italian churches the *fenestella* comprises a single aperture on its own, but in others it is flanked by a pair of blind arches or cosmatesque panels, forming a tripartite façade to the *confessio*. That façade, particularly in the case of San Giorgio in Velabro, provided the inspiration for the tripartite south elevation of the lower chest of Henry III's tomb (p. 581). In all the Italian examples, short flights of steps to the north and south of the *confessio* facilitated access from the lower to the upper level; some are approached from the west, as we envisage was the case at Westminster (Figs 533 and 534), but in other instances the steps are turned through ninety degrees, so that they run parallel to the retaining wall and are integrated with low cosmatesque-decorated screens (Fig. 532B). The crypt at Westminster was necessarily

larger than some of the Italian *confessiones* because it enclosed a complete *in situ* tomb, rather than a portable relic.

There was another significant difference too: in Italy, the *confessio* lay directly beneath the high altar, whereas in Westminster it was surmounted by the shrine altar. The high altar lay further west, and access to the *fenestella* was from behind it (Fig. 533). The topography of the presbytery underwent fundamental change in the early 1440s, when the interface between the sanctuary and St Edward's chapel was remodelled and the present stone altar screen erected, creating total visual separation between the two areas. Floor levels in the eastern part of the sanctuary were adjusted and doorways incorporating steps provided access through the screen, to reach the chapel pavement. Access to the entrance to the Confessor's tomb-chamber was cut off, and its very existence soon forgotten.

The façade to the crypt may still be preserved beneath the chapel floor. We have noted that the new stone screen of 1440 was not erected directly against it, but 80cm to the west (p. 553; Fig. 534). Furthermore, it is just possible that cosmatesque decoration is still present on the now-buried façade around the *fenestella*: a tantalizingly brief newspaper report of 1827 mentions digging a hole in the chapel floor and finding intact mosaic.[127]

The decision to elevate the chapel brought with it the need to provide stepped access not only for the brethren, but also for pilgrims. Henry III wished St Edward's shrine to be the most spectacular in England, and hence to attract flocks of pilgrims. Two short flights of steps in the sanctuary would have satisfied the needs of the brethren, but making provision for the anticipated crowds of laity surely demanded another solution, one that incorporated a circulatory system. The fact that Westminster failed to become one of the most popular shrines in medieval England would not have been countenanced in the 1250s, and we must assume that Henry's scheme was devised to accommodate a high foot-fall.

We have argued the case for flights of steps in the north and south ambulatories, providing entry to, and egress from, St Edward's chapel through the westernmost arcade bays (p. 311; Fig. 535). The laity could easily be channelled from an external entrance in the north transept to the ambulatory, without impinging upon the inner workings of the monastery; a doorway at the north-east corner of the transept communicated directly with the

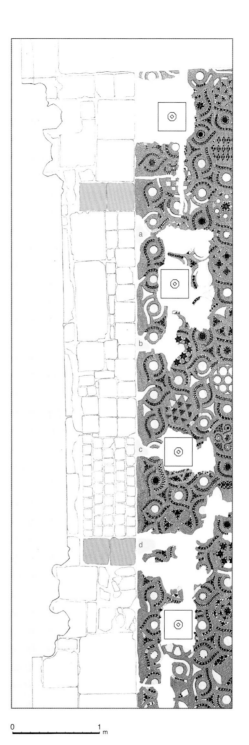

534 St Edward's chapel. Western edge of the Cosmati pavement, showing the two projecting stub-walls, with medieval Purbeck marble paving to the north and south, and mixed tile and stone infill between the walls. This anomalous band of flooring – shown in outline – infills the gap between the Cosmati pavement and the altar screen of 1440. Areas of damage on the edge of the pavement (a–d) may mark the positions of medieval stanchions for an iron railing. The four prominent, square stanchion bases were cut into the pavement in 1954. *Authors*

outside world (Fig. 6, marked 'A' and Fig. 293). It must be acknowledged that no specific evidence for steps survives in the ambulatory, but the moulded string-course on the edge of the westernmost bay of the chapel platform was partially renewed before Edward I's tomb-chest was installed. Since that moulding was made from part of an indent containing lettering that can be dated to *c.* 1300, an alteration to the platform edge has unquestionably occurred. When the posited steps

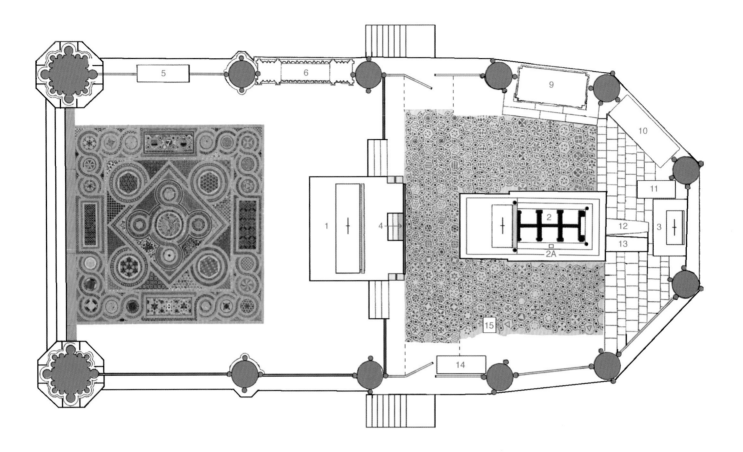

535 Reconstructed plan showing the topography of the sanctuary and St Edward's chapel in *c*. 1300.

Key: 1. High altar and retable; 2. Shrine and altar of St Edward the Confessor; 2a. Henry of Almain, heart burial (d. 1271); 3. Holy Trinity altar; 4. Crypt protecting the site of St Edward's primary tomb (1066); 5. Aveline, Countess of Lancaster (retrospective monument, *c*. 1297); 6. Edmund, Earl of Lancaster (d. 1296); 7. Abbot Richard de Ware (d. 1283); 8. Ossuary; 9. Henry III (d. 1272); 10. Eleanor of Castile (d. 1290); 11. John of Windsor (d. 1271) and brother Henry (d. 1274); 12. Aveline, Countess of Lancaster (d. 1274); 13. John and Margaret de Valence (d. 1277); 14. William de Valence (d. 1296); 15. Site of St Edward's Chair (Coronation Chair, 1300). *Authors*

were in place they would have interrupted the string-course, necessitating the addition of a new length of moulding upon their removal. Thus, the fortuitous inclusion of a datable fragment of tomb-slab provides indirect evidence that there were indeed steps up from the ambulatory to the chapel at this point (p. 522; Fig. 518). Additionally, it has already been noted that the north–south 'carpet' of Cosmati mosaic traversing the west side of the chapel appears to extend into the arcade bays, where it would form thresholds at the points of entry and departure (p. 222; Fig. 227).

The only alternative to the foregoing scenario would be to accept that pilgrims were permitted, *ab initio*, to enter the sanctuary from the north transept, via the crossing (which was part of the monks' quire), and follow the walkway bordering the Cosmati pavement, to reach the steps up to the chapel. Although not without precedent, such an intrusive arrangement would have been unorthodox and extremely unlikely in the context of Henry III's Westminster Abbey. In addition, it would mean that pilgrims had either to return from the shrine by the same route as they entered the chapel, or exit via the walkway along the south side of the sanctuary pavement, into the quire and south transept; they would then have to circumnavigate the ambulatory to exit via the north side of the Abbey (p. 311). Such intrusion into the heart of the church was surely uncountenanceable?

Henry designated Westminster Abbey as the royal mausoleum, not only by installing his own tomb

in the second bay on the north side of the shrine chapel – the most prestigious location, and traditional for a founder – but also by his treatment of the inter-bay retaining-walls buttressing the platform. The face of each section of walling is relieved with a rectangular panel, giving it the appearance of the side of a tomb-chest. Thus, when a tomb was constructed on the chapel pavement, and centred under one of the arcade bays, it would automatically appear from the ambulatory to be a two-tiered structure. This was no more than *trompe l'oeil*, but it instantly imparted *aggrandisement* to the tomb (cf. Figs 292 and 433).

As a mausoleum for monarchical tombs, the chapel was not large, there being only seven arcade bays in all, including the two that we have proposed as access points. Also, the easternmost bay could not be utilized as a tomb setting because its axis ran north–south and it was occupied by the altar of the Holy Trinity, where the Abbey's relics were assembled.[128] Hence, if all the other bays were filled with the tombs of monarchs, the total would still only amount to six. Octagonal side-chapels ringed around the ambulatory could, of course, accommodate many more royal tombs, and several could fit under the north and south arcade bays of the sanctuary.

From the outset, unoccupied bays around St Edward's chapel and alongside the sanctuary had to be screened from the ambulatory, to maintain security. One small piece of spiked iron railing survives at the west end of Henry III's tomb, demonstrating that even a narrow gap had to be obstructed, to prevent anyone from squeezing through (Figs 431 and 433). No evidence remains to confirm the material from which the screens in the empty bays were made, but wrought iron is perhaps the most likely. Had they been walls of ashlar we would expect to see evidence for occasional bonding with the arcade piers and probably vertical lines scribed by masons at the points of abutment.[129] Timber panelling, or studwork and plaster, are the other options, but the usual tell-tale evidence one might expect to see on the piers is lacking.[130]

The shrine pavement

East of the altar screen lay the shrine chapel of St Edward which, despite having a gross floor area in excess of 90m², was exceptionally constrained in its layout. In the first place, the plan is not rectilinear, the north and south sides being canted on account of the polygonally apsidal termination to the eastern arm of the church. Secondly, the centre of the chapel is occupied by the monumental shrine-tomb, its stepped podium and St Edward's altar. Effectively, these obstacles compartment the floor into four areas of differing plan: rectangular to the west, irregular quadrilaterals on the north and south, and trapezoidal on the east (Fig. 221).

For reasons that have not hitherto been explained, the easternmost part of the chapel never received decorative paving. Instead, it is floored with regular Purbeck marble slabs of two different sizes, laid in north–south rows. Some of this paving must have been laid, or re-laid, following the construction of Henry V's chantry in *c.* 1437–41, a major intrusion into the chapel. In the northeast corner, five rows of primary paving remain, and the slabs are, alternately, 30cm and 45cm square (Figs 225 and 230). These dimensions accord with surviving 13th-century paving elsewhere in the Abbey.

The likely reason for not continuing the mosaic work further east was to provide an area within the chapel where the floor could be easily lifted and interment take place, especially of young children, enabling them to be buried close to their royal parents. The account of the burial in 1284 of Alfonso, the eleven-year-old son of Edward I, confirms not only that his grave was in the paved area, but also that he was interred 'among his brothers and sisters', already there (p. 484). Similarly, John de Valence had been buried 'beside his sister' in 1277. Moreover, the GPR survey revealed a north–south row of small graves beneath the paving (Fig. 258). In similar vein, the mosaic pavement was not continued into the arcade bays (with the exception of the westernmost bay), so that royal tombs could be sited there in the future. The tightly interlocked arrangement of the Purbeck marble slabs forming the matrix of the mosaic pavement indicates that there was initially no intention of disrupting the tessellated area for burials, although by the 1390s respect for its integrity had waned and graves were thereafter cut through it with impunity.[131]

This left the remaining three paving zones, which together constituted a roughly U-shaped plan around the shrine pedestal. It is immediately obvious that a formal geometrical design, or one with a strong rectilinear emphasis, would have been

aesthetically incompatible with the space, and was out of the question: the floor plan demanded a pattern that would not visually fragment the area into three separate compartments, but would unite them and flow seamlessly around the sides of the shrine and altar, while at the same time coping unobtrusively with the cants on the north and south. It had also to provide a suitably rich setting for Henry III's own mosaic-encrusted tomb, and to be harmoniously in scale with both it and the shrine pedestal. The solution was to design a pavement with a small-scale pattern that was non-geometrical and non-linear; in other words, a fluid 'carpet' design (Plan 4). That is precisely what was achieved with the shrine pavement, and the additional goals were successfully met through the shared use of design components, such as small roundels packed with tiny coloured glass tesserae, quincunxes and six-pointed stellar motifs. Certain materials, principally purple and green porphyry and translucent glass, were also common to both monuments and the pavements.

The marked difference in style and appearance between the floors of the sanctuary and shrine has often been commented upon, some writers citing this as evidence for different teams of mosaicists, working at different times. There has also been a tendency to denigrate the shrine pavement as inferior, and even assert that it is of British rather than Italian workmanship. Burges, for example, stated:

> … a small pattern is cut in square slabs of Purbeck, and could easily be prepared in advance, and would require little skill to lay down. The disposition of the circles partakes more of a diaper than any Italian example, and in all probability must be referred to a Northern workman endeavouring to do something like Abbot Ware's pavement, only in his own way.[132]

What this principally reveals is Burges's failure to grasp the intricacy of the shrine mosaic, or to understand the methodology and skill required to create it. Comparison with the sanctuary mosaic is futile since the two floors were intentionally dissimilar not only in style and construction, but also in the scale of the motifs displayed. Moreover, differences in the geological composition of the pavements provide crucial evidence for their relative chronology. Carrara marble was employed for the white tesserae in the shrine pavement, and is also present amongst the surviving mosaic on the shrine pedestal, but is not found in the main body of the sanctuary pavement, where English white lias was substituted. Significantly, the only occurrence of Carrara marble in the primary phase in the sanctuary is in Ware's tomb-cover, the design details of which were replicated from the shrine and Henry III's tomb. The shrine pavement is undoubtedly the earlier of the two, and is unconnected with Abbot Ware.

Burges was also in error when he described the Purbeck marble matrix as 'cut in square slabs'. Unlike a panelled tomb, it was not something that could be prefabricated in a workshop, and rapidly assembled on site thereafter. Paving the irregular plan of St Edward's chapel demanded a tailor-made solution. Hence, the area designated to receive cosmatesque decoration was paved with Purbeck marble slabs, fitted together so tightly that they required no mortar in the joints. It was inconsequential that the slabs were all of different sizes: the aim was to create what would appear – once it had been inlaid with mosaic – to be a seamless pavement.

Accordingly, the mosaic draughtsman treated the floor as though it were a single slab, on which he drew an uncompartmented, flowing design based on medallions and small roundels, linked together by curvilinear bands. The design was modest in scale, and indefinitely expandable in all directions, thereby having the ability to mould itself around the irregularities in the chapel's plan. Essentially, it was a 'fitted carpet' in marble and glass mosaic. The masons then chased the patterns in the Purbeck marble in the same way that they would for prefabricated panels, except that in this instance the entire floor comprised a single *in situ* panel, and could not be taken into the workshop.

Templates, which the Cosmati workers would have brought with them from Italy, were employed to delineate the matrices for the medallions. Thirty-eight different patterns have been recorded (Figs 231–239).[133] Only in the case of the Catherine wheel did it make any difference which way up the template was placed on the floor, and there is just one example where the wheel spins anti-clockwise.[134] The number of patterns represented in the medallions far exceeds the total of four that we have been able to discover in any Italian floor or monument. The implications are far-reaching: massive losses of small-scale medallions containing intricate Cosmati work must have been incurred in Italy.

Although intricate 'carpet' designs that lack the geometrical formality and monumentality of schemes involving bold squares, straight-line borders and circles of large diameter, are rare in Italy, examples can be found in Rome, as at Santa Maria in Aracoeli. There, a reticulated pattern is based on small hexagons, the pavement filling an apse far more effectively than a rectilinear design ever could.[135] Hutton recognized similarities between the design of the shrine pavement – with its all-over pattern of medallions and roundels, bound together by sinuous curves of finely detailed mosaic – and a section of pavement at Farfa in Sabina (Fig. 536).[136] However, the scale of the work is larger and the technique of execution different, since the geometrical framework was assembled in the usual Italian way by cutting curved sections of marble and fitting them together. We have been unable to find another example of a 'carpet' pavement where the entire decoration was chased, *in situ*, into a pseudomonolithic stone floor.

The closest analogy for the design of the shrine pavement is found at San Lorenzo fuori le Mura, Rome, where a strip of pavement alongside the altar not only exhibits the same carpet-like design of medallions, bound together by sinuously curved mosaic bands, but the principal motifs are also replicated at Westminster.[137] The comparison with San Lorenzo is made stronger by the fact that the mosaic decoration is not fitted within an assembled framework of curved bands of marble (as at Farfa in Sabina), but is set in matrices chased into a rectangular marble tray, exactly as at Westminster (Fig. 537).[138] Comparisons between the shrine pavement and other monuments are not easy to draw on account of the detailing being on a much smaller scale. Nevertheless, there are some striking analogies, such as the single occurrence of an eight-petalled rosette in medallion 25b of the pavement, which is not dissimilar to those on the front and south end of the sarcophagus of Pope Clement IV at Viterbo (Figs 241 and 538).[139] Intriguingly, the same motif predominates in the pattern woven into the cloth-of-gold covering Henry III's coffin (Fig. 478). The cluster of seven circles found in pavement medallion 16a is precisely matched by the heads of the blind Gothic tracery in the backs of the niches of the shrine (Fig. 337); it also occurs on the front of the pope's sarcophagus. The seven hexagons within a circle (roundel 11b) is geometrically the same as a roundel on the lower chest

536 Farfa in Sabina, Italy. Detail of a pavement comprising medallions linked by curvilinear bands. The scale of the design is relatively large and the matrix composite. *Hutton 1950, pl. 62*

of Henry III's tomb (Figs 241 and 470B), and the cluster of seven six-pointed stars within a circle (medallion 15a) relates to another roundel on the same tomb (Figs 241 and 467B).

The *cross pattée* is not found on the sanctuary pavement, but is a recurrent motif in several medallions on the shrine pavement (e.g. 21b, 27b, 35a), and also occurs prominently in a group of interlaced circles in the back of niche 6 of the shrine pedestal (Figs 233, 236 and 350). Additionally, there are two less conspicuous examples in the altar retable (Figs 331 and 332B). A motif that is, however, shared by the two pavements is a large, six-pointed star composed of spindles, set in a concave-sided hexagon. It is found in panel 52 in the sanctuary and medallions 4b, 32i and 38d in the chapel (Figs 90 and 231–238). Another is the concave-sided square, in positive form on the chapel floor (panel 20b) and negative on the sanctuary (panels 34 and 44); it is not uncommon in Roman monuments and pavements, as at San Giovanni in Laterano and Santa Maria Maggiore.[140] The stencils used for the pavement in the sanctuary were considerably larger than those for the shrine.

We have noted that greater care was expended on chasing the designs in the marble matrix on the north and west sides of the chapel pavement, than on the south. There, the work was unregulated

537 San Lorenzo fuori le Mura, Rome. Part of the pavement alongside the altar, consisting of small medallions linked by curvilinear bands. The matrix was chased into a marble tray. *Drawn by A. Terzi, 1915*

with no attempt made to terminate the decoration neatly around the margins, which were simply left ragged. Differences are also apparent in the distribution of various types of small roundels (Fig. 245), and with the quantity of glass inset into the pavement, the overwhelming majority of it occurring on the north side. It may be argued that there was an intention to create a strong aesthetic link between the pavement, the Confessor's shrine and Henry III's tomb, all of which were heavily decorated with glass.

We have discussed the sequence of tomb construction and flooring within the chapel (pp. 221–5): it is inconceivable, given the innate delicacy of this pavement, that cutting the matrices and inserting the mosaic decoration would have occurred until both the shrine pedestal and Henry III's tomb had been installed.[141] One gains a clear impression that much care was lavished on the northern and most of the western sections of the pavement (especially in front of the shrine altar), and that there was then a hiatus. That was followed by an urgent instruction in 1267 to complete the pavement, whereupon a less conscientious team of carvers hurriedly chased out the matrices, which were then infilled by mosaicists who had very little glass to hand.

The masons who chased the southern section of paving did not continue the regular rhythm of the designs in the medallions, but adopted a random-selection approach: they picked up and drew around whichever template came readily to hand. Interestingly, several of the designs occur only once here, and are unrepresented in the northern and western parts of the floor, e.g. the *crosses pattées* and large triangles (two types of each).[142] Fortunately, this final phase of work on the south side of the pavement – and in St Edward's chapel generally – is datable. The king's expenditure on the Abbey in the first nine months of 1267, mentioned various craftsmen, including the wages of 'certain masons, paviours [working] before the shrine of St Edward'. Since a further payment was made to the men for continuing into the following year, they were not engaged on a minor task.[143] The implications of these references for the dating of the shrine pedestal were noted by Claussen and Carpenter, but refuted by Binski, yet they are crucially important.[144] There can be no serious doubt from the very specific wording, *ante pheretrum Sancti Edwardi*, that the paviours were working to one side of the shrine, and that it was already *in situ*.

In sum, there were five stages to laying the floor and erecting the two primary monuments in the chapel. First, a deep sub-floor structure had to be built to support the pedestal. Secondly, the footprint for the shrine was marked out and paved with plain Purbeck marble slabs, followed by construction of the stepped podium. Thirdly, rectangular marble slabs of random sizes were cut and laid throughout the chapel, providing a working floor for the teams erecting the monuments. The largest of those slabs also doubled as the capstone for the crypt containing the saint's primary burial place. Fourthly, the components for the shrine of Edward the Confessor and tomb of Henry III were brought into the chapel from the workshop where they had been made, and were erected. Fifthly, the master mosaicist set out the decorative scheme on the pavement, and the masons and paviours chased the Cosmati design in the floor and installed the mosaic decoration therein (Plan 4). The structural sequence is straightforward and there is no logistical obstacle to seeing the shrine pedestal, Henry III's tomb and the pavement complete by the end of 1268, and certainly well before the saint's translation in the following October.

ST EDWARD'S SHRINE-TOMB AND ALTAR

Making liturgical provision during the structural interregnum

Before the first stage of demolition of the Confessor's church began in 1245, the Romanesque shrine and high altar had to be dismantled. Logically, they would have been re-erected in one of the more easterly bays of the nave, which had to serve as a temporary sanctuary at least until 1259, when the second stage of demolition began. The saint's empty tomb was also protected, so that it could be incorporated in the rebuilt presbytery, as a cenotaph. Planning the rebuilding of Westminster Abbey must have begun *c*. 1240, and work was put in hand on the new shrine and feretory in 1241. Once demolition began, access to the site of the 11th-century sanctuary for any form of religious observance would have been impossible for at least five years, while the new presbytery was under construction. Inevitably, the king would have been anxious to regain limited

access to the *locus sanctus* as soon as building works permitted, and it is just possible that two surviving, although somewhat enigmatic, documents shed light on religious activity during what we may term the 'structural interregnum'.

The Westminster Domesday cartulary contains a hitherto unexplained reference to two chapels, one seemingly above the other.[145] It is an indulgence of Richard, Bishop of Bangor, granting release from twenty days of enjoined penance to those 'entering the chapel which is built under the chapel of the Blessed Edward for the sake of prayer and making there any kind of benefaction'. The document is undated, but Richard's episcopate lasted from 1237 to 1267. He was absent from his diocese from 1248 to *c.* 1258, but his movements are not recorded. The bishop is most likely to have granted this indulgence during, or immediately following, a visit to Westminster Abbey in the 1250s. The wording implies that he had seen the two chapels.

To add to the intrigue, a contemporary marginal note in the cartulary states *le capella sub capella S[ancti] E[dwardi] non comparet*. Robinson interpreted this as indicating that the chapel was 'proposed but not carried out'.[146] But it is hardly credible that a bishop should have granted an indulgence in respect of a non-existent chapel in Westminster Abbey, and the *marginalia* need only imply that construction was incomplete at whatever date they were added, and cannot be construed as evidence that the work was never commenced or, necessarily, that it was not brought to completion in due course. The episcopal indulgence is compatible with pilgrimage to a sepulchre that was still in the process of construction.

Despite the locality being firmly tied to St Edward's chapel, interpretation of the document has remained obscure. If the indulgence dates from the 1250s, that would place it in the decade when the present sanctuary and shrine chapel had reached an advanced stage of reconstruction, and Henry III was aiming to complete and dedicate it by 1255 or 1258. Hence at least limited access to these areas must have been feasible. There is nothing to indicate that a subterranean chapel *sensu stricto* was ever proposed or constructed beneath the present St Edward's chapel, but there was of course the Confessor's empty tomb, which we know Henry preserved in an accessible form. The creation of a small enclosing crypt with a west-facing entrance has already been discussed (p. 554).

Laying the present pavement slabs could not have taken place until the decision had been made to create a cosmatesque floor, and that is unlikely to have occurred before *c.* 1260–62. However, it is possible that the temporary roof to the crypt was replaced with the massive capstone at an earlier stage, and that it was initially intended to be part of a more conventional Purbeck marble pavement. The archaeology of the floor confirms that the capstone was the first slab to be laid, followed by the blocks of paving abutting it to north and south. Although in essence the crypt was constructed in 1245–46, it is unlikely to have been structurally and decoratively completed until *c.* 1260. We cannot determine when or why the *non comparet* note was written, but there was certainly an ample window of opportunity for the temporary chapel to be erected, finished and used, before it needed to be cleared away.

A second, also hitherto unexplained, reference to a temporary 'chapel' must be mentioned. In 1252 the king ordered Edward of Westminster to erect a structure 40 feet long by 25 feet wide, but where was it and what was its purpose? The chapel was to be made 'in the new work on the fabric of the feretory of St Edward' (*in novo opera fabric feretri*). It was to be gabled, with at least one window, and the walls made of plaster of Paris, painted with the story of St Edward. Mention is made of a lower chamber (*camera*) which was to be wainscoted and also painted.[147]

Scholars have long debated the interpretation of this instruction, but without conclusion.[148] Lethaby and Colvin opined that it was a temporary structure located somewhere in the palace precinct, close to the workshop where the shrine was being fabricated, and that its purpose was to display the new shrine until such time as it could be installed in the presbytery.[149] This lacks conviction, particularly on account of the allusion to chambers at two levels. Also the wording strongly implies that the chapel was *inside* the Abbey. There is no reference to the materials or external appearance of the structure, but the need for window(s) and a plastered interior are mentioned, both being provisions that one would normally take for granted. Interestingly, this is one of the earliest recorded mentions of plaster of Paris in England, a material that cannot withstand dampness and is suited only to dry, internal conditions.[150] Describing it as 'in the new work' is therefore

compatible with the chapel's erection inside the partially completed eastern arm of the Abbey.

We may concur with Lethaby and Colvin that the king was ordering a temporary structure to be created, and the explicit reference to the subject-matter of the wall paintings confirms that it was associated with honouring Edward the Confessor. Some commentators have assumed that, because it does not feature again in the historical record, and its whereabouts could not be determined, the chapel was never built. Whether or not that was the case, remains an open question, but there is one further clue pointing to the structure's intended location, which was surely the new St Edward's chapel in the Abbey? Mention of decorating the lower *camera*, without any specification for its construction, points to the likelihood that the latter was already in existence; that being so, the 'chapel' above may be seen as an impermanent superficial structure intended to protect the chamber and facilitate divine worship there. Arguably, the *camera* was the small crypt that had already been constructed to enclose the Confessor's former tomb, and was the same feature to which the Bishop of Bangor alluded. The coincidences between these documents are too great to be disregarded.

If we have correctly identified the location of the temporary chapel, its purpose and physical nature are more easily comprehended. It would have been a light-weight, timber and plaster, box-like feature with gabled ends and some window openings (to admit borrowed light), erected on the floor of St Edward's chapel (at this stage probably paved with squares of plain Purbeck marble). By 1252 all the structural work would have been completed in the area of the presbytery, but glazing and decoration of the central vessel of the eastern arm would still have been in progress, for which scaffolding had to remain in place alongside the arcade walls for several more years. Entry to the crypt and its tomb (the 'lower chamber'), as well as to the site designated for the new shrine, need no longer have been obstructed. Hence, there was no reason why a temporary 'chapel' could not have been created here, to provide access to the *locus sanctus*, while finishing-works continued all around and overhead.

The erection of temporary internal hoardings and enclosed structures, to allow partial use of spaces inside buildings still under construction, or repair, was normal practice in the Middle Ages, just as it is today. Finally, the ground dimensions cited for the 'chapel' – 40ft by 25ft (12.19m ×7.62m) – fit the location perfectly. The former equates to the full length of the present chapel, and the latter is 10ft (3.0m) narrower than its internal width, which would leave 5ft (1.5m) clear for retaining scaffolding against the north and south arcade walls, respectively. Once the high-level works had been completed and the scaffolding struck, the temporary enclosure could be dismantled, making way for the erection of St Edward's shrine and Henry III's tomb, and laying a new pavement in the chapel, eventually to be inlaid with cosmatesque mosaic. Meanwhile, as Bishop Richard's indulgence confirms, the laity were actively encouraged to visit the work in progress, and contribute to it.

Aspects of the design of the shrine pedestal

The manufacture of the shrine's components and the processes involved in their assembly have already been discussed (p. 382), but some aspects of the design of the tomb call for further comment, particularly the interaction between its Roman and Gothic architectural vocabularies. The shrine pedestal cannot have been the product of a single designer, either English or Italian, but must have resulted of an imposed change of plan, presumably by the king, in the early stages of its construction. Three features of the shrine unmistakeably proclaim it as English. First, its basic form: a pedestal with niches or apertures in its sides is characteristically Gothic, with Romanesque ancestry. Second, is the design of the seven arched niches, the external openings of which have pointed trefoil heads of Gothic form, exactly similar in elevation to the wall-arcading around the eastern arm of the Abbey. This arcading must have been the model for the micro-architecture of the shrine-tomb (cf. Fig. 480). The moulding profiles are, however, different. The arches rise from diminutive capitals and slender *en délit* shafts in the Gothic manner, but the capitals have un-English upright leaves and the shafts are spirally twisted. Shafts with two-strand twists survive in bays 2, 5, 6 and 7. Bay 3 has a shaft with a single-strand twist which may have come from another monument; this variation was observed by Talman (Figs 26 and 300). Additionally, there were taller nook-shafts (now missing) recessed into the eastern corners of the shrine. Plain shafts with

two-strand twists are present in some Italian Cosmati assemblages, such as the cloister colonnettes at San Paolo fuori le Mura.[151]

The third Gothic component relates to the backs of the niches in the shrine: all resemble blind traceried windows, each of two, pointed and uncusped lights, surmounted by sexfoiled tracery. This detail is so characteristic of Henry III's fenestration of the 1250s in the Abbey that a direct association between the two was clearly intended by the architect of the shrine. When standing beside the shrine, one cannot help noticing that the blind 'windows' in the pedestal are geometrically identical to the windows and blind wall-panels in the ambulatory chapels and transept aisles (Figs 381 and 382). It is not in the least surprising that the micro-architecture of the furnishings should emulate the macro-architecture of the building. Again, this reinforces the view that the whole Abbey project was an architectural entity. Plainly, a Gothic shrine was initially designed to be *en suite* with its surroundings, and work was in hand towards that end when the king made the critical decision to switch the architectural vocabulary of the furnishings from Gothic to Roman.

We have shown that the slabs of Purbeck marble comprising the pedestal had been acquired and prepared for carving, the trefoiled heads on the exterior of the niches had already been roughed out, and the backs of the niches on the south side (at least) decorated with blind traceried 'windows' (p. 326). Changing architectural styles at this stage had considerable repercussions, not least because the trefoil arches could not be recut to a semicircular profile: too much stone had already been cut away in creating the pointed apices, and the essential Gothic form of the monument was unalterable, but it was not too late to clothe it in Roman style, thereby creating a cosmatesque work. For this, exotic marbles and glass were imported.

The moment at which Henry III ordered the style-change from Gothic to Roman is fossilized in the spine wall of the shrine pedestal, a single, massive slab of Purbeck marble that simultaneously formed the backs of all the niches on both the north and south faces. We have noted that the tracery sexfoils on the south face were chased with correct cusping, but when the slab was turned over to chase the north face, the sexfoils assumed slightly more the appearance of a ring of six closed circles, surrounding a seventh (Fig. 337). Cosmati

mosaicists were unfamiliar with Gothic foiled tracery of this kind, but clusters of seven identical circles, each of which could be filled with a small roundel of marble or mosaic, were part of their basic repertoire. Examples of this motif occur on the shrine pavement (Fig. 232, 16a-b).

It was doubtless originally intended that the backs in the shrine niches would be treated as blind panels, and decorated with painted images, perhaps including pairs of standing figures in each bay. The decision to replace paint with Cosmati mosaic was not difficult to implement, and only required the backs of the niches to be chased with the required designs, ready for inlaying with glass tesserae. Various cosmatesque designs were accordingly executed in the seven niches, but most did not chime successfully with the pointed heads of the paired lights. In the instance of bay 2, each light contains a single, upright motif based on chain guilloche, a strikingly inelegant feature in this context, but one that is precisely replicated, more aesthetically, in the Gothic trefoil-headed arches on the lower chest of Clement IV's tomb (Fig. 538).[152]

Intimately associated with the shrine, and abutting its west end, was the altar of St Edward. The initial scheme for the shrine would have included a Gothic altar and retable, but they are unlikely to have been fabricated prior to the decision to adopt the Roman style. The altar, which must have been part of the cosmatesque ensemble from the outset, was lost in *c.* 1540, but the Purbeck marble retable that rested on the back edge of the *mensa* has survived. Another decorated panel was required for the front of the altar (*paliotto*) and the two sides would also have borne mosaic. Finally, a narrow band of inlay probably ran around the edges of the *mensa*. None of this has survived.

Since the most prolific motif on the shrine is the quincunx (in a variety of styles), and the retable is dominated by a further six bold examples, it is highly likely that the front and sides of the altar were similarly decorated. Each end panel may have displayed a single quincunx, akin to that on the east face of the child's Cosmati tomb (Fig. 492B). Examples of Italian altar panels decorated with quincunxes include: the crypt altar at Santa Prassede, Rome;[153] and Sacro Speco, Subiaco.[154] The panel on the front of the latter has been compared by Pajares-Ayuela to the north face of Henry III's tomb.[155] More than that, we can match

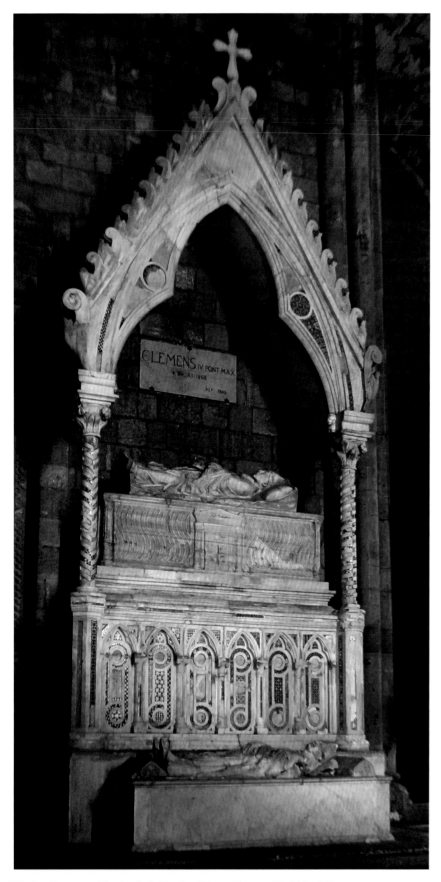

538 San Francesco, Viterbo, Italy. Tomb of Pope Clement IV. *Richard Foster*

every component of the decorative scheme on the Subiaco altar with St Edward's shrine pedestal (Fig. 539).[156] If this altar (minus its canopy) were at Westminster, it would be regarded as *en suite* with the shrine pedestal.

The ubiquitous quincunx in Cosmati work most frequently takes the form of five circles. The Westminster monuments, as well as including numerous quincunxes with circular centres, also display a variety of examples containing poised squares which were either tessellated or filled with panels of marble. Curiously, most of the centres are not truly square: some are rectangular, having one dimension marginally greater than the other (e.g. panels on the north face of Henry III's tomb), and some are slightly lozenge-shaped, having one diagonal longer than the other (e.g. the altar retable). These small but aesthetically jarring discrepancies were doubtless deliberately introduced in order to fit the design into the space available. The third type of quincunx is based on a prominent central lozenge. This form occurs all round the upper register of the shrine, where the longer axes of the lozenges are, alternately, horizontal and vertical. Two exactly similar examples, flanking a regular quincunx, are also present on the northern tomb-cover in the sanctuary pavement.

Apart from the common decorative elements of Cosmati work, several lesser details link the shrine and its pavement. Thus, multiple examples of a small roundel containing an equilateral triangle of mosaic were present in the guilloche borders on the north face of the shrine (Fig. 321),

539 Sacro Speco, Subiaco, Italy. Cosmati altar. *Hutton 1950, pl. 25*

and similar but larger triangles occur in the medallions of the surrounding pavement (34h and 35i). Close comparisons are also evident between details of the shrine and Italian monuments, especially at Anagni Cathedral. There, the low screen in front of the high altar is decorated with a series of rectangular panels in two registers, similar to the flanking panels within the niches of St Edward's shrine (cf. Fig. 347). In every case, the field is plain marble – Purbeck at the Abbey, porphyry at Anagni – framed by a narrow band of mosaic. Additional narrow, ribbon-like bands of tessellation, their ends not connecting with any other decorative element, flank the panels to either side of the sanctuary gates at Anagni, and the altar front at Subiaco; similar groups of parallel bands are also found in the reveals and soffits of several niches in the Confessor's shrine (e.g. Fig. 352).[157]

Dating the construction of St Edward's shrine

Historical references pertaining to the construction of the Henrician shrine have been cited in chapter 9, and are included in the list of shrine-related documentation in appendix 1. That the process of creating a new shrine for St Edward was long drawn-out is not in doubt, and there were two distinctly separate components to manufacture that did not necessarily have the same commencement and completion dates. First and foremost was the sumptuously decorated casket (*feretrum*) that was intended to contain the corporeal relic (i.e. the entire body) of the Confessor. It comprised a timber chest, plated with gold and encrusted with precious jewels. The second was the monumental stone pedestal, or base, upon which the feretory was raised aloft. A further two components were required to render the shrine fully functional. One was a stone altar, dedicated to St Edward, that stood adjacent to the west end of the pedestal, and the other was a canopy (*cooperculum*) that hung by ropes or chains from the ceiling vault above the shrine, and which could be lowered over the feretory to conceal it from the public gaze.

Quite separate from these essential elements were the various gifts and peripheral furnishings that all shrines attracted over the course of time. Typically they comprised quantities of jewellery, statuettes, images, vessels of precious metal, candlesticks, candelabra and other holy relics, both primary and secondary. Also, supplementary furnishings such as freestanding pedestals for statuary and metal screens might be gifted. These sometimes required the skills of artisans to install them, or to rearrange furnishings in the chapel. Thus, as Carpenter stressed, shrines and their immediate environs continued to be embellished which, in a sense, meant that they are never absolutely 'finished'.[158] Recognizing this fluidity is important if we are to identify the point at which St Edward's shrine reached structural completion – so that it could function – and to separate this from secondary accretions and associated works.

It is necessary to remind ourselves of these generalities when attempting to date the shrine, because previous discussions of the subject have failed to review the full range of available evidence, paying scant attention to the earlier documentation, and confusing chronological analysis by embracing secondary works and gifts as having a bearing on the date of construction. Archaeological evidence has not been taken into consideration, nor have the practical and logistical issues attending the construction of the chapel, and the fabrication and installation of the shrine as its liturgical focus. Added to these shortcomings, has been the protracted and inconclusive debate concerning a lost inscription that purported to date the shrine pedestal to 1279, rather than the expected 1269.

The one, absolutely incontrovertible piece of evidence we possess is that on St Edward's Day, 13 October 1269, the completed eastern parts of Henry III's new abbey church were dedicated with great ceremony, and at the same time the corporeal relic of St Edward the Confessor was translated into its new shrine. Most scholars of the last two hundred years have not questioned this substantive evidence, concluding that Richard Sporley, the monk who reported the 1279 date in his *Historia* (1450) was mistaken. However, in 1990, Binski challenged this, arguing that in 1269 there was no shrine into which Edward could be translated, and that it was only completed ten years later. He unwaveringly upheld Sporley's 1279 date (p. 385).[159] This was challenged by Carpenter, who pointed out some of the serious ramifications of such a claim.[160] Binski subsequently restated his belief in the later date.[161]

If we are to contemplate such a calamitous failure on Henry's part, we need to be mindful of its full consequences. The entire Westminster

project pivoted around Edward the Confessor: honouring him was paramount. The design of the new sanctuary and shrine chapel was cleverly contrived to encompass and respect the core liturgical elements of Edward's 11th-century church. His tomb – an important secondary relic in its own right – was carefully protected by encasing it in a small crypt; the new Gothic shrine perpetuated the *locus* of its Romanesque predecessor; and the site of the former high altar was marked by the new shrine altar. None of this was coincidental: it was all planned. Construction of Henry III's shrine and feretory was commenced in 1241 and continued for twenty-eight years, culminating in a flurry of activity in 1268–69.

Meanwhile, the eastern arm of the new church was structurally complete, or nearly so, by *c.* 1250, and in the following year Henry ordered work to start on the great sacristy, adjoining the north transept, implying that the latter was already standing. The south transept, half of the east cloister, the lesser sacristy (St Faith's chapel) and the chapter house complex were not only structurally complete by 1255, but the chapter house was also being furnished (Fig. 1). In 1259 the next phase of demolition and reconstruction of the nave of the Romanesque church began, again confirming that the eastern arm of the Henrician building was finished and usable. By 1268 the sanctuary was furnished, not least with a Cosmati pavement, and was ready for the great dedication in the following year.

Set against the backdrop of this staggering level of architectural achievement by Henry III, how could St Edward's chapel – the very core of the new Abbey, and its *raison d'être* – have been left unfurnished for the greater part of two decades following its effective structural completion? Binski's model envisaged the chapel in 1269 with no shrine, no tomb for Henry III, and no Cosmati pavement: just an empty space, a gaping *lacuna*, directly behind the high altar. He conceded that the Purbeck marble stepped base for the shrine pedestal might have been present, but that would not have provided a suitable feature upon which to rest the golden feretory. It would have been no less ignominious than simply placing it on the floor and, moreover, conflicts with Wykes's statement that the Confessor's body was translated to 'a supereminent place'.[162] Speculating that a 'temporary' shrine might have been constructed to ameliorate the indignity of the occasion carries

no conviction. And what about the shrine altar? If that too was non-existent, why did Henry order a new embroidered covering for it in the run-up to the dedication? (p. 613). We can do no better than quote Carpenter, who percipiently summed up the sorry situation that would have greeted the distinguished company attending the translation and dedication in 1269:

> If either of Binski's hypotheses is right, the translation on 13 October 1269 was a bizarre affair. All the nobles of the kingdom were summoned to Westminster. The Confessor's body was removed from its old feretory by the high altar and carried round the new church on the shoulders of King Henry, King Richard of Germany, the princes Edward and Edmund, the Earl of Surrey and Philip Bassett.[163] When this imposing party reached the Confessor's chapel, it must have looked down on the shimmering marble of the Cosmati pavement, gazed up at the gleaming gold of the reliquary, and then shuddered as it saw the totally unworthy 'provisional or earlier' base.[164] Those present must have been painfully aware that the Confessor would soon have to resume his travels to allow the construction of a more worthy feretory …. Just why King Henry put his patron saint through such humiliation is far from clear. The climax of all the work at the abbey was to be the translation of the Confessor to his new shrine.[165]

The situation would have been even less glamorous than Carpenter's description concedes: there would have been no 'shimmering' Cosmati pavement in the chapel at this stage, only a dull grey Purbeck floor, since the mosaic decoration was not applied until after the monuments (shrine pedestal and Henry III's tomb) had both been erected. Carpenter's arguments in favour of the shrine being effectively complete by 1269 are straightforward, cogent, and do not place heavy reliance on negative evidence, or the need to concoct temporary arrangements (for which there is not a shred of evidence). In 1996, he concluded that there are 'considerable arguments, both evidential and circumstantial, for accepting the traditional view that Edward's shrine was substantially complete by 1269'.[166] Augmented by archaeological evidence, that remains the position today.

Given the paucity of documentation, it is not easy to estimate the time it would have taken to

construct the new shrine, but we know that work on the two major components – feretory and pedestal – commenced concurrently. Mindful of the fact that Henry drove the entire Westminster project at a breathtaking pace, there is no rationale for supposing that work on the shrine was permitted to languish unduly. Indeed, the king's commitment is made plain by his instruction in 1241 to begin the new shrine, four years before demolition of the Norman presbytery began. He allocated ten marks for the timber carcase of the *feretrum*, and £6 10s. for marble for the pedestal.[167] In 1242 goldsmiths were engaged on plating the timber carcase, and marble work was continuing.[168] The king's personal involvement is made clear by his instructions, which were issued 'by our inspection, testimony and advice'. Numerous subsequent gifts to the feretory and accounts demonstrate that work on it continued for the next two decades.[169]

Unfortunately, progress on the pedestal after 1241 is effectively undocumented, and work may well have been suspended for several years. By 1250 the shell of the chapel that was ultimately to house the shrine had been built, and was probably being roofed. Henry's impatience for keeping the Abbey project moving at as fast a pace as possible comes across clearly in some of his instructions. His concern to progress the shrine should not be underestimated, and he ordered four silver-gilt candlesticks to be made in 1251. They were intended for the new shrine, but were to be temporarily attached to the old one.[170]

This provides the first indication that the king was preparing to translate Edward into the new shrine. Also in 1251 three papal bulls were issued mentioning the translation of the saint's body as imminent, noting also that the king proposed to knight his son on that day. In recognition of these events, the pope released forty days of enjoined penance 'to all truly penitent and confessed persons' who each year visit the Abbey on the anniversary of the translation.[171] At the same time, workmen were engaged on the construction of the shrine.[172] In 1252 the sacrist was given ten marks to buy gold for gilding the images around the feretory.[173] The pope issued another bull releasing a year of enjoined penance for all who contributed to the cost of the new work at Westminster.[174]

When the king made his will in 1253, he bequeathed 500 marks of silver to finish the feretory.[175] Although clearly not then complete, there can be no reasonable doubt that work on the shrine was well in hand, and that a translation date was firmly in the king's mind. In September 1254, more episcopal indulgences were granted, this time by the bishops of Conches and Segovia.[176] Then on 7 November the king issued a mandate ordering the recall of workmen who had left the Abbey, 'so that the work may proceed, as the church must be consecrated at the latest on the Translation of St Edward, the quinzane of Michaelmas'.[177] Hence, there was a clear expectation that by 13 October 1255 the sanctuary and St Edward's chapel would be complete and adequately furnished for seemly use. Along with that goes the implication that the feretory would be finished, and the pedestal to support it would be *in situ*.

The intended translation did not take place in 1255, but the reason for deferring it is unrecorded. Meanwhile, gifts, variously designated for the shrine and the feretory, poured in. Most were in the form of money, jewels, cameos, buckles and other adornments, but they also included copes, a censer and a precious cloth for the altar of St Edward.[178] The king assigned twenty marks in June 1257 for making the cloth, 'which may not be delayed by fault of the Exchequer'. In August, an intriguing mandate was issued to the Constable of the Tower of London, instructing him to hand over to the Sacrist, *without delay*, the elephant bones recently buried in the bailey of the Tower, and 'there make what the king orders him'. Clearly, there was a sense of urgency at Westminster, and Carpenter has persuasively argued that Henry was now aiming to carry out the translation and dedication in 1258.[179] Calendrically, that was a year of signal importance: the first translation of the Confessor, took place on Sunday 13 October 1163, and there were only two symmetrical years in Henry's reign (i.e. when the Saint's day fell on a Sunday): 1258 and 1269.

Once again, the posited translation did not take place, and may have been a consequence of the domestic turmoil that the king faced around this period; also, the appointment and death of the new abbot, Philip of Lewisham, occurred in 1258. In December, Henry assented to the election of Richard de Ware as his successor.[180] We next learn that in June 1259 the king issued a mandate to Edward of Westminster to pull down another section of the Confessor's church, and to proceed

westwards with the reconstruction.[181] However, at the same time he ordered the 'altar in the new work' to be 'repaired', so that the monks could celebrate mass there. The full significance of this statement seems to have escaped general notice. It almost certainly implies that the new high altar was already in place (or at least under construction) and needed finishing in order to render it serviceable.[182]

More importantly, this order reveals that the new sanctuary must have been sufficiently complete and seemly for mass to be celebrated at the altar of St Peter. Nor can it escape our attention that the sanctuary had also to be fully paved by 1259. The question is: with what was it paved? It could have been a geometrical arrangement of Purbeck marble, or patterned and glazed tiles, or a combination of both. There is no evidence to indicate that Cosmati work had already arrived in Westminster, and Abbot Ware was only just in post, and could not have had a hand in flooring the sanctuary. The Cosmati pavement's inscription date of 1268 is specific (p. 120). Hence, it is inescapable that whatever the sanctuary was paved with in the late 1250s was removed and replaced with mosaic a decade later. By extension, we must accept that St Edward's chapel had been paved too, otherwise there would have been nowhere seemly in 1255 or 1258 to set up the new shrine, or even temporarily install the old one, should that have been considered as a potential expedient, albeit highly unlikely.

Although the details frustratingly elude us, it remains an inescapable fact that the new sanctuary and shrine chapel, together with their essential furnishings, must have been sufficiently close to practical completion in 1258 (if not in 1255) for dedication and translation to have been seriously mooted. Calendrically, the next important date was 1269, and deferring completion for a full decade provided Henry with the opportunity to reassess and aggrandize his rebuilding scheme for the liturgical heart of the Abbey, and that is what he certainly did.

To summarize: by 1259 the structural envelope was complete, the Confessor's empty tomb was safely encapsulated in a small crypt, the foundation raft had most likely been constructed for the shrine pedestal, and the stepped podium could have been in place too. The floors were paved, but not with mosaic. Initially, the shrine was intended to be a wholly Gothic structure, its micro-architecture mimicking the vocabulary of the contemporary work in the eastern arm of the new Abbey. Dressing the major blocks of Purbeck marble and roughing-out their features began according to the prescribed design, and the project may have been geared to a completion date in 1255; the king's instruction in November 1254 to recall men who had left the site is surely relevant. Even to meet the next target date of 1258, carving and moulding work on the Gothic pedestal would need to have been in hand early in the decade, so that polishing, painting and gilding could be undertaken in 1257. But it did not happen.

Work on the feretory also resumed in 1259, and fifty marks were made available for the purpose in October, the king having ordered precious stones, cameos and images to be attached to it prior to his arrival back in England.[183] Numerous further gifts to the shrine are recorded in subsequent years. However, one event stands out as potentially significant for influencing the change of direction, and that concerns the king's abiding interest in Canterbury. In November 1262 Henry ordered two 'great and precious buckles' to be acquired for him to offer at the feretories of St Thomas the Martyr, Canterbury, and St Edward, Westminster, respectively. Twelve days later, he ordered two more buckles of equal value to be provided for the queen to offer at the same two feretories.[184]

Something must have happened at about this time, causing Henry to reconsider the intended appearance of the shrine, and to abandon Gothic decoration in favour of Roman. He never travelled to Italy, and thus could not have seen Cosmati work in its homeland, but he must have encountered it somewhere nearer at hand, and Canterbury was the most likely place. He had been acquainted with the Trinity chapel pavement for forty years and, although it is not truly cosmatesque, numerous similarities are apparent in its decoration. While we can only speculate as to whether there was any Cosmati work in Canterbury Cathedral, there is no doubt that it was introduced, albeit at an unrecorded date, into St Augustine's Abbey, just outside the city (p. 531). There, the most likely monument to have received Cosmati decoration was the shrine of St Augustine. Moreover, the discovery of curved sections of Carrara marble in the excavations points also to the former presence of a Cosmati pavement in true Italian style.

The implications are significant: at least for

their first English commission, the Cosmati mosaicists would have brought all the materials they needed from Italy, including Carrara marble for framing the pavement. They had no first-hand knowledge of substitute materials that might be available in England, least of all Purbeck marble, a stone so utterly different, both visually and texturally. There are thus grounds for proposing that the first Cosmati pavement – and perhaps also a shrine – constructed in England was at St Augustine's, and that provided the inspiration for Westminster. On his visits to Canterbury, Henry may even have encountered mosaicists at work. Furthermore, both the king and the Italian marblers would have seen how Purbeck marble had previously been employed for the matrix of the Trinity chapel pavement.

In terms of logistics, we offer the following scenario as feasible for bringing the shrine pedestal to fruition in the 1260s. The slabs of Purbeck marble had long since been acquired, the heads for the niches roughed-out, and chasing of the blind 'windows' in the spine-wall slab begun. There may then have been a considerable hiatus, during which time Henry became acquainted with cosmatesque decoration. A small team of mason-carvers working full-time on the project could have prepared and chased out all the Purbeck marble components for the shrine in about two years. The composition of the team must have included both English and Italian masons: the former were well versed in the art of carving Purbeck marble, but knew nothing of Roman mouldings, capitals and complex spirally-fluted colonnettes. On the other hand, Purbeck marble was an alien material to Italian carvers, unless they had already become conversant with it at Canterbury, or elsewhere in England.[185] Logically, a combined team would have tackled the project: the routine chasing of panels to receive tesserae and inlaid slabs of exotic marble could have been undertaken by English carvers, working under the direction of a *marmoranus*, but exquisitely carving the colonnettes, classical mouldings, capitals and other purely Roman detail was safer in the hands of Italian craftsmen.

Once the carcase had been finished, polished and assembled in the workshop as a 'dry run', a team of four or five mosaicists would have been able to install pre-prepared tesserae in the matrices in a matter of months. Moving the completed sections of shrine into the chapel, assembling them on the podium and carrying out finishing works could have taken another two or three months. The practicalities of constructing and decorating the pedestal are comfortably in accord with the available timescale for the project. There would have been no difficulty in completing the shrine well in advance of the October 1269 deadline. That was essential, not only to ensure that the pedestal was in place, but also to allow the necessary time subsequently for the Purbeck marble paving to be chased with its Cosmatesque design, and the tessellation installed.

It has been necessary to describe in some detail the processes and logistics involved in constructing the shrine, in order to counter hypotheses that it was incomplete in 1269, when the corporeal remains of Edward the Confessor were translated.[186] Credence cannot be given to the suggestion that the intended glass mosaic inscription was omitted at this stage, and that Petrus returned to Westminster a decade later, and installed it as a way of 'signing off' the completed works in the chapel.[187] As with the rest of the mosaic decoration, the matrices for the eighteen separate sections of inscription were cut when the entablature blocks were on the mason's bench, and the glass tesserae would have been embedded in them as part of the primary work. We cannot seriously imagine that the pedestal was erected in 1269, leaving the matrix of the entire inscription course empty for a decade. The concept that the shrine was 'unfinished' seems to have been adumbrated purely to accommodate the 1279 date that Sporley claimed was recorded by the lost inscription. The argument is circular.

St Edward: housing the corporeal relic

We must next consider the physical relationship between the Confessor's encoffined body and the marble shrine base. Instinctively, one would assume that the pedestal had a flat masonry top, upon which the saint's body rested inside the 'golden feretory', and over which the hoist-operated timber canopy could be lowered. Matthew Paris, who saw the shrine for himself, stated that the coffin was of gold and of fine workmanship.[188] Together, the feretory and coffin would have constituted a considerable weight, and that needed firm support, which in turn would argue for a flat stone top to the pedestal. However, the upper register, above the arched niches, contains a substantial rectangular chamber that could only

be accessed from above (Fig. 374). Descriptions of this chamber by previous writers have been notably vague, eschewing serious discussion of its purpose. Most commentators have assumed that the saint's body was contained within the *feretrum*, and thus by default the chamber must have been empty prior to Feckenham's reconstruction. Lethaby was unequivocal in his view that 'the golden shrine and the body it contained ... rested free on the top of the marble work'.[189] He went on to state that the upper part of the pedestal had been displaced 'by forming a receptacle for the coffin in Abbot Feckenham's time'. This is incorrect, since the chamber was a primary feature and its dimensions were unchanged, but because the slab that originally formed the west end had been lost, brick and stone were substituted in the reconstruction. Other writers tacitly acknowledged the existence of a void within the pedestal, but made nothing of it.[190]

However, our chamber was not only of ample proportions to receive a timber coffin, but the masonry of the sides and floor was well finished internally. Consequently, there can be little doubt that the chamber was a deliberate creation, and not merely a by-product of constructing the pedestal. The question is: was it designed to serve *ab initio* as a stone outer sarcophagus, into which the Confessor's timber coffin was placed? If that were the case, the golden feretory would have been empty, and it is inherently unlikely that Henry III would have lavished untold wealth and decades of work on the construction of this magnificent receptacle if it only ornamented the shrine, rather than serving as the container for the saint's corporeal remains. Nevertheless, Nicola Coldstream accepted that the coffin was housed within the stone sarcophagus.[191]

Certainly, the coffin has been housed within the pedestal – not on top of it – since 1557. Henceforth, the earlier Tudor feretory canopy, with nothing inside, has merely crowned the monument. The contents of the Confessor's coffin have been discussed (p. 420). An 11th-century king of Edward's standing unquestionably merited burial in a monolithic stone coffin, even if that was to be placed inside a chamber constructed of masonry (a *hypogeum*: see p. 554). Two coffins of Barnack limestone, dating from the 10th or early 11th centuries have been excavated in the late Saxon cemetery outside the present south transept. When Edward was canonized and his body placed

in a feretory, it could not remain in a stone coffin.

The only known description of Edward's coffin dates from 1685, which reported that it was of elm and bound with iron. This is probably not the coffin of 1066, but one into which the corpse was transferred at the time of its first enshrinement in 1163; indeed, the primary sepulchre seems to have comprised a stone sarcophagus, sealed with a slab.[192] When a translation occurred, it was not unusual to move a saint's remains from an old coffin into a new one, and to rewrap the body at the same time; the latter, too, is said to have occurred. Consequently, we suggest the extant timber coffin dates from 1163; early accounts also variously refer to a cloth of gold, a precious silk cloth, and three unspecified pieces of fabric that were removed from the body and embroidered into copes.[193] However, when the tomb was opened in 1685 Edward was still wrapped in 11th-century Byzantine silk and wore a gold cross and chain around his neck (Figs 415, 416 and 420). This silk can only relate to the primary burial, but was retained during any subsequent rewrapping of the body.

The shrine dismantled and reassembled

Before being dismantled in 1540, the shrine was already in damaged condition, having been stripped of a high percentage of its tesserae within arms-reach by pilgrims and souvenir hunters. All the precious metals and jewels having been sequestered by the Vicar-General in 1536, the shrine would have presented a forlorn appearance. Possibly it was a result of foresight by the monks that the pedestal was systematically dismantled, the Confessor's body retrieved and re-entombed in the Abbey, thereby avoiding total destruction of the saint's burial, as happened with the tomb of St Thomas at Canterbury. Edward's kingly status doubtless also played a significant part in securing the preservation of his body.

No record exists of the king's remains being removed from the chapel, and there was no need for that, when a simple solution to his 're-interment' was at hand. The coffin was removed from the feretory or the pedestal, and the latter dismantled and carted away. The coffin could then be placed on the chapel pavement, where the shrine-tomb had stood, and the Tudor timber canopy that previously covered the feretory, but

was now suspended in mid-air, lowered over it. At a stroke, the Confessor was re-entombed by the redundant canopy, thereby saving it from the destruction that would otherwise undoubtedly have followed. Conveniently, the canopy bore no popish symbolism and, when standing on the pavement, assumed the appearance of a two-tiered chest-tomb.

It can only have been in consequence of dismantling, rather than demolition, that Abbot Feckenham was physically able to retrieve the majority of the shrine's components and re-erect them in 1557 (p. 409). But the decoration of the pedestal was in such poor condition that he caused large areas of its mosaics to be recreated in paint on plaster (likewise, the less damaged mosaics on the tomb of Henry III); the abbot could not afford the time or money to restore the shrine in materials compatible with the original. Nevertheless, he enabled it once again to be a major liturgical focus, a magnet for pilgrims and a source of revenue. Restoration of the surrounding floor mosaic was not attempted, and continued to suffer degradation. Its repair would have been a task of considerable magnitude.

Feckenham was in office for a little over two years from November 1556, until he was deprived in January 1559, following the death of Queen Mary. He was precluded from completing a broader programme of restoration and, given the swiftness with which the repairs in plaster and paint were executed – to a remarkably high standard – it presupposes that a competent artisan was on hand. In 1956 Tanner drew attention to the fact that during the reigns of Henry VII and Henry VIII Italian craftsmen were working in the precinct of Westminster Abbey and one of them was Nicholas Bellin of Modena.[194] He was a painter, sculptor and stucco-worker whose career in England ran from 1537 until his death in 1569; he resided in the 'Tombe House' in Dean's Yard, and was buried in St Margaret's church, Westminster.[195]

Bellin was certainly well qualified to supervise or undertake the painting of imitation mosaics and it is not inconceivable that he, or one of his team, was the artisan responsible for the surface restorations of the shrine and tomb. Pigments commonly imported from Italy, probably Venice, include purpurinus (a substitute for gold), vermilion and bone black, all colours available to paint the tomb.[196]

Reconstruction of the shrine-tomb was a hasty affair, reusing as many of the original components as could be found (but not always in their correct positions, resulting in a shift of patterns), utilizing elements that did not form part of the original structure, and augmenting them with other reclaimed materials. At the same time, the monument was simplified: the stepped podium was dispensed with, the entablature was reworked and a new cornice added, all of which had to be painted as *faux* mosaic. The original inscription band was plastered over and a replacement text painted thereon. Gothic capitals to the colonnettes at the eastern corners were substituted for the lost Roman ones (Fig. 354).

The altar of St Edward that originally stood at the west end of the pedestal had been dismantled and if the parts had survived they could have been re-assembled by Feckenham. Otherwise, a substitute altar may have been built in brick, and plastered to simulate stone; this seems more likely, since Scott removed a block of rough Tudor brickwork at the west end of the shrine, upon which the retable rested (p. 314). Feckenham doubtless managed to retrieve one of the *mensae* that had been ejected from the Abbey, and install it (not necessarily the original slab). The disproportionately long altar shown adjacent to the shrine pedestal on the plan of the chapel, at the time of Elizabeth I's coronation, may represent Feckenham's restoration with a substitute *mensa* (Fig. 17).

The Cosmati-decorated retable slab was recovered intact, although missing much of its mosaic and lacking the pair of postulated hinged panels that may originally have been attached to it. In the reconstruction, the slab did not rest on the altar; instead, it was supported by a pair of cosmatesque columns, previously unconnected with the shrine. Remarkably, these columns are much taller than they now appear, since their lower ends are deeply buried in the floor of the chapel. While the retable still stands on them, the altar itself was destroyed *c.* 1560. The claim that the child's Cosmati tomb, now in the south ambulatory, was once the shrine altar has been re-examined and its status as a modern myth reaffirmed.[197]

A careful re-examination of the painted and mosaic-inlaid timber canopy that still surmounts the shrine pedestal has also been undertaken (Fig. 383). It was formerly the *cooperculum* that enveloped the *feretrum*, and has been widely regarded as a

furnishing of the Marian period. The case for its being a unique survival from the pre-Dissolution era was made by O'Neilly, but not embraced by other scholars;[198] the high-quality workmanship and gilt glass mosaic point to a costly product by Italian craftsmen. It served no practical purpose in relation to the rebuilt shrine, there being no feretory to require a cover; also, it could never have been afforded by Feckenham or manufactured within the brief period of his abbacy. Moreover, the west end of the canopy displays a feature that is not part of the English Tudor architectural vocabulary, the expanded semicircular arch (Fig. 393).

O'Neilly searched for parallels, and recognized that the canopy had much in common with the quire screen in King's College Chapel, Cambridge,

540 Artist's reconstruction of the shrine of St Edward on the eve of the Reformation. *John G. O'Neilly, 1958/59 © Dean and Chapter of Westminster*

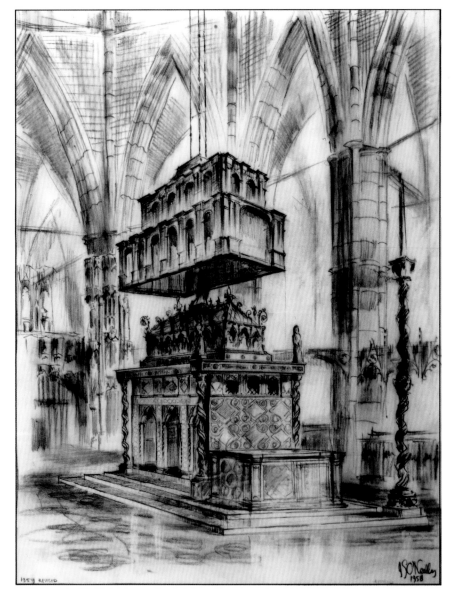

a structure of Italian workmanship, dating from the early 1530s (Fig. 396). The arch-type is also represented in the chapel's glazing of the late 1520s. Moreover, two documentary sources provide the clue to its date of manufacture. The first is Henry VII's will, in which he ordered a gilt kneeling figure of himself to be erected on the crest of the feretory, and since that increased the height of the structure by a metre, the medieval canopy could not accommodate it (p. 406). Hence replacement with the extant two-stage canopy was necessitated. The date of its manufacture can confidently be assigned to 1516, when new ropes were purchased to hang it. It was also the year in which Henry VII's magnificent Lady Chapel was dedicated. The canopy – a unique survival – thus ranks as one of the great works commissioned during the abbacy of John Islip (1500–32). O'Neilly's artistic reconstruction of the shrine of St Edward provides a useful image of the complete *ensemble* on the eve of the Reformation (Fig. 540).[199]

Feckenham's remarkable achievement in reconstructing the shrine-tomb must represent one of the earliest exercises in the conscientious restoration of a sepulchral monument. In due course, his extensive work in plaster also suffered from vandalism, although the motivation for this damage is unclear: crumbling pieces of plaster could hardly be classed as worthwhile souvenirs. Nevertheless, some entire sections were defaced, whereas other panels remained virtually untouched. A second phase of repair, crudely executed in unpainted plaster can be dated to the 17th century. Graffiti were also liberally applied.

HENRY III AND HIS TOMB

Historical context

The circumstances surrounding Henry III's burial are far from clear. Several brief accounts of it have survived, but they do not agree on the location of his initial interment. Indeed, they are manifestly incompatible. Henry died on 16 November 1272, and the official proclamation issued by Lord Edward to the magnates on 23 November states that the body of the king was taken to the church of Westminster for burial before the high altar (*ante magnum altare*).[200] This can only refer to the eastern part of the present sanctuary. The site in question has therefore to lie between the edge of

the Cosmati pavement and the high altar, a distance of only 2.5m. This area is now covered by the altar pavement of 1868. When Scott took up the previous paving of 1706, he caused some excavations to be undertaken by Henry Poole, the Abbey mason and his men, who discovered an abbatial burial in a monolithic stone coffin and an infant in a lead casket; further south, another burial was uncovered in front of the sedilia (p. 44).[201] These were noted and plans drawn. Neither Scott nor Poole – both of whom were archaeologically minded – recorded any evidence for a tomb chamber that could have held Henry III's coffin.[202]

It has been suggested that Henry might have been buried under the rectangular panel in the eastern border of the pavement,[203] but this can be discounted for three reasons. First, it is inconceivable that Henry would have been buried on a non-Christian north-south orientation; second, the panel was not long enough to accommodate his coffin, let alone the walls of a burial chamber; and, third, no such structure was encountered here by Scott when he restored the damaged mosaic panel.

As part of the present project, GPR scanning was carried out across the altar pavement with different machines, on two separate occasions, but no evidence for another tomb in front of the high altar was encountered (pp. 147–56 and 250). We can therefore state with confidence that there is no chamber in this locality that could have held Henry's coffin, which leaves three options:

(i) Henry was interred in the floor in an earth-cut grave without a stone lining; when he was exhumed in 1290 the grave was backfilled with earth, leaving no visible evidence for Scott, Poole or the GPR scanner to record. Had the body been buried in the ground for eighteen years (even in a timber coffin), it would have deteriorated considerably, and that clearly did not happen. Hence, this is not a credible option.

(ii) A temporary tomb-chest to hold Henry's coffin could have been constructed on the floor surface. It would have been dismantled when the coffin was moved to its final resting place, leaving no archaeological traces. However, this option raises serious logistical issues. A stone tomb-chest in this prestigious location had to be worthy, not only of the king, but also of its setting in the Abbey's new sanctuary. Even if it was relatively plain, creating such a tomb would take many weeks, if not months. It is extremely unlikely that a temporary stone tomb would have been constructed on top of the newly laid marble and glass mosaic, and we must presume that it would have been situated immediately east of the main pavement (although there was doubtless ornamental paving in front of the altar too). Even if the chest were thin-walled, its overall length had to be at least 2.15m, which would have left only 40–50cm of space between its east end and the front of the altar. We might make allowance for the altar being slightly further east in the 13th century than it is today (i.e. before the 1440 stone screen was erected), but even that could not have facilitated more than one metre of clear space, at most. To suggest that the area west of the high altar was obstructed to such an extent for eighteen years would stretch credulity to its limit. The same applies to the notion that masons were concurrently working on both Henry's cosmatesque tomb and a temporary one. We therefore opine that this option too is not credible. Also, if Henry's temporary tomb had been dismantled when the coffin was moved, there would have been no sepulchre in which subsequently to deposit Queen Eleanor's body (p. 306).

(iii) In view of the insurmountable archaeological and logistical objections, the possibility that Henry was never physically interred in front of the high altar, above or below floor level, must be carefully considered. The proclamation does not state that interment had taken place, merely that the king's body had been conveyed to the Abbey for burial and was *ante magnum altare*. It is entirely reasonable to envisage the coffin lying in state in front of the altar for a period, prior to interment elsewhere. The proclamation goes on to speak of the acclamation being made 'while the tomb is not yet closed' (*nec dum clauso iam tumulo*). This clearly implies that there was already in existence a tomb destined to receive the

coffin, and that must have been constructed before the king died. To propose that a second tomb was constructed in the sanctuary, in the king's lifetime, would be risible.

Based on the proclamation alone, evidence for the location of the tomb is admittedly inconclusive. Stephen Wander claimed, without reservation, that the sanctuary pavement was conceived as a royal burial floor, and that Henry's initial interment took place there in the Confessor's original grave (albeit 'the location must remain open to question'). But that is manifestly not the case.[204] No tomb was ever cut through the pavement, and no monarch even buried in the sanctuary. The only interment *per se* is Ware's, and his stone sarcophagus was installed in the floor as part of its construction; whatever lies in the chamber beneath the second east-west aligned panel (probably an ossuary) was similarly placed there before or during the creation of the Cosmati pavement. Unlike the shrine chapel, this floor has never been breached by later graves, and no royal interments even took place on the periphery of the sanctuary prior to 1296 (Edmund Earl of Lancaster).

Turning to other sources, we find mention of Henry's interment in 1272 being in the same place as the Confessor had been buried, and most modern authorities have cited this.[205] The chronicle of Thomas Wykes gives a fulsome account of the burial, stating that Henry

> ... was borne to his tomb in his portable coffin by the nobles of the realm ... in the same place which the most blessed king and confessor Edward was buried, and for many years, before his own remains were translated to his shrine, there rested the body of King Henry who while he was alive venerated the same St Edward over all saints[206]

Significantly, Wykes makes no mention of the high altar, and the most straightforward reading of this account would place Henry in the Confessor's primary tomb, which had lain in front of the high altar in the 11th-century church. No evidence regarding the location of that altar was known, or could reasonably be surmised, until 1910, when an archaeological investigation located the apsidal sanctuary of Edward's building (p. 216). That discovery effectively revealed, within a metre or thereabouts, where the 11th-century high altar

must have stood, and hence betrayed the location of the Confessor's primary grave that lay in front of it. As we have demonstrated, by 1272 the grave site had long been encapsulated in a small crypt beneath the Cosmati pavement in St Edward's chapel (p. 556).

We now know that Edward the Confessor's high altar was approximately 5m east of its 13th-century successor. Hence, it is not difficult to appreciate how confusion has arisen in the writings of both medieval and modern historians. What is surprising is the fact that no 20th-century commentator seems to have registered the significance of the discovery of the sanctuary apse in 1910, proving as it does that the sites of the 11th- and the 13th-century altars could not be coincident.

The account of Henry's burial place in the *Flores Historiarum* is also of interest:

> ... *in ecclesia Westmonasterii* ... *coram magno altari sibi dignam meruit sepulturam*

Instead of describing the location as *ante magum altaro*, we find here the designation *coram magno altari*, which does not carry the express meaning of 'before' or 'in front of' but refers more generally to the locality of the high altar, or within sight of it.[207]

> ... in the church of Westminster ... he warranted a burial/burial place worthy of him in the vicinity of the high altar[208]

This could perfectly well describe Henry's burial in the Confessor's former tomb, which lay axially to the east of the Henrician high altar, and the entrance was immediately behind the latter. The *Flores* later refers to miracles that occurred after Henry's death.

Historical references to the fabric of this tomb are very few, and none provides any substantive clue to its date of manufacture (pp. 439–40). However, in this regard archaeological and circumstantial evidence is more informative and compelling than historical, and we must now embrace this as part of the total picture. Chronicle references relating to 1280 and 1290 indicate activity in connection with Henry's burial and tomb, but they do not date the construction of the latter. The chronicles of Nicholas Trivet and William Rishanger both record that in 1280 Edward I brought precious stones of jasper from France for his father's tomb.[209] Trivet states:

Edwardus *rex hoc anno reversus de partibus Gallicianis, de lapidis jaspidum quos secum attulerat, paternum fecit reparari sepulcrum*

Rishanger slightly enlarged on this:[210]

Eodem anno, Edwardus, Rex Angliae, de lapidus pretiosis jaspidum, quos secum attulerat de partibus Gallicanas, paternam sepulcrum apud Westmonasterium, fecit plurimum honorari

A somewhat similar account is given by Thomas Walsingham for 1281.[211] These chronicles have been cited by both early antiquaries and modern scholars as evidence for the tomb having been constructed, or at least completed, by Edward I, a decade or more after Henry's death. In 1812 Ackermann, alluding to the chronicles, stated unequivocally, 'The whole [tomb] was made of precious stones, jasper, &c. which Edward I brought with him out of France.'[212] There is nothing to support such a sweeping generalization. Binski redressed this: 'Edward came from France with jasper stones with which to adorn his father's tomb'. That is precisely what the chronicles tell us, and no more.[213] Explicitly, they say nothing about constructing the tomb: one source says that he 'repaired' it (*reparari*); the other that he 'embellished' it, making it more worthy to be honoured (*plurimum honorari*). Both ostensibly imply that the tomb was already in existence, and that the stones of jasper were for some form of additional ornamentation.[214]

It is well to deal next with a persistent ambiguity relating to the identification of 'jasper', a term loosely employed by antiquarian writers to describe strongly variegated marbles, sometimes even including onyx and alabaster (pp. 263 and 266); it turns up repeatedly in accounts of the Cosmati work at Westminster. Jasper is a brecciated limestone occurring in a wide range of colours – red, yellow, brown, green – and is capable of being highly polished.[215] There is *no* jasper in either the structure or primary decoration of Henry III's tomb and nothing (such as onyx or alabaster) that could have been mistaken for it. Indeed jasper is wholly absent from the Westminster Cosmati assemblage. Nevertheless, some scholars have chosen to ignore this fact, or have elected to substitute 'porphyry' for 'jasper'.[216] There can be no justification for such a substitution. Notwithstanding, although jasper is absent from the primary structure of all the cosmatesque monuments, and from tessellation in

the pavements, the possibility that it occurred in secondary adornments – now lost – is certainly admissible.

The tomb's basic structure is entirely of Purbeck marble and the mosaic inlay is nearly all of glass, which leaves only ten rectangular panels and a single roundel of porphyry, and they are extremely unlikely to have been acquired in France. The 'precious stones of jasper' brought back by Edward in 1280 can only have been for embellishing the tomb, as the chronicles tell us: we should accept that as a plain statement of fact, without manipulation. So, where were these embellishments? Although the evidence is plainly visible, it seems to have escaped notice hitherto that *cabochons* were formerly attached to the blue glass tesserae on the east end of the lower chest, and were added after the tomb had been constructed. The centres of the relevant tesserae were deliberately scored to aid adhesion (Figs 458–460 and 541D), the same treatment as was applied to the surface of glass on the Westminster Retable where it was desired to attach cameos or precious stones (Fig. 541A, B).

The *cabochons*, which could not have measured more than 10–12mm across, were attached only to the larger square blue glass tesserae on the east end of the lower tomb-chest. There is no hint of deliberate abrasion to tesserae of other colours or

541 Decorative elements adhered to glass. A–C. Oval glass discs scored for the attachment of cameos on the Westminster Retable; D. Square glass tesserae scored for the attachment of jasper *cabochons* on Henry III's tomb. *A–C. © Dean and Chapter of Westminster; D. Authors*

A B C

D

577

shapes, or to the slightly smaller blue tesserae that are found around the plinth, in the rebated corners of the chest, and on the well preserved mosaic of the north elevation. The large blue tesserae are found in only a few places: the pilasters (35, 41) and two lower panels (39, 40) on the east end (Fig. 454). The west end has been so thoroughly robbed of its tesserae that no evidence is present upon which to make a judgement, and the tessellation on the north and south faces, being of finer quality, did not include any squares of the relevant size. Hence, the addition of *cabochons* was confined to large blue tesserae on one, or possibly both, ends of the lower chest alone. There can be no doubt that abrading the tesserae and attaching the stones occurred sometime after the tomb had been erected, since the row inserted to cover the construction joint between the two Purbeck marble panels comprising the east end displays the same evidence (Figs 460A and 541D).[217]

We may thus accept without reservation the chroniclers' account that when Edward I was in France in 1280 he acquired a bag of 'precious stones of jasper', which he brought back to Westminster and caused to be adhered to his father's tomb. This was an era when gifts were being made to Henry's tomb, and it is likely that Edward did not acquire the *cabochons* with deliberation, but was given them. Moreover, he may have regarded them as an unwanted and embarrassing gift, which would account for their attachment to the lower parts of the ends of the tomb, where they were so close to the arcade piers that they would pass almost unnoticed. Patently, they were not part of the original design, but merely *ad hoc* additions. Indeed, gluing stones onto a few of the tessellated panels detracted from the overall aesthetic of the monument, rather than enhancing it. But it happened. One suspects that the stones were only appreciated by the souvenir hunters who subsequently pilfered them. The important point to make here is that the addition of some jasper *cabochons* has no relevance to dating the construction of Henry III's tomb *per se*. The myth, based on misinterpreted evidence, that construction took place in the 1280s, has been repeated by many writers since the mid-19th century, but must now be dispelled.[218]

No further references to the king's tomb occur for a decade, until a continuation of Florence of Worcester's Chronicle records that, on 10 May 1290, Henry III's body was transferred from its resting place in the Confessor's former tomb to his own monument in St Edward's chapel:

… *dominus rex regem, patrem suum, apud Westmonasterium intumulatum, nocte Dominicae Ascensionis, subito et inopinate amoveri fecit, et in loco excelsiore, juxta S Edwardum collocari*

Our Lord the King caused the body of the King his father, which was interred at Westminster, to be suddenly and unexpectedly removed on the night of the Feast of the Ascension [10 May] and deposited in a more elevated position, near the tomb of St Edward.[219]

This account unequivocally implies that the night-time translation took place hastily and, potentially, in semi-secrecy. Why, after lying in the Confessor's tomb for eighteen years, did the need suddenly arise to move the body under such conditions? There are no clues to guide us and speculation is pointless. If Henry's coffin was being transferred to a new tomb of exceptional magnificence – one that had been under construction for two decades, but was now finally finished – we would expect the translation to have been effected with great ceremony. On the other hand, if the tomb had been a fixture in the chapel since the 1260s – almost a generation – and Henry had failed to be canonized, there would have been no obvious motive for an extravagant ceremony. Edward may simply have viewed the translation as a filial commitment that he was morally obliged to undertake, and did so quietly and without undue ceremony.

Carpenter has pointed out that there is another entry, in the *Annales Monastici*, to corroborate the translocation in 1290, but not the conditions under which it was effected:

Eodem anno, quinto idus Maii, die Ascenscionis, amotum est corpus domini Henrici Regis tertii, et positum juxta feretrum Sancti Edwardi, integrum cum barba prolixa.

In the same year, on Ascension Day, the body of King Henry III was moved, and placed next to the feretory of St Edward, complete with his luxuriant (or long) beard.[220]

These brief accounts provide no hint that Henry's tomb was 'new' or had only recently been completed, and they cannot be cited as dating evidence for anything other than the translocation. Moreover, the accounts must represent over-simplifications of the actual events, since there

were logistical issues involved, preventing the transfer from being a quick process: preparations were necessary. Lifting the coffin out of a chamber under the floor of St Edward's chapel (accessed from behind the high altar, as detailed on p. 556) may not have been arduous, but hoisting it aloft and inserting it into the upper tomb-chest was a different matter (p. 587).

The upper tomb-chest

Henry III's tomb has two principal faces, north and south (Figs 432 and 433). The former can only be viewed from the low level of the ambulatory, but the latter may be closely examined from the shrine chapel. The east and west ends, being near to the arcade piers, are seen obliquely and not to good advantage (Figs 431 and 432). Nevertheless, the end-panels were richly decorated, although not to the same degree as the principal faces.

The aspect that elevates this tomb to the rank of *primus inter pares* in the Abbey is the conspicuous display of sheets of purple porphyry on the north and south faces of the upper chest. Measuring 1.22m by 44.4cm, and having a surface area of 0.54m², they were doubtless the two largest panels of this highly prized material to be seen in a medieval church in England, and undoubtedly imported specifically for the tomb.[221] Moreover, smaller panels formerly adorned the east and west ends of the same chest, and even they had an area nearly four times greater than the next largest porphyry slabs in the Westminster assemblage.

Similarly impressive rectangular sheets of porphyry clad some of the finest Cosmati monuments in Italy, such as the right-hand ambo and bishop's throne at San Lorenzo fuori le Mura, Rome.[222] The origin of these large pieces cannot, of course, be ascertained, but they are most likely to have been wall-sheathing from Roman public buildings or palatial residences of the Antique era. Roman emperors controlled the quarrying and use of purple porphyry, and in later centuries the reclaiming and disposal of it was in the gift of the popes. The significance of the papal monopoly, in relation to Henry III's acquisition of porphyry, has been discussed by Binski.[223]

By the 1260s, there can have been few, if any, ancient ruins in Rome that had not been totally stripped of porphyry wall-sheathing, it being much sought-after to embellish churches and palaces. Possibly the Westminster porphyry came from a more distant source and the imperial palace at Constantinople springs to mind, where the great porphyry-lined purple bedchamber was the birthplace of numerous legitimate children of the Byzantine emperors.[224] The importance of legitimacy – especially in relation to succession – was paramount, and one of the so-called 'purple-born' was Constantine VII, who took the name Constantine Porphyrogennetos to reinforce his status (A.D. 905). Constantinople was sacked in 1204, during the Fourth Crusade, but was recovered by Michael VIII in 1261. By then, however, the imperial palace was in serious disrepair and had been abandoned as a high-status residence. Consequently, in the 1260s a large quantity of wall-sheathing is likely to have become available for recycling. The powerful symbolism of legitimacy that purple porphyry from this source carried with it would have appealed enormously to Henry III. By cladding the faces of the upper chest with large panels of purple porphyry, the king ensured that he was buried 'in the purple'.[225] He would have been aware that, since the late Roman period, sarcophagi hewn out of solid blocks of purple porphyry were provided for some of the highest-ranking burials in Italy.[226]

The north and south panels on the chest are secured with four iron clips that have certainly prevented the porphyry from being stolen, although attempts to remove it were made (Fig. 448). On the south side, three holes were chiselled into the interface between the porphyry and the Purbeck marble, to obtain leverage behind the panel (Fig. 447).[227] The east and west ends of the chest also originally bore smaller, but nevertheless sizeable, panels of purple porphyry which were not secured with iron clips, and could be prised out with ease. That happened some time prior to 1557; the matrices were then infilled with plaster and painted in imitation of porphyry (Fig. 444).

In addition to the purple panels, the chest carried a good deal of cosmatesque decoration in glass, and the four corners were punctuated by spirally-fluted colonnettes encrusted with mosaic. However, the treatment of the colonnettes is less elaborate than that accorded to those on the lower chest. Thus, the upper-tier capitals carry only plain leaves, whereas those of the lower tier have additional decoration (Figs 438 and 450); and the nooks into which the detached lower shafts fitted are embellished with vertical bands of mosaic,

even though these would have been barely visible when the colonnettes were in position (Fig. 461). The design of the upper chest symbolized powerful elegance.

The lower shrine-like chest

The fundamental question to be addressed is: what was the purpose of the lower chest? It was self-evidently much more than just a base upon which to elevate the chamber holding the coffin. There are two undeniable facts: first, the chest served no direct sepulchral function; and, second, elements of its design proclaim its shrine-like affinity. It is *sui generis* and, as Binski has observed, there is nothing comparable: 'The fact remains, however, that Henry's tomb represents a combination of motifs and details cumulatively unlike anything in Italy, and yet utterly un-English'.[228] No convincing explanation for the presence and design of the lower chest has yet been advanced. It is so evocative of Italian *confessiones* that there had to be a powerful, cogent reason for its construction. This deserves further exploration, but is outside the scope of the present study.

It can hardly be coincidental that in two respects Henry's tomb outshines the other Cosmati works in the Abbey, with the possible exception of St Edward's shrine. Although the latter has been extensively robbed of its decoration, indications are that the two monuments were once of

542 Tomb of Henry III. Detail of the top of colonnette 7 (flute d), showing the micro-mosaic infill between red and gold squares and triangles. *Authors*

comparable magnificence, but direct comparison is now difficult. The density and intricacy of some of the mosaic inlay on the king's tomb is the finest surviving. Moreover, the flutes on one of the extant colonnettes retain vestiges of micro-mosaic work, which was probably matched on the others (Fig. 542). Nothing survives of the tessellation on the shrine's original colonnettes. While traces of micro-mosaic have been observed on the child's tomb and the cover of Ware's tomb, they appear to have been very restricted in extent. The finest display of high quality tessellation is to be seen on the north side of the lower chest of Henry's monument, particularly in the curvilinear banding of panel 55 (Fig. 470B). The south face of the same chest – now utterly robbed of its tessellation – was equally fine, but only the mortar impressions survive in the matrix to inform us of its intricacy; the colouring of the designs is almost wholly lost. We have previously noted that the only surviving occurrence of silvered glass tesserae is in the two columns that once supported the tomb's canopy (Figs 362 and 363), but may well have been present in the colonnettes too, especially in those that stood prominently *en délit* at the angles of the two chests.

The architectural composition and mosaic decoration on the north face of the chest – a triple quincunx panel – is wholly Roman and finds analogues in numerous Italian tombs, altars and screens. Similarly, in form and detail, it is not difficult to seek parallels for the south face either, but they are not with tombs: close comparisons are with altars and *confessiones* (shrines beneath altars). Carved from a single block of marble, the front elevation is divided into three, equal-sized, square panels, the central one breaking slightly forward (Fig. 439). All three are pierced by openings that give access to small rectangular chambers which early antiquaries erroneously referred to as 'lockers' (p. 437).[229] The central opening is represented as a portal, flanked by small pilasters carrying a pediment. In style, it is closely similar to the front panel of the *Praesepe* (Sacred Manger) altar at Santa Maria Maggiore, Rome (Fig. 440B), a comparison that has frequently been cited.[230]

All three chambers are wider and higher internally than their apertures and are lined with plain Purbeck marble, which is surprisingly clean and free from graffiti and other markings.[231] The east and west chambers are elongated in plan and

their floors lower than the sills of the apertures, whereas in the central chamber (effectively a niche) the floor is at sill level. The only internal decoration consists of a large, but slim Greek cross made of glass mosaic, set into a shallow matrix in the back wall of each compartment.[232] The crosses provide an explicit hint that the chambers were not simply ornamental but fulfilled a ritual function: they were *fenestellae*. Precisely similar crosses are found in the backs of *confessiones* in Italy: for example at San Giorgio in Velabro (Figs 532A and 543), and there is one on the end of the sarcophagus of Pope Clement IV at Viterbo, a tomb of the early 1270s that shares several stylistic traits with Henry's (Figs 538 and 544). Moreover, the extremely rare band pattern identified by Foster on Clement's cross is identical to that on the edge of the top slab of Henry's upper tomb-chest (Figs 463 and 465B), as well as a band in panel 53 (Fig. 467B). The same decoration also occurs on the sanctuary pavement, (panel 83; Figs 86B, 87A and 545),[233] where it is composed entirely of stone tesserae, the red and gilded glass on the tomb being represented by purple porphyry and golden white lias, respectively. The distinguishing feature of this pattern is the prominent row of lozenges running longitudinally down the spine of the band, instead of being placed transversely.

Inspiration for the three-panelled arrangement on the south face of the lower chest must have been provided by a monument such as the *confessio* at San Giorgio in Velabro.[234] It has a tripartite front panel, the central section with a semicircular arch and the flanking ones pedimented (Fig. 543).[235] Only the central arch opens into a niche, wherein relics can be displayed. A similar composition is seen in the *paliotto* at Santi Nereo ed Achilleo, Rome,[236] although being an altar front, the panels are blind, rather than framing niches: the central one is pedimented, the others semicircular. Examples of *confessiones* with a single semicircular arched opening are found at Anagni and Ferentino cathedrals and Sant'Andrea in Flumine, Ponzano.[237]

There is only one remarkable anomaly in the architectural vocabulary of Henry III's monument, and that occurs in the two panels flanking the portal: they are both pierced by trefoil-headed openings of typically English Gothic form. Many a parish church has a 13th-century piscina with a comparable arch, as does St Faith's chapel in Westminster Abbey (Fig. 441B).[238] The profiles

543 San Giorgio in Velabro, Rome. West-facing *confessio* beneath the altar, showing the mosaic cross in the back wall. Photographed for J. H. Parker, 1864–70. © *Victoria and Albert Museum, London, 70539*

544 San Francesco, Viterbo, Italy. Mosaic cross on one end of the sarcophagus of Pope Clement IV. *Richard Foster*

545 Sanctuary pavement. Detail of band 83 with the same pattern as on Clement IV's sarcophagus (Fig. 544). The defining feature is the longitudinal porphyry lozenge. On the pavement, groups of purple lozenges alternate with groups of green (the latter seen here). *Authors*

of these arches provide the only hint of Gothic in the tomb, and must represent a deliberate instruction to the designer to incorporate a single characteristic trait of Westminster's micro-architecture in an otherwise Roman monument. The mouldings of these arches do not have Gothic profiles.

We have already discussed the fusion of several elements of Gothic micro-architecture with Roman in the Confessor's shrine pedestal, necessitated by a decision to change the architectural style of the monument after work had begun on

546 Tomb of Henry III, south elevation, lower tomb-chest. Pilaster 17 flanking the pedimented aperture, showing the lunette-ended sunk panel (Fig. 440A). *Authors*

it (p. 564). The reason for the appearance of trefoil-heads on two of the openings in Henry's tomb is not comparable, since the design of that monument was unerringly Roman from the outset. Semicircular heads to the openings would be expected in this context, and they could have been formed here just as easily; the fact that they were not, simply confirms that the trefoils were deliberately introduced to provide a visual link between Henry's monument and the Confessor's.

The lower chest is more intensively decorated than the upper, there being small circular and rectangular panels of porphyry on the north, east and west faces: two were certainly green, and the others are lost. There were clearly intentional differences between the upper and lower chests, and it seems likely that all the inset marble panels on the latter were originally green. Glass mosaic covered every available surface, and each corner was clasped by a pair of pilasters and punctuated by an *en délit* spirally-fluted colonnette. All their capitals were more ornately carved than those on the upper chest (Fig. 438).

Pilasters clasping the corners of Cosmati monuments, and those flanking openings, commonly embody a sunk-panel, infilled with tessellation, and edged with a roll-moulding. They occur in profusion on altars, tombs, screens, thrones and pulpits, and in the vast majority of Italian examples the upper and lower extremities of the sunken panels are square-ended, whereas at Westminster they are lunette-shaped (concave) at both ends, an exceptionally uncommon detail to which Binski first drew attention.[239] Identical pilasters occur in pairs at the angles of Henry III's tomb

547 Castel Sant'Elia, Nepi, Italy. Fragment of a panelled pilaster with semicircular ends, reused in the step to the altar dais. *Hutton 1950, pl. 19*

and the child's Cosmati tomb (Figs 461, 467, 488 and 491). Smaller versions also flank the pedimented recess on the south face of the king's monument (Fig. 546). Although very rare on Cosmati work, this distinctive pilaster detail is found in Italy as, for example, on the panelled front of the tomb of Alfanus at Santa Maria in Cosmedin, Rome;[240] on the episcopal throne at San Cesareo in Palatio, Rome;[241] and a single pilaster was reused as a step in the altar dais at Castel Sant'Elia (Fig. 547).[242] These and other examples all date from the 12th and early 13th centuries, and therefore the pilaster type was anachronistic when it appeared at Westminster in the 1260s.[243]

While chest-tombs generally stand directly on the floor of a chapel, in this instance the whole monument is raised on two Purbeck marble steps, integral with the layout of the Cosmati pavement. The upper step has four widely-spaced pockets for anchoring the stanchions of a protective iron grille, while the lower is broader and seemingly designed for kneeling. Although fewer in number, the steps emulated those upon which the Confessor's shrine was elevated.

Thus, features of the lower tomb-chest point explicitly to its shrine-like status, as previously noticed by Binski, Carpenter, Palliser and others.[244] They have drawn attention to supporting evidence for Henry's popular recognition as a potential saint, citing the parallel circumstance in France, where Louis IX (d. 1270) was progressing towards beatification (which was finally confirmed by Boniface VIII in 1297). According to the Westminster *Flores Historiarum*, a miracle occurred at the time of Henry's burial in the Confessor's former tomb in 1272, and it was further claimed that blind people were healed at the tomb.[245] Since healing miracles were also associated with Edward the Confessor, we appear to be witnessing a popular coalescence of the sanctity of the two kings. This popularity was evidently not a fleeting event, since in 1276 bishops of several dioceses (English and continental) granted indulgences for those who visited the king's tomb,[246] and in 1287 another spate of indulgences was granted to pilgrims who visited St Edward's relics and prayed for the soul of Henry III at his tomb (*ad tumulum*).[247] The first indulgence was granted by the Bishop of Ely, followed six months later by Irish and Scottish bishops.[248] But to which tomb do they refer? Henry's body still lay in Edward's primary

sepulchre, and since that was not an upstanding structure, and its entrance was directly behind the high altar in the sanctuary, it is unlikely to have been accessible to the laity. Consequently, the indulgence presumably relates to visiting the Cosmati tomb: with its kneeling step, three *fenestellae* (at least one probably housing a relic) and, potentially, with a supplicant figure of the king crowning the monument (see below). This was ostensibly a structure to which pilgrims could relate.

The tomb itself was not fully enclosed by railings, but narrow gaps between the east and west ends of the upper chest, and the adjacent arcade piers were deliberately obstructed. A single stanchion with laterally projecting spikes is still in place on the west, but its eastern counterpart has been lost since 1711 (Figs 431 and 450). The function of these spiked stanchions was to prevent anyone from gaining access to the chapel, from the ambulatory, by climbing onto the platform and squeezing through the narrow gap. This confirms that the entire platform upon which St Edward's chapel stood was securely enclosed by railings.

Although the *fenestellae* were not individually fitted with *ferramenta*, a bespoke iron grille formerly protected the apertures and chambers in the south side of the lower chest. There are four pockets for stanchions in the upper step, and another four to hold stays, in corresponding positions, in the top slab of the lower chest.[249] However, the small number and wide spacing of the stanchions confirms that the monument was not surrounded by a close-set railing, as was the case with, for example, Edward I's tomb. The positions of the stanchions marked the three bay divisions of the chest, and did not obstruct the apertures. Consequently, the *ferramenta* were placed there to control, but not prevent, access to the chambers in the lower chest.[250] The physical evidence is consistent with a rectilinear iron frame containing a series of individual grilles, hinged and lockable. That being so, when the grilles were open, a person kneeling on the lower step could have inserted a hand with ease, to touch a devotional object within the central niche. The two flanking recesses, with their internally lower floors, are more plausibly regarded as receptacles into which pilgrims could deposit gifts. Since the roofs and interiors of all the recesses are remarkably clean and do not exhibit smoke staining, it may be deduced that candles were not burned in them.[251]

Effigy

The subject of the king's effigy must next be addressed. We might naturally suppose that the upper chest was designed with a view to supporting a recumbent figure, lying on a shallow bed edged with an inscription, which is what we see today. But that is of gilt copper-alloy and is unlikely to have been the type of funerary effigy envisaged by Henry. He would have been mindful of stone effigies, the norm on Italian tombs of this period. Scholars have accepted without question that there was no effigy on the tomb prior to 1292, but the reality is not as simple as that. One crucial piece of evidence to the contrary, which was discovered in 1871 but has been overlooked ever since, is the large square mortice in the centre of the top slab of the tomb-chamber (Fig. 476). The purpose of this was to receive the tenon on the base of a figure crowning the monument. The function of the mortice-and-tenon union was both to locate that figure and to prevent it from toppling over, which confirms that a recumbent effigy was not intended. Hence, either a standing or, more likely, a kneeling figure was placed here. We suggest its pose showed Henry III kneeling as a supplicant. This presages the instruction given two-and-a-half centuries later, in Henry VII's will of 1509, that a kneeling, supplicant figure of him should be fitted to the crest of the feretory on the Confessor's shrine. The image was to be three feet high, carved in oak and plated with gold (p. 406). This is exactly the sort of figure that could initially have crowned Henry III's tomb. Moreover, there was precedent: Henry previously commissioned Simon de Welles to make a tomb effigy of his recently deceased daughter Katherine (d. 1257), and the figure was to be of silver, plated on to an oak core.[252]

Six months after Henry's translocation, Eleanor of Castile, Edward I's queen, died unexpectedly at Harby (Nottinghamshire), and her body was brought back to London and temporarily placed in the Confessor's tomb-chamber that was once again vacant. Early in 1291 William Torel, a goldsmith, was contracted to cast gilt metal effigies for Henry's and Eleanor's tombs, and they were installed late in the following year.[253] Walter of Durham, the king's painter, decorated canopies

over both monuments in 1292–93.[254] Hence, it was Eleanor's death that finally spurred Edward to crown his father's monument with a recumbent cast-metal effigy, on a low table edged with a Norman-French inscription (Fig. 434). This leaves the tantalizing question as to what was envisaged by Edward in May 1290, as the permanent crowning feature of his father's tomb. Eleanor had no relevance at this juncture, her death not being anticipated. Perhaps the previous kneeling figure was simply reinstated, although the composite nature of the top slab strongly suggests that, *ab initio*, it was meant eventually to be covered by a recumbent effigy, concealing the metal-cramped joints.

Canopy

Henry's monument was incontrovertibly designed in such a way that it could support a *ciborium*-type canopy. In plan, the lower chest is significantly larger than the upper, creating a broad, flat ledge all round the monument (Fig. 436). Moreover, it has prominently eared corners, the ostensible purpose of which was to provide seatings for four column bases, 20cm square. Roman tombs, altars and *confessiones* supply numerous analogues. Spirally-fluted, Cosmati columns of similar scale to the two displaced examples that remain at Westminster were employed either as pairs or quartets, to support canopies on Italian tombs and altars: e.g. the tomb of Clement IV at Viterbo and the altar at Sacro Speco at Subiaco.[255] Clement's monument has multiple affinities with the Westminster assemblage. Binski acknowledged that the design of Henry's tomb allowed for the addition of a canopy, but concluded 'it was omitted in order not to overshadow the main shrine'.[256] However, we suggest that Henry not only envisaged aggrandizing his tomb with a *ciborium*, but actually did so. Apart from the design of the lower chest, the case is made *a fortiori* by two other pieces of evidence: first, the setting-out lines for positioning the column bases, scored on the top slab of the lower chest[257] and, second, the survival of two Cosmati columns of the appropriate scale and dimensions, for which no other function has been identified.

Suspended from the arcade piers above the tombs of Henry III and Eleanor are oak canopies, or testers (*coopertoria*), and both have been loosely assigned to the 15th century.[258] The two extant canopies are replacements, but not a matched pair, Eleanor's being the more decorative. Her original canopy, painted by Walter of Durham, was presumably of timber, suspended from the arcade piers like the present one.[259] Its replacement is datable to the 1440s, after Henry V's chantry chapel had been constructed.[260]

There are no comparable circumstances to account for the substitution of Henry III's canopy.[261] Although Edward was responsible for the addition of the precious-metal effigy and for painting a canopy over his father's tomb in 1292–93, this does not date the erection of the *ciborium*, nor confirm its materials. The structural framework of Henry's *ciborium* would have been of Purbeck marble, comprising four Cosmati columns and a similar number of lintels spanning between them. There are several options for the treatment of the top: it could have been provided with a low-pitched timber 'roof', or a flat boarded ceiling. Most likely, it was a ceiling or roof-soffit that Walter of Durham painted in the early 1290s.

We have noted the registration-lines scored on the top of the lower chest, indicating that the column bases were 20cm square (p. 442). The diameter of the shafts rising from these would have been *c.* 15–17cm, the height of the bases *c.* 15–18cm, and the capitals *c.* 24–28cm high, with square abaci. The overall proportions of the monument suggest that the height of the columns, including capitals and bases needed to be in the region of 2.0m. Unrecognized hitherto for what they are, two of the posited column-shafts have survived as a result of being incongruously incorporated in the 1557 reconstruction of St Edward's shrine (Figs 359, 361 and 365). The surviving shafts are decorated with high-quality Cosmati work, the materials and patterns of which are closely related to the mosaic on Henry's tomb-chests. However, in one respect, the shafts stand out as being even more luxurious than any other extant component of the cosmatesque assemblage. Their tessellation not only comprises coloured and gilded glass, but also the much rarer silvered glass (Figs 362 and 363). Being partially buried in the chapel floor, the height of the two extant shafts cannot now be measured, but it was certainly not less than 1.75m, and perhaps as much as 1.9m (pp. 371–2). Thus, overall, the columns of which they formed part must have been in the region of 2.1–2.2m high. In design and scale, they are perfect for Henry III's tomb-canopy.

The fact that the columns were available for Feckenham to incorporate in his 1557 reconstruction of the shrine is consistent with the *ciborium* canopy having been dismantled around the time of the Dissolution. Moreover, since the tessellation was seemingly in a reasonable state of preservation when the shafts were salvaged, we have argued that the two extant columns came from the north side of the tomb, where they were virtually inaccessible to souvenir hunters (p. 372). Although seemingly not motivated by any particular ideology, the canopies of many English medieval tombs were demolished in the 16th and 17th centuries. The plain oak tester now suspended above Henry III's tomb is assignable to the former century.

Constructional logistics

We must now review the logistics of constructing Henry III's tomb. First, it would be obtuse to argue that Henry, who enjoyed such a long reign and was personally responsible for the rebuilding of Westminster Abbey as England's coronation and royal burial church, did not take charge of the design and fabrication of his own tomb. As early as 1245, he had designated Westminster Abbey as his burial place, in preference to London's Temple Church. When it came to determining the detailed layout and furnishing of the sanctuary and shrine chapel, which must have been by 1260 at the latest, he would undoubtedly have begun to make arrangements for his own sepulchre, if indeed he had not already put them in train in the previous decade. Logic and practicability both demand that the king's tomb should have been constructed at the same time as the shrine, so that the main components of both were in place before the chapel pavement could be inlaid with fragile glass mosaic (p. 562). It occasions no surprise that the archaeological evidence points to that being the case.

Particularly instructive is the way that the Purbeck marble paving of the chapel runs under the lower step of the monument, but the mosaic inlay abuts it and, like the tomb itself, conforms to the canted plan of the middle arcade bay. Explicitly, when the matrix for the mosaic inlay between Edward's shrine and Henry's tomb was set out and chased, it related meaningfully to both monuments. The design towards the northern edge of the floor terminates in a very precise manner, just short of the steps; this stands in marked contrast to the situation on the south side of the chapel, where the mosaic inlay simply peters out in an overtly haphazard fashion, there being no defined edge here (Fig. 227).

The physical process of constructing the tomb was precisely the same as that already described for Edward the Confessor's shrine. The two chests were separately assembled from blocks of Purbeck marble, the components being butt-jointed and cramped with iron set in lead. The blocks were prepared and the mouldings cut on them; then the intended decoration was delineated on the surface of the marble, the matrices cut, and the mosaic elements inlaid. All of this was done on the bench in the marbler's workshop, not in the chapel. Utilizing large panels of Purbeck marble enabled the majority of the mosaic decoration to be accommodated without bridging joints between slabs, but where that was unavoidable small numbers of tesserae were temporarily omitted from the matrix and the carefully measured gaps infilled after the tomb had been assembled. Areas where the tesserae had to be inserted when the chest *in situ* are detectable to the archaeological eye, and the clearest instance is on the east end of the lower chest, where structural movement has resulted in the tessellation becoming ruptured (Figs 458C and 460A). The point of union is further emphasized by the fact that the inserted tesserae are slightly different in colour from those above and below the joint, which were fitted on the workshop bench.

As with Edward's shrine, once the prefabricated panels were complete and transferred from the workshop to the chapel, the tomb could have been assembled and brought to completion very rapidly. This operation would have been accomplished in a matter of weeks. Again, it must be emphasized that there was no question of the monument being constructed piecemeal, on this site, over the course of many years, as has some commentators have envisaged. The materials and construction techniques of Edward's shrine-tomb and Henry's tomb are so similar that it would be disingenuous to argue that they were pre-fabricated and erected by different teams of mason-carvers and mosaicists, at different dates.

We have seen that the Purbeck marble floor of the shrine chapel was laid initially as a plain pavement, using slabs of various shapes and sizes (p. 221). That provided a clean and level working

area for the monument builders. It was only after the two tombs had been erected that work could begin on chasing the matrices and inlaying the delicate tesserae. Interestingly, the mosaic work in the pavement itself provides stratigraphical and chronological ties between the two monuments. The tessellation in the northern arm of the floor is of a higher quality than elsewhere, not only in the layout and execution of the design, but also in the materials employed (p. 223; Fig. 230, Zone C). Notably, this section of pavement incorporates a good deal of glass mosaic, which is scarce or lacking in other areas of the chapel floor.

The coffin

A factor of critical importance for elucidating the details of his sepulture, not hitherto considered, concerns the coffin in which Henry's body was placed in 1272. It was not a monolithic stone sarcophagus of the kind that contains Abbot Ware's corpse or that which was provided for Edward I's interment in 1307.[262] Instead, it was a robust, plain oak coffin. Monolithic stone coffins were a hallmark of high-status burials of the period, but were essentially immoveable. We cannot doubt that, before he died, Henry would have determined exactly where he wished to be buried, in what type of coffin, and whether that was intended to be temporary or permanent. Having been mindful of his desired funerary arrangements since 1245, it is not credible that he would have left decision-making on such fundamental matters to others. If the king had intended that his body should rest permanently in the Confessor's tomb-chamber, he would undoubtedly have been laid in a monolithic stone coffin.[263] Instead, he was placed in one made of oak. There is no reason to suppose that the extant coffin is other than the one in which the king was laid in 1272.

Almost certainly, the coffin was made in Henry's lifetime. It was of simple but very sound construction, with bespoke iron banding to which chains and lifting-rings were attached, the latter unequivocally indicating that, from the outset, there was an intention to relocate the corpse in a stone chest at a later date (Fig. 477). Moreover, the depth of the coffin, plus the length of the chains, presupposes that the blacksmith who made the *ferramenta*, in or before 1272, knew the depth of the stone chest into which the coffin would later be lowered. This is another pointer to the

erection of the tomb prior to Henry's death.

The coffin was well made, with bespoke ironwork, and the whole was clearly designed to fit snugly into the upper tomb-chest. Most coffins of this era were markedly tapered in plan, but Henry's is not, additionally confirming that it was made to be a comely fit within a rectangular chamber. The provision of the iron stirrups that completely cradled the coffin is exceptional (if not unparalleled), indicating that the weight it contained was considerable, and that there was a need to prevent distortion or collapse when it was moved. It would not be surprising to find that the oak planks housed a lead lining, but we have no information on this point. If so lined, it could not have been a conventional, sealed coffin-shell because we know that the oak lid was not fixed to the side-planks, so that it could be lifted off to expose the corpse. This indicates the potential for repeated inspection, or even overt display, of the body. The *Annales* make a point of mentioning Henry's luxuriant beard (*barba prolixa*), confirming that the body was inspected when translocation took place.

All the constructional details point to a pre-planned, orderly burial procedure in 1272, and one would expect nothing less of Henry III, who doubtless took every precaution to ensure that his corpse would be preserved 'incorrupt'.[264] Henry instructed that his heart should be buried in Fontevraud Abbey. The heart, which would have been removed in 1272 prior to his encoffinment and placed in a casket, was apparently kept with the body while it lay in the Confessor's tomb; it is not unlikely that total evisceration took place at the same time, providing better conditions for 'incorrupt' preservation of the corpse.[265] It could certainly not have been left until 1290 then the heart was collected from Westminster by the abbess of Fontevraud.

The coffin was robustly made, so that it would withstand secondary handling, and when it reached its final destination it could be lowered into the tomb-chest that had already been constructed to receive it, without disturbing the contents. Moreover, the coffin was a snug fit inside the Purbeck marble chest, and an interesting detail demonstrating the care that was taken with its placement is worthy of mention: the lower part of the inner face on the east side of the chest is recessed, as though it were intended to receive the foot-end of the coffin. Creating this recess,

which is shown on the 1871 section drawing (Fig. 477), was clearly a deliberate adjustment made during construction, but it was not necessary for simply lowering the coffin into the chest. It must therefore have had another purpose. Once the coffin had been inserted, it could be eased slightly eastwards into the recess, thereby creating a small space between the head-end and the west wall of the chest.[266] The requirement for a gap all round the coffin is readily explained since the latter was covered with a pall made of 'cloth of gold', after insertion in the tomb. Stanley described the cloth as being 'in one continuous piece extending over the top, sides, and ends; the four corners not cut away but folded'.[267] That could not have been achieved if there was little or no gap between the coffin and the end-walls of the chest. The cloth, which is decorated with a pattern strikingly reminiscent of Cosmati work, was probably the pall that covered the coffin when it reposed in the Confessor's tomb chamber (Fig. 478).

There is a significant corollary to this seemingly trivial detail of the tomb's construction: the coffin must have been to hand while the tomb-chest was under construction, and before the mosaicists installed the tessellation. When the panels for the sides of the upper chest had been prepared, they would have been assembled as a 'dry run' in the workshop, the coffin would also have been tried in the chamber, to ensure that it fitted and could be inserted without snagging, also checking that the lengths of the attached chains and lifting-rings were correct. It is not unreasonable to suppose that Henry himself inspected this trial. While it was found that the chest was large enough to receive the coffin, somebody (perhaps the king?) with a keen eye for the details of the eventual funeral would have noticed that there was insufficient space for a pall to be draped neatly over the coffin once it was installed in the chamber. A larger gap was needed at the ends.

The only way to increase the internal length of the chest was by reducing the thickness of one of the end panels.[268] The amount of marble that had to be removed, using hammers and chisels, was not insignificant, but could easily be done in a matter of two or three hours on the bench. It would not have been achievable once the tomb was finished and *in situ*, without incurring serious damage: percussive action on the interior wall of the chamber would certainly have displaced the end panel and doubtless dislodged most of the

fragile glass tesserae. An adjustment of this nature had to be made in the workshop.

Returning to the logistics of the translocation in 1290, access to the upper tomb-chest needed to be pre-arranged. Scaffolding had to be erected in St Edward's chapel and in the north ambulatory, to provide working platforms on both flanks of the chest. The interim figure that crowned the tomb was removed, and the composite top slab disassembled and set aside, after which the two iron tie-bars securing the north and south panels of the chest from spreading were temporarily removed. Then Henry's coffin was brought into the chapel and hoisted on to the scaffold platform. Six men were required to manoeuvre the coffin and position it over the upper chest, where it was probably set down temporarily on timber bearers. Correct positioning was crucial since there was very little free space between the coffin and the sides of the chest (Fig. 477). The six rings and short chains attached to the stirrups were not only useful for lifting and carrying the coffin, but essential for lowering it into the chamber. Three iron bars could be passed transversely through the rings, for six men to grip as they lowered the coffin. The rings and chains remain attached to the stirrups and still lie loose in the gap between the coffin and the sides of the tomb-chest.[269]

Once the coffin was installed, a mason had to re-fit the iron bars tying the side-panels of the chest together. The bars have hooked ends, leaded into pockets cut in the upper edges of the north and south sides. Finally, the pieces of the top slab had to be reassembled and cramped and, presumably, the crowning figure reinstated. Only then would the scaffold platforms be dismantled. Although the coffin itself could have been moved from one tomb to another on the night of 10 May, the complete operation would have taken several days to accomplish. The logistics of the translocation would have been slightly more exacting with the *ciborium* in place over the tomb, but it should not have been necessary to dismantle it.

Another remarkable aspect of the design of the coffin deserves mention: although it is not tapered in plan, in elevation it tapers along its length: the height at the west end is greater than that at the east (Fig. 477). There can be only one reason for this, and that was subtly to enhance the presentation of the body when it was lying in state and viewed longitudinally. By reducing the height at

the lower (foot) end of the coffin, and raising the head and shoulders on a pillow, the body would have appeared more imposing. We see a similar effect in one of Matthew Paris's illustrations in the Cambridge *Estoire*, depicting the Confessor's body with the head and shoulders slightly raised (p. 552).

Since the board forming the lid was never physically attached to the coffin, repeated access was not inhibited, and if Henry's corpse had been eviscerated it would desiccate slowly and could continue to be venerated in the open, without fear of losing its 'incorrupt' appearance. However, if the body was placed in the tomb chamber, facing eastwards, the sloping coffin would have provided no advantage for viewing the corpse from the west, through the *fenestella*. That would only obtain if the orientation were reversed. Hence, we should perhaps seek another circumstance to explain the unusual profile of the coffin; for example, the posture would have been suitable for lying in state in front of the high altar.

A failed cult?

Finally, we come to the all-important question: why was Henry initially interred in the Confessor's old tomb? If the foregoing arguments are accepted, and his own Cosmati monument was finished by 1269, there was no necessity to inter the king elsewhere, but indisputably that did happen. Arguably, it was by choice and not a matter of expediency. Henry's desire to be with the Confessor in both life and death was intense and undeniable, and has been repeatedly stressed by Binski and Carpenter. The closer he could get to Edward – and thereby imbue his sanctity – the greater was the chance of beatification, miracles at his tomb and eventual canonization for himself. Henry was driven by ambition, and it would be naïve to suppose that eventual beatification was not on his mind, particularly in later life as he saw what was happening in France. He would doubtless have regarded a period of repose in the Confessor's old tomb as facilitating the route towards that goal. The tomb was still accessible and would have been revered as a powerful secondary relic. Henry had caused it to be protected within a masonry chamber, a *hypogeum*, constructed beneath the elevated pavement of the Confessor's chapel, with permanent access from the west. The affinity with Italian *confessiones*,

having a single west-facing opening and flanking flights of steps is striking (Fig. 533). The principal difference at Westminster was that the high altar did not stand directly above the chamber: that position was occupied by St Edward's altar.

Henry could get no closer to Edward in death than by being interred in the saint's own tomb; to repeat Carpenter's words, Edward would 'succour him in this life and conduct him to the next' (p. 2). Binski similarly reinforced the intimate association between Henry and the Confessor, in both life and death: 'Henry slept with Edward in life much as in death, in his chamber at Westminster adorned with images from the saint's life'.[270] Christopher Wilson has expanded this conclusion by arguing that the sumptuously adorned Great Chamber in the Palace of Westminster – in which the king slept – was a 'monument to St Edward the Confessor'.[271] That being so, it provides added strength to our contention that Henry's sojourn in the Confessor's tomb was pre-planned by the king himself, even though his own canopied tomb was most likely already complete and awaiting its occupant.

Despite many writers having alluded to the shrine-like appearance of the tomb, all have stopped short of labelling it as a shrine. But there must have been a purpose behind designing and constructing such a monument. It is, as Binski remarked, without parallel, and is perhaps best described as a hybrid between a tomb and a shrine; undeniably, the three small chambers with crosses in their backs indicate an association with relics. At the very least, the monument must have been designed to encourage pilgrims to St Edward's shrine to pray also at Henry's, and make donations.[272] There are good indications that an incipient cult began to develop, but it did not flourish, and by 1290 it was all but forgotten. There are no signs that Edward I did anything to promote a popular cult of his father, and no application was ever made to the pope for canonization. Although we may accept that neither Henry nor his son Edward would have displayed such a shocking lack of humility as to construct something that was unashamedly a shrine, before the prospect of sainthood was even on the horizon, the shrine-like tomb that we see today does not give the impression that its creator was particularly humble or self-effacing. Maybe the reason why history is silent on the matter of its construction is because knowledge of Henry's shrine-like tomb had

come to the pope's attention, and he regarded it as presumptuous and improprietous. That would have closed the door firmly on sanctification.

Many scholars have attempted to explain the long delay in transferring Henry's coffin to his own tomb by making two assumptions, first that the latter had not been constructed by 1272 and, second, that his son Edward made little effort to expedite its construction (or completion). In seeking to explain Edward's dilatoriness some have cited his all-consuming commitment to wars in Scotland and Wales, or his supposed reluctance to devote hard-pressed resources to finishing his father's flamboyant tomb. These arguments and the assumptions that have given rise to them are incompatible with the archaeological evidence. If any of this were true, Henry certainly would not have ended up with a tomb so lavishly decorated that it rivalled the Confessor's shrine and outshone the other cosmatesque works in the Abbey.

Whether Henry requested that his interim interment in the Confessor's former tomb should be for a specific period, we cannot say, but Edward I was away and heavily committed for much of the interval in question, and consequently there may not have been a specific reason for the eighteen-year delay in translating his father's coffin. Quite simply, once it had been deposited in the Confessor's tomb, there was no imperative to move it, especially if canonization was not imminent. As is often the case, an absence of urgency encourages a lack of action. It is futile to speculate as what finally stirred Edward into moving his father's body to its ultimate sepulchre in 1290. Perhaps it was merely conscience?

Dating the construction of the tomb

Antiquaries have been attempting to date the construction of Henry's tomb for over two centuries, almost exclusively by citing and interpreting two recorded events. First, the acquisition of jasper embellishments in 1280 by Edward I and, second, the translocation of Henry's coffin from the Confessor's former tomb to his own in 1290. The latter has been interpreted as definitively proving that Henry's own sepulchre was unfinished in 1272, when he died, and that reuse of the Confessor's grave was a necessary expedient. Inexplicably, the obvious possibility that it was reused by choice – and on the instruction of

Henry himself – seems never to have been entertained.

The fact that some ornamentation of the tomb occurred in 1280 has been seized upon, irrationally, as indicating a commencement date for the work only in the late 1270s. Many writers in the 19th and 20th centuries have repeated this myth, with varying emphasis and elaboration, with the result that it has become deeply embedded in academic literature as 'fact'. But gluing some *cabochons* on a few of the tomb's already complete mosaic panels is irrelevant to dating the structure. Burges asserted 'we may be pretty well certain that Henry was buried first of all before the high altar, that sometime before 1280 a fresh supply of mosaics and porphyry had been obtained from Italy, and that the work went slowly on until it was completed by Torel's bronze figure in 1291.'[273] Binski took the argument a stage further: 'There is one apparently irrefutable argument for the extension of cosmatesque operations . . . after 1272: namely, that the magnificent Cosmati tomb of Henry III . . . was not in construction much before 1280 and was only completed in the early 1290s.'[274]

The implications attendant upon such a claim are momentous and need to be examined. First, it would mean that Henry had no hand in the construction of his own tomb. Secondly, the entire cost of the work must have been found by his son, Edward. Thirdly, since there is no record of petitioning the pope to beatify Henry, why would Edward construct what is overtly a shrine-like tomb for his father? Fourthly, what would have motivated him to commission an extraordinarily sumptuous cosmatesque monument that was without parallel in England or Italy? Fifthly, how was all this achieved without any record of the work taking place, or of the prodigious expenditure involved appearing in surviving royal or public accounts?[275] Such a scenario is wholly lacking in credibility, but nevertheless has been repeated so often that it has gained limited acceptance in the scholarly world.

One further account, sometimes cited as 'evidence' that the tomb was still under construction in 1290, is the payment of 40s. to Henry of Lewes for unspecified *ferramenta* (p. 590).[276] This may have been related to the translocation of Henry's coffin, the provision of railings, or the addition of funerary accoutrements to the tomb. In this connection it should be noted that there are three large iron hooks, or pintles, leaded into

the south-east quadrant of the arcade pier abutting the tomb on the west (i.e. close to the head of the king's effigy). Two of these fittings are vertically aligned, the lower one being just above tomb-top level, and the third is higher up the pier, but not aligned with those below (Fig. 548). Self-evidently, these hooks were installed for the attachment of ironwork of some description. They could, for example, have been supports for the king's sword, shield and helm. A little later, Edward III's tomb, on the south side of the chapel, was accompanied by his Sword of State and shield, both of which are still extant. Henry V's helm, sword and shield were similarly displayed close to his tomb. Hence, it would occasion no surprise if Henry of Lewes was commissioned to produce the ironwork necessary to hang similar military accoutrements above Henry III's tomb in the year that his body was finally laid to rest.[277] Whatever they were for, the *ferramenta* ordered in 1290 had no relevance to the construction of the king's tomb *per se*.

This example, like that of the jasper *cabochons*, previously discussed, demonstrates how a failure to distinguish between the tomb's constructional processes and peripheral activities of later date has compounded the confusion. Archaeological and logistical evidence, however, suggests a rational sequence of events and a much shorter chronology for the tomb's construction.

In summary, although 'altar' tombs were a well established feature of English 13th-century funerary architecture – and Westminster Abbey houses several fine examples – Henry III's monument differs from all others in Britain at this period. It comprises two chests, stacked one upon the other, and surmounted by a gilt copper-alloy effigy: the lower chest proclaims itself to have close affinities with Italian *confessiones*, and the upper simulates a purple porphyry sarcophagus. The whole was then crowned by a now-lost canopy supported on four columns. Additionally, when the tomb is viewed from the north ambulatory, one gains the impression that it comprises not two, but three, superimposed chests (Figs 31 and 433), an illusion arising from the fact that the ashlar wall forming the 1.5m high plinth to the chapel platform presents a panelled aspect to the ambulatory (pp. 440–1).[278] It can hardly be accidental that Henry's tomb was aggrandized in this way.[279]

Binski has drawn attention to comparable Italian examples of tiered chest-tombs, such as those of Pope Clement IV (d. 1268), Peter de Vico (d. 1270) and Pope Hadrian V (d. 1276).[280] But there is one major difference between these and Henry III's monument, namely that the lower chest of the latter is not merely a deep plinth to elevate the sarcophagus, but also has shrine-like qualities, as displayed, for example, in the *confessio* at San Giorgio in Velabro (Fig. 532A).[281]

In view of the lavishness of Henry's tomb and the integrated relationship between it, the shrine pedestal and the intervening mosaic pavement, we submit that there is a compelling case for concluding that the king's monument was constructed by the same artisans, using the same consignment of imported materials, and more-or-less at the same time. It is clearly an Italian creation, and unlike the Confessor's shrine pedestal, it was not conceived as a Gothic monument; hence its construction could not have begun until the change of style had been embraced. It was perhaps on account of the unavoidable acceptance of the basic Gothic form and some decorative detail on the shrine, that Henry asked for the two arches on the front of the lower chest to be given trefoiled heads, rather than semicircular ones, which would have been the Italian norm in this situation. We have argued above that the style change-over occurred around 1260 (p. 565). When Henry wrote his will 1253 he was mindful of his decease, and

548 Tomb of Henry III. The lower pair of iron pintles set into the arcade pier adjacent to the south-west corner of the tomb (top slab intruding on the right). These were probably for displaying the king's shield and sword. *Authors*

the need to complete the feretory but, unfortunately, he did not include any instructions regarding his tomb or funerary arrangements, other than stating that he wished to be buried in 'the church of St Edward, Westminster'.[282] We must assume that there was either a later will (lost) or detailed instructions to his executors were contained in a separate document that has not come down to us. Nor should we overlook the fact that pilasters with lunette-ended panels were already anachronistic by the mid-13th century, and their appearance later would be even harder to explain.

There is no sound evidence for claiming that Edward, as king from 1272 onwards, had any involvement with Cosmati mosaicists, and he plainly had no affinity with Roman architectural style or cosmatesque decoration. The lavish tomb that he provided for his beloved queen, Eleanor, when she died in 1290, is resoundingly Decorated Gothic; so too is the magnificent canopied tomb for his brother, Edmund Earl of Lancaster (1297), and that which was created retrospectively for Edmund's wife, Aveline (c. 1295–1300; Fig. 516).[283] Finally, Edward did not devote any significant resources to preparing a fine tomb for himself: his sepulchre is the plainest and meanest of any English monarch's, and has been described as a 'barbarically plain stone chest' (Fig. 387).[284]

Consequently, there is a sustainable case, based on a body of circumstantial evidence, that Henry personally oversaw the design and manufacture of his own tomb entirely within his lifetime, and work ran in tandem with that on the shrine pedestal. A reasonable estimate for the time it took to construct the tomb would be three-to-four years (i.e. about the same length of time as it took to create Clement IV's tomb). The complete absence of financial records relating to the monument is most easily explained if the king managed and paid for the project himself. Had the task of commissioning, or completing, the tomb fallen to Edward I, there is a greater chance that either the work or the prodigious expenditure involved would have been noticed in a source that has come down to us.

The only component of Henry's tomb that we can be certain was not manufactured in his lifetime was the gilt copper-alloy effigy crowning the monument.[285] It, along with Eleanor's two effigies, was cast by William Torel in a workshop set up in the Abbey cemetery in 1291–92.[286] Henry must have anticipated completing his monument with

a recumbent effigy, and the fact that the top of the upper chest comprised an undecorated, composite slab of Purbeck marble confirms that a further component was envisaged *ab initio*. We have argued that there was initially a kneeling, supplicant figure mounted on the chest, which was perhaps an interim gesture, with the intention that it would be superseded by a recumbent effigy and inscription when the king's coffin was finally installed.

OTHER TOMBS

Having created a spectacular display of Italian marble and glass mosaics in Westminster Abbey, it is inevitable that a new 'market' for such work would have been generated in England, perhaps not for pavements, but more particularly in respect of shrines and tombs. We have good evidence from St Paul's Cathedral, St Augustine's Abbey, Canterbury and Wimborne Minster, although none of these works can be closely dated. At Westminster, additional cosmatesque furnishings that have not survived may have been commissioned after the 1269 dedication, and two more royal tombs were made, both dating from the early 1270s.

The child's Cosmati tomb (John of Windsor)

The case for this being the tomb housing Edward I's two youngest sons – John of Windsor and his brother Henry – is strong. They are the only offspring of either Henry III or Edward I who could, chronologically and physically, have fitted in the tomb which, moreover, can arguably be linked to surviving documentation. Most likely, the monument was constructed in or just after 1271, to contain John's body (p. 484). When his brother Henry died in 1274, he was also interred in the shrine chapel and may have been given a separate monument or, as we have argued, the Cosmati tomb may have been adapted to receive the second coffin (p. 484). Either way, it is now understood that the repositioned chest contains two coffins, and when the children were removed from the east end of the shrine chapel in c. 1437, to make way for the erection of Henry V's chantry, the boys were united in the rebuilt Cosmati tomb (Fig. 480).

Like Henry III's lower tomb-chest, this has an eared top slab supported at the corners by clasping pilasters (but no colonnettes). Of particular interest is the design of the sunken panels in the faces of the pilasters, with their lunette-shaped ends (Fig. 491). The king's and the child's tombs are undoubtedly products of the same workshop. The composition and execution of the mosaic work is, however, markedly different in some respects, but closely related in others. Of critical significance is the mixture and origin of the materials employed in the child's tomb. Mortar impressions and a few surviving tesserae show that both coarse and very fine mosaic work was present, and that the materials matched those found in the other monuments. However, very little porphyry seems to have been incorporated, and some of that was in the form of cut shapes, perhaps left over from *opus sectile* work. One small disc of purple porphyry occurs in the east end-panel, and there seems to have been only a single stone disc (now lost) in the top slab. The other medallions were all mosaic-filled.

The layout is unusual: in most panels and pavements decorated with multiple quincunxes, they are squarely placed, side-by-side; here, however, they are rotated through ninety degrees, so that their four smaller 'satellite' roundels face the cardinal points (Fig. 493). Each roundel is shared by an adjacent quincunx, thereby creating an overall reticulated design, indefinitely extensible in all directions. In other words, it is a carpet pattern, and is relatable to the shrine pavement. There, each central medallion is ringed by six satellite roundels, whereas on the tomb it is ringed by four (Fig. 494). Essentially, the design on the tomb-top is a smaller-scale, simplified version of the carpet pavement in the Confessor's chapel. The small roundels in the pavement were variously filled with porphyry discs and mosaic, but in the case of the tomb we can be certain that neither stone discs nor mosaic was present. Instead, the matrices for the roundels were fitted with pre-cast plano-convex discs, most likely of mastic resin, coloured dark red with haematite (p. 501). If that was so, a link with the sanctuary pavement is indicated, since it employed dark red resin as part of the decorative schema (p. 120).

The mosaic in the medallions, bands and interspaces on the top slab is unlike anything else in the Abbey, and comprises straight rows, chequers and reticulations of uniformly small tesserae,

somewhat discordantly arranged (Figs 496 and 497). The colours are muted: black, white and gold. Blue and red glass, both highly favoured in the other monuments, are absent from the top of this tomb, and the east end-panel. Moreover, on this monument the black and white tesserae are not glass but marble, and are less well cut than most tesserae in the other monuments. They are likely to have been manufactured on site, especially since the black examples are of Belgian marble, and would not have come via Italy. Exceptionally, green glass was substituted for red, as the base for the gilded tesserae. The source of this glass is unknown, but it also appears, ungilded, in the niches of the Confessor's shrine.[287]

Although the Purbeck marble carcase is indicative of high quality work, the nature of the tessellation varies considerably. The last remnants of micro-mosaic in red and white are present on the north-west pilaster, whereas its north-east counterpart, despite having lost all its tesserae, retains mortar impressions demonstrating the mosaic pattern was larger in scale and the same as that in the east-facing pilasters of Henry III's tomb-chest (diagonal chequering). No clear indications are present to confirm how the two principal panels on the north side were filled, especially the western one. The Gotland limestone in the eastern panel may have replaced a previous slab of stone, but almost certainly that was not porphyry. The border around it was chequered in red, white and gold, again consonant with borders on Henry III's tomb (Fig. 490B).

Little can be said about the west end-panel, where a mixture of tessera sizes seems to have been employed somewhat haphazardly in an uncompartmented space. The quincunx panel on the east was competently executed, but in a markedly different style. The pattern and tessera sizes relate it to the top slab, and almost certainly the colour palette was similar: black, white and gold. Significantly, the tessellation in the borders around the east-end panels on Henry III's tomb is arranged in blocks alternating between red, white and gold, and black, white and gold (Fig. 458A, B).

One gains the clear impression that the mosaicists were using up the residue of assorted tesserae and pieces of porphyry brought from Italy for the main furnishing campaign, and supplementing these with locally available Belgian marble. An assistant mosaicist may have stayed

behind in England, to complete the task. Either way, relatively uninspired mosaic designs, a very limited range of colours and the absence of Italian red and blue glass are pointers to the supply of the prime materials having become exhausted.

The circumstances are thus consistent with this tomb being the last item in the main suite of Cosmatesque furnishings created for the Abbey. John of Windsor was Edward's first-born son and heir-apparent; he was also Henry III's first grandson, and it is entirely plausible that, shortly before he died in November 1272, the king commissioned this tomb. Purbeck marble for the top and sides of the chest was readily available, and was carved by the marblers who had been responsible for Henry III's own tomb and the shrine pavement. With the supply of fine materials exhausted, a makeshift solution was adopted for creating coherent mosaic designs for the two most important aspects of the tomb: the top and the east end. If our suggestion is correct that the monument initially stood in the north-east corner of St Edward's chapel, against the arcade pier, the markedly different treatment of the two ends of the chest can be explained. The quincunx presently facing east was clearly the finer panel, and it would be logical if this had originally faced west, so that it was seen upon entering the chapel. The plainer end panel – which was possibly no more than a patchwork of mosaic and left-over pieces of cut stone – would then have been against the arcade pier, where it would have been scarcely visible. The single extant side (now north) was presumably once on the south. The tomb, together with the coffins of John and Henry, was moved to the south ambulatory in *c.* 1437, where an existing wall-arch was adapted to receive it.

The discredited hypothesis that the cosmatesque chest was not a tomb at all, but the 'lost' altar for St Edward's shrine, has been adequately discussed (p. 518). Similarly, the suggestion that the broken fragment of marble crudely inserted into the matrix of one of the roundels on the top slab is a holy relic is the product of vivid antiquarian imagination.[288] In reality, there can be little doubt that it is simply the post-medieval plugging of an inconvenient cavity in the top of the chest, from which a porphyry roundel had been lost.

The 'de Valence' tombs: a conundrum resolved

The tombs of monarchs and lesser royalty, including young children, continued to crowd into St Edward's chapel during the late 13th and 14th centuries, until the point was reached where displacement became unavoidable, if fresh arrivals were to be admitted. Some tombs were moved to side-chapels, others disappeared altogether (pp. 312–13). It is known that, in addition to John and Henry, Edward I's third son, Alfonso (d. 1284), was entombed at the east end of the chapel, between the shrine and the altar of the Holy Trinity, as were his sisters. Their mother, Eleanor, joined them in 1290, followed by Edward himself in 1307. We cannot account for Alfonso, whose tomb has vanished without trace; it was doubtless lost, or resited elsewhere in the 1420s or 1430s, when Henry V's tomb enclosure and chantry chapel were created.

Concurrently, several members of the de Valence family secured places in the Confessor's chapel. Henry III's half-brother, William de Valence (d. 1296), was buried in a tomb surmounted by a magnificent effigy of copper-alloy enriched with Limoges enamel (plated on an oak armature; Figs 505 and 506). Although the interment is not specifically recorded as being in St Edward's chapel, that may be taken for granted since two of his children were buried there, and a third one in the sanctuary. Before William's tomb was ejected to St Edmund's chapel in the late 14th century, it probably stood to the south-east of the shrine. The two offspring interred in the Confessor's chapel, in quick succession, were Margaret (d. 1277?)[289] and John (d. 1277). Since the 17th century, antiquaries have asserted that they are marked by two Purbeck marble tomb-slabs immediately east of the shrine pedestal. Despite the inscriptions having been lost since the 1420s, and archaeological evidence indicating otherwise, these unsubstantiated identifications have entered the history of the Abbey as 'fact'.

The earlier of the slabs lies on the axis of the shrine. In essence, it is a straightforward latten-inlaid grave-cover by a London marbler, but it has the remarkable addition of rectilinear panels of Cosmati chequerwork in red, white and gold glass, and a pair of Cosmati shields, now devoid of their mosaic (Figs 508–510 and 513). There is no evidence that this is a de Valence tomb, and a

compelling argument has now been advanced to identify it with Aveline de Forz, Countess of Lancaster and daughter of the Count of Aumale (d. 1274; p. 514). The shields would have displayed the arms of Lancaster and de Forz (as on the retrospective canopied monument in the sanctuary). The quality of the mosaic work is high and closely matches that on Henry III's tomb. This was an outstanding hybrid monument, undoubtedly without parallel in medieval England. The second slab, however, retains the letters spelling out the Valence family name, but not the personal name. There is no archaeological obstacle to identifying this with John de Valence, or to accepting that the wide grave it covers also contains his young sister, Margaret (p. 515).

From the point of view of the archaeologically demonstrable sequence, the inlaying of Aveline's tomb-cover with red, white and gold mosaic was the final Cosmati commission in the Abbey, executed by the mosaicist who had recently carried out, or was still engaged upon, the decoration of the John of Windsor's tomb and, before that, Henry III's monument. Not only did the mosaicist show a predilection for chequerwork in red, white and gold (also black, white and gold), but the visually identical nature of the glass itself on Aveline's tomb and on the east end of Henry III's, indicates that the materials probably came from the same batches.[290]

LOGISTICS AND CHRONOLOGY OF THE WESTMINSTER COSMATI EPISODE

Logistics of introducing Cosmati work into Westminster Abbey

We have already touched upon the progenitor of Cosmati work in England, and postulated that it was at St Augustine's Abbey, Canterbury, and that in turn its antecedent was the *opus sectile* pavement in the Trinity chapel of Canterbury Cathedral (p. 527). The latter, dating possibly from the 1180s, but certainly before 1220, it is the earliest known use of porphyry in ornamental paving, and it may not have been alone. We scarcely know anything about the 1220 shrine of St Thomas, and there is a realistic chance that it too was decorated with exotic stones. The cosmatesque materials discovered at St Augustine's Abbey were doubtless associated with the shrine there, and its immediate setting. Hence Italian marble workers were already here and familiar with locally available materials long before Henry III commissioned Cosmati monuments for Westminster Abbey.

Cosmati episode at Westminster commenced after 1258, and Flete's statement that Abbot Ware brought marble workers and their materials back to England with him, when he returned from a trip to Italy, is an oversimplification. The *marmorani* must first have visited the Abbey, discussed the commissions, agreed the basic designs, inspected the materials that were to be sourced locally, and measured and estimated the quantities of glass and stone that had to be imported. Different types and ratios of materials were required for the various monuments, and these needed to be specified individually and sent from Italy. Thus the sanctuary pavement required a large and precious disc of Italian calcite-alabaster for its centrepiece; up to twenty discs of *giallo antico* needed to be sawn from columnar sections to create the centres of the medallions. For the construction of Henry III's tomb, four large sheets of purple porphyry were necessary to clad the upper chest. Squares, lozenges and discs of both purple and green porphyry, measuring 20–25cm across, had to be supplied to fill the larger panels on Henry's tomb, the shrine pedestal and the altar retable.

For the sanctuary pavement, stone tesserae in the form of squares, rectangles, trapezia, lozenges and triangles were needed in four basic colours (purple, green, grey-black and white/cream), and all in ranges of three or four sizes. Moreover, the triangles had to cater for locations requiring different shapes: isosceles, equilateral, right-angled and obtuse, and the smallest triangular tesserae filled the tiniest spaces. Additionally, there were some bespoke tessera shapes for a few of the stars. Literally millions of tesserae were required to supply the Cosmati industry, and they were manufactured in specialist workshops in Italy and bagged ready for transport to the sites where the mosaicists needed them. More than half a million came to Westminster Abbey in two shipments. It would have been nonsensical to transport raw materials and a small army of tessera-cutters to England, and production could never have kept pace with the rate at which mosaicists needed to lay them. Confirmation that tesserae were not cut and bagged in England is additionally provided by the trickle of exotic 'strays' that found their

way into the bags, and thence into the Abbey's mosaics.[291]

Considering the range of materials present, it is readily apparent that more than a hundred individual bags were required simply to hold the different stone types, shapes, colours and sizes for the sanctuary alone. The tessera assemblage for the shrine pavement was distinctly different. We do not know how large the bags were, and thus cannot determine how many were actually required to pack the relevant quantities of each tessera type. When the mosaicists were at work, they presumably had assistants who placed piles of tesserae of the appropriate types on trays, so that they could quickly pick out and lay what was needed. One further complication deserves mention: linear bands of decoration could be constructed using regular tesserae, where they were on a straight-run, but when it came to carrying the pattern around a curve, one of two things had to happen: either the tesserae could be laid with triangular, mortar-filled gaps between them, or they had to be clipped so that the tesserae themselves were tapered to the required degree to maintain narrow joints. For the most part, the latter course of action was adopted. Presumably the relevant tesserae were trimmed on site.

When we come to the glass tesserae, there are only two types – opaque and translucent – but the range of shapes, colours and sizes was no less than that for the stone tesserae. The finest work was executed in glass, with some of the triangles measuring only 3mm across. This was micro-mosaic, which occurred on parts of Henry III's tomb, the shrine and Ware's tomb-cover. There was further elaboration in the form of gilding, which is found on opaque red glass and some translucent green glass. Finally, a small quantity of silvered glass occurs in the decoration of the columns that putatively supported the canopy over Henry III's tomb. The opaque glass tesserae were made in Italy, as were the red ones with gold flashing. The source of the translucent tesserae is less certain: they could have been made on site, using offcuts from the glaziers' workshops.

The numbers of tesserae required for every panel, irrespective of material, in each of the cosmatesque works, have been counted, revealing widely differing densities of tessellation even within a single monument, or area of pavement. To illustrate this and facilitate comparison between the larger panels, figures have been extrapolated

to establish the notional numbers of tesserae in a 10cm square. In the sanctuary pavement, for example, the typical density range for panels is twenty to fifty per square; few exceed that, but one spandrel has 106. Ware's tomb-cover, which incorporates micro-mosaic, comprised an estimated 6,600 tesserae.

Henry III's tomb and the shrine pedestal employed smaller tesserae than the pavements, and the average density was 100–150 per square, but the figure rises to three hundred, or more, in the shrine frieze and the soffit face of the inscription course. The columns and colonnettes had high densities of tessellation in their flutes, including micro-mosaic work; and the approximate overall numbers can be calculated where blocks of tesserae survive in flutes. Each of the columns currently supporting the shrine altar retable must have held at least 5,500 tesserae; hence the posited original set of four columns would have held not less than 22,000. A conservative estimate for the total number of stone and glass tesserae required to decorate the Westminster pavements and monuments is in excess of half a million. Quantifications of tesserae in all the cosmatesque works are given in appendix 2.

Variations in the composition of the tessellation point potentially to two shipments from Italy: the first for the shrine, Henry III's tomb and the northern and western arms of the chapel pavement; the second primarily for the sanctuary pavement. Carrara marble was imported for white tesserae in the earlier work, but when the latter pavement was laid the mosaicists embraced English white lias as a substitute. Hence, local production of these tesserae must have been put in hand. The sanctuary pavement also incorporated three discs of Belgian *rouge de Rance* and a few pieces of Belgian black marble which, again, will have been sourced locally. The first consignment also included sheets of purple and green porphyry that were cut up to create sizeable rectangles, squares, lozenges and discs for incorporation in Henry III's tomb, the shrine and retable. Along with the selected sheet material doubtless came boxes of porphyry offcuts, out of which small rectangles and roundels could be fashioned for the shrine and the chapel pavement. There is evidence to suggest that some of the rectangular matrices in the monuments were cut to hold pre-selected pieces of sheet porphyry. This is clearly seen in the back of niche 2 of the shrine pedestal, where

the symmetrical design was obviously intended to incorporate a pair of rectangular panels. One panel (65c) fits the space perfectly, but the other (64c) is smaller, and the matrix was chased accordingly (Figs 305 and 341).

Perhaps the most striking difference between the sanctuary pavement and its Italian counterparts is the complete absence of large and medium-sized discs of porphyry. Presumably, these were too expensive, and a decision was made to purchase just one impressive disc of exotic stone (calcite-alabaster) for the centre of the pavement. Similarly, large pieces of sheet porphyry were only purchased to clad Henry's upper tomb-chest; smaller pieces were acquired to make square and rectangular panels for the shrine and retable (and probably for the shrine altar too). The fact that Ware was unable to have the panels on his tomb-cover inset with porphyry confirms that the sheet material had been used up before work started on the sanctuary pavement. Although the second shipment of materials contained a good deal of porphyry, it was all in the form of prefabricated tesserae. Consequently, the medallions where one would have expected to see porphyry, were either filled with discs of *giallo antico* (potentially all cut from a single section of Antique column), or were tessellated. A few small rectangular and triangular offcuts of porphyry were incorporated in minor border panels.[292]

Attention has been drawn to the wide variations present in the density of the tessellation, and these are recorded graphically in appendix 2. For example, the number of tesserae recorded in one spandrel can be double that in another of identical area. We have also noted the ineffectual and wasteful use of glass in some areas, where the tesserae are predominantly of stone (p. 540). On the sanctuary pavement, the results are consonant with several mosaicists of varying abilities working side by side, particularly on the outer border: one man would take the time to construct an intricate pattern using a large number of small tesserae, while another would select large tesserae, to fill the matrix as quickly as possible.

Chronology of the Cosmati assemblage

Both the relative chronology and the absolute dating of the cosmatesque works at Westminster have been disputed by scholars for three hundred

years. In the second half of the 19th century, antiquaries began to take a serious interest in the subject, but the level of scholarship was less than rigorous. In 1863 Burges cited Sporley's account of the inscription on the shrine pedestal, but decided either to gloss over the fact that it was at variance with the known date of translation of St Edward's relics by a decade, or his interpretation of the Latin rendering of the date differed from that currently accepted by most scholars. Indeed, he claimed that the translation of the relics in 1269 'agrees perfectly with the inscription'.[293] On the other hand, Micklethwaite, writing in 1895, stated 'It has generally been understood to give the year 1269 … but for several reasons [not stated] I think that 1279 is the real date of the work.'

In 1868 Dean Stanley published the first of many editions of his *Historical Memorials of Westminster Abbey*, a volume that has fundamentally influenced scholars to this day. Writing of the death of Henry III and the construction of his tomb, Stanley alluded to Edward I's 'trip to Palestine', stating that on his return journey to England in 1280:

> From the East or from France, he brought the precious marbles, the slabs of porphyry, with which, ten years afterwards, the tomb was built up, as we now see it, on the north side of the Confessor's Shrine; and an Italian artist, Torel, carved the effigy which lies upon it. Yet ten more years passed, and into the finished tomb was removed the body of the King.[294]

Out of this seriously erroneous account was plucked the date 1281 for the supposed construction of the tomb.[295] Micklethwaite, obviously influenced by Stanley, claimed that the tomb 'is known to have been set up in 1281, which confirms the later date I have assigned for the shrine.'[296] One wonders how he made that connection, the 1281 date being spurious, and the argument circular.[297]

There has been a tacit assumption on the part of many commentators on the subject of the Westminster Cosmati episode that Abbot Ware was its initiator on account of his recorded involvement with procuring the sanctuary pavement, in or slightly before 1268. Binski intimated that the presumed sequence was irrational when he wrote: 'In principle we might have expected the shrine base for the king's patron saint to have had higher priority than the pavement before the

high altar, and so to have been the prior commission.'[298] He is certainly correct in deducing that. There is neither evidence nor any rationale for crediting Ware with having a hand in the Confessor's shrine, Henry III's tomb or the chapel pavement; and there is no basis for claiming that construction of the sanctuary pavement preceded them. Indeed, the primary inscription on the shrine expressly stated that Henry III commissioned it, and that the king was the 'friend' (*amicus*) of the Confessor (p. 546). It is most unlikely that such an expression would have been included in the inscription if it post-dated the king's death.

Assessing the volume of work carried out on the Cosmati projects in the mid and late 1260s has sometimes been regarded as indeterminable on account of the fact that the king was faced with series of domestic crises, including acute financial embarrassment in 1267. It resulted in his pawning a large number of jewels and other high-value objects that had been assembled for embellishing the shrine.[299] However, the financial crisis was of short duration, liquidity was restored and the items were recovered.[300] Some writers have assumed that work on the Cosmati pavements and the shrine must have been halted or scaled down during this period of financial constraint, but there are two major flaws in this argument. There is no hard evidence that the building programme in general was adversely affected to an appreciable extent, let alone the Cosmati work, which was only a very small part of a huge project. It was certainly not halted.

If we consider logically the situation that faced Henry III, it is apparent that little would have been gained by targeting the Cosmati project. The pawned jewels were not relevant to the progress of the work *per se*, and the Italian craftsmen and materials were already in Westminster: from a financial perspective, suspending work on the sanctuary and shrine chapel, and dismissing the specialist team, would have been sheer folly. Moreover, it would have delayed completion of these seminally important aspects of Henry's new abbey church, which in turn could have caused the looming and calendrically critical date of 1269 for its dedication to be missed. The king would not have contemplated that, the previously projected dedication dates of 1255 and 1258 having already passed by.

Honouring St Edward was the absolute focus of Henry's rebuilding operation: halting or crippling progress towards that goal would have been the last resort. By 1267 structural work on the sanctuary and shrine chapel had long been complete, leaving only the monuments and decoration to be finished. The new high altar was brought into commission in 1259. The expenditure on the final-stage works in those areas would have constituted only a modest fraction of the monthly building costs. On the other hand, huge economies could instantly be effected by halting or scaling down building work by local teams on the nave and transepts. We therefore consider it highly unlikely that progress with the cosmatesque elements was disrupted by Henry's short-term financial crisis.

Incidentally, recorded offerings at St Edward's altar in 1267x1269 were £18 11s. 9d., after which they fell dramatically to 3s. 10d. The considerable difference must surely reflect the disruption caused by dismantling the temporary shrine in 1267–68, and preparing to bring the new one into commission.[301]

The account of the translation of the Confessor and dedication of the new church by a London chronicler in 1269 mentions that some metalwork associated with the shrine remained to be completed.[302] It is generally assumed that this referred to the feretory itself, and that may be the case, but it is inappropriate to cite this as evidence that the shrine was not ready for use. Apart from the integral iron cramps holding the blocks together, there is no metalwork associated with the structure of the pedestal, so that can be ruled out. The reference is non-specific and could relate to something closely associated with the shrine pedestal, such as pricket-stands, which have nothing to do with the serviceability of the structure.

There is, however, another explanation for unfinished metalwork that has been overlooked: the new shrine canopy had been made and was being painted in 1268–69, when accounts mention materials 'for painting the *capse*'.[303] This cannot refer to either the feretory or the shrine pedestal (neither of which was designed to be painted), but to the timber canopy (*cooperculum*) that hung from ropes or chains and covered the *feretrum*. Later references to that canopy routinely describe it as the *capse*, *capselle* or *capsella* (pp. 394–407). It is unlikely that the canopy would have been made until the feretory was complete and in position

on the pedestal, and painting would not have taken place until it was ready to be hung. Consequently, this supplies another piece of sound evidence pointing to the fact that the shrine complex was, for all practical purposes, complete in 1268–69. The canopy required chains and metal fittings for hanging it, and a mandate issued on 5 March 1270 to supply four timbers to make charcoal for work on the shrine would have been for the blacksmith who was forging the iron fittings.[304]

The numerous mentions of the shrine, from 1241 to 1270, have not collectively received the attention they merit, although a small number of datable but disparate references to the shrine, Henry III's tomb and work on floors, between the late 1260s and the 1290s, have been repeatedly quoted in attempts to evince construction dates. Finally, the paucity of surviving financial information for certain periods in Henry III's reign has been seized upon in an attempt to explain why we do not have records for the beginning, progress and completion of work on the cosmatesque monuments. Negative evidence can have value, but relying on it as a principal dating tool undermines the foundations of scholarship.

To set all this in context, we need to remind ourselves that, apart from the single reference to the king reimbursing Ware for expenses in relation to, *inter alia*, the sanctuary pavement in 1269, there is no mention in royal administrative records of paying paviours, Italian *marmorani*, purchasing cosmatesque materials, or anything else specifically associated with the sanctuary floor. The sole reference to payment in connection with the shrine pavement was for paviours who were hurriedly finishing it in 1268–69, and that harmonizes perfectly with the archaeological evidence. The only recorded payments in respect of work on the shrine pedestal were in the 1240s and 1250s, and no financial information can be associated with Henry III's tomb, apart from some ironwork that was added in 1290. Most likely, the tomb was paid for by the king personally, drawing on funds that did not appear in the usual royal accounts. In attempting to establish the relative and absolute chronologies of the Cosmati pavements and monuments, we are not merely faced with negotiating a few gaps in the financial records of the third quarter of the 13th century, but with a near-total absence of surviving relevant material.

In short, solid facts are exasperatingly few: the sanctuary pavement is epigraphically dated to 1268; the dedication of the present church and translation of the body of St Edward into his new shrine took place on 13 October 1269; Henry III died in 1272, but was interred in the Confessor's original grave, rather than in his own tomb; Henry's body was transferred thence in 1290, and the recumbent effigy was added in 1291–92. There was only one other substantial piece of primary dating evidence – no longer extant – and that was an inscription on the west end of St Edward's shrine pedestal. According to an account written by Sporley in 1450, the inscription indicated the date 1279, ten years after the saint's remains were translated. Much ink has been spilled in attempting to explain the apparent discrepancy, but there are insuperable difficulties and certainty cannot obtain.

It was clear from the outset of our investigation that a wider approach to dating was needed, if the Westminster Cosmati episode was to be rescued from the quicksands into which it had slipped. The evidence-base needed to be broadened, setting aside myth and preconception, and taking cognizance of the available documentation *in toto*, rather than attempting to wring dates out of a very small number of brief and ambiguous references. A prerequisite for this review was also a detailed and accurate record of the construction and materials of all the Cosmati monuments within their evolving architectural setting, a need that was first articulated by Binski in 2002. A comprehensive record, coupled with rigorous archaeological analysis, was duly compiled between 2008 and 2018, expanding the data-base exponentially.

Setting aside the irresolvable problems surrounding the lost inscription, sundry other documentary references to the shrine occur from the 1240s to the 1290s, and although none provides an explicit date of its completion, collectively they leave no room for reasonable doubt that practical completion was achieved in 1269. Many of the references in the first two decades relate to gifts of money and precious items that were expressly for the construction of the shrine, but in most instances it is impossible to determine whether the benefaction was for the feretory or the pedestal.

However, accounts relating to the period 1267–69 reveal a flurry of activity in anticipation of the all-important dedication date. An embroidered cloth was purchased on 18 October 1267 for St Edward's altar, confirming that the latter was already in existence.[305] At the beginning of 1269,

paviours were completing the Cosmati pavement adjacent to the shrine (archaeologically that can be identified as relating to the south side; p. 562), and William de Gloucester and his five assistants were working on the fabric of the shrine.[306] Although not stated, it is likely that they were polishing the marble. In July, the king made preparations to celebrate the Feast of the Translation of St Edward on 13 October 'in the new church of Westminster with as much solemnity as we can'.[307] On 19 August Henry wrote to the Constable of the Tower, stating the same, and instructing him to give twenty marks to the keepers of the feretory because 'we wish that the feretory of St Edward, before the feast of the same saint … should be completed with[out any delay]'. If the Constable did not have the money to hand, he was to borrow it.[308] This reference is of seminal importance, being an explicit statement that the shrine was on the verge of completion. On 7 October, Henry ordered fifty pairs of new shoes for the Feast of the Translation, and required them to be delivered within three days,[309] and on 10 October a liberate was issued to pay the stipends of the 'servants of the shrine'.[310] The dedication of the new church and the translation of St Edward duly took place on 13 October 1269. No chronicle or other source intimates failure.

There then follows a series of references to activities relating to the aftermath of the dedication. Indulgences were issued for those who had contributed to the works on the shrine, and pilgrims who 'flocked' to it.[311] A liberate was issued for 56½ marks, to pay for gold that had been used on the shrine.[312] Other debts were settled and several payments for arrears were made to the keeper of the works of the shrine.[313] We have noted that the canopy for the feretory was being painted, and most likely its ironwork was still being made and fitted. Finally, funds were allocated on 2 June 1271 to pay for a pair of silver-gilt images of the king and queen, which were to be mounted on the shrine.[314] This was surely a royal gesture to celebrate the successful completion of the work. The perplexing lack of any further recorded expenditure on the shrine in the 1270s has been discussed by Carpenter.[315] However, if one accepts that the shrine had already been completed, as we argue here, the problem evaporates.

No less significantly, after the dedication, gifts for the shrine's construction ceased. Collectively, the battery of evidence provided by the documents cited here leaves us in no doubt that practical completion of St Edward's shrine and the surrounding Cosmati pavement was achieved in 1269. As we would expect, there are subsequent records of gifts and minor embellishments, but no hint of urgency or of significant work continuing into the 1270s.[316] Gifts are known to have included three marble columns in 1290–91.[317] They were ordered by Edward I, to stand 'around the shrine'. Although it is clear from the wording that the columns were not part of the structure, they have nevertheless been cited in some discussions of the shrine as though they were.[318]

Another minor issue also needs to be dispatched: a payment in the 1290s by Queen Eleanor's executors, for the sum of sixty shillings, to William le Pavour, *pro pavimento faciendo in Ecclesia West.*, has generated discussion, and some scholars have attempted to link this to the Cosmati pavement in the shrine chapel.[319] The location of William's paving is not stated, and there is no basis for associating him, or Eleanor, with cosmatesque work. The payment might relate to the plain Purbeck marble paving adjacent to Eleanor's tomb, or the east end of the chapel generally, where the floor had been disturbed in recent years by the interment of at least half-a-dozen royal children, including four or five of hers. Equally, the paving may be entirely unconnected with the chapel, relating instead to the north ambulatory alongside Eleanor's tomb, or elsewhere; further speculation is futile. The pavement in the shrine chapel is datable to the late 1260s, with its completion recorded in 1269.

Intrinsically, the cosmatesque child's tomb in the south ambulatory is undated, and there has hitherto been much uncertainty for whom the monument was made. However, now that it can be linked with near-certainty to John of Windsor, it has a documented commencement date of 1271–72. Finally, one of the grave-covers in the floor of the chapel, east of the shrine, retains high-quality Cosmati decoration, and in the past it has been persistently but incorrectly described as John de Valence's burial (d. 1277). Recent research has identified him with the adjacent inscribed slab in the floor, and assigned the cosmatesque one to Aveline de Forz (d. 1274; pp. 513–16).

That just leaves Henry III's tomb, which hardly appears in the records at all, and there is nothing to date either its commencement or its structural completion (provision of the present effigy does

not date the latter). Apart from the fact that it is inconceivable Henry would have failed to make provision for his own burial, archaeological evidence links his tomb firmly to aspects of the construction and/or decoration of the Confessor's shrine, the chapel pavement, Ware's tomb-cover, John of Windsor's tomb and Aveline's grave-slab.

Assembling the archaeological and architectural evidence has not only indicated the relative chronology of the monuments, but has also enabled us plausibly to place all extant historical references in context, without the need to strain the interpretation of historical sources. Essentially, the sequence is as Binski envisaged it ought to be (p. 596): beginning in the early 1260s, St Edward's chapel and its three primary monuments – shrine, tomb of Henry III and pavement – were commissioned, designed and constructed as an ensemble, using the same consignment of materials: the archaeological evidence is clear on that issue. The sanctuary pavement was a separate and secondary commission of *c.* 1267–69, grandiose in its original concept, but sharply curtailed in its execution. Finally, John of Windsor's tomb and Aveline's floor slab were tertiary, *c.* 1272–74. There is no reason to suppose that these were not contiguous operations, employing the same teams of masons and mosaicists, and there is nothing to lend credence to the hypothesis that there was ever a 'second' Cosmati campaign between *c.* 1279 and 1290.

Essentially, the foundation upon which the long drawn-out and chaotic Cosmati episode – promulgated since the early 19th century, to explain misunderstood events in the 1270s and 1280s – is a single piece of negative evidence, simply that Henry III was not interred in his own tomb in 1272. The resultant scenario is no longer supportable.

Attribution of the Cosmati authorship

It is beyond the scope of this project to embark upon a detailed discussion of Italian *comparanda* for the designs and patterns exhibited by the Westminster Cosmati pavements and monuments: that is a magnitudinous task which awaits the undertaking. We have merely noted some of the more obvious analogues, and in so doing stylistic connections with certain monuments have repeatedly manifested themselves. Similarities between Westminster Cosmati work and Clement

IV's tomb have been discussed by art historians since the late 19th century, and Lethaby and Foster have listed additional comparisons.[320] In particular, the large, slender-armed Greek crosses with concave terminals seen in the backs of the three niches of Henry III's tomb are replicated on one end of the pope's monument (Fig. 544), and also in the back of the *confessio* at San Giorgio in Velabro (Figs 532A and 543). Numerous other matches, or close similarities, are apparent between certain Italian monuments and the intricate designs in the mosaic bands on Henry III's tomb, the *ciborium* columns, the Confessor's shrine and the sanctuary pavement. The *comparanda* especially include Anagni Cathedral, the tomb of Clement IV at Viterbo, and the churches of San Paolo fuori le Mura, San Lorenzo fuori le Mura, Santa Maria in Aracoeli and Santa Maria Maggiore in Rome.

The question of authorship of the Westminster Cosmati work has been much discussed, since the Abbey has two signed monuments: *Petrus civis Romanus* on the Confessor's shrine, and *Odoricus* on the sanctuary pavement. Antiquaries have long sought to identify both names with a Cosmati mosaicist recorded in Italy as *Petrus Oderisius*.[321] Two of the churches providing the closest parallels for the Westminster mosaics have monuments signed by a master named *Petrus*. Thus, the cloister at San Paolo bears an inscription: *Magister Petrus fecit hoc opus*, as does the tomb of Clement IV: *Petrus Oderisi sepulcri fecit hoc opus*. Given certain very precise correspondences between the monuments at Westminster and those in the two churches just mentioned, the case for identifying the author of all these works as the same *Petrus* is strengthened.

While *Petrus* was one of the commonest names at this time, *Oderisius/Odoricus* was not. It must also be borne in mind that when an Italian mosaicist signed a monument, he did so personally in glass or marble tesserae; the spelling would therefore appear as he wished it. The name in the Purbeck marble frame of the sanctuary pavement, however, was created by an English marbler who chiselled pockets and inserted cast latten letters. If, as we suspect, the relevant inscription was not added until sometime after the king's death in November 1272 (p. 545), and the master mosaicist had left Westminster, there was an opportunity for a variant spelling of his name to creep in.

Foster strengthened the case for identifying the Cosmati work at Westminster with *Petrus Oderisius*

by pointing out that the distinctive mosaic pattern formed by the tesserae in Clement IV's cross is precisely matched on band 83 in the sanctuary pavement (Figs 87A and 544).[322] We have additionally noted the same pattern on the north side of Henry III's tomb and, in view of its demonstrable scarcity, this can hardly be dismissed as coincidental.[323] Similarly, the employment of single units of chain-guilloche, standing vertically, occur in the trefoil-headed arcading on the lower chest of Clement's tomb, just as they do in one of the niches in the Confessor's shrine (Figs 341 and 538); and the same motif stands at either end of the large porphyry panels on the upper chest of Henry III's tomb (Figs 449 and 465).[324]

Finally, it is worthy of note in this context – and for dating the Westminster Cosmati episode – that Clement IV died in 1268, but work seemingly did not begin on his tomb until sometime in 1271, implying that *Petrus Oderisius* was unavailable in the interim. The tomb was finished by him in 1274.[325] It is interesting that his non-availability coincided with the period when the major Cosmati commissions in Westminster were drawing to a close, ready for the 1269 dedication. Not only does this dovetail neatly with the Cosmati chronology proposed here, but it may also help to explain why aspects of Gothic decoration in Henry III's Abbey appear to be replicated in the papal tomb. Thus, the blind trefoiled arches that adorn the wall-faces in the eastern arm, and also define the niches of the Confessor's shrine, are matched by the canopy arch over Clement IV's tomb.[326] Binski opened a discussion of this subject by comparing the micro-architecture of the Westminster Retable with the tomb of Clement IV.[327] The proportions and components of the trefoil-headed arch and its superincumbent crocketed gablet on the Retable so closely resemble the detailing of the canopy on the pope's tomb that it would be difficult to deny a direct connection (cf. Figs 194 and 538). Although French derivation is usually invoked, the possibility that the Westminster arch-form directly influenced tomb-canopy construction in Italy in the 1270s may merit further exploration.

★ ★ ★

This study of the cosmatesque assemblage in Westminster Abbey does not purport to be definitive, but it does constitute a complete record of the surviving mosaics and the structures that carry them. It also provides the first detailed archaeological, structural and chronological analysis of the ensemble and its setting. As recording proceeded, further potential lines of enquiry for future research manifested themselves. These mostly require comparative research in Italy, to seek out those pavements and monuments which have identical patterns in their tessellation, particularly in the bands, flutes of columns and roundels. While some patterns are commonly found and cannot be claimed as diagnostic of any particular *atelier* or period, others are very scarce, and it is likely that the output of the individual mosaicists responsible will become more clearly identifiable, albeit that they cannot be named. Although the basic designs (and probably unit dimensions) clearly come from workshop pattern books, the decorative detailing that infills the matrices represents the 'fingerprints' of the mosaicists themselves. Study of this tell-tale evidence could lead to the more secure identification of the products of individual workshops, some of which have, of course, left their names on those monuments that bear inscriptions.

Little attention seems to have been paid to the subject of 'carpet' designs in Cosmati work, as evidenced at Westminster on the chapel pavement and the top of the child's tomb: comparanda for these need to be sought. Furthermore, the design on the shrine pavement involved the use of more than thirty stencils, but we have only noted four of these on Italian monuments. Three of the same stencil patterns also turn up, in larger format, on the sanctuary pavement. Since the study of stencilled designs on medieval floor tiles has proved crucial for indentifying groupings and elucidating the factories that made them, accurately recording and matching Cosmati stencils could prove just as informative. We hope that future scholars will pursue these and other Westminster-related lines of enquiry, with a view to providing more definitive associations between the English and Italian cosmatesque pavements and monuments.

Appendix 1: The Shrine in the Records

Matthew Payne

The following schedule of references was compiled in the course of work for this book. No schedule of this nature can ever claim to be exhaustive, and what follows is certainly no exception. However, it is to be hoped that it contains the majority of primary references to the fabric of the shrine between 1235 and 1560, with some related material, much of which is alluded to in the main text. In this schedule the focus has been on the shrine itself, rather than other tombs in the chapel of St Edward, for which citations and discussion generally appear in the main text (although some of these references are included here, particularly to the tombs of Edward I's sons).

In the end it was felt that it might be helpful to include what began as working notes as an appendix, both for ease of reference in the main text, and to avoid repetition, and for the future convenience for those working on this subject.

ARCHIVAL REFERENCES

1. 22 April 1236: Grant to the abbot and monks of Westminster of 100s receivable yearly at the Exchequer for the maintenance of four wax candles before the shrine (*feretrum*) of St Edward at Westminster, as an addition to the old lights about the body of that saint, until the king or his heirs shall provide for the maintenance of the said lights by a sufficient gift of land. *Charter Rolls 1226–57*, p. 219.

2. 8 November 1236: Liberate to Odo the goldsmith, keeper of the king's works at Westminster … £4 2s 8d to make a figure of the queen to be placed upon the shrine (*feretrum*) of St Edward at Westminster … And to Odo £23 3s 5½d to pay for a thousand of wax bought to make tapers at the feast of the Translation of St Edward to be placed about the shrine of that saint. *Liberate Rolls 1226–40*, p. 243.

3. 26 February 1240: grant to the abbot and monks of Westminster of £10, receivable yearly, half at the Exchequer at Easter and half at that of Michaelmas, to keep up four wax candles before the shrine of St Edward at Westminster in addition to the old light there; until the king shall provide land sufficient for the support of the said candles. *Charter Rolls 1226–57*, p. 250.

4. 22 November 1240: Liberate to the abbot and monks of Westminster 100s for Michaelmas term in the 24th year out of the king's grant of £10 yearly to maintain 4 tapers before the shrine of St Edward at Westminster. *Liberate Rolls 1240–45*, p. 8.

5. 8 April 1241: Liberate to the abbot and monks of Westminster 100s for Easter term out of the £10 granted to them to maintain 4 tapers before the shrine of St Edward at Westminster. *Liberate Rolls 1240–45*, p. 41.

6. 15 September 1241: To W. de Haverhull, treasurer. Contrabreve to make 5 tapers of 15 pounds each, only that the one to be in the middle of the others is to be greater and more excellent; and to offer 12 halfpence of musc at the shrine of St Edward, to which they are to be attached at once and the tapers set round. *Liberate Rolls 1240–45*, pp. 71–2.

7. 11 October 1241: Liberate to the abbot and monks of Westminster 100s for Michaelmas term in this year out of the king's grant of £10 yearly to maintain 4 tapers before the shrine of St Edward at Westminster. *Liberate Rolls 1240–45*, p. 78.

8. 28 October 1241: Liberate to Edward son of Odo, king's clerk, £258 9s 3½d, to pay for the

king's work at Westminster from Trinity in the 25th year till the feast of St Simon and St Jude following; 10 marks for a wooden shrine to the use of St Edward; £6 10s for marble for the same shrine. *Liberate Rolls 1240–45*, pp. 83–4.

9. 18 December 1241: Allocate to Benedict Crespin, in the 100 marks which he owes as part of the tallage of 300 marks at which he was assessed as part of the common tallage on all Jews, 40 marks which Master Simon the Norman took from him for this he gave a mark of gold to the king, who offered it to the fabric [construction?] of the shrine of St Edward/. *Liberate Rolls 1240–45*, p. 98.

10. 10 March 1242: Grant to Richard, the abbot, and the monks of Westminster of £20 yearly, receivable at the Exchequer, for keeping up four wax candles around the shrine of St Edward at Westminster in addition to the old lights about the body of the saint, and for providing at Christmas and on the two feasts of St Edward three hundred wax candles at each feast; the said sum to be received until the king provide an equivalent endowment of land. *Charter Rolls 1226–57*, p. 268.

11. 20 April 1242: Liberate to the abbot and monks of Westminster £20 yearly granted to them by the king at the Exchequer, to wit £10 at Easter and £10 at Michaelmas to maintain 4 tapers around the shrine of St Edward at Westminster, and to the sacrist of Westminster half a mark yearly to maintain the great chandelier which hangs in St Peter's church at Westminster. *Liberate Rolls 1240–45*, p. 119.

12. 20 April 1242: Grant to St Edward the king, for the safety of the souls of the king and Eleanor the queen and their children of twenty-four half-penny weights (obols) of musk yearly, by way of chevage, to be laid upon the great altar of the church of Westminster, by the hand of the king, the queen, or his heirs, if within the realm, or otherwise by the hand of the Treasurer, half on the feast of St Edward and half on the feast of the Translation of St Edward. *Charter Rolls 1226–57*, p. 268.

13. 2 May 1242: Mandate to the treasurer and chamberlains to let Edward of Westminster, king's clerk, have money for the maintenance of the work of the shrine of St Edward, Westminster, and for the liveries of the goldsmiths working upon the said shrine and for the marble work thereof, by view and testimony and counsel of the said treasurer and chamberlains and of Robert Passelewe; and when the king knows the cost of the said work he will let them have a writ of liberate. *Patent Rolls 1232–47*, p. 285.

14. 2 May 1242: Order to the treasurer and chamberlain of the Exchequer to let Edward de Westminster have money to maintain the work of the shrine of St Edward and to pay the goldsmiths working thereon, and for the marble work of the shrine, by view of Robert Passelewe. The king will give them a writ of Liberate when he knows the amount. *Liberate Rolls 1240–45*, p. 134.

15. [2 May] 1242: Henry by the Grace of God etc: We command you, that you cause to be delivered to our Clerk, Edward of Westminster, money for the support of the works of St Edward's tomb at Westminster and pay to the goldsmith for workmanship bestowed upon the same tomb, and for cutting marble for the same tomb, by our inspection, testimony and advice; and to our beloved and faithful Robert Passelewe, when we shall have incurred the expense for the aforesaid works, we will command the same to be paid by our writ of liberate. *Exchequer Issue Rolls* (as printed in Devon 1837, 31).

16. 15 April 1243: On finding wax tapers: Mandate to W. de Haverhull, treasurer, to find 15 wax tapers for around the feretory of St Edward until the arrival of the king in England. *Close Rolls 1242–47*, p. 21.

17. 30 August 1243: On silver candlesticks: Mandate to W. de Haverhull, the king's treasurer, that he should have made 4 silver candlesticks, and have them set around the feretory of St Edward. And when the king knows the cost, he will return it. *Close Rolls 1242–47*, p. 42.

18. November 1243: Notification from Roger de St Elphege, Prior and the Chapter of Christ Church Canterbury, that at the request of their Lord Henry King of England, they have provided that the Feast of the Translation of the Confessor King Edward shall be made a principal one in their church like the Feast of the Ascension. *Westminster Abbey Domesday*, fol. 409v.

19. 30 November 1243: On the candles to be set in the church of Westminster: Mandate to Edward son of Odo that he should have made for Christmas 4 square candles, which should contain about 100 pounds of wax, and 15

tapers of the king, which should burn continuously through day and night around the feretory of St Edward, and which should contain about 2 pounds of wax, from the Friday next before Michaelmas until the Feast of St Peter ad Vincula. And he should have so many made about the church of St Peter at Westminster burning on the feast of St Edward as the king ordered for the arrival of the Count of Provence. *Close Rolls 1242–47*, p. 138.

20. 7 February 1244: On buckles: Mandate to W. de Haverhull, the king's treasurer, and to Edward son of Odo, that they should buy two buckles, the largest that they can find in London, and 1 buckle of less value, and the same Edward should have them attached to the feretory of St Edward for the health of the king, queen and their son Edward. *Close Rolls 1242–47*, p. 156.

21. 8 February 1244: On a ring to be set on the feretory of St Edward: Mandate to Edward son of Odo that that ring which the king sent him with a gem which the sensechal of Monte Alto gave to the king, receive it from the archdeacon of Westminster and set it in the works of the feretory of St Edward according to what seems best. *Close Rolls 1242–47*, p. 157.

22. 16 February 1244: On precious stones to set on the feretory of St Edward: Mandate to Edward son of Odo that two precious stones, that is an emerald and a ruby, sent to him on two rings which R. bishop of Chichester left to the lord king in his will, should be properly set on the front of the image of the Blessed Virgin which the queen had built on the feretory of St Edward. *Close Rolls 1242–47*, p. 157.

23. [*c.* 10?] March 1244: On the works being done at Westminster: Mandate to Edward son of Odo that the king's chamber at Westminster should be panelled with good and strong boards, and the columns around the king's bed should be spangled with new painting of a green and gold colour, and curtains should be set around the bed that are fitting for that noble king; and that he should provide that four silver basins which he formerly had made, should be set around the feretory of St Edward with silver bowls, and all the works which the king has ordered, should be made ready before Easter. *Close Rolls 1242–47*, p. 169.

24. 5 July 1244: Liberate to Edward of Westminster £322 2s 1d for lead bought for the works

executed at Westminster all the time the king was in Gascony; and £100 for gold bought for the shrine of St Edward and for wages of goldsmiths during the same time. *Liberate rolls 1240–45*, p. 248.

25. 19 September 1244: On the oblations of the king and queen: Mandate to W. de Haverhull, the king's treasurer, and to Edward son of Odo, that they should provide 48 obols of musc which they should give to Guy de Palude, warden of the queen's wardrobe, and from which the king wishes that the same queen may offer 12 to the feretory of St Edward on his next coming there, and E. son of the king 12, M. daughter of the king 12, and beautiful B. daughter of the king 12 should offer them there. *Close Rolls 1242–47*, p. 228.

26. 27 October 1244: On the works to the feretory of St Edward: Mandate to the justices assigned to the custody of the Jews that 10 marks of gold by which the Jews made a fine with the king in council they should immediately make available to Edward son of Odo for the works on the feretory of St Edward. *Close Rolls 1242–47*, p. 232.

27. 22 November 1244: On the many things to be done by Edward of Westminster: Mandate to Edward of Westminster that he should have made one very beautiful and appropriate cope unless he can find one to be bought in London, so that it may be ready for the arrival of the king in London, and which he can offer to the feretory of St Edward at Christmas … *Close Rolls 1242–47*, p. 270.

28. 6 December 1244: On the buying of a silk cloth: Mandate to William Hardel, keeper of the treasury, that as it pleases the king and as he does not want to suffer the perpetual indignation of the king, and if he wishes to appear before the king on his next coming to London, he should buy a certain silk cloth which Matthew de Venice recently brought to London, so the king heard, and he should offer that cloth on the king's behalf at the feretory of the most Blessed king Edward at Westminster … *Close Rolls 1242–47*, p. 274.

29. 13 December 1244: On obols of musc: Mandate to William Hardel who should buy for the king's work 6 marks of gold in obols of musc and 100 obols of musc from it should be given to Edward son of Odo for setting toward the works on the feretory of St Edward, and the rest should be given to Brother Robert de Sikelingeham, treasurer of the New Temple

of London, to be kept safely in his custody there in the king's treasury. And when the king knows the cost, he will allocate funds from the treasury. *Close Rolls 1242–47*, p. 277.

30. 24 June 1245: On gold to be found for the king's work: Mandate to the justices assigned to the custody of the Jews that all the gold that they can they should assign to the king's work from these Jews, from which the king wishes that 3 marks should be given to the works to the feretory of St Edward, and the rest should be given to the wardrobe of the king to Peter Chacepore, keeper of that wardrobe. *Close Rolls 1242–47*, p. 317.

31. 31 July 1245: papal bull of Pope Innocent IV addressed to the Faithful throughout England that whereas Master Laurence, clerk to the King of England, has informed the pope that the king proposes to transfer to another spot the body of St Edward King of England, the pope enjoins them for remission of sins to flock to Westminster Monastery in London (where, as it is said the body of the saint rests) on the day of the Translation. For all such persons the pope releases from enjoined penance, namely on the day of the Translation one year and 40 days and on the Anniversary thereof 140 days. Dated at Lyons. *Westminster Abbey Domesday*, fol. 386v.

32. 9 October 1245: On the works at Westminster: The king sends to Edward of Westminster a Liberate by which he gives orders to the treasurer and chamberlain that they should give him 60 marks to make the gate of Westminster, and mandate to the same Edward that he should finish all the works so that the king will find it done or nearly done; and he should have made a cope for the choir made from good red or indigo samite, and he should decorate it, with the orphrey which was found over the body of queen Edith, one time wife of St Edward, with silver gilt bells, so that the king can find it ready and is able to make an offering at the feretory of St Edward. *Close Rolls 1242–47*, p. 344.

33. 10 May 1246: Liberate to Edward of Westminster 60 marks for the work of the feretory of St Edward. *Liberate Rolls 1245–51*, p. 52.

34. 6 June 1246: Computate to W. Hardel keeper of the exchange in the issues thereof, 26s 8d delivered to Adam de Stanes for 3 cameos (*catmatheus*) delivered to Edward son of Odo for the feretory of St Edward at Westminster this Easter. *Liberate Rolls 1245–51*, p. 57.

35. 19 September 1246: Liberate to Matthew of Venise and his partners £100 of the first money coming to the Exchequer within 8 days from Michaelmas for a mitre which the king gave to St Peter's church at Westminster and for precious stones bought for the works of the feretory of St Edward. *Liberate Rolls 1245–51*, p. 81.

36. 10 October 1246: On the works at Westminster: mandate to John de Wyvull and Master Roger de Gosebek, justices assigned the custody of the Jews, that 4 marks of gold which they had as perquisites they should give to Edward son of Odo for the work on the feretory of St Edward. *Close Rolls 1242–47*, p. 466.

37. 24 February 1247: Liberate to Adam de Basing £14 6s 8d for 8 pieces of gold-worked baudekin bought of him for the king, 7 of which were delivered in the wardrobe in the 27th year after the king's return from Gascony, and the king offered the 8th to the feretory of St Edward when he was last there. *Liberate Rolls 1245–51*, p. 110.

38. 28 July 1247: To W. Hardel, keeper of the exchange: Contrabreve to cause … William de Colchester to have 72s which he paid for a gold buckle of 8s weight delivered to Peter Chaceporc and offered by Alice the king's sister at the feretory of St Edward at Westminster on the Tuesday before St George … *Liberate Rolls 1245–51*, p. 135.

39. 7 January 1249: Papal bull from Pope Innocent IV addressed to archbishops, bishops, abbots, priors, archdeacons, deans and other prelates of churches both exempt and non exempt throughout the realm of England, ordering them to religiously observe the Feast of the Translation of St Edward the King and Confessor every year on its return. Dated at Lyons. *Westminster Abbey Domesday*, fol. 406.

40. 20 January 1251: On the making of copes. Mandate to Edward of Westminster that he should provide the king with one embroidered cope, very precious, and another not embroidered, and four albs of silk, and from the old albs at Westminster he should take the golden clasps (*ligatura*) to be set on the new albs, and he should buy other clasps for these old albs, and he should provide some cloth bordered with samite, to be hung in the choir of the church of Westminster as a match for the cloth which the king last caused to be hung there; and he should cause to be made a silver gilt cup worth £10 or more, to place

over the high altar there. They should be made swiftly in advance of the king's next coming there. *Close Rolls 1251–53*, p. 40.

41. 11 March 1251: On banners to be made at Westminster: Mandate to Edward of Westminster that he should have made a banner of white silk and in the middle of the banner a cross with a crucifix and images of the Virgin Mary and St John embroidered in gold, and over this should be a star and the new crescent moon, and you should provide that the said banner is ready for Easter. And again he should find another great gem for the feretory of St Edward, if he is able to find one. *Close Rolls 1247–51*, p. 422.

42. 14 March 1251: On candles to be made around the feretory of St Edward: Mandate to Edward de Westminster that from the three marks which the sheriffs of Norfolk and Suffolk gave him … he should make four silver candlesticks to fit around the feretory of St Edward, and from the remaining 10 marks to have them gilded, provided that they may be easily attached on the said feretory and that if necessary they can be attached on the new feretory of the said Saint. *Close Rolls 1247–51*, p. 423.

43. 11 April 1251: papal bull from Pope Innocent IV to the King of England that learning the devout affection which he is credited with feeling for the church of Westminster, where the body of the Blessed Edward the Confessor rests, and that the King proposes to knight his son there on the day when the same body is to be translated, and the pope, wishing that spiritual gifts may concur with this temporal honour, he releases each year on the Anniversary 40 days of enjoined penance to all truly penitent and confessed persons who reverentially visit that monastery on that day. Dated at Lyons. *Westminster Abbey Domesday*, fol. 406v.

44. 12 April 1251: Papal bull from Pope Innocent IV to the abbot and convent of Westminster releasing one year and forty days of enjoined penance each year to all truly penitent and confessed persons, who shall have visited their Monastery on the day of the Translation of the body of St Edward the Confessor which as the pope hears is about to be translated to another spot more celebrated (*ad alium locum celebriorem*) and not without much expense. Dated at Lyons. *Westminster Abbey Domesday*, fol. 406v.

45. 5 May 1251: Liberate without delay to Walter of Bromwic', king's yeoman, 30 marks for an embroidered cope bought of him for St Edward of Westminster. *Liberate Rolls 1245–51*, p. 349.

46. 3 June 1251: bull from Pope Innocent IV to the abbot and convent of Westminster, that, seeing that they propose to translate the body of the Blessed Edward the Confessor which rests in their church to another honourable spot, he releases one year and a hundred days and afterwards each year on the Anniversary of the Translation one hundred of enjoined penance to all truly penitent and confessed persons who reverentially visit the same church on the day of the Translation, and during the eight days following. Dated at Genoa. *Westminster Abbey Domesday*, fol. 406v.

47. 12 July 1251: The king sends a ring with a large ruby to Edward of Westminster to keep for the use of the shrine of St. Edward. TNA: C 60/48, *Fine Roll*, no. 800.

48. 22 July 1251: receipt of moneys after Christmas for the fabric of the church of the Blessed Peter at Westminster....: On Saturday on the feast of the blessed Mary Magdalen from the Exchequer, £300 from which were made payment for wages of workmen and certain purchases for the 8 preceding weeks; and from elsewhere for the shrine, £33 6s 8d. TNA: E 101/466/29 (Colvin 1971, 210).

49. 25 November 1251: On buckles to be made. Mandate to Edward of Westminster that he should cause to be made two gold buckles, big and broad, so that the king should have them at York for Christmas, to offer at the feretory of St William of York. And he should buy one buckle and one ring to be given on the Feast of the Circumcision of the Lord to St Edward at Westminster as a new gift of his. *Close Rolls 1251–53*, p. 15.

50. 8 Dec 1251: Nottingham. Concerning taking Westminster abbey into the king's hand. Order to Edward of Westminster to take into the king's hand the abbey of Westminster, vacant by the death of Richard, formerly abbot of the same, and to keep it safely so that from the issues of the lands formerly of the same abbot he causes a precious cope to be bought for the use of the same abbey, and to cause a large cloth to be made in the style of the large cloth which, at the king's command, he caused to be made, to hang on the other side of the choir of the same abbey opposite the aforesaid

cloth. He is also to cause a cloth of gold to be bought to cover the tomb of the aforesaid abbot, and he is not to omit to cause the feast of St Edward to be celebrated as solemnly as usual on account of the death of the same abbot, so that the venerable fathers the bishops of Ely and Chichester shall lie in the aforesaid abbey. By the king. TNA: C 60/49, *Fine Roll 36 Henry III*.

51. 17 February 1252: Liberate without delay to Thomas de Dunolm, citizen of London, 80 marks for an embroidered cope bought of him for the king and given of the king's gift to St Edward. *Liberate Rolls 1251–60*, p. 27.

52. 17 May 1252: To the sheriffs of London. Contrabreve to pay 10 marks to the sacrist of Westminster to buy gold and gild the images round the feretory of St Edward. *Liberate Rolls 1251–60*, p. 49.

53. 20 June 1252: Liberate to…Bernard de Porta £6 for a precious gold buckle bought of him and offered at the feretory of St Edward at the Circumcision in the same year. *Liberate Rolls 1251–60*, p. 55.

54. 29 September 1252: bull from Pope Innocent IV to the king of England that understanding that the king is building at Westminster in London a church of wonderful beauty, although royal wealth does not need external assistance, yet in order that others might be sharers in so good a work, the pope releases one year of enjoined penance to all truly penitent and confessed persons who have stretched out a helping hand to the fabric of the same church which involves very great expense. Dated at Lyons. *Westminster Abbey Domesday*, fol. 407r.

55. 9 December 1252: On the works at Westminster. Mandate to Edward of Westminster that he should cause to be made in the new work of the structure/workshop (*in novo opere fabrice*) of the feretory of St Edward a chapel/shrine (*capella*) where it can be made more appropriate (*commodius*), and it should be 40 feet long and 25 feet wide, and its walls should be of plaster of Paris, and in (on?) the same chapel should be painted the story of St Edward; and he should make panelled (*lambruscari faciat*) the lower storey (*camera*), in which the story of St Eustace should be painted; and in the gable window the story of Solomon and Marculf. Witnessed by the king at Gillingham. *Close Rolls 1251–53*, p. 290.

56. [1237×1267]: Indulgence of Richard bishop of Bangor conceding for 20 days of enjoined penance granted to those entering the chapel/shrine (*capella*) which has been built under the chapel/shrine of the Blessed Edward for the sake of prayer and making there any kind of benefaction:

To all to whom this present writing comes, Richard, by the grace of God bishop of Bangor, eternal greeting in the Lord. How fitting it is and we believe pleasing to God that those who venerate the holy church with faithful devotion and strive to sustain it with the goods conferred on them by God, should receive fitting spiritual benefit from those to whom power is given for temporal things, so we, by the mercy of God and trusting in the merits of the Blessed Mary and all the saints, to all the faithful who will enter the chapel at Westminster, which has been constructed under the chapel/shrine of the blessed Edward, for the sake of prayer or for any other benefit, or will promote the same chapel/shrine with alms, oblations or any other benefit or will honour it whenever divine service is celebrated there, we will relax twenty days of enjoined penance for capital sins and other things which they will have confessed and for which they are truly contrite. That, however, the perpetual grace of this our concession may continue in future times and be stable, we have caused our seal to be placed to this present writing.

[marginal note: 'the chapel/shrine under the chapel/shrine of St Edward was not completed' (*de capella sub capella S E non comparet*)]. *Westminster Abbey Domesday*, fol. 405r.

57. 1253: [Will of Henry III]: … and to the completion (*perficiendum*) of the feretory of St Edward I leave five hundred marks of silver, to be taken from my treasures (*de jocalibus meis*) by the hand of my aforesaid queen and my executors. (Nichols 1780, 15–17).

58. 4 September 1254: notification from the bishop of Conches that to all truly penitent and confessed persons visiting Westminster monastery in the city of London on the days of the Deposition and Translation of St Edward, and on the quinzaine of the said festivals, he releases 40 days from penance enjoined on them. Dated at Bordeaux. *Westminster Abbey Domesday*, fol. 393r.

59. 4 September 1254: notification from the bishop of Segovia that to all truly penitent and confessed persons visiting Westminster

monastery in the city of London on the days of the Deposition and Translation of St Edward, and on the quinzaine of the said festivals, he releases 40 days from penance enjoined on them. Dated at Bordeaux. *Westminster Abbey Domesday*, fol. 393r.

60. 7 November 1254: Mandate to Philip Lovel, treasurer, and Edward de Westminster out of money of the treasury or elsewhere to recall the workmen of the church of Westminster, who have left as the king is informed, so that the work may proceed as the church must be consecrated at the latest on the Translation of St Edward, the quinzaine of Michaelmas. *Patent Rolls 1247–58*, p. 381.

61. 1 May 1255: On one precious stone or other precious jewel to be bought for the king's work. Mandate to Philip Luvel treasurer and Edward de Westminster that with all speed they should make a search for 60 marks or 100 marks from his treasury for the king's work, and from it they should buy another precious stone or precious jewel for the feretory of St Edward of Westminster. *Close Rolls 1254–56*, p. 74.

62. 29 August 1255: On an embroidered cope and a precious buckle to be mended: Mandate to Eubold de Montibus that on his arrival back in England he should buy at Paris the best embroidered cope that he can find there and one precious buckle to be offered to the use (*ad opus*) of Edward son of the king at the feretory of St Edward at Westminster, at his next coming there. Witnessed at Newcastle upon Tyne. *Close Rolls 1254–56*, p. 130.

63. 18 October 1255: Liberate to William de Chenney, steward of the king's daughter the consort of Edward the king's son, 50 marks for [her] expenses, and 3.5 marks for a gold buckle which she offered at the feretory of St Edward on her arrival at Westminster. *Liberate Rolls 1251–60*, p. 243.

64. 29 October 1255: For the abbot of Westminster. The king has given and granted, as much as pertains to him, by his charter, to the abbot and convent and sacrist of Westminster that strip of land (*garam illam*) at Nonemaimeslond which is called the gore of Lambert which Nicholas de Stanes formerly held towards finding a lamp for around the shrine of the Blessed Edward, rendering annually therefor four pennies at the Exchequer for all service at the Exchequer of Michaelmas. TNA: C 60/53, *Fine Roll, 40 Henry III*, no. 8.

65. 28 October 1256: Liberate to Richard Boxe, citizen of London, 66s for 200 pounds of wax taken from him by the hand of William de Haselbech, late the king's chamberlain of London, and delivered to the sacrist of Westminster, to make a light about the feretory of St Edward against the nativity of St Mary last past. *Liberate Rolls 1251–60*, p. 332.

66. 17 January 1257: Liberate to William of Gloucester, goldsmith, 5 marks 14d for a gold buckle bought by order of the king and delivered to offer at the feretory of St Edward on the said saint's day last past. *Liberate Rolls 1251–60*, p. 351.

67. 19 January 1257: Liberate to William the king's goldsmith 60s for a censer which the king offered to the feretory of St Edward. *Liberate Rolls 1251–60*, p. 353.

68. 18 June 1257: Liberate to William of Gloucester, goldsmith, 20 marks to work a precious cloth for the altar of St Edward as enjoined on him, that the repair may not be delayed by fault of the Exchequer. *Liberate Rolls 1251–60*, p. 383.

69. 4 August 1258: On elephant bones: Mandate to the Constable of the Tower of London that he should give to the sacrist of Westminster without delay the elephant bones recently buried in the bailey (*ballivum*) of the tower to make there what the king orders him. *Close Rolls, 1256–56*, p. 256.

70. 15 December 1258: Signification to the pope of the royal assent to the election of Richard de Ware, monk of Westminster, to be abbot of Westminster in place of Philip de Lewisham, sometime prior of Westminster, whom the sub-prior and convent had elected to be abbot, but who has gone the way of all flesh. *Patent Rolls 1258–66*, p. 7.

71. 3 June 1259: On the church of Westminster. Mandate to Edward of Westminster, that the sub-prior and sacrist of Westminster should take down the old fabric of the church of Westminster up to the vestry which is next to the king's seat and renew the same church from money assigned to the works of the same church just as the other work there is looked after. And they should also repair the altar in the new work and that work should be done so that the monks of the same house can celebrate mass there. *Close Rolls 1256–59*, p. 390.

72. 25 July 1259: Grant to Hawise late the wife of Patrick de Chaworth, in consideration of his services and for a fine of 1000 marks

payable to the works of the church of Westminster, whereof she is to pay 50 marks this Michaelmas, and 50 marks at Easter next, and after that at the rate of £100 a year, of the wardship of the heirs and lands of her husband, with foes and advowsons of churches; saving to the king the marriage of the heirs when this falls in. Mandate to the escheator of Wilts to give her seisin of the said wardship, with the issues received by him since the death of the said Patrick. *Patent Rolls 1258–66*, p. 32.

73. [after July 1259]: John de Chilmerford and Aubrey his wife to Dame Hawise de London and Payn her son: Bond for the payment of 100 marks to the fabric of St Edward of Westminster if the said Hawise and Payn be impleaded in respect of a quitclaim to them of the manor of Standen and Oakhill (Ochulle) formerly of Hugh de St Martin, father of the said Aubrey: Wilts. TNA: DL 25/119.

74. 17 August 1259: Mandate to the sub-prior and convent of Westminster, to whom the king granted for a fine the guardianship of that abbey during its late voidance, to restore the temporalities thereof to Richard de Ware, whose election as abbot has been confirmed by the pope. *Patent Rolls 1258–66*, p. 39.

75. 11 October 1259: Liberate to Edward of Westminster, keeper of the feretory of St Edward, 50 marks for that work. *Liberate Rolls 1251–60*, p. 478.

76. 19 November 1259: For the king. On the feretory of St Edward. Mandate to Edward of Westminster to receive from Hugh le Bygod, justiciar of England, treasurer and chamberlain of the Exchequer 50 marks, and from the same money to cause to be set in place precious stones and cameos (*camautos*) on the feretory of St Edward, so that the images (*imagines*) should be attached on the feretory before the king's arrival in England, so that it will seem better and more competently put together, provided that the aforesaid stones and all the other ornaments of the same feretory should be safely guarded. Witnessed by the king at [Mustroll']. *Close Rolls 1256–59*, p. 223.

77. 19 November 1259: For the king. On the feretory. Mandate to John de Crachal, treasurer, and the chamberlains that they should give to Edward of Westminster, keeper of the works to the feretory of St Edward, 50 marks for the repair (*reparacione*) of the same feretory, over which the king has ordered Hugh le Bygod, justiciar of England, that he should give these

coins to the same Edward for this. *Close Rolls 1256–59*, p. 224.

78. 19 November 1259: For the king. On the same. On top of this, mandate to Edward of Westminster that he should receive the said money from them towards the works. *Close Rolls 1256–59*, p. 224.

79. 19 November 1259: For the king. On the same. On top of this, mandate to Hugh le Bygod, justiciar of England, that he should give to Edward of Westminster, and the other keepers of the works on the feretory of St Edward, 50 marks from the king's treasury, for the repairs for the same feretory. And mandate to the treasurer and chamberlain that the money should be given in the same way. *Close Rolls 1256–59*, p. 224.

80. 14 January 1260: For the King. On a cope and chasuble. Mandate to Edward of Westminster that he should cause to be made without delay, from the saffron silk, which the king has sent him via his beloved cleric John de Kokefeud, one chasuble and one cope for the choir with appropriate golden hems ... so that the king should have them ready for his arrival as his oblations at Westminster at his arrival. And mandate to John de Crackale, treasurer of the King, that those things which are necessary for this work he should give to the same Edward without delay. And when the king knew the cost he would make a brief from the liberate of the same treasury for them to have. Witnessed at St Denis. *Close Rolls 1259–61*, pp. 233–4.

81. 24 February 1260: For the king; on the gold to be offered at the feretory of St Edward: The king sends greetings to William of Gloucester, keeper of his exchange. When we make any journey overseas one mark of gold is held at Westminster to offer to the feretory of St Edward on our return, and we have now travelled overseas four times and not made the said oblation at this feretory, we order you to provide us without delay from the revenue of the same exchange of four marks of gold in money, so that you may have these ready in advance of our coming to Westminster to offer there for the aforesaid arrears; and in advance of our coming to England we will make the allocation to you. Witnessed at St Omer. *Close Rolls 1259–61*, p. 243.

82. 27 April 1260: Mandate to William of Gloucester, the king's goldsmith of London, that he should take from the gold of the king

which he has in his possession at Dartford on the Thursday immediately before the Feast of the Apostles Philip and James, four marks of gold so that on the Friday following he may make an offering at the Feretory of St Edward at Westminster. And he should not overlook this. *Close Rolls 1259–61*, p. 258.

83. 9 June 1260: Allocate to William de Gloucester, keeper of the exchange, in the issues thereof, 40 marks of silver in lieu of 4 marks of gold which he delivered to the king on his last return from beyond the seas to offer at the feretory of St Edward at Westminster as arrears of his oblations for his four voyages, he being bound so to offer a mark of gold every time he returns from beyond the seas. And 42s of silver for 36 gold obols, 9 marks of silver for a gold buckle, 2.5 marks of silver for 20 golden pennies of the new coinage, all of which he delivered to the king on his last return from beyond the seas to make his oblations as above, as testified by the same clerks of the wardrobe. *Liberate Rolls 1251–60*, p. 509.

84. 14 November 1260: Liberate to Hermann the goldsmith of Cologne, from whom the king long ago bought a cameo (*camahutum*) for the shrine of St Edward at Westminster, 10 marks of the king's gift for his expenses because of his poverty, as the king cannot at present satisfy him of the money due for the cameo. *Liberate Rolls 1260–67*, p. 6.

85. 8 December 1260: Concerning a jewel to be made and offered to St Edward: mandate to the Abbot of Burgh St Peter, the king's treasurer, and Edward de Westminster that they should without delay cause to be made a beautiful jewel at a price of 15 or 20 marks to offer to St Edward on the day of the Circumcision of Our Lord, and that one of them should offer that jewel on behalf of the king at Westminster on the aforesaid day. And, when the king knew the cost that they quoted for this, the king would make a brief from the liberate for them to have. *Close Rolls 1259–61*, p. 314.

86. 6 January 1261: Liberate to Hugh de Sancto Paulo 12 marks for a precious jewel lately bought of him and offered at the shrine of the blessed Edward on St Edward's day last. *Liberate Rolls 1260–67*, p. 15.

87. 16 July 1262: On the goldsmith of the feretory of St Edward of Westminster. Mandate to Edward of Westminster that he should provide what the king's goldsmith of Westminster

needs to work, lest through a defect of his there is a delay in what is needed. *Close Rolls 1261–64*, p. 140.

88. 13 September 1262: For the king. On his oblations. Mandate to the Treasurer of the Exchequer that 70 obols of musc should be attached to the feretory of St Edward and two ounces of gold as an oblation of the lord king and thirty candles should be set around the said feretory which the sacrist should have for the said Feast, and that he should provide what the whole convent needs with the king on the day of the same Feast and he should have wine and other things that are required for the feast. *Close Rolls 1261–64*, p. 151.

89. 24 October 1262: For Edmund the king's son. Mandate to the abbot of Burgh, treasurer, that he should give Edmund son of the king a beautiful and large circular cloth to offer at the feretory of St Edward at the arrival of Edmund at Westminster; and the cost which he quote for this the king will cause to be allocated to him. *Close Rolls 1261–64*, p. 161.

90. 6 November 1262: Mandate to Philip Basset, justiciar, the abbot of Burgh, treasurer, and W. de Merton chancellor, that they should prepare what is necessary to hold Christmas at Westminster … and similarly a great and precious rounded cloth of gold to be offered at the feretory of St Edward … *Close Rolls 1261–64*, pp. 179–80.

91. 15 November 1262: Mandate to J. abbot of Burgh, treasurer, that, just as the king recently ordered him, he should provide 5 marks of gold for the king's oblations and a large and precious rounded cloth of gold to be offered at the feretory of St Edward on the arrival of the king at Westminster, and a certain large and precious buckle, worth up to 15 marks to be offered at the feretory of St Thomas the Martyr, and to be sent from the king for his arrival at Canterbury; and that he should similarly provide for the king a great and precious buckle worth up to 20 marks to be offered at the aforesaid feretory of St Edward, and a cup worth 10 marks and another cup worth 5 marks, so that all of them should be ready for the king's arrival in England. And he should not overlook this. *Close Rolls 1261–64*, p. 180.

92. 27 November 1262: For the queen. Mandate to the abbot of Burgh, treasurer, that he should provide the queen with a buckle worth 100 shillings to be offered at the feretory of St

Thomas the Martyr at her arrival at Canterbury, and another buckle worth the same to be offered at the feretory of St Edward at her arrival in Westminster. And he should not overlook this. *Close Rolls 1261–64*, p. 167.

93. 1 July 1263: notification from Augustine, bishop of Laodicoea, that to all truly penitent and confessed persons who on the days of the Deposition and Translation of St Edward, and on the quinzaine of the said festivals shall visit Westminster monastery near the city of London, he releases 40 days from penance enjoined on them. *Westminster Abbey Domesday*, fol. 394r.

94. 11 December 1263: Liberate to Edmund the goldsmith 6d daily for his wages while engaged in making the shrine of St Edward. *Liberate Rolls 1260–67*, p. 126.

95. 10 November 1264: Allocate to William son of Richard, keeper of the exchange, in the issues thereof, 14s for 12 gold obols, delivered in the wardrobe to Master Henry de Gaunt, keeper, on Wednesday after St Martin, to offer at the shrine of St Edward. *Liberate Rolls 1260–67*, p. 147.

96. 29 December 1264: Henry III to the Keepers of the Exchange. Provide obols of musc for the Feast of St Edward. TNA: SC 1/2/86.

97. 24 February 1265: notification from Fr Maurice, bishop of Finnabar, that to all and each truly contrite and confessed persons who have devoutly flocked to the relics of St Edward in St Peter's church, Westminster, and have humbly said the Lord's Prayer with the salutation of the Blessed Virgin (whose diocesans have ratified this indulgence) he releases 40 days from enjoined penance on them. Dated at London. *Westminster Abbey Domesday*, fol. 394r.

98. 12 September 1265: On cloth of gold for the tomb of Joanna, daughter of Edward. Mandate to Richard de Ewell, buyer for the King's Wardrobe, that he should provide one good and beautiful cloth of gold to cover the tomb of Joanna, daughter of Edward, the king's eldest daughter, who recently died and is buried in the church of Westminster. And he should not overlook this. *Close Rolls 1264–8*, pp. 70–1.

99. 14 February 1266: Liberate to Nicholas de Castello, king's clerk, appointed to enrol the expenses to be incurred in the work on the shrine of St Edward, 50s yearly at Easter and 50s at Michaelmas to maintain himself so long as he continue in that office. *Liberate Rolls 1260–67*, p. 198.

100. 22 June 1266: Papal bull releasing from penance enjoined on them all truly penitent and confessed persons who with due reverence and devotion yearly visit Westminster church in London (whereof the King of England is Patron), namely on the Feast of the Deposition of St Edward the King [5 January] a release of 2 years and 80 days, and on the Translation of the same Saint [13 October] one year and 40 days. Dated at Viterbo. *Westminster Abbey Domesday*, fol. 386.

101. 23 August 1266: Liberate to Master Thomas of Wymundham, king's clerk, 40s for a cloth of gold and 11s 3d for wax bought by him, and offered at the shrine of St Edward; and £7 8s 9d spent in feeding the poor, all on the day of the churching (*relevacionis*) of Eleanor, consort of Edward the king's firstborn. *Liberate Rolls 1260–67*, p. 229.

102. Christmas 1266 x Michaelmas 1267: Account of the works at the church of Westminster … by Master Robert Beverley, mason, and brother Ranulf, lay-brother … And in the wages of certain masons, paviors [working] in front of the shrine of St Edward, carpenters, painters, plumbers, glaziers, labourers, and in works put out to task to masons, carpenters and painters, and in the expenses of certain messengers sent to various places on business connected with the said works throughout the aforesaid time … £614 10s 1½d. TNA: E 372/112, rot. 1d (Colvin 1971, 422).

103. 10 January 1267: Liberate to … Robert de Cornhull £7 10s for 300 pounds of wax bought of him and placed around the shrine of St Edward, as testified by Nicholas de Luekenore, keeper of the wardrobe … *Liberate Rolls 1260–67*, p. 254.

104. 27 January 1267: For wax to be given to the sacrist of Westminster: Mandate to Thomas de Wymundham, treasurer of the king, that without delay he should buy for the king's work thirty pounds of wax and these should be given to the sacrist of Westminster for the king's portion to make light there around the feretory of St Edward. And, when the king knows the cost he quoted for this, he will let him have a brief of Liberate. *Close Rolls 1264–68*, p. 288.

105. 31 January 1267: Indulgence of Octobonus Cardinal Deacon of St Adrian and Legate touching 40 days of enjoined penance granted

to those who shall have stretched out a helping hand to the completion of the work on the church of Westminster by gifts and alms. *Westminster Abbey Domesday*, fol. 389.

106. 15 March 1267: Papal bull addressed to the abbot and convent of Westminster, granting them permission to translate the body of St Edward to a fitting spot at a suitable opportunity with a convocation of clergy and people, and releasing from enjoined penance all truly penitent and confessed persons who on the day of the Translation shall flock to the Saint's body, namely 3 years and 140 days, but to those who flock thither each year on the Anniversary of the Translation one year and 40 days and to those who flock thither within the Octaves 100 days. Dated at Viterbo. *Westminster Abbey Domesday*, fol. 386.

107. 4 April 1267: Mandate to the prior and convent of Westminster to deliver to the legate all the king's jewels and precious things in their keeping, as well those assigned for the building of the shrine of St Edward, as others, except regalia, for the legate to pawn as above mentioned. *Patent Rolls 1266–72*, p. 52.

108. 28 May 1267: Whereas the king received from the abbot, prior and convent of Westminster, London, gold, precious stones, jewels and other things deputed to the casket/reliquary or feretory (*casse sive feretro*) wherein the king has arranged for the body of the blessed Edward to be placed, and other precious things of the monastery, for his present necessities, part of which he has now sold and part pawned, and another part of which he intends to pawn; he promises the said abbot, prior and convent that he will restore the same or the value thereof within a year of Michaelmas next, and binds his moveables for this, submitting himself to the jurisdiction of the pope and of O. cardinal deacon of St Adrian's, the papal legate, for this, and subjecting his chapel to ecclesiastical interdict and other ecclesiastical censures. And these letters are strengthened by the seals of the king, the legate, and Edward the king's son. *Patent Rolls 1266–72*, p. 135 (Rymer 1744, **I**, pt ii, 106).

109. 30 May 1267: Royal promise to restore to the abbot, prior and convent of Westminster, the gold, precious stones, jewels and other ornaments belonging to the shrine of Edward the Confessor. WAM 9464★.

110. 1 June 1267: Whereas the king has received gold and precious stones and jewels deputed for the shrine wherein he has arranged for the body of St Edward the king to be placed and certain other precious things of the monastery of Westminster ... [there follows an inventory]. *Patent Rolls 1266–72*, pp. 135–6.

111. 1 June 1267: Inventory of the gold, precious stones, and jewels of the shrine of Edward the Confessor and other precious goods of the Abbey of Westminster received by Henry III for his pressing needs and those of his realm ... all of which he promises to restore to the abbot and convent within one year from next Michaelmas. Sealed with the Great Seal and that of Ottobonus, Cardinal Legate. WAM 9464.

112. 15 October 1267: Liberate to the sacrist of Westminster £7 10s for 300 pounds of wax used for tapers of the king's height (*pro mensuris nostris*) round the shrine of St Edward. *Liberate Rolls 1260–67*, p. 292.

113. 18 October 1267: Allocate to Richard de Bamfeld and William son of Richard late keeper of the exchange, in the issues thereof, £30 for an embroidered cloth which the same William delivered to Nicholas de Leukenor, keeper of the wardrobe, and Richard de Ewell, buyer therefor, for St Edward's altar at Westminster. *Liberate Rolls 1260–67*, p. 293.

114. Michaelmas 1267 x Christmas 1269: [receipts] ... And £18 11s 9d received from the offerings coming from the altar of St Edward by the hands of Adam of Wycombe, monk and sacrist of the same place ... [payments] ... and in the wages of 4 goldsmiths working on the new shrine of the blessed Edward as is contained in the same particulars, £6 12s 8d [this sum covers more than just this entry] ... And in the wages of certain masons, paviors [working] in front of the shrine of the blessed Edward, carpenters, painters, plumbers, glaziers, labourers, and in several works put out and done at task, and in the expenses of certain messengers sent to various places on business connected with the said works during the aforesaid time, as is contained in a roll of the same particulars, £1,344 19s 5d. TNA: E 372/113, rot. 1d (Colvin 1971, 426).

115. 1268–69: And ruby stones bought for certain vestments which the queen caused to be made to celebrate divine service at the high altar before the feretory of St Edward & the repair of the garlands and belts, buckles, cloaks, saucers, dishes, mantles and divers plate and buttons bought over the whole of that time

£161 11s 9.5d. TNA: E 372/113, rot. 1d, *Pipe Roll.*

116. 1268–69: to Peter of Lincoln, the king's mason and his assistant 'for white stone to be crushed and to make repairs [*frangendam et reparandam*] at the pavement of the church of St Edward of Westminster, and for their expenses for making repairs to the same', 50s. TNA: E 372/113, rot. 18d; *Pipe Roll: payments by Reginald de Grey, 1st Baron Grey de Wilton, High Sheriff of Nottinghamshire, Derbyshire and the Royal Forests and Hugh de Stapleford, under sheriff.*

117. 10 February 1269: Memorandum of the restitution by Henry III to the abbot and convent of Westminster of the jewels from the shrine of Edward the Confessor, delivered to him to pledge for his most pressing needs, according to the subjoined list. WAM 9465.

118. 15 February 1269: Liberate to William de Gloucester, citizen of London, 4s daily on wages for the expenses of himself and five assistants (*socii*) working on the fabric of the shrine of St Edward from Monday next so long as they shall be engaged thereon. *Liberate Rolls 1267–72*, p. 66.

119. 4 May 1269: notification from Richard, bishop of St David's, that wishing to prosecute with pious effect the devotion and fervent charity of Henry King of England at his devout instance and trusting in the mercy of Almighty God, and the merits and prayers of the Virgin Mary, and of St Andrew, and David Confessor and all the Saints, he releases 40 days from enjoined penance to all truly contrite and confessed persons who have entered St Peter's church at Westminster for the sake of prayer and have poured out devout supplications for the estate of the king and peace of the realm before the feretory of St Edward King and Confessor, whose remains rest there. Dated at Windsor. WAM 6668★ and *Westminster Abbey Domesday*, fol. 394r.

120. 8 May 1269: whereas the abbot of Westminster, by reason of the fine which G. bishop of Worcester, made with the king for the tenth of his bishopric, made fine with the said bishop for the tenth of his temporalities and spiritualities in that bishopric for £50, and the king is bound to the abbot for £50 as well for a pavement which he brought with him from the court of Rome to the king's use [for the king's work?], to be put in the church of Westminster before the king's great altar there, and for the service which he did for the king in the siege of the castle of Kenilworth, as for money which he lately paid in the wardrobe; grant that he be quit of the said £50 of the tenth granted to the king for three years as well as on his temporalities as on his spiritualities in the said bishopric. Mandate to the bishop to acquit the abbot of the said 350 and the king will cause it to be allowed in his fine. *Patent Rolls 1266–72*, p. 338.

121. July 1269: [letter to Llewelyn] … and we will celebrate the Feast of the Translation of St Edward King of England in the new church of Westminster with as much solemnity as we can on the feast of the same saint, which will be on the fifteenth day after Michaelmas next … *Close Rolls 1268–72*, p. 71.

122. 19 August 1269: Henry III to Hugh fitz Otto, Constable of the Tower of London: because we wish that the feretory of St Edward, before the feast of the same saint, which is fifteen days after Michaelmas next, which we are going to celebrate with all solemnity at Westminster, should be completed with[out any delay] … we order that you should give twenty marks from the issues of the City of London to Walter de London, monk of Westminster, and Richard Bonaventure, keepers of the aforesaid feretory for the making of the feretory there … And if you cannot raise the said twenty marks from the revenues, then you should look to obtain them on loan … Given at Winchester. TNA: SC 1/2/88.

123. 20 August 1269: Liberate without fail to Richard Bonaventure and his fellow keepers of the shrine of St Edward 8 bezants and two golden bulls (*bullas*) which are in the keeping of the treasurer and chamberlain of the inventory of 12 bezants which they received from a Jew, to make the said shrine. *Liberate Rolls 1267–72*, p. 94.

124. 7 October 1269: Henry III to the bailiffs of London: order to prepare 50 pairs of shoes some at the cost of 5d and some 4½d for the upcoming Feast of the Translation of St Edward. And they are to be given to John the almoner so that he has them on Thursday next [10 October]. And he should not overlook this. And once he knows the cost quoted for them he will allocate a brief. Given at Westminster. TNA: SC 1/2/89.

125. 7 October 1269: Liberate to Master Thomas de Wymundham, king's clerk, 56½m for 6m

of gold spent on repair of the shrine of St Edward against the feast of the saint's translation. *Liberate Rolls 1267–72*, p. 97.

126. 10 October 1269: Liberate to Richard Bone Aventure, keeper of the shrine of St Edward, 10m to pay the stipends of the servants of the shrine. *Liberate Rolls 1267–72*, p. 97.

127. 25 December 1269: Henry III to the keeper and bailiffs of London: provide flour for the feast of St Edward, 'which we are going to celebrate at Westminster'. TNA: SC 1/2/90.

128. 26 December 1269: Henry III to the keeper and bailiffs of London: money for the poultry-men and scullerymen and others to purvey for the feast of St Edward. TNA: SC 1/2/91.

129. 28 October 1269 x 27 October 1270: Liberate to Thomas de Wymundham, treasurer, 55½ marks [*sic*] for 6 marks of gold which by our precept was spent on the repair of the feretory of St Edward before the Feast of the Translation of the said Saint, witnessed by me on 7 October, by this brief 49½ marks delivered to Walter de London, monk of Westminster. TNA: E 403/1227, m.1; *transcriptum brevium inchoatorum vel inchoandorum: Queen Eleanor.*

130. Christmas 1269 x 2 Feb 1271: Accounts of the works at the church of Westminster ... [receipts] ... and of 3s 10d received from John of Sutton, sacrist of Westminster, from the offerings at the altar of the blessed Edward ... [payments] ... And in gold leaf, enamels, various colours and other things necessary for painting the casket (*capse*) in which the body of the blessed Edward is laid and for painting the images in the said church and in the king's great chamber as is contained there £32 16s 1½d. TNA: E 372/114, rot. 19 (Colvin 1971, 428).

131. 6 January 1270: Liberate to ... Thomas de Wynmundham 12m for a buckle (*firmacula*) bought by him for the fabric of St Edward's shrine. *Liberate Rolls 1267–72*, p. 110.

132. 26 January 1270: ... to William de Gloucester, goldsmith, late keeper of the works of the shrine of St Edward, 100s, for the said works; to Richard Bonaventure, the present keeper of the works of the said shrine, £4 ... *Patent Rolls 1266–72*, p. 404.

133. January 1270: indulgence of Hugh of Taghmon, bishop of Meath of 40 days from enjoined penance to all truly penitent and confessed persons who have flocked to the High Altar in St Peter's church Westminster (which the bishop in honour of the same

Apostle consecrated) on his feasts to implore pardon for sins, and who from their goods have added to the ornaments of the same Altar. *Westminster Abbey Domesday*, fol. 390r.

134. January 1270: indulgence of Hugh of Taghmon, bishop of Meath to all truly penitent and confessed persons who have devoutly flocked to the altar of Edward the Confessor in St Peter's church at Westminster (which altar the bishop has consecrated in the Confessor's honour) on his feasts to implore pardon of their delinquencies, and who have contributed of their goods to the ornaments of the same altar and to the repair (*reparacioni*) of the feretory or casket (*feret' sive capse*) wherein the saint's corpse rests, he releases 40 days of penance enjoined on them to wit to his parishioners and others whose diocesans have ratified this indulgence. *Westminster Abbey Domesday*, fol. 394r–v.

135. Feb. x July 1270: Grant from Henry de Almain to the abbot and convent of Westminster of the whole tenement held in the vill of Westminster by grant of his father, in order to find a lamp about the shrine of St Edward. WAM 17360.

136. 5 March 1270: Mandate to the keeper of the king's forest of Havering, that in the same forest he should give to Richard Bonaventure four timbers for making charcoal for the works on the feretory of St Edward of Westminster. *Close Rolls 1268–72*, p. 177.

137. 20 June 1270: Allocate ... £13 6s 8d delivered to brother Walter de London, monk of Westminster, and Richard Bonaventure to make the shrine of St Edward. *Liberate Rolls 1267–72*, p. 130.

138. 4 July 1270: Power to John le Moyne, escheator on this side Trent ... for 100 marks to be paid in the wardrobe and for 2 marks of gold to be delivered to the keepers of the shrine of St Edward for the making of that shrine ... *Patent Rolls 1266–72*, p. 437.

139. 8 July 1270: Whereas Henry de Almain, the king's nephew, gave by charter to the abbot and convent of Westminster the land in Westminster, the king, out of devotion to St Edward and special favour to the said abbot and convent, has granted that all the said land and the houses there built shall be quit of the livery of the king or his marshals, so that no one shall be lodged there without the licence of the abbot and convent or their assigns. *Charter Rolls 1257–1300*, p. 146.

140. [March 1271: burial of Henry of Almain] … but his heart was buried honourably in a gilt cup (*in cuppa deaurate*) next to the feretory of St Edward in the church of Westminster. *Flores Historiarum, III* (Luard 1890, 22).

141. 22 March 1271: Liberate to the sacrist of Westminster 8½m for a buckle taken from him to make the king's oblation at St Edward's shrine on Palm Sunday 55 Henry III. *Liberate Rolls 1267–72*, p. 165.

142. 2 June 1271: Allocate to Bartholomew de Castello, keeper of the exchange of London, £20 3s 10d for two silver gilt images of the king and queen for St Edward's shrine and 3 gold buckles delivered in the wardrobe to Peter de Winton, keeper, on Thursday after Ascension to make the king's oblation at Pentecost. *Liberate Rolls 1267–72*, p. 171.

143. 1271–72: for 2 cups of gold £9 4s 6½d; of which one was for the said feretory of St Edward by the King, one worth 51s 10½d and the other worth £6 12s 8d. TNA: E 372/116, rot. 1r; *Pipe Roll 56 Henry III*.

144. 1271–72: For 2m of gold dust (*aur' de pall'*) delivered to the sacrist of Westminster and the aforesaid Richard Bonaventure keepers of the aforesaid feretory for the same feretory made there, £12 by the king's brief. And to the same Richard for his arrears for the whole time that he has been keeper of the said feretory, 60m, by the king's brief. TNA: E 372/116, rot. 2r; *Pipe Roll 56 Henry III*.

145. 28 February 1272: Grant to Richard Bonaventure, citizen of London, keeper of the works of the shrine of St Edward, of 20 marks a year out of the issues of the king's change of London, so long as he be intendant upon the keeping. *Patent Rolls 1266–72*, p. 630.

146. 4 June 1272: Liberate to Richard de Ewell and William de Arundel 110m for two (?) embroidered copes bought by them to make the king's oblations at the shrine of St Edward. *Liberate Rolls 1267–72*, p. 219.

147. 8 June 1272: Allocate to Bartholomew de Castello, keeper of the exchange of London and Canterbury, 60m delivered to Richard Bonaventure, keeper of the works of St Edward's shrine, for all arrears of his keepership. *Liberate Rolls 1267–72*, p. 219.

148. 10 August 1272: Allocate to Bartholomew de Castello, keeper of the exchange of London and Canterbury, £12 for 2m of gold dust (*auri de palliolo*) delivered to the sacrist of Westminster and Richard Bonaventure, keepers of St Edward's shrine, to make the shrine. *Liberate Rolls 1267–72*, p. 225.

149. 14 December 1272: To the barons of the Exchequer: Order to audit the account of the executors of William of Gloucester in accordance with the late king's order in their hands at the exchequer, as William received at divers times great sums of money from the late king's treasury and chamberlains of the exchequer and from the said king's wardrobe and from elsewhere in order to make divers jewels of the said king, and for the repair of his jewels, and to make a frontal for the great altar of the church of Westminster, and to make a silver image over the tomb of Katherine, daughter of the said king, in that church, and for the making of the shrine of St Edward, and for divers other works, for which William in his lifetime did not render account before them at the exchequer or elsewhere, wherefore the late king ordered them to audit William's account of the said works by Henry de Otinton, clerk, and the other executors of William's will, and they have deferred doing so by reason of the late king's death. *Close Rolls 1272–79*, p. 3.

150. 1271–2: Compotus of William of Gloucester of money received from the king's treasury by the hand of the treasurer and by the hands of various chamberlains of the king's wardrobe … for making and repairing and mending various of the king's jewels, and for the frontal of the high altar of Westminster and image of silver over the tomb of Katherine the king's daughter, and towards the works on the feretory of St Edward, and various other of the king's works …

…And for the stipend of Robert and Thomas goldsmiths for working on 6 marks 4s worth of gold in decorating? (*in trifura*) the bases and columns around the said feretory, 60s. And for one casket (*acha* for *arca*) bought for the aforesaid and other ornaments to be built, 4s. TNA: E 372/116; *Pipe Roll 56 Henry III* (printed in Scott 1863, 113–14).

151. Easter 1273: to Robert de Beverley, £6 16s 4½d for stipends of divers works around the tomb of John of Windsor, son of the king, for sixteen weeks. TNA: E 403/21A, *Exchequer Issue Roll*; TNA: E 403/1229, *Exchequer Liberate Roll*; TNA: E 101/467(8), particulars of divers works.

152. 9 July 1274: to Master Robert de Beverley the king's mason 105s 3d that is 40s 3d liberate to

Ralph de Guildford, Ralph de Corfe, Robert Polissur and Osbert le Polissur for their stipends for work around the tomb of the king's son, and 65s liberate to Hartman de Cologne for 60 garbs of iron for divers works at the Tower of London. TNA: E 403/25, *Exchequer Issue Roll*; TNA: E 403/1234, *Exchequer Liberate Roll*; TNA: C 62/50, m.4, *Chancery Liberate Roll*.

153. 7 December 1275: Liberate to Robert de Beverley, keeper of our works at Westminster and the Tower of London, £65 3s 6d for divers work at Westminster and the Tower of London from the Friday after Michaelmas 2 Edward I [5 October 1274] to the Saturday after St Martin's Day [17 November 1275] 3 Edward I and for the stipends for masons, carpenters, plumbers, glasiers, and other craftsmen of ours for the said time, and for repairing a marble tomb, recently made there by the same Robert, to the use of Henry our son, to be accounted for before treasurer and barons of the Exchequer. Witnessed at 'Gastinton'. TNA: E 403/1235, *Exchequer Liberate Roll*.

154. 1274 x 1277: payment to William de Corfe for the tomb of Lord Henry son of the king, 53s 4d. TNA: E 101/467 (6/2), m.1, *London and Westminster: Roll of particulars of expenses of works*.

155. 1274 x 1277: for (*vica tumba*) bought for the tomb of Henry son of the king, 53s 4d. TNA: E 101/6(5), m.1, *London and Westminster: Account of Robert de Beverley of wages and expenses of works at Westminster, the news at Charing, and the Tower of London*.

156. 1274 x 1277: payment to William de Corfe for 2 days, 9d; for 6 masons for 1 day around the tomb (*circa tumulum*), 2s 3d; to Robert Pollisur for polishing the tomb (*pro pollicione tumbe*), 2s 3½d. TNA: E 101/467 (7/2), m.1, *London and Westminster: Roll of particulars of expenses of works*.

157. 24 May 1276: notification of Gerard bishop of Verdun that he releases 40 days of enjoined penance to all his parishioners and to others whose diocesans have ratified this his indulgence, being truly penitent and confessed persons who have visited the tomb of Henry III (*qui tumbum inclite recordationis domini henrici…visitaverint*) whose body rests in the conventual church of Westminster, or have contributed ought for their goods to the same church, or have devoutly said the Lord's prayer with the Blessed Virgin Mary's salutation for

the said Henry's soul and those of the faithful deceased. Dated at Westminster. *Westminster Domesday*, fols. 404v–405r.

158. 24 May 1276: notification of Robert bishop of Bath and Wells that he releases 40 days of enjoined penance to all his parishioners and to others whose diocesans have ratified this his indulgence, being truly penitent and confessed persons who have visited the tomb of Henry III whose body rests in the Conventual church of Westminster, or have contributed ought for their goods to the same church, or have devoutly said the Lord's prayer with the Blessed Virgin Mary's salutation for the said Henry's soul and those of the faithful deceased. Dated at Westminster. *Westminster Domesday*, fol. 405r.

159. 1278: offering by Edward I of a brooch to the feretory of St Edward. TNA: C/47/4/1, *Wardrobe account book*.

160. 3 December 1280: Royal grant to the abbot and convent of Westminster that the house in their graveyard built anew by the abbot with intent that the profits arising therefrom … should go to augment the support of the lamp of the high altar and feretory of St Edward, be quit of all livery of seneschals, marshals and other of the king's servants. WAM 17458.

161. 4 December 1280: Grant to the abbot and convent of Westminster that house in their churchyard, which stretches from the gate thereof by the wall towards the belfry and which the abbot has built in order that the issue thereof at the fairs of the two feasts of St Edward and at all other times may be applied to the increase of the support of the light at the great altar and the shrine of St Edward, shall be quit and free for ever from all livery of stewards, marshals, and other ministers of the king, so that no person in the future shall lodge therein without licence of the said abbot and convent or of the sacrist of the said house. *Patent Rolls 1279–80*, p. 481.

162. May 1282: Notification that the lord king has restored to the abbot and convent of Westminster the jewels assigned to the shrine of St Edward, and he had handed them over (*liberavit*) to be pawned for their urgent business (*negotiis eorum urgentissimis*), as is made clear in his letters patent. (Rymer 1744, **I**, pt ii, 202).

163. 11 May 1287: Indulgence of John de Kirkeby bishop of Ely, that to all truly penitent and contrite persons who have entered St Peter's

church at Westminster, and have honoured the same with alms, oblations or any munificent benefits out of love and reverence for the said Prince of the Apostles or the glorious Edward, King and Confessor (who rests therein) or Christ's Blood (a portion whereof is contained herein) or the girdle of the Blessed Virgin Mary, or Christ's footstep (contained therein) or St Edward's ring transmitted to the same by St John the Evangelist or for any other saint or saints whose relics are adored by the faithful in the same church, or who have furthered it by ornaments or other largesse, or even who have flocked to the tomb (*ad tumulum*) of the late king of England Henry, and there for his soul and the souls of all the faithful departed have devoutly said the Lord's Prayer with the salutation of the Blessed Virgin Mary, he releases 40 days of penance enjoined on them. Dated at Westminster. *Westminster Domesday*, fol. 398v.

164. 19 November 1287: Indulgence of William de Clifford, bishop of Emly, that to all truly penitent and contrite persons who have entered St Peter's church at Westminster, and have honoured the same with alms, oblations or any munificent benefits out of love and reverence for the said Prince of the Apostles or the glorious Edward, King and Confessor (who rests therein) or Christ's Blood (a portion whereof is contained herein) or the girdle of the Blessed Virgin Mary, or Christ's footstep (contained therein) or St Edward's ring transmitted to the same by St John the Evangelist or for any other saint or saints whose relics are adored by the faithful in the same church, or who have furthered it by ornaments or other largesse, or even who have flocked to the tomb (*ad tumulum*) of the late king of England Henry, and there for his soul and the souls of all the faithful departed have devoutly said the Lord's Prayer with the salutation of the Blessed Virgin Mary, he releases 40 days of penance enjoined on them. Dated at London. *Westminster Domesday*, fol. 398r-v.

165. 22 November 1287: Indulgence of William Freysel, bishop of St Andrews in Scotland, that to all truly penitent and contrite persons who have entered St Peter's church at Westminster, and have honoured the same with alms, oblations or any munificent benefits out of love and reverence for the said Prince of the Apostles or the glorious Edward, King and Confessor (who rests therein) or Christ's Blood

(a portion whereof is contained herein) or the girdle of the Blessed Virgin Mary, or Christ's footstep (contained therein) or St Edward's ring transmitted to the same by St John the Evangelist or for any other saint or saints whose relics are adored by the faithful in the same church, or who have furthered it by ornaments or other largesse, or even who have flocked to the tomb (*ad tumulum*) of the late king of England Henry, and there for his soul and the souls of all the faithful departed have devoutly said the Lord's Prayer with the salutation of the Blessed Virgin Mary, he releases 40 days of penance enjoined on them. Dated at London. *Westminster Domesday*, fol. 398v.

166. 12 January 1291: Liberate to Brother Raymond de Wenlock, monk of Westminster, for 46s 8d for making three columns of marble which we have recently ordered by our precept to be set around the feretory of St Edward in the church of Westminster. Witnessed by Edward I at Ashridge. TNA: E403/1256.

167. 9 December 1292: Acquittance from Fr William de Epping in the stead of the Abbot of Convent of Waltham, collector of the tenth granted to Edward I by the pope, for the tenth of the first year from the temporal goods of the sacrist of Westminster, 20s 2d; likewise for 20s from the oblations and offerings accruing to St Edward's shrine. WAM 28917.

168. 24 October 1293: Acquittance from Fr William de Epping in the stead of the Abbot of Convent of Waltham, collector of the tenth granted to Edward I by the pope, for the tenth of the first year from the temporal goods of the sacrist of Westminster, 20s 1½d; likewise for 20s from the offerings at the shrine. WAM 28941.

169. 21 October 1299: Deed setting forth that inasmuch as in the 38 marks which Walter de Wenlock, abbot and the convent of West-minster borrowed from the gold assigned to but not yet laid upon the shrine of the Confessor, for the cost of the jewels given by them to Margaret, second wife of Edward I, on her first arrival at Westminster, there were certain pollards [clipped coins] which the goldsmiths and other merchants refused to take, they (namely the abbot for his share of 19 marks and the Convent for their share of 19 marks) hereby bind themselves to make good the deficiency by substituting sterling coin for the pollards. WAM 9464**.

170. 1308: oblation by Edward II at his coronation of two gold figures representing St Edward and the pilgrim receiving the ring, one of a pound and the other of one mark. BL: Cotton MS Vitellius C XII, fols. 231r-v (see Richardson 1938).

171. 1323–4: Inventory and accompt of jewels and plate, with notes of gifts made by the King, including to the Queen, to St. Edward's shrine, Westminster, to St. Wulstan's shrine, Worcester, to the tomb of Gilbert de Clare, Earl of Gloucester, at Tewkesbury, etc. BL: Add MS 35114, *Accompt-book of Robert de Wodehouse as Keeper of the King's Wardrobe.*

172. 1363: Payment for some iron chains hanging before the feretory, newly made by Brother John Redyng, 6s. *Sacrist's Roll*, WAM 19629.

173. 23 May 1369: Will of Lewis de Charlton, bishop of Hereford: … Item I leave to the feretory of St Thomas of Hereford all my rings except two, namely the one with the great sapphire pierced, in which I was consecrated at Avignon, which with its sapphire I leave to the feretory of St Edward at Westminster. C. M. Woolgar (ed.), *Testamentary Records of the English and Welsh Episcopates, 1200–1413* (Canterbury and York Society, Woodbridge 2011), 109.

174. 1377–8: For one large rope bought for the feretory of St Edward, 2s 8d; ~~for the ornaments of the body of Christ hanging over the high altar, £3 2s 4d … for a silver board (tabula argentea) for the altar of St Edward; for mending those of the feretory, 16d.~~ *Sacrist's Roll*, WAM 19637.

175. 14 November 1388: royal grant to the shrine of Edward the Confessor of a ring of gold with a ruby set therein to be worn by the king during his lifetime except he go abroad, when it is to repose on the shrine, and after his death it is to be used as a coronation ring by his successors, but at other times to remain on the shrine. WAM 9473.

176. 20 August [1393?]: royal letter to the abbot and convent of Westminster sending them papal bulls whereby the eve of the Confessor St Edward is made a Vigil, and ordering two monks to convey them to the Archbishops of Canterbury and York. WAM 5624★.

177. 1394–5: for removing a tomb with its image (*pictura*), 20s, and the fee for the carpenter for one board for the feretory of St Edward, 46s 8d, and for painting the same board, 106s 8d. *Sacrist's Roll*, WAM 19654.

178. 14 December 1395: To Master Peter the sacrist of the church of St Peter Westminster. In money paid him by the hands of John Haxey in discharge of £20 which the Lord King commanded to be paid to him, as well as for painting the covering of the tomb of Anne, late queen of England, buried within the said church, as for the removal of a tomb near the tomb of the said Queen; also for painting the same tomb so removed, and for painting an image to correspond with another of the King placed opposite in the choir of the aforesaid church. By writ etc. £20. TNA: *Exchequer Issue Roll* (Devon 1837, 262).

179. 1395–6: for painting a board ~~at the altar of St Edward~~ in the choir, 60s; for ironwork for the same board, 8d. *Sacrist's Roll*, WAM 19655.

180. 1396–7: the fee for a covering (*coopertura*) for the king's chair (*cathedra*) at the feretory of St Edward, 6s 4d. *Sacrist's Roll*, WAM 19656.

181. 1397–8: given to the esquire of the Duke of Norfolk for carrying the jewels to the feretory of St Edward [at the burial of the Duke of Gloucester], 20s. *Sacrist's Roll*, WAM 19657.

182. 20 February 1398: the king sent and gave a small piece of cloth of gold, wherein are contained 54 gold buttons (in which cloth lay in the ground the virgin body of St Edward for 90 years and more uncorrupted) to his dearest uncle the Duke de Berry by Casimir de Survelles, esquire to the Duke, to be carried to him with a letter testimonial of the said king. WAM *Liber Niger*, fol. 87.

183. 1422–3: For mending the casket (*capselle*) of the feretory of St Edward this year, 6s. *Sacrist's Roll*, WAM 19663.

184. 1423–4: Fee for part of two new ropes made of twine for raising the casket (*pro capsella… trahend'*) of the feretory of St Edward, 66s 8d. *Sacrist's Roll*, WAM 19665.

185. 1424–5: for the part payment (*inpersolu'*) for two ropes made of twine for raising the casket (*capsella*) of the feretory of St Edward, 66s 8d. *Sacrist's Roll*, WAM 19666.

186. 1425–6: for the cost of making two new ropes of twine to be installed (*inponend'*) for raising the casket of the feretory of St Edward, with one rope bought on the 2 May this year, 8s 4d; and the fee for a smith from London making one barrel (*barell'*) for raising the casket of the feretory of St Edward, 5s. *Sacrist's Roll*, WAM 19667.

187. 1448–9: for ropes (*funis*) bought this year for the bells and for the feretory of St Edward, 9s 8d. *Sacrist's Roll*, WAM 19698.

188. 21 December 1467: Inventory of jewels, books etc delivered by Thomas Arundell, late keeper of St Edward's shrine and the relics of St Peter's church at Westminster, to Richard Tedyngton, his successor. WAM 9477.

189. 9 October 1479: Inventory of jewels, books etc delivered by Richard Tedyngton, late keeper of St Edward's shrine and the relics of St Peter's church at Westminster, to John Watirdene, his successor. WAM 9478.

190. 1481–2: for repairs made in the north aisle above the feretory of St Edward over the roof of the church. *Sacrist's Roll*, WAM 19728.

191. 1488–9: stipend for Thomas Devenysh, carpenter, for working on repairing the wheels of the feretory and the wheels of the great beam hanging before the high altar … *Sacrist's Roll*, WAM 19736.

192. 1490–1: for nails for the sepulchre and the canopy, 3d. *Sacrist's Roll*, WAM 19740.

193. 1491–2: for nails for the sepulchre and the canopy, 3d. *Sacrist's Roll*, WAM 19742.

194. 1492–3: for nails for the sepulchre and the canopy, 3d. *Sacrist's Roll*, WAM 19744.

195. 1493–4: for nails for the sepulchre and its canopy, 3d; … wages of Richard Russell, carpenter, for working on the wheels ('Whelis') of the feretory of St Edward for 2 days, at 8d per day … for repairing the sepulchre … *Sacrist's Roll*, WAM 19745.

196. 1495–6: for nails for the sepulchre and the canopy, 3d ; … wages to Richard Russell, carpenter for … repairing the sepulchre and the coffin under the feretory of St Edward and also the wheel of the said feretory … *Sacrist's Roll*, WAM 19748.

197. 1496–7: for nails for the sepulchre and the canopy, 3d. *Sacrist's Roll*, WAM 19750.

198. 1497–8: fee for making 4 valances of red colour around the feretory of St Edward, 2s; for 5 images of gold embroidery fixed to the said valances, 9s; in the 'settyngupon' 102 Garters over the said valances, 4s 4d; in fixing 6 gold flowers, 18d; for eight virgates of buckram bought for the same, 3s 4d; for fixing the 6 buckram fringes of silk (*serico*) bought for the same, at 14d per piece, 7s; for 1 and a half virgates of sarcanet bought for the same, 4s 6d; for fixing the 19 letters (*litteris*) with crowns of gold bought for the same, 3s 8d; … for carpenter's work including the bell wheels and the shrine wheels in the vaults … [this becomes a regular entry hereafter]; and for grease bought for the bell wheels and the pulleys of the shrine, 6d. *Sacrist's Roll*, WAM 19752.

199. 1498–9: for eight wainscot bought this year for the wheel of the feretory (*rot' feret'*) and other wheels in the church, 8s 8d; and for the sawing of the said wainscot, 2s 8d; and for six nails bought for the same, 12d. *Sacrist's Roll*, WAM 19753.

200. 1505–6: paid 4d for hides (*pelle*) for the canopy of the feretory of St Edward; and for nails for the same, 1d; … for mending the pulleys (*pullez*) of the feretory of St Edward, 2s 8d; and for the grease (*pinugedine*) for the same, 1d. *Sacrist's Roll*, WAM 19761.

201. 31 March 1509: … Also we wol that our executours, yf it be nat doon by our self in our life, cause to bee made an ymage of a king, representing our owen persone. The same ymage to be of tymber, covered and wrought accordingly with plate of fine gold, in maner of an armed man; and upon the same armour, a coote armour of our armes of England and of Fraunce enamelled, with a swer and spurres accordingly. And the same ymage to knele upon a table of silver and gilte, and holding betwixt his hands the crowne which it pleased God to geve us, with the victorie of our ennemye at our furst felde. The which ymage and crowne, we geve and bequethe to Almighty God, our blissed Lady Saint Mary, and Saint Edward, King and Confessour; and the same ymage and crowne in the fourme afore rehersed we wol be set upon, and in the myydes of, the creste of the shrine of Saint Edward, King, in such a place as by us in our life, or by our executours, after our deceasse, shal be thought moost convenient and honourable. And we wol that our said ymage be above the kne of the height of thre fote, soo that the hede and half the breste of our sid ymage may clierly appere above and over the said crowne; and that upon booth sides of the said table be a convenient brode border; and in the same be graven and writen with large lettres, blak enameled, this words REX HENRICUS SEPTIMUS. TNA: E 23/3, will of Henry VII (transcribed in Condon, 2003, 133).

202. 1513–14: for repair work in divers parts of the church, namely the stipend of Richard Russell, carpenter, working there on the mending of the bells and wheels of the feretory of St Edward and other parts of the church this year for 22 days, 8d per diem – 14s 8d. *Sacrist's Roll*, WAM 19772.

203. 1516–17: for ropes (*cordul'*) of 'fynetwyn' bought this year for the feretory of St Edward, 57s 4d. *Sacrist's Roll*, WAM 19775★.

204. 10 November 1520: Inventory of jewels, books etc delivered by William Grene, late keeper of St Edward's shrine and the relics of St Peter's church at Westminster, to Henry Wynchester, his successor. WAM 9485 (for full transcript, see Westlake 1923, **2**, 504–5).

205. 1522–3: for sawing 5000 of slitting work for the 'Stepe Rouff' of the church over the feretory of St Edward, at a price per 100 of 12d, 56s. *Sacrist's* Roll, WAM 19790.

206. 1540: 'A fayre godly Shrine of Seynt Edward in marble in the myddes of the chappell with a case to the same' (Walcott 1873, 351).

207. 5 January 1556: 'there was sett up the scrynne [shrine] at Westmyster, and the aulter with dyvers juelles that the queen [Mary] sent thether' (Nichols 1852, 94).

208. 1557: The xx day of Marche was taken up at Westmynster agayn with a hondered lyghtes kyng Edward the confessor in the sam plasse wher ys shryne was, and ytt shalle be sett up agayne as fast as my lord abbott can have ytt don, for yt was a godly shyte to have seen yt, how reverently he was cared from the plasse that he was taken up wher he was led when that the abbay was spowlyd and robyd; and so he was cared, and goodly syngyng and senssyng as has bene sene, and masse song. (Nichols 1848, 130).

209. 1557: The same day [19 April] went to Westminster to hear mass, and to the lord abbot's to dinner, the] duke of Muskovea, and after dener [came into the monastery, and went] up to se sant Edward shryne nuw set up, [and there saw] alle the plasse thrugh; and after toke ys leyff of [my lord abbot], and ther mett hym dyvers althermen and mony [merchants]; and so rod in-to the parke, and so to London. (Nichols 1848, 130).

CHRONICLES

1. *Matthew Paris, Historia Minor* (Madden 1866, 454–5). [compiled to 1259]

On the gold feretory of St Edward
1241: Also in the same year Lord King Henry III for his salvation and that of his queen, and his sons and daughters and the health of both their bodies and souls, and the state of the kingdom, and the souls of his ancestors, caused to be made a most noble feretory, from pure gold and most precious gems. In which before the total completion of the work (*perfectionem operis consummativam*), he spent and was going to spend more than 100,000 marks, as he swore on oath to this writer, to honourably rebury the glorious king and confessor St Edward, whose body, because it was believed to be virgin, was uncorrupted.

2. Matthew Paris, *Chronica Majora, vol. IV* (Luard 1878, 156–7); *vol. V* (Luard 1883, 195). [compiled to 1259]

1241: In this year the lord King Henry III caused to be skillfully made, at his own expense, a feretory from purest gold and precious gems by select goldsmiths at London, so that in it the relics of St Edward should be set. In its construction although the materials used had been the most precious ones, yet, according to the poet: 'The workmanship surpassed the material'.

1250: Chief events of the last 50 years: The church of Westminster was rebuilt and the golden feretory was made by King Henry III for the use of St Edward with most precious work.

3. Arnulf Fitz Thedmar, *Chronicles of the Mayors and Sheriffs of London 1188–1274* (Riley 1863, 120–31); *De Legibus Antiquis Liber* (Stapleton 1846b). [compiled to 1274]

13 October 1269: Be it remembered, that in this year, after the Feast of Saint Michael, as also, five weeks before the said Feast, his lordship the King sent his writ unto the citizens of London, commanding them that, as they loved him, they should hold themselves in readiness to do him the service of the Butlery on the Feast of Saint Edward then next ensuing; upon which day he had purposed to translate the body of that Saint, and, himself and his Queen, to wear the crown. The citizens accordingly, although at that time they were not bound as a matter of duty to such service, for the purpose of gaining his good-will gave their assent thereto, and made preparation, at great outlay and great expense, with noble vestments of scarlet and of silk, and other raiment duly befitting. But when all had been now prepared, and the citizens were ready to perform the said service, behold! on the Vigil of Saint Edward, his lordship the King caused proclamation to be made in the King's Hall at Westminster, as also in Chepe in London, that he was not advised that he should wear his crown on

that occasion. For that it ought to suffice for him once to have worn his crown; and that no person, Londoner or others, was on the morrow to take part in doing any service before him, but only those of his own household. Any person however who should wish to come to the dinner, would be admitted thereto gratuitously. And thus was this noble service on part of the Londoners left out. However, on the morrow, the citizens, who had made all due preparations, set out for Westminster, carrying neither goblet nor cup, but offering their prayers in presence of his lordship the King, together with their oblations, to the Saint. After Mass too, those who wished, remained to dinner, while the others returned home.

On the same day, the King had the body of the Saint before-mentioned translated from the spot where it had been placed, when first translated in the time of King Henry the Second; the shrine in which it lies, together with the body, being transferred to another spot, where it now lies. He also had a new basilica made over the Saint, all covered and adorned with the purest gold and costly gems.

It ought not here to be past over in silence, that the Archbishop of York, still persisting in his pretensions, had his cross borne before him, to the prejudice of the church of Canterbury, and he himself upon this day took precedence in the celebration of divine service; upon which, not one of the bishops, who were there present arrayed in their pontificals – having come by the King's command, about thirteen in number, from various parts of England and the parts beyond sea – would follow the said Archbishop in the procession when the body of the Saint was carried round the exterior of the church; but remained, all of them, within the church. In like manner, when the body was deposited where it now lies, he was the only one who censed it, all the other bishops remaining seated on the sedilia in the stalls of the monks. At this time in fact, and so long as he remained in the neighbourhood of London, the interdict continued, both in all places and in just such manner, as in this Book is before set forth.

4. *Annales de Wintonia*, in *Annales Monastici, II* (Luard 1864b). [compiled to 1277]
 Also *Annales de Waverleia*, in *Annales Monastici, II* (Luard 1864b, 375). [compiled to 1291]

1269: The body of St Edward king and confessor was translated from its old feretory into a new one, that the lord king had prepared for him, on which day at a gathering of bishops, earls, barons, abbots, priors and many others, the lord king proposed that the crown should be worn. Arising from this, to the citizens of Winchester and London, who were claiming for themselves the right and custom of royal butler, the lord king was unwilling that either of them should serve him, because of the discord and danger that might threaten. But he ordered each side to a separate sitting. Whereupon the indignant Londoners withdrew. The men of Winchester, on the other hand, remained, feasting and drinking at court, and then moved out with the permission of the lord king, and retired to their own quarters.

5. *Chronicon Thomae Wykes*, in *Annales Monastici, IV* (Luard 1869, 227–9). [Compiled to 1289]

1269: The lord king of England Henry, with the drive of pious devotion, no longer able to bear further the venerable remains of the most sacred king Edward the Confessor, whom he esteemed over all other saints with a special veneration, to lie in so humble a place that a light so bright should be hidden for so long beneath a covering, but that he should give out his spiritual light more abundantly for those coming in and going out, from a loftier edifice rising above the Candelabrum, on the third of the Ides of October, which day in that year fell on a Sunday, on that very same day of course which he had a long time beforehand been translated into a less precious shrine, having called together all the prelates and magnates of England, and equally the most powerful men of the cities and boroughs of his kingdom gathered, so that they might add glory to the ritual of his translation; and also with a not inconsiderable tumult of the common masses gathering at the same time, transferring the venerable relics from their old shrine into a lofty one, in view of such a multitude of his people and of his most serene brother the King of the Romans, he placed them, on shoulders as supports, with his noble sons lord Edward, the lord Edmund, the lord Earl of Warrene, the lord Philip Basset, and many of the other more powerful men of the kingdom, as many as could put their hands to so noble a burden, and drawing on this help, and he buried them with all due reverence in a golden shrine decorated with most precious stones, in the most eminent spot. All these things took place in the conventual monastery church of Westminster, which the same king had built with the utmost sumptuousness, once the old one had been removed to the disquiet of nobody at all; he constructed it with funds paid out from his own royal treasury; it was decided in this to outdo in both richness and beauty churches throughout

the world so that it would be seen to have no equal. On the same day the monks of Westminster celebrated the eucharist beneath the new structure for the first time; and it was nothing less in the palace of the king, after the rituals of the translation had been done there was a feast so solemn as could be the admiration and wonder of everyone.

6. *Annales de Dunstaplia*, in *Annales Monastici, III* (Luard 1866, 252). [compiled to 1297]

1270: In the same year on the Feast of St Edward, in October, was translated St Edward into a new precious feretory, which the Lord King Henry had caused to be made for him. And there was celebrated on the same day high mass in the same church, which that king had built with all suitable sumptuousness. And there was great joy there; and the king gave many and great gifts.

7. *Annales de Oseneia*, in *Annales Monastici, IV* (Luard 1869, 227–9). [compiled to 1297]

1269: In that year, on the Feast of the Translation of St Edward, king and confessor, the gracious body of the same Edward was translated a second time into a new and wonderful feretory, made with as much gold as silver and precious stones, by the venerable father Walter Gifford, archbishop of York and many other bishops, abbots, and other prelates of the realm, in the presence of lord Henry, king of England, son of King John and the person responsible (*procurantis*) for all these matters, surrounded by a number of earls, barons, knights and other nobles of the realm, with a multitude of clerics and laymen, all watching such a miraculous and glorious spectacle, to the praise and glory of Our Lord Jesus Christ and the glorious Confessor St Edward.

8. *Flores Historiarum, III* (Luard 1890, 18–19). [compiled to 1306]

1269: At the feast of the Translation of St Edward, at the instance of King Henry, the churchmen of the realm translated that saint more honorably into a new feretory, which the said king caused to be made. In the translation of this saint, Benedict cleric of Winchester and John, a layman who had come from Ireland, possessed by demons, had their sanity restored through the favours (*merita*) of the saint king.

9. *Willelmi Rishanger, Annales Regum Angliae* (Riley 1865, 429). [compiled to 1307]

1268: In the year of Grace 1268 [*sic*] on the 13th of October, at Westminster, he buried St Edward in a gold feretory.

10. *Annales Londonienses*, in *Chronicles of the Reigns of Edward I and Edward II* (Stubbs 1882, 80). [compiled to 1330]

1269: With the golden feretory decorated becomingly with stones and precious gems, but with its preparation not yet complete (*nondum tamen completo parato*), the lord king called together all of the magnates of England that he could, and they celebrated the second translation of St Edward with great joy.

11. *Annales de Wigornia*, in *Annales Monastici, IV* (Luard 1869, 458). [compiled to 1377]

1269: St Edward was translated from the old feretory into a new one. Preset was the Lord King Henry who set down his second edict to wear the crown, but he did not wear it. Arising from this, to the citizens of Winchester and London, who were claiming for themselves the right and custom of royal butler, the lord king was unwilling that either of them should serve him, because of the discord and danger that might threaten. But he ordered each side to a separate sitting. Whereupon the indignant Londoners withdrew. The men of Winchester, on the other hand, remained, feasting and drinking at court, and then moved out with the permission of the lord king, and retired to their own quarters.

12. *Ypodigma Neustriae a Thomas Walsingham* (Riley 1876, 43, 163). [compiled 1419]

1241: In the year 1241 the king of England had made a gold casket, for the reburial of the remains of the most holy King and Confessor Edward, in the church of Westminster.

1268: The body of St Edward, King and Confessor, at the instance of the king of England, was translated into a golden feretory, which he had prepared for him.

THE COSMATESQUE MOSAICS OF WESTMINSTER ABBEY

13. *The History of Westminster Abbey by John Flete,* (Robinson 1909, 113). [compiled to 1443]

Richard de Ware was, after the death of the said Philip, elected to the Abbacy of Westminster by way of an electoral compromise. Travelling by sea to the Roman Curia, he obtained confirmation of his office as quickly as possible, and thereupon withdrew from the Papal presence. During his journey home, he gathered traders and workmen, and brought with him stones of porphyry, jasper and marble from Thasos, which he bought there at his own expense. From these materials, these same workmen created a pavement in front of the high altar at Westminster, of wonderful workmanship. On the north side of this they made a most fitting tomb for the said Abbot, as part of the said work. Lines were written in a circle around this pavement:

> Should the reader wisely contemplate all these things
> He will find here the end of the Prime Mobile
> A triple fence, you add dogs, horses and men,

deer and ravens, eagles and huge whales
And the whole world. Each as it follows triple the years that precede it
The spherical globe shows here the archetypal macrocosm

In the year of Christ one thousand, two hundred, twelve
With sixty, less four
King Henry III, the City, Odoric and the Abbot
Put together these stones of porphyry

14. *The History of Westminster Abbey by Richard Sporley,* BL: Cotton MS Claudius A.VIII, fol. 59v. [compiled *c.* 1450]

scriptura versum in literis lapideis et deauratis per circuitum feretri sancti Edwardi seorsum talis est

> Anno milleno domini cum septuageno
> Et bis Centeno cum completo quasi deno
> hoc opus est factum quod petrus duxit in actum
> Romanus civis homo causam noscere si vis
> Rex fuit henricus \iij/sancti presentis Amicus

Appendix 2: Quantification of Tesserae in the Mosaic Pavements and Monuments

There is a wide range of sizes of tesserae on the floor and tomb mosaics. Panels and bands with similar schemes and patterns can differ in technical merit and could therefore lead to an assumption that they are repairs, and of different phases. Quantification has been undertaken to compare ratios of tesserae in panels of like type, and between the different mosaics, to establish whether further information regarding their construction is revealed. The results are represented in the accompanying tables and graphs showing, (a) overall numbers of tesserae within each panel or band, (b) the area of each panel or band (cm²), and (c) ratios of tesserae within a 10 × 10cm area. This approach, therefore, provides a common standard for both floor and tomb mosaics and highlights differences in workmanship which, almost certainly, cannot be interpreted as distinguishing different phases but, rather, simplification perhaps due to constraints in the timetable for completing the project and availability of materials.

In most cases, counting the tesserae was done individually although with repeat patterns the number within each segment was multiplied by the number of segments. Establishing the quantity of lost tesserae, especially on the shrine of Edward the Confessor, is based on surviving impressions but, as stated elsewhere, it was often difficult to determine whether triangular interspaces originally contained a smaller triangle within, thus increasing the number of tesserae in each interspace from one to four. Fortunately, where surviving, the *faux* mosaic decoration depicted in painted plaster provides useful evidence for the original pattern. Where both the tesserae and bedding mortar are lost, the ratios of tesserae are based on adjacent patterns, if the evidence suggests a pattern repeat. We are grateful to Takako Kanazome for her assistance with the quantification of tesserae.

TABLES

Table 1 Sanctuary mosaic pavement

Table 2 St Edward's chapel mosaic pavement

Table 3 Shrine of Edward the Confessor

Table 4 Tomb of Henry III

Table 5 Child's tomb

Table 6 'Valence' tomb

Table 7 Ratios between tessellation and plain areas of Purbeck marble in the floor mosaic and tombs (excluding the 'Valence' tomb)

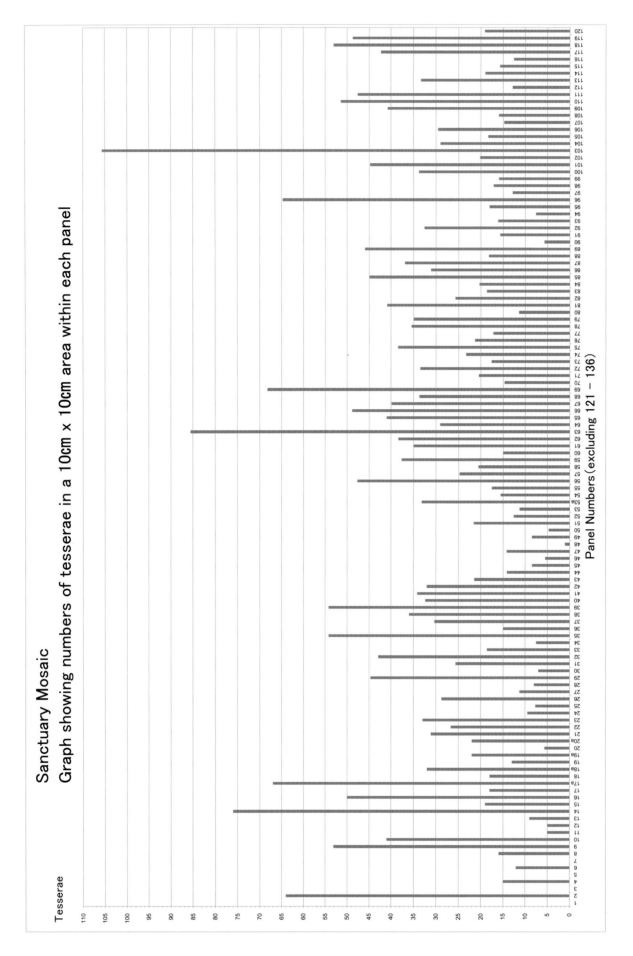

549 Sanctuary pavement. Graph showing numbers of tesserae per 10cm square.

TABLE 1. SANCTUARY MOSAIC PAVEMENT (Fig. 549)

Panel no.	No. of tesserae	Area of panel (cm²)	Tesserae in 10×10cm
1	–	–	–
2	1,744	2,728.7	64
3	–	–	–
4	550	3,709.1	15
5	–	–	–
6	286	2,374.6	12
7	–	–	–
8	355	2,205.1	16
9	2,158	4,064.4	53
10	1,655	4,064.4	41
11	196	4,064.4	5
12	205	4,064.4	5
13	46	537.5	9
14	410	537.5	76
15	100	537.5	19
16	267	537.5	50
17	1,040	5,694.0	18
17a	1,808	2,697.7	67
18	1,032	5,694.0	18
18a	855	2,797.7	32
19	748	5,694.0	13
19a	610	2,797.7	22
20	320	5,694.0	6
20a	610	2,787.7	22
21	1,350	4,334.6	31
22	1,156	4,334.6	27
23	1,430	4,334.6	33
24	412	4,334.6	10
25	334	4,334.6	8
26	1,245	4,334.6	29
27	490	4,334.6	11
28	347	4,334.6	8
29	540	1,209.4	45
30	85	1,209.4	7
31	310	1,209.4	26
32	518	1,209.4	43
33	426	2,289.1	19
34	174	2,289.1	8
35	1,242	2,289.1	54
36	343	2,289.1	15
37	694	2,289.1	30
38	824	2,289.1	36

Panel no.	No. of tesserae	Area of panel (cm²)	Tesserae in 10×10cm
39	1,424	2,289.1	54
40	741	2,289.1	32
41	782	2,289.1	34
42	734	2,289.1	32
43	491	2,289.1	21
44	324	2,289.1	14
45	195	2,289.1	9
46	126	2,289.1	6
47	325	2,289.1	14
48	25	2,289.1	1
49	195	2,289.1	9
50	108	2,289.1	5
51	495	2,289.1	22
52	288	2,289.1	13
53	1,518	13,464.0	11
53a	1,078	3,250.0	33
54	2,113	13,561.0	16
55	2,400	13,680.0	18
56	6,595	13,824.0	48
57	1,060	4,320.0	25
58	888	4,320.0	21
59	1,624	4,320.0	38
60	646	4,320.0	15
61	3,160	9,035.0	35
62	3,463	9,035.0	38
63	7,729	9,035.0	86
64	2,629	9,035.0	29
65	1,188	2,900.0	41
66	777	1,590.0	49
67	818	2,050.0	40
68	1,297	3,850.0	34
69	2,595	3,800.0	68
70	287	1,950.0	15
71	590	2,880.0	20
72	496	1,480.0	34
73	370	2,100.0	18
74	996	4,268.0	23
75	1,618	4,213.0	38
76	416	1,950.0	21
77	451	2,620.0	17
78	542	1,530.0	35
79	684	1,960.0	35
80	444	3,900.0	11
81	1,775	4,345.0	41

Panel no.	No. of tesserae	Area of panel (cm²)	Tesserae in 10×10cm
82	519	2,020.0	26
83	544	2,910.0	19
84	328	1,610.0	20
85	876	1,950.0	45
86	1,206	3,870.0	31
87	1,414	3,830.0	37
88	364	2,000.0	18
89	200	435.4	46
90	24	420.0	6
91	66	420.0	16
92	137	420.0	33
93	68	420.0	16
94	32	420.0	8
95	76	420.0	18
96	282	435.4	65
97	54	420.0	13
98	72	420.0	17
99	67	420.0	16
100	142	420.0	34
101	188	420.0	45
102	85	420.0	20
103	460	435.4	106
104	122	420.5	29
105	77	420.5	18
106	124	420.5	29
107	62	420.5	15
108	67	420.5	16
109	171	420.5	41
110	224	435.4	51
111	200	420.5	48
112	54	420.5	13
113	140	420.5	33
114	80	420.5	19
115	66	420.5	16
116	53	420.5	13
117	137	324.0	42
118	172	324.0	53
119	158	324.0	49
120	62	324.0	19
121–136	324	1,750	–

Total number of tesserae: 92,759

TABLE 2. ST EDWARD'S CHAPEL MOSAIC PAVEMENT

Four separate lists are presented: (a) tesserae in the large medallions, (b) tesserae in the small roundels, (c) tesserae in the S-shaped loops and (d) tesserae in the concave-sided triangles.

(a) Large medallions

		No. of tesserae				No. of tesserae
1	a–b	–		32	i	240
2	a–b	400		32	j	–
3	a–b	–		33	a–e	1,350
4	a–b	480		33	f	78
5	a–b	–		33	g	244
6	a–b	390		33	h	180
7	a–b	400		33	i	144
8	a–b	366		34	a–d	1,260
9	a–b	630		34	e	210
10	a–b	240		34	f	240
11	a–b	369		34	g	264
12	a–b	544		34	h	115
13	a–b	120		35	a–e	1,540
14	a–b	240		35	f	108
15	a–b	340		35	g	264
16	a–b	720		35	h	96
17	a–b	936		35	i	400
18	a–b	700		36	a–d	1,320
19	a–b	622		36	e	78
20	a–b	544		36	f	104
21	a–b	320		36	g	–
22	a–b	240		36	h	104
23	a–b	272		37	a–e	896
24	a–b	180		37	f	261
25	a–b	–		37	g	304
26	a–b	272		37	h	320
27	a–b	–		37	i	261
28	a–b	480		38	a–d	960
29	a–b	320		38	e	320
30	a–b	624		38	f	270
31	a–e	1,055		38	g	–
31	f	180		38	h	–
31	g	174		39	a–d	1,500
31	h	102		39	e	336
31	i	186		39	f	225
31	j	96		39	g	225
32	a–e	1,250		40	a–d	1,440
32	f	118		40	e	246
32	g	102		40	f	324
32	h	324				

Total number of tesserae: 30,563

Originally the number of tesserae in the 145 surviving medallions (assuming each one as being complete) was 30,563. The average number of tesserae in each is 210, and nine medallions are lost. Therefore, the total number of tesserae in 154 medallions would have been 32,340. If the medallions extended onto the north and south landings, as indicated on Fig. 227, the quantity of tesserae within them would have been approximately 36,000.

(b) Small roundels

Originally there were 447 small roundels, with possibly another fifty-five on the north and south landings. Eighty-one examples survive and can be divided into eleven types (Fig. 244, A–K).

Roundel type	No. of surviving examples	No. of tesserae in each	Total
A	42	33	1,386
B	16	30	480
C	9	37	333
D	6	21	126
E	2	33	66
F	1	25	25
G	1	28	28
H	1	17	17
I	1	25	25
J	1	?	?
K	1	58	58
Totals	81	307	2,544

The average number of tesserae per roundel is thirty-one. Assuming 447 examples, the overall number of tesserae would be 13,857. Alternatively, assuming 499 roundels (to include those potentially on the landings), the total number would be 15,469.

Total number of tesserae: 13,857

(c) Tesserae in the curvilinear bands

There are two curvilinear bands for every small roundel. Hence, there were originally 894 examples with possibly another 110 on the north and south landings. 595 examples survive in part and can be divided into twenty types (Fig. 246, A–T).

Band type	No. of surviving examples	No. of tesserae in each type	Total
A	102	113	11,526
B	84	41	3,444
C	81	64	5,154
D	76	79	6,004
E	64	52	3,328
F	51	66	3,366
G	34	141	4,794
H	29	51	1,479
I	13	84	1,092
J	13	90	1,170
K	10	47	470
L	9	72	648
M	7	64	448

Band type	No. of surviving examples	No. of tesserae in each type	Total
N	6	50	300
O	6	42	252
P	5	74	370
Q	2	80	160
R	1	22	22
S	1	23	23
T	1	54	54
Totals	595	1,309	44,104
Lost examples	299		
Average number of tesserae per band, 65, multiplied by 299			19,435

Total number of tesserae: 63,539

(d) Tesserae in the concave-sided triangles

The concave-sided triangles are all the same and contain patterns of reducing triangles. There are 292 examples, excluding those covered by tombs on the landings. 172 have traces of decoration, all with 47 tesserae (with minor variations).

Total number of tesserae: 13,724 (estimated)

Overall totals of tesserae on St Edward's chapel mosaic pavement

(a) Large medallions	30,563	
(b) Small roundels	13,857	
(c) Curvilinear bands	63,539	
(d) Concave-sided triangles	13,724	
	Grand total	**121,683**

TABLE 3. MOSAICS ON EDWARD THE CONFESSOR'S SHRINE

(A) TESSERAE

Panel no.	Description	No. of tesserae	Tesserae in 10×10cm
South elevation			
1	Frieze	2,070	118
2a	Inscription course	1,500	–
2b	Underside of above	2,646	154
3–9	Upper panelled zone	4,730	104
10	Lintel	3,230	98
11	West flank of niche 1	1,600	125
12	Pier between niches 1 & 2	1,597	132
13	Pier between niches 2 & 3	1,876	156
14	East flank of niche 3	2,050	132
15	Niche 1, west spandrel	624	124
16	Niche 1, east spandrel	624	124
17	Niche 2, west spandrel	624	124

Panel no.	Description	No. of tesserae	Tesserae in 10×10cm
18	Niche 2, east spandrel	624	124
19	Niche 3, west spandrel	624	124
20	Niche 3, east spandrel	624	124
East elevation			
21	Frieze	830	126
22a	Inscription course	750	–
22b	Underside of above	1,250	154
23–25	Upper panelled zone	2,934	160
26	Lintel	766	160
27	South flank (inc. decoration on N rim)	1,264	120
28	North flank (inc. decoration on S rim)	1,388	120
29	South spandrel	650	113
30	North spandrel	650	113
North elevation			
31	Frieze	1,790	96
32a	Inscription course	1,500	–
32b	Underside of above	2,646	154
33–39	Upper panelled zone	4,471	115
40	Lintel	2,910	280 (bands) 100 (roundels)
41	East flank of niche 5	1,734	280 (bands) 100 (roundels)
42	Pier between niches 5 & 6	1,379	280 (bands) 100 (roundels)
43	Pier between niches 6 & 7	1,122	280 (bands) 100 (roundels)
44	West flank of niche 7	1,235	280 (bands) 100 (roundels)
45	Niche 5, east spandrel	580	104
46	Niche 5, west spandrel	580	104
47	Niche 6, east spandrel	450	102
48	Niche 6, west spandrel	450	102
49	Niche 7, east spandrel	580	104
50	Niche 7, west spandrel	580	104
West elevation			
51	Frieze	855	117
52	Inscription course (lost)	–	–
53	Face of retable	13,053	167
54	North edge of retable	–	–
55	South edge of retable	–	–
56	Reverse side of retable, north	711	135
57	Reverse side of retable, south	1,075	135
The niches			
South elevation			
Niche 1			
58	Back, west light	2,960	145
59	Back, east light	2,856	145
60	Sexfoil and spandrels	606	145
61–62	East and west reveals	3,096	108
63	Vault	2,456	80
Niche 2			
64	Back, east light	2,191	150
65	Back, west light	1,616	150

Panel no.	Description	No. of tesserae	Tesserae in 10×10cm
66	Sexfoil and spandrels	464	150
67–68	East and west reveals	3,070	106
69	Vault	5,448	80
Niche 3			
70	Back, west light	2,121	150
71	Back, east light	2,405	150
72	Sexfoil and spandrels	464	85
73–74	East and west reveals	4,400	108
75	Vault	1,749	80
East elevation			
Niche 4			
76	South light	1,542	160
77	North light	1,320	160
78	Rebuilt panels above 76 and 77	2,328	96
North elevation			
Niche 5			
79	Back, east light	1,701	147
80	Back, west light	1,662	147
81	Sexfoil and spandrels	430	–
82–83	East and west reveals	4,076	186
84	Vault	996	90
Niche 6			
85	Back, east light	1,762	108
86	Back, west light	1,678	108
87	Sexfoil and spandrels	426	147
88–89	East and west reveals	1,926	75
90	Vault	1,384	60
Niche 7			
91	Back, east light	1,561	176
92	Back, west light	1,500	176
93	Sexfoil and spandrels	422	176
94–95	East and west reveals	3,106	70
96	Vault	1,426	70
Columns and colonnettes			
97	Lost colonnette, SW corner (estimate)	5,018	179
98	Surviving colonnette, SE corner	5,018	179
99	Lost colonnette, NE corner (estimate)	5,018	179
100	Lost colonnette, NW corner (estimate)	5,018	179
101★	Column supporting north end of retable	–	–
102★	Column supporting south end of retable	–	–

★Note: columns 101 and 102 on the west side of the shrine, and now supporting the retable, originally supported a ciborium-canopy over the tomb of Henry III. The numbers of tesserae on these columns are not therefore represented here, but shown on Table 4 quantifying tesserae on the tomb of Henry III.

Total number of tesserae: 158,446

(B) GLASS ROUNDELS

These were not quantified in the table of tesserae above.

Panel no.	No. of examples	Diameter (cm)	Area (cm²)	Total area (cm²)
South elevation				
1	7	7	38.47	269.29
2a	4	6	28.26	113.04
2b	21	6.5	33.17	696.57
3	4	3	7.07	28.28
9	4	3	7.07	28.28
10	8	3	7.07	56.56
58–59	28	3	7.07	197.96
60	1	6	28.26	28.26
66	1	6	28.26	28.26
72	1	6	28.26	28.26
East elevation				
21	5	7	38.47	192.35
22a	2	6	28.26	56.52
22b	9	6.5	33.17	298.53
23–25	8	3	7.07	56.56
76–77	32	5	19.63	628.16
North elevation				
31	7	7	38.47	269.29
32a	4	6	28.26	113.04
33, 35, 37, 39	16	3	7.07	113.12
81	6	5	19.63	117.78
87	6	5	19.63	117.78
93	6	5	19.63	117.78
West elevation				
51	4	7.5	44.16	176.64
53	24	10	78.50	1,884.00
Total number of roundels	**207**		*Total area (cm²)*	**5,588.05**

TABLE 4. TESSERAE ON THE TOMB OF HENRY III (Fig. 550)

Panel no.	Description	No. of tesserae	Tesserae in 10×10cm
Upper tomb-chest, south elevation			
1	Main panel (surround)	1,100	85
2–3	Guilloche, panel 1	2,400	202
4	Border around panels 1–3	6,230	142
5–6	Colonnettes, SW corner	2,200	–
7–8	Colonnettes, SE corner	2,200	–
9	Band on rim of tomb-cover	1,180	134
10	Base strip	1,065	184
--	Lost, free standing colonnettes on SW and SE corners (estimate)	2,900	

635

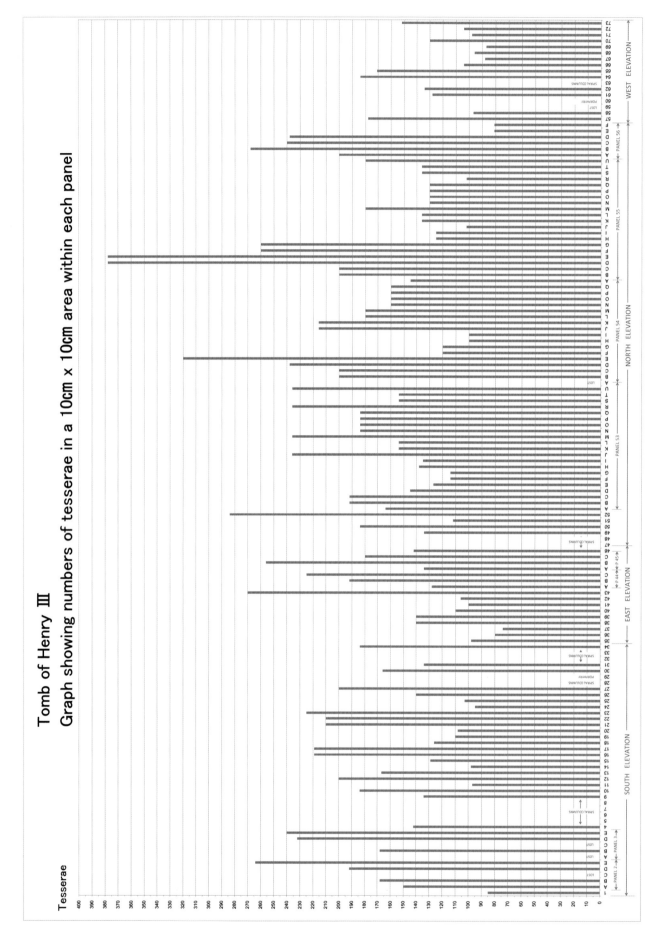

550 Tomb of Henry III. Graph showing numbers of tesserae per 10cm square.

Panel no.	Description	No. of tesserae	Tesserae in 10×10cm
Lower tomb-chest, south elevation			
11	South side of pilaster 71	400	97
12	Pilaster, west side	430	200
13	Outer surround, west niche	2,500	167
14	Inner surround, west niche	1,500	98
15	Cross, west niche	390	129
16	Pilaster, west side of central niche	330	219
17	Pilaster, east side of central niche	330	219
18	Band around central niche	1,070	126
19	Entablature above central niche	330	110
20	Pediment above central niche	500	108
21–22	Triangular panels above pediment	660	210
23	Cross, central niche	390	225
24	Outer surround, east niche	1,650	95
25	Inner surround, east niche	1,500	103
26	Cross, east niche	390	140
27	Pilaster, east side of tomb	430	200
28	Colonnette SE corner	1,450	–
Upper tomb-chest, east elevation			
7–8	Colonnettes, SE corner (see S elev.)	–	–
29	Main panel	1,180	166
30	Border around 29	1,722	166
31	Band on rim of tomb-cover	300	134
32–33	Colonnettes, NE corner	2,200	–
34	Base strip	420	184
--	Lost free-standing colonnette between 32–33 on NE corner	1,450	–
Lower tomb-chest, east elevation			
28	Colonnette, SE corner (see S elev.)	–	–
35	Pilaster, south side	260	98
36	Outer surround & divisions of 37–40	1,680	80
37–40	Rectangular panels	2,440	116
41	Pilaster, north side	180	100
42	Side of pilaster 51, N elevation	500	106
--	Lost free-standing colonnette at NE corner	1,450	–
Upper tomb-chest, north elevation			
43	Main panel	1,180	270
44–45	Guilloche on E & W sides, panel 43	1,740	186
46	Border around panels 43–45	3,162	142
32–33	Colonnettes, NE corner (see E elev.) –	–	
47–48	Colonnettes, NW corner	2,550	–
49	Band on rim of tomb-cover	1,180	134
50	Base strip	1,065	184

Panel no.	Description	No. of tesserae	Tesserae in 10×10cm
Lower tomb-chest, north elevation			
51	East side of pilaster 42	400	112
52	Pilaster, east side	570	284
53	East panel	4,950	172
54	Central panel	4,900	177
55	West panel	6,490	176
56	Borders around panels 53–55	7,353	185
57	Pilasters, west side	560	178
58	Pilaster 64, west side	400	97
--	Lost colonnette at NE corner	1,450	–
59	Base of tomb (not tessellated)	–	–
Upper tomb-chest, west elevation			
60	Main panel	–	–
61	Border around 60	1,932	128
62	Band on tomb-cover	600	134
63	Colonnette	1,080	–
64	Base strip	420	184
5–6	Colonnettes, SW corner (see S elev.)	–	–
Lower tomb-chest, west elevation			
65	Side of pilaster 58 (see N elev.)	510	171
66	Pilaster, north corner	600	104
67	Surround and divisions of 68–71	2,180	88
68–71	Rectangular panels	2,320	103
72	Pilaster, south side	600	104
73	Side of pilaster 12 (see S elev.)	510	152

Columns 101 and 102 at the north-west and south-west corners of the Confessor's shrine (numbers relate to the sequence for panels on the Confessor's shrine) are believed to have supported a ciborium over the tomb of Henry III, and hence are included here.

101	Column at NW corner	8,481	
102	Column at SW corner	7,952	
--	Two lost columns	16,433	

Total number of tesserae: 127,171

Quantification of tesserae in the flutes of columns 101 and 102

Estimate of tesserae on the columns once associated with a ciborium-type canopy over the tomb of Henry III, but now supporting the retable on the west side of the shrine of Edward the Confessor. The quantities of tesserae are estimated on the assumption that the decorated shafts of the columns were about 1.70m tall (excluding bases and capitals). Two columns survive; the northern example has four flutes and the southern, six. The numbers of tesserae for the two lost columns are based on the average numbers in the surviving flutes. Descriptions of their patterns are given on pp. 373–6.

North column	*(101)*		
Flute (a)	2,420		
Flute (b)	1,600		
Flute (c)	3,161		
Flute (d)	1,300	Total	8,481

South column (102)			
Flute (a)	1,480		
Flute (b)	1,720		
Flute (c)	1,407		
Flute (d)	861		
Flute (e)	1,546		
Flute (f)	938	Total	7,952

Two lost columns			16,433

Total number of tesserae on all four columns			***32,866***

TABLE 5. CHILD'S TOMB

Panel no.	*Description*	*No. of tesserae*	*Tesserae in 10×10cm*
1	Top slab		
	Tesserae in the roundels	8,239	144
	Tesserae in the S-shaped loops	2,040	98
North elevation			
2	Rim of top slab (all sides)	1,052	92
3	Band below top slab (all sides)	1,398	92
4	East panel, surrounding fillet	522	96
5	Border around 4	3,466	210
6	West panel	3,400 (estimate)	–
7	East pilaster	168	90
8	West pilaster	474	220
East elevation			
9	Main panel	1,000 (estimate)	–
10–11	North and south pilasters	340 (estimate)	–
West elevation			
12	Main panel	1,000 (estimate)	–
13–14	North and south pilasters	340 (estimate)	–
South elevation			
15	Assuming similar decoration as N side, 7200 (estimate)		–

Total number of tesserae: 30,639

TABLE 6. THE 'VALENCE' TOMB

Estimate of total number of tesserae: 5,400

SUMMARY: TOTAL NUMBERS OF TESSERAE

Table 1. Sanctuary mosaic pavement	92,759
Table 2. St Edward's chapel mosaic pavement	121,683
Table 3. Shrine of Edward the Confessor	158,446
Table 4. Tomb of Henry III	127,171
Table 5. Child's tomb	30,639
Table 6. 'Valence' tomb	5,400
Grand total	**536,098**

TABLE 7. RATIO OF TESSELLATION TO PLAIN MARBLE

Ratios, in percentages, between the tessellation and plain areas of Purbeck marble in the pavement and tomb mosaics (excluding the 'Valence' tomb). Calculations based on illustrations (held in archive) distinguishing tessellated and Purbeck marble surfaces and subjecting them to a computer programme devised by Atsushi Yoshizawa.

		Mosaic	*Purbeck marble*
1	Sanctuary mosaic	53.40%	46.60%
2	Shrine chapel mosaic	34.90%	65.10%
3	Shrine of Edward the Confessor		
	South elevation	59.38%	40.62%
	East elevation	38.95%	61.05%
	North elevation	55.44%	44.56%
	West elevation	58.69%	41.31%
4	Tomb of Henry III		
	South elevation	53.00%	47.00%
	East elevation	47.00%	53.00%
	North elevation	52.00%	48.00%
	West elevation	48.00%	52.00%
5	Child's tomb		
	North elevation	52.00%	48.00%

Notes

Notes to chapter 9 (pp. 303–20)

1 Sacrist's roll, 1441, WAM 19693.
2 The actual date of dismantling the shrine is not recorded, but it was presumably in 1540–41.
3 Luard 1858, 156, 310.
4 Scholz 1961, 47–8.
5 *Ibid.*, 52–3.
6 Mayor 1863; transl. Barlow 1970, 278.
7 Barlow 1970, 281.
8 Flete: Robinson 1909, 71–2; Barlow 1970, 262.
9 Cf. Binski 1995, 94.
10 Cambridge Univ. Lib., MS Ee.3.59 (*Estoire*), fol. 36. Reproduced in Binski 1995, fig. 76; Burges 1863b, pl. 28 (line drawing).
11 *Ibid.*, fol. 30. This has often been reproduced, as in Burges 1863b, pl. 27 (line drawing); Scholz 1961, pl. 3; Binski 1995, figs 77, 129.
12 Binski 1995, 94.
13 For the Lady Chapel, see Tatton-Brown 2003.
14 For Windsor, see Brindle 2018, 60–6.
15 *Liberate Rolls 1240–45*, **2**, pp. 83–4, 98. Appendix 1, items 8 and 9.
16 Luard 1877, 156–7. The quote is from Ovid, *Metamorphoses.*
17 Appendix 1, chronicle no. 1.
18 Luard 1883, **5**, 195. Appendix 1, chronicle no. 2.
19 Nichols 1780, 16.
20 As Colvin (1963, 147–8) noted, the medieval terminology used in connection with the shrine is loose and inconsistent. Strictly speaking, the shrine comprised a stone base or pedestal, which supported an ark-shaped, gabled oak receptacle – the *feretrum* – that was clad with sheets of silver or gold and other precious materials. Over this, and completely enveloping it, stood an ornate gabled timber canopy (*cooperculum*), which could be raised and lowered by ropes and pulleys suspended from the vaulted ceiling, high above the presbytery. In the Romanesque shrine only the *feretrum* could have contained the corporeal remains of Edward the Confessor, but the replacement of 1269 had a chamber within the upper stage of the shrine, large enough to hold a coffin; this presents a conundrum (p. 572).
21 *Patent Rolls 1232–47*, p. 285, *Liberate Rolls 1240–45*, pp. 83–4, 134. Appendix 1, items 8, 13 and 14.
22 *Close Rolls 1242–47*, p. 344. Threads from textiles removed from her coffin were also said to have been woven into copes.
23 *Close Rolls 1247–51*, p. 423. Appendix 1, item 42. Here, the use of *feretrum* clearly relates to the shrine as a whole, since the candlesticks would have been attached to the pedestal, rather than the gilt feretory.
24 Carpenter 2007a.
25 Appendix 1, items 43, 44 and 46.
26 Burges 1863b, 133.
27 Tanner and Clapham 1933.
28 Early plans and views confirm that there were three steps up to the crossing and quire from the nave and transepts (expunged in 1844), but they variously show one or two steps at the entrance to the sanctuary where there are now five.
29 Rodwell 2015b, 160.
30 O'Neilly and Tanner 1966, figs 16–18.
31 Peter Foster drew a hypothetical plan showing a multi-chambered, vaulted crypt accessed from the south ambulatory via a tunnel. He posited an entrance in the wall recess where the Cosmati child's tomb stands. Plan in WAL.
32 The step stands 20–24cm high, and the bench rises a further 35cm.
33 The wall is 95cm high, including the top moulding.
34 The primary nature of these three panelled bays has not been hitherto appreciated (cf. Rodwell 2015b, 161, n.17).
35 Ackermann 1812, **2**, pl. 50. Although the tomb proper has been omitted, the two-stepped plinth upon which it stood is depicted.
36 Most of the metal fixing-points seem to be associated with supporting canopies and other tomb paraphernalia.
37 Klukas 1984, 148.
38 The nave aisle doorway was one of two entrances to Henry III's great sacristy, which formerly lay in the angle between the transept and the north aisle (Fig. 1). The sacristy was demolished in *c.* 1739, and neither doorway could ever have been used by pilgrims.
39 Bond 1909, 67.
40 The doorway has a plainer counterpart in the eastern aisle of the south transept, where it is known as Poets' Corner door. Its function was to provide direct access

41 The decoration on the early 13th-century north and south doorways of the Lady Chapel at Glastonbury Abbey (Somerset) is similarly unfinished, displaying both uncarved and partly carved voussoirs.

42 Walcott 1877, 173.

43 From the 8th century onwards, many English shrines – especially those in confined spaces, such as crypts – had dual access points so that a circulatory system could operate efficiently.

44 For a general discussion of pilgrim access, see Nilson 1998, 92–9.

45 In fact, southern access to the chapel may have been obstructed even earlier, since a pre-existing tomb had to be removed in order to make way for Richard II's. However, if the earlier tomb was of modest proportions, access past it would still have been possible: for discussion, see p. 506.

46 Nilson 1998, 99.

47 Wilson 1977, 19–20.

48 McRoberts 1976, 67.

49 This curious sequence of events is discussed by Badham (2007b, 136–8).

50 *Ibid.*, 138–40.

51 The outside date-bracket is 1458–60, with the probability that the king determined his burial site in late 1459. We are grateful to Matthew Payne for his assistance in this matter.

52 Henry VIII appointed Thomas Cromwell, Earl of Essex, as the King's Vicar-General in summer 1536, whereupon he began to purge idolatrous furnishings in churches, including the shrines at Westminster and Canterbury.

53 Walcott 1873, 350–2.

54 For the location of this tomb, see O'Neilly and Tanner 1966, fig. 16.

55 Micklethwaite (1895, 412) opined that the Confessor was buried on the site of the demolished shrine, which is the most plausible option.

56 WAM 37417.

57 Prince Philip of Spain took the title 'King of England' when he married Mary in 1554.

58 WAM 34719. We owe these references to Matthew Payne.

59 Nichols 1852, 94.

60 Nichols 1848, 130–1.

61 Taylour 1688; Perkins 1940, 93–105; Tanner 1954, 2–6. Dart (1723) claimed that 'Taylour' was actually Henry Keepe, but this was robustly refuted by Westlake (1916, 70) and Perkins (1940, 96–7).

62 One piece is currently held by Westminster Cathedral, and was displayed in an exhibition, 'Treasures of Westminster Cathedral', in July 2010 (Browne and Dean 1995, 217). Other pieces are in the Victoria and Albert Museum. A fragment of shroud is also illustrated in Perkins 1940, pl. opp. 98.

63 WAM 44802A.

64 Vertue 1770, 32; Lethaby 1925, 266. This was confirmed by Gough (1786), who drew the outline of the destroyed inscription on 14 Apr. 1781.

65 *Gents Mag.* **78** (1808), 1088.

66 WAL: newspaper cutting dated 15 Jul. 1827. No further information has been found regarding this investigation.

67 Scott 1861, 46–7; 1863, 58–60.

68 The investigation was recorded graphically. The V&A Museum has a drawing inscribed, 'Done in 1850 by uncovering the base of the columns of the tomb of the Confessor. I made this drawing, and then we covered it up again. A. MacCallum'. Noted by Lethaby (1925, 229).

69 Poole 1890, 114. The colonnette was illustrated by Talman in 1713 (Fig. 301A).

70 Poole 1890, 187. The dormitory is now part of Westminster School hall.

71 Accn. No. 0940. Reynolds 2011, 44, 30N.

72 Poole 1890, 170. The discovery was later concealed by cement.

73 Brayley and Neale 1823, 76. See also E. W. Brayley, *Londiniana, or Reminiscences of the British Metropolis.* 4 vols. London 1828–29.

74 Scott 1861, 46.

75 WAM fabric voucher dated 9 Feb. 1870. It covers work from Jan. 1869 onwards.

76 Burges 1863a, 103.

77 Although the situation is complicated by the fact that a replacement altar was erected here under Mary I, and that too was later removed and superseded by a wooden table. Scott (1863, 59) found a slab from a 17th-century tomb 'at the back of where the altar has stood'.

78 Westlake 1916, 69. The pall and chain are seen in Westlake 1923, 1, opp. 228. The pall, which bore an inscription, is also well illustrated in RCHME 1924, pl. 45. The chain alone remained in position until it was taken down in 2017.

79 Hope 1914, 149; Lethaby 1925, 233.

80 Photograph in WAL.

81 Westlake 1916. A sketched plan and cross-section by Thomas Wright (Clerk of Works) in WAM (P)751. The photograph was taken from Henry V's chantry, looking west.

82 WAM S/1/64. Reynolds 2018, nos 20, 25.

83 WAM S/1/67. Reynolds 2018, no. 24.

84 Photograph in WAL.

85 WAM S/1/98, S/1/99. Reynolds 2018, nos 58, 59.

86 WAM S/1/100. Reynolds 2018, no. 60; Tanner 1969, 183.

87 O'Neilly and Tanner 1966. The models are held in the Abbey Collection.

88 WAL: J. G. O'Neilly, 'The altar of the shrine', unpublished typescript, 1966.

89 *West Sussex Gazette*, 20 March 1960.

90 WAL: Foster files, box 2(i). Dykes Bower's report for 1960 referred to the shrine canopy as having 'become so unsightly an object that for long it had been concealed under a pall'.

91 Cost £69.50. WAL: Foster files, box 2(i).

92 WAL: Foster files, box 2(ii).

93 This investigation took place between 22 Jan. and 2 Feb. 2018, when a scaffold platform was constructed to provide access all round the pedestal at cornice level. The tomb was not disturbed in any way.

94 Mitchner 1986, 89.

95 Museum of London.
96 Spencer 1980, 21, fig. 80.
97 Cf. Spencer 2010, nos 202, 202a.
98 Spencer, 1980, 21, fig. 82.
99 Museum of London: accn. 8879. For other examples (fragmentary), see Spencer 1980, 21, figs 83–6.
100 Hope 1914; Colvin 1963, 489.
101 Keepe 1683, [unpaginated preface] 'To the Reader . . .'
102 Malcolm 1802. He was referring here to the sanctuary pavement in particular.
103 Brayley and Neale 1823, **2**, 69.
104 Anon. 1841, 179–80.
105 E.g. Bonney 1875, **I**, 257.
106 Five documents have been identified:
(i) T. L. Donaldson, 'On the present condition of the royal tombs in Westminster Abbey around the shrine of Edward the Confessor', paper read at the RIBA, 23 Feb. 1852 (RIBA/MS.SP/11/2).
(ii) C. C. Nelson, report on an inspection of the royal tombs by members of the RIBA who were concerned about their state of preservation, 15 Mar. 1852 (RIBA/MS.SP/11/2).
(iii) Letter by E. Richardson to the RIBA on the propriety of restoring royal tombs, 8 Mar. 1852. (RIBA/MS.SP/11/2).
(iv) Correspondence with G. G. Scott, regarding the tombs, 10 Apr. 1852 (ScJ/1/2/34).
(v) Notes on types of stone used in the royal tombs, Mar. 1852 (RIBA/MS.SP/11/2).
107 The relics were contained in a box bearing the initials of either James II and his second wife Mary or, less likely, of his son James and his wife Marie: *Proc. Soc. Antiquaries* (ser. 2) **20** (1905), 209; Westlake 1916, 78. The present whereabouts of the box and relics are unknown.
108 It is on the right-hand spandrel of bay 1, where there are also many other graffiti, including the date 1678 and, separately, the name COUDRAY. The left-hand spandrel of bay 2 bears the dates 1659 and 1679, and the right-hand spandrel 'EB 1779' (Fig. 311). For the plan and bay numbering, see Fig. 299.
109 With the '5' reversed. On the framing between niches 5 and 6 (north face) is the date 1651.
110 On the framing above bay 2.
111 Tanner 1969, 183.
112 Rodwell 2013, 129–30, 169–72.

Notes to chapter 10 (pp. 321–92)

1 For a useful, wide-ranging discussion of English shrine bases from *c.* 1270 onwards, see Coldstream 1976.
2 The risers were originally *c.* 10cm; the height of the present step was increased to 17cm by packing rubble and mortar under it.
3 O'Neilly and Tanner 1966, fig. 8.
4 The shafts have gone, but the rebates for them are still present at the east end.
5 O'Neilly and Tanner 1966, fig. 11, 147–8.
6 Binski 1990, 13.
7 The first mention of marble for the shrine pedestal occurs in 1241 (appendix 1, item 8).

8 In niches 1 and 7 there is only a single panel on one flank, but that may be a consequence of the 16th-century restoration. The flanking panels were not correctly paired when the shrine was reconstructed, as first observed by O'Neilly.
9 Luard 1890, 22. Appendix 1, item 140.
10 TNA: E 372/116, *Pipe Roll 56 Henry III*, rot. 1r. Appendix 1, item 143.
11 Tanner 1969, 183.
12 Talman employed many symbols to indicate different materials and treatments, but there is no known key. Some are recognizable abbreviations (e.g. *az.*, for *azure* = blue), others not.
13 This appears to be *ae* ligatured, normally an abbreviation for *aes*, bronze, but that seems unlikely in this instance.
14 Green porphyry was often erroneously described as serpentine, a rock type that is not found in the primary Cosmati work at Westminster. Talman routinely described green porphyry as *serp.* or *Sp.*, reserving *por.* for purple.
15 The original arrangement was first deduced by O'Neilly.
16 O'Neilly and Tanner 1966, fig. 13.
17 The retable slab is 13.5cm thick. The truncated pilasters on the west end of the pedestal are 16cm wide, but project by only 4.5cm. They could never have supported the retable.
18 O'Neilly and Tanner 1966, fig. 8.
19 The relative crudeness of the finish is uncharacteristic of Scott's work, but there is no doubt that it was executed at his behest, and the work billed in 1869 (p. 315). The 16th-century architrave moulding was partly cut away in order to fit this block; when it was removed again in 1902, the moulding was made good. The repair can be seen on Fig. 330 (paler stone at the right-hand end).
20 The slab was 12mm thick and comprised two separate pieces of marble; the narrower was 9cm wide, and there was a slight difference in their thicknesses which left a shallow but clear offset in the mortar bed.
21 Matrices intended to receive marble slabs were normally 25mm deep, but this one has a greater depth, and the extant mortar bed reveals that the slab it once contained tapered in thickness, from *c.* 18–32mm. This points to the matrix having been cut specifically to receive a particular piece of porphyry.
22 Although the overall appearance is black, traces of blue can be detected under magnification.
23 It appears that circular discs were trimmed to make them fit into the available spaces: thus the disc in niche 1 was an irregular octagon; niche 2, roughly circular; and niche 3, an irregular hexagon. Although partial impressions of the edges of the discs survive in the mortar, in all three cases the bed also has ridges, indicating that the back of the disc was scored to aid adhesion.
24 The construction is well illustrated in O'Neilly and Tanner 1966, fig. 3.
25 The joint across the central panel cannot be seen because it is covered with paint, but is visible on the east side of niche 7.

26 Brayley and Neale 1823, **2**, 69. The surviving capital was the 13th-century one at the north-east corner.

27 The flange is part of the lead-dowelling process that secured the shaft to the base.

28 The capital was 17cm square, but the abacus has been hacked off the east and west sides, and there is much other damage to the decoration.

29 This fragment was found during excavations in 1904 at the corner of Great College Street and Tufton Street, just outside the Abbey precinct (Warren 1904). It was not used in the 1557 reconstruction (p. 378).

30 This capital was also 17cm square, and has lost its abacus moulding on the north side; parts of the decoration have been hacked away, and the south-west corner is rebated where the capital once clasped a salient angle. None of this relates to its incorporation in the shrine pedestal in 1557.

31 There is an exception in the case of the division between bays 1 and 2, where the mason inadvertently ran the rebates on both the east and west faces from top to bottom, with the consequence that the capitals and bases of the two shafts had to be made and fitted separately, or integrally carved with the shafts. The rebates are now empty and the components in question do not survive.

32 In those too, the rebates are unstopped and no capitals or bases are present.

33 Notwithstanding, Lethaby proposed that these columns had once supported the eared projections at the west end of the pedestal (Lethaby 1925, 229).

34 Hutton 1950, pls 43, 44.

35 Cf. Pajares-Ayuela 2001, figs 4.73 and 4.84. The cloister was completed *c.* 1240, when it was signed by 'Magister Petrus' (Hutton 1950, 49).

36 Cf. the numerous cloister colonnettes at San Paolo fuori le Mura, Rome, and the pulpit-supports at Ravello Cathedral (Pajares-Ayuela 2001, figs 2.233 and 4.60).

37 Scott 1863, 60–1. This was a recollection thirteen years after the event, and may not be reliable or even based on actual measurement.

38 That is less than the height of the eastern colonnettes in the 13th century, the bases of which were founded on the second step, not the top step; the current arrangement relates to the 1557 reconstruction. Hence the original heights would have been *c.* 1.90m. Since the western colonnettes supported the eared projections, they stood at a slightly greater remove from the pedestal, and must have been founded on the next step down, which would indicate their heights to have been *c.* 2.05m. However, they could have been raised on plinths, in which case all four colonnettes would have been of the same height. O'Neilly's reconstruction showed the western colonnettes standing on plinths (O'Neilly and Tanner 1966, fig. 18 and pl.61).

39 Poole 1890, 187.

40 Since Scott lowered the retable by 12–15cm, less shaft is now visible than was previously. Hence, prior to 1868, the visible height must have been *c.* 1.3m, potentially indicating that the shafts measured around 2.6–2.7m. In 1713 Talman recorded the visible column height as 1.28m (Fig. 302).

41 The platform upon which the pedestal rests has been altered at the south-west corner (probably in 1868), evidently to create a pocket for viewing the preserved tessellation on the lower part of the column.

42 The existing stanchion could, of course, have been reduced in height when the present Tudor canopy was installed.

43 O'Neilly and Tanner 1966. Images of the model, which is in the Abbey Collection, were published in *loc. cit.*, pls 58–60. In addition to the demountable model, there is a second one showing the shrine in the form in which it survives today. An excellent summary and succinct discussion of O'Neilly's arguments was prepared by Platt and is included in his inventory of the former Lapidarium in the triforium gallery at Westminster (item B4). For the Lapidarium Inventory, see note 52 below.

44 Lethaby 1925, 266. He thought the shrine was then moved 'a few feet farther west'.

45 As seen at the east end of the chapel (Fig. 230); also in the north and south ambulatories (Figs 6 and 7) and in the east cloister walk.

46 O'Neilly and Tanner 1966, 136. Margaret, daughter of Edward IV, died 1472, aged nine months. The tomb must have been relocated to its present position against an arcade pier on the south side of the chapel in *c.* 1540–41, when the shrine was dismantled.

47 For the detailed argument, see O'Neilly and Tanner 1966, 140–1.

48 O'Neilly and Tanner 1966, 142–3, 147.

49 Although it is often described as a 'reredos' (including by O'Neilly and Tanner 1966), this altarpiece was never freestanding, but required a solid base to support it. Scott, however, always referred to it correctly as a *retabulum* (Scott 1861, 46).

50 Since the panels were inverted when the pedestal was rebuilt, as noted on p. 378, the rebate and bevel would originally have been on their lower edges.

51 O'Neilly and Tanner 1966, 148–50.

52 These items were researched by Tony Platt, formerly Keeper of the Abbey's Lapidarium, and described in his carefully referenced ms inventory (see items B1–B3). A copy of the Lapidarium Inventory is in WAL.

53 WAM 65072. Platt inventory item B2. Westminster Abbey Coll., accn. 0940.

54 Poole 1890, 187.

55 A rare photograph of the shrine with the corner block *in situ* was published in an album, *Twenty-four Gems of Westminster Abbey: A Collection of Permanent Photographs* (Graphotone, London 1902). The relevant image can be intrinsically dated to between 1897 and 1902. See also Bond 1909, 23 for a different view. Less clear images are reproduced in Hiatt 1902, 66, 76.

56 Perkins 1940, 109.

57 The conclusion reached by Platt (see note 52). The block had certainly been removed by 1906, as noted by Lethaby (1906, 326n, fig. 115). An undated view, published in 1924, shows the removed block lying loose on top of the eastern cornice (RCHME 1924, pl. 45).

58 Today this is the junction of Tufton Street and Great College Street. The find was made where St Edward's House now stands.

59 Inventory item B1. Westminster Abbey Coll., accn. 0939. Cocke 1995, 112, pl. 71. The piece measures 24cm long by 12cm in diameter.

60 Tatton-Brown 2015, fig. 4.

61 Acquiring and roughly sizing all the Purbeck marble in one operation was important for ensuring that colour and texture were consistent, and that there were no fissures or flaws in the stone that could lead to rejection at a later date. However, since work on the pedestal began well before the decision to embrace cosmatesque ornament was made, stone colour may have been less important if it was intended to embellish some areas of the pedestal with gilding and polychromy.

62 National Museum of Rome, Baths of Diocletian.

63 On the retable, the deeply set porphyry panels (a) and (c) survive, surrounded by the shallow rebates containing the mortar beds into which the glass mosaic borders were set. In panel (e) the completely empty matrix reveals that the former panel was flanked by shallow borders on only two sides (Figs 327, 331 and 332A). Hence this porphyry slab had a more rectangular appearance than the others.

64 These small, non-structural shafts were slipped into rebates, and not pinned at the top and bottom as the larger shafts were. They relied on an adhesive to retain them in place; that could have been lime putty, or possibly hot shellac. The latter was much used by English medieval masons for repairing fractured stones and adhering small parts.

65 BL: Cotton MS Claudius A, VIII, fols 22r–70r.

66 WAL MS 29. Robinson 1909.

67 Widmore 1751, 75.

68 E.g. Brayley and Neale 1823, **2**, 69; Hutton 1950, 24; Colvin 1963, 149–50 n.4; Tudor-Craig 1986, 117–18. On the other hand, several of the early historians followed Sporley but made no comment about the ten-year dating discrepancy: e.g. Keepe 1682; Dart 1723/1742. It seems that they read *septuageno* as implying 1269–70, rather than 1279–80 (see further p. 387).

69 Binski 1990, 15.

70 Most writers have restored *copleto* to *completo*: e.g. Keepe 1682; Dart 1742, **2**, 25; Robinson 1909, 114; Binski 1990, 14.

71 Binski 1990, 14; 1995, 99–100.

72 Note 68.

73 Carpenter 1996, 188–9.

74 For discussion of this potential solution, see Payne and Rodwell 2017.

75 The issue of correct scansion is not straightforward. Prof. David Carpenter, Dr David Howlett, Dr Daniel Hadas and Peter Pickering all contributed most helpfully to discussion of this matter. The last-mentioned kindly pointed out that Sporley's own version of the opening line does not scan in the way that it superficially appears, and is thus incorrect.

76 Payne and Rodwell 2018, 146.

77 *Ibid.*

78 E.g. O'Neilly and Tanner 1966, 146; Binski 1995, 99. Among authors who did not include a cross is Perkins 1940, 49.

79 E.g. Binski 1995, 99–100.

80 Burges 1863b, 130.

81 Lethaby 1906, 322, fig. 111.

82 Lethaby 1925, 226.

83 Perkins 1940, 50. Likewise, Colvin 1963, 149 and Binski 1995, 99.

84 Davison 2009, figs 8, 11, 15, 19.

85 Sauerberg 2013, 93–9.

86 The sexfoils in the spine wall of the shrine are fully rounded like those in the ambulatory chapel windows, designed in the late 1240s. Although only a few years later, the foils in the west side of the transept are slightly pointed.

87 O'Neilly and Tanner (1966, 152) conceded that there was a coffin-sized chamber within the upper part of the shrine pedestal in the 13th century, but did not discuss its implications. Coldstream (1976, 17) ceded that 'at Westminster and Whitchurch the coffin actually rested inside the shrine base'.

88 E.g. Lethaby 1925, 266; Tanner 1969, 181.

89 An empty space is not necessarily a major issue, since many medieval tomb-chests enclose voids, the corpse being interred below floor level.

Notes to chapter 11 (pp. 393–433)

1 TNA: E403/1256. *Liberate Roll, 18 and 19 Edw. I.* Burges 1863c, 136–7; Gardner 1990. See here appendix 1, item 166.

2 Appendix 1, item 170.

3 Latin: *capsa, capsella*, box or case. There is a clear distinction in terminological use between this and *feretrum*.

4 TNA: E 372/114, rot. 19. Colvin 1971, 428. The account relates to a period of just over one year, from Christmas 1269 to the beginning of February 1271. Appendix 1, item 130.

5 Sacrist's Roll, WAM 19629. Appendix 1, item 172.

6 Sacrist's Roll, WAM 19637. Appendix 1, item 174.

7 Sacrists' Rolls, WAM 19663, 19665 and 19666. Appendix 1, items 183–5.

8 *Barell* was the term used for a winding-drum for ropes and, later, metal cables; it is still applied to the winding-drums of weight-driven clocks.

9 Sacrist's Roll, WAM 19667. Appendix 1, item 186.

10 Several holes for ropes or chains were variously drilled through the crown of the vault, directly above the shrine, but have long since been infilled. Their presence was noted in the 1950s, when the vaults were being cleaned (O'Neilly and Tanner 1966, 131).

11 Sacrist's Roll, WAM 19668. Appendix 1, item 187.

12 WAM 19736, 19745, 19748 and 19752. Appendix 1, items 191, 195, 196 and 198.

13 WAM 19753. Appendix 1, item 199.

14 WAM 19745 and 19748. Appendix 1, items 195 and 196.

15 See, for example, appendix 1, items 192–7.

16 WAM 19748. Appendix 1, item 196.

17 WAM 19761, 19772 and 19775★. Appendix 1, items 200, 202 and 203.

18 Edward's body still lies in an ancient, iron-bound elm coffin (p. 420). Since this is inaccessible for study and there is no certain record of the body being re-encased,

we cannot be sure whether the extant coffin dates from 1066, the 1163 enshrinement, or that of 1269 (see also p. 423).

19 The plates were usually of silver, covered with gold leaf. However, Matthew Paris was insistent that at Westminster the plates were of pure gold (Fadden 1866, 454–5; Luard 1883, 156–7). See appendix 1, chronicle nos 1 and 2.

20 O'Neilly and Tanner (1966, 148, fig. 1) did not address the issue of the empty chamber: on fig. 1 they show the coffin inside the stone chamber (as it now is), and on p. 148 they merely refer to 'the golden feretory containing the saint's coffin'.

21 O'Neilly and Tanner 1966, 147, figs 7, 8, 11.

22 At Westminster, as elsewhere, the term 'feretory' has been loosely employed by past writers to describe: (i) the receptacle containing the saint's body; (ii) the removable canopy that covered it (*cooperculum*); (iii) the entire shrine structure; (iv) St Edward's chapel. The first and third uses are attested by the medieval records cited here.

23 O'Neilly and Tanner 1966, 153.

24 Perkins 1940, pl. opp. 105. Photographer unknown; no copy of the image in WAL.

25 WAL. Perkins 1940, 97.

26 Gables might have appeared slightly uneasy above the paired arches on the east and west ends; a hipped roof was incompatible with a classical façade.

27 Dart 1742, **2**, 24.

28 No trace of iron fittings can be seen today.

29 The canopy is in three separate parts: lower chest, upper chest and roof.

30 Heavily infested with woodworm and largely defrassed in 1958.

31 Pre-restoration illustrations of the chest appear to show a full set of twenty-two capitals.

32 O'Neilly and Tanner 1966, 150–1. O'Neilly stated that prior to restoration 'only a few fragments of glass remained to give a clue to the original form; Talman's measured drawing of the shrine in 1713 gives details of the glass.

33 Perkins 1940, 85.

34 If the partitions had been fixed to the wainscoting there would have been nail-holes visible on the undecorated back of the latter, but there are none.

35 Apart from some chalked numbering and annotation dating from 1958–60.

36 Inexplicably, Pugin omitted the glass roundels from his drawing.

37 The panels are tightly contained by the framing, and no end-grain is currently accessible; a superficial inspection revealed vestigial traces of sapwood on one or two boards. The worm-eaten and defrassed boards of the entablature are not suitable for dating. The horizontal planks forming the sides of the upper chest might be datable, but again access to end-grain is impossible. Even if a tree-ring match for the boards were established, the loss of virtually all the sapwood would prevent absolute dating within a bracket of 10–15 years.

38 E.g. Burges 1863b, 130; Micklethwaite 1895, 413;

RCHME 1924, 28–9; Perkins 1940, 85; Carpenter 1966, 125.

39 Some early commentators wondered whether its design was based on or inspired by the original 13th-century canopy, but that is stylistically impossible and can be dismissed.

40 Micklethwaite 1895, 413.

41 O'Neilly and Tanner 1966, 151–4.

42 Appendix 1, items 208 and 209.

43 Walcott 1973, 351. Appendix 1, item 206.

44 Bradley and Pevsner 2014, 137.

45 *Op. cit.*, fig. 14.

46 WAM 19775★. Appendix 1, item no. 203.

47 In the following year a small quantity of similar fine twine rope, costing 2s., was purchased for the high altar; this was presumably for operating the Lenten veil. If the same gauge of rope was bought on both occasions, it would imply that 28.5 times more was needed for raising the shrine canopy than for the Lenten veil. However, a thinner gauge was probably purchased for the latter, and therefore the respective quantities involved cannot be calculated. The veil is unlikely to have required more than *c.* 30m of rope.

48 Prof. Richard Marks, pers. comm.

49 WAL: Tanner ms.

50 See P. Lindley, in Tatton-Brown and Mortimer 2003, 266–70.

51 Tatton-Brown and Mortimer 2003, 133. Appendix 1, item 201.

52 An observation also made by Tony Platt in his Lapidarium Inventory, item B4. See chapter 10, note 52. WAL.

53 An analogy may be drawn with the Westminster Retable, Henry III's monumental altarpiece (Fig. 501). This survived the Dissolution and later turmoils on account of a new, mundane use being found for it as the top of an effigy press (Rodwell 2009b).

54 Knighton 1997, xviii-xx; Duffy and Loades 2006, 79–82.

55 Knighton 2003, 9.

56 WAM 43297.

57 Edwards 2011, 224.

58 Nichols 1852, 94. Appendix 1, item 207.

59 Bodleian Library, Oxford: MS Rawlinson D 68. Stanley 1868, 546–7; the full text is transcribed in a *Supplement* (published separately, 1869). Stanley does not give the date of the speech, and later authors incorrectly cite it as 1557 (e.g. E. T. Bradley, in *ODNB* (1885–1900), **18**, 284). It is correctly given as 1557/58 in W. Macray's library catalogue entry (1893), and is backed up by the *Journal of the House of Commons*: http://www.british-history.ac.uk/commons-jrnl/vol1/pp48-49. The question of Sanctuary was debated on 11 February 1558, where 'It is Ordered, That the Abbot of Westminster shall come to this House with his Counsel To-morrow, to declare what he can say for the Having of a Sanctuary at Westminster'. Hence, Feckenham's speech was delivered on 12 February.

60 Nichols 1848, 130–1.

61 There is no factual basis for explicit statements such as 'the body itself was quietly and secretly buried' (Tanner 1969, 181), and 'when the shrine . . . base was pulled

down to the ground, and the body of the Confessor was buried in a grave on its site' (Micklethwaite 1895, 413). The latter may not, however, be far off the mark.

62 E.g. Scott (1861, 46) championed partial demolition, but later conceded that total removal had taken place (1879, 284). Lethaby (1925) and O'Neilly and Tanner (1966, 134) were unequivocal in supporting the latter view.

63 The decoration is on the underside of the slab, but can be glimpsed by peering into the pocket that holds the removable block in the south side of the frieze.

64 O'Neilly and Tanner 1996, 152.

65 The bricks measure 20 × 11 × 5.5cm; the peg-tiles 24 × 15 × 1.5cm. Half-bricks were mostly used.

66 Also, there is no logical reason why one flank would be rebated and the other bevelled; a simple ledge or rebate on each side would have sufficed.

67 Removing the blocks reveals the original western returns (13cm on the north and 12cm on the south) and two matrices for lost roundels.

68 Similarly, he created three manholes in the floor of the sanctuary, to enable scholars to inspect the 11th-century pier bases (p. 43).

69 Westlake 1916, 73–4, fig. 4.

70 It was just east of the exact centre, which is occupied by a roundel in the Purbeck marble matrix.

71 The glass was only c. 3mm thick, and the smooth surface of the plaster around the margin reflects the area of total contact; this is not present in the centre. The plane of the plaster bed changes slightly on either side of each disjuncture, confirming that the glass fractured whilst pressure was being applied to it.

72 The fact that the impression of the lost disc, within the primary mortar bed, was capable of being infilled with plaster indicates that it had significant depth (i.e. the disc was not of thin translucent glass), but was insufficient to have accommodated stone; hence, the likelihood is that it held a material of intermediate thickness, namely opaque glass.

73 Tanner 1969, 183.

74 For other examples of painted *tabulae* relating to the presbytery, see appendix 1, items 177 and 179.

75 Camden 1606, 12–13; Rodwell 2013, 2.

76 WAM 19637. Part of the entry has been crossed out. Appendix 1, item 174.

77 WAM 19654. Appendix 1, item 177.

78 Camden 1606, *passim*.

79 The earliest record was by Camden (1606, 3), but this is not a faithful transcript since the extant evidence reveals that he rearranged some of the wording and did not record the punctuation marks.

80 Widmore 1751, 75.

81 Gough 1786, 3. He failed to appreciate that the flower head had a very thin stem connecting it with the pair of outcurved leaves at the base, and hence together formed a rather florid letter 'I'.

82 For the cross and chain, see Perkins 1940, 103–4 and Tanner 1954.

83 Transcript, slightly edited, in Perkins 1940, 100–1; for a reproduction of one page of the ms, see pl. opp. 98.

84 CUL: Add. MS 36. Cited in Perkins 1940, 101. However,

Bishop Patrick, as he was by then, wrote his auto-biography twenty-one years after the event.

85 Elaborate ferramenta of the kind seen on Henry III's coffin were exceptional (Fig. 477).

86 Seen and described in 1685 by Patrick (Perkins 1940, 100).

87 Westminster Cathedral and the VAM have pieces. See report by Lisa Monnas, below.

88 CUL: attached to Add. MS 36, fol. 213. Illus. in Perkins 1940, opp. 98.

89 WAM: *Liber Nigra*, fol. 87. Appendix 1, item 182.

90 A split in the lid of the latter enabled a thin blade to be inserted, which passed through a void 12.5cm in depth before encountering what is presumed to be the lid of the primary coffin within.

91 Coffin F5328 (Rodwell 2011, 210, fig. 216).

92 Westlake 1916. The Abbey's Clerk of the Works, T. J. Wright, sketched a cross-section through the pedestal at the same time: WAM (P)751. For another photograph of the exposed shrine top and coffin, probably taken around the time of World War II, see Tanner 1954, pl. 2.

93 Curiously, there is a deep scar on the southern edge of the lid, formed by a single blow from an axe. The location and angle of the cut imply that the damage was inflicted prior to placing the coffin in the shrine chamber.

94 The lid is 7cm thick and made of two planks; the larger has split (superficially giving the impression that the lid comprises three planks); the south side board is 57cm wide, and below that the visible edge of the base board is 5cm thick; the main north side board is 40.5cm wide, with an additional piece 10cm wide at the bottom. The last is too thick to comprise the base alone; hence the side plank must clasp the base on the north, rather than resting on it as the plank on the south does.

95 These are difficult to see, but appear not to be common nails: the heads are well driven into the timber, creating a star-shaped indentation with five points. The base is presumably attached to the sides by spikes that cannot be inspected owing to the narrowness of the gap between the coffin and the walls of the chamber.

96 Cited in Perkins 1940, 96.

97 Wren later became the first Surveyor of the Fabric of Westminster Abbey (1698–1723).

98 The secondary coffin comprises at least 13.5ft³ (0.38m³) of oak that was not fully seasoned. The weight of such timber would have been upwards of 50 lb/ft³ (750kg/m³). Hence, we must be looking at a minimum figure of 675 lbs for the empty coffin, plus about 20 lbs for the ferramenta. It is impossible to provide a similar calculation for the medieval coffin, there being too many imponderables. The thickness of the elm boards would have been at least 3cm, and a reasonable figure for such a coffin and its contents might be 200 lbs, giving a total of 895 lbs (8cwt; or 405kg). It must be stressed that this figure provides only a general order of magnitude.

99 Bloch 1923, 5–131, esp. 121–3; Barlow 1992, 151–2; Robinson 1911, 24; Mason 1996, 27.

100 Bertram 1997, 108–9; the *Vita S. Eduardi Confessoris* depends heavily upon Osbert de Clare's text, and the

shroud's removal is mentioned by Osbert, but only Aelred claims that it was retained and replaced with a new shroud (Bertram, *op. cit.*, 109).

101 Perkins 1940, 31. Albert Kendrick doubted that the king's clothing would have furnished enough for three copes: VAM Archives, Nominal File Mrs A. L. Inge, MA/1/I121 (henceforth VAM Nominal File, Mrs A. L. Inge); there is no record of a set of three comparable relic-copes in the 1388 inventory (Legg 1890).

102 Perkins 1940, 31.

103 *Ibid.*, 29, 31, 41–2.

104 Taylour 1688, 10–11; this account has been attributed by some to Keepe himself, but Perkins (1940, 96–7) supports Taylour's authorship.

105 Taylour, *ibid.*; Perkins 1940, 95, 100, 102–3.

106 Taylour, *ibid.*; Perkins 1940, 95–6.

107 Patrick 1839, 193–4; quote from 193.

108 The silk in Patrick's diary is recorded by Perkins (1940, 101, and ill. facing p. 98); the scrap of silk is now conserved, with its pin, in a Melanex pocket bound into Patrick's diary: CUL: Add. MS 36, between pp. 214 and 215.

109 Thoresby relates that the silk was removed at the same time as the gold crucifix, but since others had access to the tomb at the time, we cannot presume that Taylor took the silk (Thoresby 1830, vol. **2**, 218–19).

110 Mrs Inge lived at Moorlands, Langton Maltravers, Swanage, Dorset; the information concerning the Museum's acquisition of the fragments is from VAM Nominal File, Mrs A. L. Inge; the fragments are VAM, inv. nos T. 2-1944 (4.3 × 9.4cm), T. 3-1944 (8.3 × 8.7cm) and T. 4-1944 (4.3 × 6.2cm).

111 Request in a letter from Mrs Inge, 19 Mar. 1945; it was, impossible to grant this request because the fragments had already been accessioned by the Museum: VAM Nominal File, Mrs A. L. Inge, letter from Sir Eric MacClagan to Mrs Inge, 23 Mar. 1945.

112 The Westminster Cathedral fragment measures 3.7 x 9cm. On 27 Feb. 1944, Kendrick wrote to Maclagan, 'I believe the pedigree of that piece can be traced to the Stuart kings…', VAM Nominal File, Mrs A. L. Inge.

113 The last two words, which are smudged on the paper label, are virtually indecipherable, but Maclagan transcribed them as 'great Relick', VAM Nominal File Mrs A. L. Inge, letter from Maclagan to Dr F. C. Eeles, 1 Jan. 1945.

114 For further details, see Hero Granger-Taylor's analysis of the VAM fragments, Buckton 1994, cat. no. 166, pp. 151–3, esp. 152.

115 Müller-Christensen 1960, 44–6, 65–8, pl. II, figs 31–8. The weave is discussed by Regula Schorta (1987, 80–90, esp. 81–2, 88).

116 For other comparisons, see Buckton 1984, 152–3.

117 Crowfoot *et al.* 1992, 87, fig. 59; drawing by Christina Unwin, fragment placement by Frances Pritchard; for the stockings, see Müller-Christensen 1960, 44 and 46, pl. II and figs 34–8.

118 The pattern repeat of the silk of Clement II's stockings measures 31 x 33cm.

119 VAM Nominal File, Mrs A. L. Inge: letters from Kendrick, Jan. 1945.

120 Kendrick identified that the VAM and Cathedral fragments as of the same weave, emanating possibly from the same 11th-century workshop, but found it impossible to reconcile them into a single, coherent design: VAM Nominal file Mrs A. L. Inge, letter 7 Jan. 1945.

121 This dating was first proposed by Kendrick: VAM Nominal File Mrs A. L. Inge, letters from Kendrick 1944–45, and is accepted by Müller-Christensen (1960), Schorta (1987), Pritchard (1992) and Granger-Taylor (1994).

122 VAM Register, entry for nos T. 2, 3 and 4-1944.

123 Ciggar 1982, 78–96, esp. 90.

124 Buckton 1994, cat. no. 166.

125 Granger-Taylor, in Buckton 1994, 151, 153.

126 The muntins that sub-divide the panelling can be seen in Carter's drawing, and confirmation that a continuous 'passage' had been created immediately behind the arches (replacing individual compartments) is demonstrated by the sight of daylight at the north-east corner of the canopy (i.e. one can look through the last arch on the north face and, simultaneously, through the first one of the east face).

127 J. Longley and Sons of Crawley. The firm was liquidated in 2000.

128 'Abbey Treasure Restored by Sussex Craftsmen', *West Sussex Gazette*, 20 Mar. 1960, p. 1. No record of the work carried out has been located, nor any detailed photographs of the canopy before or during restoration. Dykes Bower was vehemently opposed to the concept of conservation, believing instead in wholesale renewal to recreate the supposed appearance of a structure or artefact when it was first made. Owing to the heavy overlay of paint and gilding, it is currently impossible to determine by external visual inspection precisely what is original. Hardly the slightest blemish can be detected anywhere, pointing to the likelihood that the mouldings have been extensively renewed.

129 Talman's sketch shows a plain plinth 8½ins high, with a hollow-moulded arris; Dykes Bower followed this, but omitted the moulding, resulting in the present ungainly appearance. The plinth that Talman recorded was more likely to date from the 17th century than represent the original arrangement.

130 The glass was made by Barton, Kinder and Alderson of Brighton, and 'matched for colour by the few pieces still remaining.' N.B. There are only 7,290 glass tesserae in the pilasters.

131 It does not appear that any were incorporated in the restoration. Some glass tesserae were found loose inside the shrine chamber in 1916, but they too have subsequently been lost (Westlake 1916, 75).

132 Instead of putty, the restorers used 'specially prepared mastic supplied by B. B. Chemicals of Leicester'.

133 Rodwell 2013, figs 45, 62, 136.

134 The restoration was partly informed by Talman's sketch, who wrote *glass & serp. [. . .] pinto* against the glass inserts in the spandrels, and the panels in the plinths he labelled *glass on serp. pinto*. He did not indicate anywhere the colour of the surrounding woodwork. However, in other areas on the shrine pedestal, when Talman referred to

glass inserts, followed by a colour and *pinto*, he was not describing what was behind the glass but its surroundings. Hence, there is room for ambiguity.

135 No explanation can be offered as to why Dykes Bower restored the colouring of the canopy in this way, even after preparing a draft painting scheme that had greater verisimilitude. Analyses of residues of the original paint would doubtless have informed a more authentic recolouring. No traces of early paint appear to have survived the restoration.

136 Davison 2009, 260, fig. 1.

137 WAL holds hand-coloured dyeline copies.

138 Although the drawing is labelled 'diagrammatic colour only', the differences between it and the canopy as seen today are slight. More of the timber carcase has been marbled as pseudo purple porphyry, in preference to green. Also, the green is represented in two tones, which was not translated into practise.

Notes to chapter 12 (pp. 435–79)

1 Keepe 1683, 147. He evidently derived his account from the chronicler Thomas Walsingham.

2 Crull 1742, **1**, 177–8, fig. opp. 177.

3 Burges 1863c, 149.

4 Dart 1742, **2**, 34.

5 Ackermann 1812, **2**, 196, pl. 48.

6 RCHME 1924, frontispiece. The name of the artist responsible is not recorded.

7 *Westminster Domesday*, fols 404–5. Appendix 1, items 157 and 158.

8 *Westminster Domesday*, fol. 398. Appendix 1, items 163, 164 and 165.

9 TNA: *Comp. Gard., 18 Edw. I.*

10 Tristram 1950, 152–3, supp. pl. 7a.

11 Geddes 1999, 346.

12 The mason failed to allow for the thickness of the partition slabs between the compartments, resulting in both the flanking crosses being too close to the central one by *c*. 5cm.

13 The chambers may have been left void, or filled with rubble and mortar.

14 Most recently by Badham and Oosterwijk 2015, 60, fig. 29.

15 The canopy is shown on Gough's illustration of 1786 (Fig. 30).

16 The clips are stamped wrought iron, taking the form of vine leaves (Geddes 1999, 346).

17 The crosses on panels 15, 23 and 26 are all similar, but on some of the arms the terminals are square-ended, and on others shallowly concave.

18 Poole 1890, 253; see note 34, below.

19 Camden 1606, 4. He also transcribed another text that existed then, but disappeared during the 17th century. Later historians quoted from Camden (e.g. Dart 1723 and Ackermann 1812).

20 Quote from the Ancient Greek poet, Pindar; popularized by Erasmus, who used it for the title of his meditations on the subject of war.

21 Vertue 1770, 34; Dart 1742, **2**, 35; Ackermann 1812, **2**, 197; Brayley and Neale 1823, **2**, 78.

22 Stanley 1880.

23 *Ibid.*, 322, pl. 23. On the right is a robed and crowned female figure with a girl behind her, both having their hands raised in an attitude of devotion; they face an incomplete figure of a man, potentially a saint.

24 Support for the smaller slabs was provided by counter-rebating the longitudinal joint between them and the large slab. The purpose of the iron cramps was to prevent the joints from separating; the inconsequential runs of lead that replaced the iron had no structural value.

25 The two smaller slabs are of unequal length, but the differential is not as great as shown on Stanley's drawing; hence the socket is incorrectly positioned by *c*. 10cm.

26 The dimensions given are: length 1.87m; breadth 57cm, tapering to 54cm; depth 55cm at the west end, reducing to 50cm at the east.

27 Stanley 1880, 320–1.

28 *Ibid.*, 319.

29 Cf. also multiple occurrences on Clement IV's tomb (Fig. 544).

30 Monnas 2017, 45.

31 Carpenter 2007b, 38, where the fragments are also illustrated.

32 The label appears to be contemporary.

33 It is commonplace to find object deliberately dropped through gaps in floorboards and holes in structures. Thus, many thousands of archaeological fragments were recovered from under the floor of the triforium gallery in 2016, including textile, paper, glass, bone and metal objects.

34 Poole 1890, 253; Reynolds 2011, 85, no. 62N. The 'titled lady' was Augusta Stanley, daughter of the Earl of Elgin.

35 E.g. Ackermann 1812, **2**, 196; Brayley and Neale 1823, **2**, 77.

36 The present roundel is slightly smaller than the matrix into which it is set, the surrounding gap being packed with lime mortar containing chips of chalk and Reigate stone.

37 The condition of the panels of the upper chest must have been the same as it is today when Dart mistakenly wrote 'the side and end Pannels of the Table being of the most polish'd Porphiry, of a clear red' (Dart 1742, **2**, 34). He was presumably so impressed with the side panels that he failed to examine the ends sufficiently closely to discover that they were *faux* porphyry.

Notes to chapter 13 (pp. 481–503)

1 E.g. Westlake 1923, **2**, 459; Lethaby 1925, 232; Tristram 1955, 200. However, it cannot have been the tomb moved by Richard II in 1395 (Badham 2007b, 129, 141–3).

2 *Cal. Liberate Rolls, 1251–60*, 376, 385. Howell 1991; Badham and Oosterwijk 2012; 2015, 59.

3 Katherine's tomb was most likely lost when the Lady Chapel was demolished and rebuilt by Henry VII in the early 16th century.

4 E.g. Strype 1720, **2**, bk 6.1, 8.

5 Brayley and Neale 1823, **2**, 152.

6 Burges 1863c, 145–7; Westlake 1923, **1**, pl. opp. 4; **2**, 459.

7 Camden 1606, 51.

8 Strype 1720, **2**, bk 6.1, 17. The reference to St Blaize's chapel is erroneous: that was in the south transept. He meant St Edmund's chapel.

9 Strype 1720, **2**, bk 6.1, 14. St Thomas and St Edmund are joint dedicatees of the first polygonal chapel off the south ambulatory; today, it is more commonly known by the latter name.

10 Badham 2007b.

11 Tanner 1953, 29; Badham 2007b, 135.

12 Speed 1611.

13 Vanessa Simeoni kindly arranged for the remains of the inscription, and other painted detail associated with this monument, to be photographed under enhanced lighting conditions in 2018, but this unfortunately did not reveal any additional evidence.

14 The myth of up to nine interments in one tomb has become firmly entrenched in academic literature, down to the present day: e.g. Trowles 2008, 74. It has been rebutted in Badham 2007b.

15 Luard 1890, 61.

16 *Ibid.*, n. 1.

17 Alfonso is still championed by Binski (1995, 104; 2002, 128–9).

18 Stapleton 1846, 141.

19 Inexplicably, Stapleton translated *basilica* as 'chapel' instead of 'shrine', which wrongly implied that John was buried in the north ambulatory. We are grateful to Matthew Payne for assistance on this point.

20 TNA: E. 403/21A; E. 403/1229. Tanner 1953, 29. Appendix 1, item 151.

21 TNA: E. 403/1234. Appendix 1, item 152.

22 The payment was *pro tumba domini Henricii filii Regis*. TNA: PRO E. 101/467/6 (2), m.1; E. 101/6(5), m.1. Appendix 1, items 154, 155.

23 TNA: E. 101/467(7/2), m.1. Appendix 1, item 156.

24 Note 17, above.

25 For Henry V's tomb and chantry, see Hope 1914.

26 Badham 2007b, 142–3.

27 TNA: PRO E. 4403/554.

28 Nightingale 1815, 92.

29 According to Lethaby (1925, 232), the tomb was cleaned at an unspecified date in the early 20th century. Although the colours of the tesserae are mostly discernible, the mortars are uniformly grey and their true colours disguised.

30 Lethaby 1925, fig. 142.

31 The decoration has been robbed from 28cm of the 44cm width of the panel; hence a 16cm-wide band of inlay presumably survives intact where it is completely inaccessible.

32 These elements appear to be porphyry, but unfortunately the visible edges are too dirty to be certain whether they are purple or green in colour.

33 Victorian machine-cut stone discs were much thinner than their medieval counterparts, and consequently deep matrices were not required to bed them: they could fit perfectly well into the shallower matrices originally intended for tesserae.

34 Lethaby 1911; Tanner 1953, 28.

35 Examination carried out by Professor P. A. Sabine from the Geological Survey of Britain: Tanner 1953, 29.

36 It is not known from whence this disc came. There is similar granite in the floor mosaics.

37 The stone is now stained and pale brown in colour, rendering it impossible to be certain of its colour.

38 On account of the tomb's relatively modest size, there was no need to interrupt the mosaic decoration by joints between slabs. Consequently, no infilling of tesserae was required after assembly, as it was with the larger monuments (Fig. 460A).

39 Hutton 1950, pl. 24A; Foster 2002, fig. 36.

40 Tanner 1969, 184.

41 Translucent green glass is found in Italian monuments, alongside other colours, but it seems only to have been used here in the top slab of the child's tomb. No analyses of the glass have been carried out.

42 As recorded by numerous entries in the Liberate Rolls.

43 The mortar beds in the matrices do not preserve impressions of pontil-marks, an essential characteristic of one face of a crown glass bull's-eye. Moreover, it would be virtually impossible to cut half-circles from crown-centres.

44 Also cleaning concavities, especially the small semi-circular ones around the perimeter of the slab, would have been tedious.

45 The simplest way to make a quantity of identical plano-convex discs would be to prepare a bed of wet clay, and to make multiple impressions in it, using a smooth ball or domed implement. The clay would then be left to dry before pouring molten resin or pitch into the individual moulds. When set, the discs could be prised out of the moulds, or the slab broken up.

46 Noted by Tristram (1955, 200), but erroneously dated to 1395.

47 Dart 1723, **1**, 104, 107; Gough 1786, 49, pl. 18.

48 Nightingale 1815, 92. Presumably he was referring to the scarred site of the lost central medallion; Strype's reference to a silver figure harks back to the erroneous antiquarian association of this tomb with Princess Katherine (p. 481).

49 Mentioned by William Croome, in a letter to Alan Rome, 4 Mar. 1965. However, in 1955 Tristram could only describe the painting as comprising 'slight traces of the four kneeling figures' (Tristram 1955, 200).

50 Badham 2007b, 130–2.

51 The polychromy doubtless suffered further damage as a result of the back of the lower niche having been dismantled twice in the 20th century (see below).

52 It also bears the graffito PH 1729.

53 In the mid-20th century, College Hall was repaved, and Swedish marble was also laid in St Faith's chapel.

54 WAL: RPHG neg. 22. Robert Howgrave-Graham (1880–1959) was a historian and photographer who served as Assistant Keeper of the Muniments at Westminster Abbey, 1948–59.

55 E.g. O'Neilly and Tanner 1966, 150.

56 The small, square block of stone at the centre of the image appears to be filling a putlog hole in the 13th-century ashlar.

57 O'Neilly and Tanner 1966, 148–52.

58 Letter to WR, dated 14 Dec. 2005. The plan is in WAL.

59 The investigation was witnessed by the late Alan Rome, who had been an architect-colleague of O'Neilly's; both worked in the office of Dykes Bower in the 1950s and 1960s (pers. comm., Alan Rome).

60 Lawrence E. Tanner was Keeper of the Muniments, 1926–66, and Librarian, 1933–72. The information came from an acquaintance of the late Mrs Lilian Carpenter (widow of Dean Edward Carpenter); she knew Tanner, who, curiously, made no mention in his *Recollections* of either Howgrave-Graham's investigation in 1937, or O'Neilly's in the 1960s. However, he discussed the tomb in some detail, including O'Neilly's proposition that it had been the altar for the shrine (Tanner 1969, 182–4). In view of the extent and significance of O'Neilly's intervention in the tomb, it is very regrettable no written account or photographs were deposited in WAL.

Notes to chapter 14 (pp. 505–23)

1 Keepe 1683; Scott 1863, 62.

2 The panelled principal face of the stone chest is currently seen from within St Edmund's chapel; reversed, a similar situation would have obtained when the monument was in St Edward's chapel.

3 Camden 1606, 12, but he makes no mention of surviving inscriptions. The de Valence names also appear in 16th-century tomb-lists, BL: Harl. 544 and Add. MS 38133, f. 98. The latter is post-1508, but pre-1532.

4 Margaret's death is assigned to 1276 on the basis of the statement in the *Flores Historiarum* that she died on 24 March preceding her brother (see note 64). However, his decease is erroneously recorded as January 1277, when it was actually around the beginning of the previous October. That would imply that Margaret and John's deaths were separated by only six months, and both occurred within the year 1277. Matthew Payne kindly drew our attention to this historical discrepancy.

5 Keepe 1683, 140.

6 Dart 1742, **2**, 40. There is no record to indicate that Wendover was buried in the chapel.

7 E.g. Boutell 1860, 106; Lethaby 1906, 317–19; 1925, 286; RCHME 1924, 27; Tanner 1953, 31; Binski 1990, 15; 1995, 113; Badham and Norris 1999, 28; Trowles 2008, 17.

8 When Scott reset the portion of step that had been sawn out he attached it to hinges so that it can be raised to inspect the unworn part of the grave-slab below. It still remains accessible.

9 Boutell 1860, 106–7.

10 WAL: LC IV, 7 (9). These show the fragmentary inscription as it is today, apart from the letter 'E' that is no longer *in situ*, and is held in the Abbey Collection. The watercolour is reproduced in Beloe, 1898, pl. 1.

11 Also preserved are the marks of deep pecking with which the shields were outlined. Similar peck-marks are all that define the location of the fillet across the west end of the slab, the channel itself having been totally worn away.

12 The surviving elements of the inscription have been re-bedded in grey Portland cement, doubtless to secure

them against accidental loss; it is not known when this occurred, but it is probably post-Scott (early 20th century?).

13 An eighth letter, 'E', is detached and is held in the Abbey Collection (Fig. 271B).

14 This pair of stops has not hitherto been noticed, having been partly infilled with mortar and dirt, and damaged by the scraping action of the iron bolt that Scott attached to the lift-up portion of the chantry step.

15 Boutell 1860, 107.

16 Scott 1863, 60.

17 Burges 1863c, 150–1 (N.B. He confused north with south).

18 Luard 1890, 61, n.1.

19 Lethaby 1906, 318–19. He later reinforced this attribution, stating that there were 'traces from which the name Willame could safely be inferred' (Lethaby 1925, 232–3).

20 Lethaby 1906, 319 and fig. 109. His drawing of the base of the cross confirms that he (or an informant) had seen it exposed, but his representation of the marginal inscription is confined to a few nondescript marks. Clearly, the inscription was not exposed.

21 Hope 1914, 149. The date of this investigation was 2 February 1914. When the floor was reinstated, the step was reduced in thickness, so that one can see underneath it, and a slot was cut through the centre of the upper face, enabling a metal key to be inserted to lift the block out. At some later date the block was mortared in position.

22 WAL: LC IV.7(9).

23 Lethaby 1925, 233.

24 It presumably became loose during the investigation in 1914, and was retained in the Abbey Library, along with two other brass letters from the sanctuary pavement (p. 278). The rubbing has a secondary annotation beside this letter: 'loose 1998'. This presumably refers to the realization that the loose letter 'K' held in the collection came from this grave-slab in 1914. No investigation of the chapel floor took place in 1998.

25 Sally Badham has kindly pointed out that repairs of this kind were sometimes made to brasses.

26 She does not even feature in the de Valence genealogy (Phillips 1972, table 1). Sally Badham also kindly points out that there was another, anonymous child, who was born and died before 1287, and is buried in the Dominican priory, Bordeaux.

27 The only other sibling certainly known to lie in the Abbey is Aymer, already mentioned (p. 507). William de Valence the Younger (d. 1282) is believed to be buried in Dorchester Abbey (Oxon.), where there is a recumbent knightly effigy attributed to him, although the identification cannot be regarded as certain (Lankester 1987; Rodwell 2009c, 153–4).

28 Dart 1723, **2**, 40.

29 Pleas of the Crown, 54 Henry III [1269–70] (Weinbaum 1976, 55–66).

30 TNA: C 47/14/2/3.

31 Luard 1890, 49n (an overwritten piece of text only in Chetham Library MS 6712).

32 TNA: E101/350, no. 23. Tanner 1953, 31.

33 The presence of William and Joan at Pembroke was recorded on 4 October. Berkeley Castle Muniments: BCM/K/4/24/1.

34 According to the pleas of the Forest, he was still alive on 4 Sept. 1277, but had obviously died before 14 Oct. 'Pleas of the Forests of Canok and Kenefare in Co. Stafford, On the Octaves of Hillary, 14 E. I., Before Roger L'estrange, Peter de Lenche, and John Fitz Nigel, Justices Assigned to Hear and Determine the Same', in *Staffs Hist. Coll.* **5.1**, ed. G. Wrottesley (London, 1884), 157–75. The reference in the *Flores Historiarum* to John's death occurring in January 1277 must be mistaken (note 58).

35 *Roll of Oblations and Alms, 5 & 6 Edward I.* TNA: E 101/350, no. 23.

36 *Obiit dominus Johannes primogenitus domini Willelmi de Valencia comitis de Pembrok, mense Januarii, et sepultus est apud Westmonasterium juxta sororem suam Margaretam ibidem xxiv die Martii praeseultam* (Luard 1890, 49). This entry has been inserted into only one manuscript of the *Flores*, Chetham Library MS 6712. The manuscript was certainly produced at Westminster Abbey, and kept there until at least the 15th century.

37 The name was spelled variously Alba Marla, Albermarlie, Albemarle, Aubemarle, D'Aumarle, and other forms. See *Complete Peerage*, **I**, 87n. For the spelling Alba Marlea, see, for example, the inquisition of 'William de Alba Marlea', in 1362. TNA: C 135/168/3; and a receipt by the executors of the testament of William de Alba Marlea, lately sheriff of Devon (deceased), 1337, Cornwall Record Office: AR/1/830.

38 *ODNB*, Forz, William de. The de Forz arms are on one of the escutcheons carved as a 'roll of arms' on the choir aisles *c.* 1260; see Binski 1995, 76–86.

39 *ODNB*, Forz, Isabella de.

40 She was 'unusually litigious', in Denholm-Young's phrase. The burial spots of all of her children are known, distant from Westminster, except for a son named John, who died young before 1260, and so is most unlikely to be a candidate for the occupant of this grave. See *Complete Peerage*, **I**, 356.

41 *Willelmi Rishanger, Chronica et Annales* (Riley 1865, 63).

42 She was born on 20 Jan. 1259. See *Complete Peerage*, **I**, 356.

43 See, for example, WAM 12780, where she is referred to as Aveline 'nuper comitisse albe marlie'.

44 *The Chronicle of Thomas Wykes* (Luard 1869, 261).

45 See WAM 12780, a notification by the Bishop of London that his presence to officiate at the imminent exequies of Aveline in no way derogates from the exemption of the Abbey. This document is dated 11 Nov. 1274, so the plans for the funeral were being drawn up very swiftly after her death. Curiously, the *Flores Historiarum*, the Westminster Chronicle, makes no mention of her death or funeral.

46 Camden (1606) notes the tomb as such, and is followed by all subsequent writers.

47 Binski 1995, 113–16; Duffy 2003, 81–4.

48 They were still attached in 1778, when Sir Joseph Ayloffe recorded them in *An Account of Some Ancient Monuments in Westminster abbey, Read at the Society of Antiquaries, 12 March 1778,* London 1780, 4–5.

49 It has been suggested that it originally stood adjacent to that of her husband, Edmund Crouchback, which lies two bays to the east, but was moved to make way for the tomb of Aymer de Valence in or soon after 1324. Or that it is in fact in its original location, and a space had been left for Edmund's second wife, Blanche of Artois, who in the end was buried in France instead (Binski 1995, 113).

50 Duffy 2003, 81.

51 Neale and Brayley **2**, 1823, 274. Some heraldic features do remain: the supports for the canopy are divided into multiple shafts, most of which are painted with generic floral designs. But the central one has a repeated series of roundels alternately bearing a lion rampant and a double-headed eagle, inevitably drawing to mind the arms of Richard Earl of Cornwall (1209–72), second son of King John, who was elected King of the Romans in 1256. A fragment of visible paintwork still on the headrest appears to contain a hatchment bearing *vairy or and azure*, but the sample is so small that it is possible this is evidence of an element of the de Forz arms, which were *gules a cross patonce vair*. For further detail on the surviving paintwork, see S. Houlbrooke, 'A Study of the Materials and Techniques of [the] 13th century Tomb of Aveline, Countess of Lancaster [*sic*] in Westminster Abbey', *The Conservator* **20** (2005/6), 105–16.

52 For the Abbey as a family mausoleum, see Binski 1990.

53 N. Denholm-Young, 'Edward I and the Sale of the Isle of Wight', *English Hist. Rev.* **44** (1929), 433–8.

54 Hope (1914, 149) recorded that the west side of the dais lay 1.05m inside Henry V's tomb enclosure, which is beyond the extent of the grave-slabs; measured from the edge of the step, the southern slab extends only 65cm into the chapel. Further floor slabs within the tomb enclosure must have been lifted in 1914, to reveal what Lethaby took to be the edge of the altar dais.

55 Unless we are to suppose that the London marblers changed from mastic-bedding of crosses to riveting and pitch-bedding in 1277. Margaret died in March and John only six months later.

56 Alternatively, the pamments could have been laid in 1557, when the shrine altar was reinstated.

57 Perkins 1940, 112.

58 Brayley and Neale 1823, **2**, 70 and pl. 35. The plate shows the third surviving square of marble in the centre of the lower register (panel 53e), but this matrix retains traces of plaster infilling. The adjacent panel to the south (53f) is devoid of filling and is more likely the home of the third piece of marble.

59 Reported by Henry Machyn (Nichols 1848, 256).

60 Although well known, details of this revelation have not previously been published. Photographs in WAL.

61 J. G. O'Neilly was an architectural assistant to S. E. Dykes Bower, Surveyor of the Fabric.

62 He persuaded Howard Colvin that there was a viable case, and thus the 'altar' theory most regrettably appeared in *The King's Works* (Colvin 1963, 479), from whence it was embraced by other scholars, including Binski (1990, 8).

63 O'Neilly and Tanner 1966, 148–50. This was a paper read at the Society of Antiquaries on 18 Feb. 1965. Ecclesiastical scholars present at the time robustly objected to the altar theory: they included the ecclesiologist William Croome and Arnold Taylor, Chief Inspector of Ancient Monuments. After the lecture, Croome set out his objections in a letter to Alan Rome, 4 Mar. 1965 (copy in WAL).

64 O'Neilly and Tanner 1966, figs 12, 13.

65 Copy in WAL.

66 Cocke 1995, 113, pl. 72. WAL: Platt Inventory item B3. Westminster Abbey Coll., accn. 0941.1; 0941.2. The longer piece measures 35cm, and has one flat end with a dowel-hole and runnel for lead; the shorter piece, broken at both ends, is 32cm long.

67 Poole 1890, 116.

68 Lethaby 1925, 230. Lethaby sketched one fragment in a notebook: WAM 59328.

69 Tanner 1934, 11. Also described in 1924 as 'parts of twisted marble shafts from the Confessor's shrine' (RCHME 1924, 82a).

70 WAL.

71 Inventory item B3: see chapter 10, note 52.

72 For a note on comparable cable mouldings, see Binski 1990, 8, n.13. He omitted to mention the similar mouldings that remain on the shrine pedestal.

73 Westlake 1923, **1**, 108. He asserts that was near the present pulpit, at the north-west corner of the sanctuary pavement, but this is surely erroneous: Henley was buried in the north-east corner of the sanctuary.

74 CUL: MS Ee 3.59 (*Estoire*), fol. 30. Burges 1863b, pl. 27; Bond 1909, 22; Binski 1995, 91, fig. 129. These are not to be confused with the silver-gilt figures of SS Edward and John, given to the shrine by Edward II in 1308.

75 Binski 1995, 58–9.

76 Burges 1863b, 136; Lethaby 1925, 230.

77 Inventory transcribed in Legg 1890 and Westlake 1923, **2**, 504–5.

78 *Close Rolls 1256–59*, p. 390. Appendix 1, item 71.

79 Hereafter, this is referred to as 'the Retable', to distinguish it from the shrine altar retable.

80 Binski and Massing 2009.

81 See, for example, the complex geometrical designs of the imitation enamels in Binski and Massing 2009, 383, fig. 21b.

82 Diane Gibbs kindly drew our attention to this highly significant comparison. For the Retable globe, see Binski and Massing 2009, fig. 22. Richard Foster also discussed the globe in the context of the sanctuary pavement, drawing attention to its depiction of the four elements (Foster 1991, 159–60, fig. 122).

83 For the painted reverse of the Retable, see Schmidt 2009.

84 The tomb was opened and investigated in 1774, but nothing was recorded relevant to the present enquiry (Ayloffe 1775).

85 Brayley and Neale 1823, 76.

86 Burges 1863a, 100n. This was another strained attempt to identify the tomb of Katherine, daughter of Henry III (p. 481).

87 Binski and Blair 1988, 236–9.

88 Poole 1890, 170.

89 Sally Badham kindly confirmed that the inscribed fragment cannot be assigned to the 1250s.

Notes to chapter 15 (pp. 525–601)

1 For a wide-ranging, well-referenced account of the Plantagenet achievement at Westminster Abbey, see Binski 1995.

2 Binski 2002, 128.

3 See Norton 2002 for a succinct review of Romanesque and early Gothic luxury paving in major English churches.

4 Tatton-Brown 1998a, 54.

5 For discussion of the Trinity chapel pavement, with full references, see Binski 1995, 97; Tatton-Brown 2001; Norton 2002, 11–17; Draper 2017.

6 For examples and discussion, see Norton 2002.

7 Hope 1914b, 107; Tatton-Brown 1998b, 213, pls 22 and 23.

8 Tatton-Brown 1998b, 33–8; 2012.

9 Tatton-Brown (1998b, 214) proposed a date in the 1180s for the erection of Osmund's tomb in the chapel.

10 For a thorough review of the archaeology of Glastonbury Abbey, see Gilchrist and Green 2015.

11 Scott 1981, 66; Mynors *et al.* 1998, 804–5. See also Norton 2002, 10–11.

12 Burnby 1984, 77. Schofield 2011, 333, site 49; for location plans, see figs 1.5 and 4.63.

13 '. . . the black marble spotted with green is none of the vilest sort, as may appear by [a] parcel of the pavement of the lower part of the quire of [St] Paul's [Cathedral] in London, and also in Westminster [Abbey], where some pieces thereof are yet to be seen and marked, if any will look for them.' (Harrison 1577; cited from 1994 edn, 358). The identity of the stone being described is uncertain, but it could be applicable to one of the beds of Purbeck marble, although that would have been too commonplace to merit being singled out in this manner. Serpentine is perhaps more likely.

14 For references, see Binski 1990, 7, n.10.

15 *Archaeologia Cantiana* **25** (1902), 243. Almost certainly in this context, 'serpentine' is a misnomer for green porphyry, a common confusion in antiquarian literature.

16 Sherlock and Woods 1988, 30–2, 135–7; Foster 2002, 53–4.

17 Rees and Lewis 2014, 3. We are indebted to Michael Lewis and Lawrence Rees for discussing the Wimborne fragment with us, and for kindly supplying the image reproduced here.

18 *Ibid.*, 4.

19 *Ibid.*, figs 2–4.

20 John Lydgate's, *Lives of SS Edmund and Fremund*. BL: Harley MS 2278, fol. 97v. We are indebted to David Sherlock for drawing our attention to the potential significance of Lydgate's ms illuminations.

21 See generally Edwards 2004; Pinner 2015.

22 *Ibid.*, fol. 4v.

23 Pajares-Ayuela 2001, figs 2.191, 2.194.

24 Rodwell and Rodwell 1993, **2**, 1–2.

25 *Papal Registers*, xxv(4), fol. 199, Mar. 1259.

26 *Patent Rolls*, 7 Nov. 1259; 19 Feb. 1260; 11 Jan. 1261.

27 WAM 5673.

28 *Patent Roll*, 18 Nov. 1262.

29 *Patent Rolls*, 14 Apr. 1265; 3 Nov. 1266.

30 *Close Roll*, 1 Sep. 1267.

31 WAM 5400.

32 *Patent Rolls 1266–72*, p. 97. Appendix 1, item 120.

33 Hearne 1774.

34 It was mentioned and dismissed by Burges (1863a, 102n).

35 Foster 1991, 20. BL: MS Cotton Tiberius A. A. 10; Luard 1866, 305.

36 Binski 1990, 10.

37 Binski 1995, 98.

38 Pajares-Ayuela 2001, 78, fig. 281; see also 102 and figs. 171–5.

39 We owe this reference to Tim Tatton-Brown.

40 Another example of a great square containing a poised square with *rotae* occurs in the nave at the Assunta, Spoleto, but that lacks a quincunx at the centre: Glass 1980, 88, 93, 130, 138, pls 20, 24, 45, 49. For further references, see also Binski 1990, 9, n.15.

41 Glass 1980, 93. However, Claussen (1987, 179, n.1006) cites seven examples.

42 The circles of the quincunx turn in the same direction on the painting as on the Abbey floor, but those of the *rotae* are opposite-handed. The 'pavement' that Holbein depicted was almost certainly Tudor painted timber or fabric, at Greenwich Palace. Nevertheless, it can hardly be doubted that Westminster provided both the inspiration and the design.

43 Glass 1980, pls 32, 34; Pajares-Ayuela 2001, fig. 2.72. Although much later in date, the basic design of the Sistine Chapel pavement, Rome, is remarkably similar to that at Westminster: its outer border is a large chain guilloche, uninterrupted by rectangular panels.

44 For a very oblique view, see Hutton 1950, pl. 34A.

45 Glass 1980, *passim*; see also a dissertation by Rees-Jones 2008. Although a detailed survey has not been carried out, the majority of Italian pavements are now devoid of glass tesserae. The floors at Spoleto are an exception.

46 In the 1963–64 Dykes Bower produced a controversial scheme to replace the entire paving in the nave of Westminster Abbey with an Italian-style cosmatesque marble pavement. A coloured plan of the proposal is in WAL. The scheme was wholly inappropriate and was vigorously opposed by the Historic Buildings Council. Consequently, the Dean and Chapter rejected it. WAM S/1/108. Reynolds 2019, 68.

47 Sampson 1998; Rodwell 2001, 29.

48 Gilchrist and Green 2015, 364–7, figs 9.8, 9.9.

49 White lias could have been used for small-scale liturgical and funerary furnishings in the Abbey that did not survive the Dissolution and later depredations.

50 Panel 37 was certainly different: inside the circular band was a square of marble, flanked on each side by a segment of tessellation; this arrangement may have been present in other panels where the evidence has subsequently been destroyed.

51 The only difference is that the outer band of tessellation does not directly abut the breccia disc, but is separated from it by a narrow fillet of Purbeck marble, being the 'rim' of the tray: cf. also panel 36.

52 Nothing is now visible of the tray, but its existence was revealed by the GPR survey (chapter 5). The rim of the tray was chiselled off when the medallion was modified, and a short section of that rim was used to repair a damaged Purbeck marble band in the adjacent panel (52), where it remains (p. 98).

53 E.g. Lethaby 1906, 314. The component of the design coloured yellow on Fig. 80 bears comparison with a mosaic tile pattern from Helpston, Northants (Keen and Thackray 1976, fig. B4).

54 The glass tesserae in band 61 are randomly distributed.

55 Scott 1879, 286.

56 The presence of two subtly different types of red glass, meaningfully arranged, points to patterning in red and gold, as on Henry III's tomb.

57 E.g. at Anagni Cathedral and San Giovanni in Laterano, Rome.

58 For the most part, the geometry of the pavement is precise, but a setting-out error on the west side resulted in this panel being only 1.90m long.

59 Marchant 2009, fig. 1a.

60 When this occurred is uncertain. The replacement marble is present along the whole of the north and east sides, and includes some short sections, typical of Scott's era, but the general appearance and surface deterioration do not closely match other work known to have been done by him in 1868.

61 Camden 1606, 31.

62 Their attachment points were *c.* 25 cm from the corners.

63 Rodwell 2013, 113–14, figs 145 and 147.

64 Cf. Edward I's coffin (Ayloffe 1775); also reproduced in Binski 1995, fig. 165.

65 It should be remembered that, prior to the 1557 reconstruction, this panel was on the north side of the shrine, and therefore faced Henry's tomb (p. 378).

66 The other occurrences are as discs in medallions 38 and 49. It is not found on the other Cosmati monuments.

67 This explanation is preferred to the alternative offered on p. 130, namely that the disc of *ammonitico rosso* could have been inserted in medallion 6 in Phase 3.1, replacing a disc of *giallo antico* (Fig. 529). It is the only piece of coral limestone from Verona in the Cosmati assemblage and, while there is no difficulty in accepting it as one of the rarities imported in the mid-13th century, there is no plausible context to explain its arrival in Westminster in the 17th century.

68 The tomb-cover would have been made and decorated in a workshop, and only brought onto site when the Purbeck marble framework of the pavement had been constructed. The slab could be lowered into position using ropes: lifting-rings would only have been required if there was an intention to extricate the slab from its compartment in the marble framework at a future date.

69 Rodwell 2015, 165.

70 Wrapson 2006.

71 Robinson 1909, 119.

72 E.g. Burges 1863a, 101; Stanley 1868, 353; RCHME 1924, 25a; Perkins 1938, 25; Tatton-Brown *et al.*, 1997, 3; Foster 2002, 59; Binski 2002, 124.

73 Rodwell 2001, 193–4, figs 184, 525. The former shows a thin mortar base to the chamber.

74 Burials of the 11th and 12th centuries in stone-lined cists have been excavated to the east of the south transept and to the west of the north transept of the present building.

75 Excavation by Pre-Construct Archaeology Ltd for the Dean and Chapter; report in preparation.

76 Rodwell 2010c, 87–8.

77 For an appraisal of the sarcophagus, see Henig 2015.

78 For the original discovery, see Poole 1869.

79 We are grateful to Prof. Simon Keynes for suggesting this potential identification of the occupant.

80 Since Edward I's monolithic stone coffin and its enclosing tomb rest directly on the chapel pavement, a cist containing Edith's remains, set into the floor in this bay, should still be undisturbed.

81 Close Rolls 1242–47, p. 344. Appendix 1, item 32.

82 Thin metal fillets in the Canterbury *opus sectile* pavement that have been described as 'brass' by several commentators (e.g. Burges 1863a, 103), and termed *cloisons* by Binski (1990, 12), are now regarded as 19th-century in date and made of gun-metal (Tatton-Brown 1998a, 55).

83 Tatton-Brown 1998a, 54.

84 Nightingale 1815, 20–1.

85 Binski 1990, 10–11; 1995, 97; 2002, 123–4; Howlett 2002, 109–10.

86 Norton 2002, 22.

87 Howlett 2002, 110.

88 Binski 1990; Badham and Norris 1999. Parts of two tomb inscriptions, with *in situ* letters survive in the floor of St Edward's chapel, together with a matrix fragment of a third (p. 522).

89 For the random mixing of different fonts in 13th-century funerary inscriptions, see Badham and Norris 1999, 25.

90 Norton 2002, 17.

91 See also Badham 2004.

92 Binski 1990, 10–11; Foster 1991, ch. 5; Howlett 2002.

93 Keen 2010, 229–32.

94 They are similarly found in Europe: e.g. at Oberpleis, Germany, there is a glazed tile pavement of *c.* 1220–30, the design being based on a large circle with multiple concentric bands of decoration; four small *rotae* are attached, and the whole is contained within a square. The innermost and outermost bands are inscribed in Latin, as are the perimeter bands of the *rotae* (Schmitz-Ehmke 1975).

95 Marks 2019. The surviving letters have heights of *c.* 9cm.

96 The tiles would not have been laid until a few years later, but they may have 'recorded' the commencement of work on the chapter house (Carpenter 2010, 37, n.71).

97 It is glimpsed obliquely in Hutton 1950, pl. 34A. Another panel (not visible) features chain guilloche.

98 Glass 1980, pls 10 and 24.

99 Glass 1980, pl. 26.

100 No evidence survives to show what the tray in medallion 51 held.

101 Attention was first drawn to these tesserae by Foster (1991, fig. 44).

102 Badham and Norris 1999, 63–6; Badham 2004.

103 Some dislodged tesserae were certainly reset by restorers, but the large quantity lost may be the result of theft by souvenir hunters.

104 Initially, medallion 6 probably held a disc of *giallo antico*, but this was replaced with a slightly larger, ill-fitting disc of *ammonitico rosso*, the sole occurrence of this stone type at Westminster.

105 Foster 1991, 73.

106 Drawings in the *Estoire de Seint Aedward le Rei*, CUL: MS Ee 3.59, fols 29v, 30 and 36. Some writers have described one of the illustrations as representing the Confessor's tomb, yet it is clear that the same stone base is shown by Paris in all three.

107 Reproduced in Crook 2011, pl. 7.3. There were probably three openings in the side of Edward's shrine, the middle one being omitted by the artist in order to place a kneeling supplicant here. The appearance of the head and shoulders of another supplicant within the right-hand part of the chamber implies that he had entered from a *foramen* in the west end, which in turn would indicate that there was no spine wall. This may simply be artistic licence, but the extant Ilam shrine demonstrates that end-access was sometimes available (Crook 2011, pl. 8.7).

108 What is illustrated here is clearly fictive ashlar, as commonly represented on 13th-century wall paintings.

109 Reproduced in Binski 1995, fig. 77.

110 *Ibid.*, fig. 76.

111 Crook 2011, 240–1, pl. 8.6.

112 For discussion of all of these, see Crook 2011, chapters 7 and 8.

113 Barlow 1979, 254.

114 See similarly Woodman 2015.

115 Despite various hypothetical reconstructions having been attempted in the past, we do not know whether any chapels opened off the apsidal sanctuary in the mid-11th century, or whether any were added in the 12th century, preceding the erection of Henry III's Lady Chapel in the 1220s.

116 Although no great reliance should be placed on such a detail, one of Matthew Paris's illustrations of the shrine shows a pilgrim looking into the *foramina* base from its west end, which would imply that access was obtainable from that direction.

117 Barlow 1979, appendix A.

118 When rebuilt in 1557, the pedestal and altar were sited 38cm west of their original location (p. 321).

119 No such conscientious re-planning is evidenced in the majority of instances where a major Anglo-Saxon church was rebuilt in the early Middle Ages: indeed, it was common for the orientation to be adjusted and/or the structure repositioned, as evidenced, for example, in the cathedrals of Exeter, Winchester, Wells and York.

120 *Westminster Abbey Domesday*, fol. 386v. Appendix 1, item 31.

121 Appendix 1, item 32.

122 The pedestal has tilted slightly to the east (Figs 305 and 320), but it is not known when that occurred: it could

123 have been occasioned by gradual subsidence, or bombing during the Second World War.

123 Broad foundation rafts, sometimes multi-stepped, were characteristic of Henry III's reconstruction of the Abbey. E.g. the chapter house is built on a raft, and its vestibule on another. The walls and arcades of the transepts are all founded on massive stepped rafts.

124 Bidwell 2010.

125 Gilchrist and Green 2015, 102, figs 4.12, 4.13, 10.3.

126 Hutton 1950, figs 20–23.

127 Chapter 9, n. 66. We do not know where or why the hole was dug, but it can only have been at the extreme west end or east end of the chapel.

128 Luxford 2019.

129 Ashlar walling occurs in two of the north bays of the sanctuary, but close examination points to its being associated solely with the erection of monumental tombs.

130 A miscellany of attachment scars and remains of fixings can be seen on the arcade piers in the few places where later works have not obscured the evidence, but no pattern of regular marks commensurate with screen attachment is discernible.

131 Binski (1990, 14) took the view that the informal design of the mosaic was 'an acknowledgement that this pavement was going to be broken into more frequently for burials *ad sanctum* than would be the sanctuary floor.' We do not concur with this view.

132 Burges 1863a, 102–3.

133 Some patterns lent themselves to counterchanging (i.e. in one version, particular elements of the pattern would be rendered in mosaic while others remained as solid stone, and *vice versa* in the alternative version).

134 Cf. Fig. 242, wheels 33h and 36b.

135 Hutton 1950, pl. 59; Glass 1980, pl. 33; Pajares-Ayuela 2001, fig. 4.105.

136 Hutton 1950, 26, pl. 62; but see also Glass 1980, 65.

137 Three patterns are represented at San Lorenzo: single-stone roundels with a narrow encircling band of tesserae (cf. Fig. 242, pattern 2b); six spindles forming a star, within a concave-sided hexagon (cf. pattern 4b); and a bold triangle within a circle (cf. pattern 35i, counterchanged).

138 Pajares-Ayuela 2001, 78, 172, figs 2.83 and 4.59.

139 Hutton 1950, pl. 50; Foster 1991, pl. 10.

140 Hutton 1950, pls 56 and 58. The motif is derived from the interstice that results when four circles of similar diameter are placed together in a block, their circumferences touching one another.

141 For precisely the same reason, glazed tile floors were only laid down in medieval buildings after all construction work and overhead decoration had been finished.

142 Cf. Figs. 240–242: crosses 37g, 37g; triangles 34h, 35i.

143 TNA: E 372/112, rot. 1d (Colvin 1971, 422). Appendix 1, item 102.

144 Claussen 1987, 178, 182; Binski 1995, 100; Carpenter 1996, 179.

145 WAM: Muniment Book 11, fol. 405r. Appendix 1, item 56.

146 WAL: J. A. Robinson notebook.

147 *Close Rolls 1251–53*, p. 290. Appendix 1, item 55.

148 Burges 1863b, 133–4; Lethaby 1906, 157–8, Tristram 1950, 148–52, 459–61; Colvin 1963, 148.

149 Lethaby 1906, 157–8; Colvin 1963, 148.

150 Henry III had seen plaster of Paris in use in France and was impressed by the fineness of the finish achievable; he actively encouraged its adoption in England, specifying it for works at Windsor (Hope 1913, 130–1, 143, 181, 185.

151 Pajares-Ayuela 2001, figs 2.219 and 2.233.

152 The similarity was first noticed by Lethaby 1925, 229.

153 Hutton 1950, pl. 24A; Pajares-Ayuela 2001, fig. 2.201.

154 Hutton 1950, pl. 25; Pajares-Ayuela 2001, fig. 4.21.

155 Pajares-Ayuela 2001, 159; figs 4.19–21.

156 Apart from the quincunx, there are direct parallels with the plain rectangular panels with slim mosaic borders, groups of vertical mosaic bands, and framing consisting of bands interrupted at regular intervals by small discs.

157 Hutton 1950, pls 21, 25; Ravasi 1995, 39.

158 Carpenter 1996, 183, n.22.

159 Binski 1990, 14–15.

160 Carpenter 1996.

161 Binski 2002, 127–9.

162 Luard 1869, 226.

163 *Ibid*.

164 Binski 1990, 17.

165 Carpenter 1996, 182.

166 *Op. cit.*, 183.

167 Appendix 1, items 8 and 9.

168 Appendix 1, items 13–15.

169 Cf. Appendix 1, items 21–24, 26, 29, 30, 33 and 36 (all 1244–46).

170 *Close Rolls 1247–51*, p. 423. Appendix 1, item 42.

171 *Westminster Abbey Domesday*, fol. 406. Appendix 1, items 43, 44 and 46. The third bull increased the number of days to one hundred.

172 TNA: E 101/466/29. Colvin 1971, 210. Appendix 1, item 48. The wording implies work on the pedestal, rather than the feretory. The sum of £33 6s. 8d was expended.

173 *Liberate Rolls 1251–60*, p. 27. Appendix 1, item 52.

174 *Westminster Abbey Domesday*, fol. 407r. Appendix 1, item 54.

175 Nichols 1780, 15–17. Appendix 1, item 57.

176 *Westminster Abbey Domesday*, fol. 393r. Appendix 1, items 58 and 59.

177 *Patent Rolls 1247–58*, p. 381. Appendix 1, item 60.

178 Appendix 1, *passim*, including items 51 (cope), 67 (censer) and 68 (altar cloth).

179 Carpenter 2002, 42–3.

180 Appendix 1, item 70.

181 *Close Rolls 1256–59*, p. 390. Appendix 1, item 71.

182 The meaning of the verb *reparare* in medieval documents is not always clear-cut, and has been debated (Wilson 2015, 165). While on occasion it could imply 'making from new', it more frequently alluded to 'completion' or 'embellishment'.

183 *Liberate Rolls 1251–60*, p. 478. *Close Rolls 1256–59*, pp. 223–4. Appendix 1, items 75–79.

184 Appendix 1, items 91 and 92.

185 We must be mindful that Cosmati mosaic was present in St Paul's Cathedral but, like that at St Augustine's

Abbey Canterbury, the date of its execution is unknown (p. 531).

186 Binski 1995, 100.
187 *Ibid.*, 101.
188 *Chronica Majora*, Luard 1872–83, **4**, 156–7.
189 Lethaby 1925, 266.
190 This was possibly because medieval and later tomb chests commonly had sealed voids within them, containing nothing of significance when the associated interment was below floor level.
191 Coldstream 1967, 17.
192 Barlow 1979, 282.
193 *Ibid.*
194 WAM 64299: L. E. Tanner, 'The Shrine of Edward the Confessor and Nicholas da Modena' [1956]. Unpubl. typescript.
195 Biddle 1966.
196 Frankopan 2015, 194.
197 O'Neilly and Tanner 1966; Tanner 1969, 184; Binski 1990, 8; Carpenter 1996, 188.
198 O'Neilly and Tanner 1966, 152–4.
199 *Op. cit.*, pl. 61. The reconstruction shows the paschal candle standing on the south-west corner of the steps, which was not its correct site (as the authors acknowledged).
200 Rymer 1704 edn, **1**, 889.
201 The coffin was not investigated in detail, but it almost certainly contained either Abbot Walter de Wenlock (d. 1307), or Anne Neville, Richard III's queen (d. 1485); both are known to have been buried in this corner of the sanctuary.
202 Although not stated, almost certainly searching for the king's tomb was what motivated the excavations in the first place.
203 Binski 1990, 30, n.117; see also Wander 1978, 138 and 154.
204 Wander 1978, 152–5. His account is somewhat muddled in both fact and interpretation. For a useful account of the sanctuary and shrine chapel in the context of royal mausolea, see Palliser 2004.
205 E.g. Wander 1978, 153; Binski 1990, 19; Palliser 2004, 5.
206 Luard 1869, 252–3. The *advocatus diaboli* might argue that this account refers not to Edward's burial place in 1066, but to one of the two locations occupied by his shrine. However, neither of these is tenable. The first shrine position (1163) was inaccessible, lying partly or wholly beneath the present shrine pedestal; the second, temporary relocation of the shrine (1245) was some distance to the west, in the nave of the Confessor's church, where demolition and rebuilding were in progress. The reference can only relate to the tomb of 1066.
207 Carpenter (1996, 180) translates *coram magno altari* as 'in the presence of the great altar'.
208 Luard 1890, 28.
209 Trivet 1845, 301. Rishanger: Riley 1865, 96.
210 David Carpenter (pers. comm.) suggests that, in this part of his *Chronica*, Rishanger was copying from Trivet's *Annales*.
211 Riley 1876. This source was suggested by Brayley and Neale 1823, **2**, 77n.
212 Ackermann 1812, **2**, 197.

213 Binski 1990, 19. He later changed that to '[the chronicles] state that in that year [1280] Edward I erected his father's tomb with precious stones of jasper which he had brought from France' (Binski 1995, 102).
214 That is precisely the sense in which *reparari* was commonly used, rather than to indicate that something was constructed *de novo* (see further Wilson 2015, 165). It is important to stress that none of the Latin verbs commonly used to signify 'construct', 'build', 'fabricate' or 'erect' appear in any primary reference to Henry's tomb.
215 The essence of jasper was neatly summarized by Pullen (1894, 28–9): 'Jasper is a material extremely difficult to define, as it appears to depend more on eccentric markings and violent clashes of colour than upon any geological characteristics of its own'.
216 E.g. Binski 1990, 19: 'by jasper is presumably meant porphyry'. It is clear that jasper was not confused with porphyry in the late Middle Ages, since both rock types appear together in antiquarian lists, beginning in the 15th century with Flete (Robinson 1909, 113). 'Porphyry' almost invariably referred to the purple variety, while the green was often erroneously termed 'serpentine'. Superficially, these two types of green stone can be sufficiently similar to excuse that particular confusion.
217 The blue glass used on the east end was derived from two batches: the tesserae from one consignment retain a shiny cobalt-blue surface and the abrasion lines are clearly seen, but in the other the glass has lost its shiny surface and now presents a matt blue-grey appearance. The abrasion marks are less conspicuous, but are nevertheless present on the majority of tesserae.
218 E.g. Binski 1990, 19; 1995, 102.
219 Binski 1995, 102.
220 Luard 1864a, 84.
221 Porphyry panels on this scale, and larger, were not seen again in England until the 18th century, when land-owners and antiquaries on the 'grand tour' returned with large quantities of *spolia*. Roman marble wall-sheathing was particularly prised for table tops: e.g. the pair of console tables at Holkham Hall (Norf.) with purple porphyry tops measuring 1.2m by 80cm.
222 Pajares-Ayuela 2001, figs. 2.117 and 2.155.
223 Binski 2002.
224 We are indebted to the Rev. Prof. Martin Henig for suggesting this source.
225 The purple panels on the ends of the lower chest are modern and almost certainly incorrect, there being no evidence for the colour of their predecessors. The green panels on the north elevation provide likely pointers to the colour of all the sheet porphyry originally on the lower chest.
226 Most famous is the richly decorated sarcophagus of Helena, saint and mother of Constantine I (d. 330), now in the Vatican Museum. The power of burial 'in the purple' continued to be recognized into recent times: thus Napoleon I (d. 1821) lies in a monumental porphyry sarcophagus in Paris.
227 They reveal that the slab is at least 22mm thick. It is fractured: a large piece of the lower right-hand corner has broken away but remains in place, and there is also

a long crack running from the upper left-hand corner, across the central area. Damage to the lower edge has been made good on two occasions: first with purple-coloured paste in imitation of porphyry, and second with the same white gypsum plaster as was used for other *ad hoc* repairs to the tomb and the Confessor's shrine in the 17th century (p. 320). The north panel, although cracked, does not exhibit obvious evidence of attack.

228 Binski 1990, 24.

229 The front panel is edge-bedded and there is a noticeable line of roughness to the marble finish around the reveals of each aperture; this is a natural bedding plane, not a vestigial architectural feature.

230 Hutton 1950, pl. 24B; Binski 1995, 102, fig. 141. There, the altar is flat fronted, and the pediment does not frame the aperture to a compartment.

231 The top slab of the lower chest forms the roof of the chambers, and immediately under it, within them, can be seen some of the structural ferramenta: three square-section bars that tie the front and back panels of the chest together, and two diagonal cramps securing the southern corners.

232 There is a vertical splatter of dark red paint on the back of the central recess, to the left of the cross, but it is clearly incidental and not decorative.

233 The comparison with the pavement was first noticed by Foster (1991, pls 10 and 11).

234 A comparison previously observed by O'Neilly and Tanner 1966, 132. Note: this and other Italian *comparanda* cited here relate to architectural form only, and not to decoration or dating.

235 Hutton 1950, pl. 20; Pajares-Ayuela 2001, 91, fig. 2.131.

236 Pajares-Ayuela 2001, figs 2.132 and 2.136.

237 Hutton 1950, pls 21–23.

238 Although this is the only such piscina to survive the depredations of later centuries, it would not be surprising if all the piscinae in the ambulatory and transept chapels were of similar form. Unified designs for wall-arcading and each tier of fenestration were adopted in the 1250s, and micro-architectural features are likely to have followed suit.

239 Binski 1990, 23.

240 Osbourne 1983; also noted in Binski 1990, 22. The tomb is 12th century, and not cosmatesque.

241 Hutton 1950, pl. 29A. The small panels in question do not have roll-mouldings, and no other aspect of this 12th-century throne is reflected in the Westminster monuments.

242 Hutton 1950, pl. 19. This fragment is also 12th century.

243 This anachronism makes it even less likely that the tomb was a product of the 1280s.

244 Binski 1995, 103–4; Carpenter 1996, 194; Palliser 2004.

245 Luard 1890, 28.

246 *Westminster Domesday*, fols 404–5. Appendix 1, items 157 and 158.

247 WAM: Westminster Domesday, fol. 398v. Appendix 1, item 163.

248 *Ibid.* Appendix 1, items 164 and 165.

249 The pockets in the upper step were designed to hold stanchions 3–4cm square; the stays that held the screen

in a vertical position were *c.* 2 cm square, and leaded into the top slab of the lower chest.

250 Binski (1995, 102) opined that the *fenestellae* were 'plainly not for physical access', a conclusion not borne out by the evidence.

251 Cleaning could not have removed all traces of soot and wax residue from the masonry, especially in the open joints.

252 Badham and Oosterwijk 2012; 2015, 59.

253 Binski 1995, 108.

254 Tristram 1950, 564. The primary purpose of these canopies was to keep dust from settling on the effigies, it being seriously damaging to gilding.

255 Hutton 1950, pl. 25; Pajares-Ayuela 2001, fig. 4.21. Most Italian canopied tombs were designed to be placed against walls and hence required only two columns to support the front of the canopy.

256 Binski 1995, 102.

257 The existence of this crucial survival has been overlooked hitherto. The lines have been worn away on the two southern corners, but are clearly evidenced under oblique light on the north-west corner. Only slight traces remain on the north-east.

258 There was a third canopy, also late medieval, but now lost, over Edward I's tomb. It collapsed, but was *in situ* when Crull illustrated the tomb in 1711, and one leg and a pierced bracket were still attached to the arcade pier in 1812 (Figs 11C and 292).

259 A variety of iron fixings and scars in the masonry of the arcade piers above all three tombs on the north side of the chapel confirm the existence of previous canopies.

260 RCHME 1924, 30, pls 50 and 53.

261 *Op. cit.*, 29–30, pls 48 and 49.

262 Ayloffe 1775.

263 Henry would not have countenanced indefinite interment in the Confessor's old tomb for two reasons: first, he would have been usurping a secondary relic and, second, he would have had no permanent, visible monument of his own.

264 A desiccated heart, almost certainly Henry III's, contained in a two-piece heart-shaped case made of lead was salvaged from the sack of Fontevraud in 1793; it was returned to the United Kingdom in 1857, with a view to its burial in Westminster Abbey. Lord Palmerston, the Prime Minister, intervened and refused permission for the burial; the heart is now in St Margaret's Convent, Edinburgh (Dodson 2004, 63–4, fig. 41).

265 Research by Sally Badham has demonstrated that so-called 'heart' burials frequently included the viscera too. See S. Badham, forthcoming. 'Divided in Death: English Medieval Heart and Viscera Monuments'. We are indebted to the author for sharing this with us in advance of publication.

266 Stanley 1880, 321 fig.

267 *Ibid.*, 319.

268 The east end was the obvious choice, since that involved removing less masonry than would have been the case with the larger west end.

269 For the construction of the coffin, see Stanley 1880; Rodwell 2013, 113–15.

270 Binski 1995, 91–2.

271 Wilson 2015.

272 Cf Appendix 1, items 157, 158, 164 and 165.

273 Burges 1863c, 148. The concept of a long drawn-out chronology was first articulated by Burges, but the practical and logistical implications have never been systematically examined.

274 Binski 1990, 19. This 'irrefutable argument' is based entirely on negative evidence.

275 Admittedly, the lack of financial records is not a major point, and applies to some extent to the entire Cosmati episode. The absence of any evidence between 1272 and 1290 for the tomb's construction is, however, noteworthy.

276 TNA: *Comp. Gard., 18 Edw. I.* Geddes 1999, 346.

277 This is seemingly the earliest surviving evidence for the display of such items alongside an English medieval tomb, but continental examples are known from the late 13th century (Dr John Goodall, pers. comm.).

278 The significance of this design was also noted by Binski (1995, 101).

279 Eleanor of Castile's and Edward I's tombs are similarly elevated above wall panels in their respective bays, but neither is as impressive as Henry's.

280 Binski 1990, figs 11, 13, 19; 1995, 102, fig. 142.

281 Hutton 1950, pl. 20; Pajares-Ayuela 2001, figs 2.131, 2.145.

282 Nichols 1780, 15–17. This must be a slip: what he meant was, of course, 'the chapel of St Edward in Westminster [Abbey]'.

283 Gee 1979.

284 Binski 1990, 6.

285 Badham and Oosterwijk 2015, 60.

286 *Close Rolls 1288–96*, p. 171. Binski 1995, 107–08; Badham and Oosterwijk 2015, 60.

287 Green translucent glass is present at the bottoms of the niches on the south side.

288 It seems to have been Lethaby who first speculated on this matter in print: *Journ. Royal Inst. Brit. Architects*, ser. 3, **18** (1911). In an uncharacteristic flight of fantasy, he even suggested that the stone might be from the Mount of Olives, Jerusalem. See also Tanner 1953, 28.

289 Margaret's death is usually said to be 1276, but the correct date seems to be 1277, five months before her brother (p. 513).

290 The red glass characteristically embodies darker swirls, and the white glass bears highly distinctive parallel striations.

291 The 'strays' consisted of very small numbers of tesserae of Mediterranean stone types that are not meaningfully represented in the Westminster mosaics.

292 E.g. panels 91, 93, 97, 100, 107, 108, 115 and 116.

293 Burges 1863b, 130. Although not currently favoured by scholars, it is possible that the Latin *could* be interpreted as referring to 1269, and that is presumably how Burges read it: see Carpenter 1996, 188–9.

294 Stanley 1911, 114.

295 The chronology of the events cited here is hopelessly muddled, and the effigy was cast in metal, not carved.

296 Micklethwaite 1895, 413–14.

297 The date was taken from Thomas Walsingham's account (Riley 1876).

298 Binski 1990, 13.

299 *Patent Rolls 1266–72*, pp. 135–40.

300 Appendix 1, items 107–111 and 117.

301 TNA: E 372/113, rot. 1d and E 372/114, rot. 19. Colvin 1971, 424–5, 428–9. Appendix 1, item 114.

302 Stubbs 1882, 80.

303 TNA: E 372/114, rot. 19. Colvin 1971, 428–9. Appendix 1, item 130.

304 Appendix 1, item 136.

305 *Liberate Rolls 1260–67*, p. 293. Appendix 1, item 113.

306 *Liberate Rolls 1267–72*, p. 66. Appendix 1, item 118.

307 *Close Rolls 1268–72*, p. 71 (July 1269). Appendix 1, item 121.

308 TNA: SC 1/2/88. Appendix 1, item 122.

309 TNA: SC 1/2/89. Appendix 1, item 24.

310 *Liberate Rolls 1267–72*, p. 97. Appendix 2, item 126.

311 Appendix 1, items 119, 133 and 134.

312 *Liberate Rolls 1267–72*, p. 97. Appendix 1, item 125.

313 Appendix 1, items 144 and 147.

314 *Liberate Rolls 1267–72*, p. 171. Appendix 1, item 142.

315 Carpenter 1996, 187.

316 In 1271–72 payment was made for gilding 'the bases and columns around the said feretory'. This embellishment presumably refers to the plain Purbeck marble capitals and bases of the four Cosmati colonnettes at the corners of the shrine pedestal. Since the colonnettes were integral to the erection of the pedestal, this reference provides additional confirmation that the shrine was structurally complete. Scott 1863, 113–14. Appendix 1, item 150.

317 TNA: E 403/1256. *Liberate Roll, 18 and 19 Edw. I.* Burges 1863c, 136–7; Gardner 1990. Appendix 1, item 166.

318 The suggestion that Edward's gift of *three* columns in 1290 relates to the marble work of the shrine pedestal is untenable (Binski 1990, 18; 1995, 101, n.81). The pedestal required *four* cosmatesque colonnettes – one at each corner – and they were cramped and leaded in place as the components were built up. Moreover, those at the west end provided structural support for the overhanging entablature: there was no question of the colonnettes being added at any subsequent date.

319 Burges 1863a, 102.

320 Lethaby 1925, 227–9; Foster 1991, 21–7.

321 E.g. Frothingham 1908, 383–4; Lethaby 1925, 227–8; Hutton 1950, 23–4, 41; Binski 1990, 18; 1995, 97–102; Foster 1991, 21–7; 2002, 50–3. A connection between *Oderisius* and Westminster was first hinted at by A. Frothingham in 1889: 'Notes on Roman Artists of the Middle Ages, I', *Amer. Journ. Archaeol.* **5**, 182–8 (pp. 187–8 refer).

322 Foster 1991, figs 10 and 11.

323 Foster searched Italian churches for further examples of this pattern, but was unable to find any, thereby confirming that it is extremely scarce. He very reasonably regards this pattern as a defining characteristic *of Petrus Oderisius'* work (Foster 2002, 52).

324 This distinctive and inelegant use of chain-guilloche was noted by Claussen (1987, 183–4), who aptly dubbed it the 'drive-belt motif'.

325 White 1993, 97. Previously, Claussen (1987, 189) had proposed that the pope's tomb was completed in 1271.

659

326 Hutton 1950, pl. 51.

327 Binski 1990, 18, figs 11–13. Notwithstanding, he did not favour English models for Italian tombs, partly because the chronology, as then understood, did not appear to support the thesis. However, now that the case for identifying *Petrus Oderisi* with Odoricus has been even further strengthened through archaeology, and the fact that construction of the pope's tomb appears to have immediately followed, rather than preceded, the bulk of the Westminster commission (White 1993), reappraisal is called for.

Abbreviations and Bibliography

Abbreviations

BAR	*British Archaeological Reports*
BL	British Library, London
CUL	Cambridge University Library, Cambridge
GPR	Ground-penetrating radar
HMSO	Her Majesty's Stationery Office
ODNB	*Oxford Dictionary of National Biography*
RCHME	Royal Commission on the Historical Monuments of England
TNA	The National Archive, Kew
VAM	Victoria and Albert Museum, London
WAL	Westminster Abbey Library, London
WAM	Westminster Abbey Muniments, London

Bibliography

Ackermann, R., 1812. *The History of the Abbey Church of St Peter's, Westminster, Its Antiquities and Monuments*. 2 vols. London.

Anon. 1841. *London Interiors: A Grand National Exhibition … of the British Capital*. London.

Arkell, W. J., 1947. 'The Geology of the Country and Weymouth, Swanage, Corfe and Lulworth', *Memoir of the Geological Survey of Great Britain*. Sheets 341, 342, 343 with small portions of sheets 327, 328, 329 (England and Wales). HMSO, London.

Arkell, W. J., 1975. *The Jurassic System in Great Britain*. OUP, Oxford.

Ayloffe, J., 1775. 'An Account of the Body of King Edward the First, as it appeared on Opening his Tomb in the year 1774', *Archaeologia* **3**, 376–413.

Badham, S., 2004. '"A new feire peynted stone": Medieval English Incised Slabs?', *Church Monuments* **19**, 20–52.

Badham, S., 2005. 'Evidence for the Minor Funerary Monument Industry 1100–1500', in K. Giles and C. Dyer (eds), *Town and Country in the Middle Ages*, 165–96. Soc. Med. Archaeol., Mono. **22**.

Badham, S., 2007a. 'Edward the Confessor's Chapel, Westminster Abbey: The Origins of the Royal Mausoleum and its Cosmatesque Pavement', *Antiq. Journ.* **87**, 197–219.

Badham, S., 2007b. 'Whose body? The Thirteenth-century Cosmatesque Tomb Chest and other Monuments Displaced from St Edward the Confessor's Chapel,

Westminster Abbey', *Journ. Brit. Archaeol. Assoc.* **160**, 135–52.

Badham, S., forthcoming. 'Divided in Death: English Medieval Heart and Viscera Monuments'.

Badham, S., and Norris, M., 1999. *Early Incised Slabs and Brasses from the London Marblers*. Research Report **60**, Soc. of Antiquaries, London.

Badham, S., and Oosterwijk, S., 2012. 'The Tomb Monument of Katherine, Daughter of Henry III and Eleanor of Provence (1253–7)', *Antiq. Journ.* **92**, 169–96.

Badham, S., and Oosterwijk, S., 2015. '"*Monumentum aere perennius"?* Precious-Metal Effigial Tomb Monuments in Europe 1080–1430', *Church Monuments* **30**, 7–105.

Barker, S., 2011. *Demolition, Salvage and Re-Use in the City of Rome. 100BC-AD315*. Unpubl. DPhil Thesis, University of Oxford.

Barker, S., 2012. 'Roman Marble Salvaging', in A. Gutierrez, P. Lapuente, and I. Roda (eds), *Interdisciplinary Studies on Ancient Stone. ASMOSIA IX*, 22–30. Documenta **23**. Tarragona.

Barlow, F., 1979. *Edward the Confessor*. London.

Barlow, F., (ed. and trans.), 1992. *The Life of King Edward who rests at Westminster, attributed to a monk of Saint-Bertin*. Oxford.

Battiscombe, C. F., 1956. *The Relics of Saint Cuthbert*. Oxford.

Beloe, E. M., 1898. *Photolithographs of Monumental Brasses in Westminster Abbey*. London.

Bertram, J., (ed. and trans.), 1997. *The Life of Saint Edward, King and Confessor, by Blessed Aelred Abbot of Rievaulx*. St Austin Press, Southampton.

Biddle, M., 1966. 'Nicholas Bellin of Modena: An Italian Artificer at the Courts of Francis I and Henry VIII', *Journ. Brit. Archaeol. Assoc.* (ser. 3) **29**, 106–21.

Bidwell, P., 2010. 'A Survey of the Anglo-Saxon Crypt at Hexham and its Reused Roman Stonework', *Archaeologia Aeliana* (ser. 5) **39**, 53–145.

Binski, P., 1986. *The Painted Chamber at Westminster*. Soc. of Antiquaries, Occ. Paper, n.s. **9**. London.

Binski, P., 1990. 'The Cosmati at Westminster and the English Court Style', *Art Bull.* **72**, 6–34. New York.

Binski, P., 1995. *Westminster Abbey and the Plantagenets: Kingship and Representation of Power, 1200–1400*. New Haven, CT.

Binski, P., 2002. 'The Cosmati and *Romanitas* in England: An Overview', in Grant and Mortimer 2002, 116–34.

Binski, P., 2009. 'Function, Date, Imagery, Style and Context of the Westminster Retable', in Binski and Massing 2009, 16–44.

Binski, P., and Blair, J., 1988. 'The Tomb of Edward I and Early London Brass Production', *Trans Monumental Brass Soc.* **14**, 234–40.

Binski, P., and Freestone, I., 1995. 'The Technique of the Westminster Retable: A Preliminary Report with an Analysis of the Glass Components', in M. Malmanger, L. Berczelly and S. Fuglesang (eds), *Norwegian Medieval Altar Frontals and Related Material. Papers from the Conference in Oslo, 16 to 19 December 1989*, 59–71. Rome.

Binski, P., and Massing, A., (eds), 2009. *The Westminster Retable: History, Technique, Conservation*. London.

Blair, W. J, and Ramsey, N. L., (eds), 1991. *English Medieval Industries: Craftsmen, Techniques, Products*. London.

Bloch, M., 1923. 'La Vie de S. Edouard le Confesseur par Osbert de Clare', *Analecta Bollandiana* **41**, 5–131.

Blockley, K., 2004. 'Westminster Abbey: Anglo-Saxon Masonry below the Cosmati Pavement', *Archaeol. Journ.* **161**, 223–33.

Bond, F., 1909. *Westminster Abbey*. OUP, London.

Bonney, T. G., 1875. *Picturesque Europe: The British Isles, Volume. 1*. London.

Borghini, G., 2004. *Marmi Antichi*. De Luca Editori d'Arte, Rome.

Boutell, C., 1860. 'The Monumental Brasses of London and Middlesex. Part I', *Trans London & Middlesex Archaeol. Soc.* **1**, 106–7.

Bradley, S., and Pevsner, N., 2014. *Cambridgeshire*. Buildings of England. Yale.

Brayley, E. W., and Neale, J. P., 1818/1823. *The History and Antiquities of the Abbey Church of St Peter, Westminster.* Vol. 1, 1818; vol. 2, 1823. London.

Brindle, S., 2015. 'Sir George Gilbert Scott as Surveyor of Westminster Abbey, 1849–78', in Rodwell and Tatton-Brown 2015a, 325–52.

Brindle, S., (ed.), 2018. *Windsor Castle. A Thousand Years of a Royal Palace*. Royal Collection Trust, London.

Browne, J., and Dean, T., (eds), 1995. *Building of Faith: Centenary of Westminster Cathedral*. London. 2nd edn 2000.

Buckton, D., (ed.), 1994. *Byzantium: Treasures of Byzantine Art and Culture from British Collections*. British Museum, London.

Burges, W., 1863a. 'The Mosaic Pavements', in Scott 1863, 97–103.

Burges, W., 1863b. 'The Shrine of St Edward the Confessor', in Scott 1863, 127–42.

Burges, W., 1863c. 'The Tombs in Westminster Abbey', in Scott 1863, 143–94.

Burnby, J., 1984. 'John Conyers, London's First Archaeologist', *Trans London Middlesex Archaeol. Soc.* **35**, 63–80.

Caley, J., Ellis, H., Bandinel, B., (eds), 1817. *William Dugdale: Monasticon Anglicanum*, **1**. Republished 1846. London.

Camden, W., 1600/1606. *Reges, Reginae, Nobiles, et Alii in Ecclesia Collegiata B. Petri Westmonasterii Sepulti*. 1st edn 1600; 3rd edn 1606. London.

Carpenter, D., 1996. 'King Henry III and the Cosmati Work at Westminster Abbey', in J. Blair and B. Golding (eds), *The Cloister and the World: Essays in Medieval History in Honour of Barbara Harvey*, 178–95. Oxford. Also published in D. Carpenter, *The Reign of Henry III*, chap. 20, 409–25. London.

Carpenter, D., 2002. 'Westminster Abbey and the Cosmati Pavements in Politics', in Grant and Mortimer 2002, 37–48.

Carpenter, D., 2007a. 'King Henry III and Saint Edward the Confessor: the Origins of the Cult', *English Hist. Rev.* **122**, 865–91.

Carpenter, D., 2007b. 'On the 800th Anniversary of his Birth – Henry III', *Westminster Abbey Chorister* **44**, Summer 2007, 34–8.

Carpenter, D., 2010. 'King Henry III and the Chapter House of Westminster', in Rodwell and Mortimer, 2010, 32–9.

Carpenter, E. (ed.), 1966. *A House of Kings: the History of Westminster Abbey*. London.

Carrick Utsi, E., 2017. *Ground Penetrating Radar Theory and Practice*, 13–24. Kidlington, UK & Cambridge, USA.

Ciggar, K., 1982. 'England and Byzantium on the Eve of the Norman Conquest', *Anglo-Norman Studies* **5**, 78–96.

Claussen, P. C., 1987. *Magistri Doctissimi Romani: die römischen Marmorkunstler des Mittelalters (Corpus Cosmatorum I)*. Forschungen zur Kunstgeschichte und christlichen Archäologie **14**. Stuttgart.

Claussen, P. C., 1996. 'Cosmati', in J. Turner, (ed.), *The Grove Dictionary of Art*, vol. **7**, 918–23. Oxford & London.

Clayton-Fant, J. (ed.), 1988. *Ancient Marble Quarrying and Trade: Papers from a Colloquium held at the Annual Meeting of the Archaeological Institute of America, San Antonio, Texas, December 1986*. BAR International Ser. **453**. Oxford.

Cocke, T., 1995. *900 Years: The Restorations of Westminster Abbey*. London.

Coldstream, N., 1976. 'English Decorated Shrine Bases', *Journ. Brit. Archaeol. Assoc.* **129**, 15–34.

Colvin, H. M. (ed.), 1963. *History of the King's Works, Volume I: Middle Ages*. HMSO, London.

Colvin, H. M. (ed.), 1971. *Building Accounts of King Henry III*. Oxford.

Condon, M., 2003. 'The Last Will of Henry VII: Document and Text', in Tatton-Brown and Mortimer 2003, 99–140.

Coombe, P. C., Grew, F., Hayward, K. M. J. and Henig, M. (2015). *Corpus Signorum Imperii Romani. Great Britain 1.10. Roman Sculpture from London and the South-East*. OUP, Oxford.

Corsi, F., 1825. *Catalogo Ragionato d'una Collezione di Pietre di Decorzione*. Rome.

Cowan, C., Seeley, F., Wardle, A., Westman, A., and Wheeler, L., 2009. *Roman Southwark Settlement and Economy: Excavations in Southwark 1973–91*. MoLA Monogr. **42**, 187–205.

Crook, J., 2000. *The Architectural Setting of the Cult of Saints in the Early Christian West, c. 300–1200*. Oxford.

Crook, J., 2011. *English Medieval Shrines*. Woodbridge.

Crowfoot, E., Pritchard, F. and Staniland, K., 1992. *Medieval Finds from Excavations in London c.1150–1450: Textiles and Clothing*. HMSO, London.

Crull, J., 1711/1742. *The Antiquities of St Peter's, or, the Abbey-Church of Westminster*. 2 vols. 1st edn 1711; 5th edn 1742. London.

Cunliffe, B. W. (ed.), 1968. *Fifth Report on the Excavation of the Roman Fort at Richborough, Kent*. Res. Rep. Soc. of Antiquaries **23**. London.

Dart, J., 1723/1742. *Westmonasterium. Or the History and*

Antiquities of the Abbey Church of St Peter's, Westminster. 2 vols. 1st edn 1723; 2nd edn 1742. London.

D'Aviler, C. A., 1691, *Cours d'Architecture … [Explication des termes d'architecture …]*. Paris.

Davison, S., 2009. 'Glass Elements on the Westminster Retable', in Binski and Massing 2009, 260–9.

De Ceukelaire, M., Dopere, F., Dreesen, R., Dusar, M. and Groessens, E., 2014. *Belgisch Marmer.* Ghent.

De Piro, T., 2008. 'Cosmati Pavements: The Art of geometry', in R. Sarhangi and C. Séquin (eds), *Bridges Leeuwarden: Mathematical Connections in Art, Music and Science, Proceedings 2008,* 369–76. Tarquin Publications, London.

Deer, W. A., Howie, R. A., and Zussman, J., 1992. *An Introduction to the Rock Forming Minerals.* 2nd edn, Longman Scientific & Technical, London.

Devon, F., 1837. *Issues of the Exchequer.* London.

Dodge, H., 1988. 'Decorative Stones for Architecture in the Roman Empire', *Oxford Journ. of Archaeol.* **7**(1), 65–80.

Dodge, H., and Ward-Perkins, B., (eds), 1992. *Marble in Antiquity: Collected Papers of J. B. Ward-Perkins.* British School at Rome, Archaeol. Monogr. **6**. London.

Dodson, A., 2004. *The Royal Tombs of Great Britain.* London.

Draper, P., 2017. 'Recent Interpretation of the Late 12th Century Rebuilding of the East End of Canterbury Cathedral and its Historical Context', in *Medieval Art, Architecture and Archaeology at Canterbury.* Brit. Archaeol. Assoc. Conf. Trans **34**, 106–15.

Dreesen, R., Marion, J-M., and Mottequin, B., 2013. 'The Red Marble of Baelen, a Particular Historic Building Stone with Global Geological Importance and Local Use', *Geologica Belgica* **16.3,** 179–90.

Duffy, M., 2003. *Royal Tombs of Medieval England.* Stroud.

Duffy, E. and Loades, D., (eds), 2006. *The Church of Mary Tudor.* Aldershot.

Durnan, N., 2002. 'The Condition and Conservation of the Cosmati Pavements at Westminster Abbey', in Grant and Mortimer 2002, 92–9.

Dykes Bower, S. E., 1967. *Cosmati Work in the Abbey,* Westminster Abbey Occ. Papers **17,** 10–14.

Eastaugh, N., Walsh, V., Chaplin, T., and Siddall, R., 2008. *Pigment Compendium: A Dictionary and Optical Microscopy of Historic Pigments.* London.

Edwards, A. S. G. (ed.), 2004. *The Life of St Edmund King and Martyr.* BL, London.

Edwards, J., 2011. *Mary I: England's Catholic Queen.* Yale.

English Heritage, 2008. *Geophysical Survey in Archaeological Field Evaluation.* Swindon.

Fadden, F., (ed.), 1866. *Matthew Paris, Historia Minor.* Rolls Ser, **2**. London.

Fawcett, J. (ed.), 1998. *Historic Floors: Their History and Conservation.* Oxford. 2nd edn 2001.

Fernie, E. C., 1973. 'Enclosed Apses and Edward's Church at Westminster', *Archaeologia* **104**, 235–60.

Fernie, E., 2009. 'Edward the Confessor's Westminster Abbey', in Mortimer 2009, 139–50.

Formilli, C., 1910. 'The Monumental Work of the Cosmati in Westminster Abbey', *Journ. Roy. Inst. Brit. Architects* (ser. 3) **18**, 69–83.

Foster, R., 1991. *Patterns of Thought. The Hidden Meaning of the Great Pavement of Westminster Abbey.* London.

Foster, R., 2002. 'The Context and Fabric of the Westminster Abbey Sanctuary Pavement', in Grant and Mortimer 2002, 49–71.

Frankopan, P., 2015. *The Silk Road: A New History of the World.* London.

Freestone, I. C., 1995. 'Ceramic Petrography', *American Journ. Archaeol.* **99**, 111–15.

Frothingham, A., 1908. *The Monuments of Christian Rome.* New York.

Gallois, R. W., 2009. 'The Lithostratigraphy of the Penarth Group (Late Triassic) of the Southern Estuary Area', *Geoscience in South-West England* **12**, 71–84.

Gardner, J., 1990, 'The Cosmati at Westminster: Some Anglo-Italian Reflexions', in J. Garms and A. Romanini (eds), *Skulptur und Grabmal des Spätmittelalters in Rom und Italien,* 201–16. Österreichische Akademie der Wissenschaften, Vienna.

Geddes, J., 1999. *Medieval Decorative Ironwork in England.* Soc. of Antiquaries, London.

Gee, E., 1979. 'Ciborium Tombs in England, 1290–1330', *Journ. Brit. Archaeol. Assoc.* **132**, 29–41.

Gem, R. D. H., 1980. 'The Romanesque Rebuilding of Westminster Abbey', in *Proc. Battle Conf. Anglo-Norman Stud.* **3**, 33–60.

Gilbert, C., Lomax, J. and Wells-Cole, A., 1987. *Country House Floors, 1660–1850.* Leeds.

Gilchrist, R., 2008. 'Magic for the Dead? The Archaeology of Magic in later Medieval Burials', *Medieval Archaeol.* **52**, 119–59.

Gilchrist, R., and Green, C., 2015. *Glastonbury Abbey: Archaeological Investigations, 1904–79.* Soc. of Antiquaries, London.

Girouard, M., 2009. *Elizabethan Architecture.* Yale.

Glass, D. F., 1980. *Studies on Cosmatesque Pavements.* BAR International Ser. **82**. Oxford.

Gnoli, R., 1971. *Marmora Romana.* Rome.

[Gough, R.] 1786. *Sepulchral Monuments in Great Britain,* **1**. London.

Gransden, A. (ed.), 1964. *The Chronicle of Bury St Edmunds, 1212–1301.* London.

Grant, L., and Mortimer, R., (eds), 2002. *Westminster Abbey: The Cosmati Pavements.* Courtauld Research Papers **3**. Aldershot.

Greenhill, F. A., 1976. *Incised Effigial Slabs.* 2 vols. London.

Harrington, J., 1869. *The Abbey and Palace of Westminster.* London.

Harrison, W., 1577 [1994]. *A Description of England* (part of *Holinshed's Chronicles*), London. 1994 edn by Dover Publications, Mineola, NY, USA.

Harvey, B., 2003. 'The Monks of Westminster and the Old Lady Chapel', in Tatton-Brown and Mortimer 2003, 5–32.

Haysom, T., 1998. 'Extracting Purbeck Marble', in Tatton-Brown 1998, 48–54.

Hayward, K. M. J., 2006a. *The Early Development of the Roman Freestone Industry in south-central England. A Geological Characterisation Study of Roman Funerary Monuments and Monumental Architecture.* Unpubl. PhD thesis, Univ. of Reading.

Hayward, K. M. J., 2006b. 'A Geological Link between the *Facilis* Monument at Colchester and First-century Army Tombstones from the Rhineland Frontier', *Britannia* **37**, 359–63.

Hayward, K. M. J., 2009. *Roman Quarrying and Stone Supply*

on the Periphery – Southern England. A Geological Study of First Century Funerary Monuments and Monumental Architecture. BAR **500**. Oxford.

Hayward, K. M. J., 2015a. Types and Sources of Stone, in P. C. Coombe, F. Grew, K. M. J. Hayward and M. Henig, Corpus Signorum Imperii Romani. Great Britain **1.10**. Roman Sculpture from London and the South-East. Oxford.

Hayward, K. M. J., 2015b. 'Building Materials', in D. Killock, J. Shepherd, J. Gerrard, H. M. J. Hayward, K. Reilly and V. Ridgeway, Temples and Suburbs: Excavations at Tabard Square, Southwark. Pre-Construct Archaeology Monogr. **18**, 172–86.

Hayward, K. M. J., in prep. a. 'Building Materials', in V. Ridgeway, J. Taylor, J. and E. Biddulph, A Bath House, Settlement and Industry on Roman Southwark's North Island: Excavations along the Route of Thameslink Borough Viaduct. OAPCA, Thameslink Monogr. **1**.

Hayward, K. M. J., in prep. b. 'Building Materials', in N. Hawkins, Excavations at Draper's Gardens. Pre-Construct Archaeology Monogr.

Hayward, K. M. J., in prep. c. 'Resources for Castle Building in Medieval Prussia and Livonia', in A. Pluskowski (ed.), The Ecology of Crusading, Colonisation and Religious Conversion in the East Baltic. Terra Sacra **2**.

Hearne, T., (ed.), 1774. Joannis Lelandi Antiquarii De Rebus Britannicis Collectanea. 6 vols (3rd edn). London.

Henig, M., 2015. ' "A fine and private place": The Sarcophagus of Valerius Amandinus and the Origins of Westminster', in Rodwell and Tatton-Brown 2015a, 23–33.

Henig, M., Coombe, P., Hayward, K. M. J., Tomlin, R., and Gerrard, J., 2015. 'Statuary, Sculpture, Inscriptions and Architectural Fragments', in D. Killock, J. Shepherd, J. Gerrard, K. M. J. Hayward, K. Reilly and V. Ridgeway, Temples and Suburbs: Excavations at Tabard Square, Southwark, Pre-Construct Archaeology Monogr. **18**, 187–98.

Hervey, M. F. S., 1900. Holbein's Ambassadors: the Picture and the Men. London.

Hiatt, C., 1902. Westminster Abbey. 1st edn. George Bell, London.

Hope, W. H. St John, 1906. The Obituary Roll of John Islip, Abbot of Westminster, 1500–32, in Vetusta Monumenta **7.4**. Soc. of Antiquaries, London.

Hope, W. H. St John, 1911. 'The Discovery of the Remains of King Henry VI in St George's Chapel, Windsor Castle', Archaeologia **62**, 533–42.

Hope, W. H. St John, 1913. Windsor Castle. An Architectural History. Country Life, London.

Hope, W. H. St John, 1914a. 'The Funeral, Monument and Chantry Chapel of King Henry the Fifth', Archaeologia **65**, 129–86.

Hope, W. H. St John, 1914b. 'Report of the Excavation of the Cathedral Church of Old Sarum 1913', Proc. Soc. Antiquaries **26**, 100–19.

Howard, H., and Sauerberg, M. L., 2009. 'Polychrome Techniques at Westminster, 1250–1350', in Binski and Massing 2009, 290–318.

Howard, H., and Sauerberg, M. L., 2015. 'The Polychromy at Westminster Abbey, 1250–1350', in Rodwell and Tatton-Brown 2015a, 158–79.

Hutton, E., 1950, The Cosmati: The Roman Marble Workers of the XIIth and XIIIth Centuries. London.

Howell, M., 1991. 'The Children of King Henry III and Eleanor of Provence', in Thirteenth Century England **4**, 57–72. Woodbridge.

Howlett, D., 2002. 'The Inscriptions in the Sanctuary Pavement at Westminster', in Grant and Mortimer 2002, 100–15.

Humphries, D. W., 1992. The Preparation of Thin Sections of Rocks, Minerals and Ceramics. Royal Microscopical Society, Microscopy Handbooks **24**. OUP, Oxford.

Jansen, V., 2015. 'Henry III's Palace at Westminster', in Rodwell and Tatton-Brown 2015b, 89–110.

Jordan, W. J., 1980. 'Sir George Gilbert Scott, RA, Surveyor to Westminster Abbey, 1849–1878', Architect. Hist. **23**, 60–87 (Appendices 188–90).

Kier, H., 1976. Schmuckfussböden in Renaissance und Barock, Kunstwissenschaftliche Studien **49**. Deutscher Kunstverlag.

Keen, L., 2010. 'The Chapter House Decorated Tile Pavement', in Rodwell and Mortimer 2010, 209–36.

Keen, L., and Thackray, D., 1976. 'Helpston Parish Church, Northamptonshire: The Remains of a Medieval Tile Pavement', Journ. Brit. Archaeol. Soc. **129**, 87–92.

Keepe, H., 1682/1683. Monumenta Westmonasteriensia: or an Historical Account of … St Peter's, or the Abby Church of Westminster. 2nd edn. 1683. London.

Kingery, W. D., Vandiver, P. B., and Prickett, M., 1988. 'The Beginnings of Pyrotechnology, Part II: Production and Use of Lime and Gypsum Plaster in the Pre-pottery Neolithic Near East', Journ. Field Archaeol. **15**, 219–44.

Klemm, R., and Klemm, D., 2008. Stone and Stone Quarries in Ancient Egypt. British Museum, London.

Klukas, A. W., 1984. 'The Architectural Implications of the Decreta Lanfranci', in R. A. Brown (ed.), Anglo-Norman Studies **6**, 136–71.

Knight, C., 1845. Old England. 2 vols, London.

Knighton, C. S. (ed.), 1997. Acts of the Dean and Chapter of Westminster, 1543–1609. Pt. I. Woodbridge.

Knighton, C. S., 2003. 'Westminster Abbey from Reformation to Revolution', in Knighton and Mortimer 2003, 1–15.

Knighton, C. S., and Mortimer, R. (eds), 2003. Westminster Abbey Reformed, 1540–1640. Aldershot.

Lankester, P. J., 1987. 'A Military Effigy in Dorchester Abbey, Oxon.', Oxoniensia **52**, 145–72.

Leary, E., 1989. The Building Limestones of the British Isles. Building Research Establishment Report. HMSO, London.

Legg, J. W., 1890. 'On an Inventory of the Vestry in Westminster Abbey taken in 1388', Archaeologia **52**, 2–92.

Lethaby, W. R., 1906. Westminster Abbey and the King's Craftsmen. London.

Lethaby, W. R., 1910. 'Note on the Existing Remnants of the Confessor's Church', in Robinson 1910, 97–100.

Lethaby, W. R., 1925. Westminster Abbey Re-Examined. London.

Luard, H. R. (ed.), 1858. Lives of Edward the Confessor. Rolls Ser. **3**. London.

Luard, H. R. (ed.), 1864a. Annales Monastici, I. Rolls Ser. **36.I**. London.

Luard, H. R. (ed.), 1864b. Annales Monastici, II. Rolls Ser. **36**.II. London.

Luard, H. R. (ed.), 1866. Annales Monastici, III. Rolls Ser. **36**.III. London.

Luard, H. R. (ed.), 1869. *Annales Monastici, IV*. Rolls Ser. **36**.IV. London.

Luard, H. R. (ed.), 1878. *Matthaei Parisiensis: Monachi Sancti Albani, Chronica Majora, IV*. Rolls Ser. **57**.IV. London.

Luard, H. R. (ed.), 1880. *Matthaei Parisiensis: Monachi Sancti Albani, Chronica Majora, V*. Rolls Ser. **57**.V. London.

Luard, H. R. (ed.), 1890. *Flores Historiarum, III*. Rolls Ser. **95**. London.

Luxford, J., 2019. 'Recording and Curating Relics at Westminster Abbey in the Late Middle Ages', *Journ. Medieval History*, 1–27. Published online. DOI: 10.1080/03044181.2019.1593626.

Madden, F. (ed.), 1866. *Matthew Paris, Historia Minor*. Rolls Ser. **44**. 3 vols. London.

Malcolm, J. P., 1802. 'The Abbey, now the Collegiate Church of St Peter, Westminster', in *Londinium Redivivum: or, An Antient and Modern Description of London* **1**, 87–265. London.

Manten, A. A., 1971. *Developments in Sedimentology 13. Silurian reefs of Gotland*. Elsevier, Amsterdam.

Marchant, R., 2009. 'Manufacture of the Wooden Support', in Binski and Massing 2009, 222–32.

Marks, R., 2019. 'The Medieval Glazing of Westminster Abbey: New Discoveries', *Burlington Mag.* **161**, 9–17.

Martinaud, M., Frappa, M., and Chapoulie, R., 2004. 'GPR Signals from the Understanding of the Shape and Filling of Man-made Underground Masonry', in E. Slob, A. Yarovoy and J. Rhebergen (eds), *Proceedings of the Tenth International Conference on Ground Penetrating Radar, June 2004*, 439–42. Delft, Netherlands.

Mason, E., 1996. *Westminster Abbey and its People, c. 1050–1216. Studies in the History of Medieval Religion* **9**. Woodbridge.

Maxfield, V., and Peacock, D., (eds) 2001. *The Roman Imperial Quarries. Survey and Excavation at Mons Porphyrites 1994–1998: Volume 1: Topography and Quarries*. Egypt Exploration Soc., London.

Mayor, J. E. B. (ed.), 1863; 1869. *Richard of Cirencester, Speculum Historiale de Gestis Regum Angliae*. Rolls Ser. **30** (2 vols). London.

McRoberts, D. (ed.), 1976, *The Medieval Church of St Andrews*. Glasgow.

Micklethwaite, J. T., 1895. 'Proceedings, 9 May 1895' [Report … 'concerning the actual Condition of the Royal Tombs in Westminster Abbey Church', *Proc. Soc. Antiq.* (ser. 2) **15**, 412–19.

Mitchner, M., 1986. *Medieval Pilgrim and Secular Badges*. Sanderstead.

Monnas, L., 2017. 'Textile Scraps give Clues to the Past', *Westminster Abbey Rev.* **2**, 45–7.

Mortimer, R. (ed.), 2009. *Edward the Confessor: The Man and the Legend*. Woodbridge.

Müller-Christensen, S., 1960. *Das Grab des Clemens II. im Dom zu Bamberg*. F. Bruckmann, Munich.

Mynors, R. A. B., Thomson, R. M., and Winterbottom, M. (eds), 1998. *Gesta Regum Anglorum*. Oxford Medieval Texts **1**.

Nairn, A. E. M., Perry, T. A., Ressetar, R., and Rogers, S., 1987. 'A Palaeomagnetic Study of the Dokhan Volcanic Formation and Younger Granites, Eastern Desert of Egypt, *Journ. African Earth Sciences* **6**, 353–65.

Neal, D. S., and Cosh, S. R., 2002–10. *Roman Mosaics of Britain*. 4 vols, Soc. of Antiquaries, London.

Nichols, J., 1780. *A Collection of all the Wills … of the Kings and Queens of England*. London.

Nichols, J. G. (ed.), 1848. *The Diary of Henry Machyn, 1550–1563*. Camden Soc., old ser., **42**.

Nichols, J. G. (ed.), 1852. *Chronicles of the Grey Friars of London*. Camden Soc., old ser., **53**.

Nightingale, J., 1815. *The Beauties of England and Wales* **10.4**. London.

Nilson, B., 1998. *Cathedral Shrines of Medieval England*. Woodbridge.

Nixon, E., 1989. 'The Sanctuary Pavement', *Westminster Abbey Chorister*, **2**(1), 21–3.

Norton, C., 2002. 'The Luxury Pavement in England before Westminster', in Grant and Mortimer 2002, 7–36.

O'Neilly, J. G., and Tanner, L. E., 1966, 'The Shrine of Edward the Confessor', *Archaeologia* **100**, 129–54.

Osbourne, J., 1983. 'Santa Maria in Cosmedin, Rome, and its Place in the Tradition of Roman Funerary Monuments', *Papers of the British School at Rome 1983*, 240–7.

Page, R., 2009. 'Glass Inlay in Europe in the Thirteenth and Fourteenth Centuries, in Binski and Massing 2009, 107–23.

Pajares-Ayuela, P., 2001. *Cosmatesque Ornament*. New York.

Palliser, D. M., 2004. 'Royal Mausolea in the Long Fourteenth Century', in W. M. Ormrod (ed.), *Fourteenth Century England III*, 1–15. Woodbridge.

Patrick, S., 1839. *The Auto-Biography of Simon Patrick, Bishop of Ely: Now first Printed from the Original Manuscript*. J. H. Parker, Oxford.

Payne, M., 2016. 'The Medieval Abbey Revealed', *The Westminster Abbey Chorister* **62**, 2–8.

Payne, M., 2017. 'The Islip Roll Re-examined', *Antiq. Journ.* **97**, 231–60.

Payne, M., and Rodwell, W., 2017. 'Edward the Confessor's Shrine in Westminster Abbey: Its Date of Construction Reconsidered', *Antiq. Journ.* **97**, 187–204.

Payne, M., and Rodwell, W., 2018. 'Edward the Confessor's Shrine in Westminster Abbey: The Question of Metre', *Antiq. Journ.* **98**, 145–8.

Perkins, J., 1938. *Westminster Abbey, Its Worship and Ornaments I*. Alcuin Club Coll. **33**. Oxford & London.

Perkins, J., 1940. *Westminster Abbey, Its Worship and Ornaments II*. Alcuin Club Coll. **34**. Oxford & London.

Phillips, J. R. S., 1972. *Aymer de Valence, Earl of Pembroke 1307–1324*. Oxford.

Pinner, R., 2015. *The Cult of St Edmund in Medieval East Anglia*. Woodbridge.

Pluskowski, A. (ed.), in prep. 'The Ecology of Crusading, Colonisation and Religious Conversion in the East Baltic', *Terra Sacra* **2**.

Poole, H., 1869. 'Some Account of the Discovery of the Roman Coffin on the North Green of Westminster Abbey', *Archaeol. Journ.* **27**, 119–28.

Poole, H., 1890. 'Westminster Abbey: Annals of the Masonry carried out by Henry Poole, Abbey Master-Mason', *Proc. Roy. Inst. Brit. Architects* (ser. 2) **6**, 113–16, 136, 169–72, 187–8, 218–20, 253–4, 281–2, 301–4. [A bound and repaginated set of these articles is held in WAL]

Price, M. T., 2007. *Decorative Stone: The Complete Sourcebook*. London.

Pringle, S., 2009. *Building Materials*, in Cowan *et al.* (2009), 187–205.

Pritchard, F. J., 1986. 'Ornamental Stonework from Roman London', *Britannia* **17**, 169–89.

Prudden, H., 2002. 'Somerset Building Stone – a Guide', *Proc. Somerset Archaeol. Natur. Hist. Soc.* **146**, 27–36.

Pullen, H. W., 1894. *Handbook of Ancient Roman Marbles.* London.

Ravasi, G., 1995. *La Cripta della Cattedrale di Anagni.* Genoa, Italy.

RCHME 1924. *An Inventory of the Historical Monuments in London, Vol. I: Westminster Abbey.* HMSO, London.

Rees, L., and Lewis, M. J. T., 2014. 'A Fragment of Cosmatesque Mosaic from Wimborne Minster, Dorset', *Antiq. Journ.* **94**, 1–17.

Rees-Jones, J., 2008. 'The Effects of Time, Restoration and Conservation Approaches on Twelfth-Century Cosmati Pavements', in *Conservation and Management of Archaeological Sites*, **10.3**, 223–50. Journal: Taylor and Francis Online.

Reynolds, C. (ed.), 2011. *Surveyors of the Fabric of Westminster Abbey, 1827–1906. Reports and Letters.* Westminster Abbey Record Ser. **6**. Woodbridge.

Reynolds, C. (ed.), 2019. *Surveyors of the Fabric of Westminster Abbey, 1906–1974. Reports and Letters.* Westminster Abbey Record Ser. **9**. Woodbridge.

Richardson, H. G., 1938. 'The Coronation of Edward II', *Bull. Inst. Hist. Research* **16**, 46, 1–11.

Riley, H. T. (ed.), 1863. *Chronicles of the Mayors and Sheriffs of London, 1188–1274.* London.

Riley, H. T. (ed.), 1865. *Willelmi Rishanger, Chronica et Annales. Annales Regum Angliae.* Rolls Ser. **28**.II. London.

Riley, H. T. (ed.), 1876. *Thomas Walsingham. Ypodigma Neustriae.* Rolls Ser. **28**.VII. London.

Robinson, E., 2005. 'Notes from the Cosmati Pavement'. Unpubl. archive report, Westminster Abbey. WAL.

Robinson, E., 2006. 'Notes from the Cosmati Pavement'. Unpubl. archive report, Westminster Abbey. WAL.

Robinson, E., 2012. 'Notes from the Cosmati Pavement'. Unpubl. archive report, Westminster Abbey. WAL.

Robinson, J. A. (ed.), 1909. *The History of Westminster Abbey by John Flete.* Notes and Documents Relating to Westminster Abbey, **2**. Cambridge.

Robinson, J. A. 1910. 'The Church of Edward the Confessor at Westminster', *Archaeologia* **62**, 81–100.

Robinson, J. A., 1911. *Gilbert Crispin Abbot of Westminster. A Study of the Abbey under Norman Rule.* Notes and Documents Relating to Westminster Abbey **3**. Cambridge.

Rodwell, W., 1979. 'Lead Plaques from the Tombs of the Saxon Bishops of Wells', *Antiq. Journ.* **59**, 407–10.

Rodwell, W., 2001. *The Archaeology of Wells Cathedral: Excavations and Structural Studies, 1978–93.* 2 vols. English Heritage Archaeol. Rep. **21**.

Rodwell, W., 2009a. 'New Glimpses of Edward the Confessor's Abbey at Westminster', in Mortimer 2009, 151–67.

Rodwell, W., 2009b. 'Post-Reformation Documentation and Use', in Binski and Massing 2009, 156–71.

Rodwell, W., 2009c. *Dorchester Abbey, Oxfordshire: The Archaeology and Architecture of a Cathedral, Monastery and Parish Church.* Oxbow, Oxford.

Rodwell, W., 2010a. *The Lantern Tower of Westminster Abbey, 1060–2010.* Westminster Abbey Occ. Paper (ser. 3) **1**. Oxford.

Rodwell, W., 2010b. 'The Chapter House Complex: Morphology and Construction', in Rodwell and Mortimer 2010, 1–31.

Rodwell, W., 2010c. 'Westminster and other Two-Storeyed Chapter Houses and Treasuries', in Rodwell and Mortimer 2010, 66–90.

Rodwell, W., 2011. *St Peter's Church, Barton-upon-Humber, Lincolnshire. Volume 1: History, Archaeology and Architecture.* Oxford.

Rodwell, W., 2013. *The Coronation Chair and Stone of Scone: History, Archaeology and Conservation.* Westminster Abbey Occasional Papers (ser. 3), **2**. Oxford.

Rodwell, W., 2015a. 'The Archaeology of Westminster Abbey: An Historiographical Overview', in Rodwell and Tatton-Brown 2015a, 34–60.

Rodwell, W., 2015b. 'The Cosmati Pavements and their Topographical Setting', in Rodwell and Tatton-Brown 2015a, 158–79.

Rodwell, W., and Mortimer, R., (eds), 2010. *Westminster Abbey Chapter House: The History, Art and Architecture of 'a chapter house beyond compare'.* Soc. of Antiquaries, London.

Rodwell, W., and Rodwell, K., 1993. *Rivenhall: Investigations of a Villa, Church and Village, 1950–77. Vol. 2.* CBA, Res. Rep. **80**.

Rodwell, W., and Tatton-Brown, T., (eds), 2015a. *Westminster I. The Art, Architecture and Archaeology of the Royal Abbey.* Brit. Archaeol. Assoc. Conf. Trans. **39** (1).

Rodwell, W., and Tatton-Brown, T., (eds), 2015b. *Westminster I. The Art, Architecture and Archaeology of the Royal Palace.* Brit. Archaeol. Assoc. Conf. Trans. **39** (2).

Rowell, C., 2013. *Ham House.* Yale.

Russell, B., 2013. *The Economics of the Roman Stone Trade.* Oxford Studies on the Roman Economy. Oxford.

Rymer, T. (ed.), 1735–45. *Foedera.* 10 vols. The Hague. Also 1704 edn.

Ryves, B., 1685. *Mercurius Rusticus: Or, the Countries Complaint of the Barbarous Outrages Committed by the Sectaries of this Late Flourishing Kingdom.* London. [originally published in parts, 1643; republished 1646, 1647, 1685]

Sandford, F., 1677. *A Genealogical History of the Kings of England.* London.

Sandford, F., 1687. *The History of the Coronation of … James II … 1685.* London.

Sauerberg, M. L., 2013. 'The Polychromy of the Coronation Chair: A Detailed Study', in Rodwell 2013, 77–104.

Saul, N., 2009. *English Church Monuments in the Middle Ages.* Oxford.

Scharf, G., 1867. 'On the Discovery of a Stone Coffin in the Choir of Westminster Abbey, 12 July 1866', *Proc. Soc. Antiq.* (ser. 2) **3.5**, 354–7.

Schmidt, V. M., 2009. 'The Painted Reverse of the Westminster Retable', in Binski and Massing 2009, 136–42.

Schmitz-Ehmke, R., 1975. 'Das Kosmosbild von Oberpleis', in A. Legner (ed.), *Monumenta Annonis, Köln und Siegburg, Weltbild und Kunst im hohen Mittelalter*, 120–3. Exhib. Cat., Cologne.

Schofield, J., 2011. *St Paul's Cathedral before Wren.* English Heritage, Swindon.

Schofield, J., 2018. 'Medieval London: Rich Resources and New Directions', *London Archaeologist* **15**, 155–62.

Scholz, B. W., 1961. 'The Canonization of Edward the Confessor', *Speculum* **36**, 51–60.

Schorta, R., 1987. 'Anmerkung zur Technik einzelner Gewebe aus der Bamberger Grabfunden', in H. Hermann and Y. Langestein, (eds), *Textile Grabfunde aus der Sepultur des Bamberger Domkapitels*, 80–90. Munich.

Scott, J. (ed.), 1981. *William of Malmesbury, De Antiquitate Glastonie Ecclesiae*. Woodbridge.

Scott, G. G., 1861/1863. *Gleanings from Westminster Abbey*. 1st edn 1861; 2nd edn 1863. Oxford & London.

Scott, G. G., 1879. *Personal and Professional Recollections*. London.

Sherlock, D., and Woods, H., 1988. *St Augustine's Abbey: Report on Excavations, 1960–78*. Maidstone.

Sicca, C. M., 2011. 'Insignia Auguralia, Sacralia, et Sacerdotalia. John Talman and English Catholic Antiquarianism', in G. Feigenbaum and S. Ebert-Schifferer (eds), *Sacred Possessions: Collecting Italian Religious Art, 1500–1900*, 140–57. Los Angeles, USA. http://www.ucl.ac.uk/~ucfbrxs/Homepage/walks/LOUGS-Westminster.pdf

Siddall, R., 2006. 'Hydraulic Mortars in Antiquity: Analyses from Fountains in Ancient Corinth', in A. Brauer, C. Mattusch and A. Donohue (eds), *Common Ground: Archaeology, Art, Science and Humanities*, 208–11. Oxbow, London.

Siddall, R., 2011. 'From Kitchen to Bathhouse: The Use of Waste Ceramics as Pozzolanic Additives in Roman mortars', in Å. Ringbom, and R. L. Hohlfelder (eds), *Building Roma Aeterna: Current Research on Roman Mortar and Concrete*. Finnish Society of Sciences and Letters **128**, 152–68.

Siddall, R., 2014. 'Westminster Abbey: The Stones of the Sanctuary Pavement', *Urban Geology in London*, No. **22**.

Siddall, R., 2018, 'Medieval Mortars and the Gothic Revival: The Cosmati Pavement at Westminster Abbey', *3rd Historic Mortars Conference*, Glasgow, 11–14 Sept. 2013.

Smith, L. T. (ed.), 1907. *The Itineraries of John Leland*. London. Repr. 1964.

Speed, J., 1611. *History of Britaine*. London.

Spencer, B., 1980. *Medieval Pilgrim Badges from Norfolk*. Norfolk Museums Service.

Spencer, B., 2010. *Pilgrim Souvenirs and Secular Badges*. Woodbridge.

Spurgeon, C. W., 2008. *The Poetry of Westminster Abbey*. Xlibris Corporation, USA.

Stanley, A. P., 1868/1911. *Historical Memorials of Westminster Abbey*. 2nd edn, 1868; 5th edn, 1911. London.

Stanley, A. P., 1880. 'On an Examination of the Tombs of Richard II and Henry III in Westminster Abbey', *Archaeologia* **45**, 309–27.

Stapleton, T. (ed.), 1846a. *Cronica Maiorum et Vicecomitum Londiniarum*. Camden Soc., old ser. **34**.

Stapleton, T., (ed.) 1846b. *De Legibus Antiquis Liber*. London.

St John, D. A., Poole, A. W., and Sims, I., 1998. *Concrete Petrography: A Handbook of Investigative Techniques*. London.

Stothard, C. A., 1817. *The Monumental Effigies of Great Britain*. London.

Stow, J., 1598/1603. *A Survay of London … written in the Yeare 1598*. 1st edn, 1598; 2nd edn, 1603. London. New edn, 1908 (ed. C. L. Kingsford). Oxford.

Stubbs, W. (ed.), 1879. *The Historical Works of Gervase of Canterbury*, vol. 1. Rolls Ser. **73**. London.

Stubbs, W. (ed.), 1882. *Chronicles of the Reigns of Edward I and Edward II, Vol. I*. Rolls Ser. **76**.I. London.

Strype, J., 1720, *A Survey of the Cities of London and Westminster*. 2 vols. London.

Sudds, B., 2008. 'Ceramic and Stone Building Material and Structural Remains', in T. Bradley and J. Butler, *From Temples to Thames Street – 2000 years of Riverside Development: Archaeological Excavations at the Salvation Army International Headquarters*. Pre-Construct Archaeology Monogr. **7**, 34–40.

Sudds, B., 2011. 'Building Materials', in A. Douglas, J. Gerrard and B. Sudds, *A Roman Settlement and Bath House at Shadwell. Excavations at Tobacco Dock and Babe Ruth Restaurant, The Highway, London*. Pre-Construct Archaeology Monogr. **12**, 103–18.

Summerly, F. [alias Henry Cole], 1842. *A Hand-Book for … Westminster Abbey*. London.

Sutherland, J., 2013. *Karystian Cipollino Marble: Its export from Euboea and its Distribution*. BAR International Ser. **2578**. Oxford.

Tanner, J. D., 1953. 'Tombs of Royal Babies in Westminster Abbey', *Journ. Brit. Archaeol. Assoc.* (ser. 3) **16**, 25–40.

Tanner, L. E., 1954. 'The Quest for the Cross of St Edward the Confessor', *Journ. Brit. Archaeol. Assoc.* (ser. 3) **17**, 1–10.

Tanner, L. E., 1969. *Recollections of a Westminster Antiquary*. London.

Tanner, L. E., and Clapham, A. W., 1933. 'Recent Discoveries in the Nave of Westminster Abbey', *Archaeologia* **83**, 227–36.

Tatton-Brown, T., 1998a. 'The two Great Marble Pavements in the Sanctuary and Shrine areas of Canterbury Cathedral and Westminster Abbey', in Fawcett 1998, 53–62.

Tatton-Brown, T., 1998b. 'Building with Stone in Wessex over 4000 Years', *Hatcher Rev.* **5** (45). Salisbury.

Tatton-Brown, T., 2000. 'The Pavement in the Chapel of St Edward the Confessor, Westminster Abbey', *Journ. Brit. Archaeol. Assoc.* **153**, 71–84.

Tatton-Brown, T., 2003. 'The Building History of the Lady Chapels', in Tatton-Brown and Mortimer 2003, 189–204.

Tatton-Brown, T., 2012. 'Porphyry', in P. Saunders (ed.), *Salisbury Museum Medieval Catalogue, Part 4*, 212–17. Salisbury & South Wilts Museum.

Tatton-Brown, T., 2015. 'The New Work: Aspects of the Later Medieval Fabric of the Abbey', in Rodwell and Tatton-Brown 2015a, 312–24.

Tatton-Brown, T., 2018. 'The Abbey's Building Blocks', *Westminster Abbey Review* **5** (2018/19), 10–15.

Tatton-Brown, T., and Mortimer, R., (eds), 2003. *Westminster Abbey: The Lady Chapel of Henry VII*. Woodbridge.

Tatton-Brown, T., Robinson, E., and Foster, R., 1997. *Cosmati Pavements in the Sanctuary and Chapel of Edward the Confessor*. Unpublished; copy in WAL.

Taylour, C., 1688. *A True and Perfect Narrative of the Strange and Unexpected Finding the Crucifix & Gold-chain of that Pious Prince St Edward the King and Confessor …* Ed. and publ. H. Keepe, London.

Thomas, J., 2008. *Dorset Stone*. Dovecote Press, Wimborne.

Thoresby, R., 1830. *Diary of Ralph Thoresby F.R.S*. 2 vols., ed. Joseph Hunter. London.

Thornbury, W., and Walford, E., 1897. *Old and New London: A Narrative of its History, its People and its Places* **4**. London.

Thornton, P., 1978. *Seventeenth Century Interior Decoration in England, France and Holland.* Yale.

Tristram, E. W., 1950. *English Medieval Wall-Painting: The Thirteenth Century.* OUP, London.

Tristram, E. W., 1955. *English Wall-Painting of the Fourteenth Century.* London.

Trivet, N., 1845. *Annales.* English Hist. Soc., London.

Trowles, T., 2008. *Treasures of Westminster Abbey.* London.

Tudor-Craig, P., 1986. 'The Medieval Monuments and Chantry Chapels', in Wilson *et al.*, 1986, 115–40.

Utsi, E., 2006. 'Improving Definition: GPR Investigations at Westminster Abbey', in J. J. Daniels and C. C. Chen (eds), *Proceedings of the 11th International Conference on Ground Penetrating Radar.* Columbus, Ohio, USA.

Vertue, G, 1770. 'A Dissertation on the Monument of Edward the Confessor. By Mr. Vertue, 1736', *Archaeologia* **1**, 32–9. [Republished as 'An Account of Edward the Confessor's Monument, by Mr Geo. Vertu. Read before the Antiquaries on 10 October 1741.']

Waelkens, M., De Paepe, P., and Moens, L., 1988. 'Patterns of Extraction and Production in the White Marble Quarries of the Mediterranean: History, Present Problems and Prospects', in J. Clayton-Fant (ed.), *Ancient Marble Quarrying and Trade: Papers from a Colloquium held at the Annual Meeting of the Archaeological Institute of America, San Antonio, Texas, December 1986.* BAR International Ser. **453**, 81–116. Oxford.

Walcott, M., 1873. 'The Inventories of Westminster Abbey at the Dissolution', *Trans London & Middlesex Archaeol. Soc.* **4**, 313–64.

Walcott, M. E. C., 1877. 'Early Statutes of the Cathedral Church of Holy Trinity, Chichester', *Archaeologia* **45**, 143–234.

Walkden, G., 2105a. *Devonshire Marbles: Their Geology, History and Uses. Volume 1 – Understanding the Marbles.* Geologists' Association Guide No. **72**. Geologists' Association, London.

Walkden, G., 2015b. *Devonshire Marbles: Their Geology, History and Uses: Volume 2 - Recognising the Marbles.* Geologists' Association Guide No. **72**. Geologists' Association, London.

Wander, S. H., 1978. 'The Westminster Abbey Sanctuary Pavement', *Traditio* **34**, 137–56. New York.

Ward-Perkins, J. B., 1992. 'Materials, Quarries and Transportation', in H. Dodge and B. Ward-Perkins (eds), *Marble in Antiquity: Collected Papers of J. B. Ward-Perkins.* Archaeological Monographs of the British School at Rome **6**, 13–22. London.

Warren, E. P., 1904. 'Discoveries at Westminster', *Archit. Rev.* **16**, 185–92.

Weever, J., 1631, *Ancient Funerall Monuments of Great Britain, Ireland and the Islands Adjacent.* London.

Weinbaum, M., (ed.), 1976. *The London Eyre of 1276.* London. Rec. Soc. **12**.

Westlake, H. F., 1916. ['Notes on a recent Examination of the Shrine of St Edward at Westminster'], *Proc. Soc. Antiq.* (ser. 2) **28**, 68–78.

Westlake, H. F., 1923. *Westminster Abbey.* 2 vols. London.

Whitbread, I. K., 1986. 'The Characterisation of Argillaceous Inclusions in Ceramic Thin Sections', *Archaeometry* **28**, 79–88.

Whitbread, I. K., 1989. 'A Proposal for the Systematic Description of Thin Sections towards the Study of Ancient Ceramic Technology'. *Archaeometry* **31**, 127–38.

White, J., 1993. *Art and Architecture in Italy, 1250–1400.* Yale.

Widmore, R., 1751. *An History of the Church of St Peter, Westminster, commonly called Westminster Abbey.* London.

Wilkins, D. (ed.), 1737. *Concilia Magnae Britanniae et Hiberniae.* 4 vols. London.

Wilkinson, J., 1997. 'Cosmati Pavement to be Conserved and Displayed', *Westminster Abbey Chorister* **3**(7), 14–18.

Williams-Thorpe, O., Jones, M. C., Potts, P. J., and Rigby, I. L., 2001. 'Geology, Mineralogy and Characterization Studies of Imperial Porphyry', in V. Maxfield and D. Peacock (eds), *The Roman Imperial Quarries: Survey and Excavation at Mons Porphyrites 1994–1998. Volume 1: Topography and Quarries*, 305–18. Egypt Exploration Soc., London.

Wilson, C., 1977. *The Shrines of St William of York.* York.

Wilson, C., 1986. 'The Gothic Abbey Church; The Patronage of Henry III', in Wilson *et al.* 1986, 22–69.

Wilson, C., 2008. 'Calling the Tune? The Involvement of King Henry III in the Design of the Abbey Church at Westminster', *Journ. Brit. Archaeol. Assoc.* **161**, 59–93.

Wilson, C., 2010. 'The Chapter House of Westminster Abbey: Harbinger of a New Dispensation in English architecture?', in Rodwell and Mortimer 2010, 40–65.

Wilson, C., 2015. 'A Monument to St Edward the Confessor: Henry III's Great Chamber at Westminster and its Paintings', in Rodwell and Tatton-Brown 2015, 152–86.

Wilson, C., Tudor-Craig, P., Physick, J., and Gem, R., 1986. *Westminster Abbey.* New Bell's Cathedral Guides, London.

Woodman, F., 2015. 'Edward the Confessor's Church at Westminster: An alternative view', in Rodwell and Tatton-Brown 2015, 61–8.

Wrapson, L., 2006. 'The Materials and Techniques of the c.1307 Westminster Abbey Sedilia', in J. Nadolny (ed.), *Medieval Painting in Northern Europe: Techniques, Analysis, Art History*, 114–36. London.

Index